W9-BQM-289

THE HISTORY OF FURNITURE

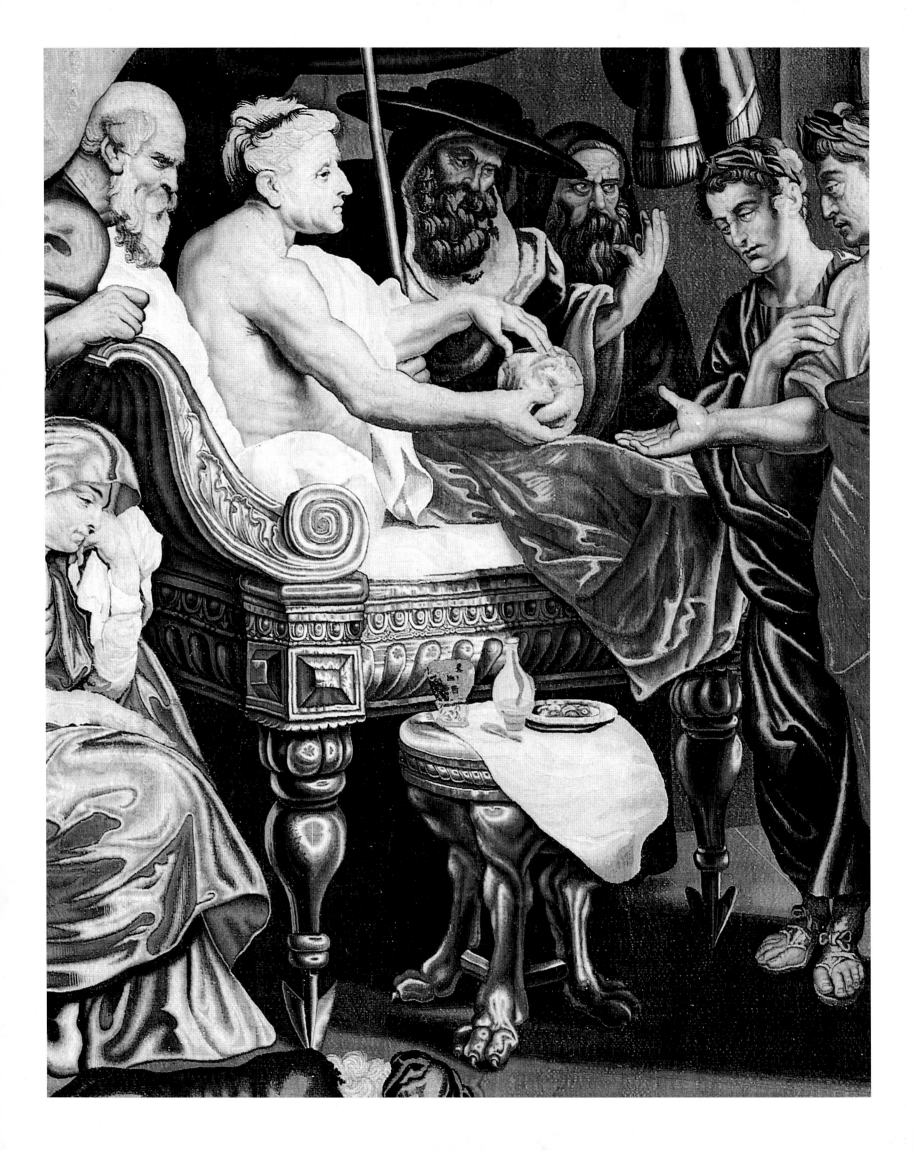

John Morley

THE HISTORY OF
FURNITURE

TWENTY-FIVE CENTURIES
OF STYLE AND DESIGN
IN THE WESTERN TRADITION

A Bulfinch Press Book

Little, Brown and Company

Boston • New York • London

For the Three Graces: Harriet, Emily and Alice

"Solomon saith, *There is no new thing upon the earth*;…
as Plato had an imagination, *that all knowledge was but remembrance*."

SIR FRANCIS BACON, LORD VERULAM

"…toujours les formes de l'ameublement se sont trouvées dans un accord parfait
avec le génie qui présidait aux inventions de l'architecte, du sculpteur, et du peintre."

PERCIER AND FONTAINE

"Damn the age! I'll write for Antiquity."

CHARLES LAMB

Frontispiece Furniture pictured in "The Death of Constantine," a wool and silk tapestry with gold and silver threads after a design by Sir Peter Paul Rubens; St Marcel Factory, Paris; French, 1623–25. The tapestry demonstrates how the researches of scholars and painters resulted not in accurate copies of ancient furniture but in furniture of a new type. Both the couch and the tripod table with lion legs are shaped generally after ancient Roman prototypes, but their ornament, although of ancient origin, has been reinterpreted by the Renaissance. That on the couch includes cabuchon bosses, convex gadrooning on the underside (a motif taken from Renaissance interpretations of antique sarcophagi and metal vessels), and fluting beneath the arm, the scroll of which has been misunderstood; the table has been given incongruous modern stretchers. Rubens was a noted antiquarian and collector, and these clumsy Renaissance interpositions must surely indicate the hand of an artisan executant rather than that of the connoisseur artist. This tapestry furniture remained in the medium of needlework, but many such imaginary re-creations were given corporeal form as real furniture.

In captions, the nationality given is that of the country of manufacture, not that of the designer or maker. Artefacts from England and Scotland are called "British" after the Act of Union, 1707.

Dates and principal occupations, where known, are given in the index.

First published in the United Kingdom in 1999 by Thames & Hudson Ltd, London

Copyright © 1999 by John Morley

All rights reserved. No part of this book may be reproduced in any form or by any electronic or mechanical means, including information storage and retrieval systems, without permission in writing from the publisher, except by a reviewer who may quote brief passages in a review.

First North American Edition
ISBN 0-8212-2624-X

Library of Congress Catalog Card Number 99-65084

Bulfinch Press is an imprint and trademark of
Little, Brown and Company (Inc.)

PRINTED IN SINGAPORE

Contents

Preface and acknowledgments

THIS BOOK TRACES THE OUTLINES of the development of furniture in the Western tradition from antiquity to the present day. The intention is to enable the reader to recognize influences which in some instances stretch back for more than two thousand years – indeed, some of the most important and persistent furniture motifs go back to the earliest days of civilization. Three ruling concepts – 'History', 'Style', and 'Design'– have governed the approach. 'History' describes the general nature of a particular society for which furniture was made. 'Style' describes the dominant visual culture that developed and changed as time went on, the sequence of styles – Gothic, Renaissance, baroque, and so on – that dictated the general appearance of furniture. 'Design' describes the way in which the components of a particular style, its forms, motifs and ornaments, were manipulated by craftsmen or designers to produce furniture of character and individuality.

Because it would be impossible to be comprehensive within the compass of one volume, this book concentrates on the centres of creation that invented the forms and motifs copied by others. In practice, this has meant an emphasis on ancient Greece and Rome and post-mediaeval Italy and France, although the story moves around as creativity springs up in different places. This concentration on the highways means that many fascinating, beautiful or interestingly idiosyncratic byways are neglected: vernacular furniture is totally ignored except where it influenced 'high-style' design. However, one hopes that the method followed here, which is devised to explain *why* a piece of furniture looks as it does, will provide sufficient information for readers to fill in the blanks themselves.

A glance down the Contents list will reveal that this book is organized stylistically rather than chronologically, a method hotly resisted by furniture specialists when proposed by the author for displaying the national furniture collections. However, it is no disgrace to follow the greatest of English historians, who 'consulted order and perspicuity, by pursuing, not so much the doubtful arrangement of dates, as the more natural distribution of subjects'. Chronology has also often been disregarded in placing illustrations; they have been put where they will make the most telling points about design.

The sources used present various hazards. Archives and inventories are useful, but their imprecise language and usual lack of pictures allow speculation free rein. Vases, sculpture, ivories, paintings, illuminated miniatures and other artefacts have all been used here to illustrate ancient furniture: the ravages of time and the disappearance of most old furniture make such expedients inevitable. They have major disadvantages. An artist's technique may make it hard to 'read' the furniture; or he may indulge in creative fantasy. Furniture depicted with holy or regal personages may be conventional to their status rather than real. People whose portraits are being painted may wish to appear grander (or sometimes more humble) than they really are; or they may be painted in company with imaginary furniture, or furniture that is studio props. Rooms portrayed in paintings have often been 'rearranged'; even photographs cannot be depended upon; every magazine that photographs interiors rearranges them beforehand. And real old furniture cannot be taken on trust: it may be partly replacement or fake, it may be

(probably has been) incorrectly or gaudily 'restored'. How do we begin to reconstruct the youthful appearance of a very old person whose face has been lifted countless times, who has put on an enormous amount of extra upholstery and had an arm and leg replaced?

In the earlier stages of this book the reader may well begin to wonder why on earth so much space is given to describing things – Egyptian pylons, Greek columns, Roman theatre awnings – that appear to have nothing whatsoever to do with furniture. The answer is simple: every feature, every motif, every ornament described within these pages, whatever its original source – religion, architecture, interior decoration, technique, personal hygiene – was sooner or later to be drafted into the service of furniture in the Western tradition and to be employed over and over and over again. Moreover, antique design ruled the roost not only at the Renaissance; it was returned to constantly. Antiquity revived its own archaisms, and even the innovatory nineteenth century fostered extensive revivals of the archaic antique.

Much space is given here to fashions that influenced both interiors and furniture. High-style furniture drew its style and design directly or indirectly from the interiors in which it was placed, thence passing new fashions down the social scale. The forms taken by furniture cannot be understood without reference to changing fashions in interiors, especially during and after the Renaissance.

The processes of design are always involved, but the problems of explaining them become formidable with periods which produced much high-quality work about which a good deal is known. It is only by over-simplifying and generalizing (two different things) that one can stagger through the complexities. It is like shining a torch on a small patch of a dark path: enough is illuminated to enable a foot to advance, but on either side lie areas of darkness where all kinds of things are going on. Over-simplification and generalization are legitimate provided the reader realizes that they are over-simplification and generalization. And exciting as it is to trace the adaptations and successive re-uses of motifs in furniture, the search is set with snares. A certainty of source is much more rare than might appear from a rapid perusal of the images in this book. The same or similar motifs or combinations of motifs appear in various cultures at various periods and they occur in diverse media – interior decoration, sculpture, painting, gems, mosaic, and so on. Given such multiplications, one needs hard evidence before one can be certain whence a particular furniture motif came. Usually, one can speak only of probabilities.

A word should perhaps be added. The author has throughout tried to restrict himself to conclusions drawn from the outward appearance of artefacts, from contemporary writings, and from historical events. This approach is unfashionable with those who prefer *licenza* in exposition – a recent criticism refers, for instance, to 'basic research' as the 'necessary substructure of the terrain', but adds 'a little speculation would have been welcome. I would even have welcomed some adventurous psycho-biography, particularly on the subject of Napoleon's sword.'[1] Napoleon's furniture is here given no 'adventurous psycho-biography'.

This book covers a long span of time and indulges perforce in guesswork; it must contain errors, omissions and

misjudgments. The author apologizes for them in advance. He thanks his wife for her elimination of most of the grammatical errors, and for her careful scrutiny of meaning. The National Gallery in Washington most generously supplied free transparencies, a great help when museum and library fees are rapidly making such books as this economically impossible for both author and publisher.

The author is greatly indebted to Professor Elizabeth Simpson, who subjected Part I, 'Antiquity', to a painfully meticulous vivisection from which it emerged quivering but relatively sound; any imperfections that remain are due entirely to his incomprehension or obstinacy.

He also wishes to thank M. Daniel Alcouffe, Don Ramon Aparicio, Don Alberto Bartolomé Arraiza, Mr Stephen Astley, Mr Anthony Beeson, Mr David Beevors, Doña Sofia Rodriguez Bernis, the late Professor Dorothy Blair, Dr Charles Burnett, Mr Stephen Calloway, Mr Giovanni Caselli, Doña Carmen Garcia-Frias Checa, Miss Wendy Cole, Mrs Jo Danzker, Doña Maria del Prado Dégano, Dr Gabriele Fabiankowitsch, Don Xabier Caracalla Bugarín Fianó, Mr Philippe Garner, Don Antonio Sánchez González, Mr Nigel Graves, Mr Håkan Groth, Frau Birgit Harlander, Mrs Eileen Harris, Dr Sabine Heym, Miss Elizabeth Horowitz, Miss Barbro Hovstadius, Herr Victor Hughes, Mrs Judy Irwin, Mr Danny Katz, Dr Dámaso de Lario, Dr Luca Leoncini, Mr Martin Levy, Mr and Mrs Ronald Lightbown, Professor Donald McDowell, Mr Max Oppel, Mr John Partridge, Mr William Rieder, Mr Christopher Riopelle, Mr Scott Ruby, Dr Sigrid Sangl, Dr Annette Scherer, Herr Ralph Stoian, Miss Marilyn Symmes, Frau Margitta Tretter, Miss Caroline Whitehead, Mr and Mrs Christopher Wightwick, Mr Christopher Wilk, Mr Angus Wilkie, Dr Paul Williamson, Dr Christian Witt-Dörring, and Mr James Yorke.

Terminology

BEFORE THE NINETEENTH CENTURY the term 'antique' was correctly applied only to ancient Greek and Roman artefacts, with some extension to Egypt. To avoid confusion this book follows that usage: 'antique' architecture, furniture, etc. here means only ancient Greek, Roman and Egyptian architecture or furniture. 'Modern' refers to the Renaissance and afterwards, and 'present-day' to the period that followed 1900. The terms used here of ornament are those of the art-historian, not those of the archaeologist – 'Vitruvian scroll' rather than 'running spiral', 'Greek key' (or fret) rather than 'meander'.

The author should here clarify his use of the word 'grotesque', a term invented in fifteenth-century Italy to denote Roman decorations found buried in 'grottoes'. Paradoxically, it is nowadays confined to non-antique 'grotesque', although up to the twentieth century it was used both of antique decorations and modern adaptations. The older, more comprehensive usage is resorted to here in order to avoid employing different terms for one genre of decoration, which is tiresome and can become confusing.

'Grotesque' is also applied here as an umbrella term to Roman interior decoration in general, including floor mosaics. This is not only convenient: it has some historical justification. Floors were published together with other 'grotesque' decorations; they shared their ornament with ceilings and walls; their motifs were utilized in concert with those of ceilings and walls by the same modern artists and craftsmen (in the late antique period the medium actually spread from floors to walls and ceilings). Mosaics were illustrated in the the 1757–92 'Antiquities of Herculaneum', the handbook of eighteenth-century grotesque; the most opulent of all the 'grotesque' books issued by the royal press at Naples was specifically entitled 'The decorations of the walls and pavements of the rooms of ancient Pompeii' (1796–1820).

It should be added that modern definitions of 'grotesque' tend misleadingly to restrict themselves to the bizarre and whimsical decorations (such as those of Raphael's Loggetta [138], influenced by the skimpier decorations of Nero's Domus Aurea) that have given the word 'grotesque' its usual modern meaning. A typical dictionary entry runs: 'a fanciful type of decoration confined to small, loosely connected motifs…including human figures, monkeys, sphinxes, etc.'[2] This implicitly excludes the harmoniously ordered, frequently stately decorations, ancient and modern, that might completely lack fantastic detail but were unquestionably called 'grotesque' – for five hundred years[3] – and which were imitated in the works of Algardi, Adam, Percier and Fontaine, and Schinkel, to name only a few of the most eminent practitioners of the genre.

The words 'arabesque' and 'moresque' also cause trouble. First invented by the Italians of the Renaissance to denote Islamic ornament, they refer to two different but related Islamic styles, that of the North African Arabs and that of the Spanish Moors. During the Renaissance both terms were used indiscriminately. In the early sixteenth century 'arabesque' motifs were absorbed into 'grotesque' decoration, and the two terms became, confusingly, interchangeable even where the motifs were recognizably different. More complications came when 'arabesque' from the 1690s onwards was applied generally to denote the synthesis of grotesque, arabesque and moresque that became rococo. Its use in that sense will be entirely avoided in this book (apart from where contemporary documents are being quoted, when its meaning will be made clear). To a certain extent the terms are 'paper tigers', since for the purposes of this book the differences between Islamic arabesque and moresque are largely immaterial, and the author has treated them as synonymous – although to avoid disconcerting readers interested in a particular period he has in those contexts inclined towards the usage most commonly adopted today by students of it (e.g., historians of the Renaissance now tend to favour 'moresque').

The decorative tricks played by antique and modern artists upon the 'herm', 'term' and 'caryatid' created capricious forms that defy orthodox description: irrespective of gender, all have here been generally called 'caryatid'.

The Argument

THIS BOOK describes the development and characteristics of furniture in the Western tradition. The form and ornament of high-style furniture follow those of architecture and interior decoration. Egypt, Greece and Rome are the most important influences on Western furniture styles. The furniture of ancient Greece followed Greek architecture in evolving from archaic simplicity to mannered elegance. By the first century AD a range of sophisticated furniture types perfected in Greece had been taken over and adapted by Rome. There were two opposing schools in Roman architecture and ornament – one preferred an august simplicity based on early Greek style, the other had a taste for the luxurious orientalizing styles of Hellenistic baroque. The creative tensions between them are most clearly seen in the contrast between the deliberate 'Greek revivals' of ancient Rome, which included revivals of ancient Greek furniture styles, and the orientalizing fantasy of 'modern' Hellenistic painted and stucco 'grotesque' interior decoration, which fostered new furniture types. The antithesis between these two main antique schools, categorized here as 'classical' and 'anti-classical', profoundly influenced interior decoration and furniture design during the centuries that followed the fifteenth-century Italian Renaissance.

The use by ancient Rome of Egyptian motifs is the first extensive instance of 'exoticism', the self-conscious re-creation by a culture of foreign motifs of alien character.

After the fall of the Roman Empire, most sophisticated furniture types disappeared in the West. The Eastern Roman Empire, however, remained in existence for a further thousand years, and its capital Constantinople continued to develop Roman late antique style. Little Byzantine furniture remains in being, but it is clear that three antique furniture styles survived and evolved at Constantinople: these were the 'encrusted' style, which had existed in fifth-century BC Greece; the 'turned' style, which had developed from late antique Roman turning; and the furniture style that used animal, human, and monster forms as decoration, a practice of great antiquity. All three were adopted by the magnates of Dark Ages Europe, to whom Byzantium represented fashion. The Byzantine turned style evolved into the characteristic furniture style of Romanesque Europe and has survived in vernacular form up to the present day. Romanesque furniture employed architectural motifs on a more considerable scale than had ever happened previously. Italy preserved late antique and Byzantine classicism through the Gothic period into the early Italian Renaissance.

When Islam became a power in the seventh century AD it took its art and architecture from Byzantium, transforming it into its own image. Islamic architecture emphasized verticality and was characterized by the pointed arch; its ornament was the abstract 'arabesque'. Both greatly influenced Gothic, the archetypal 'anti-classical' European style that arose in the twelfth century. Gothic furniture followed Romanesque in its extensive employment of architectural features: furniture in the advanced Gothic style is amongst the most 'architectural' that has ever existed. Gothic 'architectural' furniture co-existed with a continuation of the turned style and with practical 'knock-down' furniture.

The Renaissance produced a new style of art, architecture and interior decoration based upon antique Roman art and artefacts. Fifteenth-century 'antique' furniture was not copied from ancient furniture but concocted from ancient sources by a 'cut-and-paste' method. These sources included Roman architecture, triumphal arches, sculpture, sarcophagi and altars; made of stone and monumental in character, these gave the new style a 'Roman' classicism which continued throughout the sixteenth century. Renaissance classicism culminated in the early sixteenth-century school of Raphael, which reproduced antique furniture forms in its paintings; these forms were revived as furniture in sixteenth-century Italy.

Towards the end of the fifteenth century ancient Roman 'grotesque' decoration was rediscovered. It exerted a powerful influence on High Renaissance architecture and art; combined with Islamic 'arabesque' or 'moresque' ornament, grotesque gave rise to a new form of 'anti-classical' furniture that during the sixteenth century spread all over Europe. France, Flanders, and Germany influenced its development, which continued in the 'auricular' style of the seventeenth century. A host of new furniture motifs and themes were engendered from grotesque and arabesque, including strapwork, the cartouche, and the still life. In Italy, furniture was affected by mannerism, by the nascent baroque, and by the sculptural style (influenced by Hellenistic baroque sculpture) of Michelangelo and his followers.

The two great furniture styles of the seventeenth century were Italian baroque and 'Louis XIV' (French classical-baroque). The influence of Bernini encouraged the paramount role played in Italian baroque architecture, decoration and furniture by the aesthetics of sculpture. France's classical-baroque compromise succumbed at the end of the century to a new and deeply 'anti-classical' style – rococo, born of a marriage between grotesque and arabesque. Rococo sculpture, painting, and interior decoration shaped the curvilinear, 'organic' rococo furniture found throughout continental Europe during the first half of the eighteenth century; it largely abandoned antique architectural forms and ornament for the scroll and the cartouche. An element new to Western furniture – asymmetry – was introduced. The rococo was easily synthesized with Chinese and Japanese techniques and ornament; in England, it was combined with yet another 'anti-classical' style, Gothic, now extensively revived. Throughout the first half of the eighteenth century, furniture in two styles, classical-baroque and a style based on antique architecture, was used to furnish English Palladian houses.

In the late 1750s, antique and Renaissance grotesque decoration were extensively revived in England, France and Italy, continuing fashionable into the 1840s. Full-blown rococo furniture gave way to the 'rococo neo-classical' furniture of the later eighteenth century, in which grotesque decoration became three-dimensional. A greater awareness of early Greek architecture and Greek vases led to the entry into furniture of 'Etruscan' (Greek) motifs; these recurred throughout the nineteenth century. These new neo-classical styles were accompanied and succeeded by 'archaeological' neo-classicism, in the course of which the Renaissance re-enactment of antique furniture forms was re-played and extended; some new furniture more or less accurately copied antique furniture. Egyptian motifs and ornament were widely employed. The influence of 'elementary' geometric forms

became strong, especially upon 'Biedermeier' furniture. All these styles mingled and combined with each other.

The nineteenth century was above all the age of 'archaeological' revivalism and indiscriminate eclecticism; by the middle of the century, both held sway. Renaissance, rococo, baroque, and neo-classical styles were revived. The decline of taste and the ravages wrought by industrialism and by a new and ignorant clientèle provoked various reform movements, including the vernacular movement that grew out of 'Reformed' ('archaeological') Gothic. 'Japonisme'

influenced Arts and Crafts and Art Nouveau. 'Etruscan' and Biedermeier influences resurfaced at the end of the nineteenth century in the Viennese school, which contained the germs of the International Modernism of the twentieth century. Inspired by the machine, the twentieth century invented dogmatic functionalism, the influence of which minimized the forms and ornament available to 'functionalist' furniture; the functionalist fashion for built-in units greatly reduced the varieties of furniture in common use. None the less, the twentieth century continued to explore revivalism.

Introduction

A definition of furniture

What is furniture? The Oxford Dictionary defines it as 'Movable articles in a dwelling-house, place of business, or public building'; if we set aside the difficulty of moving very heavy furniture, this is fair enough. The Dictionary definition implicitly excludes fitted furniture, which becomes part of room decoration.

Furniture began by being simple. The multifarious types of furniture that exist today – dining tables, card tables, library tables, nests of tables, for instance – are luxurious elaborations of simple ideas. This underlying simplicity emerges from a definition less elegantly succinct and comprehensive than that of the Dictionary: namely, furniture consists of things to put people on, things to put things on, things to put things in. In other words: the seat or bed in all its forms, from the milkmaid's three-legged stool, made low so that she can get at the belly of the cow, to the royal throne, set high so that monarchs dominate their subjects; the table in all its forms, from the teak garden trestle to the silver pier tables of Louis XIV; the container in all its forms, from the painted kitchen dresser to the baroque secretaire of tortoiseshell, ebony and gilt bronze. Much furniture performs more than one of these basic functions – the enclosed seat holds the miser's money box, the bed has cupboards in its base to hold blankets – but the classification by and large holds.

Utility: the influence on furniture of social use

As soon as we ask what furniture is, the question of its use comes to the fore. The word 'utility' has a barren sound, a reflection partly of the arid doctrines of 'utilitarianism' and partly of a depressing British style of the Second World War. Primitive utility does tend to austerity; one might again cite the stool of the milkmaid, which has three gawky legs splayed out to stand firmly on the uneven ground of the farmyard. However, there is nothing necessarily austere or puritanical about utility: the word really means 'fitness for purpose', and the purposes of the Emperor Heliogabalus differed from those of Jude the Obscure.

For some uses, furniture positively needs to be splendid. Rich furniture has the function of demonstrating wealth and power, it is a weapon in the battle for status. The idea that beauty and splendour may have utility is resisted by some people. Nothing more aroused the spleen of Pericles' enemies than 'the money…lavished by the Athenians in gilding their city, and ornamenting it with temples, and statues that cost

1,000 talents, as a proud and vain woman decks herself with jewels'.[1] The fame of those temples and statues, two and a half millennia later, was a powerful factor in the creation of modern Greece and a 'Greek' people. France has never forgotten the aulic pomp of the court of Louis XIV; 'la gloire' supports a national self-confidence engendered by a great national culture. The centuries-old search for splendour and novelty has led to the design of artefacts that are fragile or overweeningly massive, delicate, impractical, difficult to clean, such whimsical creations as the eighteen-foot high, befeathered baroque bed [261], full of dirt and (in its period) bugs, or, at another extreme, the blown-up transparent plastic chair, permanently dusty with static electricity and liable at any moment to a deflating puncture.

Particularly significant has been the influence on furniture of religion, poetry and government. Religious and secular rule were frequently identical, or almost so: pharaoh was divine; the ancient Roman emperors were *pontifex maximus*; in the twelfth century the post-antique Empire became 'Holy' as well as being 'Roman'. In ancient societies poetry and religion were virtually the same thing. When Montaigne in the sixteenth century wrote that 'Antient Divinitie is altogether Poesie…it is the original language of the Gods'[2] he was only repeating what had been written in the fifth century BC by Herodotus: 'Homer and Hesiod are the poets who composed our theogonies and described the gods for us, giving them all their appropriate titles, offices and powers.'[3] The religious emblemism that permeated myth and poetry found its way into architecture, ornament, interior design and furniture. Some of the most prominent types of ancient furniture were connected with religion, and were to be found in the house as well as in the temple. One especially influential example is the ancient Greek and Roman tripod [10].

Secular hierarchies used furniture to denote status. The seat has in particular always been significant; its rejection or acceptance might be as symbolic as the taking off or putting on of a crown. In the eighth century BC, Hesiod recounted that the goddess Demeter, grieving for the rape of her 'trim-ankled' daughter Persephone by the King of the Underworld, renounced the privileges of divinity; she refused 'the bright couch' and instead stood humbly by until 'careful Ianthe placed a jointed seat [the humblest type of seat] for her and threw over it a silvery fleece'[4] (the fleece had been taken from the rejected couch, the grandest form of domestic seat). Two thousand years later, in the France of 1701,

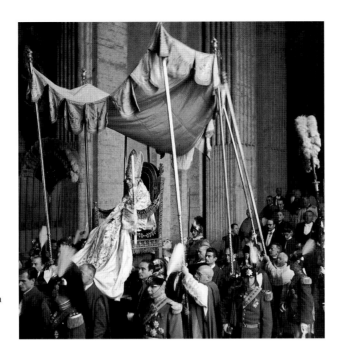

2 His Holiness Pope Pius XII (pope 1939–58) enthroned aloft on the papal *sedia gestatoria*, beneath a canopy and accompanied by ostrich-feather ceremonial fans.

Materials and techniques

The substances of which furniture is made may be simple or luxurious, refractory or easy to work, colourful or monochromatic.

All kinds of materials have been employed. The most common is wood. Others include stone, from limestone to figured and coloured marbles and quartzes and the sumptuous porphyry that is so hard that it could be fashioned only with stone tools; metals, from gold, silver and bronze to brass and lead; the skins of cows, sheep, sharks, antelope, a complete menagerie of animals and fish, even insects, the wings of butterflies and the carapaces of beetles; shells, corals, ivory and bone; glass; straw, both as a veneer and as a structural material; paper and papyrus; precious and semi-precious stones; even coal. The basic incompatibility of certain materials inhibits their alliance; a conspicuous instance of defiant impracticability was the opulent furniture of Boulle [255], in which a civil war between brass and tortoiseshell began as soon a piece left the workshop.

For monarchs and magnates, furniture made of precious metals was entirely appropriate. In a period when silver and gold were scarcer than they later became, Charlemagne (*c.* 742–814), the restorer of the Roman Empire, made a will which records his possession of 'three tables made of silver and a particularly big and heavy one made of gold'. Three are described: the first, 'which is square in shape and on which is traced a map of the city of Constantinople', was bequeathed to the papacy; the second, 'which is circular and which is engraved with a map of the city of Rome', was bequeathed to the bishopric of Ravenna; the third, 'which is far superior to the others, both in the beauty of its…workmanship and its weight, and on which is engraved in fine and delicate tracery a design which shows the entire universe', was left to Charlemagne's heirs.[9] The subjects with which the tables were ornamented – Constantinople, Rome, and the world – were much more than a decorative 'travelogue'; they were invested with political ambition; the silver and gold on which they were engraved forcibly conveyed the power of the revived Empire.

Rich textiles accompanied rich furniture; essential in giving an impression of luxury, they were often subject to sumptuary laws. Gold and silver thread made textiles even more sumptuous; at the Revolution the tapestries of Versailles were burnt in the courtyard for the sake of their gold. Until well into the nineteenth century, the finest textiles were usually more costly than carved and gilded furniture. Colour also was significant. 'Purple' (nearer to the modern crimson) was the royal colour: the Empress Theodora, urged to flee by her trembling husband from insurgent Constantinople, declared that he could do as he wished: for her part, 'purple was a very good colour for a shroud'.[10]

Technique is as important as materials. Furniture may be born of an idea, but the idea is incarnated in particular techniques used with particular materials; craftsman and designer work together; quite often the two are combined in one person. According to Sir Francis Bacon (1561–1626), that disenchanted analyst, the 'mechanical arts and merchandise' characterize 'the declining age of a state'.[11] His observation was borne out in the nineteenth century, when the technical advances of the Industrial Revolution coincided with the vulgarizing effect of what contemporaries called 'commerce'. In these circumstances handiwork assumed a symbolic importance, a demonstration of

Madame de Maintenon sat in an armchair in Louis XIV's presence; since the etiquette of Versailles dictated that nobody save the Queen sat in an armchair when the King was in the room, the King's secret marriage to a parvenue became apparent: the Duchesse d'Orléans, the King's sister-in-law, a haughty German, indignantly asked her husband 'how it comes about that I am offered only a footstool when visiting the Dame [Madame de Maintenon]…the lady…is allowed [a chair] because of her bad health. In this way nothing is said as to whether she is the Queen or not, but at the same time she takes her rank.'[5] In other circumstances the despised footstool itself became a badge of rank, since duchesses sat on it in the King's presence whilst others stood: Madame de Sévigné called it 'the divine *tabouret*'.[6]

Such is the conservatism of furniture design that forms evolved in the service of pagan gods and aristocracies are still employed today. An august survival only recently discarded was the *sedia gestatoria*, a portable throne accompanied by fans and a canopy [2] that had shielded the autocrats of the ancient empires of Nineveh and Tyre from the Eastern sun; adopted by the orientalizing emperors of Rome, it was subsequently taken over by a triumphalist papacy. Only in the 1970s was a piece of furniture used by Hammurabi, Darius, Diocletian, and Pope Alexander VI abandoned, a victim of 'religious correctness'. In use, it had swayed above the faithful like a ship, heralded and followed by lofty ostrich-feather fans; no more dramatic piece of furniture has ever existed. Another chair of state, the type originally constructed as a folding X, has survived in dignified use from ancient Greece and Rome [60] through the Dark and Middle Ages [87, 103], the Renaissance and baroque periods [182, 183], Napoleonic France [523] to present-day royal Britain and papal Rome. When his rule was tottering, Napoleon asked: 'Do you imagine that I consider the throne as nothing more than a piece of velvet spread over trestles?'[7]

Such ancient forms drift down the social scale. For example, the mediaeval Coronation Chair of the English monarchs (which until recently held in its base the Stone of Scone, itself probably a prehistoric 'coronation' seat) was imitated in Gothic Revival chairs that held the bottoms of nineteenth-century municipal dignitaries and other 'chairmen'.[8]

craftsmanship as opposed to factory production, and an end in itself; the reaction against indiscriminate ornament encouraged a particular type of doctrinaire utilitarianism, which was given the moral sanction of 'honesty'. The craft movement made the outward display of constructional techniques a dogma; every effort was made to eliminate 'meaningless' decoration. Despite which, the serpent of ornament raised its deathless head, and the constructional techniques exhibited to emphasize 'integrity' became unnecessarily ostentatious – and therefore ornamental!

Style and fashion

Furniture is judged to be of a particular period or country by its style. The word 'style' implies change or variety: if the form of a chair were constant and unchanging it would become superfluous to speak of its 'style'; 'chair' would be sufficient for all purposes, as 'grass' (occasionally qualified with the word 'rye') is sufficient for the British suburban gardener (the African of the savannah is said to have a hundred different words for 'grass').

As cultures become more affluent, styles and types multiply; the few ancient Greek words for different types of seat, half a dozen or so, have increased into the hundreds that exist in modern European languages. New terms and types constantly appear. A twentieth-century instance is the low 'coffee-table'; low tables are a new concept in the modern European tradition, and people who want 'Louis' coffee-tables are driven to convert eighteenth-century bidets, an adaptation that might make one pause as one raises the cup to one's lips. The form is still changing; the long, narrow coffee-table of the 1950s became much wider to accommodate the 'coffee-table book', made for show as much as to be read.

And so it goes on, since over the last few centuries style has succumbed to its fast, not to say whorish, acolyte – fashion. If the word 'style' implies change, 'fashion' implies rapid change. Fashion is competitive; it began to mature only with the beginnings of a 'consumer' society in the early eighteenth century, and for long was confined to the upper classes. Conspicuous display is not inevitably accompanied by 'fashion'; fashion did not influence the shape or decoration of the dazzling contents of the tomb of Tutankhamun [4], and even today true regality is thought to be 'above fashion'. Innovations do not improve coronations, courts of justice or academic processions. In ancient Egypt furniture styles remained basically unchanged for thousands of years; in the Europe of the nineteenth century they changed every twenty years, and if impermanent materials become as acceptable for furniture as they are today for clothes (George Eliot somewhere remarks that a farm labourer once expected his son to inherit his corduroys after a lifetime's wear) there is no reason why a fashionable household should not change its furniture every few years – or every month. There have been false dawns of this kind of furniture already.

The influence of architecture, sculpture and painting

Since ancient times, style in Western furniture has followed architecture, sculpture, painting and the interior decoration that often unites motifs from all three. The most inventive minds in the visual field have been those of great painters and architects; their new ideas have been eagerly picked up by lesser artists, including gardeners, potters, and designers and makers of furniture. Many painters and architects have designed furniture: it is probable that Phidias and Raphael did; Bernini and David certainly did.

Furniture evolved from being an isolated object made for a utilitarian purpose to becoming a component of a designed setting, indoor or outdoor; sometimes, indeed, it loses all functions save that of decoration – some Adam commodes are empty shells. Style becomes all-pervading, and individual objects, including furniture, are designed to accord with it. The Renaissance interest in the individual artist has preserved their names and doings, making the process clearer. Modern artists became archetypes of their periods: Raphael of High Renaissance classicism; Michelangelo of Counter-Reformation expressionism; Rubens and Bernini of seventeenth-century baroque; Algardi and Le Brun of baroque classicism; Watteau of French rococo; David of post-rococo neo-classicism; Schinkel of Romantic neo-classicism. All influenced furniture design. And as they encapsulated their own periods, so they contained the germ of future developments; Raphael contained the baroque and David the Romantic.

As style in architecture and painting is subject to revivals, so it is in furniture; a revival of antique, Gothic or Renaissance architecture is accompanied or quickly followed by a revival in furniture styles of the period. There is usually a sea-change; conscious archaisms give birth, willy-nilly, to new styles, usually by some process of synthesis. At a stage of extreme sophistication (or creative exhaustion), eclecticism and an interest in 'antiques' appears.

Beauty

New styles and fashions are adopted because they are thought to be beautiful. The aesthetic impulse appears to be fundamental – 'the urge to decorate…is one of the most elementary of human drives, more elementary in fact than the need to protect the body'.[12] There are instances of what appears to be aestheticism amongst animals, like the bower made by the bower bird for courtship or display. Man is a bower bird, and even the most primitive domestic objects were made in accordance with an aesthetic idea, however crudely expressed. Beauty may be simple or elaborate; on the one hand stand the klismos [28] and a Queen Anne chest [522], on the other, the Egyptian throne [4] and a Dubois secretaire [579].

Since at least the time of Plato, an idea of permanence has been attached to 'beauty' that has nothing to do with 'fashion'; 'timeless beauty' is understood by all, but 'timeless fashion' is paradoxical. Ancient Greece gave beauty a high place: Apollo, the god of the arts, was also the god of the sun, of the light whence comes vision itself. Of very little furniture can it be said that it has a 'timeless' beauty; furniture does not carry such a weighty significance. The qualitative judgment implied by the modern distinction between the 'fine' and 'applied' arts has reason behind it. An old term for the applied arts is the 'ornamental arts', which is in some ways more descriptive. Ornament is often beautiful, and is more timeless, less bound to a particular period, than form. It is for that reason that this book devotes so much space to describing ornament.

overleaf 3 Greek furniture, including (centre row) klismos chairs, a throne with three-dimensional erotes, scrolls and finials, a turned stool and a multiple X-frame stool; and (bottom row) an X-frame stool with Medusa head, a stool and a table; from a volute krater called the 'Darius Vase' [60], Apulian, *c*. 425 BC.

4 The ceremonial chair and footstool of Tutankhamun, in ebony covered partly in gold foil, inlaid with ivory, glass, faience and coloured stones; Egyptian, *c*. 1320 BC.

THE INTER-RELATIONSHIPS OF ANTIQUE ART make it sensible to discuss the antique – Egypt, Greece and Rome – as a whole; the art of Egypt has much in common with that of Greece and Rome, and has been utilized in antique-based decoration in both ancient and modern times. The most striking fact about virtually all post-antique furniture in the European tradition is that it either directly reflects antique design or is a development from it; this is true even of such highly idiosyncratic styles as 'moresque', Gothic and rococo. The forms and ornament of an extraordinarily high percentage of this post-antique furniture are inspired by antique architecture, antique sculpture, antique interior decoration, or antique furniture itself; a piece frequently combines motifs from all these sources. For these reasons it is essential to know something of antique design before attempting to understand the furniture design of later periods.

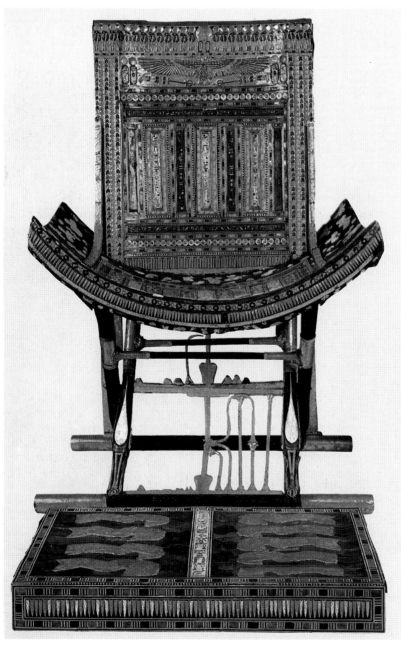

The nature of ancient furniture

Occasionally the arts of ancient Egypt, Greece, and Rome exhibit similarities that arise from cultural interchanges: Egypt influenced Greece, Greece influenced Egypt, and Egypt and Greece influenced Rome. Political events helped; Alexander the Great added Egypt to his Greek empire, which collapsed at his death in 323 BC leaving a Greek dynasty – the Ptolemies – in control of Egypt; the 'Hellenistic' art of Alexander's former empire remained in being, with Alexandria and Pergamon as its centres. Between about 150 and 50 BC the Romans conquered Greece and its southern Italian colonies, having already absorbed Etruria, whose arts were partly dependent on Greece. Augustus, the first Roman 'emperor', conquered Egypt. Everything then came together in Roman art, which displays in full measure the deliberate archaisms and exoticisms of an empire that, spreading from Mesopotamia to Britain, recognized peoples of all origins as its citizens and accepted Spaniards and Africans as its emperors. The visual arts of Egypt, Greece and Rome reached an elevated, at times supreme, level, though Rome has been condemned as a brutal and decadent society – a criticism that early nineteenth-century Greek Revivalists had more right to make than the twentieth century, brutal and decadent on a scale never approached by ancient Rome.

The imagination finds it difficult to encompass the majestic unchangeability of Egyptian architecture and art. Other appurtenances of life, dress and furniture, for example, shared this immobility. The basic forms and decoration of Egyptian furniture endured largely unaltered from about 2600 BC – before the building of the Pyramids – to beyond the Ptolemaic period that ended with Cleopatra's suicide in 30 BC, a span of time equal to the distance between the end of the European Bronze Age and the New Millennium of AD 2000. Greek and Roman furniture enjoyed a long if less continuously extended life. During the 'archaic' period, the period in which Greek classicism came into being (700–500 BC), new forms of furniture replaced or supplemented shapes borrowed from Egypt and the Near East; this furniture, strikingly different in spirit and form from the old, is strongly and individually 'Greek', having little in common with the Mycenaean furniture that had immediately preceded it. By 500 BC most of the basic forms of Greek furniture had been invented.

Greek forms and ornament were inherited by Rome. Many of the same types of chairs, couches and tables as those used in Greece, Asia Minor, southern Italy, and southern Russia from the sixth to the second century BC spread during the first three hundred years of the Christian era into Italy, Gaul, Britain, North Africa and the East. Roman furniture shows influences other than Greek, such as motifs from Etruria and from the Greek-influenced style of the Ptolemies. However, many artists working in Italy were expatriate Greeks, and certain Roman emperors nurtured conscious 'Greek revivals' which affected all the arts, including furniture (p. 22). The Greeks were both admired and despised by the Romans, whose sneers at the Emperor Hadrian and his Greek proclivities were couched in the same terms as the jibes directed in 1807 at the French and Italian designers of the English King George IV: 'we confess we are not a little

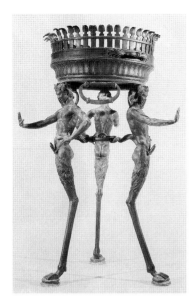

5 A bronze tripod brazier on satyr legs found at Pompeii; Roman, first century AD.

right 6 A 'turned' throne with lion legs, sculptured feet and 'tassels', depicted on a ceremonial doorframe; Persian, sixth century BC, published in Paris in 1719–24 by Bernard de Montfaucon (from *L'Antiquité expliquée*).

7 Detail of a couch showing 'orientalizing' ornament, including Persian-type 'tassels', a sheepskin cover, and a stool, from a south Italian ossuary, second century BC.

proud of the Roman spirit, which leaves the study of [these] effeminate elegancies to slaves and foreigners…'[13]

The collapse of the Roman Empire was followed by antique revivals in an order that reversed that of the styles they revived: thus the antique revival of Charlemagne reflected late antique art; that of the Renaissance reflected classical Roman art; those of the eighteenth and nineteenth centuries reflected Greek and Egyptian art. The twentieth century has turned to primitive art.

Evolution of basic types

Furniture in the form we have it seems obvious enough, but was not inevitable; even now, some peoples rely on cushions and carpets. Beds, couches, tables, chairs – most of the basic forms we use today have been inherited from remote antiquity.

The couch or bed existed in Egypt by 3000 BC. People slept and reclined on couches that were sometimes completely covered with mattresses and fabric. In post-Homeric Greece it became a mark of distinction to recline at meals, as it eventually did amongst the well-to-do in Rome: 'now we have reached such a pitch of effeminacy as to lie down at our meals'.[14]

Successive refinements brought the chair (developed originally from the backless stool) to a point of extreme sophistication. The Egyptian high-backed chair had appeared by 2800 BC and the double armchair by 2500 BC; by 1800 BC an inclined back-rest had been added to the vertical stile [8]; by about 1500 BC the concave back, curved arm and rounded stretchers were common. No state chair has surpassed the Egyptian for hieratic grandeur [4], as no domestic chair has surpassed the Greek klismos [28] for beauty and utility. The most splendid of chairs was the 'throne' [6]; in Greece the word *thronos* became synonymous with royal power; the epithets attached to it include 'high, gleaming, golden, silver-studded, many-coloured, beauteous, strewn with purple coverlets'.[15] Thrones were also used in wealthier private houses.[16] Specialization reached a point where couch making became a trade distinct from chair making,[17] a distinction similar to those observed in eighteenth-century France.

Stools and footstools [29, 4] were common in antiquity; cushions were sometimes used as footstools. Benches (a long seat with a back) were also in existence; none appear on Greek vases or reliefs, but the marble seats in amphitheatres and gardens are sometimes benches, occasionally in the form of klismoi joined together or extended into a graceful arc. The ottoman's Turkish name belies its history: it was in Knossos ages before the Turks were heard of.

Tables are an ancient form, well developed by Egyptian and Greek times. The Greeks had few possessions, so there were only a few types of table. The rectangular tables shown beside Greek couches in surviving bronzes and terracottas usually had three legs [26]; they were portable, used for serving meals. Homer records that Hephaistos, the smith-god, made a set of twenty three-legged (metal) tables that ran by themselves (on wheels) to a meeting of the gods and back again.[18] Some tables had four legs; they were often given bracing stretchers in Egypt and Greece. The round table on three legs seems to have been a fourth-century BC Greek invention. The Greeks and Romans had an important piece of three-legged furniture lacking in the modern world, of which the forms acted as prototypes for much modern furniture – the tripod [5, 10, 42] supporting a cauldron or brazier used for both religious and domestic purposes.

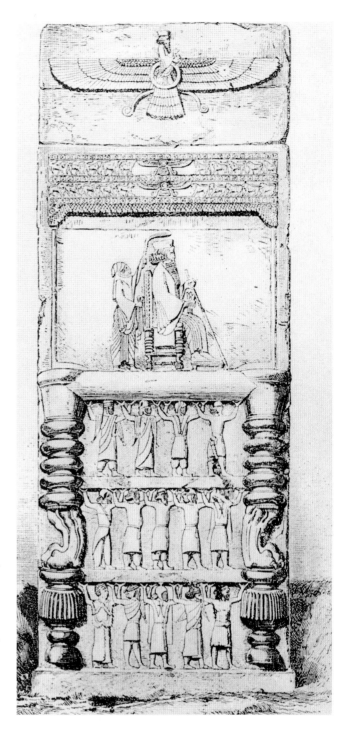

Chests (without drawers), cupboards and sideboards existed in antiquity [9]. Some were highly elaborate; Pausanias devotes eight (modern) pages to the scenes in cedarwood, gold and ivory on an ancient chest in the Temple of Hera at Olympia.[19] Greek and Roman sideboards displayed costly and glittering gold and silver plate [25] in much the same way as did the Renaissance buffet or the eighteenth-century sideboard. Etruscan and Roman candelabra looked much like the modern standard lamp [45]. Even the smaller conveniences of life could be found, such as the tray.[20]

It would be perfectly possible to exist in luxury today using only the furniture of two thousand years ago. Antique forms have been elaborated upon in modern times, and specialized modern items such as dressing tables or desks combine several functions in a way foreign to antiquity, but a drawing room furnished entirely with Roman furniture would today be completely acceptable in function and, even more amazingly, in style; it would look self-conscious, perhaps, but at the same time 'high-style', distinguished.

8 An Egyptian chair with a sloping back.

Techniques and materials

The techniques and materials used for furniture have enjoyed a remarkable continuity since remote antiquity.

Primitive furniture is often made of plaited and woven straw and withy and the same materials, in basically the same shapes, are still in use; Romans sat in basket chairs [520] that could have been made today. However, wood was the material employed for the earliest substantial furniture, and when one thinks of furniture wood still comes first to mind. It easily decays, and ancient wooden furniture – apart from that of Egypt, preserved in large quantities and excellent condition in the dry air of Egyptian tombs [4] – survives only exceptionally. Ancient furniture made in bronze and stone, usually after wooden prototypes, exists in quantity, and depictions of it in stone bas-reliefs and statuary, or painted upon the terracotta of Greek vases, provided a clear record of ancient furniture long before the advent of archaeology. After the collapse of the Roman Empire, when existence itself became primitive and precarious, little furniture was made and less has survived.

Wood comes in multifarious varieties, ranging from the common pine, soft and fibrous, to the uncommon ebony, dense, smooth, and, when polished, darkly glittering. Egypt was rich, and employed many different woods – from native trees such as acacia, almond, fig, date palm, tamarisk, willow and poplar, to exotic timbers such as 'African ebony' (dahlbergia), cedar, ash, beech, oak, yew, elm and cypress. Literary sources reveal a similar choice in Greece and a wider choice in Rome.

The basic joinery techniques were much the same fifty centuries ago as they are today. By about 3000 BC the Egyptians had at their disposal techniques that included the mortise and tenon joint, the dowel, and carving, and tools that included the adze, chisel, saw, awl, and bow-drill; metal tools were confined to copper, since the earliest Egyptian furniture preceded their Bronze Age. When bronze did appear, it was used for tools and nails. By 2000 BC the number of joints available included dovetails, halving joints, shoulder-mitres and double shoulder-mitres.[21] Vegetable gums were used before the discovery of animal glue; the latter was common by 1500 BC. Early furniture can look remarkably timeless: an Egyptian chair [8], wooden with a seat of woven string, with slats in the back and stretchers in the legs, held together by mortise and tenon joints and secured by dowels (which also provide decorative circles), has as its only specifically Egyptian feature its form of back, supported behind the slats with a vertical member going down to the seat.

9 A chest containing money with a miser sleeping on it: detail from a kalyx krater signed by Asteas; Greek (Paestum), c. 345 BC.

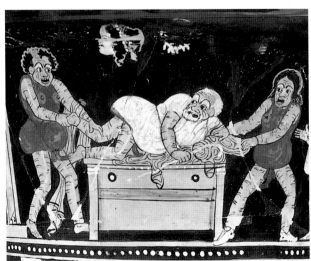

The size of a piece of wood is limited by the size of the tree whence it came, and at an early period the technique known as 'panelling' was evolved; this permitted much larger assemblages than the size of a single wooden plank allows, and also helped to avoid the splitting that results when wood is joined in a way that inhibits the natural shrinkage and expansion caused by changes in humidity. Panelling became a common technique in the construction of wooden artefacts, from coffins to houses and their interiors. Plywood was an ancient technique: a coffin from the Step Pyramid at Saqqara (2700 BC) is made up of six thin layers of wood held together by wooden pegs, with the grain running in alternating directions just as practised today.[22]

Turning,[23] another influential technique, differs from panelling in that it was evolved as decoration, not as construction (unless the lessening of the weight of a piece of wood be so interpreted). It was in use by the second millennium BC; Plato mentions the wood-turning lathe.[24] The bow-drill and the making of pottery by revolving motion had been long known in Egypt, and perhaps the principle was applied in some way to the 'turned' legs of Egyptian stools.[25] Persian furniture was profusely turned [6], and by the end of the sixth and the beginning of the fifth century BC the turning of Greek couches was very accomplished. Turned materials on furniture come in many guises, including shallow reeding, gentle convexities, fat superimposed globes [21], 'wave–moulding' [249], and single and double 'twists' [267, 268]. The process of turning has a fascination that has made it the hobby of princes, both in antiquity and in the modern period.

It is not known when 'bentwood', the shaping of wood by heat and moisture in the form of steam, was invented. Some Egyptian stools and tables shown in paintings look as if they were braced by bentwood, but no example has survived. It had probably appeared by the time the graceful leg of the klismos had been evolved[26] (whether or not the klismos employed bentwood). Bentwood was used for wheels; wheelwrights made furniture in the Middle Ages [73], and may have included bentwood parts.

Metals, including precious metals, were used to make and decorate furniture from an early date. A cuneiform tablet of c. 1390 BC that lists furniture sent as a present by the King of Egypt to the King of Babylon mentions beds, chairs and footstools of ebony overlaid with gold; another speaks of bedsteads of pure silver.[27] In the extravagantly luxurious tent of Ptolemy Philadelphus (309–246 BC) were 'golden Delphian tripods, having pedestals of their own', with 'golden couches, with feet made like sphinxes…a hundred on each side' and 'tripods for the guests, made of gold, two hundred in number,…and they rested on silver pedestals'.[28] Some precious furniture, if the tales be true, was incredibly sumptuous, like the 'table of solid silver twelve cubits round' mentioned by Athenaeus in about AD 230.[29] Less luxurious furniture was made of baser metals; Thucydides says that after a battle of 427 BC beds were made of bronze and iron and dedicated to Hera.[30] The couch made entirely of metal seems not to have existed in antiquity; some wood was always used for convenience.[31] The metal was usually hollow-cast, and the different components joined together.[32]

The most economical way of giving furniture that precious golden appearance was to gild it, to cover a baser material with a thin sheet of gold. Gold leaf can be beaten so thinly as to disappear without trace when rubbed in the palm of the hand, and the Egyptians could beat precious metals to an extreme thinness; the Greeks 'were able to beat out silver

DÉTAILS ROMAINS. *AUTELS, TREPIEDS, CANDELABRES, LAMPES, MEUBLES.*

10 Roman altars, tripods, candelabra, lamps and furniture, published in Paris in 1802 by J. N. L. Durand (from *Recueil et parallèle des édifices de tous genres, anciens et modernes*). The superimposed letters relate to points made in the text.

till it was as thin as a piece of skin'.[33] However, much ancient furniture was gilt not with gold leaf but with thicker gold foil or sheeting, which gives an impression of heavy sumptuousness. The discovery of the tomb of the young pharaoh Tutankhamun (d. 1352 BC) in 1922 gave an astonished world examples of the extraordinary richness of undespoiled ancient Egyptian furniture [4] This came early in time – the late Bronze Age, when even the king of Egypt possessed only one small iron-bladed dagger.[34]

Ivory was one of the most valued of substances, employed extensively on furniture from the earliest times. Phoenician ivory furniture mounts (stylistically influenced by Egypt) were often inlaid with semi-precious stones or glass and leafed with gold. The ivory appliqués from couches found in the tomb of Philip II of Macedon[35] combine realism with an ideal beauty. The high-ranking Roman X-frame chair became known as the *sella eburnea*, the 'ivory chair'. Ivory was costlier than silver, which at some periods was costlier than gold: the Roman satirist Juvenal, writing in the reign of the Emperor Domitian (AD 81–96), said that 'our rich Gluttons take no pleasure at a Feast…unless a huge Pedestal of Ivory bears up the wide Circumference of your Table, supported by a lofty Panther, gaping with his wide Jaws, carved from the Teeth of Elephants.…A Table with a Silver Foot they scorn, as they would to wear upon their Finger an Iron Ring.'[36] Ivory and gold together, 'chryselephantine', was the most precious of combinations, worthy of Phidias'

celebrated statue and throne of Zeus; the white-painted and gilded furniture characteristic of modern European palaces and great houses echoes that august alliance, so often celebrated in ancient literature.

Veneering, one of the most prominent forms of decoration, involves the overlaying, usually gluing, of choice woods over more ordinary woods; the technique dates back to before 3000 BC. A bed of about 1400 BC[37] has veneer a quarter of an inch (6 mm) thick fixed with pegs. Ivory and bone were both used as veneers, sometimes together [12]. Tortoiseshell, a material with a beautiful figure, was employed by 100 BC as a veneer on couches, combined with silver, gold and jewels. Ebony and other woods served the same purpose; curly maple was highly prized. The figure was brought out by polishing with the rough skins of skate lubricated with cedar and juniper oil (both of which smell sweet). Exotic woods were described as 'like a peacock's tail'.[38] Cicero gave half a million sesterces (a member of the Senate had to have an annual income of 40,000 sesterces[39]) for a citron table of which 'the veins are arranged in waving lines to form spirals like small whirlpools'.[40] A contemporary description of a table in its setting recalls Alma Tadema's gaudy Roman re-creations or a 1950s Hollywood film:

The citrus tree,
Uprooted from the soil of Africa,
Provides the table whose bright surface gleams,

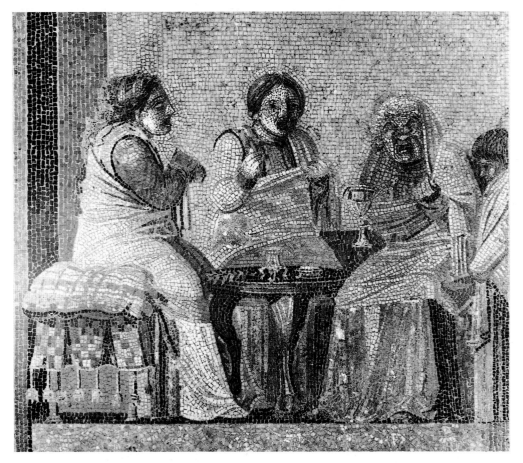

Reflecting hordes of slaves, and purple drapes,
Its golden markings, costlier than gold,
Are there to attract the eye[41]

The technique of inlay is as old as that of veneering. A chair of Queen Hetepheres[42] (*c.* 2500 BC) is the oldest extant chair in the world; its decayed companion was originally decorated with coloured composition inlays, set in gold.[43] Homer tells us that Odysseus' bed was made of olive wood (which has a finely marked grain) and that he 'beautified it with an inlay of gold, silver and ivory, and fixed a set of gleaming purple straps across the frame'.[44] The extraordinary furniture found at Gordion in Turkey from the 'Tomb of King Midas', of the seventh century BC, shows the highly accomplished standard of ancient craftsmanship in wood [34].[45] A Pompeian couch is decorated with bone and with glass and ivory inlay [12] – bone was a cheap substitute for ivory. Some elaborately inlaid bronze furniture survives [31].

From an early period, furniture has delighted in the sophisticated deceptions of trompe l'oeil. The simulation of other materials in paint can be a cheap substitute; some Egyptian furniture was painted in white lines to simulate ivory inlay. Sometimes, however, trompe l'oeil was an expensive game, played with the most luxurious furniture and the most costly materials: an X-frame chair elaborately made of ebony and ivory in or about 1352 BC [4] is inlaid with hieroglyphs and other motifs in stones, faience and glass; the cross bars of its legs terminate in the heads of ebony and ivory ducks; its ebony and ivory inlaid seat imitates the striking skin of a Nubian goat and other piebald hides.[46] The curvature of Egyptian seat and bed rails may have begun as a trompe-l'oeil imitation of sagging leather or fabric. Sometimes trompe l'oeil became perverse: 'recently, in the principate of Nero, it was discovered by miraculous

11 Square-patterned textiles, tassels and a goat-legged table: detail of a mosaic from Pompeii of 'The consultation with the sorcerer', from a comedy of Aristophanes; Roman, second–first century BC.

below 12 A couch in wood veneered with bone, with ornament that includes turned legs with 'architectural' capitals, lion masks, and geometrical and curvilinear ivory and glass inlay, from Boscoreale; Roman, before AD 79.

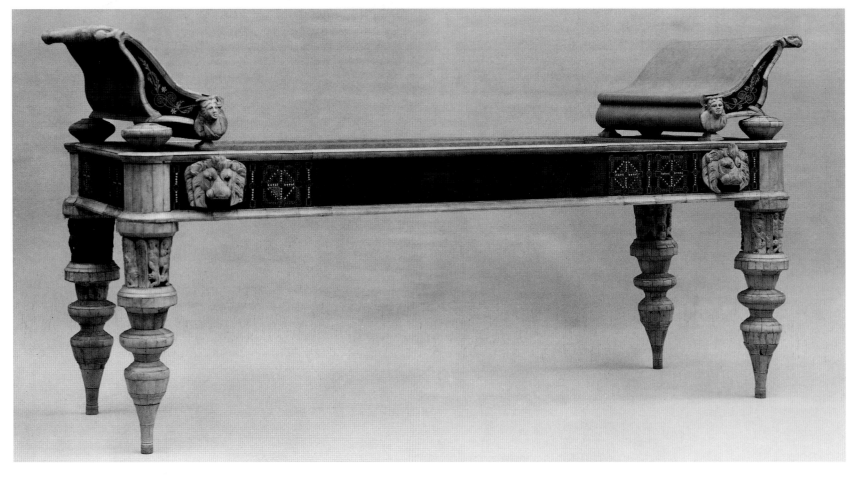

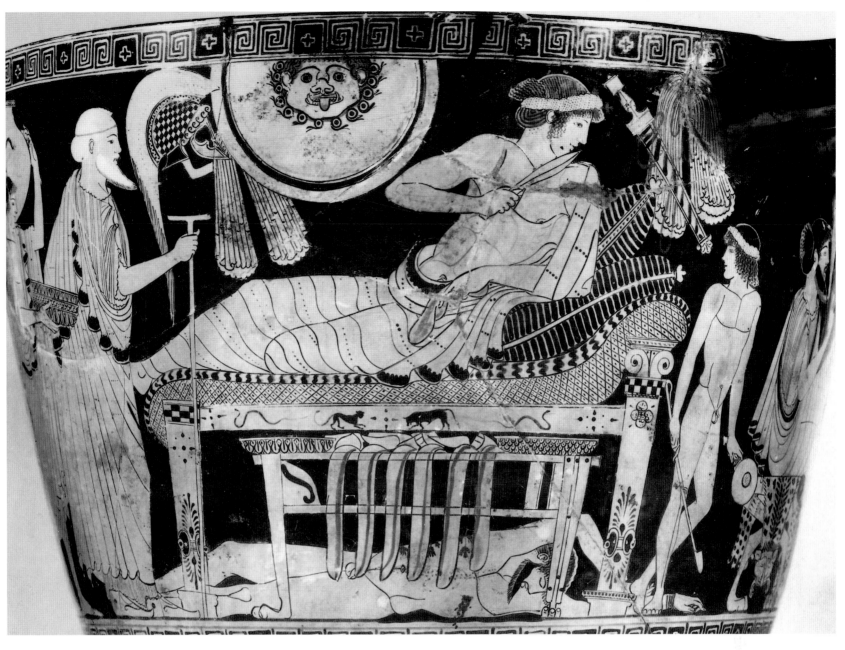

13 A 'cut-out' couch with striped cushions, decorated with an Aeolic capital and with inlaid or applied ornament that includes a frieze of a fight between a lion (?) and a bull, and squares in what might have been églomisé work; the three-legged table has lion-paw feet; on the right is an animal-legged X-frame stool with a leopard skin; from a beaker by the Brygos Painter depicting Achilles with the body of Hector, Greek, c. 490 BC.

devices how to cause [tortoiseshell] to lose its natural appearance by means of paint, and by imitating wood fetch a still higher price'.[47]

To luxury of appearance was added luxury of sensation; the comfort afforded by textiles was important in most early societies: mattresses, cushions, valances and draperies succoured the seated body and shielded it from draughts [11, 13]; rooms had carpets spread beneath the couches. Fabrics were often elaborately decorated; bed-covers were 'glistening, shining, shot with gold, with stars gleaming on them';[48] this description is substantiated by the sumptuous purple and gold textiles that wrapped the bones of Philip of Macedon's Queen.[49] Catullus takes two hundred lines to describe the covering which 'embraced and shrouded with its folds the [ivory] royal couch' of Peleus and Thetis.[50] The Egyptians had striped mattresses and cushions on their beds; Greek couches often have striped and chequered cushions in various patterns [13], a mode adopted by the Romans. Some Greek beds resembled ottomans, completely covered in

fabric. Beds were sometimes hung with embroidered bed-hangings on rings.[51] The grotesquely thick mattresses of the Etruscans may have encouraged Roman mattresses to become very thick; sculptures and terracottas indicate that some late Roman couches may have had fixed upholstery.

Decorative fringes and tassels appeared early. A Mesopotamian ivory relief from Nimrud shows heavy tassels;[52] the Egyptians had reticulated fringes with long tassels;[53] Greek vase paintings frequently show fringes and tassels; two stools, 'pulvinars',[54] on which statues of the gods were placed in Greek temples, have buttoning on the cushions, with tassels at the corners. Chairs were draped with negligently elegant fabric [452]; a sinister Roman mosaic of women in masks [11] shows the striped and chequered patterns and fringes that were easily accommodated within the weaving process. A mural from Herculaneum shows not only a fringe on a chair, but a realistically tattered fringe.[55] Had Rome achieved that final sophistication – smart shabbiness?

I *Chapter 2* Furniture and its background

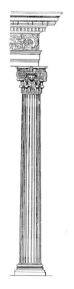

14 The classical orders: Greek Doric, Roman Doric (here shown unfluted), Ionic, Corinthian and Composite.

Architecture: Egyptian, Greek and Roman

The grandest ancient Egyptian buildings were temples and pyramids; had the activities of the Egyptian tomb-robber not enforced discretion and driven tombs underground, they might have disputed architectural primacy with the temple. Pyramids and obelisks, both Egyptian inventions, had solar connotations: the Great Pyramid at Gizeh (*c.* 2750 BC) symbolizes pharaoh rising towards the sun; the obelisk, as a Roman fourth-century historian wrote, 'little by little grows more slender, to imitate a sunbeam'.[56] Not far from the Great Pyramid sits the Great Sphinx; other extraordinary monsters, often beast-headed, inhabited the Egyptian temple and its precincts.

The main features of the Egyptian temple – the pylon and the column – had an immense weight and power. Pylon and temple had characteristic massive 'battered' (sloping) walls [607], a form originating in the need to stabilize large masses of fragile building materials such as mud brick. This is an example of the propensity to translate primitive mud or wooden architectural forms into stone. One of the earliest surviving dressed stone buildings in the world, the Step Pyramid of Djoser at Saqqara, has a stone wall in its precincts (*c.* 2700–2615 BC) bearing ornament that imitates a wooden fence.[57] Even the monoliths of Stonehenge have totally unnecessary mortise and tenon joints, inherited from wooden prototypes. This transference of form from a medium that required it to one in which in which it was redundant was of the highest importance for furniture design, in antiquity and afterwards [608].

The Egyptian column came in various guises – the palm, the papyrus bundle, the lotus, the 'tent pole', the papyrus column with open bud [613, 614, 619]. Columns of about 2750 BC imitate the bundles of reeds once used to support roofs; other half-columns have flared, ovoid papyrus flowers at their tops (the papyrus flower symbolized Lower Egypt).[58] Certain ornaments, like the rows of bewigged heads that crown the Ptolemaic columns of Dendera [607], signal affinities between the column and the human figure. The 'cavetto' cornice [607] was used to 'crown' walls; it has been conjectured that its outward curve was derived from a heavy timber roof pushing out reed-built walls (wood was scarce in Egypt), but this seems unlikely (and unsafe!), and the cavetto cornice may have been influenced by furniture design rather than vice versa.[59] In which case, it found its way back.

The later centuries of Egypt coexisted with classical and Hellenistic Greece. Greek temples inherited Egyptian force and grandeur; indeed, the funerary temple of the bearded woman pharaoh, Hatshepsut, of *c.* 1430 BC, had proto-Greek Doric columns nine hundred years before those of Paestum. At Paestum, the Egyptian inheritance is plain; the 'Basilica' (*c.* 550 BC) is one of the first Greek temples to have entasis, a swelling of the column that resembles the swelling profile of Egyptian 'papyrus' columns. The Egyptian temples of the Ptolemies – kings who 'liked to be called Macedonian, which indeed they were'[60] – often have something of the graceful suavity of Hellenistic architecture (which recommended them to eighteenth-century taste).

The most distinguished features of the Greek temple were the orders (column and entablature) [14] and the pediment.

Furniture possibly helped to create the Doric and Ionic orders; if so, both returned to furniture [247, 298]. The Corinthian capital may have appeared first in interior decoration; invented before 500 BC, it was first used externally in 335 BC.[61] Other features of the temple represented primitive wooden construction turned into stone. The naturalistic sculptured ornament of the classical entablature, however, derived not from construction but from ornaments hung about the primitive temple – the leafy garlands, no doubt soon to be withered in the hot Greek sun, the ribbands that bound them, the fly-blown skulls of sacrificial animals. Greek temples were distinguished from all others by the mathematical subtlety that gave an extraordinary harmony of proportion. They were originally colourful – early colours were bright but not strident or muddy, as is clear from the transparently glowing lapis lazuli and copper sulphate blues, the yellow oxides, that still survive on Egyptian temples. Ancient colour influenced post-Renaissance arts only when revealed by archaeological research. The pediment was surmounted by terracotta or stone acroteria, which gave a flamboyant and extravagantly decorated skyline.

Greek art developed from strength into lightness and grace. The severe Doric was complemented and supplemented by the chastely swelling Ionic, the order of the Ionians of Asia Minor, who had been influenced by Egypt, Anatolia, Syria and Persia; in the fifth century BC, Ionia brought to Greek architecture a refinement that mediated between the fantasy of the East and the rigour of Athenian Doric. The sweetly pleasing form of the round temple or tholos had become well established by the early fourth century BC. Hellenistic architecture included the great public buildings of the agora, characterized by the rows of pillars of the peristyle (an open court surrounded by porticoes); the peristyle also appeared in the house. Doric columns became progressively thinner; by the second century BC they had become slender, and entasis had been largely abandoned. The third major order, the Corinthian, had a festive luxuriance (and perhaps a religious significance) that made it the most popular of the orders in the Rome of Augustus.

The Romans built baths, markets, huge temples and palaces, and developed the architectural extravagances of theatrical scenery and the theatre's *scaenae frons* into the painted fantasies of 'grotesque' [32]: an unimaginatively practical people that began by naming its children in order of birth 'Three', 'Five', 'Six', ended by indulging in architecture, interior decoration, and furniture of unprecedented richness. They absorbed nearly everything found in high classical and Hellenistic Greece. They played with Egyptian motifs [44] and appear to have dabbled with Chinese [559]. Their technical genius was incomparable. The arch had been used by the Greeks occasionally, as a decorative device; the Romans combined it with the vault and concrete to create overweening buildings like the Baths of Caracalla, or sublime buildings like the Pantheon. From the Etruscans they took the 'Tuscan' order, perhaps also the idea of using the Greek orders as non-structural decoration, seen at its grandest in the tiered sequence of Doric, Ionic,

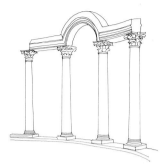

15 Details of Roman ceilings and vaults, from a plate published in Paris in 1802 by J. N. L. Durand (from *Recueil et parallèle des édifices de tous genres, anciens et modernes*).

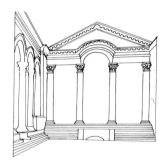

16 A detail of the Canopus at Hadrian's Villa, Tivoli, AD 118–134. Like the following buildings, this displays the 'broken curve' (see p. 68).

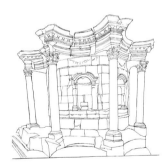

17 Part of the Palace of Diocletian at Split, c. AD 300.

18 The Temple of Venus at Baalbek, third century AD.

19 Faience tiles, perhaps furniture ornaments; Minoan, from Knossos, c. 1750 BC.

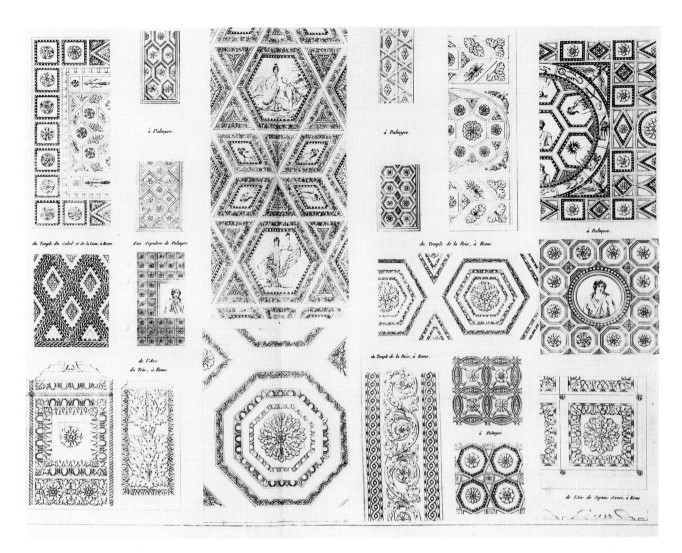

Corinthian and Composite orders that decorates the gigantic ellipse of the Colosseum – a building which also displays the Roman invention of the massive structural arcade supported on piers. All these devices extensively influenced furniture during and after the Renaissance [247, 249]. The Roman fondness for lavish decoration became in later centuries a byword and a reproach: the pilaster, always decorative and never structural, existed in Greece but flourished in Rome; the Greek entablature, with its contrasts of decorated and plain surfaces, was in Rome often entirely decorated; the Corinthian entablature was given the ornate scrolled console and rosette [15].

Opposed to Roman ostentation of surface was a liking for the grand severity of large volumetric and geometric forms (opposed, because decoration obscures volume). The Greek temple had had size and geometric volume combined, two Greek desiderata: Aristotle had opined that 'beauty consists in magnitude and order…no very minute animal can be beautiful',[62] and Archimedes requested his friends to place above his tomb a sphere containing a cylinder inscribed with the ratio which the contained solid bore to the container.[63] Smaller buildings such as the Lysicrates monument in Athens (about 340 BC) played with geometry, producing the influential idea of a cylinder on a square base. The Romans carried volumetric geometry further, and much of their architecture is based on the cube, the cylinder and half-cylinder, the segmental ovoid, and the hemispherical dome. The Mausoleum of Hadrian in Rome (AD 140) consisted of a cube topped by a cylinder topped by another cube and cylinder, the whole surmounted by a pyramid; stripped of its pillars, statuary and ornament by Time and the popes, the magnificent simplicity of its forms emerged. The same sense

of geometric force informs the semi-cylindrical apse of many Roman buildings, the tall cylinders of the great isolated monumental columns of Trajan and Marcus Aurelius, the ovoid of the Colosseum and the accumulated segmental ovoids of the tomb of Augustus, Roman pyramids like that of Cestius, even the triumphal arch, despite its complex form and rich surface ornament. Size was important in conveying the full effect, but not essential; the combination of cube and cylinder in the small 'tower-tomb' is effectively monumental – and certainly looked monumental enough when translated to the drawing-room eighteen hundred years later.

Furniture and architecture: general influences

In all developed societies, furniture is influenced by developments in architecture. From early times, exterior Egyptian ornament was applied to interiors and furniture. A burial chest pictured in an Egyptian painting[64] has panelled sides and a vaulted lid, possibly simulating the exterior appearance of large contemporary dwellings;[65] chests shown on paintings and bas-reliefs have façades that resemble the sides of a house, even to having little 'windows'.[66] Minoan coloured faience tiles an inch or so square [19], perhaps employed as decorative inlays for wooden chests,[67] are decorated with little squares representing windows, little circles that represent the ends of beams, and stripes that represent walls made up of alternate layers of rubble and beams. Squares, circles and stripes were turned into abstract ornament on Egyptian coffins [661] and Greek vases [663], ultimately to reappear on the furniture of Mackintosh and the Wiener Werkstätte.

Changes in Greek architecture were paralleled by changes in furniture: much architectural detail, disconnected,

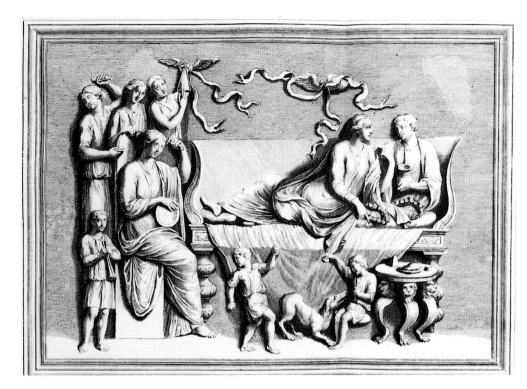

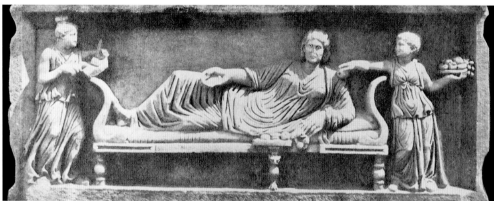

was imposed upon the headboards and footboards. This outward curve has something in common with the volute of the 'volute-calyx' (p. 38) or with the curve of an Ionic or Corinthian capital; looked at entire, such couches can resemble the profile of a capital (especially after they acquired a back in about AD 50 [20]. Roman couches commonly used this motif, and it was revived as an essential part of the ubiquitous 'Grecian' couch of neo-classical Europe and America.

The evolution of 'façade architecture' in the Hellenistic period was to have a momentous influence on furniture, especially when furniture that reproduced architectural façades became part of the great mise-en-scène of late Renaissance and baroque 'parade' [198, 247]: 'façade architecture' also became an immensely important constituent of grotesque painting, another all-pervading influence on furniture design.

If it were so easy for the grandest of architectural inventions to become ornament, what of the baldest, most humble of utilitarian devices – the round or square bolt or dowel used to join two pieces of wood together in most wooden construction, from a temple to an ancient Egyptian chair or a 1950s 'G-Plan' table? The wooden bolts that held the timbers of primitive temples together were reproduced as part of the ornament of the marble temple entablature, and thence were transferred to neo-classical chimneypieces and furniture [395]. Dowels often project as their ground shrinks; sixteenth-century German furniture designers used this feature as an ornament.

'Revivalism' and 'modernism'

Revivalism, the deliberate re-creation of earlier styles, may express nostalgia for a lost golden age, a respect for fine design, the search for novelty, not infrequently all three combined. It is nothing new: the Hellenistic Greeks revived their own archaic sculpture, and the generally pervasive influence of Greek arts in ancient Rome was supplemented by at least two deliberate Roman full-blown Greek revivals; the eager humility of Roman disciples of Greek art gained for them the appellation 'dociles vires' ('submissive fellows').[70] These Roman Greek revivals made Greek forms and ornament familiar and available for copying long before the eighteenth century focused on Greece itself. For example, a particularly refined form of the Greek acanthus scroll (p. 39) used to decorate Roman monuments erected during the Augustan Greek revival [52] became a key motif of Italian Renaissance furniture [156, 207]. This Greek revival – the first – was partly political, intended to put a respectable face on a dictator and his new dynasty; its splendid but seemly official architecture and decoration and impassive sculptural style were inspired by Greek art of the fifth century onwards.

Official policy reflected private taste. Roman poets, dramatists and connoisseurs admired and imitated Greek literature, architecture, sculpture, paintings, silver and 'Corinthian' bronze. Greek paintings had been assiduously collected in their homeland – the phantasmagoric entrance to the Acropolis, the Propylaea, had housed a picture gallery – and the Romans followed Greek example in displaying art collections in their temples. Greek paintings of the great period were extensively copied for Roman patrons; transportable paintings have totally disappeared, but written sources and surviving murals reveal the considerable interest. An Empire-wide market for Greek statues and statues in Greek style developed; they were made in huge quantities in Greece, Italy and Alexandria; white marble sarcophagi were

top **20** A couch with 'lyre' arms, high back and and turned legs decorated with acanthus, and a round table with lion legs that approach a cabriole shape; Roman, published in Paris in 1719–24 by Bernard de Montfaucon (from *L'Antiquité expliquée*).

above **21** A backless couch with curved 'lyre' arms and heavily turned legs, and a monopodium table, in a bas-relief; Roman (Constantinople), second–third century AD.

fragmented, dandified and miniaturized, must have travelled to furniture via interior decoration (its use was eventually to prompt absurdities equal to any engendered by the use of exterior 'architectural' ornament in interior decoration – especially when the classical idea of decorum was abandoned). In the fifth century BC the legs of beds, chairs and stools became slimmer and longer, following temple columns. In the fourth century the turned leg of the Greek stool, which had no obvious architectural affiliation, became taller and more spindly [3 *centre right*, 29], and the customary single turn was accordingly increased in number. The lure of the column and capital proved at times irresistible – to a point of surrealistic unease: Greek vases and sculpture show whole capitals used as seats. Not only did features migrate from architecture to furniture: the reverse may have happened. Turning is an instance. The Greek Doric column [14] has no base, turned or otherwise, and the 'turned' base of the Ionic column may, together with its capital, have originated in furniture (p. 38).[68]

The Greek couch was frequently treated architecturally. Homer implies that beds might be fixed; the beds pictured on Greek vases are sometimes placed on a rectangular platform, as were Greek temples and the more or less immovable stone thrones. By the late sixth century BC 'rooms in private houses were…being specifically designed to accommodate… chaises-longues around their walls'[69] and these couches were integrated with the decoration of the room [51]. A beautiful innovation was developed just before 400 BC: a scrolled-over curve, sometimes flattened like the curve of a lyre [20, 21],

exported from Rome, Athens and Asia Minor accompanied by sculptors who finished them after they had reached their destinations.[71] Many exist still, after centuries of pillage, Christianity and lime-burning.

The reign of Hadrian, from AD 117 to 138, saw the most notable Greek revival after that of Augustus. This is not surprising when one recalls that Hadrian was said by a contemporary to have spoken Greek in an affectedly archaic way, a current fashion.[72] The Emperor's Graecophilia prompted his unprecedented desire for Greek and Roman political parity – the rich corselet of his headless statue in the Agora at Athens shows crowned Athena standing on the Roman wolf. His prodigious Villa at Tivoli was the most intelligently singular creation of the ancient world,[73] determinedly eclectic in form and content; its Greek or Greek-orientated objects outnumbered Roman and Egyptian. The multitude of columns included many Doric; there were countless copies of Greek statues, including the Erechtheion caryatids; there must have been Greek paintings in equal number. Over the Villa's vast ranges of buildings shone the Indian summer of Graeco-Roman civilization.

What of furniture? Furniture is much easier to move than sculpture. The only complete surviving piece of wooden classical Greek furniture was found far from Greece, in an Egyptian tomb,[74] and Rome also must have imported Greek furniture. An impressive and influential stone throne exists in three identical versions [22]; they could be either Greek or Roman, but the triplication suggests Roman Greek revival. Were replicas of stone thrones made in the same workshops as replicas of Greek statues?

The presence of Greek artisans in Rome would have made easy the manufacture of Greek revival furniture in Rome. Models for ancient Greek furniture were at hand on the walls of houses: copies of great Greek paintings were incorporated into the Hellenistic wall decorations that came later to be known as 'grotesque' (pp. 30–33), and these frequently showed Greek furniture in antiquated styles; the best-known Roman copy of a Hellenistic Greek painting, the 'Aldobrandini Marriage', accurately portrays furniture of the time of Alexander the Great. Some magnificently grand

palace furniture in stone survives from Hadrian's Villa; a monumental tripod [10:1] that has a fluted bowl with lion masks, a baluster stem and three pilaster legs decorated with griffins and erotes that stand on lion paws, with vines along the pilasters, was sufficiently Greek revival for the eighteenth-century savant Caylus to describe it as Greek.[75]

Roman Greek revival furniture coexisted with something quite different, modish furniture that employed the capricious and luxurious ornament of grotesque wall decorations [42]. The stately candelabra or torchères [10:B], such as the 'Barberini Candelabra' or those that stand on storks, were not so much a revival as an accomplished synthesis of Hellenistic monumental architectural ornament with Roman grotesque themes as adapted by Flavian sculptors [38]; imaginatively restored, they inspired some of Piranesi's most grandiloquent plates [328].

Certain pre-eminent forms and ornaments shared by Greek and Roman furniture (and sometimes Egyptian) supplied models for two thousand years thereafter. One might perhaps attempt to distinguish the various strands.

Animal and monstrous ornament in furniture

Wildlife drafted into furniture design can have a ridiculous 'Farm and Field' effect; Victorian furniture sometimes swarms with horribly banal realistic detail. However, animal or monstrous features were anciently employed as religious allusions, and the intention gives such ornament a numinous force. Antique piety most honoured the lion and the bull, and Egyptian and Assyrian furniture often stood on lion or bull legs. Bulls were generally fashionable before lions; neither was confined to royal furniture. Strongly carved, ivory bull legs standing on a reeded cylinder dating from about 3100 BC were found at Abydos in Egypt;[76] the larger ones have a tenon at the top probably meant to attach them as furniture supports. Bull legs are common on early Egyptian couches. However, in about 2500 BC the lion began to replace the bull in popularity. This is the date of the chair of Queen Hetepheres,[77] which rests on the legs of a lion; the side panels of the arms each have three smoothly modelled papyrus flowers, bound with reeded bands beneath the flowers. The quality of this piece vindicates the contention of Owen Jones, the Victorian ornamentalist, that 'the more ancient the [Egyptian] monument the more perfect is the art'.[78]

Bull legs appeared occasionally on Greek couches, but lions greatly outnumber them. Couches and chairs sometimes took on the appearance of whole animals – head, body, tail and legs, as seen in an Egyptian type that was to inspire Vivant Denon [605, 606]. The use of a complete lion within the solid side panel of a chair had appeared by 2500 BC; lions were also set within open chair arms and uprights. In Greece and Rome the leg was often a monopodium, an animal head and leg combined, the latter larger in proportion than in nature. A slender bull leg was used in ancient Egyptian furniture by 2650 BC,[79] and the legs of the antelope or goat became generally popular in antique furniture. The original association was probably sacrificial, especially in the case of tripods.

Other creatures were used: in Egypt furniture was decorated with the ibex, the monkey, and the scarab, the dung beetle that pushed the sun across the sky. The sacred Egyptian cobra [43] had by the Eighteenth Dynasty (1567–1320 BC) appeared on bed legs. Trompe-l'oeil devices made animals and birds on furniture more realistic; for instance, the ducks on an Egyptian stool of about 1352 BC have tongues of ivory reddened to imitate flesh.[80]

22 A marble throne, in S. Gregorio Magno, Rome, decorated with winged lions and acanthus scrolls; Greek, or Roman Greek revival.

23 The marble throne of the priest of Dionysus, with fluted and scrolled 'cabriole' paw legs, in the Theatre of Dionysus at Athens; Greek, first century BC.

24 A support in the shape of two griffin-like monsters, with anthemion and acanthus ornament, from a Roman rectangular marble table [cf. 36].

25 A pier table supported by a dancing nymph and a satyr, with two rhyton drinking vessels upon it: detail of a silver cup from Berthouville, Hellenistic style.

Animal legs are common on Greek and Roman tripods, tables and chairs, although rare on Greek and Roman couches. Chairs sometimes combine animal legs at the back with turned legs at the front. A form of X-frame stool with refined claw or hoofed feet had appeared in Greece by the sixth century BC or earlier. Serpents, emblems of Hermes, Hygeia and Aesculapius, were common in Greek and Roman art and often appear on tripods [10:J]. Other creatures used on Greek and Roman furniture include panthers, elephants, swans, cranes, and owls[81] (the owl was the bird of Athena [413], patron goddess of carpenters). The goat-leg table, usually a tripod and often round, was extremely popular in Hellenistic Greece and Imperial Rome: [30] it had a mannered daintiness that accorded well with the fin-de-siècle atmosphere of some Roman conversation pieces. Animal feet and members were popular for bronze candelabra; they appear on Etruscan bronzes of the sixth century BC and terminate Roman candelabra [10:A,K, 45].

Monsters were incorporated into the solid-sided stone thrones [10:F, 22] with a rounded or rectangular back, an influential type that developed in archaic Greece into one of the most majestic of all pieces of furniture. Animal feet or monopodia often decorated the front; animal or monster legs were frequently topped by volutes, and bold scrolls [23] and other ornaments were carved on sides and back. Monsters frequently decorate the Greek marble tables that were copied in large numbers in Rome; many seem to have been for outdoor use. These splendid pieces of furniture often display an archaistic muscular vigour; in one type marble monsters of impressive weight uphold massive rectangular marble slabs [24, 36]; solid ends are boldly carved with the 'peopled scrolls' (p. 40) of wall decoration. Other tables, sometimes round, were supported by chunky animals or monsters, monster-monopodia [61], or terms. Some tables were supported on bronze mythological groups or figures that remarkably anticipate baroque and later furniture [42, 251]. There was perhaps a link with interior decoration: lion feet were often used as the base both of Greek doorposts and of architecturally fluted legs [27]. Such fluted legs – pilasters deprived of their capitals and equipped with lion feet – closely resembling each other but separated by

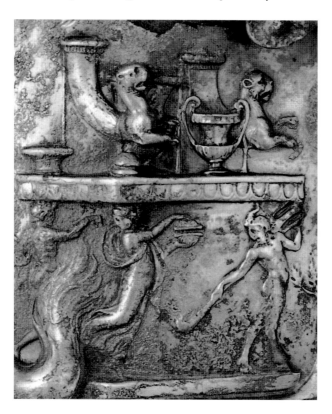

hundreds of years have been found at Delphi and at Constantinople.[82]

Some Greek furniture tends towards abstraction. Altars were frequently virtually plain rectangular blocks, and the animal legs of tables and stools pictured on Greek vases display degrees of abstraction that can only to a limited extent be the result of conventions in drawing. These were reproduced in publications in the late eighteenth and early nineteenth centuries. Does one see abstraction in course of evolution? – for instance, tables are given volutes on the inner part of their animal legs that are really a formalization of the back muscle. Other vases show three-legged tables with formalized animal legs, including muscles so treated as to resemble triangular incisions [26]. A domestic altar with three balls on top[83] has an abstracted, squared-off version of an animal leg. The cabriole leg is nothing other than an animal leg with the sharp angle at the hock smoothed into an abstract curve [20]. It may be seen in embryo on vase painting and in such artefacts as the marble throne of the priest of Dionysus at Athens [23]. Did the sharp angle of the animal hock, abstracted, perhaps contribute to the strange motif of the 'broken curve' [276, 277]?

The 'cut-out' couch and chair

Nothing in classical furniture combines simplicity with strangeness to quite the same degree as the Greek couch with 'cut-out' legs [13]. The deeply invaded cut-out flat face, with two, four or sometimes six[84] discs or balls and volutes emphasizing the excisions, is highly eccentric, mannered to a point of unease – a Chicago furniture company was prompted by a sceptical furniture historian to test its practicality[85] – and very beautiful. The motif is of the same genre as the curves of the volute-calyx (p. 38). Technically, the 'cut-out' couch was obviously and uncompromisingly based on the plank – a joiner's piece of furniture, a fact that was to exercise a strong influence two thousand years later (p. 225). The end of the tenon that attached the side-rail to the flat front is often indicated.[86] The cut-out motif was used also for armchairs; depicted side-view on vases, the broad ornamented face of the plank is usually placed facing the viewer.[87] The Greeks liked the contrast of thick and thin, which is exploited in these cut-out and turned couches and chairs (and in the marble tables with wide but comparatively narrow-sectioned end supports, a feature adopted by Renaissance tables [24, 36, 189]). On some the cut-out pattern was indicated by surface decoration rather than excisions.

Such couches, often shown resting on a base, were probably more or less immobile. The head and foot are generally differently shaped. The flat board received such decoration as anthemions, animals and monsters, zig-zags, 'Vitruvian' scrolls, etc.: a stone funerary couch has a complete chequerboard of squares.[88] Popular in the sixth century BC were the stellate ornaments that were also employed in Egypt; they might have been painted or inlaid (extant ivory stars from Gordion in Asia Minor seem to have been meant for inlay[89]). Cut-out armchairs were popular in Rome, sometimes in elaborately decorated forms.[90] A Roman bas-relief of the throne of Neptune shows a throne with cut-out legs of a somewhat different type combined with Greek revival scrolls [40].

How did this furniture appear in reality, rather than as a disembodied linear pattern on a Greek vase or petrified in the three-dimensional rigidity of stone sculpture? Remains discovered in the royal tombs of Macedonia[91] of wooden cut-out couches reveal that they were elaborately decorated

26 Three-legged tables with formalized animal legs, the muscles turned into triangular incisions, and a severely functional couch; Greek, from an 'Etruscan' vase published in Paris in 1810 by A. L. Millin (from *Peintures des vases antiques vulgairement appelés étrusques*).

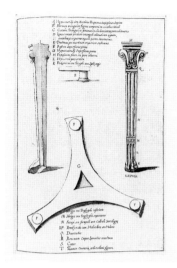

27 The Peiresc Tripod, an antique bronze tripod in Roman Greek revival style, depicted by a French artist, *c.* 1629–30.

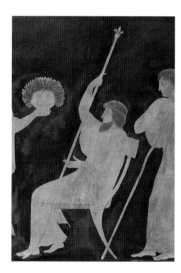

28 A klismos with criss-cross ornament on the seat; Greek, from an 'Etruscan' vase published in Paris in 1810 by A. L. Millin (from *Peintures des vases antiques vulgairement appelés étrusques*).

with applied ornaments on all sides, mostly in carved and gilded ivory; some ivory scrolls are outlined in inlaid gold wire in a manner that anticipates Boulle. Each leg originally bore eight light-emanating glass bosses at the centre of ivory 'cut-out' spirals and a group of nine square plaques containing figurative scenes in gilded verre églomisé. A deeply recessed frieze between the legs of one couch held virtually three-dimensional chryselephantine figures of Greeks, including portraits of Philip of Macedon and his son Alexander the Great, engaged in fighting barbarians; griffins, acanthus monsters, Victories and quadrigas were set off by a background of gold parcel-painted in red and green. Where it remains undegraded by Time, the ivory carving possesses a virtuosity equal to that of the best baroque work, and a large dignity of form superior to it. These ancient couches were remote ancestors of the gilded and polished 'archaeological' couches and chairs of the late eighteenth and early nineteenth centuries, at once more vigorous and more refined than their descendants.

Cheaper wooden cut-out couches, probably coloured in those bright but soft pigments that still cling to some stone furniture, perhaps had something of the quality of peasant art, furnished as they were with striped and chequered fabrics that have much in common with peasant weaving [11, 13].

The klismos

The most famous, beautiful and successful of all chairs is the antique klismos [3 *centre left*, 28], a purely Greek invention; it is the ancient chair most often copied in modern times, either in its original form [393] or in one closely approximating to it. Despite the elegance and charm of many modern klismoi, no addition to or subtraction from the classical Greek form has ever improved it. It had been established by the sixth century, and by about 400 BC had become the most popular of Greek chairs. Its characteristic outswept legs may possibly have been made of bentwood, or of wood trained or naturally curved, as are the legs of the Gordion furniture[92] (this solution to the problem of the leg's weak point, the cross-grain, was adopted over two thousand years later by the Danish neo-classicist Abildgaard). The klismos curve was a brilliant solution to the inherent ungainliness of the slanting leg, which gave seats stability on uneven ground. In their most elegant form, back and legs formed a continuous curve

made of one piece of wood that became more slender as it reached the floor or the horizontal back-board; sometimes the back leg was in two pieces.[93] The forward projecting end of the side rails frequently terminated in a sharp horizontal point. The dowels that fixed the legs to the seat rails often show as a fine decorative punctuation mark (occasionally a round dowel sits within a square dowel[94]). The chair might have a vertical splat in the centre of the back; the seat was generally set slightly lower than the top of its rails. In the fourth century BC and later the back-board was often broader, with a more pronounced curve, and sometimes had one central support rather than two stiles with a splat in the middle. Some Roman klismoi were highly mannered, with a back-board so flared out as almost to look like wings [392]. Sometimes the back was made in one solid curve.

The Greek klismos was plain or lightly ornamented; the occasional criss-cross decoration on the side rail [28] may have imitated leather thongs; variety was given by subtle differences in shape. It was sometimes draped. Only one ancient example (seen on a Greek vase) has surfaced of a plain post front leg and a klismos-type back and leg.[95] Greek klismoi were light enough to be carried with graceful nonchalance [521];[96] the Roman version was usually less lyrical, heavier [10:H]; both might be painted or inlaid with various designs. Greek vases and sculpture show men seated in the klismos, but the Romans seem to have regarded it as a woman's chair.[97] Klismos legs appear on Roman tables, and a wall painting from Pompeii of erotes making garlands shows klismos-legged stools like those painted in Raphael's Logge.

The X-frame stool, chair and table

The X-frame folding stool or chair is one of the oldest of all furniture forms; the Greeks attributed an ancient X-frame chair in the Temple of Athena Polias at Athens to Daedalus, the mythical Inventor.[98] The folding table may be as ancient.[99] The chair may have originated in the ancient Near East, and was in ancient Egypt – and Denmark! – by about 1500 BC; it also occurred in Crete and Mycenae. In most ancient societies its use seems to have been restricted to men.[100] In all societies this chair, usually portable, has had an hierarchical meaning: 'And their [the Athenians'] slaves followed them, bearing folding chairs for them, in order that, if they wished to sit down, they should not be without some

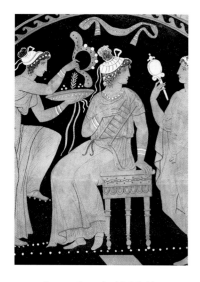

29 A turned stool with inlaid or applied decoration that includes dots and interlace; Greek, from an 'Etruscan' vase published in Paris in 1810 by A. L. Millin (from *Peintures des vases antiques vulgairement appelés étrusques*).

opposite 31 Detail of a 'turned' couch in bronze, with cast ornament and inlaid decoration in silver, from Amiternum; Roman, first century AD.

30 A 'turned' chair with a pointed foot, and a table with goat or antelope legs, from 'The Enrobing of the Priestess', a mural at Herculaneum; Roman, before AD 79.

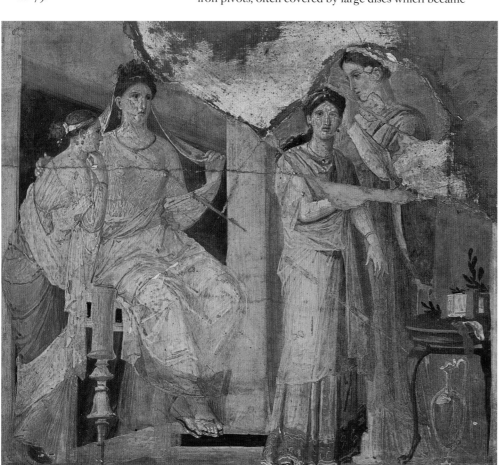

proper seat.'[101] Exactly as film directors are today followed by slaves with practically the same support. The X-frame now has democratic and populist associations: as a deck chair it litters the beaches of the modern world.

Egyptian, Greek and Roman X-frame chairs have similarities and differences. That found in the tomb of Tutankhamun [4] combines an X-frame stool with a back that was added later. Many Egyptian X-frame stools were fairly plain, with lion legs and duck heads terminating the feet; only folding chairs were allowed animal skins, which were of symbolic significance, especially when combined with lion legs. The Greek X-frame stool [3 *centre right and below left*] also often had lion legs and animal skin seats; the form with crossed lion legs is most common, although goat, S-curved, straight, and multiple legs were frequent; the last was to become popular at the Renaissance [182]. Unlike Egyptian X-frame stools, the Greek type tended to lack a foot rail. Very slender members betray the frequent use of iron or bronze.

The Roman X-frame stool (the *sella curulis*, or curule stool) was used by the emperor and important officials. The Romans believed they had taken it over from the Etruscans[102] with other royal insignia – the fasces, the crown of laurel, the ivory sceptre with eagle, and the purple toga. It had its plain military version, the *sella castrensis* or camp stool, which was used by the emperors on campaign, a chair in no way inferior in status to that of its more elaborate civilian counterpart, a fact that was to be utilized for propaganda purposes thousands of years later [526]. Exceptionally, the Roman *sella curulis* was made of gold or gilded; a *sella aurea* or gold stool was granted to Julius Caesar: 'they…voted that his sella aurea and his crown set with precious stones and overlaid with gold should be carried into the theatre in the same way as those of the gods.'[103]

The crossed legs of the *sella curulis* were held by bronze or iron pivots, often covered by large discs which became

ornament; these were also placed on the end of seat rails. The empty stool was frequently shown on coins with the two pairs of crossed legs moved from the sides to the front and placed beneath the seat rail [447], a distortion that was misinterpreted in the later eighteenth century. Certain Roman monuments are shaped like an abstract *sella curulis*, a cryptic form later copied in neo-classical tables. The X-frame principle was also used for Greek and Roman tables and tripods, elegantly emaciated objects on stick-like folding bronze or iron legs, or excessively slim half-human half-animal legs with stick-like stretchers [10, 519]. The numbers that have survived testify to their popularity, a popularity that was to recur [368].

The 'turned' couch and chair

A restrained form of turning was common in Egypt, and an exaggerated form in Persia [6]. Egypt may have influenced Greece, but the lure of Persian orientalism and theatrical exaggeration may persuade one that Persia played the greater part. Persian royal gifts probably helped – in the fourth century BC, for instance, King Artaxerxes sent to Entimus the Gortian 'a couch with silver feet, and cushions for it, and a flowered tent surmounted with a canopy, and a silver chair, and a gilt parasol'.[104] All the components of this gift – the legs of couch and chair, the poles of canopy and parasol – were probably turned, or imitated turning in materials other than wood.

The turned style had appeared in Greece as early as the eighth century BC. It coexisted with the cut-out style, which it eventually overtook. By the fifth century BC, 'turned' legs were common on couches, chairs, and stools; this often took the form of elegantly long concave sections that met at a thickened centre, with the bottom section of the leg tapering thinly – utterly different from Persian turning; elaborated forms of this type were later synthesized with bamboo [29]. By 300 BC turned legs had become much more elaborate, often using concave and convex turnings in various combinations; on couches, various motifs were added such as animal claws, sphinxes and acanthus; with these features, they became closer to the Persian types [6, 7]. The later Greek couches and chairs in this style were imitated by Rome and became standard, often in elaborately 'turned' bronze. The rails of Roman couches, which rested upon turned legs instead of extending between them, were often panelled. A couch with 'turned' legs and simple outcurved 'lyre' arms was developed [20], of the type that was to become famous in the 1790s as the 'Récamier' couch. Sometimes the curved arms were replaced by ends that were perpendicular, solid and high without turning [10:L]; sometimes the back was given a horizontal bar with rails, something like a modern garden bench.

The fat, congested 'turning' on some Roman chairs and couches [21, 269] resembles that of the Persians [6] (and also, incidentally, that of seventeenth-century Iberian furniture [270]). Rome produced some extraordinarily mannered furniture, like a chair in which Juno is depicted which is so peculiar that it is difficult to 'read', let alone to describe.[105] Other chairs have a stilted daintiness, the legs ending in a pointed foot reminiscent of a modern stiletto heel [30]; this type of leg may have helped to steady a chair on uneven ground, since it would have sunk into it. The Romans were conscious of the feminine air of these beautiful chairs: the throne of Venus [452] was given delicate turnings, whilst the thrones of Mars [396], Dionysus[106] and Neptune [40] were in the archaizingly virile cut-out style.

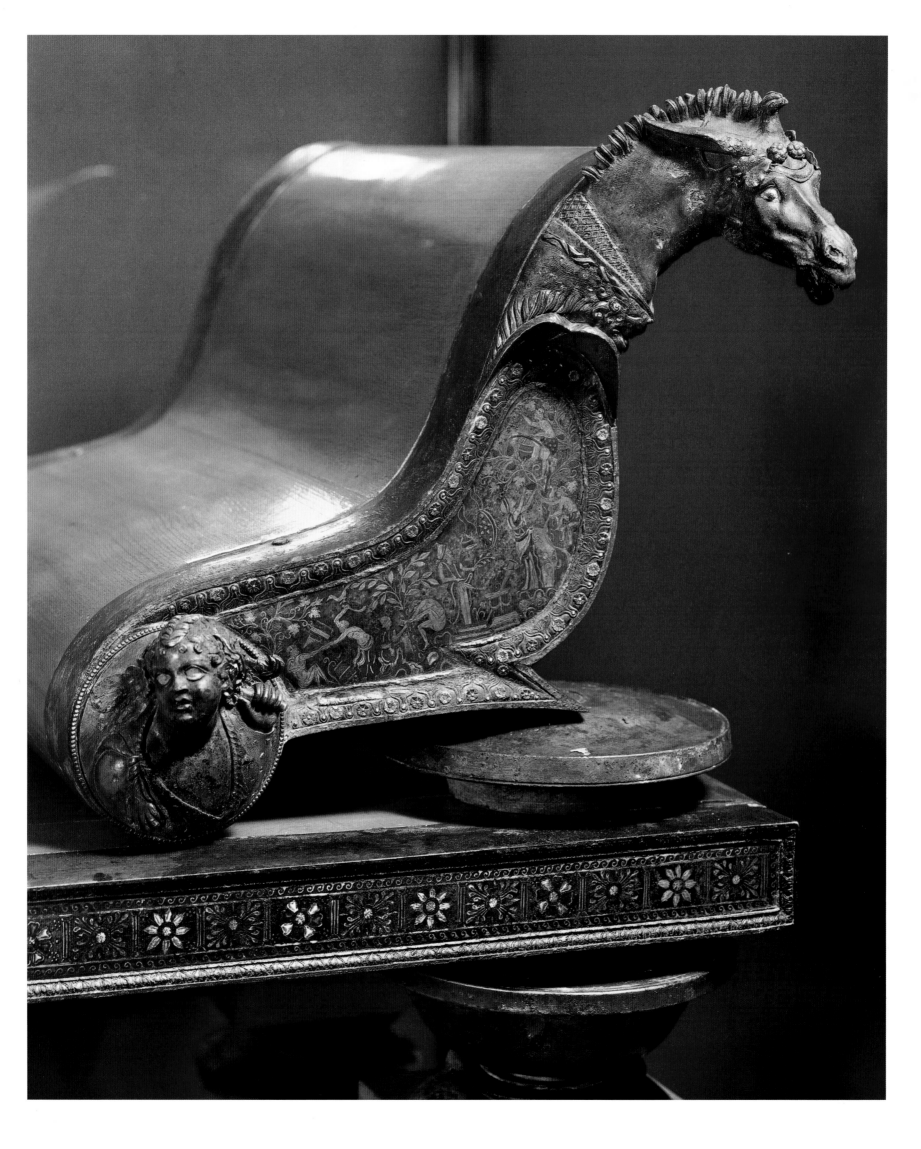

32 A wall painting from Pompeii showing padiglioni, draperies, wiry scrolls, birds, landscapes with putti, still lifes, elephants, colonnades, and pictures set into plain areas of wall; Roman, published in Naples in 1808 (from *Gli ornati delle pareti ed i pavimenti delle stanze dell' antica Pompeii*).

33 A wall painting from the Domus Aurea, Rome, showing 'airy pergolas' and delicate extended garlands; Roman, published in Rome in 1781 by Brenna, Mirri and Smugliewicz (from *Vestigia della Terme di Tito*).

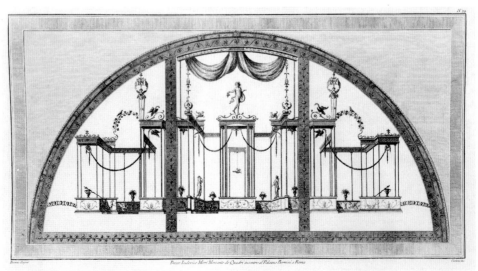

Furniture and interior decoration

34 Detail of boxwood and juniper inlay on a serving stand from the 'Tomb of Midas' at Gordion; Phrygian, eighth century BC.

Interior decoration and architectural ornament

The movement of ornament from furniture and interior decoration to exterior architecture is rare and conjectural; the reverse movement is common and unquestionable. Interior walls were ornamented in stone or stucco with three-dimensional pillars, pilasters, pediments and entablatures [32, 33, 37]; stone, stucco and painted ceilings [15] imitated the coffered patterns derived from the arrangement of the wooden beams used to support the roofs of temples and other large buildings. Architectural interior decoration frequently retained the volumetric formality of exterior architecture; gilded and coloured, it achieved in Rome an overwhelming magnificence.

Looked at logically, the concept is absurd: of what use is a pediment inside a building, where the rain should not enter? Or a column or beam that supports nothing? Architectural motifs brought indoors were treated with a levity that robbed them of even a specious function – columns were miniaturized and sunk into walls, fluting separated from pillars or pilasters, dentils detached from entablatures, pediments curved and flared, and so on (some of these wayward motifs migrated back from interior decoration to exterior architecture in Roman times). Such interiors have been subjected to severe criticism by rationalists who uphold proprieties and reject the concept of 'play'. Architectural ornament on furniture is even more impure; it is, and must be, completely play.

Paint, the easiest way of decorating an interior with architectural ornament, gives the greatest freedom. Much 'architectural' interior decoration was executed in paint, and since economy and ease were motives, exterior forms were originally transcribed in a fairly straightforward manner. However, riches and sophistication brought experiment and architectural outrage. Paint allows latitude: it can be exploited to produce effects impossible or extraordinarily difficult to achieve in three dimensions. Painted illusionistic architecture, especially, need obey no structural rules [32, 33, 37]; it can stand on clouds. Fantasy is easier to execute and accept in paint than in any other medium. Moreover, paint is unrivalled for effects of rich sumptuosity.

Egyptian and Greek interior decoration

Egyptian palaces have disappeared, and Egyptian tombs contain a miscellaneous mass of objects visually unattached to their surroundings. However, the painted murals and sculptured scenes that survive in the the tombs reflect something of the general character of Egyptian exterior and interior decoration, and supplied information on which later Egyptianizing interiors and furniture were to be based. They depict architectural, human and vegetal motifs, all converted into formalized patterns in brightly contrasting yet elegant and harmonious colours [43].

Little survives of Greek interior decoration: the domestic wall decorations preserved show pilasters and restrained figured friezes. The Greek style of interior decoration that imitated masonry employed the idioms of architectural construction in a straightforwardly rational way. Adjacent Phrygia may give a clue to relationships in Greece between furniture and interior decoration: the elaborate patterns

inlaid into the extraordinary eighth-century BC wooden furniture [34] found in the 'Tomb of Midas' at Gordion – the patterns look like a rehearsal for the Wiener Werkstätte – are closely related to the intricate patterns that decorate the exterior walls of sixth-century cult monuments in the Phrygian highlands.

There are indications that sobriety and simplicity were not always observed in Greek decoration. Contacts between Greece and the east had existed for many centuries before the classical period; Greek art of between 1000 and 500 BC received new influences from Mesopotamia, north Syria, Egypt and neighbouring areas. Fifth-century Athens attracted artists from outside Attica. The aedicules and shrines pictured on Greek vases have elongated columns and cavetto entablatures, their pediments are decorated with wiry scrolls and sphinxes – do they reflect the idioms of interior decoration? Are they a step towards the later fantastic aedicules of Roman grotesque? Did Greek interior decoration move towards the colourful, extravagant and anti-classical 'orientalism' that reached its height in the Roman painted decoration influenced by the hybrid styles of the Graeco-Egyptian city of Alexandria?

Of all the oriental cultures, Persia most fascinated the Hellenistic Greeks. They viewed the Persian empire, which became mighty in the sixth century BC, with sympathy as well as fear; the Macedonian Alexander the Great said: 'All things take on the same colour; it is neither unbecoming for the Persians to simulate the manners of the Macedonians, nor for the Macedonians to copy those of the Persians.'[107] Greeks and Romans saw Persia as the incarnation of glamorous orientalism and transmitted that idea to Western posterity: 'For they [the Persians], of all men, are those who hold pleasure and luxury in the highest honour; and they, at the same time, are the most valiant and magnanimous of all the barbarians.'[108]

35 Ornament including open double twists, garlands, scrolls and an elongated caryatid supporting the base of a multiple column, in a wall painting from the House of the Vettii, Pompeii; Roman, *c. AD* 62.

36 A marble table, with erotes engaged in making wine, in a wall painting from the House of the Vettii, Pompeii; Roman, *c. AD* 62.

Persian art was capricious and barbarically rich; the god of the Persians being immaterial, it concentrated not on temples but on palaces. Alexander the Great, who defeated the Persians, imitated their luxury in his quarters; the four-day marriage feast that followed the overthrow of Darius was celebrated with Eastern ostentation.[109] Even the harsh Spartans succumbed to Persian allure: 'Pausanius, the king of Lacedaemon [Sparta], having laid aside the national cloak of Lacedaemon, adopted the Persian dress.'[110] The luxury of the Ionians, which was proverbial, owed something to Persian influence; Athenaeus mentions 'the violet and purple robes of the Ionians, and their saffron garments', 'their garments embroidered with animals', and their 'Persian calasires,[111] which are the most beautiful of all'.[112] The influence was mutual. The Ionian Greeks employed on the Persian royal palace at Persepolis (518–460 BC) left their graffiti on the site, and the famous Hall of a Hundred Columns exhibited an eclectic synthesis of Persian and 'Greek' forms [46]. By the time 'orientalism' invaded Roman decoration (and furniture) the path had already been opened by an earlier Greek/Persian synthesis.

Roman painted interior decoration

Roman interior decoration survives in great quantities; at Pompeii and Herculaneum entire houses stand. The Greeks were the Italians of the ancient world, highly cultivated artists and artisans who sold their superior talents to the nations that surrounded them. Horace (65–8 BC) wrote to the Emperor Augustus:

> Greece, conquered Greece, her conqueror subdued,
> And Rome grew polished, who till then was rude…[113]

Hellenistic Greek interior decoration is best seen in the marvellous 'Pompeian' extravagances of Rome and Pompeii. Many Greek artists who worked in ancient Italy settled there; did their creative genes remain as a vital strain in the prosaic people that had given them employment, ready to flower when the conditions became right – as they did in the

Renaissance and for centuries afterwards, when Italian taste and skill carried ancient Greek and Roman styles throughout Europe?

Walls
The sophistication, originality, and aesthetic distinction of Roman interior decoration have had few equals. The combination of shallow three-dimensional stucco with paint in the grander types of grotesque decoration offered a middle way between the dignity of stone and the freedom of paint; even when composed in formal patterns it retained a spontaneous vivacity. Its phases were categorized in the late nineteenth century as 'First', 'Second', 'Third', and 'Fourth' Styles, called somewhat misleadingly 'Pompeian' after examples disinterred from the provincial Roman city. The categories have their uses, but the dates are approximate and the motifs wander; they are used here merely as a convenient descriptive shorthand. Such decorations, which became known to the Renaissance as 'grottesche', deeply influenced the design of furniture, both in antiquity and from their rediscovery in the late fifteenth century onwards.

The First Pompeian style, established by the second century BC, echoed the conventional 'masonry' decoration in use in Greece by the fifth century BC. Walls were painted in simple, strong colours in bands that imitated ashlar masonry or marble; they were divided horizontally into three: a dado at the base (a dado is related to the placing of furniture), a large middle section and cornice, and a frieze and another cornice above. The decoration emphasized the flat wall; there was no illusionism apart from trompe-l'oeil marbleizing. These divisions, conventional in classical decoration ever since [336, 356, 601], have since the Renaissance fundamentally affected the design of the furniture that until the nineteenth century was traditionally pushed against walls.

The Second or 'Architectural' Style flourished from about 80 to 15 BC. Columns and an architrave were set in front of the simulated masonry or marble horizontal divisions of the First Style, thus opening up the wall by giving an illusion of recession. Occasionally large-scale human figures were painted on the wall in frieze-like compositions. Or columns and architrave framed fantastic architectural scenes with accumulated buildings in unsystematic but receding perspective. Sometimes the background was pierced by large or small landscapes, mythological scenes, or still lifes [169]. Still life (including the 'Vanitas'), together with domestic genre, landscapes, and animal painting, had been amongst the most original creations of Hellenistic culture, appearing in about 300 BC; especially attractive are the little animals, birds, and insects that accompanied the vases and baskets of fruit and flower painting. The other added elements – landscapes, mythologies, architectural scenes – were also drawn from older Greek sources; the last probably reflect the demands of the stage (the Hellenistic term for perspective was *skenographia* or 'stage painting'). The mythologies (usually copies of well-known Hellenistic paintings) often pictured Greek and Roman furniture [30, 269, 392, 444].

The Third Style, fashionable from about 15 BC to AD 70, abandoned realism; instead, scenic fantasy was held together by slender 'candelabraform' columns (p. 41) and eccentric canopies. Three-dimensional architectural ornament such as egg-and-dart became linear ornament, and the pilaster and column were stretched out to an impossible height and thinness (as both were on Greek vases); to their slender stems were added a rich and strange medley of capricious

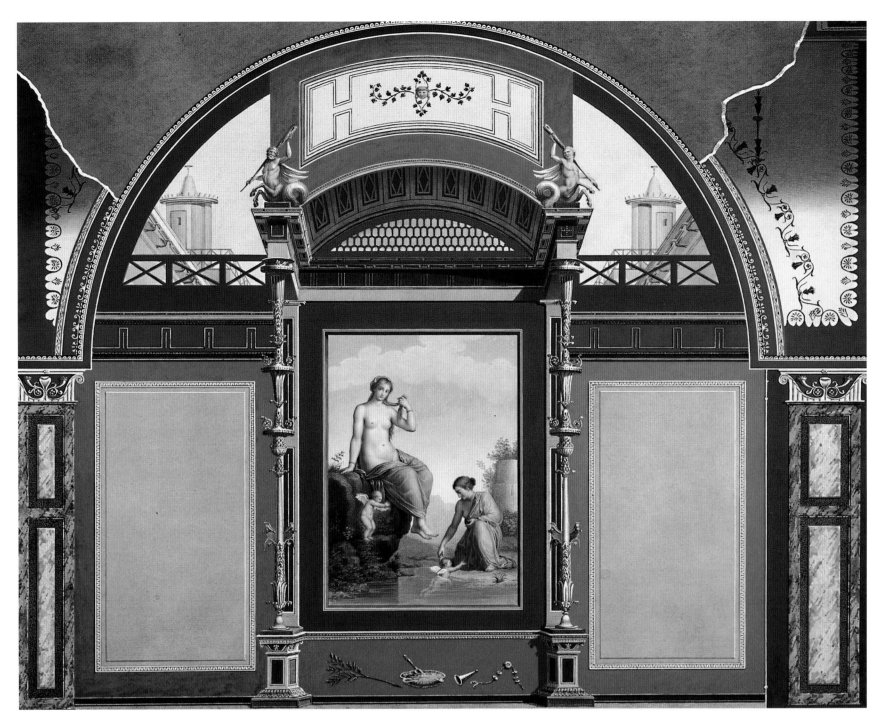

37 Candelabraform columns, composite monsters, marbling, still life and linear ornament, in a wall painting found in a villa in the grounds of the Villa Negroni, Rome; Roman, Hadrianic period, published in Rome in 1778 by Angelo Campanella.

embellishments. Walls were often given a dominating central compartment decorated with a large painting or landscape and a smaller compartment on each side containing one small picture in its centre fastidiously isolated in an expanse of plain strong colour. Landscapes, subjects copied from nature, temples or other buildings, and figures commonly occur in these small paintings. Sometimes landscapes or gardens, often containing trellis, filled a whole wall, which was divided into sections with pilasters.

The Fourth Style, which combined the solid architecture of the Second Style with the fantasy of the Third, surpassed all others in fantasy. Appearing in about AD 70, it was employed in that most scandalously luxurious of all Roman palaces, the Emperor Nero's Domus Aurea, the 'Golden House' (AD 64–68). Walls were covered with a framework of airy 'pergolas' and scattered with capricious monsters, baldacchinos, trellis, and other decorations [33]. Or they could be more soberly organized, with rich compartmentalism that used such motifs as velaria [39:D]; the most esteemed example from the Domus Aurea was the 'Volta Dorata', the 'Golden Ceiling'. A simpler and cheaper

variant, which was used in less important locations such as corridors, had delicate decorations on a white background articulated by pilasters filled in with vertical candelabraform or scrolling decorations.

The repertoire of ornament displayed in Roman interior decoration was extensive, and the use of stucco meant that much was already more or less in three dimensions – a step towards the emancipation from flatness that was to reach its height in post-rococo neo-classicism (pp. 197–98) [373]. Fanciful caryatids and terms were sometimes used as a support in a way that suggests a pier table [35, 592]. To the single twist of the Solomonic column were added fantastic open double twists [35] that anticipate the twists of the seventeenth century. Geometrical interlacing approached the later Berainesque.[114] An architectural capriccio combines a pergola with hanging garlands and trellis like those that were to decorate eighteenth-century furniture [559]. It is impossible to imagine a greater inventiveness of fancy than in these designs.

In about 31–27 BC, the classicizing Roman architect Vitruvius contrasted ancient and contemporary decoration

38 An acanthus monster and a monster with some features of a griffin, from the Forum of Trajan, Rome; Roman, c. AD 110.

in words that influenced architects and designers from the sixteenth to the nineteenth centuries AD. He detested the grotesque decoration of his own time as modern, unnatural, bizarre, whimsical, and irrational – in short, anti-classical: 'subjects, which our forefathers copied from nature, are now, by our depraved manners, disapproved: for monsters, rather than the resemblances of natural objects, are painted on the stucco; reeds are substituted for columns, and for the pediments, fluted harpaginetuli, with curling foliage and volutes; also candelabra supporting the forms of little buildings, their pediments rising out of roots, with numerous volutes and tender stalks, having, contrary to reason, images sitting on them; so also the flowers from stalks have half figures springing from them with heads, some like men, some like those of beasts…they ought…to be immediately condemned, unless they can bear the trial of rational examination.'[115]

This diatribe recognizes that antique art had separated into two main streams, two stylistic antitheses which easily came together again but could as easily express diametrically opposed ideals. These opposites, 'classical' and 'anti-classical', which will become one of the main themes of this book, correspond with the two poles of Greek religion – the harmony, balance and order of Apollo, and the exaltation and excess of Dionysus. The vice of classicism is dullness or pomposity; that of anti-classicism is profligacy.

Vitruvius' ideal was the 'classical' art that had reached its apogee in fifth-century Greece, disciplined, volumetric, rational, impassive and static (Edmund Burke thought 'A bird on the wing is not so beautiful as when it is perched'[116]). Classical art portrayed the human body without stress, exaggeration or 'manner' – 'classical naturalism', as it has recently been called – and employed botanical forms as a basis for an ordered and geometricized ornament. Above all, classical art was 'timeless'. This timelessness is not a Romantic invention: it was perfectly caught in the comment of Plutarch on the buildings of the Acropolis: 'we have the more reason to wonder, that the structures raised by Pericles should be built in so short a time, and yet built for ages: for as each of them as soon as finished had the venerable air of antiquity;[117] so, now they are old, they have the freshness of a modern building. A bloom is diffused over them, which

preserves their aspect untarnished by time, as if they were animated with a spirit of perpetual youth and unfading elegance.'[118]

Opposed to 'classicism' was the Alexandrian or orientalizing strain that is 'anti-classical', irrational, expressionistic, fantastic, often agitated, restless or excited, subjective, linear, exaggeratedly and at times violently naturalistic, which was seen at its most extreme in grotesque decoration and in such flamboyant Hellenistic and Roman architecture as the tombs of Petra or the third-century Temple of Venus at Baalbek [18], which have dramatic opposed curves. Proto-baroque architecture and fantastic grotesque painting had alike been influenced by the scenic art of the theatre.[119] Antique baroque was to be reproduced and developed further in modern baroque architecture and furniture: as the architect Francesco Borromini wrote, 'I made use of a bizarrerie which I had seen in antique things.'[120]

Flavian architectural sculptors took the bizarre motifs repudiated by Vitruvius and disciplined them for the purposes of monumental architecture [38]. Thus came into being the frigid grandiloquence of the famous frieze of the Temple of Antoninus and Faustina, later to be reproduced on innumerable items of furniture. Stone ornamental sculpture of this kind, more disciplined than painted grotesques but containing the same or similar motifs – and available above ground – was to influence the arts of the early Renaissance almost a hundred years before the rediscovery of grotesque painting.

Ceilings and floors

Ceilings might be as elaborate as walls. Fantastic decorative detail was held together by strong [39:F], in some cases almost brutal, geometricizing shapes. Radiating caryatids and terms, elongated to incredibly mannered lengths (probably originally to accommodate beams), articulated ceilings of the Domus Aurea and Hadrian's Villa [591]; these motifs eventually became prominent furniture decorations. Popular patterns were repeated and varied: a type of simple curvilinear interlace consisting of intersected circles of which numerous examples survive from ancient Egypt now occurred outlined in exiguous garlands, a device that came into general use with charmingly verdant effect [39:F]. Many painted ceiling patterns can be traced back to the structures of coffered timber or stone ceilings [15]; their fantasy did not inhibit their later translation back into the medium of carved wood. As time went on, stucco coffering became much shallower; complex reticulated and other patterns were adopted, often studded with rosettes and lozenges and bedecked with other ornaments, including monsters and gods.

Floor patterns were similar but simpler, partly because the mosaic technique, which had developed in Greece in the third century BC, was usually coarse compared with stucco and paint. Hellenistic and Roman mosaic floors came in various styles. At one extreme, contemporary wall decoration was reflected on the floor, fantastic fictive architecture or detailed pictorial compositions with human figures and animals, the whole framed in columns and 'antique drapery' [39:E] like a proscenium stage. Other designs were geometric [341], or incorporated Greek key patterns (often in 'shot' colour) [334], or frigid abstractions of the lotus [668]. Mosaic floors sometimes included an area outlined to contain large pieces of furniture, a practice that began in Greece. They contained charming vignettes, like the famous design of

doves sipping water from a vase, of which at least twelve antique variants exist; or they are witty, like the mosaic of the unswept kitchen floor scattered with detritus dropped by the cook (as still happens in some Mediterranean kitchens). These last two compositions derive from celebrated Greek paintings.[121] Many of these designs were to be repeated on veneered eighteenth-century commode fronts and mosaic table tops, the latter sometimes ancient, sometimes new.

Furniture and interior design

Was ancient furniture ever designed in concordance with interiors? Once interior decoration had emerged as part of the civilized way of life, furniture was likely eventually to be regarded as a part of a designed whole; the hedonist of antiquity needed no great leap of the imagination to regard furniture as part of interior decoration. Two considerations come to mind. The first is – would the designer/decorator of a luxurious room have been able to keep his hands off the furniture when working for a sophisticated client? The second is that furniture could easily have taken ornament casually, as it were, from architecture or interior decoration; the resultant harmony would have resulted not from the conscious activities of a designer but from the migratory adaptability of ornament and the antique unity of taste and motif. This unity came from an interrelated and familial vocabulary of ornament and the coherence of a period where poetry, myth, religion, and art were largely one; it is quite foreign to the eclectic fragmentation of our own times. Despite the importation of Persian furniture into Greece or Babylonian into Egypt, there could be no such problem in antiquity as a Gothic chair in a classical room.

The furniture depicted on Greek vases has not the aseptic grace of the old 'Children's Encyclopaedia' Greek ideal; some is boldly capricious, even bizarre.[122] Was it affected by 'orientalizing' interior decoration, for which the Greeks of the fourth and third centuries BC clearly had a penchant? They used Persian tents, for instance, which had dramatically exotic interiors. Alcibiades put up 'a Persian tent',[123] and a permanent building said to copy the tent of Xerxes existed at Athens in about AD 170.[124] The celebrated tent of Ptolemy

39 Columbaria (A), a façade with segmental (B) and triangular (C) pediments, a velarium (D), 'antique drapery' (E), and a 'grotesque' ceiling (F); Roman, published in London in 1721 (from D. Humphreys' version of Bernard de Montfaucon's *L'Antiquité expliquée*).

40 The 'throne of Neptune', a cut-out and scrolled throne decorated with acanthus dragons and a sea dragon, fitted into a wall decoration of Corinthian pilasters, tridents, dolphins and shells, with erotes playing with a trident and a shell, from a bas-relief; Roman, published in Paris in 1719–24 by Bernard de Montfaucon (from *L'Antiquité expliquée*).

right 41 Egyptian deities and ornament, in a Roman bronze tablet in Egyptian style, the *Mensa Isiaca*, published in Amsterdam in 1669 (from *Laurentii Pignorii Patavini Mensa Isiaca*).

below 42 A bronze tripod brazier from the Temple of Isis, Pompeii, decorated with sphinxes, scrolls, acanthus(?) finials, garlands and skulls; Roman, first century AD.

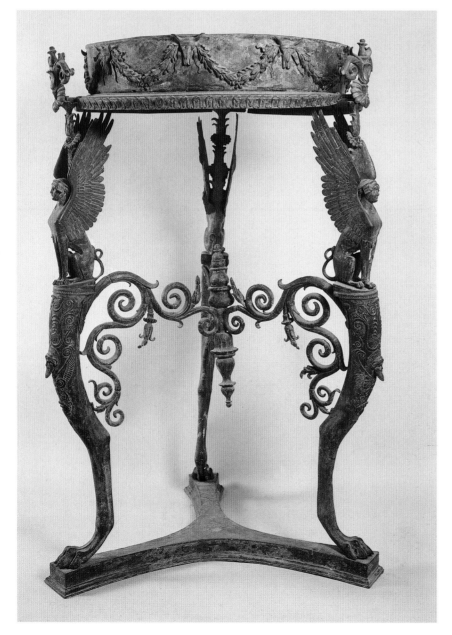

Philadelphus, whose court has been compared with the Versailles of Louis XIV,[125] was held up with pillars 'supporting the whole weight of the roof of the banqueting room. And over this was spread in the middle a scarlet veil with a white fringe, like a canopy; and on each side it had beams covered over with turreted veils, with white centres, on which canopies embroidered all over the centre were placed [this recalls the huge square velarium edged with bunched draperies of the Domus Aurea's 'Volta delle Civette']. And of the pillars four were made to resemble palm trees, and they had in the centre a representation of thyrsi.'[126] The Greeks acquired Persian furniture and used Persian textiles with Greek furniture – couches had 'smooth Persian hangings' between their legs.[127] Did these interests go further back? An archaic black-figure vase shows Zeus on an incised throne that is decorated on either side of the back seat rail with the forequarters of two large prancing horses; other vases show similar motifs.[128] The sumptuous columns of the Persian/Ionian Hall of a Hundred Columns at Persepolis [46] were decorated with double bull motifs that resemble certain Greek furniture ornaments (these columns have also, incidentally, some affinities with the small wooden columns that supported Egyptian kiosks [43], which themselves were adorned with animal heads[129]). Were the Persepolis columns – light, elongated, and separated along their length into differently decorated areas – themselves a barbaric rehearsal of the candelabraform columns later employed in Roman grotesque painting [37] and post rococo neo-classical furniture [584] ?

There are other hints of interplay between furniture and decoration. Greek thrones and couches were decorated with chariot, mythological, or contemporary historical scenes that resemble sculptural bas-reliefs or painted interior decorations. The three-dimensional scrolls and other ornaments that protrude from the frames of Greek chairs and tables, precursors of the scrolls and sphinxes of the famous tripod from Pompeii [42], frequently recur in Roman decorations [39:F]. A throne of the fourth century BC [3 *centre*] has three-dimensional erotes, scrolls and finials fixed to a broad back-board which is painted with a decoration that resembles coffering or panelling; sphinxes uphold the throne arms and scrolls adorn the seat rail; an X-frame stool [3 *bottom left*] has a mask at the crossing of the legs and scrolls above. Scrolls and a palmette placed above

the stretcher of a throne[130] remind one of Schinkel or Pelagio Palagi [418], whose furniture took its detail from the 'Etruscan' and 'Pompeian' rooms that housed it [416].

The availability of the same motifs for miscellaneous purposes – Hellenistic jewellery, for instance, is decorated with miniature erotes that resemble those seen on chair backs – warns against easy assumptions. But the probability that interiors and furniture were deliberately brought into mutual harmony in ancient Greece remains high, and is increased by what certainly happened in Rome. For extensive Roman remains dissipate doubts about the close interrelationships of interior decoration and furniture. It was, in any case, hardly likely that Nero or Maecenas would be content to leave the design of his furniture to the artisan and chance. Roman society saw signature and provenance enjoy as much prestige as in a present-day auction-room catalogue; narcissistic orators who suffered from the general 'mensarum insania' – 'table lunacy', a term used by women against men who reproached them for extravagance in pearls[131] – paid 'the price of a large estate' for a table. Taste in 'designed' furniture would have drifted downwards; as the decorated walls of the Domus Aurea or Hadrian's Villa influenced the decoration of lesser mortals than emperors, so would palace furniture have influenced the furniture of people who did not live in palaces.

There are many examples of apparent unity of design between Roman furniture and interior decoration. A splendid bas-relief shows the throne of Neptune[132] integrated into a line of Corinthian pilasters decorated with dolphins, shells and tridents [40]. If this reflects a practice seen in real interiors, it becomes inevitable that throne and wall were designed by one person. 'Pompeian' wall painting affords numerous examples of correspondences between decoration and furniture. A fictive 'Pompeian' door and surround is shown with what looks like tortoiseshell inlay: Ovid refers to 'three chambers, richly adorned with ivory and tortoiseshell';[133]

43 Wooden columns from kiosks at Thebes, with ornament that includes the volute-calyx, lotus, cobra, rosette and a papyrus column; Egyptian, Eighteenth–Twentieth Dynasties, published in Paris in 1868–78 by E. Prisse d'Avennes (from *Atlas de l'histoire de l'art égyptien*).

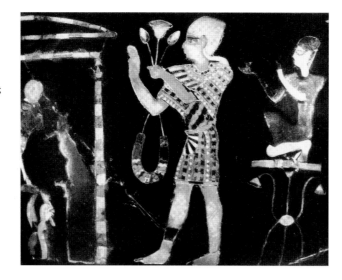

44 A table in Romano-Egyptian style with papyrus flower supports, in a detail of an *opus sectile* panel of pietra dura and gold on obsidian; Roman, Augustan period.

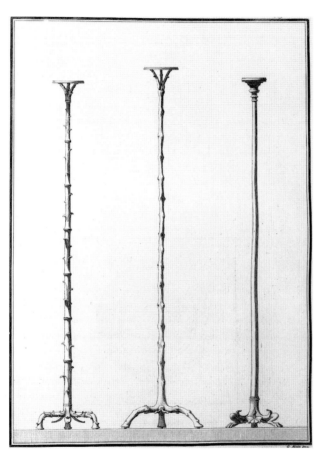

45 Bronze candelabri, one (left) apparently simulating bamboo, the others twigs; Roman, published in Naples in 1792 (from *Delle antichità di Ercolano: Le lucerne ed i candelabri d'Ercolano*).

46 Columns from the palace of Persepolis; Persian, late fifth–fourth century BC.

both substances were much valued on furniture,[134] and the same craftsmen may well have made door, walls and furniture, as happened in the Renaissance. The candelabraform columns of wall paintings [37] are very similar to slender Roman bronze candelabra [45]. The griffins, sphinxes and scrolls [32] so often painted on walls or assembled in mosaic floors are found in surviving bronze furniture, especially as legs and decorations for chairs, tables and tripods: one of the most beautiful and elaborate surviving pieces of Roman furniture, a bronze tripod brazier from Pompeii [42], has legs of winged sphinxes set on elegantly slender paw feet and united by stretchers of elaborately

curling scrolls; the brazier is be-garlanded and decorated with goat skulls. The tripod stood in the Temple of Isis, which had a painted room with sphinxes in the dado and pillars entwined with similar scrolls;[135] another room of the temple displays Isis on a throne decorated with the same type of scroll.[136]

Many other motifs were common to furniture and wall decoration. The human or animal torso combined with foliage and/or animal legs had appeared in furniture by the second century BC.[137] A tripod almost as famous as that with sphinxes has satyrs in their place [5]. Nymphs and satyrs supported furniture: the sylvan duo dances beneath a sideboard on a Hellenistic silver cup from Berthouville [25]. 'Antique drapery', another wall-painting motif [39:D], which came to be extensively used with post-rococo neo-classical furniture, had already been combined with furniture in Roman times [444, 452], perhaps sometimes as an integral part.[138]

Certain pieces of furniture indicate a possible concordance with the type of interior decoration that pictured garden scenes. Candelabra simulate twigs [45]; a candelabrum with a tree-like shape has multiple lamps hanging from it.[139] An eccentric stand for hanging lamps, with a wavy, branch-like stem and lamps in the form of shells, goes far beyond 'normal' design to suggest a possible connection with a total fantastic decorative scheme.[140]

Exoticism

Egyptian deities, images and ornament became common ingredients of early Roman imperial art, the oldest known instance of a large-scale adoption for exotic frissons by a Western society of the arts of another continent; they decorated the walls of the Villa of Augustus, the conqueror of Cleopatra, and adorned lamps and other small objects, obelisks and shrines. Numerous Egyptianizing sculptures stood in Hadrian's Villa; the defunct favourite Antinous was reincarnated in beautiful pharaonic guise, complete with wig. Sometimes Egyptian furniture was pictured as a motif of Egyptianizing wall decorations; was Roman Egyptianizing furniture (such a table was found on the Aventine in 1709[141]) designed to harmonize with them? The famous *Mensa Isiaca*, a tablet (probably not the table top it has been taken for) which surfaced in the Renaissance[142] and became a potent source for designers, was surely meant to fit into such an environment [41].[143] An Egyptianizing scene from an Augustan bowl in *opus sectile* [44] shows a metal table of unequivocally Graeco-Roman form decorated with the same papyrus flowers as those held in the hands of the principal figure.

The Romans skirted the confines of 'chinoiserie'. Silk was a favoured material, too favoured according to Juvenal, and textiles brought through the silk route from China carried Chinese ornament with them. Roman bronze candelabra exist in what appears to be simulated bamboo [45], and Pompeian wall paintings display upturned roofs with curled-up eaves, dragons, and other 'Chinese' features [559]; some have dark backgrounds and disconnected detail that make them resemble later Japanese lacquer [558]. Such hints were not lost on the eighteenth century.

I *Chapter 4* Ornaments and motifs

ORNAMENT has been mentioned above in various contexts, but its overriding importance to later ages, and the frequency with which it will be cited in these pages, makes it useful to bring the subject more into focus. The importance of antique ornament is inestimable: the story of the Western tradition in furniture is largely the story of inherited form and mobile ornament.

Two characteristics of ornament stand out above all others. The first is its wealth, the coruscating swarm of motifs at the disposal of the artist or craftsman; the second is its protean ability to change shape and dimensions whilst retaining its essential identity – a Corinthian column moves from a Greek temple to a Fornasetti secretaire [678]; garlands and skulls move from a temple to a 'Grand Tour' Roman table [348]; a sphinx moves from the desert sands to a Pompeian wall or a Biedermeier cupboard [611]; an acanthus scroll moves from a Roman sarcophagus to a William Morris tapestry via a Romanesque miniature – at each stop recognizably different but recognizably the same. Trying to grasp the essence of an ornament is like trying to catch a falling star or the Fata Morgana: how can one make sense of such elusive entities? Two principal approaches to ornament offer a way forward, each illuminating in a different way.

The first is through the evolution of ornament as perceived by academic historians. Theory gives insights into the general nature of ornament; it also often influences practical artists and craftsmen in what they do; even theories that turn out to be largely wrong, such as the mechanistic theories of ornament evolved in the nineteenth century, influenced the arts and furniture of their period. This academic, theoretical approach entails scrutiny of a particular ornament as it changes and adapts, a process that here will occur naturally as particular ornaments, the scroll, for instance, are considered on a piece of furniture at a particular time. The second approach is through the eyes of philosophers, artists – and poets. Antique philosophy and criticism (the theories of Aristotle on poetry, or those attributed to Longinus (AD 217–273) on the sublime) greatly affected the visual arts and furniture, especially after the Renaissance. Four opinions that mix theory and practice, those of Leone Battista Alberti (1404–72), Federico Zuccaro (c. 1540–1609), Owen Jones (1809–74) and Christopher Dresser (1834–1904), all designers as well as theorists, are given immediately below as samples (others are mentioned in the context of their periods).

Alberti, the great architect and theorist of the early Italian Renaissance, defined 'Beauty' as 'a harmony of the parts…nothing could be added, diminished or altered, but for the worse'; 'Ornament' was 'a kind of auxiliary brightness and improvement to Beauty…somewhat added or fastened on, rather than proper or innate'.[144] This sounds contradictory, implying that the addition of ornament can only impair the harmony of beauty (a conclusion drawn by twentieth-century anti-ornamentalists) – but if one thinks of a pair of dark eyes, perfect in themselves, glowing and symmetrical, but enhanced by kohl, one perhaps grasps what Alberti meant. Alberti's definition encapsulates two characteristics of ornament: its role as an 'auxiliary brightness', an enhancement of the beauty of an artefact; and its nature as

an appendage, independent of the artefact to which it is attached. Alberti's view matches the classical idealism of early Renaissance architecture and art, as one would expect.

Equally, the system expounded by Zuccaro, one of a family of late sixteenth-century Italian decorative painters, reveals much about the art of his own period as well as illuminating the nature of ornament in general. Zuccaro separated the 'arti del disegno', the visual arts, into three categories: the natural, the artificial, and the fantastic. Natural ornament was drawn from animate and inanimate Nature; this would be taken to include sun [584], moon [604], stars [598], tortoises [232], palms [263] and shells [311]. Artificial ornament was drawn from man-made artefacts, which would include the Ionic temple [298], lyres [397, 442], trophies [62], and canopies [261]. Fantastic ornament comes in all shapes and sizes, ranging from beautiful [63] or ugly [211] monsters to the luxurious abstractions of the scroll [324]. Zuccaro's definition is a decorative artist's definition, firmly bound to the nature of the ornament as it is used.

The theories of the British Victorian ornamentalist Owen Jones influenced design over several generations. His systematic pictorial survey, *The Grammar of Ornament*, was published to assist the 'future progress of Ornamental Art' through 'engrafting on the experience of the past the knowledge we may obtain by a return to Nature for fresh inspiration'; he thought that 'To attempt to build up theories of art, or to form a style, independently of the past, would be an act of supreme folly.'[145] He enunciated influential theories: 'The Decorative Arts arise from, and should properly be attendant upon, Architecture'; 'Construction should be decorated. Decoration should never be purposely constructed'; 'All ornament should be based upon a geometrical construction'; 'Imitations, such as the graining of woods, and of the various coloured marbles, [are] allowable only, when the employment of the thing imitated would not have been inconsistent.'

His maxims, eagerly seized upon by designers of all kinds, included 'evidence of mind will be more readily found in the rude attempts at ornament of a savage tribe than in the innumerable productions of a highly advanced civilisation'; 'Individuality decreases in the ratio of the power of production. When Art is manufactured by combined effort, not originated by individual effort, we fail to recognise those true instincts which constitute its greatest charm'; 'the Egyptians are inferior only to themselves'; '[Greek] ornament was no part of the construction, as with the Egyptian: it could be removed, and the structure remain unchanged'; 'Pompeian ornament was carried to the very limit of caprice, and…almost any theory of colouring and decoration could be supported by authority from Pompeii'; 'The traditions of the Byzantine school…have served, in a great degree, as a basis to all decorative art in the East.' And so on.

Jones greatly influenced Christopher Dresser, who defined ornament in a way that had much in common with that of Alberti, save that 'utility' casts the long shadow that for a time almost destroyed ornament (p. 271): 'Ornament is that which, superadded to utility, [bestows] upon it an amount of beauty it would not otherwise possess…the application of ornament to objects cannot be said to be absolutely

47 The 'Tree of Life': detail of an Assyrian stone relief from the palace at Nimrud.

48 A Greek tendril, after a Greek vase.

49 A sphinx scratching itself: a Hellenistic gem, published in Amsterdam in 1724 by Baron Stosch (from *Pierres antiques gravées*).

necessary'; 'Utility, or adaptation to the purpose intended must precede enrichment.' Dresser comes near to defining painting, sculpture and architecture as decorative arts. He thought 'Knowledge is essential to the production of the beautiful' and that 'the greater the manifestation of mind in a work of art of any description, the more pleasure we derive from it; also, the absence of the manifestation of mechanical labour in its construction tends to the same result' (one's pleasure in the first excellent principle is dashed by Dresser's instancing the paintings of John Martin as an embodiment of mind in pictorial art!). He grades ornament according to its mental power, with Greek, Moorish, and Early English Gothic at the head of the list, and Late Gothic, and much Chinese and Indian, towards the bottom. Lowest of all is 'Pompeian' and 'our modern floral patterns'.[146] Dresser preferred Nature geometricized; he stresses the importance of order, pattern, and repetition.

The practical list that follows is inevitably severely restricted. It chronicles widely used ornaments that continually recur over thousands of years, selected to facilitate recognition when applied to furniture at different periods. Ornaments included are occasionally grouped within certain categories: those assembled under 'grotesque', for instance, occur elsewhere and the grouping is artificial, but it is convenient because later periods took them over entire from grotesque and applied them en masse to furniture.

Some pre-eminent motifs

Three forms of ornament – monsters, the volute-calyx, and acanthus – stand out as paramount influences on furniture in the Western tradition. Monsters are extremely ancient and persistent; the connections of the volute-calyx with the Egyptian lotus, Ionic and Corinthian capitals, and anthemion and palmette ornaments, give it an extraordinary significance; the acanthus, which joins the volute-calyx in the Corinthian capital and forms the basis of the peopled scroll, has been called 'by far the most significant vegetal motif in history'.[147] Almost as important are garlands.

The monster

A monster is 'an imaginary animal, either partly brute and partly human, or compounded of elements from two or more natural forms'.[148] Man painted artificial monsters on the walls of caves when mammoths walked the earth; the poets of antiquity created monsters by allegorizing religious practice as it turned from barbaric cruelty to civilization. Monsters became ubiquitous, portrayed in all kinds of artefacts, from the colossal to the minuscule.

The most universal monster – and one of the simplest – is the winged human, seen in pre-Christian antiquity in exactly the same form as that in which it still occurs [446]. Another winged monster, the bull, was sacred in the early Near East. The most famous of monsters, the sphinx, was in its Egyptian version half a lion, half a man, broodingly and forbiddingly hieratic: it sprouted wings and became furniture mounts, sometimes in the popular form of two monsters facing each other in heraldic uniformity, a motif that originated in the Near East. The griffin had the head, wings and claws of an eagle and the body of a lion, and was used as seat terminals in Persia. Other antique monsters included the centaur, half human, half horse; the harpy, half bird, half maiden and mischievous, very bad; the Greek satyrs with tails and pointed ears who were endowed by later Roman poets with the goat legs of their native fauns [5], thus causing confusion; the sea monsters, mermen, mermaids, and tritons, all with human

head and torso and a fish's tail; the 'hippocamp' with a horse's head and forequarters combined with a fish's tail.

The religious significance of animal motifs used in furniture faded, but the monster was too attractive a genre to be abandoned, and new monsters were created that were capricious decorative inventions lacking mythological significance. The archaistic solemnity of animal or monstrous forms softened into genial, sometimes humorous ornament. An ancient story of the Great Sphinx recounts that its originally tinted cheeks led the Greeks to call it 'Rhodopis' ('rosy-cheeked') and think it female:[149] the Egyptian 'riddle in the head-cloth' assumed the smile of an archaic Greek *kore* [660] and became a skittish domestic monster that scratched itself like a cat on a hearthrug [49]. Elegantly elongated sphinx supports to arm rails [10:E], an enormously influential motif in ancient and modern furniture, first became popular in fifth-century BC Greece; later they perched as a decorative flourish on the legs of a tripod [42].

The Rome of Ovid's *Metamorphoses* was a world in which floating devotees drifted towards the softer attractions of Isis and Christ. Archaizing animal or monstrous forms in later Roman furniture were a matter not so much of religious symbolism as of fashionable revival – play, just as much as their descendants on a fierce Russian porphyry bowl were play [428].

The volute-calyx

The late nineteenth-century term 'volute-calyx'[150] is employed here as a convenient and neutral way to describe an abstract version of a flower, possibly originally the profile view of the lotus [50]; its connections with the Aeolic, Ionic and Corinthian capitals are apparent. The angle created by the two diverging volutes was usually, but not invariably, filled by an arc topped by a fan of leaves. Probably originating in Egyptian art, it quickly spread; it occurs, for instance, in Mycenae. Other important architectural motifs may have been derived from the lotus, including the 'palmette' and the 'anthemion', evolved by the Greeks by 700 BC; it has also been postulated that lotus blossoms and buds in alternating rows provided the ultimate basis for the Greek Ionic cyma, egg-and-dart, and leaf-and-dart mouldings. Whatever their origin, all eventually became amongst the commonest of furniture ornaments.

The volute-calyx raises the question of the relationships in antiquity between furniture, architecture and interior decoration – volute-calyx capitals may have originated not in architecture but as furniture decoration.[151] An important early volute-calyx capital, the proto-Ionic form called 'Aeolic', often adorned the extraordinary cut-out couches [13], and it has been noted that 'The first instance of the portrayal [on Greek vases] of volutes as a support is as a capital of a couch leg.'[152] An Etruscan tomb [51] of which the roof is supported by pillars with Aeolic capitals contains a couch, also decorated with Aeolic capitals,[153] placed against the wall. Here, the relationship between the decoration of pillars and couch is obviously deliberate; at some distant time, the motif or its predecessors may have migrated from furniture to walls.

The Aeolic capital is seen in embryo amongst the crowd of motifs that adorned painted representations of Egyptian kiosk 'columns' [43]: significantly, these 'columns' may possibly have been flat, a fact that, through the Greek cut-out couch, may have helped to influence the Biedermeier furniture of over three thousand years later (p. 225). From hundred-gated Thebes to Metternich's Vienna?

50 A drinking bowl decorated with the volute-calyx (a lotus flower), the prototype of the Aeolic capital and other ornament, and a rosette; Cypriot, *c.* 725-600 BC.

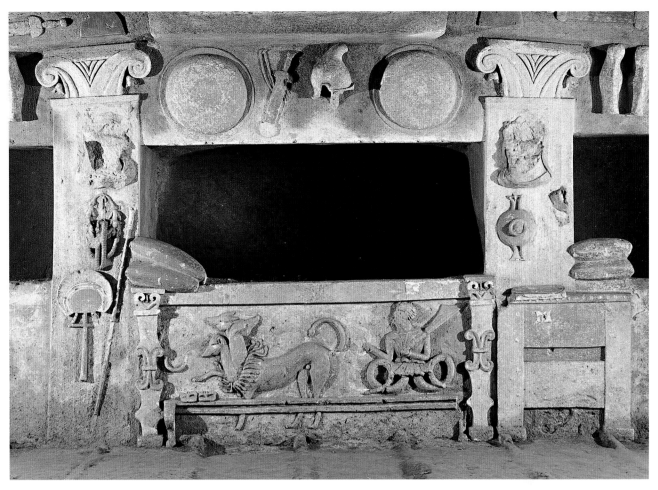

51 A wall couch and table in the 'Tomb of the Reliefs', Cerveteri; the couch, decorated with 'cut-out' Aeolic-type ornament, is set within an alcove with Aeolic capitals; it has a frieze of two monsters; in front of it is a long stool with scroll legs, and beside it a chest with cushions on top; Etruscan, probably sixth century BC.

The acanthus and the peopled scroll

The union of a horizontal, undulating line with vegetal ornament led in the fifth century BC to the appearance of a most important decorative motif, the continuous tendril [111], often in the form of the 'acanthus' scroll [52, 53]; the earliest known examples occur in sculpture of about 450–430 BC. Real acanthus grows as leaves with no tendrils, but Hellenistic art introduced the botanical features of acanthus into existing tendril ornament [48][154] that wound over large surfaces, continuous, intermittent, and interlaced [53]. In late antiquity and Byzantium, the movement of the acanthus scroll towards greater naturalism was reversed, and together with other naturalistic ornament it became increasingly abstract, a process that culminated in the completely abstract scroll of Islamic 'arabesque' [109, 110] – which had, in essence, already existed in Greek art.

The pure curves of the Greek scroll, especially the acanthus scroll, were used to cover an area with elegantly symmetrical decoration, as on the backs of the splendid Greek or Roman monumental thrones [22]. The scroll was also employed in a horizontal or vertical line; in the latter form, it somewhat resembles the ancient 'Tree of Life' [47]. Greek and Roman ornamental sculpture often disciplined the vertical or horizontal scroll within the confines of a pilaster or frieze [52]. Beautiful and versatile in itself, the scroll was from about 400 BC elaborated into one of the most attractive

52 Acanthus scrolls, with a Greek key fret above and decorated Corinthian pilasters on either side, on the Ara Pacis, Rome; Roman, Augustan period.

53 A stag hunt bordered with a Vitruvian scroll and with scrolling decoration that includes acanthus as a motif: a pebble mosaic by Gnosis at Pella, Macedonia; Greek, *c.* 330–300 BC.

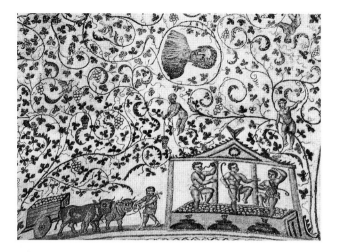

54 Curvilinear interlace, a peopled scroll of a vine containing grape-gathering putti and a head (probably depicting Christ); detail of the mosaic ceiling of the mausoleum of Constantia (S. Costanza), Rome, early fourth century AD.

of all ancient ornamental motifs, the 'peopled scroll'.[155] Greek acanthus scrolls were 'peopled' first with little figures of human beings, beasts, and birds; by 200 BC inanimate objects such as weapons had been added, and as time went on more diverse objects were incorporated. By about 30 BC the peopled scroll had entered Roman architectural sculpture and wall and ceiling painting, and a whole population of beasts, birds and monsters, many half hidden, was scattered discreetly or indiscreetly amongst scrolling foliage. These fanciful inhabitants were added also to the unconfined scrolls that often curled around the fantastic architecture of painted wall decorations. From about AD 75 the peopled scroll was used extensively by Roman metropolitan sculptors. It became one of the most constantly used motifs in furniture [173, 207, 408].

Garlands, ribbons, skulls, and cornucopias

A motif of great importance was perfected in classical Greece – the sacrificial ornaments of garlands, ribbons and skulls. Taken over entire by Rome, they thence entered the modern vocabulary of decoration.

Garlands played a prominent role in Greek and Roman life. Real, they decorated the house and the palace, were customarily worn on the person, and were indispensable to the etiquette attached to dining; real and in stone, they decorated the temple, the altar, and the sarcophagus. Sculptured garlands can be light, but tend to a heavy stateliness [10]; the painted garlands of wall decoration are often attenuated, wayward and free-floating [32, 33]. Garlands were frequently bound with ribbons [169], a motif that allowed fancifully convoluted intertwinings; it was probably from this source that the 'ribbon' interlace of Roman ceilings derived. Ribbons and ribbon interlace were to have an eventful future, not least on furniture.

Associated with the garland was the *bucranium* [55], the skull of the sacrificial ox, around the neck of which garlands were hung. Bucrania – and by extension, ram or goat skulls with horns [42] – migrated from temple entablatures, altars and sarcophagi to become a universal ornament that still spells the two magic words 'classical antiquity': 'In Arcadia,' Miss O'Brookomore declared in 1916, 'I intend to coil my hair like rams' horns.'[156] Another horn, the cornucopia, was associated with the goat that suckled the infant Zeus; it became a symbol of fecundity [86].

Motifs associated with Roman grotesque

Certain motifs that did not originate in grotesque wall paintings occur in them in quantity and thence were copied in later ages. They include acanthus monsters, candeliere, candelabri and candelabraform decorations, gods and goddesses, caryatids, architectural vignettes, fantastic

miniature buildings (temples, shrines, altars, palaces, cottages), canopies with lambrequins, 'antique drapery', trophies, animals, attenuated terms, 'animal protomai' (animals that project forward from the acanthus scroll that forms their hindquarters), and other motifs. Those taken over by Flavian sculptors entered the general repertoire of architectural ornament.

The acanthus monster

An antique ornament of singular beauty united the charms of the monster with those of acanthus: it consisted of some combination of the human, bestial or monstrous head and torso with scrolling acanthus foliage [38]; the hair and beard of the male may turn into fanciful acanthus scrolls [343]. The strange attractions of this half-vegetable oddity, the ability of the acanthus 'tail' to fit into awkward shapes, its complete flexibility, encouraged its use in all kinds of contexts, including furniture [344].

Candeliera, candelabro, and candelabraform ornament

Dominant ornaments in ancient times, these forms re-emerged in the Renaissance and maintained their importance up to the present century; they became ubiquitous in modern furniture. The ornaments are wonderfully decorative, but the terms are wonderfully confusing. 'Candeliera', 'candelabro' and 'candelabraform' distinguish different but related forms of ornament: they do *not* refer to the three-dimensional lamps or lights which are usually known as 'candelabrum' or 'candelabra' (Latin singular and plural) [10:A–C,K, 45].

Candeliera[157] (Italian, plural *candeliere*) literally means 'candlestick'; as used by present-day Italian art-historians, the term denotes a more or less symmetrically disposed vertical pattern of foliage scrolls and other miscellaneous ornament – cornucopias, monsters, pillars and pediments, etc.; its airy scrolls and festoons often issue from a vase. Usually elaborate, it could be highly fantastic. It could be confined within a pilaster [52] or used independently of it. Candeliere reached the heights of ornate elaboration in ancient and modern painted decorations [375], although their delicate fantasy is capable of realization in bas-relief and woodwork. One of the most versatile of ornaments, the candeliera surpasses the trophy [62, 375] in its capacity to absorb miscellaneous detail, and is appropriate where the trophy is not. Vine and vintage scrolls, originally from the Eastern Mediterranean, appear in the late imperial period as candeliere, with little Bacchic fauns and satyrs within the vine scrolls; this became the most commonly used form of peopled scroll, partly because of the beauty of the vine leaf and grapes, partly because of their associations with

55 A Roman altar with a dancer, garlands of fruit, and skulls: drawing from an early eighteenth-century English collection.

56 A marble baluster table with a bronze tripod animal-legged foot and a bronze rim decorated in silver and niello, from Boscoreale; Roman, first century AD.

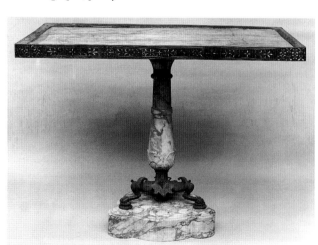

La Chausse

57 A bas-relief showing a candelabro ornament with concave/convex moulding, acanthus ornament, and tripod animal feet; Roman, published in Paris in 1719–24 by Bernard de Montfaucon (from *L'Antiquité expliquée*).

Christianity, the new dominant religion – all in all, the most genial possible instance of Christian iconography [54]. Candeliere were influenced by the same Greek liking for human and animal figures in decoration as is apparent in the peopled scroll. The vertical spiral filled in with palmettes (a more disciplined relation of the candeliera) became a separate Greek motif.

Candelabro (Italian, plural *candelabri*) denotes a decoration in the shape of a candelabrum or torchère [57, 164]. The essential difference between a candelabro and a candeliera ornament is that the latter may be utterly fantastic, in a form capable only of being reproduced flat in paint or bas-relief, whilst the former, however elaborate, should be capable of being realized in three dimensions. The candelabro is common in ancient sculpture in bas-relief and in stone furniture, again often combined with a vase. Its 'turned' stem has resemblances with the concave/convex 'turned' legs of Greek and Roman couches [57]. The simple baluster resembles the candelabro and was often incorporated into it in ancient and modern times; it was also used to support furniture, as in a Roman marble and bronze table [56]. Renaissance artists and architects invented the balustrade, which is merely a row of balusters. The balustrade became a common furniture ornament in the baroque period [244, 243].

The word 'candelabraform' is an English hybrid, and denotes the decorative elongated shafts (usually 'turned' in parts), without decorative offshoots, which are common in 'Pompeian' decorative painting [37]. Many Etruscan and Roman bronze candelabra are in three-dimensional candelabraform shape; Roman stone candelabra tend to be stockier. Candelabraform ornament is of a more architectural order than the candeliera and candelabro. The Renaissance fountain, a closely allied form, was often incorporated into later candeliera decoration.

Caryatids

Ancient architecture used the carved human figure structurally, to uphold entablatures; the most famous example is the sublime maidens of the Erechtheion in Athens (*c.* 420 BC). Female caryatids had their male equivalents, 'atlantes', derived from Atlas, who held the world on his shoulders (in the eighteenth century AD the world dwindled into a clock face). Vitruvius held that male caryatids represented Persian captives enslaved by the Greeks, and thence the term 'Persic' entered the vocabulary of ornament. Herms and terms are hybrid, a pillar topped by a human head and sometimes a torso; they were originally used as mile-stones and boundary marks (Hermes and Terminus were the gods who carried messages and marked boundaries). All these forms of caryatid became furniture ornaments in antiquity.

'Antique drapery', the velarium, the tent and the canopy

'Antique drapery', the velarium, and the canopy all originated in utilitarian textile hangings. The folds into which textiles fall have a natural freedom and grace, and textiles may easily be coaxed into an extravagance, not to say wildness, that offers excellent decorative possibilities [261].

'Antique drapery'[158] [39:E] was a simple hanging that probably owes its elegant folds to its being made up from cloth of restricted widths. Almost certainly originally a wall hanging meant to conserve domestic warmth, it occurs as decoration on Greek vases, in Roman sculpture and subject paintings, and in wall and ceiling decoration, including the interior decoration of tombs; it was frequently depicted in mosaic.

The *velarium* was a fabric, sometimes huge in extent, spread as an awning to protect householders or theatre-goers from the hot rays of the Greek or Italian sun. It might be dyed in myriad hues. It existed also as an extended awning; the ancient Sybarites, shrinking from the sun, covered roads that led to their country houses with awnings along their length.[159] Velaria and long awnings entered painted and stucco Roman wall decoration, the former as a full, half or quarter circle marked by a web of radiating lines on walls and ceilings: the velaria and canopies of the Domus Aurea possibly originated in the Hellenistic palaces of the Ptolemies in Alexandria (Nero was interested in Graeco-Egyptian art). The velarium's similarity to the shell has led to confusion, and the learned antiquarian Piranesi called it a 'conchiglia'.[160] The confusion may be excused, since in antiquity it was hybridized with the shell [39:D]: an example in Hadrian's Villa[161] is half shell, half velarium; the presence of tassels at the end of the 'ribs' weights it towards the latter.[162] The velarium was frequently ornately decorated with key patterns, scrolls, monsters, etc. One of the most beautiful ornaments of antiquity, it never fell into eclipse, becoming especially popular as furniture decoration in the later eighteenth century and remaining in frequent use until the twentieth.

Like the velarium, the canopy originated as a sun shield, but unlike the velarium it could be portable. A symbol of rank [2], it was borne over the ancient kings of Assyria and Persia, accompanied by fans; the kings of Persia sat on a golden throne 'surrounded by four small pillars made of gold, inlaid with precious stones, and on them was spread a purple cloth richly embroidered'.[163] Xerxes' defeat was lamented as the loss of a golden canopy.[164] The same arrangement, give or take a few precious stones, is still used today. The aedicules containing couches seen on Greek vases have much the same effect as the canopied 'four-posters' of the seventeenth and eighteenth centuries AD; the essential difference is that the couch is independent.[165]

Velaria and canopies have affinities with the tent. Tents and canopies were often decorated with fringes and with lambrequins [196], a festive motif that has had a long career. Antique drapery, velaria, canopies, tents, and lambrequins all became celebrated forms of ornament. The pompous 'state bed' seen during and after the Renaissance was to owe more to these ancient forms than to anything else [261, 263, 349, 580]. A late descendant of the state canopy was the fringed canopy or sun-shield that adorned the stately perambulators in which babies rode until the 1970s – now replaced by the folding push-chair, a déclassé descendant of the hieratic X-frame chair.

The pergola, trellis, trees, birds, naturalistic flowers and leaves

Trellis, pergolas, fountains, birds and vases of flowers were arranged to frame and formalize the plants and trees depicted in Roman wall decorations. Not only did such motifs appear on walls: 'many of the floors in the men's apartments were inlaid with flowers…by the artists'.[166] Trellis appears in various patterns, including lozenges.[167] Some Roman wall paintings of gardens have the informality and nonchalant grace that are the last mark of a developed culture. Baskets of flowers or fruit, emblems of fecundity, occur frequently in diverse contexts [86]. All these motifs were revived at the Renaissance, and were used extensively in decorating furniture during the rococo and 'rococo neo-classical' periods.

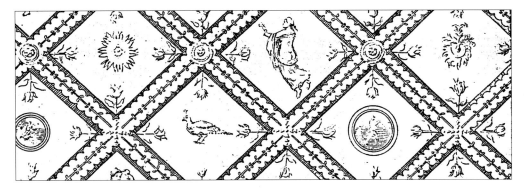

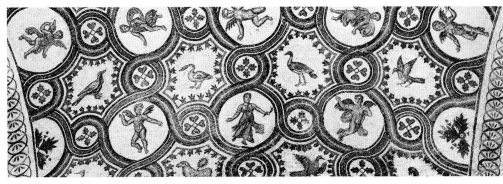

top 58 Geometrical interlace with vegetal elements, from a Roman ceiling painting from Stabiae.

above 59 Curvilinear interlace, partly bordered by vegetal interlace, on the mosaic ceiling of the mausoleum of Constantia (S. Costanza), Rome, early fourth century AD.

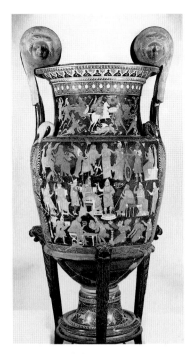

60 A so-called 'Etruscan' vase, a volute krater known as the 'Darius Vase'; Apulian, *c.* 425 BC [cf. 3].

Motifs associated with mosaic: infinite rapport and geometrical and curvilinear interlace

'Infinite rapport' signifies the orderly repetition of a motif as the basis of an entire decorative composition.[168] The convention presupposes an exterior frame enclosing a decoration – which seems obvious enough now, but had to be discovered. Infinite rapport that used geometric shapes – squares and lozenges, for example – had long been practised (in Egypt, for example [661]), but it was only after the high point of naturalism had been reached in the Hellenistic period that non-geometric patterns in infinite rapport began to appear in antique art.[169] Geometricizing wall and floor decoration based on infinite rapport occurs frequently in Pompeian and Hadrianic art [58, 334, 668]. This principle of orderly repetition, handed down from antiquity, is the basis of all such repeating patterns in furniture.

Geometrical and curvilinear patterns in infinite rapport provide the designs of many mosaic floors, and these were to be a potent post-antique influence. Many of the geometrical designs were highly ingenious. Geometry need not exclude fantasy: it sometimes engenders it, and in Roman mosaics it engendered it with the same playful duplicity as did the false perspectives on the walls. Some of these floors are dazzlingly (literally) illusionistic: the whole surface seems 'in the twinkling of an eye' to flick and twist into a completely different perspective, planes dip and rise as one looks at them [341]. The emphasis is on Euclidean elementary forms; squares, triangles, circles, pentagons, hexagons, octagons, cones and spheres.

Post-Renaissance antiquarians were fully aware of the antiquity and variety of interlace, of its use in ancient Assyria and Persia, and of the role played by mosaics in its transmission.[170]

A beautiful new Pompeian variant of geometric interlace constructed geometric compartments – for instance, lozenges, hexagons and circles – of blossoms, rosettes and leaves; ornamental motifs, including mythological figures, animals and rosettes, were often included within the vegetal geometric shapes [58]. Botanical motifs were also formed into spirals or scrolls of regular shapes. This entrancing invention fully entered its furniture kingdom when French eighteenth-century marquetry covered secretaires and commodes with decussated lozenges and massed polygons copied from Pompeian artefacts [340, 363].

A flowing, curvilinear interlace called the guilloche, also known as the 'plait' or 'twist',[171] had been used in Mycenae, Assyria, Egypt and classical Greece; it frequently served to define the borders of Roman mosaics, a curvilinear alternative to angular, broken bands of geometrical interlace. In late mosaics the number of interlaced strands increased, and they spread from the borders into the main areas of design. Thereafter, the guilloche never went out of use; it became, for example, a typical ornament of English Kentian and Regency furniture.

Also ancient was a particular pattern of bold intertwining circular shapes, which became popular both for mosaic floors and as a strong shape to hold together the intricate detail of Roman ceilings. It never disappeared; it appears in a simple form in S. Costanza [59], was popular with the Cosmati and, revived at the Renaissance, became an important constituent of furniture design in the late seventeenth and early eighteenth centuries [279].

Other antique artefacts that supplied form and ornament to furniture

Some of the motifs described above, 'antique drapery' for example, began as real artefacts; becoming ornament in antiquity, they were handed down as such to succeeding periods. Sometimes they reverted back to a 'real' form, as did 'antique drapery' in the late eighteenth century [398]. Other antique artefacts, not ornament in antiquity, were raided by posterity for ornament and forms. Some were incorporated more or less entire into new contexts: the carved sarcophagus, for example [185], was transformed into the carved sixteenth-century Michelangeloesque cassone [186]. The miscellaneous and by no means exhaustive selection of arte-facts given below includes examples most often employed by later furniture makers as sources of form and ornament.

Greek and Roman painting and sculpture

Paintings and sculpture have been potent catalysts in creating style, and famous Greek paintings and sculpture have proved the most potent of all. The fame of the great Greek painters – which outlasted their works by two thousand years and more – and sculptors was recorded in written texts, some of which survived the Dark and Middle Ages to inspire painters and designers of the Renaissance and afterwards. The works themselves were copied and adapted wholesale in marble [251], terracotta, paint, mosaic, and other media throughout the Roman Empire. The quality of the copies fluctuates, that of paintings being especially uneven – great paintings reproduced as incidental ornament for a Pompeian wall by a hack painter frequently travestied the original, sometimes painfully – but the original's intention is usually fairly clear, and in the case of sculpture the quality of the copy may be high. The availability of paintings as a mine for revivalist furniture has been mentioned. Famous pictures and sculptures were also used for gems, coins, and vases.

Roman portrait busts forcefully combined realism and style; imperial majesty, senatorial gravitas, vestal severity provided memorably impressive images. The bust within a roundel was often a feature of Roman tombs. Contemporary Roman literature makes clear the importance of ancestral busts; they were eagerly taken up in the Renaissance and drafted into the service of exterior and interior decoration and furniture, either contained within a Roman-type roundel [188] or free-standing.

Painted Greek vases

Although largely restricted to a colour scheme of black on red, red on black, and various uses of white, the classical Greek terracotta vase [13, 60] gives an idea of the spontaneity and elegance the lost miracle of Greek painting must have had in the greatest hands. Gods, heroes and hetaerai were depicted amongst furniture, textiles, and such objects as household altars.

Vase pictures were commonly framed within rectangular, square or circular borders made up of various motifs including architectural ornament rendered in line, anthemions, dots, and stellate ornament. Some of the abstract motifs suggest the traditional criss-cross repeating patterns employed in basket work, whence comes an affinity with trellis that in the eighteenth century suggested new ornaments. Some of the motifs, notably the Greek key pattern and the various systems of interlocking circles, lozenges and squares, have affinities with Chinese and Japanese ornament [561–568].[172] These likenesses were to make easier the syntheses between classical and oriental styles that occurred from the late seventeenth century onwards. The shapes of the vases varied from grand rotundity to elegant slimness; as d'Hancarville said in 1785, they provided for the designer more than two hundred 'new' forms, and from 'the purest source'.[173]

Admiration for the vases in the later eighteenth century led to the 'Etruscan' fashion (pp. 202–8); it profoundly affected furniture and decoration for more than a hundred years.

Coins and gems

Coins were a Lydian invention, first appearing in the seventh century BC (they were often mistakenly called 'medals' in the Renaissance and afterwards). They quickly became extremely beautiful [413]. Greek classical and Hellenistic carved gems reached even greater heights, and were collected and imitated by the Romans, for whom magnificent cameos [445] were produced. Coins and gems often exhibited emblems – erotes, wheat ears, various animals and implements such as ploughs; they also reproduced images of Greek sculpture. Coins were confined within a circle; for gems the favourite shape was the ovular scarab [49]; this concentration of much decorative interest within a small, regular confining shape encouraged their later incorporation into furniture, sometimes in the form of antique originals, sometimes as copies [385]. Coins usually contained a head on one side; Imperial Roman coins often bore the profile of an emperor, reproducing the forceful vitality that was to prove so attractive to designers during and after the Renaissance, corrugated and often brutal features with eagle eye, swelling neck and Roman nose, the head crowned with a laurel wreath decorated with fluttering ribbons.

Gods, heroes, bacchantes, erotes

The gods and heroes of the complex pagan myths were often illustrated in ancient painting and sculpture. Unlike the animal-headed gods of Egypt (which became ornament in the Rome of Augustus, eighteen hundred years before they became ornament in the Rome of Piranesi [598]), the premier gods of Olympus were a comely lot; the human form corporeal in its most beautiful incarnation acted as a model for the human form divine; since humanity was itself 'in the form of the masterful gods',[174] there was nothing improper in the lovely (and rich) Athenian prostitute Phryne posing for the Cnidian Aphrodite by Praxiteles.[175] In guises made famous by Greek painters and sculptors, the gods were

61 A tripod table in marble, with heads of Hercules arising from acanthus, and lion-paw feet; Roman.

right 62 A trophy with armour, shields, scabbard and quivers with arrows; Roman, published in Rome in 1753 by G. B. Piranesi (from *I trofei di Ottaviano Augusto*).

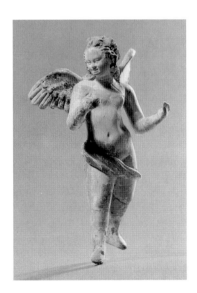

63 Eros: a Greek terracotta statuette, second century BC.

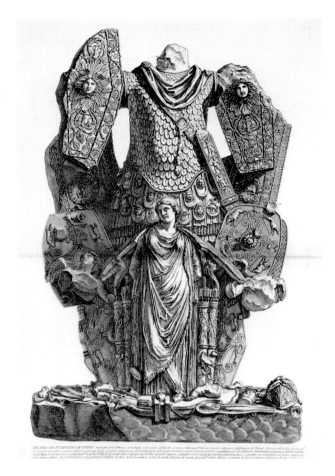

reproduced ad infinitum in paintings and sculpture, as figurines in bronze and ivory, on coins, gems, oil lamps and so on. They were frequently separated from the accoutrements which were their symbols, and these became emblematic ornament – the thunderbolt and lightning of Jupiter, the shield of Mars, the doves and peacock of Venus, the bow, quiver and arrows of Cupid, the caduceus of Mercury, the lyre of Apollo, the pipes of Pan, the thyrsus of Bacchus, and so on. Other appendages were invented: amongst the charming standardized motifs that decorated Roman painted walls were the thrones of Jupiter, Venus, Mars, and Neptune, each differentiated in character – majestic; dainty; simple and strong; majestic again – and decorated with the symbols of the deities who had (for the moment) vacated them [40, 452]. Hercules was one of the most popular heroes; a Roman round tripod table in marble [61] has feet in the shape of lion paws combined with the head of Hercules, hooded with the head of a lion, arising from acanthus: a superb design, strong and dignified but fantastic, with a hint of the caryatid.

Bacchantes and maenads, the frenzied votaries who tore Orpheus to pieces (and originally ate him), were frequently depicted dancing and playing musical instruments, and were as popular in stone [55] as in paint; together with satyrs and fauns,[176] they became common furniture ornaments [402]. So too did the erotes or cupids, whose proportions ranged from the slender [35, 63] to the chubby [40]; as later used in Western furniture, they varied according to their sources. Sheraton recommended the slender Hellenistic type as seen in the paintings of Herculaneum [452].

Trophies and panoplies: shields and standards; the palm

One of the most beautiful of ornaments is the trophy [62, 65:B], which originated in the Greek custom of hanging the military arms of the conquered on a tree; the Ephesians

64 Roman incense caskets, published in Paris in 1719–24 by Bernard de Montfaucon (from *L'Antiquité expliquée*).

erected a trophy of brass to Alcibiades.[177] The trophy shared the continued popularity of other types of triumphalist ornament – Victories [65:A], the laurel wreath, the palm, the crown and diadem. Trophies were sometimes economical, a pole hung with a sparse collection of weapons; sometimes luxurious, a massed assemblage of armour, shields, spears and other weapons; the former type was more 'Greek', the latter more 'Roman'. Both were revived at the Renaissance. The trophy (and its horizontal equivalent, the 'panoply') became a popular ornamental motif in antique architectural sculpture and grotesque painting; trophies hang on excessively elongated delicately decorated 'palm' columns in a wall painting from Pompeii.[178] They were to prove endlessly versatile after their fifteenth-century revival, being especially favoured as an ornament by the warlike – Renaissance condottieri, Louis XIV, Napoleon, and other doubtful characters. In the rococo period they became amorous, musical, even ecclesiastical. Modern weapons were incorporated into them. Trophies and panoplies often occur as furniture decoration [65:C, 342].

Shields (often in Gothic form) and standards were turned into pole-screens in the later eighteenth century, and assumed the new function of protecting ladies' faces from the fire [407]. The idea of turning military equipment into furniture was extended; the modern drum became a braided stool, and the sabre supported a Napoleonic X-frame stool.

Altars, ossuaries and sarcophagi

Few ancient artefacts have had a greater influence on modern design than altars [10:M], ossuaries [7] and sarcophagi [65, 185]; form and decoration provided models for a huge variety of objects, from wine-coolers to couches to cathedral cantoria. Altars tended to share the motifs of the temple, for obvious religious reasons; antique sarcophagi survived into modern times in large numbers, and in Italy were often re-used as altars or for an eminent corpse. They frequently exhibited imposing swelling shapes [65:D], shared by the magnificent stone baths that also were to attract the imitative attentions of posterity. Garlands, palms, erotes, roundels with busts, torches, and other ornaments commonly adorned them, but two ornaments in particular were influential on later ages.

The first was 'strigillation' [65:E, 477], a scooped-out decorative motif that derived from the strigil, a curved implement used for cleaning the skin both in the toilet and in ritual cleansing – hence its appearance amongst the religious symbols on altars and sarcophagi. The second was the 'opposed scroll' [65:F, 477], a single formal scroll joined to its laterally inverted fellow; ubiquitous in antiquity, it was especially useful as a means of decoratively capping a horizontal coping. This simple but energetic motif was to make a contribution to Western arts after the Renaissance that was astounding in its range (p. 175).

Urns, vases, and miscellaneous ornament and objects

Urns and vases, in all their considerable variety, were employed as ornament in antiquity; they were often hung with drapery and garlands, a motif that reflected ancient funeral practice.[179] Canopic jars, the Egyptian artefacts designed to hold entrails or small mummies such as those of cats, were to be copied as furniture ornament in later ages [609]. Artefacts employed as emblematic ornament in antiquity include tripods, temples, ewers, jugs and miscellaneous tools. Household objects of all kinds, such as stands for braziers and lamps [459] and oil lamps in all their bizarre variety, were to influence furniture design, as musical instruments such as Apollo's lyre were to assist the fury of composition by emblematically ornamenting secretaires and library chairs.

Such ornaments, a small selection from an antique whole of unequalled strength, beauty and elegance, contributed, in concert with forms and motifs taken from Greek and Roman furniture, to the making of the furniture of 'realms that Caesar [and Alexander!] never knew'. The history of Western furniture is largely the history of the development and renaissance of this antique inheritance. As the old woman said to the scents drifting up from an empty Falernian wine jar:

> O suavis anima, quale in te dicam bonum
> antehac fuisse, tales cum sint reliquiae!
>
> (Ah, sweet ghost, how good you must have been,
> when even your remains are so excellent!)[180]

65 Roman standards, trophies, a Victory, and sarcophagi; detail of a plate published in Paris in 1802 by J. N. L. Durand (from *Recueil et parallèle des édifices de tous genres, anciens et modernes*). The superimposed letters relate to points made in the text.

The fall of the Western Roman Empire: barbarian art and furniture

overleaf 66 Detail of the front of the 'Throne of Maximian', in wood covered with plaques of carved ivory; Constantinople (?), *c.* 546–556.

IN ITS LATER YEARS the Western Empire suffered political and social decline punctuated by periodic attempts at renewal; a graph of the period would show the line sinking inexorably if waveringly to the foot of the chart. The most imaginatively positive event was the foundation by the Emperor Constantine of the Eastern Roman Empire at Constantinople (May 330); momentous not only politically but aesthetically, it centred the Empire in the East and produced a rich and strange hybrid of antique and oriental styles. In the West, the most obviously catastrophic events were the sackings of Rome by the barbarians in 390 and 410, and the surrender to the Ostrogoths in 476 of the last emperor, named by an irony of fate Romulus Augustulus. The line of the graph then runs off the page; the Empire in the West lay in ruins. In ruins… but not annihilated.

For more than a century before the débâcle, Roman art in Italy had shown unequivocal signs of decline. One of the finest examples of late antique architecture, the gargantuan palace at Split in Dalmatia (*c.* AD 300) to which Diocletian withdrew in order to grow cabbages, was fairly assessed by Gibbon as 'not less expressive of the decline of the arts, than of the greatness of the Roman Empire in the time of Diocletian'.[1] The palace has fine examples of the arcade carried on columns [17], a Roman innovation employed earlier by Hadrian at Tivoli [16] that has since never entirely fallen into disuse; it was to become common in furniture [208, 512]. Roman late antique sculpture and painting is coarse and decadent. Renaissance critics such as Raphael noticed that Constantine's triumphal arch (AD 315) was partly decorated with re-used earlier sculpture, partly with the short-legged and big-headed troglodytes in togas of contemporary Roman 'proletarian' sculpture. Recent critics have seen this latter style as the result of sophisticated intention rather than primitivism or incapacity. The Emperor, however, complained of the lack of architects and issued edicts to encourage sculptors, painters, mosaic workers, cabinetmakers, and goldsmiths to 'become more skilled, and train their sons',[2] which might be taken to indicate some imperial dissatisfaction.

Constantine built extensively. The demolition in the early sixteenth century of his vast basilica in Rome in honour of St Peter has led to an underestimation of its long influence; its decorations included a canopy set on twisted Solomonic columns above the relics of the saint, an antique motif that had an eventful future as far as furniture was concerned, not least because Bernini perpetuated the motif in the new St Peter's [264]. The mausoleum of Constantine's daughter Constantia, erected in Rome in about AD 350, exerted a considerable influence on architecture and decoration [54, 59] for fifteen and more centuries. Constantine built much in the provinces; at Trier in Germany he erected a splendid basilican audience chamber with bare astylar walls and monotonously magnificent repetition of arches that is already proto-Romanesque. His 'Anastasis Rotunda', erected in Jerusalem above the reputed site of Christ's tomb, had a triple row of arcades, the lower two supported on columns; the building became well-known, and repeated arcades and arches, common in late antique architecture and sarcophagi, became a feature of Byzantine architecture.

Other late antique churches that survived to influence later ages include S. Maria Maggiore, Rome (432–440), a revival of the earlier classical basilican style; its mosaics are in the grand imperial Roman tradition that, despite the steady decline into which it fell after 500,[3] never entirely departed; perpetuated by the occasional importation of artists from Constantinople[4] it was resurrected in Cosmati work [107] and eventually influenced the arts of the Renaissance.

Monumental art north of the Alps declined from 500 until after 700; the depression extended over half a dozen or more generations, and during those centuries skills such as Roman concrete construction, monumental vaulting, and monumental planning were largely lost. In parts of France, Rome and Italy the situation was happier, due partly to a continued relationship with Constantinople: the Lombards' building tradition had taken over and preserved the seventh-century Roman techniques which helped to create Romanesque. However, the builder's craft had by and large degenerated by the eleventh century to a point where the stability of large buildings became dubious.[5] Its revitalization came from oriental sources.

The general decay of architecture and sculpture, accompanied as it was by social dislocation, brought in its train a decay of form and technique. Carving, painting, and mosaic work continued, but the finest things seem to have been imported or made by Byzantine craftsmen. The utilitarian art of casting in metal survived, but sophisticated techniques such as inlay that had been practised for untold generations ceased to be employed over much of Western Europe – even the mortise and tenon joint retreated from large areas. Furniture forms associated with civilized luxury that had existed for centuries, some from the great age of classical Greece, totally disappeared, the klismos and scroll-ended couch amongst them. Some antique forms survived in a degraded state – especially those symbolic of the authority that was so desperately needed; the *sella curulis* became a chair not only of kings but of bishops, as did the antique stone throne with rounded or square back.

Disintegration and survival

Despite the political and social disasters that engulfed the Western Empire, the great Graeco-Roman culture, visual and literary, continued in the West for centuries as a wraith, a wraith that was remarkably tenacious of existence. The popes, sitting upon their X-frame chairs in Rome itself, were part of it, the 'Ghost of the deceased Roman Empire, sitting crowned upon the grave thereof';[6] they helped to perpetuate a nostalgic conservatism that never died, and came to play a leading role in the revival of antique letters and style in the Renaissance. The Germanic barbarians, the Goths who overran the Empire in the fifth century, imitated the civilization they had conquered; probably comparatively few in number, they quickly became 'Roman'. Even the least Romanized of the successor kingdoms, that of the Merovingian Franks in Gaul, whose king's sacral character was marked by his uncut hair, clung during the sixth and seventh centuries to Imperial traditions; Frankish laymen could read and write in an un-Germanized Latin that continued to be generally spoken until about 800. The

67 Celtic ornament that includes an 'imprisoned body', knot interlace and geometric patterns,: detail of the beginning of St Mark's Gospel in the *Book of Kells*, made in Lindisfarne or Iona, c. 850–920.

68 Romanesque interlace showing an 'imprisoned body', monsters and scrolls: the initial 'A' from a Canterbury manuscript, English, c. 1100–1130.

Merovingians 'could not conceive of any art other than that of the Empire'.[7]

The Merovingian kingdom fell into decadence; the bishoprics of southern Gaul disappeared from about 680 to the tenth century, a sign of the obliteration of urban life. From about 650, Europe became de-Romanized. The disabling effect of the barbarian invasions on culture was compounded by the calamitous initial effects of Islamic expansion. The followers of the prophet Mohammed, who died in AD 632, gave the world a new and devastatingly destructive concept, that of the 'holy' war; by 700 the Western Mediterranean had become an Islamic lake, the frontier between two civilizations. Before 750, the Islamic empire included Spain, part of southern France, and much of the old Byzantine Empire. Constantinople had been besieged more than once, albeit unsuccessfully; Rome was again sacked. During the course of the ninth century Sicily was taken.

The Mediterranean was no longer a politically and culturally united area, and Rome no longer the first of cities. Trade was blighted to a point where it almost ceased; not entirely, since the Jews remained as an economic link between Islam and Christendom, importing textiles from Byzantium and the east into Spain and thence to the Frankish kingdoms.[8] Byzantium still held the eastern Mediterranean, retaining contact with Venice; during the ninth century Scandinavian traders maintained relations with Islam by way of Russia, thus bringing Islamic goods to Scandinavia and the Low Countries. The economic renaissance of the eleventh century began in the Low Countries and in Venice, and was assisted by the effects of the crusades. These exchanges explain cultural links that influenced all the arts, including furniture.

The result of Islamic dominance was that gold became rare and its minting ceased; the circulation of money became minimal; taxes were no longer collected; merchants became few; oriental products such as papyrus, spices, and silk disappeared or became extremely scarce; laymen could no longer read and write; towns became fortresses, villas became farmhouses, and agricultural primitivism replaced urban civilization. The failure of governments throughout Europe to protect people and their goods led to the rule of feudalism, which has been described as 'confusion roughly organized'.[9] Private law replaced public law.

In 751 the Carolingian mayor of the palace had the hair of the last of the Merovingians forcibly cut and founded his own new dynasty; in 800 pope and barbarian king conspired to re-establish the Western Empire, an extraordinary act of homage to a reality that had disappeared four hundred years earlier. The new empire of Charlemagne signalled a fundamental change: the North now dominated the South; the new political and aesthetic traditions were as much Germanic as Roman; the term 'Europe' appeared in language for the first time in history. Yet the old spell was strong, and Charlemagne's empire sponsored a new 'antique' revival, helped by Anglo-Saxon missionaries[10] who had absorbed Graeco-Roman culture in the seventh century and who spoke and wrote correct Latin.

The revival of government under Charlemagne could not halt its progressive weakening, and Viking and Magyar invasions exacerbated the disruption. The ninth century marks the nadir of European fortunes. Only the great monasteries, little cities in themselves, preserved some of the civilized activities that had vanished from the towns. The powerful ecclesiastical and seigneurial households, including

royal households, became largely mobile, travelling their fiefs in search of sustenance. The effects of poverty and mobility on decoration and furniture were far-reaching; such social conditions hardly encouraged gracious living. Textiles are readily mobile, furniture is not (as anybody who has moved house knows – and the modern van has some advantages over the Dark Ages cart, lurching springless on wooden wheels over muddy ruts). One result was that the more studied pieces of furniture were made to be stationary in churches and cathedrals; the contents of the castle were always on the move. The eleventh century saw commerce and towns slowly re-established, but the climb back was painfully long.

Barbarian art and furniture

The barbarians of the Dark Ages brought with them their own art. Barbarians, even nomadic barbarians, come accompanied by bag and baggage, and their baggage – weapons, jewellery, textiles, ships – was adorned with barbaric ornament. Ornament also spread via trade goods. By whatever means it travelled, it travelled widely.

Barbarian art includes variants of the scroll, the monster, the fret, and the plait. The barbarian plait is sometimes virtually indistinguishable both from the antique guilloche and Byzantine plait which had influenced it and from the Islamic motifs that themselves had evolved from the same sources. The Byzantine plait spread to Italy and thence north, being adopted first by the Lombards, then the other Germanic tribes. In their hands it was influenced by the barbarian knot and became something different. The art of tying a knot had been vital to the barbarian nomad; he had developed specialized varieties for purposes that varied from the putting up of a tent or sail to the tying of a saddle bag. The knot had inevitably entered nomadic ornament, and as inevitably influenced the ornament that the nomad, now settled in one place, took over from other sources.

In this way the barbarians enriched and supplemented the Byzantine plait with curvilinear knots [67], geometric knots, and Celtic-influenced monsters twisted into knots.[11] These hybrid knots[12] entered the main streams of European art and survived there indefinitely (for instance, they became a common ornament in miniatures [68], and were much used by artists of the Italian Renaissance). Revived in their original shapes in the nineteenth century, they contributed towards the development of new and in some instances highly original styles. Beautiful, rich and inventive as barbarian art often is, it always retains a tincture of the barbaric. A loose knot is a knot that will become untied, and the principal characteristic of any art based on knots is *horror vacui* and restlessness, most 'unclassical' characteristics.

Giraldus Cambrensis, a Welsh monk writing in about 1185, expresses the fascinations of the knot: 'Fine craftsmanship is all about you, but you might not notice it. Look more keenly at it, and you will penetrate to the very shrine of art. You will make out intricacies, so delicate and subtle, so exact and compact, so full of knots and links, with colours so fresh and vivid, that you might say this was the work of an angel, not of a man.…I am ever lost in fresh amazement, and I see more and more wonders…'[13] He was speaking of a most striking achievement, the barbarian version of the art of the illuminated manuscript [67], that was carried all over Europe by the Irish and Anglo-Saxon missionaries who took their books and knots with them. It employed motifs borrowed from most available barbarian sources, including Celtic art, Viking art, and, as far as the

69 A bronze mirror from Desborough, Northamptonshire, with 'thick-and-thin' Celtic scrolls; British, *c.* 100 BC–AD 100.

right, above 70 Byzantine ornament showing emperors hunting, with lions and other animals, all in 'heraldic apposition', surrounded by a typical Byzantine pattern of animals within roundels: detail of a silk textile, probably from Constantinople, *c.* 800.

right 71 A chair in carved oak, in Heddal Church, Telemark; Scandinavian, twelfth century.

below 72 A Viking bench in carved wood, from Kungsara Church in Västmanland; Scandinavian, *c.* 1100.

later illuminations were concerned, late eleventh-century Romanesque. It also contained Coptic geometrical and curvilinear interlace of antique 'mosaic' descent (Coptic monks probably emigrated west before the Arab invasions, carrying their books with them[14]).

For the purposes of this narrative, barbaric art can be broadly divided into three groups: that of the Celts, that of the Germans, and that of the Vikings. However, the barbarians were a heterogeneous lot, and there was as much intermingling of motifs as there was of races.

The Celts can be clearly identified from the fifth century BC onwards. Much is unclear about them, including whether the languages now called 'Celtic' had anything to do with the language of the Celts. From Central Europe they moved south, east and west to Italy, the Balkans and Anatolia, Gaul and Britain. Most Celtic tribes were absorbed into the Roman Empire, but their culture survived on the western edges of Britain and Ireland. The Celts were adept at copying foreign motifs and then transmogrifying their copies; the motifs they absorbed include sphinxes, griffins and lions, which in their Celtic form then influenced Germanic and Viking art. As did the Celtic scroll, one of their most striking creations; it is an abstraction based ultimately on the plant tendril – Celtic art prefers the abstract. The Celtic scroll has a characteristic 'thick-and-thin' movement [69], nearly allied to that of a certain type of Islamic scroll [177, 648].[15] One finds occasionally in 'thick-and-thin' Islamic scrolls a propensity, which is pronounced in Celtic scrolls, for furtive eyes and mouths that are there and not there, abstractions that are not quite abstract, always disturbing and sometimes sinister; other forms manifest themselves in the same 'underground' way, for instance, birds' and bulls' heads. These perverse features reappear in later European art, most noticeably in the 'auricular' style of the seventeenth century [239] and the Art Nouveau of the nineteenth – always with the same discomposing effect.

The Germanic tribes who invaded Europe (pre-eminently the Franks, Ostrogoths, Visigoths and Lombards) did not evolve a truly original art. Their native ornament became restricted to the people, whereas the magnates wanted something better, something 'Roman' (Theodoric, King of the Goths, had spent ten years at Constantinople). They depicted animals, monsters and ornament in a way influenced by the emphatic outlining that is part of the technique of cloisonné work, 'ars barbarica' as the Romans called it; its origin lay in Persia and south-eastern Europe. This art was to be revived and to influence furniture in the late nineteenth century.

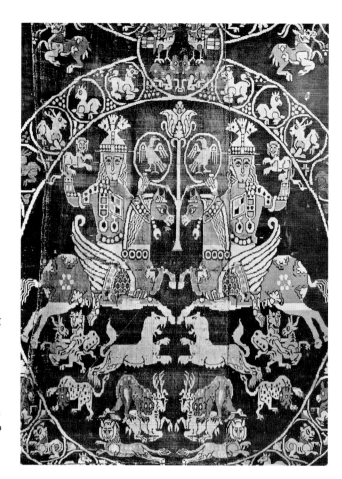

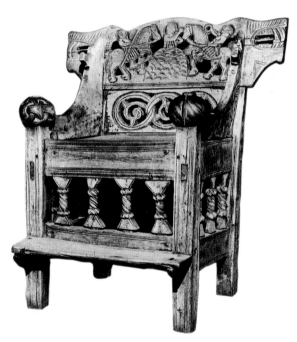

The Vikings, the 'Northmen', came from northern Europe, and between AD 800 and 1000 they settled in Ireland, Britain, and 'Normandy' combining terrorism with trade. They formed the Varangian Guard of the Byzantine emperor, and their runes are found in Hagia Sophia and in North America. In the late eleventh century they wrested Sicily from the Arabs and created a brilliant Islamic/Norman culture that reached its apogee under the Emperor Frederick II, who fostered a proto-Renaissance in southern Italy and Sicily.

The character of Viking furniture is shown by a Scandinavian bench of about 1100 [72]; it has a pair of superb winged and knotted monsters, of which the wings

73 A table top in oak with early sixteenth-century painted decoration, in Winchester Castle; English, probably end of the thirteenth century.

show the strong tendency to abstraction that is characteristic of barbarian art. Monsters' heads decorate the back, the sweeping curve of which recalls Viking ships. The bench is held together with mortise and tenon joints, and exhibits the same degree of sophistication as contemporary illuminated manuscripts. A Norwegian chair of about the same date, also constructed with visible mortise and tenon joints, has a frame similar to the lower part of the Virgin's throne shown on a plaque from the Throne of Maximian [79], a basic shape that had descended from antiquity. However, the decoration is typical Scandinavian barbarian ornament – knots, geometric interlace, beasts interlaced in scrolls, and beasts in heraldic opposition; the centre of the back is occupied by a 'Celtic' cross. Another Norwegian chair of about a century later [71] has 'heraldic' riders in apposition on the back, abstracted foliage, curvilinear interlace (a motif that probably came via Byzantium [70]), and extremely crude Solomonic columns – yet another motif that came from Rome or Byzantium – between stretchers and seat.[16]

Knock-down furniture and 'revealed construction'

The furniture described above is barbarian but comely, the sophisticated possession of the rich. Little of what might be called 'ordinary' wooden furniture survives from the troubled times of the Dark and Middle Ages; that which does usually has distinguished associations. A chair that has been the subject of learned doubt,[17] the 'Throne of Augustine' preserved in Canterbury Cathedral, could, just, be the very one from which the Saint discourteously failed to rise on the approach of the Celtic bishops in 603, thus precipitating schism and slaughter of the most horrible kind.[18] Such an unprepossessing object needed an eminent provenance to have been preserved over so many centuries. The chair is a primitive 'knock-down' assemblage that could easily be dismantled for transport and preaching beneath the oak trees.

Family wanderings and versatile uses of domestic spaces led to the common use of such knock-down furniture, which persisted from the Dark Ages throughout the Romanesque and Gothic periods and beyond. It exhibits 'revealed construction', having the utilitarian removable and projecting pegs that were to become fashionably avant-garde in the mid-nineteenth century [488, 494]. The character of Dark Ages and early mediaeval examples of knock-down furniture can probably be fairly accurately gauged from later examples that have survived or been pictorially recorded. The design of these was sometimes extraordinarily conservative. For instance, a once-common type of simple fifteenth-century knock-down table [495] had three out-splayed flat legs, broader at the base than at the top and joined by a stretcher, that are comparable not only to those – for example – of a

Roman butcher's chopping table (which is not knock-down and lacks the stretcher)[19] but even to the flat legs broadening towards the base of Egyptian and Greek stools. Unlike the nineteenth-century version [494], that of the fifteenth century has no Gothic features.

Other antique traits seem to have survived in knock-down furniture, of which beds, tables and buffets were prime examples. A Spanish bed [74], witness of a dismal scene, has massive posts at either end that clearly show tenons held by removable pegs; without the turned elements (p. 60) at the top and bottom, the posts would begin to resemble a common antique type in which the feet usually ended in a point [269]. Tables in mediaeval Gothic halls and chambers were frequently knock-down boards set upon trestles, large and rudimentary, many of which had an X-frame construction related to that of the antique X-frame chair (an X-frame variant is used today for small tables in the Near and Middle East, which preserved antique design and technique from the Dark Ages to the Renaissance).

At Winchester, a town associated with the Saxon kings and an early centre of royal ceremony, is an 18-foot (5.5 m) diameter round table top [73]; made from at least twelve oaks, it weighs one and a quarter tons even without its base. Legend gave it to King Arthur and Queen Guinevere, of Dark Ages romance and Round Table fame, and although a recent analysis has dated it to the early reign of Edward I (1272–1307) – who in 1278 had reinterred Arthur at Glastonbury – it might well represent an older type. Mortise holes reveal that the table had twelve legs and a massive central support, and the technical devices used in its construction indicate it was probably made by a wheelwright. The top remained unpainted until about 1522, in which year Henry VIII brought the Emperor Charles V to see it and its allegorical propaganda. The present repainting dates from 1789.[20]

'Revealed' or 'knock-down' construction was still ubiquitous in fifteenth-century furniture: an X-frame chair, for instance [103], shows the mortise and tenon joints of the splat of the back, the seat, and the rail of the legs allowed to project as decorative features; the pegs that hold the rail in place indicate that the features originated in knock-down mobility. Pegs tended to become ornamental rather than functional, but a Polish miniature of about 1470–80 shows a knock-down table with an obviously easily removable, working peg.[21]

74 A turned bed and canopy, showing 'knock-down' pegs: from a Spanish manuscript, late thirteenth century.

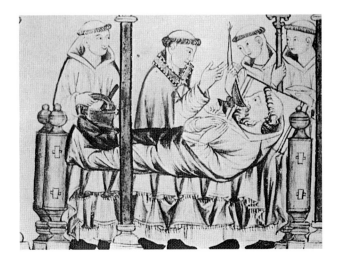

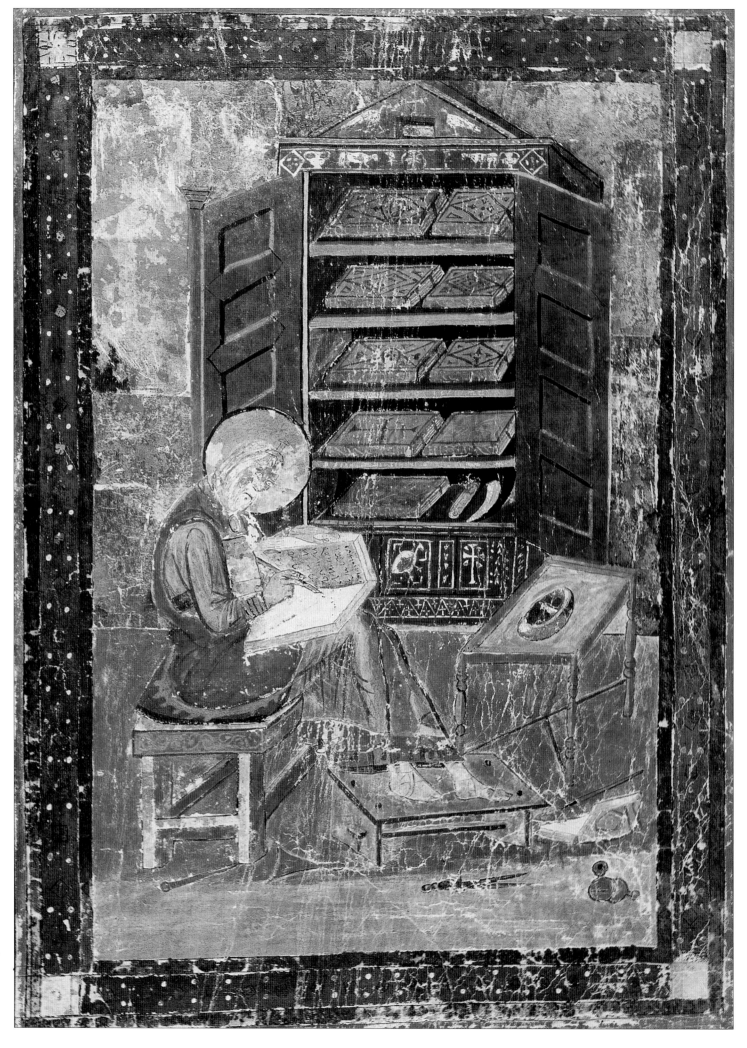

The Eastern Roman Empire: Byzantine and Byzantine-inspired furniture

opposite 75 Byzantine-style furniture: a pedimented cupboard decorated with peacocks, crosses, and other Christian symbols perhaps meant to represent inlay or simulated inlay, a chair, a footstool, and a 'turned' table, perhaps with bronze or iron stretchers: 'the Prophet Ezra', from the *Codex Amiatinus*, *c.* 689–716 (see p. 54).

76 A cupboard with inlaid or painted decoration and paw feet: detail of a wall painting from the House of the Vettii, Pompeii; Roman, *c.* AD 62.

AFTER ITS FOUNDATION the 'New Rome' of Constantinople became the centre of civilized Christendom. Constantinople was the only great late antique city that was never invaded by the barbarians, and its art belongs both to antiquity and to the Middle Ages. Its furniture reveals this as much as do its architecture, painting and mosaics. Periodic renaissances of Byzantine art occurred that created close imitations of past models.

Constantinople's links with Rome were weakened by the nearness of Greece; the Emperor Heraclius' adoption in the early seventh century of Greek, not Latin, as the official language of the Empire openly acknowledged Greece's predominant influence: henceforward the Empire became the 'Greek' Empire, and its inhabitants 'Greeks'. However, its civilization was nothing like that of ancient Greece: the development of Greek rationalism into Hellenistic irrationalism continued in Byzantium and reached its apogee in a society overrun with magicians and astrologers. Byzantine art was stamped with orientalism. Orientalism had been increasing in Roman life and art since the time of Augustus, to the fury of traditionalists like Juvenal. The Emperor Heliogabalus, 'in his sacerdotal robes of silk and gold, "after the loose flowing fashion of the Medes and Phoenicians,"'[22] had memorably paraded the Syrian deity that was his namesake through the streets of Rome. In Palmyra and Baalbek, the great Roman cities of Asia Minor, orientalism had been richly combined with Roman forms. The orientalism of Byzantium was all-pervasive; its art, influenced by Persia and by the Persian workmen employed by the Eastern emperors, was more oriental than Roman.

Byzantine art was hieratic, bejewelled, richly sumptuous, glittering, and numinous, quite different from anything that had preceded it. Although deeply anti-classical, it was not expressionistic as were barbarian art, Gothic art and Northern Renaissance art. It was mystic without being sinister: 'the horrors of hell and the demons that dwell there, hardly figure in Byzantine art. In this the Greeks, now become Christians, remained faithful to the ancient tradition.'[23] Byzantine ornament was anti-naturalistic, linear, congested and flat; its formalized versions of acanthus and the peopled scroll [105] are thronged with orientalized parrots, peacocks, griffins, lions, serpents and deer – often in heraldic apposition [70], a motif that began in Assyria. Trees and foliage are clipped, globular and prim [662] (qualities that were to influence Secessionist art and interior decoration). The simple interlace of Roman mosaics was developed into highly complex forms in which geometrical and curvilinear interlace were combined in flat-looking plaits, often accompanied by stylized acanthus. The Byzantine vocabulary was much reduced from the 'inexhaustible wealth of bright, decorative forms [of ornament] amassed during the Hellenistic and early Roman Imperial periods'.[24]

Byzantine architecture reached its height in Justinian's Solomon-surpassing church of the Hagia Sophia (532–537). From outside, it is a jumble of domes: inside, the magic circle of the large central dome, shallow and ribbed (utterly unlike the heavily coffered and hemispheric classical dome set on a cylinder of the Pantheon in Rome), floats above a continuous line of windows separated by springing pendentives from the square body of the church; the central dome is as it were supported by two large half-domes and five smaller half-domes. Such half-domes had been present in Roman art for centuries, three-dimensional in architecture and interior decoration, and fictive in grotesque. The church has rows of arched colonnades and a multiplicity of arched windows, often very closely spaced; the columns are 'admirable by their size and beauty, but every order of architecture disclaims their fantastic capitals'.[25] The multiplicity of arcades was a dominant feature in much Byzantine architecture over a long period, reappearing in St Mark's in Venice (1063–94).[26] The motif inevitably entered furniture [84].

What of Byzantine domestic interior decoration? Here the visual evidence is scanty.[27] This despite the fact that Constantinople, the largest city in the mediaeval world with nearly a million inhabitants, was full of the palaces of a resident nobility, and the Great Palace of the Emperor housed workshops that produced all the decorative artefacts used in the imperial palaces – a distant forerunner of the centralized organization of Louis XIV's Gobelins. Can we deduce what Byzantine interior decoration was like? An intimation is given by contemporary descriptions and a few late and restored interiors [662]. The mosques of Damascus and Medina give the best clue: the Caliph decorated them using gold, mosaic cubes, and workmen supplied by a conciliatory Byzantine emperor; their dazzling secular mosaics, very different from those of Byzantine churches, most probably resemble the vanished contemporary decorations of the palaces of Constantinople. Another, less heavily luxurious mode was used for lesser buildings, a style 'hellenistic, pastoral, idyllic' that employed pagan imagery.[28] This imagery almost certainly included versions of famous antique paintings of the type so common in 'Pompeian' painting, which frequently depicted furniture in the old antique modes.

What evidence there is indicates that Byzantine interior decoration was of great splendour, and its attempted imitation in Europe is a practical certainty. Despite its barbarism, the West had interior decorators: for instance Gregory of Tours, the sixth-century Frankish historian, speaks of one Gondovald as a 'pictor' whose speciality was the decoration of houses.[29] It is a short step from designed interior decoration to designed furniture. Did Byzantine furniture influence that of Europe? And if so, in what direction?

Byzantine furniture

The destruction of Byzantine furniture has been catastrophic; much must have gone during the iconoclastic controversies, not to mention the final sack of the city by the Turks in 1453. A unique survival is the Chair or Throne[30] of Maximian at Ravenna [66, 77, 79], a work of great beauty. It bears the monogram of Maximian, Bishop of Ravenna from 546 to 556 and viceroy of Justinian after the Emperor's reconquest of Italy. There has been argument over its origin – Antioch? Alexandria? Ravenna? – but 'it must be placed within the atmosphere of *renovatio* unquestionably generated in the reign of Justinian at the metropolis'.[31]

The church of S. Vitale at Ravenna was finished in the first year of Maximian's episcopate, and its magnificent

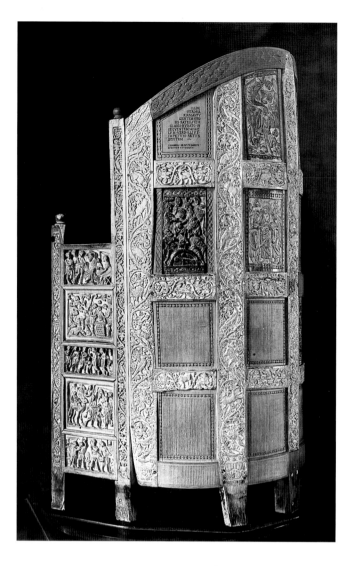

77 The Throne of Maximian, of wood covered with plaques of carved ivory; Constantinople (?), c. 546–556.

78 A carved ivory chair back organized in panels; from Nimrud, ninth–eighth century BC.

mosaics probably belong to his reign; they are adorned with a wealth of decorative incident – peacocks, cornucopias, vases of fruit, flowers and acanthus. Amongst the sages and saints stand the Emperor Justinian and his formidable consort Theodora. The chair was probably a political gift from the Emperor to his viceroy; was it made in the workshops of the Great Palace at Constantinople? These probably manufactured imperial gifts as the Gobelins a millennium later manufactured royal gifts. Does the throne represent the style of some of the furniture in the Great Palace itself? Ivory furniture would have 'told' exceedingly well against rich mosaic or marble backgrounds. Some of the couches in the Great Palace, as we know from a later period, were symbolic and unused;[32] the Throne of Maximian has also been thought symbolic, an impractical piece made for ritual purposes such as being borne ceremonially in procession (the X-frame chair was so carried in ancient Rome – and in Venice well into the eighteenth century).

The Throne of Maximian is made of wood covered with carved ivory panels. Its general shape owes something to the stone thrones of classical antiquity [22, 23]. The figurative panels on back and sides show scenes from the lives of Christ and St Joseph; St John the Baptist and the four Evangelists decorate the front [66]. These last imposing full-length images are in the classical tradition of the toga-clad figures seen on late antique sarcophagi. The panels of peopled scrolls that frame the figure panels, richly crowded with birds and beasts, are in an orientalizing taste; the grape and vine scrolls are also of the type seen on late antique sarcophagi and on the vaults of S. Costanza [54]. The assembling of the

ivories resembles that seen on contemporary Italian and Byzantine panelled ivory caskets,[33] but despite the differences in figure and ornament style it is also not so far removed from much older artefacts, a group of north Syrian ivory panels of the ninth and eighth centuries BC[34] [78]. These, probably from beds and chairs, were found at Nimrud near Nineveh; they provide direct evidence that, from an early date, entire pieces of furniture were made of ivory. It is known that the emperors employed Syrian craftsmen, and traditions died hard in antiquity. Ivory was popular over an exceedingly long period: St Philaretos had an 'old' table that was covered with ivory.[35]

Maximian's chair is a lonely representative of the furniture of one of the most luxurious civilizations that have existed. Can we reconstruct the nature of other types of Byzantine furniture from other sources? Some idea may be gleaned from representations in sculpture, mosaics, textiles and manuscripts; care has to be exercised, since the furniture depicted may not be 'real' but conventional to the particular religious or historical scene depicted. Moreover, furniture may have changed and developed over the long period covered by these conservative pictorial sources. No doubt it did, but on the other hand the almost Egyptian unchangeability of Byzantine art has to be taken into account, an unchangeability not confined to the visual arts – Byzantine schoolboys as late as 1400 used textbooks of the fourth century (literature itself continued the forms of the sixth century). What schoolboy today uses an Anglo-Saxon textbook?

The most frequently depicted item of Byzantine furniture is the throne. Nothing seems to have been too extravagant for the Byzantine court. A matter-of-fact German bishop, Liutprand of Cremona, before whom scepticism recoils – he later described a Byzantine emperor as 'a monstrosity of a man…dressed in a robe made of fine linen, but old, foul smelling, and discoloured by age'[36] – recorded in 949 the spectacle of his presentation as ambassador to the then Eastern Roman Emperor: 'Before the emperor's seat stood a tree made of gilded bronze, whose branches were filled with birds also made of gilded bronze, which uttered different cries, each according to its species. The throne itself was so marvellously fashioned that at one moment it seemed a low structure, and at another it rose high into the air. Of immense size, it was guarded by lions made either of bronze or of wood covered over with gold, who beat the ground with their tails, and gave a dreadful roar with open mouth and quivering tongue.…At my approach the lions began to roar and the birds to cry out, each according to its kind. So

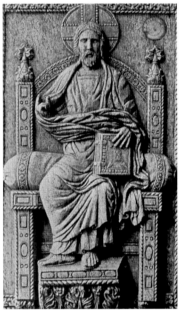

top 79 A high-backed throne with a curved top, depicted on a carved ivory panel of the Virgin and Child on the Throne of Maximian; Constantinople (?), *c.* 546–556.

above 80 A throne inset with matched 'jewels' and decorated with acanthus knops, in a Byzantine ivory, eleventh century.

after I had three times made obeisance to the emperor with my face upon the ground, I lifted my head, and behold! the man whom just before I had seen sitting on a moderately elevated seat had now changed his raiment and was sitting on the level of the ceiling....I was neither terrified nor surprised, for I had previously made enquiry about all these things from people who were well acquainted with them....How it was done I could not imagine, unless perhaps he was lifted up by some such sort of device as we use for raising the timbers of a wine press.'[37]

This throne, reputed to have been designed for the Emperor Theophilus (829–842) by 'Leo the Mathematician', was perhaps inspired by the descriptions of the Abbasid caliph's court at Baghdad that had inspired the ceremonial halls added by Theophilus to the Imperial Palace.[38]

We lack the furniture itself, but we frequently see in sculpture, mosaics and illuminations grand thrones on which sit Christ, the Virgin, or high secular magnates; some of the clearest depictions occur in ivories, which have the nature of bas-reliefs. The thrones fall generally into four groups: those with animal legs; those with studded, embossed or inlaid rails and stiles; those with turned legs and backs; and those with pronounced architectural features.

Some elaborate thrones depicted in the prismatic medium of Byzantine mosaic (individual tesserae are tilted to catch the light) look as though decorated with applied gems and pearls; the same type of embossed decoration, which could be jewels or enamels, is shown in three dimensions on thrones depicted on Byzantine ivories [80]. Did these 'jewelled' thrones exist in reality? The extraordinary ostentation of Byzantine court and aristocratic life is attested by many witnesses over a long period: Constantine himself refers to the 'precious table of gold' of the emperor.[39] Jewelled thrones cannot be dismissed as artistic fancy; there are precise literary references – Marcellinus Ammianus, writing in the fourth century, often mentions them, and in the eighth century a long table decorated with precious stones was described in the Life of Basil the Younger. In about AD 420 an antiquarian eunuch had had installed in his private museum in Constantinople the great Olympian ivory statue of Zeus by Phidias; it had lost its golden cloak and hair, and no doubt its ebony and ivory throne had lost its gold and jewels – did the empty sockets remain? There had been a long Western Asian and Greek tradition of bejewelled thrones. Persian bejewelled furniture was referred to by the most famous of Greek Fathers, St John Chrysostom (*c.* 345–407).[40] The connections between Greek, Persian and Byzantine art were close.

Precious stones then had meanings that now survive only in the 'lucky' stones of the tabloid newspapers. Their employment in Christian art – for example, 'jewels' replace antique linear ornament in a velarium placed above a Byzantine-inspired mosaic of the Crucifixion [105] – is illumined by St Thomas Aquinas (*c.* 1227–74) in his categorization of the three qualities essential to beauty: integrity or perfection (which excluded the damaged or the ruined), symmetry, and *claritas* or lambency.[41] The 'claritas' of precious stones is used by the Book of Revelations to illustrate the 'clarity' and crystalline 'light' of God.[42] All three of St Thomas's categories are incarnate in antique carved gems, which are perfect (resistant to damage), symmetrical, and often lambent. Their indestructibility enabled them to survive in great numbers into post-antique times, which valued them both for their antique associations and for their beauty, their 'permanent form, the opposite of the ruin'.[43]

Precious stones also had mystical and magical connotations. A Chaldean astrologer had compiled one of the earliest lapidaries, associating certain stones with planets and signs. Christianity showed much interest in astrology, despite the denunciations of its clearer thinkers; Byzantium intensified the Hellenistic interest in magic and mysticism. Mediaeval commentaries and artefacts reveal that precious stones were applied to works of art both for the intrinsic virtues attributed to them and for the powers attributed to the pagan images pictured on them. Ancient gems were used on liturgical objects to point particular iconographical meanings[44] (the Church exorcised and sanctified antique gems before using them). Moreover, royal and religious power were closely interrelated, as they had been in antiquity. As early as about 432–440, a mosaic in S. Maria Maggiore showed Christ as an infant 'Porphyrogenitus', seated on a bejewelled couch and surrounded by 'courtiers'.[45] Byzantine and Carolingian rulers adopted antique intaglios as their seals; the 'ancient gem became the credential which both signified and secured the regalis potestatis'.[46] Such concepts were obviously suited to the Byzantine liking for mystic effulgence, and it would be surprising indeed if antique gems and precious stones were not used in analogous ways to adorn real furniture.

There is every reason why such furniture should have vanished: it is only in comparatively recent years that crowns and jewels have ceased to be treated as treasury reserves, and when the New Dark Ages arrive they will be so treated again. Byzantine ivories reveal a great, sometimes eccentric variety of throne shapes, which argues against their being merely iconographic convention despite their otherworldly splendour. Some have similarities with thrones shown in Western manuscripts. The backs are straight or curved, often decorated with fanciful knops, sometimes in rows; one example has an extraordinary cusped back, almost Gandharan in effect, with legs made up of acanthus separated by turning; another has what looks uncommonly like a quilted back, a motif with antique antecedents.[47] Possible explanations for the decoration of the more ambiguously 'bejewelled' thrones include the covering of the wooden surfaces with heavily embroidered and bejewelled textiles. Or they might have been inlaid, the Byzantine heirs of decoration such as the glass inlay on a Roman bone sofa and footstool from Pompeii [12]. Ruskin picked out as the leading characteristic of Byzantine architecture and decoration its 'confessed *incrustation*';[48] the same principle seems to have been followed in its most majestic furniture.[49]

Christ, the Virgin and other eminent personages were frequently depicted in or before a niche of which a common decoration was a shell [83]; niches of this kind were common in Roman architecture and decoration, and are frequently to be seen on sarcophagi (the origin of the motif lies in the Greek use of a shell to symbolize the genitals of Aphrodite). When the figure is seated, the eye tends to read the architectural details of the background as part of the seat (which they sometimes are). This may have contributed to the invention of high-backed thrones with curved tops decorated with shells or other motifs; high-backed thrones existed in classical antiquity, but not in this particular form. An ivory plaque attached to the Throne of Maximian [79] shows the Virgin sitting in a throne of this type. Such thrones and chairs were to become familiar in Europe – especially Italy – and to persist over many centuries. As depicted, niches sometimes contained a simple curtain hung from a rail [83]. This may have influenced the evolution of a type

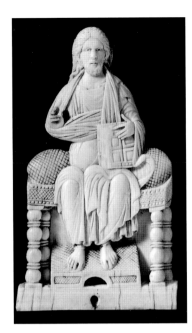

of chair which has a straight or curved back with a curtain, still hanging on a rod, along it [82], an arrangement perhaps as much for state as comfort.

Hieratic as Byzantine society appears to the imagination, people did not spend all their time sitting on thrones. The Virgin's throne pictured on Maximian's chair [79] is an elaborate version of a common type with straight legs and back and stretchers; the details varied, it could have armrests. This chair is one of the most ancient known, in its simplest form used by the tomb artisans of ancient Egypt;[50] it occurred ubiquitously in classical antiquity, sometimes tricked out in sophisticated accoutrements that concealed its basic structure.

Turning was a commonly used technique of Byzantine furniture. One type of Byzantine throne was decorated wholly or partly with what looks like lathe-turning, often in the form of large spherical or ovoid members alternating with narrow horizontal banding. A throne shown in an ivory has slender apparently turned back and legs, a draped back rail decorated with turning, and two angelic finials [82]. A backless throne on another ivory [81] has much heavier turning. Byzantine beds were given the same type of turned bulbous legs, as in the bed shown on an ivory panel [90] on the cover of Otto III's Gospel Book; the panel may have been brought from Constantinople by the Byzantine princess Theophano, who had married the Emperor's father in 972.[51] Such turning must descend from the swollen and bulbous Roman leg, which had become much heavier in the late antique period; it is depicted in a relief of the second to third century AD found in Constantinople itself [21]. This heaviness was possibly affected by orientalizing influences; it is interesting, in view of the interrelationships of Persian and Byzantine art, that 'turned' legs were common in ancient Assyrian and Persian furniture [6].[52]

Byzantine manuscripts display a variety of turned furniture. A tenth-century Gospel Book shows a low table with cross-over legs and a central support;[53] were these latter elements possibly made of metal, in which case they may have been a distant precursor of a later Iberian type? The Evangelist's stool is decorated with paint, inlay or studs. An eleventh-century Gospel Book [84] shows a chair with turned legs and arcaded columns on the stretchers; could the arched-over back have been derived ultimately from the curve of certain Roman basket chairs, perhaps meant to deflect draughts? Behind the decorated footrest is a desk with shelves, sloping top and a panelled front; a lectern has spiral turning of the type used for Roman torchères [10:A]. Yet another manuscript, of about 1100, has a foppish, almost fin-de-siècle chair with a decorated upper back (the back itself seems to be filled in with a woven lattice), a delicate round-headed arcade of architectural type beneath the seat, a footstool with pendant trefoils, a panelled cupboard, and a knopped lectern made up of an extraordinary fish (a religious symbol).[54]

Many manuscripts by Byzantine artists that picture furniture entered Western Europe in early times. The *Codex Amiatinus* (c. 689–716), a manuscript in impeccable Byzantine style, has a Byzantine or Byzantine-derived illustration that shows the Prophet Ezra with his feet comfortably up in a well-furnished little apartment [75]. The table depicted beside him has cross-pieces between the legs; it could almost have come from a Pompeian mural, and could certainly have come from a Sheraton pattern book. The form of the cupboard has much in common with that beside which the erotes of the House of the Vettii in Pompeii

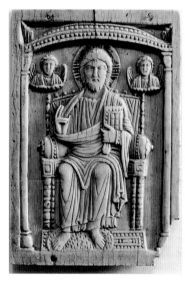

top **81** A backless throne with turned legs, in a Byzantine ivory, eleventh century. The background has been cut away, possibly to accommodate the ivory to a book cover.

above **82** A turned throne with knops along the back and draped fabric, in a Byzantine ivory, eleventh century.

right, above **83** A chair with lion legs and a shell niche behind, in an ivory diptych depicting the Virgin and Child enthroned; Constantinople, c. 550.

right **84** A chair with 'architectural' arcades and a curved-over back, a footstool, a desk with panelled decoration, and a lectern on a Solomonic column: 'St John', from a Byzantine Gospel Book, eleventh century.

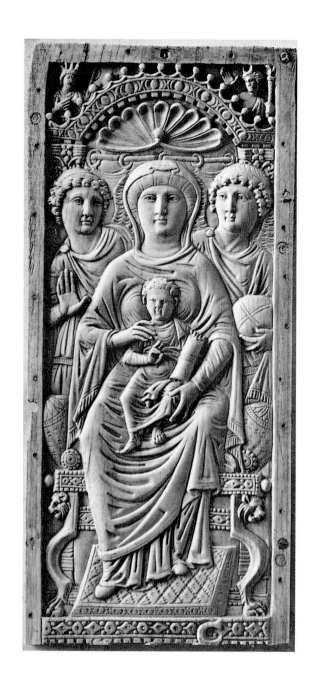

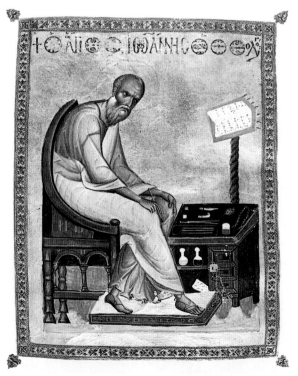

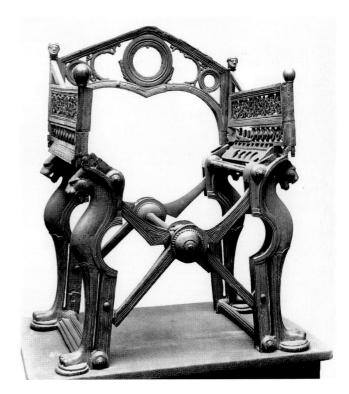

86 Crossed cornucopias and a basket of fruit, in a leaf of an ivory diptych made for the consul Flavius Areobindus; Constantinople, 506.

87 An X-frame iron folding stool with inlay of bronze wire, and plaques; from northern Italy or southern France, probably sixth century.

pretend to be engaged in serious tasks [76]. The Pompeian cupboard appears to be inlaid or painted, as do the cupboard and stool of the Prophet – the motifs on his cupboard include Byzantine peacocks and crosses, both religious symbols. A very similar cupboard, with pediment and panelled doors, is pictured in a Byzantine mosaic of 424–450 in the Mausoleum of Galla Placidia at Ravenna, which a Spanish critic has seen as a precursor of a Mudéjar fifteenth-century cupboard [116].

Painting can be a cheap method of simulating more expensive finishes; however, there is every reason to believe, even lacking furniture to back the belief, that elaborate inlay was a feature of Byzantine furniture that was passed on to Islam, thence becoming a major legacy to Western furniture (a legacy not fully enjoyed until the fifteenth century; the social chaos and technical incompetence of the Dark Ages and early mediaeval periods made it inaccessible). The argument is both historical and teleological; the Spanish fifteenth-century cupboard [116] is again relevant.

Other antique/Byzantine motifs, not necessarily connected with furniture, provided a jumping-off point for later furniture designers. An instance is cornucopias crossed to make up the consular *sella curulis* [86] – the symbolism is obvious (is the basket of fruit also symbolic – a fructified footstool?). In the fifteenth century, when artists looked hard at all kinds of 'antique' detritus, a cassone painter invented a whimsical X-frame chair for Alexander the Great that consisted of crossed cornucopias with paw feet [158]. The motif appeared later in real furniture [446].

The influence of Byzantine culture in the West

Byzantine goods travelled to the uttermost confines of Europe, and continued to do so in varying degrees up to the city's fall to Islam in 1453: Byzantine taste and luxury set European *ton* until home-made sophistication appeared in the thirteenth century. Byzantine influence is seen in European architecture, furniture, goldsmiths' work and clothes up to and beyond the fifteenth century. The crusades brought hosts of Europeans to Constantinople, and the creation of the Latin kingdoms in the Holy Land established a permanent Western presence in the East for many generations. The sack of Constantinople by the crusaders in 1204 brought much Byzantine loot to Europe, especially to Venice, which 'lost no time in clothing herself in the robes of the conquered city'.[55]

The barbarians of the Dark Ages were deeply affected by Byzantine culture. Lombardic, Germanic, and Celtic art all showed its influence. Goods were ordered direct from Constantinople, and were highly esteemed: the Merovingian king Chilperic (d. 584), in speaking of a golden dish he had had made in Constantinople, declared he would have others made 'to honour the race of the Franks';[56] Chilperic himself was entombed in a sarcophagus made by Byzantine artists established in Gaul.[57] Byzantine silks and other textiles were exported in huge quantities. Dagobert (d. 639) offered oriental tissues to St Denis;[58] Pope Adrian (772–795) gave 903 pieces of silken fabrics woven in Constantinople to the basilican churches of Rome.[59] Byzantine influence continued with Romanesque and Gothic art. Treasured Byzantine fabrics were used to wrap the relics of saints and were interred with the corpses of ecclesiastical and secular magnates, including Pope Clement II (d. 1047) at Bamberg and Edward the Confessor (d. 1066) at Westminster.[60] Textiles were a potent medium for transmitting ornament [70]; much of the decorative detail of the Romanesque style is seen in the Byzantine and other Eastern fabrics that were

sent from Byzantium, Damascus, Jaffa and Beirut to the ports of the north-western Mediterranean.

Local workmen were frequently employed to install imported Byzantine-made artefacts, such as the columns and capitals of the famous church of S. Vitale in Ravenna. A Byzantine ship laden with columns, ambo, chancel screens, a whole assemblage of fittings prefabricated for a European church, sank off the coast of Sicily.[61] In the eleventh century a flow of orders came from Italy for Byzantine bronze doors.[62] Would a commercial city that could export the fittings of a whole church or weighty bronze doors have balked at exporting furniture? As well as artefacts, Byzantium sent artists and craftsmen to Europe; the Greek and Syrian illuminators at Charlemagne's court were probably deliberately invited;[63] the Byzantine weavers used by the Norman king Roger Guiscard to establish a silk factory at Palermo in 1147 were (in the best Viking tradition) captured. In the 1070s a workshop of Byzantine mosaicists was set up at Montecassino. The doges of Venice frequently imported Byzantine craftsmen. Byzantine artists and craftsmen followed the trains of the Byzantine princesses who became empresses and queens of Frankish and Germanic rulers; Greek tastes ruled the German court when the Byzantine princess Theophano became Empress-regent after the death of Otto II in 983.

Byzantine-inspired furniture

A famous X-frame chair known as the 'Throne of Dagobert' [85] is, or originally was, a majestic folding stool that retained enough significance in the early nineteenth century to be used at Napoleon's coronation and at the inauguration of his new chivalric order, the Legion of Honour.[64] Dagobert was Merovingian king of the Franks from 622 to 638, and the throne was mentioned in 1151 by Suger, Abbot of St Denis, as having been his. Suger, a great man who inaugurated the Gothic style in Europe, was no dry-as-dust monkish chronicler. He was a visual voluptuary, greatly interested in works of art, a Neoplatonist who believed that meditation on beautiful artefacts leads to an apprehension of higher realities.

The throne is made of bronze, and has remains of gilding. The legs fold across the front in the 'modern' manner, unlike the side-folding antique X-frame construction. The back and

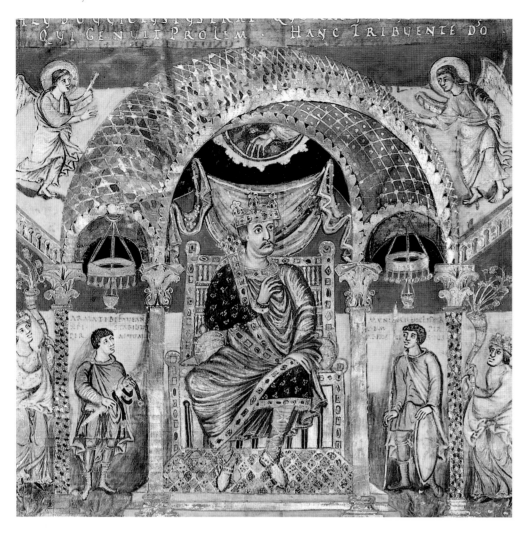

88 The 'jewelled' throne and canopy of Charles the Bald: a detail from the *Codex Aureus* of St Emmeram of Regensburg; Carolingian, late ninth century.

89 A turned X-frame stool and a turned lectern: 'St Matthew', from the *Coronation Gospels*; probably Byzantine, before 800.

arm-rests are obviously later than the folding legs; one theory, partly based on the likenesses between the back of the 'Dagobert' chair and that of a famous chair reputed to have been St Peter's, is that they were added in the twelfth or early thirteenth century by a Roman master influenced by the Cosmati.[65] The date of the earlier, folding part of the throne with its lion heads has been debated for almost two hundred years; recent opinion has been inclined to place it in the early Carolingian period.[66] This may well be correct. On the other hand, it seems unlikely that any tradition connecting it with the Carolingians existed in the twelfth century; would Suger, a churchman and politician, have wished to re-direct tradition away from Charlemagne, the hero of the West who received the military standard from St Peter, towards a sacred king with long hair from a deposed dynasty? And would a Carolingian provenance for the chair really have been forgotten by the twelfth century? Churchmen and kings have long memories.

The animal-legged stool or chair was an antique Roman form that survived indefinitely.[67] There was in Byzantium a 'recurrent taste for classical allusion, a recurrent awareness of the Graeco-Roman inheritance',[68] and Byzantine stools and thrones of a type related to the 'Throne of Dagobert' did exist, as a mid sixth-century diptych [83] demonstrates; many such diptychs celebrate contemporary official personages.[69] The form of Dagobert's stool is therefore much in line with late antique Byzantine tradition, and whatever its date, it seems likely it was influenced by the antique strain in Byzantine furniture. Its massive lions are similar to the animal legs of Roman marble tables [10:N], and derive from stone rather than metal prototypes – such thick forms are totally unnecessary in metal, but weight gives majesty. An early, probably sixth-century AD, non-royal

X-frame stool is much lighter [87]; a stool that folds double (also across the front), it is made of iron inlaid with bronze wire and decorated with plaques, and came probably from northern Italy or southern France. The legs end in hoofs, and four small bearded heads adorn the seat corners.

The fashion for 'encrusted' thrones seems to have existed in Europe as well as Byzantium; the influence behind them must have been Byzantine. The European throne, the greatest sign of majesty, was included as part of the royal regalia with the sceptre and orb, and had a particular importance in elective monarchies such as the Empire which needed to emphasize the status of a non-hereditary ruler.[70] A Carolingian illuminated manuscript shows the Emperor Charles the Bald seated on such a throne [88], within an aedicule and with 'antique drapery' hanging behind his head; he is in Frankish leggings but wears a toga-like over-robe; his tunic, robe and crown are adorned with what look like jewels. The throne has three rows of turning in the back, but otherwise it is in the 'jewelled' style (p. 53). Were these real gems? There is no reason to suppose not. Ostentatious display was a court habit; we know that Charlemagne had tables of gold and silver (p. 11), and rubies and emeralds were buried with him.[71] Moreover, there is a significant difference between the 'jewels' shown on Byzantine ivories and mosaics and those depicted on Charles the Bald's throne. Byzantine sources show them symmetrically disposed in regular shapes [80], much like the orderly array on surviving Byzantine enamelled and bejewelled book covers and icon frames.[72] Charles the Bald's throne has 'jewels' placed at random in settings that clearly show their irregular shapes (which may indicate that they were real jewels, not glass) – exactly as do still extant Western works of art, like the barbarically encrusted cover of the Gospel Book of Otto III (998–1001) [90]. The unity of decoration of Charles the Bald's robes and throne is repeated in the extraordinary reliquary of Ste Foy at Conques, of about 1000, where the saint's Romanized head stares blankly above the splendid, irregularly encrusted tunic and throne.

Fashions in turning in Europe seem to have been as influenced by Byzantium as were jewelled thrones. An

X-frame stool and a lectern from an illumination of before 800 [89], probably by a Byzantine artist at Charlemagne's court,[73] show Byzantine turning well on the way to Romanesque turning. A table in another Byzantine manuscript, of about 1000, is fully fledged Romanesque, and the 'modern' table is all the more striking when contrasted with the conscious archaizing of St Luke's 'toga' (the Evangelist as antique Philosopher).[74] Such turning is shared by furniture depicted in manuscripts written and decorated in the West, and it seems highly likely that the Byzantine motifs of architectural arcades and turning encouraged the adoption of similar motifs in Romanesque chairs, beds, tables and chests [96].

Two late chests, one from Westphalia of about 1300 [91] and one from northern Italy made at about the same time as the fall of Constantinople to the Turks [92], sufficiently demonstrate the awesomely long period over which Byzantine style influenced Western furniture. The first is decorated with Byzantine beasts set in circles; the resemblance of the motifs to those pictured in Byzantine art is obvious [70, 662]. The second, made of cedar in a style old-fashioned for its date, is decorated with flat carving, a technique common north of the Alps; contrasts are heightened by the coloured gesso that fills the depressed areas. Its shape is plain and primitive, with dovetails visible. There is a hint of Gothic in the apron, but the main motif of the decoration is a degenerate Venetian/Byzantine version of the peopled scroll containing birds of prey, pheasants, deer, lion and unicorn; they issue in time-honoured fashion from a central vase (here insignificant); the border is of oak leaves. The underside of the top is decorated with a crude Annunciation, again with a Byzantine flavour. The peopled scroll on this fifteenth-century chest is quite close to the patterns of Venetian fifteenth-century silks, but it may also be compared with the beautiful frieze below Christ and the Apostles on the sixth-century Throne of Maximian [66]. Byzantine influence had by this time become dispiriting rather than inspiring.

90 Jewelled decoration, and an ivory plaque depicting a bed with turned legs within an aedicule, on the cover of the Gospel Book of the Emperor Otto III; the ivory is Byzantine, the cover Western work, 998–1001.

91 A chest of carved oak in Byzantine style; German (Westphalia), c. 1300.

92 A small chest of carved cedar in Byzantine style, with insets of coloured paste; northern Italian, fifteenth century.

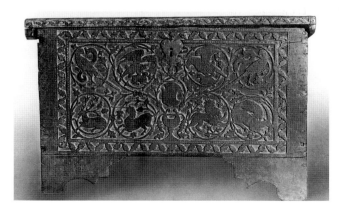

II *Chapter 3* Romanesque art and ornament: Romanesque furniture

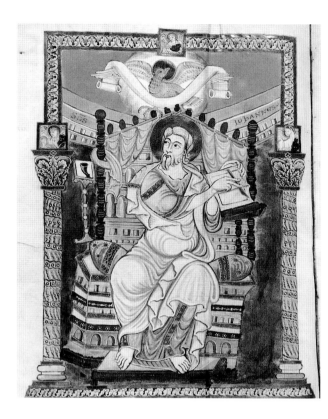

93 A throne with a turned and knopped back and an architecturally decorated base, the back hung with drapery: 'St John', from a manuscript; German (Fulda), *c.* 970–980.

opposite, above 94 A chair and desk in Romanesque architectural style: 'the scribe Eadwine', from the *Canterbury Psalter*, English, *c.* 1150.

opposite, below left 95 An oak armoire in Romanesque architectural style, in the abbey church of St Étienne, Obazine; French, *c.* 1176.

opposite, below right 96 A chest on a Romanesque 'architectural' stand, in carved oak; German, twelfth century.

'ROMANESQUE' art and architecture united motifs drawn from late antique Rome, Byzantium, and the barbarians: they really began with Charlemagne's self-conscious 'Roman revival'. The modern name reflects the nature and aspirations of this style of mixed origins; it was the first, albeit incompletely realized, neo-classical style attempted in Europe. Another, older term also reflects its nature – it was the art of 'Christendom', a word which in the eleventh century became attached to a geographical area, an area which 'inherited through a Latin-based culture the traditions of the ancient classical past'.[75] Charlemagne had been a new type of king, king of the Franks 'by the Grace of God'. The concept was new and immensely important, not least for furniture; henceforth the Western tradition in furniture was to be that of 'Christendom'. When Christendom divided into warring factions in the sixteenth and seventeenth centuries, the divisions were clearly reflected in the arts, including those of furniture. These divisions were disseminated wherever the Western tradition spread; they account for the divergences between Shaker furniture and Peruvian baroque.

Romanesque architecture has a rough, overwhelming grandeur that communicates the tension of the mighty effort required to summon up a great style from the ruins of a civilization. Its barbarically sumptuous ornament, which synthesized Celtic, Scandinavian and German ornament with that of late antiquity and Byzantium, contributes much to its rugged magnificence. Barbarian interlace is prominent in the capitals adorned with animals and birds imprisoned in winding coils of foliage. The monsters of antique sculptural grotesque were mediaevalized, appearing everywhere, from cathedral roofs to the borders of manuscripts. One of the most typical Romanesque ornaments is its version of classical acanthus, splendid, curling, heavy and static [492].

Romanesque architectural form and ornament are less successful applied to furniture; strength turns into heaviness, the grand architectural forms become gauche, especially conjoined with the heavy turning taken over from late antiquity and Byzantium; the richly intricate decoration turns into a clumsy hodge-podge, all defects that were to recur in nineteenth-century Romanesque Revival [504]. As time went on, Romanesque architecture became more refined; in the twelfth and thirteenth centuries it transformed itself over most of Europe into Gothic, but in Italy it resisted Gothic, continuing and developing until the fifteenth century, when it merged into the more self-conscious and fulfilled neo-classicism of the Italian Renaissance.

Compared with the elaborate sophistications of antique and Byzantine architecture, Romanesque relied for its effects on a small number of motifs. Most of those used in conjunction with vertical architectural surfaces sooner or later occurred in furniture.

The most prominent motif is the row of arches set above piers or columns, heavy and inert in its early days and quite without the springing movement of the antique Roman original; square-edged piers frequently alternate with round columns. The columns are often incised and carved with diaper patterns, Solomonic spirals, or zig-zag 'dog-tooth' motifs (the last originating in ancient Near Eastern patterns that symbolized water); they appear all over Europe, from Monreale in Sicily to Durham in northern England. Another common motif is the round-headed niche. As time went on the interior walls of which piers, columns and niches were a component developed a multi-layered look; the nave of Speyer Cathedral in Germany (1030–60) is a superb early example: giant arcades embracing both storeys are fronted by pilasters, to which superimposed half-columns are attached. Speyer had taken as inspiration the exterior of the late antique basilica at nearby Trier, yet another instance of the familiar evolution of exterior architecture into interior decoration, albeit in this instance of a church rather than a house.

The twin-towered façade is another Romanesque feature that began out-of-doors, came indoors, and was eventually used for furniture. The ancient motif (Egyptian and Assyrian) of twin 'towers' had been developed by the Romans for defensive gates (the Aurelian wall built around Rome between AD 272 and 275 had many twin-towered gates); the twin-towered façade became a feature of Islamic military architecture and appeared in Carolingian churches after 800. Romanesque towers were often capped with spires, another feature that may have been influenced by Islamic example; some of the early Islamic spires that top minarets are elongated. Islamic influence encouraged Romanesque architecture to evolve from barbarism to suavity – it was the probable source of the dramatically soaring interior and pointed vault (that presaged Gothic) of the gigantic and influential abbey church at Cluny in Burgundy (1088–1121). Pointed arches were used for the nave arcades and vault of Autun (1120–30). The static was about to be superseded by the dynamic throughout Western Europe – except in Italy – with mighty consequences for architecture, art, and furniture.

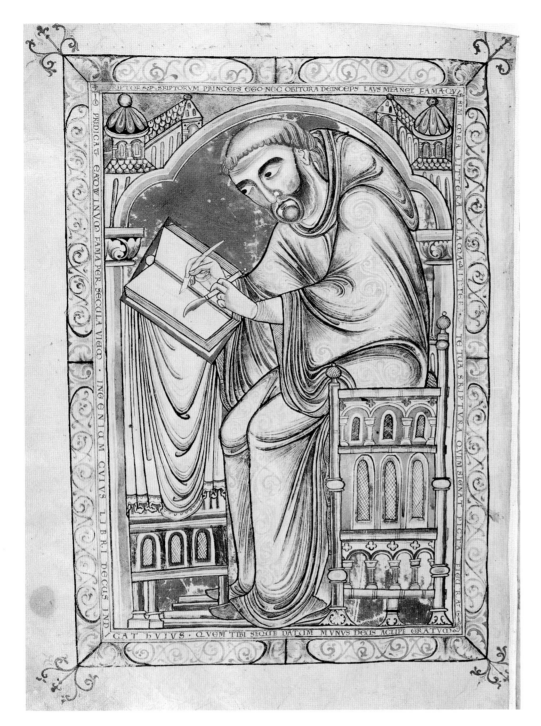

Architecturally influenced furniture

Furniture had reflected architectural style for untold centuries before the Romanesque period, but the influence was usually confined to proportion and detail. In late antiquity it extended itself; for example, sarcophagi were often decorated with an arcade, or with a row of connected niches into which figures were inserted. However, proto-Romanesque furniture pictured in manuscripts, and Romanesque pieces still extant, exhibit a use of architectural motifs in furniture unprecedented in extent. A codex from Fulda of about 970–980 [93], for instance, shows an extravagant chair that combines the dense turning related to that shown on Byzantine ivories [81, 82] with drapery and extraordinary 'architectural' decoration the nature of which it is impossible to determine; the most likely supposition is that the illuminator intended to indicate painting simulating architecture. Another extravagant chair, together with a desk and cupboard, is depicted in an English twelfth-century illumination [94] that derives from a Carolingian archetype:[76] could such ever have existed in actuality? The scribe, Eadwine, is seated in what looks like a mini-cathedral, with the tripartite divisions of a nave interior; the 'windows' even have 'glass'. His desk shares the same decoration. One might think it unlikely that such a fanciful thing ever did exist, but the decoration could be simply executed in paint… One casts one's mind forward to a Fornasetti secretaire [678].

A splendid twelfth-century walnut chest on legs [96] displays chip-carved Romanesque arcades in bas-relief and in the round; at either end are roundels. The three-dimensional openings on the chest, no less elaborately worked than the 'architecture' of Eadwine's chair, are 'windows'; as such they directly compare with those on Eadwine's chair and desk. This arrangement of chests upon legs is seen in stone tombs as well as wooden chests: did it begin in wooden tombs, which would tend to rot upon the damp stone or earth floors of churches? Or did the development occur as a result of the need for mobility? It would be natural to carry a travelling coffer into a hall and place it upon a table. Coffins today are carried upon biers and rested upon trestles.

Another twelfth-century piece, a large armoire in the abbey church of St Étienne at Obazine [95], has elegantly two-tiered round arches in relief on the sides, similar in detail to arches in the nave of the church whence it comes;[77] the doors on the front have flat round arches which continue down to the feet with architectural consistency. The iron hinges end in fleurs-de-lis, and the locking bolt has a

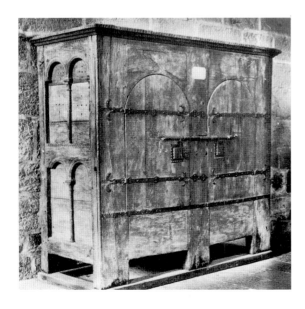

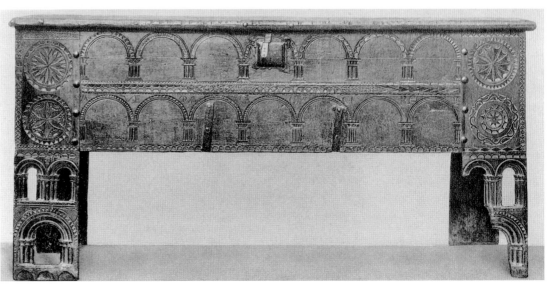

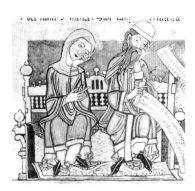

97 A turned bench: detail from the *Moralia* of St Gregory on Job; French, twelfth century.

98 A throne in turned oak, at Kloster Isenhagen; German (Lower Saxony), *c.* 1200.

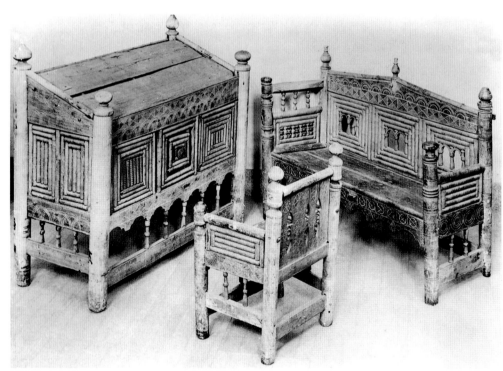

99 A desk, bench and chair in carved and turned wood, from Vallstena Church, Gotland; Scandinavian, *c.* 1200.

100 A throne in carved wood in Byzantine style, in the church at Old Uppsala; Scandinavian, *c.* 1200.

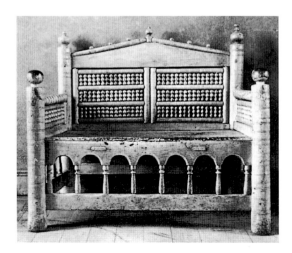

grotesque head at each end. This is one of the earliest surviving cupboards of its kind in Europe. Compared with antique and Byzantine cupboards, it is massive and solemn.

Romanesque turning

Turned furniture became ubiquitous in Europe in the Romanesque period: a splendid Scandinavian turned chair [100] with an architectural arcade along its front has rows of turning at the back that recall those on Charles the Bald's bejewelled throne [88], and the design as a whole shows strong Byzantine influence.

Typical of the turned genre without architectural elements is a German chair of about 1200 [98]. It is closely if simply turned, with large knops and 'panels' containing rows of spindle-turning also not unlike the turning in the back of Charles the Bald's throne; the shapes of the spindles hint at a lingering influence from the concave/convex turning of antiquity. The lines of the chair are straight, including the slope of the sides. A Scandinavian group of desk, settle and chair, also of about 1200 [99], is of a related type: the uprights are turned and knopped and the sides are decorated with panels composed of turned lengths arranged to form squares and rectangles. The settle has Romanesque arches set into its back and a pedimented top. The arches at the front of the desk are cusped, and there are intersected arches inscribed on front and sides. Intersected round arches appear on North African mosaics of about AD 400 and in Carolingian manuscripts; the intersected blind arcade with pointed arches, a motif of Islamic origin, had appeared by 1174 on the exterior of the apse of Monreale Cathedral. The pointed arches on this Scandinavian group appear only as a result of the intersections, the main arch still being round. The Scandinavians traded with both Sicily and Byzantium,[78] and intersected arches combined with cusping suggest Islamic influence (cusped roundels of a 'Gothic' type occur on the Islamic/Byzantine ceiling of the Sala di Ruggero in the palace at Palermo [662]).

Chairs, beds, and cradles of basically the same turned type were to be found all over Europe. St Peter sits in a convincing Italian example of a turned chair with a curved back in Giotto's frescoes in the Arena Chapel at Padua. An English armchair in Hereford Cathedral, traditionally used by King Stephen in 1142, has turning and a Romanesque arcade; it originally possessed a footstool and, according to observations of 1865, vermilion paint and gilding.[79] So early a date has been doubted, but poor Stephen is hardly a charismatic figure and scepticism seems largely to be based on the occurrence of similar types much later on – which is indisputable: turning descended the social scale over the centuries to vernacular furniture, where it has continued more or less up to the present day (with fashionable trimmings, including baroque and rococo, added).

Also of the twelfth century is a realistically depicted knopped double bench or throne [97] which has a turned gallery, knopped pegs inserted into the top rail, mortise and tenon joints, and what appears to be the beginning of an arcade along the front; seated on it are the lugubrious figures of Job and his wife, pillaged by the Chaldeans.

Antique survivals

The hieratic significance of the antique folding chair ensured its survival in large numbers throughout the Romanesque and Gothic periods. Edward the Confessor sits on an X-frame chair in the Bayeux Tapestry. Barbarian embellishments were often applied to antique form: a fine Spanish

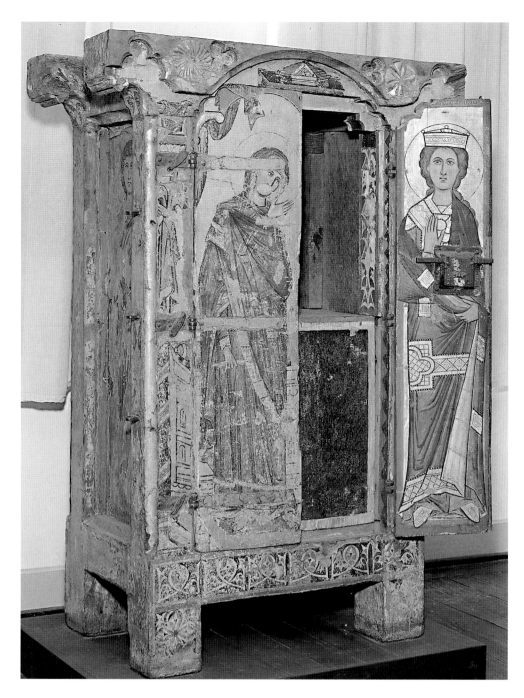

'peasant', but no peasant would have had such a fireplace and such furniture) comfortably warming his feet before a fire in a Flemish miniature of 1406–7 [122], is sitting in a completely functional folding chair that is nothing other than a mediaeval version of the antique multiple-legged X-frame stool.

Stone thrones also preserved echoes of classicism. On an episcopal throne of the latter half of the twelfth century in the Cathedral at Avignon, the winged bull of St Luke and the winged lion of St Mark flank the massive sides in a manner strongly reminiscent of the antique.[83] There are few traces of Gothic in a thirteenth-century German sacristy wardrobe [101]: the arch above the doors is round, and the painted figures, with their frontal gaze and sharply folded robes, are,

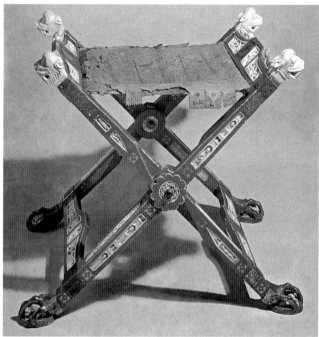

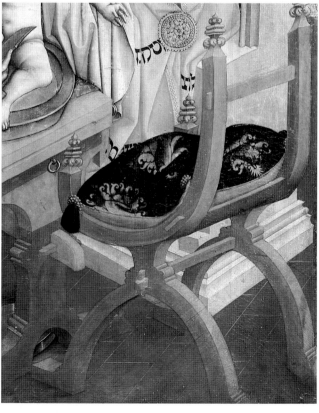

101 A cupboard in painted oak, at Halberstadt Cathedral; German, thirteenth century.

right, above 102 An X-frame painted folding stool, decorated and inlaid with carved ivory, with gilt bronze feet, at Kloster Nonnberg, Salzburg; German, *c.* 1240.

right, below 103 An X-frame chair and part of a knock-down table: detail of a fragment of *The Circumcision* by the Master of the Tucher Altarpiece; German (Nuremberg), *c.* 1450.

boxwood stool of about 1150 from Huesca Cathedral has barbaric lion heads and paws and is decorated with barbaric curvilinear knots.[80] Illustrations of X-frame chairs that appear to be fantastic seem less so (allowing for drawing styles) when compared with extant furniture; for example, a draped X-frame stool on which St Augustine sits in an illumination of about 1130[81] has rapacious and unlikely-looking eagle claws as feet but otherwise closely approximates to the real twelfth-century thing; a German stool [102], presented to a convent in 1242 by the Pope, has barbaric lion heads very similar in style to those of St Augustine's stool; the heads are ivory and the stool is decorated with ivory plaques that may be earlier; it is painted red and has claws of gilt bronze.[82]

The elegant paintings of the Sienese Simone Martini (*c.* 1284–1344), the friend of Petrarch, contain versions of ancient furniture which might be deliberate attempts at painterly re-creation; he also shows X-frame chairs (such as one in which the Emperor Constantine sits) that reflect reality. Even fifteenth-century X-frame seats remained defiantly uncrocketed and untraceried: a stool pictured on a fragment of a Nuremberg altarpiece of about 1450 [103] has paw feet and finials. And a man (he has been called a

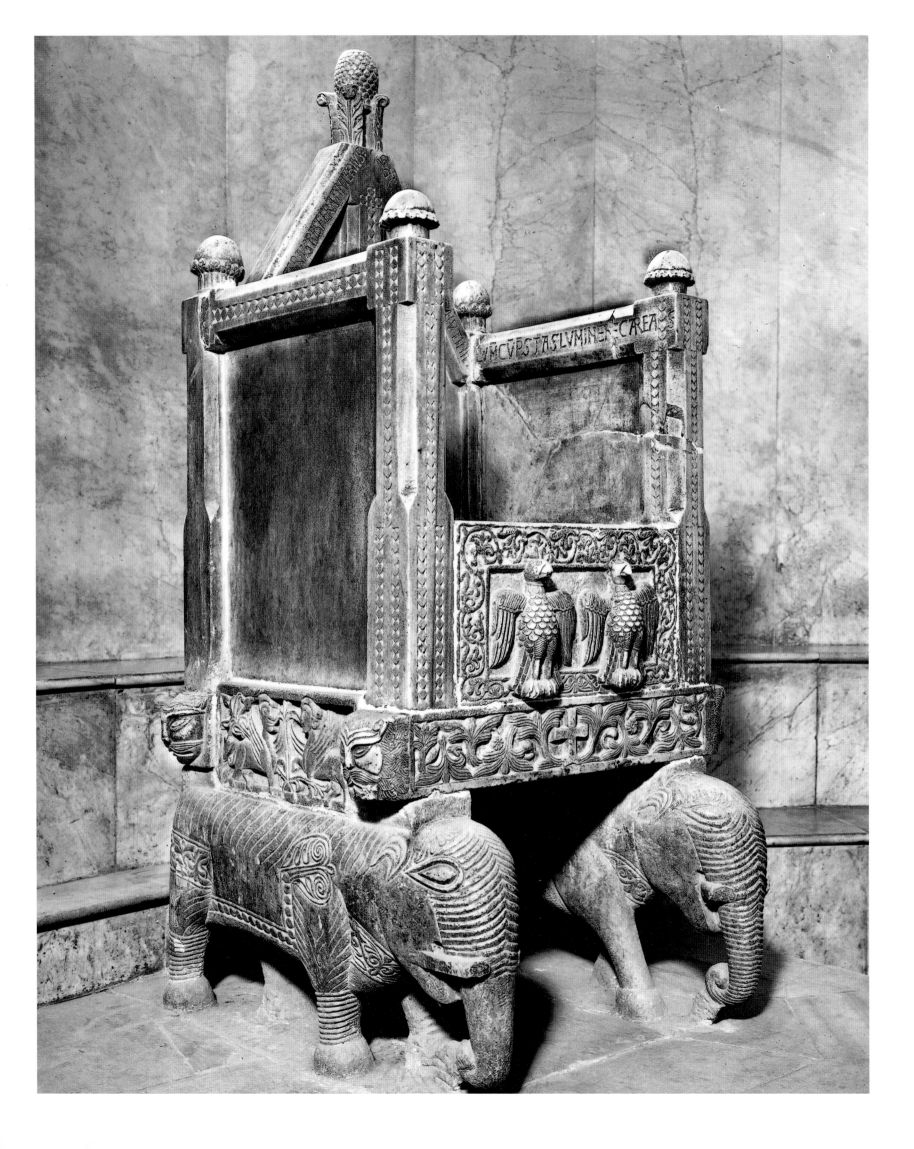

opposite **104** The marble throne of
Archbishop Elia, in S. Nicola, Bari;
1098.

save for a certain thin angularity and ambiguous cusping, as
much Byzantine as anything else.

Antique ornament survived in many guises. The originally
gilded ironwork of a French armoire of about 1290–1320
[106] – set in later woodwork: the border was originally
attached to the rails and stiles, not the doors – has a design
of scrolls with floral and animal forms, including oak leaves,
strawberries, fig leaves, pigs and monsters. The scrolls have
an antique lucidity; they are closely related not only to the
peopled scrolls of ancient Greece and Rome [52] but to
ornaments such as the acanthus scrolls in mosaic (themselves
thought to be taken from a particular antique original) in the
church of S. Clemente in Rome [105];[84] very similar scrolls of
about 1294, exactly contemporary with the presumed date
of the armoire, are to be seen in S. Maria Maggiore.[85] Iron
ornament of this kind, produced with dies of steel or
hardened iron, was international.

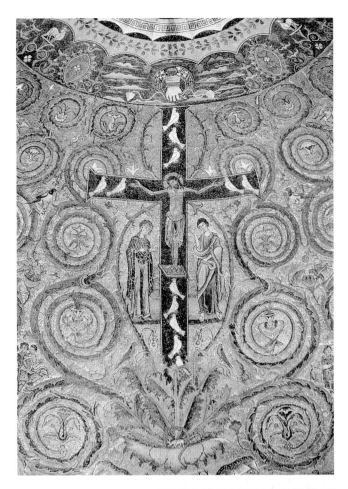

Italian Romanesque and 'classical' furniture

Italy especially always remained (despite Gothic flirtations,
which at Milan culminated in ecstatic surrender) more or less
faithful to classicism, and practised late antique style up to
the Renaissance. The country contained many forces that
pulled it in different directions from the rest of Europe: these
included Rome, capital of the old Empire and full of ancient
Roman buildings, many of which were far from being the
dilapidated wrecks they had become by the time of the
Renaissance. Rome's late antique churches, beginning with
the vast St Peter's, provided a school of architecture and
decoration in themselves. The Papacy, an institution both
dynamic and conservative, had revived earlier antique
architectural styles as early as the fifth century: once set
on this course, it continued on it, and Rome (and Venice,
a proud and powerful state that faced Byzantium as much
as it faced Europe) remained architecturally conservative
throughout the Middle Ages. It should be recalled that Rome
was nearer to Byzantium than to Paris or York, a disparity
aggravated by the hardships that beset Continental
travel at that time.[86]

Thus Italian Romanesque is a special case. During the
twelfth century the reforming Papacy rebuilt churches in
Rome in an early Christian style, identical to late antique
buildings; they contained extraordinarily unmodern mosaics,
pastiches of much earlier work [105]. In 1256 the Pope gave
orders that the mausoleum of the Emperor Constantine's
daughter Constantia should become a church, 'Santa
Costanza' [54, 59]. A limited but real Italian classical revival
occurred in architecture, painting, sculpture and decoration,
which was not confined to Rome. Tuscan Romanesque
is so classicizing that the learned Florentine architects of
the fifteenth-century Renaissance believed many Tuscan
Romanesque buildings, notably the Baptistery and S. Miniato
al Monte (c. 1060–1150), to be antique. The polychrome
patterns which decorate their exteriors (interior decoration
taken outside) were used also on buildings influenced
by Gothic, and were taken up by the early Renaissance
antique-oriented architect Alberti [154]. The decoration
of the fifteenth-century Lombardi is related to it; the circular
interlace on the façade of the Venetian Palazzo Dario of 1487
exactly parallels that found in the mosaics of S. Costanza and
on the capitals of the pillars of the Byzantine S. Vitale at
Ravenna – and on the stretchers and fronts [279, 281] of
later tables and cabinets.

In southern Italy lay the joker in the Italian pack – the
exotic Kingdom of Sicily, an amalgam of Islam, Byzantium,

105 A mosaic depicting an acanthus
scroll and a 'jewelled' velarium, in
S. Clemente, Rome, before 1128.

106 Doors decorated with iron,
originally gilded, from an armoire;
French, c. 1290–1320.

and Norman: the mighty tombs of the Hohenstaufen in
the Cathedral at Palermo are amongst the most impressive
monuments of its antique 'renaissance'.

What of furniture? Two southern Italian episcopal stone
thrones at Bari [104] and Canosa that date from before that
renaissance may give a hint of what the grandest eleventh-
century Italian wooden furniture looked like. Both convey

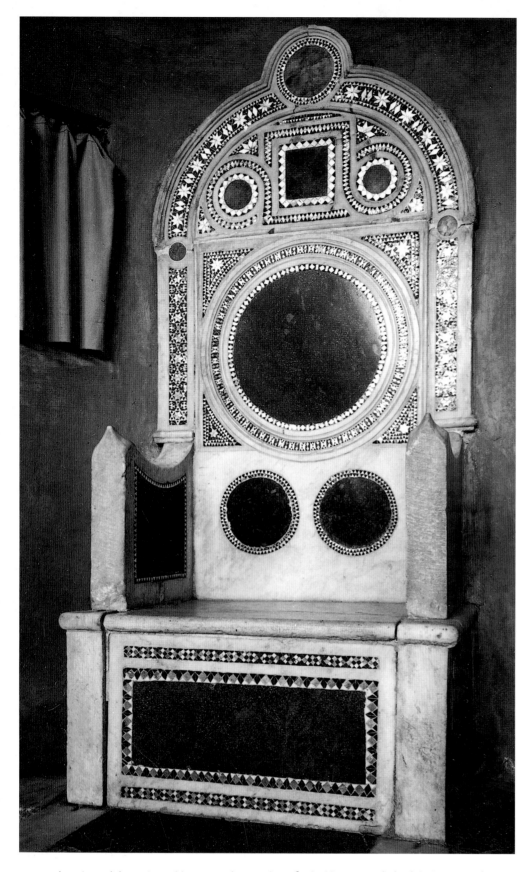

took every opportunity to acquire elephants from their Muslim counterparts – the line began with Charlemagne and Harun al Rashid.[87] The throne at Canosa,[88] on the other hand, is upheld by anguished 'slaves' of ultimately antique inspiration; although they are crude, the use of the motif indicates that Italian eleventh-century innovatory classicizing sculpture probably influenced grand furniture. Once again, however, the theme appears to have been filtered through Islamic art: the slaves' crinkly hair and loincloths are similar to those of a bearing figure in an Umayyad palace of the early eighth century in Palestine, and a similar figure that supports a chair at Salerno Cathedral wears a turban.[89]

The most famous of mediaeval classicizing styles is associated with the Cosmati, a clan of architectural decorators whose signatures occur over four generations on work of a distinctive character: inspired by late antique style, and perhaps by Islamic work in Sicily,[90] they associated glass and stone tesserae with marble inlay; the motifs include geometrical and curvilinear interlace, Solomonic, twisted and spirally turned columns, Corinthian and Byzantine-influenced capitals (Gothic influenced some of their works). The sculpture associated with Cosmati work, frequently emblematic lions and eagles, is often strongly classicizing.[91] Examples of the style spread over Europe; Cosmati work adorns the Confessor's shrine at Westminster Abbey (c. 1268). Cosmati motifs are reflected in the furniture seen in Italian paintings; they also survive in situ in the grand episcopal thrones still extant in many Italian churches. One such throne in a Roman church is of a type repeated with minor variations in many other twelfth-century thrones [107]: most of the decoration is completely flat, and the strong geometrical shapes and simple interlacing are of an antique type that could obviously be easily translated into wooden inlay; the shapes and patterns survive in early Renaissance furniture.

Italian thirteenth- and early fourteenth-century furniture shows classical and Gothic in uneasy coexistence. No stirrings of antique renaissance are evident in the thrones of the Madonnas of Cimabue[92] and Duccio;[93] they are elaborate variants, probably completely visionary, of the turned Byzantine/Romanesque throne. Giotto sometimes painted thrones that are hierarchically Gothic;[94] on the other hand, the draped chairs and throne depicted by one of his followers in *The Vision of the Chair* at Assisi are thoroughly practical pieces of furniture with a distinctly non-Gothic air. A Giottoesque altarpiece of the *Life of St Cecilia* (c. 1300–1320)[95] shows the Saint sitting on a throne of proto-Renaissance character: it needs a second glance to confirm that not sphinxes but angels support the upper part of her chair. Both Giotto and his pupil Taddeo Gaddi had a direct connection with furniture, and both decorated armoires.[96] One does not know what these looked like, but it is unlikely that their creators' revivification of classicism would have been confined to thrones.

The evidence indicates that Italian mediaeval furniture followed in the steps of Italian architecture and decoration; it was not untouched by Gothic [139, 140, 141], and Byzantine decoration continued to be used almost undiluted [92] – but there was also much use and development of a classicizing late Romanesque style that must have eased the adoption of the more exacting, precise, and inspired neo-classicism of the fifteenth-century Renaissance.

107 An episcopal throne in marble inlaid with 'Cosmati' work, in S. Balbina, Rome, twelfth century.

an impression of primitive strength; both imitate wooden construction rather than taking their features from antique stone thrones. Some of the decoration on the Bari throne looks somewhat like chip-carving (or it may imitate tesserae); the pronounced linear tendencies apparent in its ornament betoken barbarian influence. It sits on elephants, an ornament frequently seen on Islamic textiles, ceramics, and miniatures, and attractive to Western potentates, who

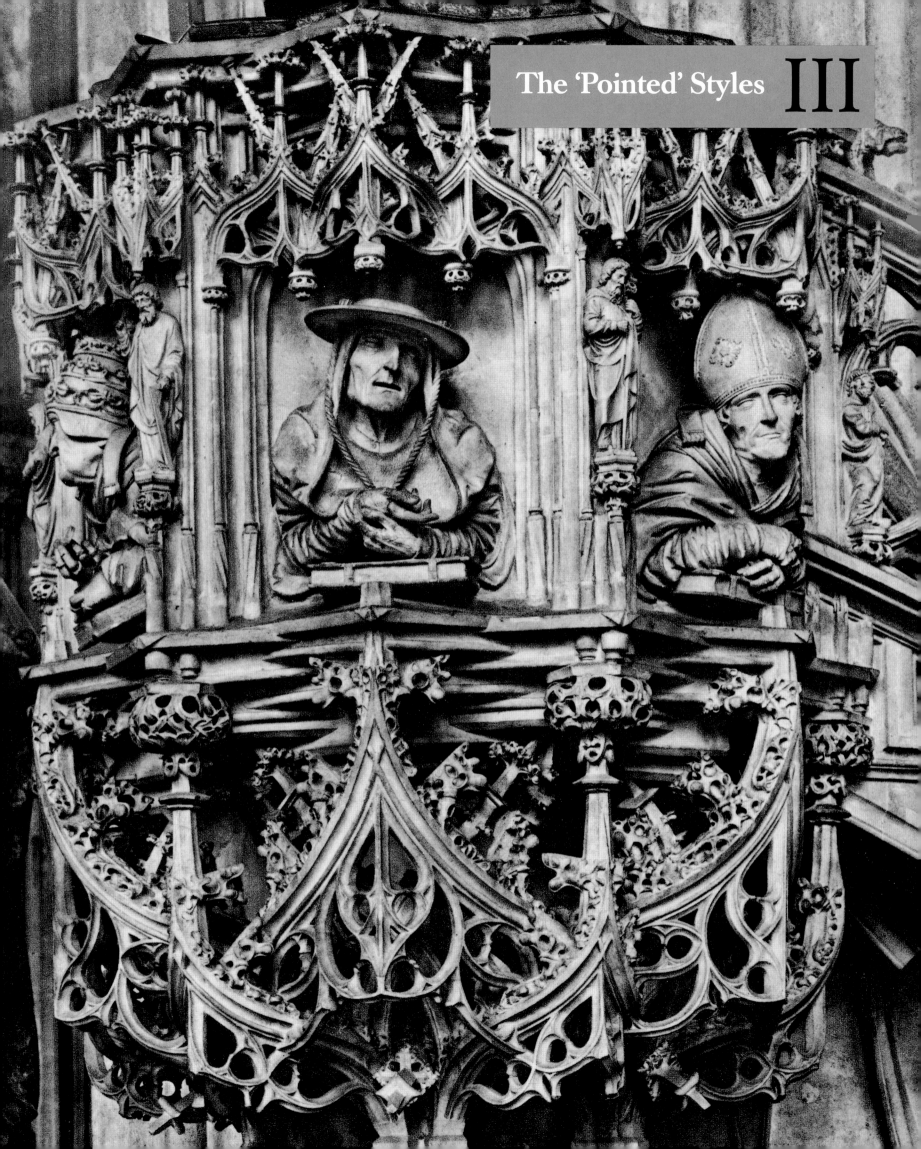

overleaf 108 A detail of the pulpit of
Vienna Cathedral, by Anton
Pilgram, 1512: late Gothic 'anti-
classical' expressionism at its height.
Motifs that probably originally
derived from Islamic sources
include ogee arches, cusping, and
'thick-and-thin' curvilinear tracery
with comma-shaped apertures that
is proto-Art Nouveau in effect.

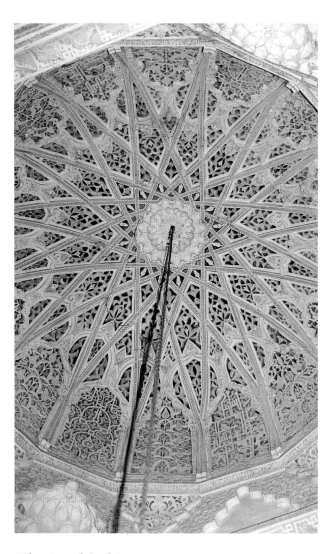

109 Islamic ornament that includes
interlaced pointed arches and
cusping, on the dome over the
mihrab of the Great Mosque, Taza,
Morocco, early twelfth century.

Islamic and Gothic

After the death of the Prophet Mohammed in AD 632,
the terrifying first onrush of his followers engulfed large areas
of the crumbling Eastern Roman Empire. These nomadic
Arabs brought comparatively little with them (they had no
architectural traditions), but they rapidly absorbed from the
conquered provinces the science of the Greeks and the art of
Rome, Byzantium, Persia and Syria. The political unification
within Byzantium of Persia, Mesopotamia, and the westerly
Asian provinces made the ornament of all these areas –
including its Sassanian and Gandharan content – accessible
to Islam. Islamic and Western styles have much in common
because of their shared root-stocks. Islam, however, did not
succumb to an alien culture, as had the Germans when they
entered Roman territory; on the contrary, after only two
generations it had engendered a new and wonderfully
original style.

Just as new, just as original, and almost as rapid was the
style that appeared throughout most of Europe in the twelfth
and thirteenth centuries. Gothic abandoned the age-old
tenets that had ruled architecture and the arts: for earth-
bound solidity, it substituted aerial tension; for breadth
and mass, it substituted line; for ornamental formalism, it
substituted naturalism. In Gothic, the spirit of the North

triumphed over that of Mediterranean antiquity. Ironically,
some of the most characteristic features of this 'Christian'
style originated in Islam. The process had begun long
before Gothic took hold: Islamic influences had entered
Romanesque art both from the south, from Islam itself, and
from the northern world of the 'Goths' (the 'Scythians' as
they were called by the Greeks) – which had itself received
influences direct from Persia. This encircling movement
perhaps helps to explain Gothic's speed of movement,
almost as quick as that of Christendom's Islamic adversaries.[1]

Islamic architecture

The architectural features that particularly concern us
here are those that influenced European architecture and
decoration – and hence furniture.

The most obvious is the pointed arch; the earliest true
example dates from AD 561,[2] but it was first extensively
employed in late ninth-century Egypt,[3] where it combined
with the ribbed vault to demonstrate the Islamic interest in
verticality. Vaults were articulated by ribs, dynamic and
'anti-classical', that might stand independent of the thin shell
or vault which filled in the space between the ribs – and do
so stand in the skeletally picturesque ruins of mosques and
abbeys. The ribbed vault implies lightness and movement,
a quite different matter from the heavy Roman and
Romanesque groin vault, which, inert and 'classical', merely
consists of two barrel vaults that cross each other at right
angles. Other Islamic architectural motifs included
intersecting round arches producing a pointed arch (seen as
ornament in ancient Roman grotesque ceilings), intersecting
pointed arches and ribs [109], the horseshoe arch, and the
triangular arch;[4] important for the future was 'cusping', the
decoration of arches with multiple lobes [110]; an example
of 965 is to be seen in the Great Mosque at Cordoba. The
scooped-out 'fans' often placed at the inside corners of
Islamic domes somewhat resemble velaria; they descend
from the scallop-shaped niches inherited from antiquity
by Byzantium.[5]

Islamic military architecture employed machicolation –
projecting galleries through which offensive materials could
be discharged on the heads of attackers – and crenellation.
The Islamic minaret was unequalled in its slender verticality
by anything in antique classical architecture except the
lighthouse. Islam also invented the ceiling pendant – a
feature of architectural decorations called *muqarnas,* a kind
of honeycomb with stalactite pendants that was sometimes
executed in wood.

Islamic decoration and ornament: arabesque

The mosaics of the Great Mosque at Damascus (706–15)
constitute the greatest of early Islamic decorative schemes.
Despite obvious 'Pompeian' and Byzantine antecedents,
they create an effect totally new and extraordinarily exotic:
'in the midst of…elements…familiar to our eyes accustomed
to classical traditions, bursts the luxuriance of Oriental
imagination, rioting in motives of another kind. Fantastic
flowers covered with jewels, covered with chains of gold and
mother-of-pearl pendants, spread over the walls. Elsewhere
necklaces and diadems are mingled with the foliage,

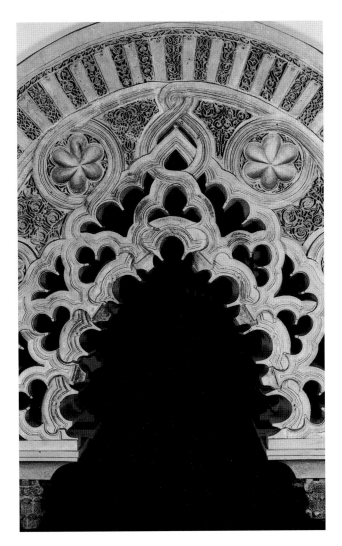

110 Proto-Gothic Islamic ornament that includes cusping, trefoils and broken curves, on an archway from the Palacio de la Aljafería, Saragossa, Spain; eleventh century

111 Winding scrolls with vestigial buds or flowers, the precursors of 'thick and thin' curvilinear arabesque, from a Greek vase published in Naples in 1766 by P.-F. D'Hancarville (from *Antiquités étrusques, grecques et romaines*).

encircling the branches and giving to the decoration a character both barbaric and refined.'[6] To the sophisticated motifs of Graeco-Roman and Byzantine mosaics was now added this further layer of orientalism. Some of it reflects Syrian Sassanian-influenced art, probably because craftsmen from Syria and neighbouring countries worked on the mosaics (the Sassanian art of Persia had itself been influenced by late antique Roman art[7]). This ornament, incidentally, was later to enter the vocabulary of the Wiener Werkstätte (p. 319).

The early proto-Islamic art of the Damascus mosaics was soon replaced by a more original, sparer but still luxuriant invention – 'arabesque', of great moment to Western style and Western furniture. It developed through the eighth and ninth centuries, attaining its characteristic form in the twelfth; the thirteenth saw it fully matured [114, 177]. It spread to all countries touched by Islam, from Spain to India. Its character, strongly individual in all its aspects, did not obliterate its origins in Graeco-Roman ornament, and this eased its assimilation in the fifteenth century and afterwards into the art and furniture of the West. Arabesque decoration observed two fundamental conventions. The first, an Islamic religious principle, rejected naturalism; the motifs used were abstract and linear. The second came from an Islamic liking for the pattern-making possibilities of 'infinite rapport'; repeated ornaments, simple or complex, tend to cover the whole area of an arabesque decoration with no particular motif dominating, often bewildering the mind with an impression of uncontrolled congestion. Motifs in 'infinite rapport' frequently encountered in antique mosaic floors were carried by arabesque to totally unclassical extremes.

A word is needed on terminology. 'Arabesque' and 'moresque' are words first invented by the Italians of the Renaissance to denote Islamic ornament. Strictly speaking, they refer to two different but related Islamic styles, that of the North African Arabs and that of the Spanish Moors: the nineteenth-century ornamentalist Owen Jones gave them separate treatment in his book and truly said that 'the main differences that exist between the Arabian and Moresque styles may be summed up thus – the constructive features of the Arabs possess more grandeur, and those of the Moors more refinement and elegance'.[8] For the purposes of this book, the differences are immaterial; the author has treated the terms as synonymous, but to avoid disconcerting readers interested in a particular period has inclined towards the usage most commonly adopted in that context.

In the early sixteenth century 'arabesque' motifs were quickly absorbed into 'grotesque' decoration (p. 102), and the two terms became, confusingly, more or less interchangeable; by the late 1550s, for example, a potter could describe a bearded figure with acanthus 'wings' and 'feet' as 'an arabesque…or one might say grotesque'.[9] Further difficulties are caused by the perfectly legitimate modern use of the term 'arabesque' to describe a scroll; this is especially confusing in the context of this book since much arabesque decoration is geometric. The word 'arabesque' as used here is not, therefore, to be taken as synonymous with 'scroll': it means only Islamic-influenced ornament (except where eighteenth-century texts are being quoted, a reservation made necessary because of further alterations in terminology in the late seventeenth and eighteenth centuries: p. 170).

Geometric and curvilinear interlace; the diaper

Islamic arabesque was both curvilinear and geometric. Curvilinear arabesque is a more or less completely abstract scroll that coils its way freely over large surfaces. It had evolved from the ancient Hellenistic continuous acanthus tendril [53, 111], which by AD 400 had already lost much of its naturalism. Antique and arabesque scrolls differ in that the former almost invariably follow a circular path in clear, independent, and sometimes asymmetrical scrolls, whereas the latter wind around in labyrinthine curves, oval or eccentrically shaped and repeatedly intersecting.[10] This interlace assumes various forms, ranging from knotted scrolls to knotted geometrical shapes, including lozenge-shaped

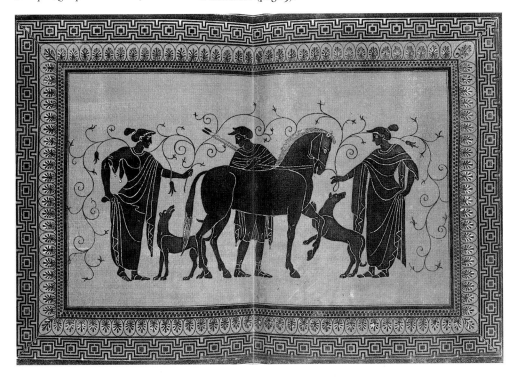

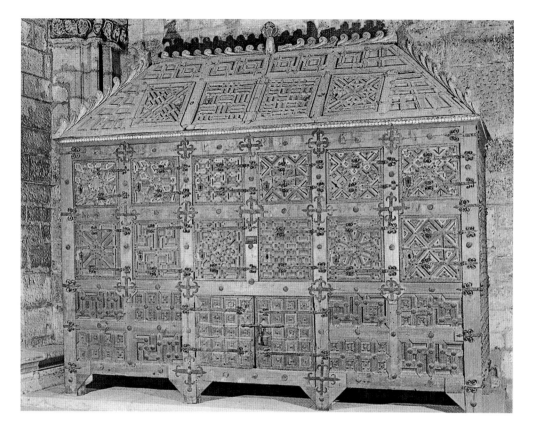

112 An armoire with Mudéjar geometrical interlace, in carved and painted wood and with wrought-iron fittings, in León Cathedral; probably thirteenth century.

knots;[11] all bear a close resemblance to the knots of Celtic art, as has been mentioned above, a similarity probably due to the shared background influence of the nomadic 'knot' (p. 47). Both Islamic and Celtic art [69] exhibit the scroll's characteristic gradations between thick and thin that became such a feature of its European use in Renaissance and Art Nouveau decoration and furniture.

Islamic geometric interlace, including some that has affinities with the Greek key, has predecessors in the ornament of late antique Graeco-Roman mosaics and sarcophagi; one of the most striking forms of Islamic geometric interlace is composed of boldly, not to say aggressively, angular forms that make up explosive 'stars' [114] (motifs that were eventually to be reproduced in Gothic window tracery [473] and inlaid wood [116]); these are reminiscent of patterns met with in the early Christian mosaics and other work of North Africa that originally came from areas east of modern Turkey.[12] Similar late antique North African influences, filtered through Islam, appear in the Byzantine/Islamic mosaics of Sicily [662]. Owen Jones pointed out that the first example of the lozenge-shaped diaper [120], common in Gothic and Mughal art and a frequent furniture ornament [118], was, together with 'the germs of all the ornamentation of the Arabs and Moors',[13] to be found on Persian Sassanian capitals.[14]

The broken curve

The two types of curvilinear and geometrical arabesque were frequently fused in one figure, as in the 'broken curve' [109, 110]. The 'broken curve' occurs in late antique Roman architecture, most commonly in colonnades or façades in which straight entablatures break into arches [16, 17], in the paint and stucco extravaganzas of the theatrical genre of Roman wall decorations, and in such extraordinary 'baroque' buildings as the third-century AD Temple of Venus at Baalbek [18].

The broken curve became a commonplace of Islamic art, especially used as a constituent of flat geometrical and shallow architectural decoration. Owen Jones remarks that

the 're-entering' curve 'was adopted in the Elizabethan ornament, which, through the Renaissance of France and Italy, was derived from the East, in imitation of the damascened work which was at that period so common.'[15] It seems likely he was thinking of 'strapwork' [213] (pp. 120–21); a print of 1541 [176] is one of many to show strapwork in course of evolution. Few motifs have had so energizing an effect on Western furniture as the broken curve.

The acanthus 'hole' and other motifs

Arabesque displays other influential motifs. They include acanthus calices set one inside the other [113:C], a development from the usual Roman naturalistic, elongated acanthus [113:A]. The acanthus underwent another curious change, significant for the future: areas of background that were encircled by scrolling fronds were eventually completely enclosed and formalized as circular and comma-shaped apertures or holes. Advances towards this abstraction (probably encouraged by the late Roman use of the drill in sculpture) are seen in 'Pompeian' paintings, where leaves were given deep indentations resembling pipes; it was complete by the ninth century [113:B,C].[16] It was later to give strapwork a characteristic motif [176].

The vertical Hellenistic candeliera and candelabro ornament also entered the repertory of arabesque decoration. It was often geometricized [174].

Ovals and polygons

Whereas Western art liked circular curves, Islam preferred pointed ovals and polygons [109]. The prototypes of these forms are to be seen in 'Pompeian' and late antique art. The liking for ogives and polygons entered Gothic art, ensuring that many nineteenth-century Gothic Revival tables would be octagonal.

Islamic woodwork; style and technique

Inlay of the most technically accomplished and artistically sophisticated kinds had long been employed in Eastern furniture [4]; it had become a feature of Greek and Roman furniture [12]. Wood inlay is closely related in concept and technique to mosaic,[17] and considering the heights to which the Byzantines took mosaic, it is likely that mosaic's sister art of wood inlay built on antique foundations to become as creatively original in Byzantium as Byzantine mosaic itself.

The disappearance of all inlaid Byzantine furniture makes this speculative. However, the largest quantity of pre-fifteenth-century inlaid woodwork extant is found in Islamic Spain and North Africa; it tends to be structural – doors, door frames, and pulpits – and it employs a combination of carved and inlaid geometrical interlace and scrolling arabesque tendrils. It seems practically certain that these techniques originated in Byzantium: were woodworkers amongst the craftsmen sent to Damascus and Medina by the Emperor of the East? He certainly sent workmen in 981 to make the *mihrab* in the Great Mosque at Cordoba. The discontinuance over most of the ravaged West of the luxurious techniques of inlay – even the simple mortise and tenon joint largely disappeared – made Islam the preserver of the art of inlaid wood as it was of Greek philosophy and mathematics.

One of the most interesting and beautiful Spanish styles is that which resulted from a blend of Islamic and Christian motifs – the Mudéjar style. An early example is an impressive thirteenth-century armoire in León Cathedral[18] [112]. Front and sides are profusely and differently decorated with

113 From Roman acanthus to Islamic 'acanthus hole': A, from the Temple of the Sun, Rome (after Owen Jones, *The Grammar of Ornament*); B, stucco ornament from the Mosque of Ibn Tulun, Cairo, 878; C, frieze from the mihrab of the Great Mosque at Cordoba, 965.

114 Panelling on the walls of the House of Sánchez in the Alhambra, Granada (after Owen Jones, *The Grammar of Ornament*).

geometric designs; the front includes diaper patterns; one side has two rows of swastikas, a form of Greek key. Decoration of a different character is displayed in a fine Mudéjar cupboard of the first half of the fifteenth century [116]: its inlay directly recalls the patterns of late antique mosaics,[19] while the stepped ornament along the top also occurs on the parapet of a thirteenth-century mosque in Cairo.[20] Originally brightly painted in red, blue, white and black, it has a secret compartment reached by a sliding door; the decoration includes Kufic inscriptions that repeat the word meaning 'prosperity'. It has been remarked that its design differs from the usual European late Gothic pattern, more resembling the cupboards of late antiquity as seen in the mosaics of the Mausoleum of Galla Placidia and the *Codex Amiatinus* [75].[21] Technique and form combine to suggest that the antique influence came to Spain from Byzantium via Islam, and the survival of both together must add to the probability that the decorations of cupboards shown in the *Codex Amiatinus* and other Byzantine manuscripts were inlaid. When sophisticated inlay once again became a common European woodworking technique, its techniques were relearned from Islam's Spain – whence also came many of its motifs.

Yet another variety of inlaid geometric arabesque is seen in a fifteenth-century chest from the Saragossa area [115]; interlaced squares surround and connect the motifs in the main panels. The 'petalled' decoration seen around the edges had appeared in Islamic lustre tiles by the ninth century.[22]

One of the most characteristic pieces of Spanish Renaissance furniture is the *bargueño* [117] (a nineteenth-century term that replaced the original *escritorio*, 'writing desk'). A chest on stand, it often has a fall front that conceals a mass of little drawers. Most surviving stands are modern; the pattern they follow, however, is old, and is interestingly reminiscent of Byzantine arcades – perhaps a coincidence. The bargueño type was, as an ancestor of the European cabinet on stand, immensely influential. The example illustrated displays the Islamic/Gothic cusped lozenge on its drawer fronts.

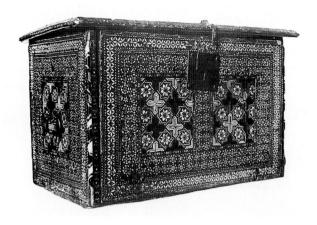

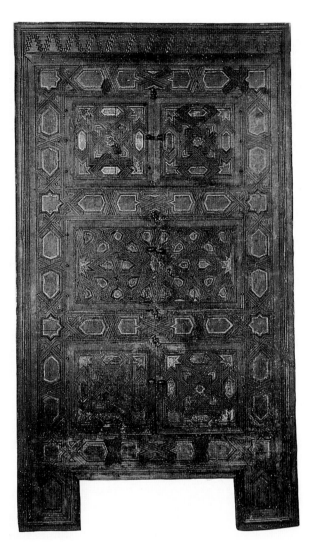

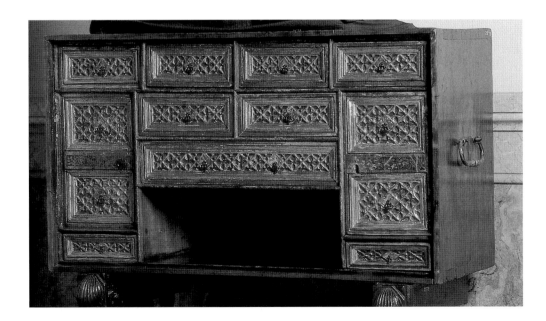

top 115 A chest decorated with geometrical moresque inlay; Spanish (Saragossa), fifteenth century.

above 116 A cupboard painted and inlaid with geometrical designs in Mudéjar style; Spanish (Toledo), *c.* 1400–1450.

left 117 A bargueño in Gothic-Mudéjar style with carved, painted and gilded decoration (the reproduction stand is not shown); Spanish, early sixteenth century.

III *Chapter 2* Gothic, 1150-1550

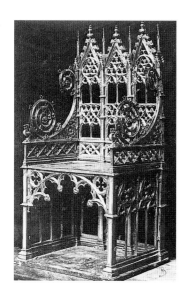

118 The silver-gilt throne of St Martin of Aragon, in Barcelona Cathedral; Spanish, *c.* 1400–1450.

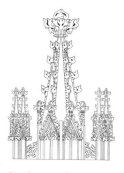

119 Crockets on the exterior of Beverley Minster, Yorkshire.

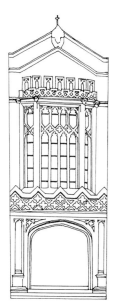

120 Gateway of St Peter's School, York.

THE FURNITURE that appears most truly 'Gothic' was that inspired by Gothic architecture, fashionable, sometimes highly wrought, and not seldom fantastic [118]; most of the furniture treated in this chapter falls more or less into this category. But two other groups survived from earlier periods that frequently display little or nothing of 'Gothic' style. These comprise the basic utilitarian furniture, frequently of knock-down construction, that probably largely represents a Dark Ages survival [495] (p. 49); and the furniture, often turned, that continued late antique and/or Byzantine tradition [102, 103, 106, 122] (pp. 60–64). Turned furniture changed so little (p. 60) that it is usually quite difficult to date; its isolation from high fashion was probably assisted by the organization of wood-turners as a separate trade throughout the Middle Ages.[23]

Gothic art and the aedicule

For many centuries people have seen the sublime in Gothic architecture; other Gothic artefacts, even furniture, share something of this emotional intensity. Emotion is an attribute of 'anti-classicism', and for Renaissance theorists Gothic architecture was the anti-classical style par excellence; it has retained this status to the present day despite competition from exotic styles such as those of China and India. John Ruskin, the arch-Goth, adumbrated in 1851 that 'All European architecture, bad and good, old and new, is derived from Greece through Rome, and coloured and perfected from the East';[24] the anti-classicism of Gothic evolved from Greek and Roman classicism via Romanesque and Islamic art. Much Gothic construction was guided by a classical architect: thirty-nine mediaeval texts containing the whole or part of Vitruvius's treatise on architecture survive that predate his 'rediscovery' in the fifteenth century.[25]

A relationship between Gothic and the un-Vitruvian and orientalizing art of grotesque was perceived ('felt' would perhaps be a more precise word) by artists and theorists of the eighteenth and early nineteenth centuries (p. 276). This connection has been reaffirmed in the present century; in a series of graceful phrases, Sir John Summerson expressed the theory that Gothic architecture was the 'recaptured inheritance' of Roman aedicular art, as expressed in the painted walls of Pompeii: 'The pointed-arch system was, I believe, adopted [because] it had an air of fantasy – perhaps, dare one guess, of Oriental fantasy – which went along with the realization of the "Pompeian" idea.'[26] For Summerson, the aedicule was 'the psychological key' to Gothic;[27] the 'ribbed vault…may be compared with the airy pergolas which make their frequent appearance in the fantasy-architecture of Pompeii',[28] and the flying buttress was 'a fairy viaduct having a ridiculous affinity with the conceits in some of the [Pompeian] stucco panels in the Naples Museum'.[29] Where such a dry-footed architectural historian is not afraid to lead, who are we to baulk at splashing about in the shallows?

Vitruvius' description of grotesque (p. 32) could be applied almost unaltered to much Gothic illuminated decoration and painting, where the affinities are even greater and where much of the action takes place in fantastic aedicules. The term 'aedicule', originally meaning a shrine in a Greek or Roman temple, came to be applied to any frame that consisted of columns or vertical supports carrying a pediment or gable; aedicules were commonly used for windows, doors or niches. The original semi-religious nature of the motif never quite disappeared, translated as it was into the language of secular obeisance and blended with the state significance of the canopy and 'padiglione' (p. 110). It assumed a great significance for the more ambitious pieces of Gothic furniture – the state bed [135, 136, 139, 144, 148], the throne, the covered seat [138], the ceremonial buffet [487].

The influence of Islam

The similarities between Islamic and Gothic architecture have been recognized for centuries, by Sir Christopher Wren amongst others.[30] The likenesses are spiritual as well as material, hardly surprising since the respective creeds have fundamental beliefs in common, as both in their saner moments recognized. Both Islamic and European architecture depended upon Euclidean geometry, preserved by its translation into Arabic in the ninth century and translated into Latin in the early twelfth century.[31] Some of the most eminent practitioners of Islamic and Gothic art had characteristics in common – 'The Persians are often called the French of Asia…[they have] a lucidity in thought, combined with emotional intensity.'[32]

Gothic architecture owed to Islam both major structural elements and ornament. Infidel and true believer met in combat and trade; Christians entered Islamic lands on pilgrimages. The contacts began early: Charlemagne's proto-Romanesque Palatine Chapel at Aachen prominently displays an Islamic feature that has no Roman Imperial precedent,[33] and many essential motifs of Romanesque architecture came directly from Mesopotamia and Persia.[34] Some travelled via Byzantium; Islamic influences on the Macedonian court (867–1056) were multiple.[35] The influential abbey of Cluny (founded 910), which developed daughter houses throughout Europe, had close links with Spain: in 1085 the rich Muslim city of Toledo was taken by the Christians and a Cluniac appointed archbishop.[36] Cluny's new church (consecrated 1095) contained pointed arches and an altar table – halfway towards furniture – that, consecrated in 1096, had the cusped arches[37] that had been first used structurally, and with great decorative versatility, in the Mosque of Cordoba in 965.[38] An eleventh-century archway from Saragossa [110] combines cusping with interlace in a form that astonishingly anticipates fourteenth-century Curvilinear Gothic tracery [123].

The contacts intensified with the crusades; the First Crusade of 1095, which planted European settlers in the civilized East, had been preceded by European excursions[39] which resulted in the permanent importation of 'Saracens' into the West. Returning knights introduced Islamic machicolations and crenellations into their Western castles. The Normans' conquest of Sicily gave the most peripatetic people in Europe dominion over Islamic artists; it was probably thus that the Islamic ribbed vault, which was sometimes used as decoration alone (many French ribbed vaults are themselves essentially decorative[40]), made its first

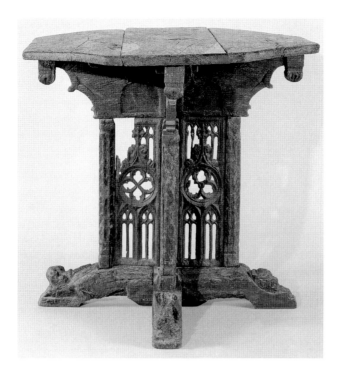

121 A knock-down table in carved oak; French, c. 1480–1500.

122 A folding multiple-legged X-frame chair, a buffet, and other furniture: 'January', by an associate of the Brussels Initials Master; Flemish, 1406–7.

European appearance in the great Norman cathedral at Durham in 1093. Fifty years later it was employed, together with the pointed arch and the huge windows that were filled with the early stained glass that derived its patterns from mosaics, in the church of St Denis near Paris. The flying buttress, the extraordinary invention that enabled the soaring forms of Gothic architecture to be supported by an elegant rib-cage of stone, and that later propped up Regency dressing-table mirrors, existed in embryo in Persia in the fifth century.[41]

The stumpy Romanesque tower cap became the Gothic spire; aspirations towards height were a feature native to Persia and Mesopotamia,[42] and the germ of both probably came from the tall and faceted spire that was the Islamic minaret, seen as early as 705 in the Great Mosque at Damascus. Gothic spires and pinnacles grew ever more attenuated and fantastic; they multiplied, large and small, on cathedrals, chantry chapels and tomb canopies to a forest-like density. They were ornamented with crockets [119], highly unclassical despite classical descent [80].[43] A verticality unknown to classicism was given by Islam to the shallow classical dome, and Gothic influence increased it; Brunelleschi's dome at Florence is of this type, as are the innumerable small 'domes', often ogee-shaped, of late fifteenth and early sixteenth-century 'Tudor' architecture and its imitations [462]. The 'Gothic' dome dominated European architecture, decoration and furniture until the eighteenth century.

The influence of Islamic culture, much more advanced and sophisticated than that of the West, was fundamental on Gothic art, much deeper than that of 'arabesque' on post-Renaissance arts (pp. 102–4). Gothic furniture shared this influence.

Primitive simplicity and mobility; the re-establishment of security

Textiles, plate, and jewels were the measure by which status was judged throughout the Middle Ages: they never lost this primacy, and furniture came a long way behind. A practical and insurmountable obstacle limited variety and sophistication in early Gothic furniture design – the primitive simplicity of

daily life, a legacy from Dark Ages dislocation. The restlessly mobile rich had to travel to eat and maintain their authority; rooms were deserted for long periods during which the character of their furnishings changed. When the family were away the villeins could play, and they played amongst the large wooden carcases that had been denuded of the fabrics used to dress them up for stately living – rather like a stage left empty whilst the company moved on to another theatre carrying its most precious props with it. In setting up the scene, textiles were the most valued element; they were versatile, gave rich effects, and could be easily stored, protected and transported. The use of rich fabrics over rough wood lasted for a very long time. A sophisticated late sixteenth-century parody of dignified chivalric dining[44] shows a chamber-organ playing beside a swathed trestle table; the buffet laden with gold and silver vessels is still covered in linen, implying that it was a rough and temporary construction, although elaborately carved and high-tiered buffets had long been in use [487].

Many of the props were carried in the chest, which was most typically a piece of luggage, iron-bound and leather-covered. Beds made of rough wood were disassembled and taken from place to place, then put together and hung with the textiles that defined precedence (p. 77). Late into the Gothic period, richly furnished travelling beds with folding frames are recorded amongst gifts to princes,[45] and they persisted into the sixteenth century [175] and far beyond. Chairs were also carried about; an inventory of 1357 mentions that Edward III of England had an 'ebony chair with a leather case',[46] probably for transporting it. Even after more primitive days had long passed, old habits died hard – a richly carved and pierced chamber table of the late fifteenth century was still made on the old knock-down principle [121], and it was not until the eighteenth century that stationary dining tables became usual in grand houses throughout Europe.

Furniture was not invariably mobile; many mediaeval armoires and chests still exist that were obviously designed to stay in one place, often a church [124]. Great bishops and abbots maintained permanent households; did some development of earlier domestic furniture types perhaps occur in monasteries? Much that was of cultural importance was centred on the monasteries, and some orders became notorious for soft living; moreover the cell had provided a small and private place from early days, well adapted for the development of specialized furniture – one has only to recall the many illuminated pictures of saints in comfortable seats at lecterns or desks [75, 138], sometimes with a little table alongside. Royal and semi-royal palaces also had permanent headquarters: lord, lady and retinue moved about, but officials remained behind. Although these palatial households had nothing that approached the leisured sophistications of Rome, Byzantium, or Islam, they increasingly provided a setting for innovatory luxury or grandeur: for example, a stationary marble seat and table stood in Westminster Hall, London, in the second half of the fourteenth century.[47] For magnates, furniture was made and finished by accomplished craftsmen and artists; it might be designed by draughtsmen such as the thirteenth-century Villard de Honnecourt, whose drawings [127] influenced William Burges in the nineteenth century [490]; some furniture was very imposing.

The development of Gothic furniture is linked with the gradual re-establishment of a secure civilization. Society became prosperous; trade and towns revived, and a rich and

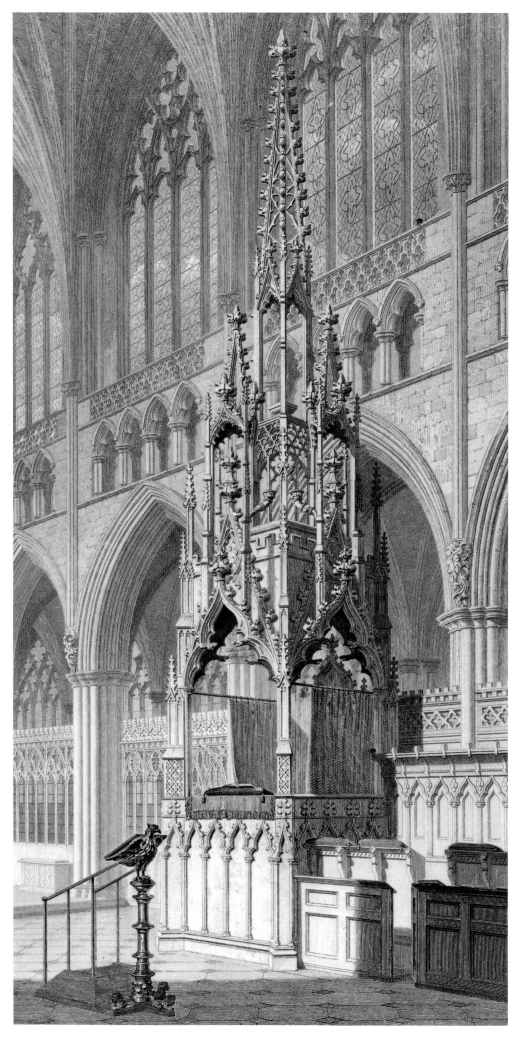

cosmopolitan merchant class reappeared. Clerks and laity retreated into more private quarters; mobility and public living was replaced by stationary privacy, always a luxury and necessary for the development of sophisticated types of furniture [146]. In place of the open accessibility of the large rooms of early households came smaller chambers with doors and locks, and pilfering and misuse became less of a problem. Furniture techniques improved – from about 1250 the joiner's plane was revived (the oldest existing planes come from Pompeii[48]) and joiners began to make and paint high-quality chests, beds and cupboards. Furniture played an increasingly important social role in the aristocratic and bourgeois interior: opulently carved, gilded and painted surfaces were exposed to view, playing their part amongst sumptuous textiles. Having become a weapon in the social war, furniture was no longer content to be, as it often had been, a framework that hardly changed with fashions. It became more inventive and extravagantly new.

The influence on furniture of Gothic architecture and ornament

Gothic architecture and ornament is so rich and strange, and became so often fantastic over the last two hundred years of its existence [108, 123], that one reasonably expects Gothic furniture to exhibit as great a variety as furniture in any other European style. It does not, and its rich, architecturally inspired decoration can become repetitive, contributing to an impression of sameness. However, the ecclesiastical origin of a high proportion of the Gothic furniture that has managed to survive – it is rare enough – may be misleading: church furniture tends to share the stylistic detail of circumambient architecture and architectural woodwork, understandably since great Gothic buildings appear to have been designed (not always built!) as a whole, probably by one person. Architect and craftsmen probably worked in harness on rood screen, throne and armoire. A soaring English ecclesiastical throne of 1313–16 [123] was made by a carpenter, Robert de Galmeton, under the supervision and probably to the design of Thomas of Winton, who had come to Exeter from Winchester in 1313. Clergymen then had a clear idea of what they wanted, and often sent far for it: many famous architects travelled to foreign countries to spend years designing and building the greatest cathedrals, including Canterbury and Burgos. Despite the national differences to be seen in Gothic architecture, it was an international style, and there seems to have been something of the same internationalism in furniture as in architecture: for example, Melrose Abbey in Scotland ordered its choir stalls from Bruges, specifying that stalls in two Flemish churches should be used as models; the work was delivered in or after 1441.[49] Such contacts must have been responsible for the striking resemblances between two fifteenth-century chests, English from Suffolk and Spanish from Palma de Mallorca.[50]

One reason for the lack of variety of early Gothic furniture may be the restricted range of basic shapes that lay beneath the decoration, nothing like the wide variety of classical antiquity. Was the gloriously new architectural style so intoxicating that people found it difficult to invent furniture shapes as individual and as devoid (or almost devoid) of architectural meaning as were the ancient klismos, scroll-ended sofa, X-frame chair or skeletal tripod? The tendency to mimic architecture in furniture had become well established in Byzantine and Romanesque times, as mosaics and illuminations abundantly demonstrate [93, 94]. Mediaeval Gothic furniture, especially of the later centuries, went a

opposite **123** The bishop's throne and canopy in carved oak in Exeter Cathedral; English, 1313–16, as depicted in 1826 by John Britton (from *The History and Antiquities of the Cathedral Church of Exeter*).

right **124** An armoire in carved oak with wrought-iron fittings and hinges, in Brandenburg Cathedral; German, *c.* 1300–1350.

125 Decorated or Curvilinear tracery, from the altar screen, Beverley Minster, Yorkshire.

126 Detail of the destroyed tomb of Cardinal Jean Cholet (d. 1292) in St Lucien, Beauvais (recorded in the Gough Drawings, Bodleian Library, Oxford).

127 A cusped rose window at Chartres Cathedral (after the sketchbook of Villard de Honnecourt).

128 A small chest carved in oak, brought into the convent at Wienhausen by a nun; German (Lower Saxony), probably 1292.

good deal further, especially in semi-domestic, semi-ecclesiastical devotional artefacts like the Memling *arqueta* in the Hospital of St John at Bruges. This mediaeval Gothic 'architectural' excess was imitated by nineteenth-century Gothic furniture designers [480].

The sumptuous, sometimes overwhelming wealth of Gothic ornament compensates for lack of variety in form. Renewed Islamic influence led to the introduction of new ornaments in the late thirteenth and early fourteenth centuries. These probably included diaper patterns [120]. An English embassy despatched to Persia in 1291 (which contained a person known as 'Robert Sculptor'[51]) was the first of a sequence which lasted until 1335; a likely consequence was the novelties, all almost certainly Islamic in origin,[52] that made English Decorated (Curvilinear) the most fantastic of contemporary Gothic styles; they include the ogee arch, the ogee-quatrefoil, and interlaced circles and hexagons [464]. Other countries followed similar paths. The thirteenth-century Rayonnant style of France and Germany has more than a passing resemblance to the explosive geometry of Islamic geometric arabesque [114]. All these motifs found their way into furniture. As did the verticals of English Perpendicular architecture [120] and the flowing curvilinear intricacies of French Flamboyant. Motifs suggestive of Perpendicular had occurred in Islamic decoration, including 'wire-netting' reticulation; the flame-like traceries of Decorated and Flamboyant [125] are seen in embryo in the undulating movement of the Islamic tendril as it converges into pointed ellipses. These origins were later to facilitate the combination of revived Gothic with styles influenced by arabesque, including rococo.

Spires [118, 132], crockets [124, 132], gables [124], buttresses [132], crenellation [129, 130], and canopies [126, 138, 467], migrated, miniaturized, from cathedrals and castles to furniture. Gothic furniture first used ornament based on arcades; it then progressed from designs inspired by Gothic window tracery to the various types of late Gothic and Renaissance panelling, which themselves sometimes employed tracery [137]. Windows displayed the developing styles of Gothic architecture over the centuries as clearly as any other single feature, and their tracery was taken over more or less entire, pierced [118] or blind [128], for decorating furniture [128, 131, 118, 132, 137]; the tracery seen in buildings varied according to nationality and period, and the differences are reflected in furniture. Thirteenth-century Gothic windows, for example, often combined two or three simple pointed arches with an arrangement of plain

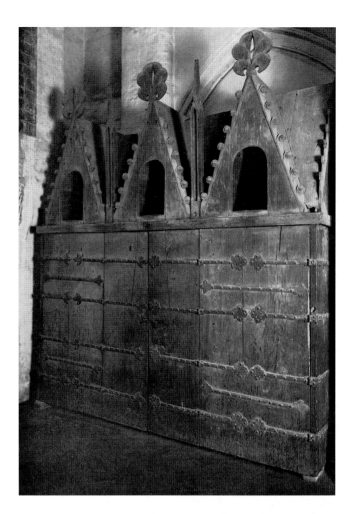

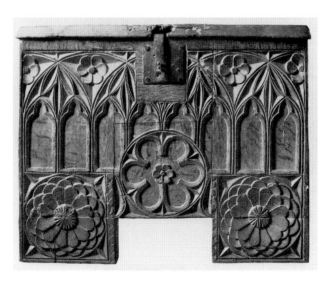

circles taken over from Romanesque work (and originally deriving from antique interlace); soon the circles were cusped, an Islamic feature that became a Gothic hallmark [127]; cusping was applied to free-standing arches, becoming ever more elaborate; it also appeared on furniture [118].

Armoires and chests

The Gothic armoire,[53] a tall block by nature, lent itself to architectural form, and was so treated. A simply made German example from the first half of the fourteenth century at Brandenburg Cathedral [124], held together largely by ironwork, has a sloping 'roof' with three gables complete with rudimentary crockets and spires; the 'windows' have old-fashioned round arches and there is no attempt at any architectural decoration of the front. More elaborate versions after this pattern exist, some with battlements, diapers, traceried windows and surface painting.[54] To judge from manuscripts, sophisticated examples of this type might have been made in the Romanesque era.

Early mediaeval chests and armoires were often bound together by fantastically designed metalwork [106], a technique employed where carpenters or wheelwrights wanted to hold riven timber together without mortise and tenon joints; this type of furniture, which is far removed from architectural concepts, survives in quantity in churches where the same kind of metalwork as that on the furniture is found on church doors. There seems to have been a close association between the furniture-maker and the smith – the iron grille of Edward IV's tomb at Windsor has its pieces jointed and pegged as if made by a cabinet-maker.[55]

A German chest probably dating from 1292 [128], from the amazing collection of dower chests in which novice nuns brought their goods into Kloster Wienhausen, has a simple

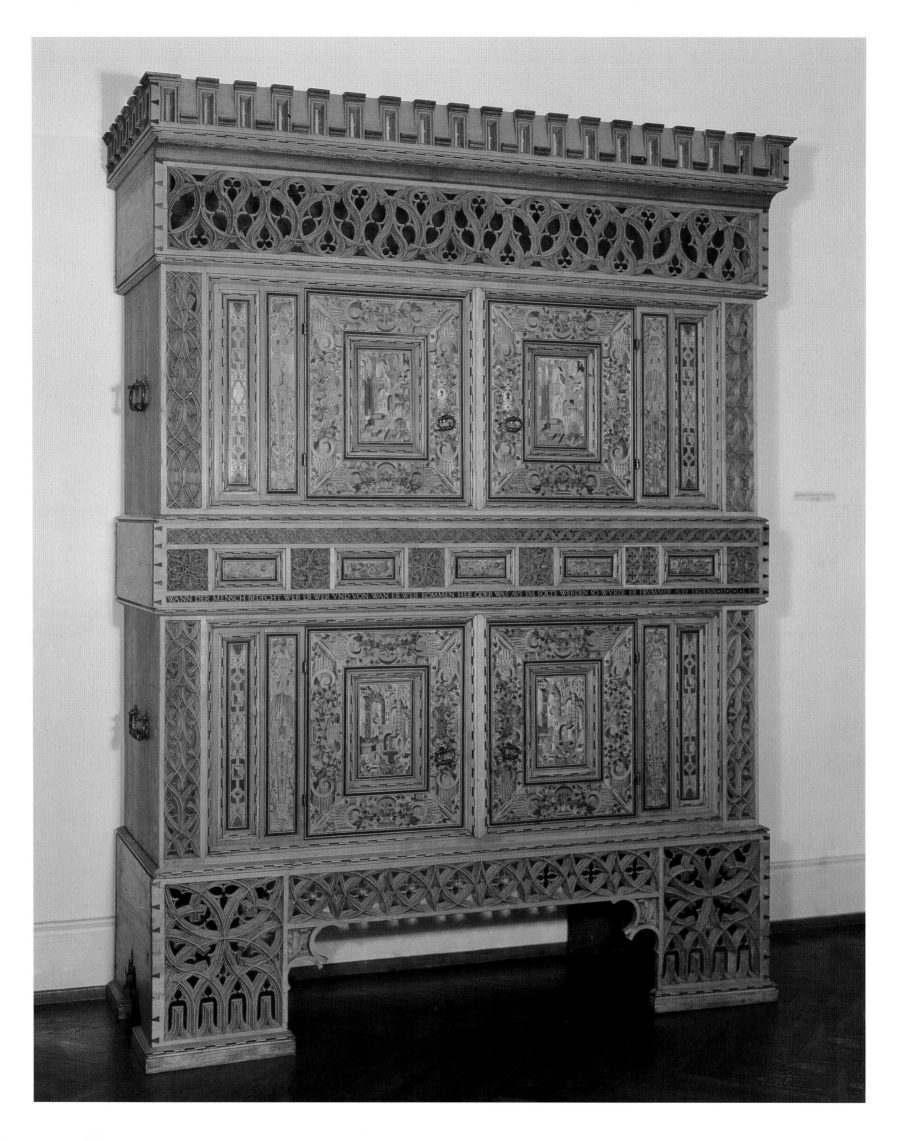

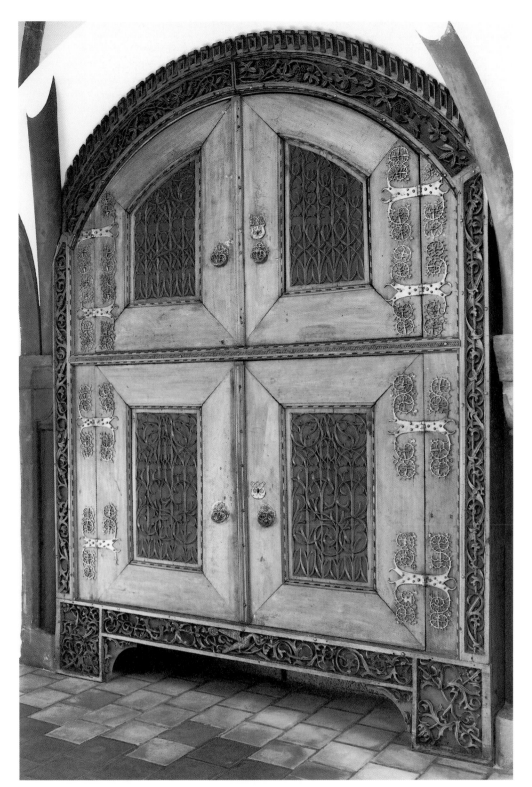

basic shape to which are added crossed round arches forming pointed arches at the intercrossings like those that originated in Islamic architecture; beneath them are unequivocally Gothic arches and a cusped circle, with two large-scale formalized flowers beside, possibly double roses; single roses appear within the arches, with a hint of naturalism in their depiction. Such chests continued to be made for centuries; later examples, like a French walnut chest of the late fifteenth century that found its way to Romsey Abbey in England, were highly worked [131]. Its corners are articulated by buttresses topped with crockets; its arcading has the repetitious verticals of the Perpendicular style, but the 'Islamic' ogee arches [109], the movement of which is continued in ingeniously patterned 'wheels', and the richly ornamented, orientalizing pointed ellipses add a note of distinction.

Late Gothic German architecture is as fantastic as any, and the sharp-angled fantasy found in church furnishings [108], so expressionist as to be agonizing, found some vent in furniture. A cupboard of 1452 from the cathedral of Basel [130] has a flat panelled front intricately carved within the panels with late Gothic tracery; the tracery bends and twists into uncomfortable, thorn-like angularities. The iron hinges end in scrolls with a pattern close to arabesque scrolls. The scroll at the top of the cupboard is related to a common late antique motif but the rounded curves of antique versions are replaced by naturalistic gawkiness. The curved top has 'battlements'. A very similar cupboard from the same area, dated 1518, with many drawers for documents, has curling Gothic scrolls and Gothic tracery;[56] yet another, from Ulm and dated 1569 [129], is an example of 'mixed Gothic and Roman manners', as such styles were called in the early nineteenth century: the basic Gothic shape persists, together with battlements and other Gothic details, although the Gothic interlace along the base is beginning to resemble a type of antique interlace and the piece has been brought up to date with Renaissance intarsia (p. 92). Such pieces of furniture are appealing, although stylistically miscegenous.

Thrones and chairs

The chair, especially the armchair, was charged with a social significance which dictated its usage: chairs were objects generally owned but, as etiquette hardened, increasingly subject to restraints. The type of chair used by a particular person depended not on rank but on precedence, which varied according to the company and circumstances in which people found themselves. A peasant in his cottage on his own could sit in an armchair with complete propriety;[57] great lords in company with greater lords or kings had to use

opposite **129** A cupboard in pine carved and elaborately inlaid with ruins and other motifs in cherrywood, pearwood, plum, maple and lime, tinted green and coloured with hot sand; German (Ulm), 1569.

above **130** A carved cupboard in maple, fir and bog oak, with wrought-iron hinges and escutcheons, from Basel Cathedral, 1452.

right **131** A chest in carved walnut, with a modern lid, now in Romsey Abbey, Hampshire; French, *c.* 1480–1500.

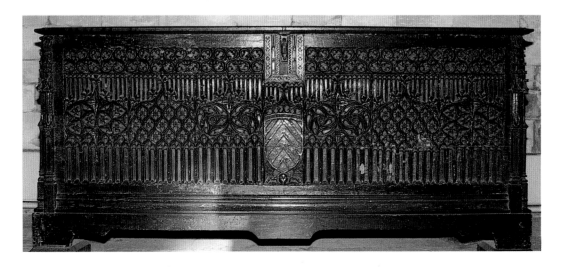

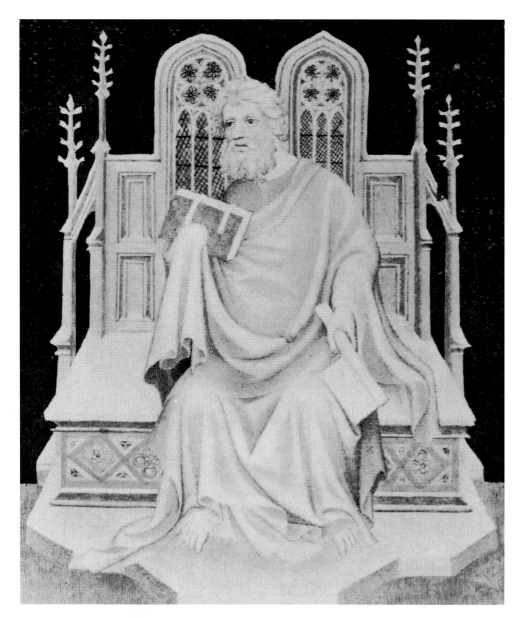

132 A Gothic throne with pinnacles, 'windows', and quatrefoil decoration: *St Matthias* by André Beauneveu; French, *c.* 1405.

133 Beds within aedicules, from twelfth-century mosaics in St Mark's, Venice.

right 134 A state cradle in oak, painted and covered with gold leaf, originally designed to swing between uprights; Flemish, 1478/79.

benches and stools. The use of the footstool with a chair, however, had denoted rank from remote antiquity, and the throne was always elevated, often by its form as well as being placed upon a platform. Testers and canopies added state to a seat. Thrones were frequently adorned with the lion, an ancient symbol associated in the Christian's mind with King Solomon, hence regality and justice.[58]

Some of the thrones decorated with 'window' tracery, spiky appendages and other-worldly colours pictured in later Gothic miniatures and paintings [132] seem to belong to fairy tales rather than real life. As with the fantastic pictured Romanesque furniture [94], we should not dismiss them too easily. Gothic architecture reached the limits of fantasy in the fourteenth and fifteenth centuries, as did aristocratic dress; it would not be surprising if grand furniture, ecclesiastical and secular, matched them. The bishop's wooden throne in Exeter Cathedral [123] is 57 feet (over 17 metres) high, and as elaborate as a chantry chapel or tomb canopy. Beside it, St Matthias's imaginary throne [132], with a seat that may contain a storage area, is modest and practical, more so than the contemporary real throne of St Martin of Aragon [118]. This, a fully fledged 'architectural' throne in silver gilt, is decorated with window tracery, pinnacles, crockets, cusping, and diaper work (the scrolls above the arms come from the vocabulary of the smith rather than that of the stonemason or carpenter).

Thrones were the ostentatious pieces of seat furniture. Lower down the scale, but still imposing enough, were such chairs as a Spanish 'box chair' [137] that combines the rounded back taken ultimately from antique thrones with contorted late Gothic tracery; a shield and coat-of-arms decorates its centre.

Aedicules and canopies: beds and buffets

The bed carried potent social messages, especially when combined with the canopy, which prominently employed precious textiles. Canopied and posted, the bed has much about it of the aedicule, a lasting concept that was particularly appropriate for the design of stately beds and chairs and that received further emphasis in the balustraded state bed placed within the alcove (yet another aedicule) of later ages. The impulse for the pillared aedicule to join forces with the couch to produce a bed with four posts must have been irresistible. It is sometimes difficult to make out whether beds placed within posts pictured in early representations are merely couches placed within an aedicule or whether beds and posts make one structure. Twelfth-century mosaics in St Mark's in Venice, which may be taken from earlier sources – for instance, the Genesis cycle in the vestibule probably used as a model a Byzantine illuminated manuscript of about AD 400[59] – show beds placed within four roofed pillars which have poles with hanging curtains and rings; the posts are strongly architectural, fluted and Solomonic with acanthus capitals [133].

Canopies, including the hovering 'sparver' or 'sperver' (sparrow-hawk; cf. p. 111), are recorded on twelfth-century beds, and over the next two hundred years the canopy became an essential component of lordly beds, remaining in use until the present centrally heated century. A bed made in the 1240s for King Henry III of England, the first recorded English state bed, had green posts powdered with gold stars and a canopy painted by 'Master William'; it may have been entirely made of wood.[60] A little later, two frescoes by Giotto at Assisi pictured different treatments of the bed. One [135] has the Pope lying beneath an early version of the sparver, with its suspension system clearly shown; the textiles dominate (those on the wall display Islamic-influenced interlace, including the Islamic/Gothic broken curve frequently used on Italian gesso chests and other furniture). The other pictures, within a curtained alcove, the bed

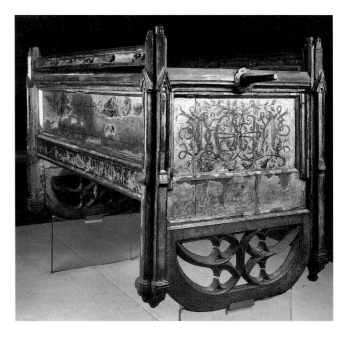

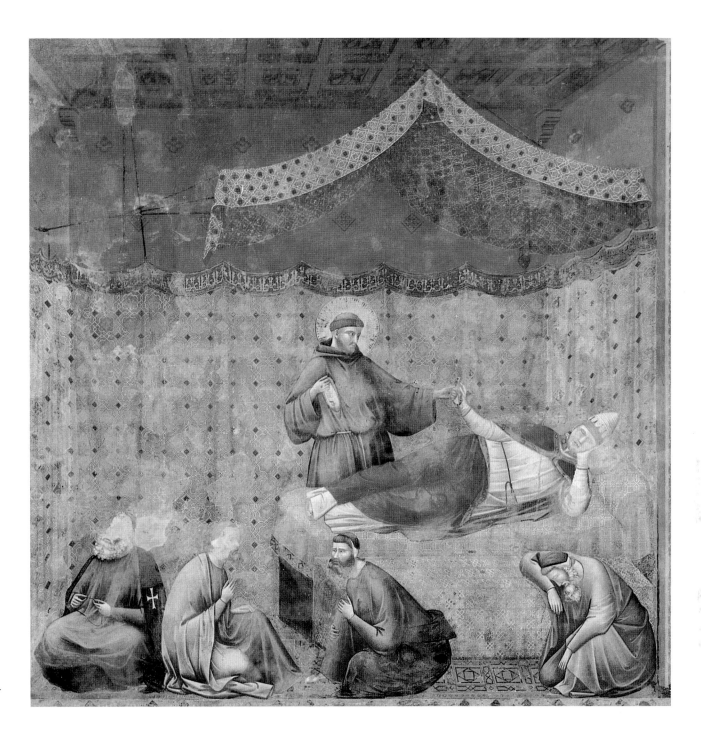

135 A bed with canopy: *The Appearance of St Francis to Pope Gregory IX* by Giotto, in the Upper Church, Assisi; Italian, *c.* 1300.

resting on Gothic legs decorated with cusping. There is early fourteenth-century French evidence for wooden four-posters supporting canopies.[61]

The size of a bed canopy denoted precedence, as did the type of fur used for the counterpane; here the custom for beds approximated to the sumptuary laws that regulated clothes. In 1396 Richard II of England gave the Duke of Burgundy a set of chamber textiles made of cloth of gold, including a celour and tester and an ermine coverlet.[62] Eventually, bed etiquette became ritualized to the extent that a bed was put on show although nobody ever slept in it; the cradle of the heir also had its state equivalent reserved for display – the heraldry displayed on such a cradle [134] indicates that it was made for Philip the Fair or Marguerite of Austria in 1478 or 1479.[63] Bed etiquette did not reach its height until the late seventeenth and early eighteenth centuries, when the witty Madame de Sévigné could refer to the French king's highest judicial activity as the 'Bed of Justice' without a smile.

It is unlikely that the Gothic state bed lagged much, if at all, behind the state tomb in Gothic extravagances; elaborate tomb canopies, supported on four corner pillars, closely resemble beds, cold and eternal beds of the most ornately bedecked kind, and such structures were as easily rendered in wood as in stone (the Gothic Revival used tombs as models for beds [474]). Pinnacles and crockets were particularly good at communicating fantasy; those that originally adorned the buttresses of the Flemish state cradle [134] have been lost, as have the uprights between which the cradle originally swung. Some state cradles might have stood under a form of free-standing canopy, as does the bed in which lies St Elizabeth [136] recovering after having given birth to another saint – the panelled headboard, decorated with (probably) blind arcading, is structurally divorced from the full tester suspended over it. St John lies in a turned cradle of Romanesque descent. A painting of 1416 by Lorenzo and Jacopo Salimbeni at Urbino that recounts the story of the same saint [139] shows a sparely elegant Gothic bed with

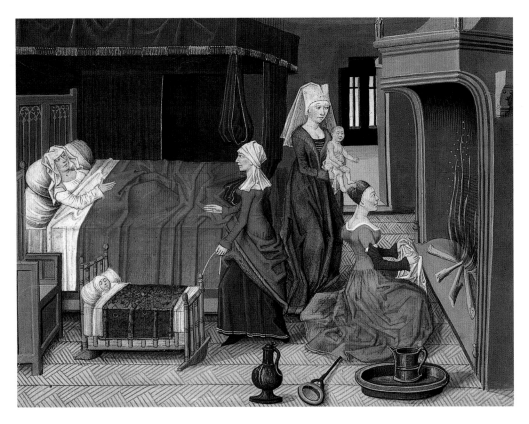

'Madame de Charrolois had only four stages on her buffet, and Madame la Duchesse her daughter had five…no Princesses should have five stages, save only those of the French Royal House.' Things changed daily, said the social mentor, but that 'should not take away from or efface the ancient honours and social distinctions which have been made and ordained by reason and thought'. According to these, the Queen of France was entitled to a buffet of five stages, Isabelle of Portugal four, the Countess of Amiens three, wives of bannerets two, and ladies of lesser rank one.[66] The usurper Henry VII of England, incidentally, who no doubt wished to stress his status, adopted a buffet of seven stages.

These socially significant pieces of furniture developed lordly canopies [467]. The underside of the arch was frequently ribbed and boarded like a ceiling, or it might imitate the Gothic ribbed vault.

Panelling

Furniture might therefore be remodelled after the forms of the new Gothic architecture, thus giving it a completely original appearance [138], or older furniture forms could be dressed up in the new architectural ornament [128]. Both could be adorned by painting and panelling. Panelling (p. 16),

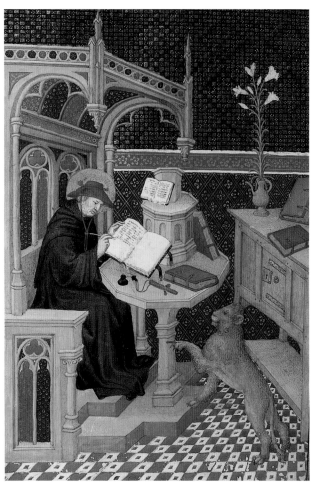

136 A bed, cradle, and chair: 'The Birth of St John the Baptist' by Loyset Liedet, from the *Histoire de Sainte Hélène*; French, *c.* 1475.

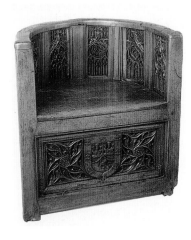

137 A chair panelled and carved in parcel-gilt walnut; Spanish, fourteenth–fifteenth century.

right **138** A Gothic canopied bench, a pedestal table, and a panelled chest on stand: 'St Jerome', from the *Hours of the Maréchal de Boucicaut*; French, 1410–15.

an undraped pedimented canopy that is undisputably attached to the couch; its ornament echoes the brackets of an adjoining whimsical roof; it has restrained inlaid work; its counterpane is decorated with geometric arabesque similar to that seen in spanish Gothic–Mudéjar furniture [116].

Great men and women sat beneath canopies: St Martin's throne [118] must originally have had a canopy. Pictured saints [138] were dignified with them; poets and sages were placed within their own little aedicules, each with their built-in table or lectern, set apart from the world beyond. The Virgin, as depicted in an early sixteenth-century French miniature,[64] receives the Angel beneath an honorific canopy that shelters a draped table and an X-frame chair; the canopy is Gothic in form and decoration although the armoire and panelled chair in the background display Renaissance motifs. Such aedicules and canopies would have had practical advantages, since saints and sages (apart from the Baptist) usually appear to have felt a need for warm clothing, and it is highly unlikely that the aedicules or the intricate little tables were entirely fantasies of the miniaturist or painter. The use of pedestal tables had existed since the Dark Ages, and by the later Middle Ages profane uses had encouraged specialized types: an inventory of the goods of a chatelaine of 1426 mentions a 'large table inlaid with a decussated pattern for gambling or playing chess'.[65]

The buffet had been conspicuous since antique times as the piece on which were assembled the intricately glittering pieces of gold, silver and jewelled plate that more than anything else revealed wealth. The late Gothic buffet's form revealed the owner's status – the number of its stages was more significant than its quality as furniture. A richly carved buffet of three stages indicated a much lowlier rank than a rough swathed buffet of five stages. The later fifteenth-century political competition of the dukes of Burgundy with the King of France was reflected in the Duchess of Burgundy's adoption of a buffet of five stages, equal to the five stages of the Queen of France. The move excited the scandalized horror of a scratchy Portuguese 'lady of quality':

opposite, above **139** A Gothic bed with a pedimented headboard: *The Birth and Circumcision of St John the Baptist,* by Lorenzo and Jacopo Salimbeni, in the Oratorio di S. Giovanni Battista, Urbino; Italian, *c.* 1416.

opposite, below **140** A chest in poplar covered with canvas painted in Gothic style, decorated in tin leaf with figures moulded in gesso, and reinforced with iron bands; Italian (Tuscan), *c.* 1350.

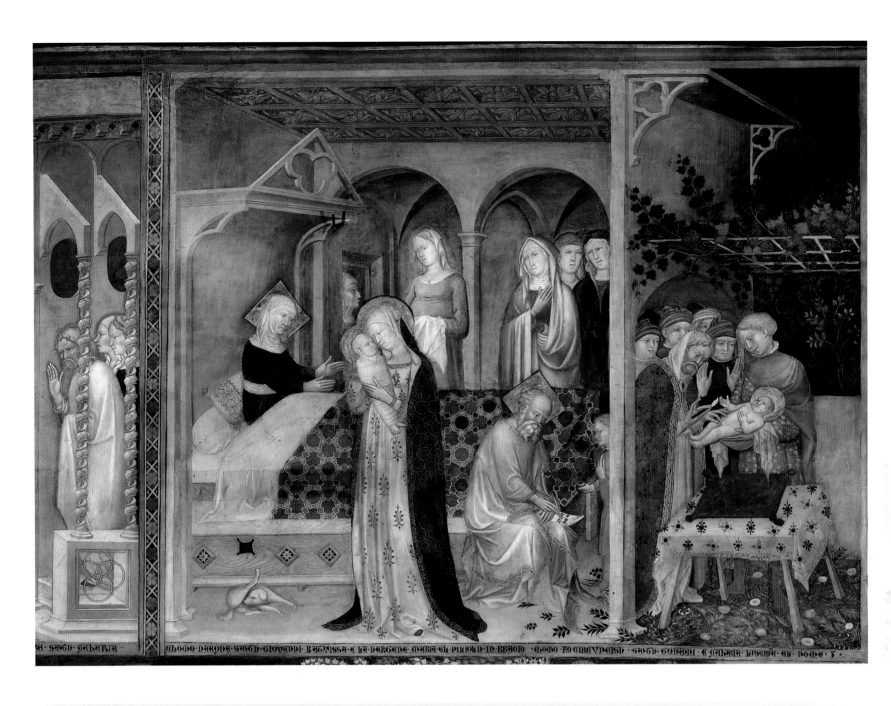

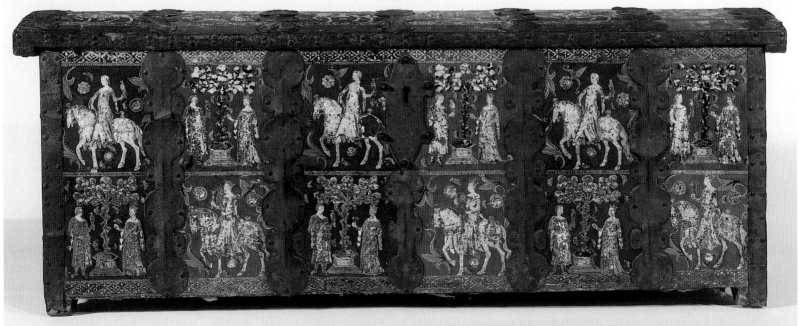

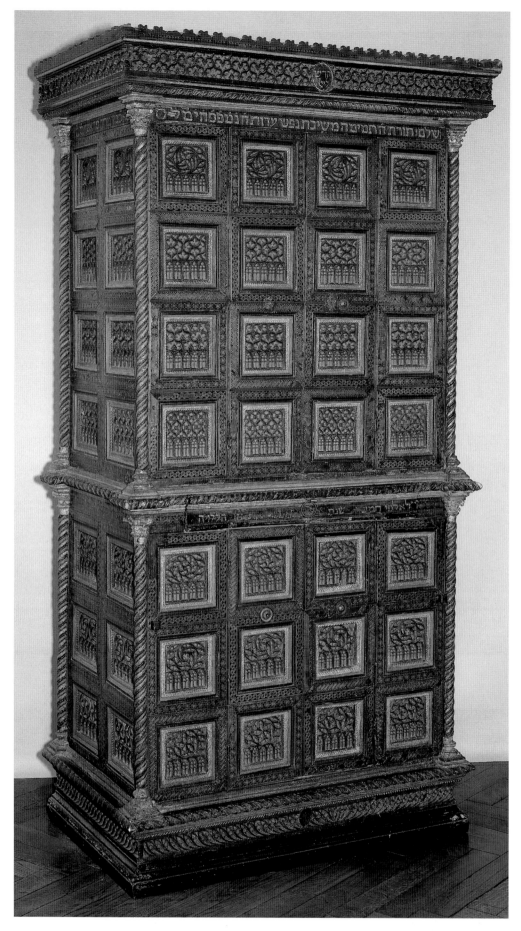

141 An ark made to accommodate the vertical books of the Sefer Torah, in walnut and other woods, painted, carved, inlaid and parcel-gilt, formerly in a synagogue in Modena; Italian, 1472.

or what looks like panelling – its evolution is obscured by the technique, probably influenced by ceiling coffering, of applying framing around boards which then look like panelling, as seen in the Coronation Chair in Westminster Abbey,[67] – is an antique and Byzantine device, both a constructional technique and a decoration. Flanders seems to have led a late mediaeval revival of panelling. The new ornament of linenfold [142], made mechanically with a moulding plane, was introduced in France and the Netherlands as a means of decorating panelling; it became ubiquitous in the fifteenth and early sixteenth centuries [188], assuming diversely elaborate forms. Its origins are unclear: it looks like folded linen – it was called at the time 'drapery' panels[68] – and might be a formalized cheaper imitation in wood of the effect of expensive textile wall and door hangings: for instance, the Virgin's seemly little chamber in a charming German painting of about 1470 [143] has a curtain on the wall (which might conceal a door) that falls into folds not entirely unlike linenfold. Textiles were also hung along the inner back of grander armchairs from Byzantine times onwards: could this practice have had an influence? Other conjectures are that linenfold arose from imitations of scrolls and folded parchment depicted in tapestries [147] and wall paintings (unlikely), or that it derived from an elaboration of tongue-and-groove boarding.

Linenfold was only one way of ornamenting panelling. A cupboard of 1472 [141] that came from a synagogue in Modena (it was made to hold the rolls of the Torah) is articulated with panels filled with ornate Gothic tracery; they are surrounded with intarsia that includes geometrical interlace and antique ribbon; the horizontal mouldings are decorated with gadrooning. Its corners are decorated with Solomonic pillars, which, used extensively by the Cosmati, occurred as an ornament throughout the Gothic period; they were also employed to support pedestal tables and lecterns; they had, of course, a different iconographical meaning for Jews than for Christians (p. 125). The two central tiers of panelling open along their vertical length; the two outer tiers are immobile. The cupboard was traditionally attributed to Cristoforo da Lendinara (p. 92); whoever was responsible for it, he was within the stylistic orbit of Venice.[69]

Innovative design in woodworking, such as the use of panelling as decoration, was sometimes obstructed by the conservative and harshly restrictive prescriptions of trade organizations intent on maintaining standards of excellence. For example, the statutes of the Arte dei Legnaiuoli (woodworkers' guild) of Florence in the fourteenth century dictated the construction and dimensions (height, length and breadth) of all furniture made in the city. A statute of 1342 ruled that chests should be made of one wood only and that such decorations as cornices and veneers should not be used: the surface was to be uniformly flat. Nothing could have been more inimical to change; if observed the stipulations would have given Florentine furniture a character 'di squallore e di monotonia desolante'.[70] Fortunately, for the rich a fee unlaced the straitjacket, and despite such regulations Italian panelled furniture, usually in two types of wood,[71] became common. It was perhaps the painters, whose art was fast changing, who helped to make the Florentine chest the important vehicle of new design that it became: when in 1349 the Florentines organized the painters' union, the Guild of St Luke, the painters of chests joined it – which ensured that their demands had a hearing.

Painting and figurative carving

Painting is an obvious and cheap method of decorating furniture, employed throughout Gothic Europe. The fascinating technical manual of Cennino Cennini (1437), the Italian painter who was taught in Florence by the son of Taddeo Gaddi, has numerous references that show painters' interest in furniture (even at this early date, Cennini insisted upon the painter's status: 'You must know that painting on panels is the proper employment of a gentleman; and that, with velvet on his back, he may do what he pleases'[72]). In explaining 'How to work on coffers or chests, and the manner of ornamenting and painting them'[73] he says that to do things properly the complete procedure for painting on panel should be followed, from the gesso onwards. He has a chapter on 'How to imitate velvet or linen on walls, and also silks on walls or panels',[74] trompe-l'oeil textiles as an alternative to histories or emblematic pictures.

Furniture decorated with paintings, including histories, was common in the Italian Trecento.[75] In many instances – the majority as far as the rich were concerned – the artists who painted furniture also painted, or designed and painted, the interiors in which the furniture stood: the panels that decorated cassoni were smaller versions of the larger panels in the same style that decorated walls. A chest of about 1350 [140], originally one of a pair, stood against a wall;[76] it is reinforced with iron bands. The paintings are on canvas; the blue is azurite, cheaper than lapis lazuli, and glazed tin leaf is employed, a cheap substitute for silver or gold. The figures are moulded lightly in *gesso duro*, a refined form of gesso.[77] This might be used to cover the whole surface; from about

1400 onwards Italian woods were commonly decorated or concealed beneath a layer of painted or gilded gesso, an antique technique revived. It was either freely modelled, for rough work or non-repetitive decoration [160], or cast in a mould and glued to prepared faces; it was often scented (an antique device) when employed for small toilet articles.

Italy was not alone in liking painted furniture: it was common in Northern Europe, where it was often of mediocre quality, probably painted by journeymen; typical is the German sacristy wardrobe [101]. The painted ornament on the Flemish state cradle [134], worn and mutilated as it is, is the work of a master, not that of an ordinary painter: it would have been decorated after its making by another craftsman. Painting was also used to brighten up or emphasize the ornamental details of furniture otherwise unpainted. The idea has grown up that Gothic woodwork was almost always colourfully painted, and that surviving plain Gothic furniture has usually been stripped. As far as the fifteenth century is concerned, paintings contradict any sweeping theories. One cannot believe that Van Eyck, who on the Ghent Altarpiece painted St Cecilia dreamily leaning over her unpainted organ and lovingly depicted every detail of its grain, did not record a conscious contemporary aesthetic delight in the beauties of undecorated wood. Was, perhaps, this liking for unpainted surfaces part of a feeling for 'honesty' in materials – and technique? A curious anticipation of the Arts and Crafts mentality of the nineteenth century? In a painting of about 1470, the Virgin's book rests on an obviously unpainted Gothic table [143] which has a panelled top with the grain decoratively aligned; the small cupboard

142 Linenfold panelling on a bench and lectern of oak of ecclesiastical type; Dutch, fifteenth century.

143 A table, a cupboard on stand, and a cushioned bench: *The Annunciation* by the Master of the Upper Rhine; German, *c.* 1460–70.

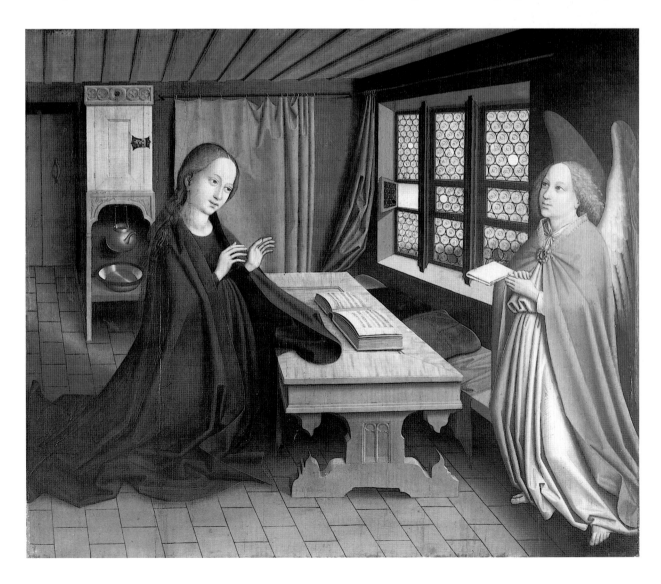

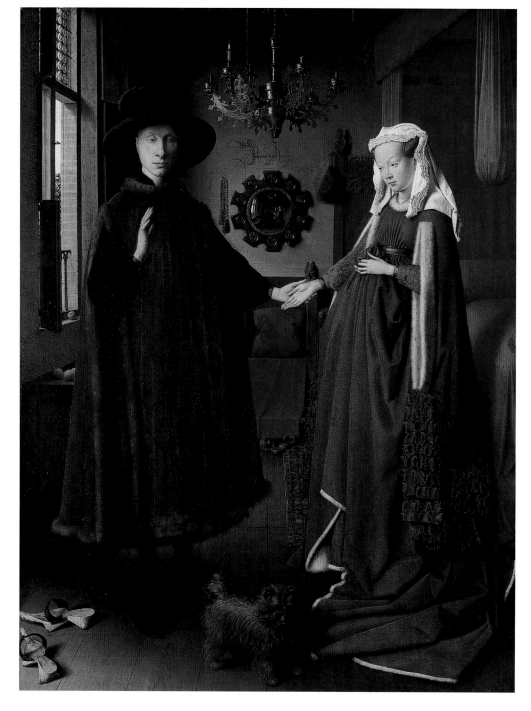

in the background is similarly treated. Her princely chamber in the Werl Altarpiece [146] contains furniture with apparently untreated surfaces: were they maintained by the same kind of constant scouring as that used in the eighteenth century to clean wooden floors? Incidentally, the seat of the bench (next to an X-frame stool) lets down.

Another way of decorating furniture was by naturalistic carving of figure scenes, many of which were probably originally painted. The body of a north German chest of the first half of the fourteenth century [145] is covered with a very Gothic scene of St George and the Dragon; there is no 'architectural' decoration or ornament of any kind, the effect depends entirely on carved pictures. The quality is the equivalent of the journeyman work seen in German painted furniture: the bas-relief is compositionally a mediaeval version of antique predecessors such as the scenes on Trajan's Column, but the crudely effective expressionism exhales the air of the north German forests. This chest is far distant from prosperous Trecento Italy or courtly fifteenth-century France and Flanders.

Other Gothic ornament: monsters, nature

There are two popular images of Gothic. One is the soaring, venerable, mysterious and devotional world of Gothic ecclesiastical architecture, the holy shrine of a fervent faith. Its architectural vocabulary was quickly taken over for the purposes of furniture design, as we have seen. The other is the world of the Gothic fairytale, peopled with princes and princesses, monsters and witches, set in moated Gothic granges, paradisial gardens, sunlit glades and dark trees. This hardly entered furniture design in the Gothic period, although it surfaced in nineteenth-century Gothic Revival painted furniture. Perhaps the nearest mediaeval approach to it was the International Gothic of the Italian painted cassone.

Gothic monsters ranged from terrifying gargoyles to the whimsical creatures that people the borders of illuminated manuscripts, such as a rabbit-headed bird that draws a bow, a bird with the head of a horned man, and so forth. The latter strain persisted and was eventually assimilated into grotesque painted ornament, whence it entered sixteenth-century furniture design. A favourite device, not strictly speaking monstrous at all, was animals parodying human activities: a fox, dressed as a Capuchin and leaning on a crutch, visits a rabbit; a monkeys' castle is besieged by foxes with catapults and other engines of war. Monkeys were prolific in decoration long before chinoiserie (p. 289); by 1400 they had become a commonplace: even a reliquary of the hair of St Catherine was supported on four monkeys.[78] Such ideas were probably suggested and maintained by the enduring interest in the fables of Aesop and Phaedrus.

Naturalistic plants and flowers had been used in the painted wall decorations of ancient Rome, where charming gardens mingle identifiable plants, trees, and flowers with birds, small beasts, trellis and fountains, exceptions to the general geometricizing inclinations of ancient art (some decorated the garden itself, extending its boundaries). Barbarian art and ornament, however, was if anything more relentlessly abstract than most other types; it had no room for realistic portrayals. A new naturalistic ornament entered the mainstream of Gothic art in the thirteenth century. The resemblance between the forest and the branching vaults and rows of columns capped with life-like foliage of the high Gothic cathedral – the capitals of Rheims were carved with more than thirty kinds of familiar plants and tree leaves[79] – has been explained by theories of atavistic barbarian longings

144 A canopied bed, a convex mirror decorated with miniatures, a brass chandelier and other furniture: *The Arnolfini Marriage* by Jan van Eyck; Flemish, 1434.

145 A chest carved in oak with St George and the Dragon; German (Lower Saxony), *c.* 1300–1350.

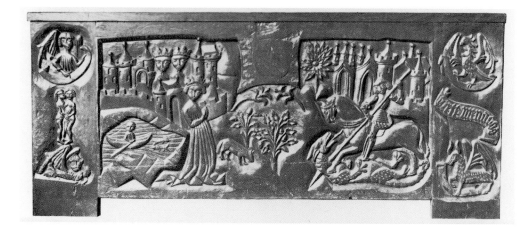

right **146** A bench and a cupboard on stand: *St Barbara*, a wing of the Werl Altarpiece, by the Master of Flémalle; Flemish, *c.* 1430.

for native glades. Other theories postulate the effect of the sense of springlike release from Dark Ages barbarism [140]. Ultimately, the efflorescence of Gothic naturalism remains unexplained. Characteristically, the classical heritage of Italy hindered enthusiastic adoption of naturalism – Fra Angelico (d. 1455) was instructed by the Vatican to substitute gold for a naturalistic landscape background in a religious painting.[80]

The 'anti-classical' botanical naturalism of mediaeval Gothic became engrained in European art and produced lasting results. In the Flamboyant Gothic period the interest in plant forms brought into decoration forms of interlace that made complex patterns of intertwined branches, sometimes given symbolic thorns. Flowers, leaves, birds and beasts crowded into the elaborate borders and initials of illuminated manuscripts, sometimes painted upon a gold ground. Naturalism spread also into interior decoration. Trees appeared on walls: in about 1360 the gallery of the Queen of France's apartments in the Hôtel St Pol in Paris was painted with a great wood of trees and shrubs which soared up into the vaulting, which imitated a sky;[81] the walls of the contemporary wardrobe room of the Papal Palace at Avignon are covered with woodland. French tapestries [147] anticipated the flower-strewn sward of Botticelli's *Primavera*. By the fifteenth century, the use of naturalistic foliage in furniture was common [130]. Unclassical foliage such as holly, thistle, seaweed, and parsley joined the classical acanthus, to which was extended a flowing naturalism; eventually, Northern painters such as Martin Schongauer (*c.* 1450–91) engraved scrolls of hops and cabbage rather than the classical vine, laurel, fig and acanthus: in the early sixteenth century these entered grotesque.

147 Flowers and intertwined 'imprisoning' curling scrolls, in a tapestry of the heraldic beasts of Charles VII of France; French, *c.* 1450.

Heraldic beasts stepped down in Alice in Wonderland fashion from their perches and entered naturalistic gardens [147]. Heraldry, an important feature of Gothic military and social life, was taken into the decorative arts and became fantastic. Classical fantasy, fantastic though it can be, is never quite as extravagantly fantastic as anti-classical Gothic fantasy.

The Gothic style had its spiritual home in the North, and it was in the North that fifteenth-century Gothic sophistication reached its height. It was centred in Burgundy and the Low Countries, with France playing an important but interrupted role – English aggression involved France and England herself in destructive mutual and civil wars. The French court was more than rivalled by the Burgundian, which led Western Europe in luxurious novelties. Burgundy was imitated by the burgesses of Flanders; Flemish culture was exported; its painters even began to teach Italians their business. The differences apparent in the various styles of painting current in different countries – the courtly style of

148 A canopied bed, a carved cupboard on stand with a framed devotional painting above, a prie-dieu, a metal X-frame chair of Italian type, a chandelier and a wall candle in a sconce: *The Annunciation* by Joos van Cleve; Netherlandish, *c.* 1525.

French miniature painting, the haut-bourgeois style of Flanders, the Gothic expressionism of Germany – are clearly reflected in their furniture. The Hanseatic towns and German principalities developed their own rich late Gothic culture, which continued well into the sixteenth century [129]. These opulent Northern societies confirm that civilized life had been successfully reassembled from the disintegrated fragments of the old Roman Empire. The convex mirror (made from blown glass) that, surrounded by scenes from the Passion, reflected and sanctified the conjugal life of Arnolfini and his wife [144], reflected also a world that for the first time in a thousand years enjoyed something of the amenities and security of the Empire of the Antonines.

The late Gothic world was startlingly different from the world of antiquity in almost every way – in religion, in social organization, in divergence of nationalities, in literary conventions. Most obviously, it looked different: vertical rather than horizontal, angular rather than rounded, particular rather than generalizing, expressionist and aspirant rather than impassive and complaisant. Furniture, together

with other artefacts, exhibited these general characteristics. The next hundred years were to see an extraordinary change, accomplished by a movement which first halted the development of Gothic style and then abandoned it. The revolution, for it was nothing else, began in fifteenth-century Italy, where rich and cultivated merchants began to abandon their acquired Gothicisms for Renaissance classicism. It quickly spread northwards, and its effect on furniture is perceptible in an interior scene of about 1525 by a Flemish painter who had been exposed to Italian influences [148]. The cupboard, still Gothic, is decorated with red and green inset panels and is covered with an immaculate cloth; above it is a holy picture in a Gothicizing frame; next to it is an X-frame gilded iron chair with winged claw feet, Italianate and 'antique' in style, with a fabric back and cushion; the tester bed is adorned with richly decorated lambrequins. The Madonna might well look somewhat complacent; all is seemliness and order: this luxurious bedchamber had come far from the primitive shifts of three hundred years earlier.

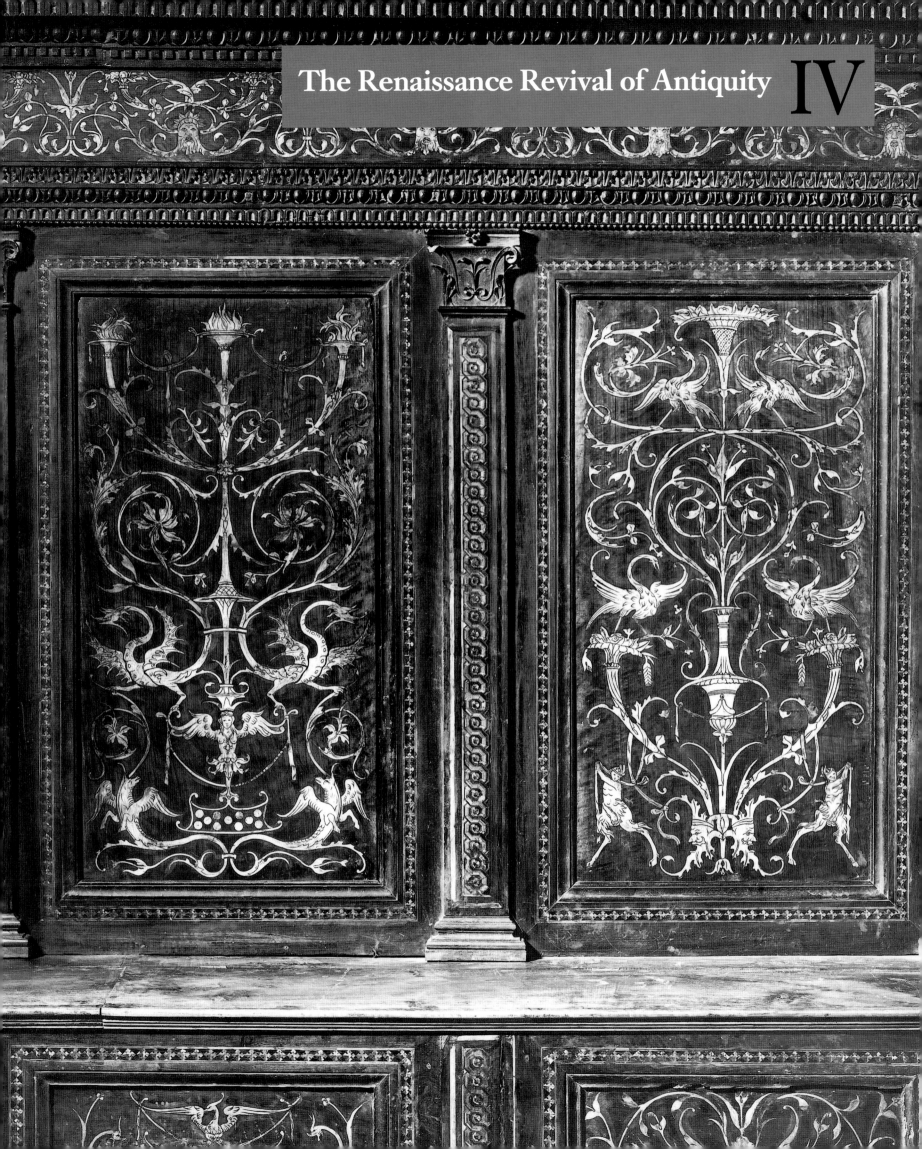

overleaf **149** Intarsia in grotesque
style designed by Perugino and
executed by Domenico del Tasso,
set within Corinthian pilasters
decorated with curvilinear ribbon
interlace, in the Cambio at Perugia;
Italian, *c.* 1499.

The general course taken by Renaissance furniture: 'classicism' and 'anti-classicism'

Themes and motifs developed during the Renaissance served succeeding periods up to and including the present century. The scale and richness of Renaissance art makes it difficult to see the underlying patterns; of all the periods with which this book deals, the Renaissance is the most complex. Furniture, because it is towards the end rather than the beginning of the creative chain, presents more problems than most types of artefact.

A clue to the complexities comes from the detection of two dominant strains in Renaissance architecture. The first is 'romance, the sense of myth', the fantasy found in quintessential form in the ecstatic antique dream of the *Hypnerotomachia Poliphili* (pp. 90–91). The second is the intellectual rigour represented at its purest by Alberti (1404–72), who '"worked" the rules as an intellectual mechanism'.[1] This opposition between intellect and fantasy largely parallels the distinction made in these pages between the 'classical' and 'anti-classical' traditions, between the discipline of antique artefacts made of stone and the orientalizing fantasy of grotesque. The distinctions cannot be pushed too hard, for two reasons: first, the categories overlap, in that some antique stone artefacts used as models in the Renaissance and afterwards have a high degree of fantasy; and secondly, the birth of Renaissance fantasy (fantasy in classical rather than Gothic dress) did not have to await the unearthing of ancient grotesque in the 1490s or thereabouts[2] – a quick glance at a wonderful painting by Cosimo Tura, of about 1450 [150], shows an elaborate 'grotesque' throne of which all the components could have been derived from antique stone artefacts.[3] But the distinctions, used as a guide-rope rather than a straitjacket, contain enough truth to be helpful.

The reader might be helped by a brief preliminary summary of the exposition of Renaissance furniture design that follows.

During the fifteenth century, the general passion for antique architecture, sculpture and other artefacts changed the appearance of fashionable Italian furniture; it became monumental and grand in an antique manner based largely on ancient Roman architecture, sculpture and sarcophagi. Furniture in this manner [159] was continued and developed during the sixteenth century, especially in Italy and France. A second type of Renaissance furniture developed from the 1490s, when the newly discovered grotesque, fantastic and linear rather than monumental and grand, was enthusiastically taken up by artists of all kinds [168]; its capacity for receiving alien ornament allowed ingress into decoration and furniture of highly anti-classical motifs and moods (including 'arabesque' and Northern expressionism): as a result, some antique detail applied to furniture was smothered in profligate grotesque fantasy. National variants of this mixed style were developed. France tended to follow Italy; Flanders and Germany developed individual grotesque styles.

These two broad types, 'classical' and 'anti-classical', both played changes upon antique themes and were not based upon ancient furniture. However, two other developments of great importance occurred in the sixteenth century. First, the lofty and pure classicism of the High Renaissance (based largely upon Roman revivals of Greek art and associated with the 'divine' name of Raphael) encouraged the copying or adaptation of real antique furniture, the first 'archaeological' furniture since ancient times [179]. This was primarily an Italian taste. At the same time, Michelangeloesque sculpture, developed from Hellenistic baroque sculpture, entered furniture, frequently taking it over completely [186]. The sixteenth century saw furniture adopt the Hellenistic baroque forms and grotesque *licenza* that were changing architecture and painting. This resulted towards the end of the century in the creation of proto-baroque cabinets, that, beginning as table cabinets and ending as grandiloquent structures executed in dazzlingly splendid materials, united sculpture, architecture and ornament. These, an essentially Renaissance creation, continued into the seventeenth century and beyond [248].

The Renaissance was like a great cornucopia that spilled out from its flaring mouth an extraordinary abundance of riches. In this plenty, furniture had its share, and the main types of Renaissance furniture as categorized here do not do anything like justice to its splendid variety.

The fifteenth-century Renaissance

The fifteenth-century Italian Renaissance differed from earlier renaissances: it was the first in which men of genius conceived the conscious ambition to revive antique style as a whole, a resurrected visual and literary entity that would replace existing styles with something more accomplished and more beautiful. The two hundred and fifty year period from 1400 to 1650 treated here as that of the 'Renaissance' is chosen to fit stylistic developments in furniture (which lagged behind those of painting and architecture), and is confessedly arbitrary.

Historians tend to see past events in terms of 'movements'. Movements certainly exist (some more than others) and furniture was fundamentally affected by great religious and political movements. But the fifteenth-century Italian furniture-maker in his workshop looked at fashionable artefacts for guidance – an antique sarcophagus or altar [65], a new church by Alberti, a fresco by Filippino Lippi. The discovery of antique grotesque, a fortuitous event, affected the arts of design and the furniture-maker over a much longer period than did that great religious and political movement, the Reformation.

The most obvious visual fact about the Renaissance is that it revived classicism. But what sort of classicism? In 1400 there still existed in Italy a strong tradition that, albeit modified by Byzantines, barbarians, and evolutionary change, was recognizedly descended from classical antiquity (pp. 63–64). Fifteenth-century Italian artists and writers constantly referred to 'antiquity', but what did they think antique style was? There was much confusion. The habit of re-using ancient bits and pieces in new buildings, the continued use of classical motifs in Italian Romanesque architecture, the survival of many late antique Roman buildings that have now disappeared, including the mother-church of Christendom in Rome, all perplexed people for

150 A throne with shell canopy and fantastic ornament derived from antique sources: *Allegorical Figure* by Cosimo Tura; Italian (Ferrara), *c.* 1450.

whom analytical historical thinking was impeded by lack of historical knowledge. Even the great innovators had hazy ideas about the antique, taking Romanesque Florentine buildings as Roman. Brunelleschi (1377–1446), a 'most subtle follower of Daedalus',[4] designed the famous Foundling Hospital [151] in a new 'antique' style influenced by Florentine Romanesque and the Constantinian St Peter's; the late antique and early Romanesque buildings of Rome were included as antique in the great late seventeenth-century compilation made by Ciampini.[5] The unknown minor painter who in the 1490s took his bread, cheese and salami into Rome's subterranean chambers in search of grotesque and wrote an amusing doggerel verse about it thought that Cimabue and Giotto were antique painters (as, for that matter, in a way they were) – but imagined he might see their work on the walls around him in company with that of Apelles![6] Such confusions did not prevent some Renaissance work from getting amazingly close to the antique (much closer than did most eighteenth-century neo-classicists), especially in details like the carving of acanthus scrolls. On the other hand, it is not surprising that fifteenth-century furniture never approached the genuine antique as closely as did certain bronzes and sculpture.

The fifteenth-century revival of antiquity in Italy was primarily the work of one town – Florence; others such as Padua contributed much, but the old equation of Athens and Florence still holds good. By the turn of the fifteenth and sixteenth centuries the creative primacy was passing to Rome (at first largely through migrant Florentine artists), and thence ideas spread to other parts of Italy and Europe – especially to France and Flanders. The mixed company of Italian, French and Flemish artists at Fontainebleau employed new ornaments that affected furniture throughout Europe. Throughout the sixteenth century the finest and most influential Renaissance furniture was still being made in Italy or by Italian-influenced craftsmen in France, Flanders and Germany.

By what kind of revived classicism was the Renaissance furniture-maker and designer influenced? Renaissance style was created by artists, usually painters who were often also architects, sculptors and goldsmiths. The earlier antique sources that shaped the visual arts of the fifteenth century came primarily from Roman antique artefacts made of stone, almost always marble; they had an overwhelmingly 'classical' character. These stone prototypes gave the forms and ornament of much early Renaissance furniture a majestic antique solidity.

However, another aspect of the antique, fantastic and anarchic, was greatly strengthened after the discovery of grotesque decoration [33]: it immediately attracted imitators. Moreover, its disinterment coincided with a new surge of interest in Islamic 'arabesque' or 'moresque' (pp. 102–4). Grotesque and arabesque, both anti-classical orientalisms with entangled histories, were absorbed into High Renaissance classicism, leading to an extraordinarily forceful and eccentric new art which fused all these influences and added a strong dash of Northern expressionism (which was ultimately of barbarian origin). The new art – 'mannerism', as it has been called – displays strong anti-classical characteristics which have prompted much twentieth-century speculation on underlying causes. All arts must reflect their periods, but sixteenth-century religious ferment, the sack of Rome in 1527, or other great political or religious 'movements' are hardly needed to explain the expressionistic distortions, shot colour and spontaneous paint of *maniera*, all

of which are to be found in antique grotesque. They were compellingly attractive to artists, and as available for the erotic fantasies of Giulio Romano or Spranger as for the religious ecstasies of El Greco. The free rein given by grotesque to fantastic classical exaggeration helped to create a new genre of furniture.

The revival of antiquity: scholars, architects and painters

Vasari thought Giotto the pioneer of the Renaissance, and nobody who looks first at Giotto and then Masaccio can doubt the painters' giant contribution. But it was scholars who gave the Renaissance coherence, and ancient Roman literature that released the Renaissance flood. The Italian language of central Italy was still close to Latin, and Latin literature was studied by Italian universities for pleasure rather than pain. The enthusiasm and genius of Petrarch (1304–74), the first 'humanist', made ancient Latin highly fashionable, and refugee scholars from Constantinople brought excitingly unknown literary material with them. Modern Latin in Italy changed: from being Christian, Gothic and barbarian it became pagan, antique and classical; even the Church eventually rewrote its liturgy in more correct Latin. Paganism came into fashion: Ciriaco of Ancona (p. 291), threatened with shipwreck, prayed to the gods, not to God.

The antique sources used by artists in the earlier fifteenth century[7] were principally Roman buildings, sarcophagi, altars, ossuaries, friezes, statues, coins and gems; with Rome came also the Greek art that had influenced Rome (much Roman sculpture, for example, copied Greek originals). Vasari tells how in 1403 the Florentine Brunelleschi began feverishly but systematically to draw and measure the ruins of Roman architecture – temples, baths and amphitheatres. True or not, the story reflects truth. Between 1420 and 1450 Florentine artists rediscovered the proportions and characteristics of the classical orders, of column and entablature. Architects created from antique Roman architecture and decorative detail an original architectural style which, continually evolving for hundreds of years afterwards, became the single most significant contributor to the design of high-style Western furniture. There is space here only to mention a few of the principal elements.

Some are so obvious that, as innovations, they are easily overlooked – such as the re-use of the antique orders, which were not only resurrected, they were (for more frivolous purposes, such as furniture) transformed [165]. Others involved imaginative syntheses of antique and later sources, such as Brunelleschi's 1419 classicization of the Romanesque arcaded portico, turning its polygonal shafts into unfluted columns with Corinthian capitals[8] [151]. In the Pazzi Chapel of the 1440s [152], he re-created the Hadrianic motif of a tall central arch flanked by lower trabeated bays [16], again with unfluted pillars and Corinthian columns, and, incidentally, employed on its exterior façade the sepulchral strigillation (p. 44) that was to become one of furniture's most common ornaments. For the façade of the Palazzo Medici of the same decade, Michelozzo employed massive rusticated blocks, not novel in Florence but here re-worked to imitate worn and battered ancient stones. In the façade of the Palazzo Rucellai (1455–70) [153] Alberti displayed three superimposed rows of classical pilasters displaying the three orders; in one revolutionary façade, that of S. Andrea at Mantua (begun 1472) [155], he combined the pedimented temple front and the triadic triumphal arch; and in S. Maria Novella

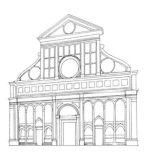

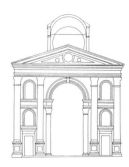

151 The Foundling Hospital, Florence, by Brunelleschi, *c.* 1419.

152 The Pazzi Chapel, Florence, by Brunelleschi, *c.* 1440.

153 The Palazzo Rucellai, Florence, by Alberti, *c.* 1455–70.

154 S Maria Novella, Florence, by Alberti, *c.* 1456–70.

155 S. Andrea, Mantua, by Alberti, begun 1472.

(*c.* 1456–70) [154], again in Florence, he masked the nave aisles by adding to each side of the upper part of the façade a new invention, a gigantic supporting scroll.

Fifteenth-century classical revivalists and humanists did not, with a few important exceptions (the architect and sculptor Filarete, for example) denigrate Gothic: the much-travelled, learned and gentlemanly antiquarian Pius II (pope 1458–64), who rebuilt his native town, Pienza, in early Renaissance style, wrote that York Minster was 'a cathedral notable in the whole world for its size and architecture and for a very brilliant chapel whose glass walls are held together by very slender columns';[9] Strasbourg Cathedral was a 'marvellous work that hid its head in the clouds'.[10] By the early sixteenth century attitudes had changed. Raphael considered antique Roman architecture as the finest of all, Gothic was clumsy (he knew at first hand only Italian Gothic); modern buildings, although more distant in time from ancient Roman buildings than were Gothic buildings, he thought nearer to the antique in quality.[11]

Antique architectural and sculptural motifs moved indoors, a step nearer towards furniture. Antique detail entered the paintings and intarsia that decorated walls; door-frames and chimneypieces, in wood or stone, were often in antique style. Furniture sometimes took over the new motifs in almost undiluted form; scattered around the rooms of the Ducal Palace at Urbino are marble stools which consist of a simple baluster leg supporting a seat decorated with the egg-and-dart motif; antique ornament was frequently used as decorative trim.

Painters were probably more important than architects in the development of Renaissance style. Alberti asked, 'Is it not true that painting is the mistress of all the arts, or their principal ornament? If I am not mistaken, the architect took from the painter architraves, capitals, bases, columns and pediments and all the other fine features of buildings. The stonemason, the sculptor and all the other workshops and crafts of artificers [in which furniture-makers were presumably included] are guided by the art of the painter.'[12] This may seem exaggerated, but it came from an architect and reflected Renaissance reality. A little later, Federico Zuccaro, completely rejecting the sciences, described painting as the mother and daughter of architecture.[13] Painters did not have to be especially good to exert an influence. The pedestrian Paduan painter Squarcione (the master of Mantegna) opened the earliest known private art school; an early biographer stresses his systematic collecting of drawings and plaster casts of and after the antique for the instruction of his pupils,[14] for which he travelled throughout Italy and to Greece. An inventory of his Paduan house taken in 1455 says it had a large *studium* 'with reliefs, drawings and other things' and a second small one in 'the house called the

house of reliefs'.[15] The use of friezes as the main teaching instrument of a painter's art school points the paradox that early Renaissance painting, inspired by the antique, evolved without guidance from antique paintings: sculpture filled the vacuum. Furniture was in something of the same situation: no ancient wooden furniture existed, although it was portrayed in antique sculpture; antique furniture did not enjoy the extensive ancient descriptions which in the case of painting had so influenced modern painters, although what few ancient references existed were eagerly picked up.

Painters must have encouraged furniture-makers by employing architectural motifs in their fictive furniture. For instance, a prie-dieu – a domestic item – pictured in the 1490s by Giovanni Bellini [156] has graceful acanthus scrolls in intarsia that closely resemble those that adorn the marble façade of S. Maria dei Miracoli in Venice [157] – the church that originally housed the painting and itself the greatest achievement of the Lombardi, who re-created the acanthus scroll in a particularly pure and beautiful form.

The antique statue, especially the nude male, taught artists the lessons of naturalistic anatomy, of how to reproduce a credible body that hung on its skeleton and was articulated by muscles and sinews. The Florentine sculptor Donatello (1386–1466) acted as a catalyst; Vasari thought that his works 'were more like the excellent works of the ancient Greeks and Romans than was ever the case with the work of anyone else'.[16] His 'antique' putti [40] began the line of those chubby amorini that were to cavort for hundreds of years on all varieties of works of art, including furniture.

Antique ornament was eagerly revived. By the mid 1430s Donatello was using the acanthus, shells, amphoras, dolphins, festoons and garlands he had studied on Roman sarcophagi and other artefacts; the heavy swags of antique stone garlands reappeared in their proper vegetal colours in paintings, especially volumetric in the work of the schools of Padua and Ferrara. Candelabro and candeliera ornaments (pp. 40–41) taken from antique artefacts were used by Masaccio, Uccello, Fra Angelico, Piero della Francesca, and many others; the vase, which played a prominent part in constructing such ornaments [164], was particularly favoured – 'the signature of the Quattrocento', as a nineteenth-century historian called it.[17] Classicizing vases, urns and ewers are pictured carried in procession as part of the gorgeous cavalcade of Mantegna's *Triumph of Caesar* (*c.* 1486–94), one of the masterpieces that imprinted images of antique glory on the condottiero mind: often accompanied by the trophy, appreciated for its symbolic assertion of victory, such assemblages became a common motif of decorative historical painting. Monsters migrated from friezes and sarcophagi to paintings [150]. Other classical detail taken from architecture and used in Renaissance intarsia and marquetry includes

156 A prie-dieu with acanthus scrolls in intarsia work, perhaps meant to indicate ivory and cedar: detail from *The Annunciation* by Giovanni Bellini, painted for S. Maria dei Miracoli in Venice; Italian (Venetian), *c.* 1490-1500.

157 Scrolls in carved marble from the exterior of S. Maria dei Miracoli, Venice, designed by the Lombardi.

Vitruvian scrolls, consoles, and rosettes. All these motifs became staple furniture ornaments.

Some detail, notably geometrical interlace, might be ambiguously classical or Islamic. Antique geometrical and curvilinear interlace had survived, in some ways remarkably unchanged, throughout the Dark and Middle Ages. The artists of the Renaissance knew interlace had been much used in antiquity, and had no inhibitions about employing it themselves. Alberti used a simple form of geometric interlace on the façade of S. Maria Novella, taking it from S. Miniato. A similar motif, copied from the vault of the late antique church of S. Costanza in Rome [59], is found in two of the early Renaissance artists' sketchbooks that were so important in disseminating design[18] – it was to be often used for the stretchers of cabinets and tables in the seventeenth and eighteenth centuries (p. 156). From the middle of the fifteenth century all forms of interlace were employed in the decorative arts of northern Italy, especially at Venice, Milan, and Padua. Mantegna used guilloche interlace in the

158 A chair made up of cornucopias, with lion paw feet: detail from a cassone painting, *The Continence of Scipio*; Italian, *c.* 1490-1500.

revolutionary ceiling of the Camera degli Sposi at Mantua. As soon as grotesque was revived, the various forms of interlace were incorporated into it. For instance, a pioneer of grotesque, Pinturicchio, used interlaced knotwork in the ceiling of the Piccolomini Library at Siena; he combined simple interlaced circles of the S. Costanza type and guilloche with complex grotesque in the Borgia apartments in the Vatican. Many elaborately decorated antique grotesque ceilings had been held together in their original form by a framework of interlace, and in their revived form such models remained influential for hundreds of years [39:F, 288, 289].

Perspectives, ruins, fantasy Roman buildings

Ancient Roman architecture gave birth in the fifteenth century to two contending offspring. One, the new classical architecture, was rational and lucid; the other, the cult of the ruin, an emotional and aesthetic reaction to the shattered remnants of greatness, was irrational, sometimes sinister [217]. Halfway between was the pictorially re-created ancient Roman building.

The ruinous state of many of the antique buildings of Rome associated antique ruins with ideas of decayed greatness and nostalgia, a beauty different in kind from that of the building in its perfect state. Romanticism was not invented in the nineteenth century, merely carried to unbeautiful excess. Ruin romanticism was not even new in the fifteenth: the Hebrew prophets had indulged in 'ruin-excitement'[19] and romantic ruins in landscapes are depicted in Roman grotesque paintings. Gothic ruin romanticism came into being in the sixteenth century. The Renaissance interest in Roman ruins was so intense as to lead to their literary, pictorial, decorative and, eventually, architectural use on a hitherto unprecedented scale. For the first time in history, ancient buildings, including ruins, were restored for purely aesthetic reasons – Sixtus IV, for instance, repaired the Temple of Vesta.[20] Picturesque, evocative, and emblematic, ruins became common in paintings, an early example being an altarpiece in Padua of *St Jerome* by Squarcione. The Nativity was often placed amongst antique ruins; saints performed their miracles amongst ruins. Pieter Coecke van Aelst's woodcuts of 1553 of contemporary Constantinople, perhaps intended as a decorative frieze or a tapestry design, show classical ruins as a background to exotic turban-clad figures.

The fifteenth-century amateurs of ruins found a more than decorative meaning in them; Renaissance interest had a philosophical as well as romantic content. Both are revealed in the *Hypnerotomachia Poliphili*, probably in being by 1467 and published in Venice in 1499 with woodcuts;[21] text and pictures were immensely influential, often reprinted, translated and re-illustrated. The theme of the book was pagan: 'Ancient Wisdom' drawn from 'ancient philosophy and the founts of the Muses'[22] – the 'founts' comprehend the arts and architecture. The hero, Polifilo, a Renaissance man moved to wonder by the flotsam and jetsam of antiquity, describes pyramids, classical temples, and hieroglyphs.[23] The pleasure of ruins is elevated to rival the pleasures of love: 'Herewithall I beeing ravished and taken up with unspeakable delight and pleasure in the regarding of this rare and auncient venerable monument of such a grace and admiration, that I knew not to which part to turne me first…as I removed my selfe from place to place, with an unknowne delight, and gaping unreportable pleasure to beholde the same, gaping at them with open mouth,

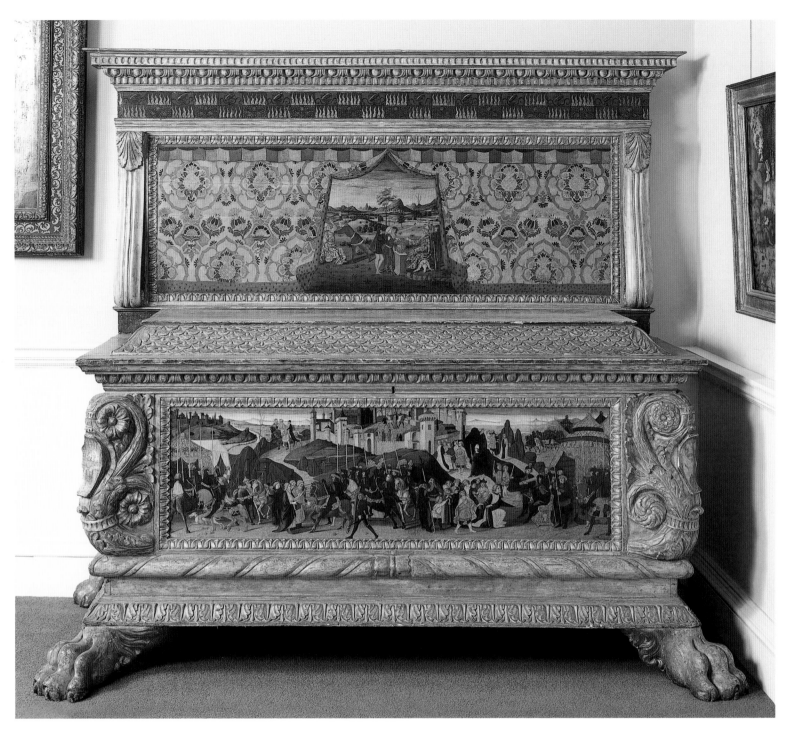

159 The 'Nerli Cassone', in carved, gilded and painted wood, with inset paintings; Italian (Florentine), 1472.

forgetting myselfe like a young childe, never satisfying my greedie eyes and insaciable desire to looke and overlooke the exquisite perfection of the auncient worke, I was spoiled and robbed of all thoughts whatsoever, the remembrance of my desired *Polia*, often recurring, onely excepted.'[24] The lady enters the rhapsody by the skin of her teeth.

Fantasy extended itself to unruined buildings. As early as 1462 Piero de' Medici had a pictorial record made of antique buildings in Rome and elsewhere,[25] and other artists produced drawings supposed to portray Rome in antiquity.[26] The buildings pictured, sometimes including legendary edifices such as the palace of Nero on the Vatican hill, were much influenced by the Byzantine liking for massed half-domes; their whimsical domes, lanterns, shell lunettes, half-round chapels, and so forth,[27] were elaborately capricious. They appear in paintings,[28] and their likenesses to the more elaborate pieces of late sixteenth-century furniture are striking. The influential designer Jacques Androuet Du Cerceau (p. 123) appropriated these early fantasies for his engravings of fantastic classical buildings.

Inevitably, all three types – antique architecture, antique ruins, and antique architectural caprices – were used to decorate furniture, and continued to influence its form and decoration up to the present day [678, 679]. The craftsman who wished accurately to portray buildings, ruined or whole, was given invaluable help by Brunelleschi's systematization of scientific perspective in about 1425, set out by Alberti in 1435 and 1436;[29] perspective became a craze, and depictions of architecture are often known simply as 'perspectives' (some sixteenth-century marquetry moves one to wonder whether certain artists and craftsmen were influenced by the decorative haphazard perspectives of grotesque to disregard the new discoveries).

Perspectives in intarsia and marquetry

It was easy to paint ruins on furniture, and furniture was so painted,[30] but the more luxurious medium was pictorial woodwork. 'Intarsia' or *tarsia* (the term refers to Italian wooden inlay in general) was a speciality of fourteenth-century Siena; in the fifteenth century, Florence took the

lead. It was also popular in northern Italy generally and in Venice. 'Certosina' work – the Italian geometric inlay influenced by Islamic geometrical arabesque [116] – is a technique in which small polygonal tesserae of wood, bone, ivory, mother o' pearl and other materials were inlaid in geometric patterns into a wooden base; it was common in Italy by the fifteenth century [174], when the geometric patterns got larger. The simpler motifs were supplemented by classical acanthus, garlands, and vases. A description in the *Hypnerotomachia* of an imaginary table conveys the attractions of inlaid pictures: 'a sumpteous table of white Ivory, bordered, trayled, and finely wrought with many small pieces upon the precious wood of Aloes, and ioyned and glued together, and…wrought with knottes and foliature, flowers, vessels, monsters, little Birdes, and the strikes and carvings filled up with a black paste and mixture of Amber and Muske…'[31] The earlier motifs were joined by ruins, classical perspectives, and (after the 1490s) grotesque. Between 1436 and 1445 perspective intarsia panels were installed in the Duomo at Florence.[32] Painted perspectives of 'ideal towns' have been associated with Piero della Francesca, who himself made designs for intarsia and was friendly with the Lendinara brothers: Lorenzo da Lendinara was 'supreme in perspective in his time'.[33]

According to Vasari, 'conjoining woods, tinted of different colours, and representing with these, buildings in perspective, foliage, and various fantasies of different kinds' had been introduced in the time of Brunelleschi and Uccello.[34] This is the technique of marquetry, which consists of veneers laid not into the surface but on it, placed together like a jigsaw; its 'technique was that of mosaic, but its effects were those of painting'.[35] The shapes depicted were coloured and shadowed; marquetry's range was greatly widened by the new discoveries in painting, its introduction of strong contrasts of light and shade and its use of scientific perspective.[36]

The Florentines were proud of their new achievements: 'from the time of the ancients until now there have been no similar masters of woodwork, intarsia and marquetry, of such skill in perspective that one could not do better with the brush.'[37] Intarsia and marquetry were used as much for church as for secular woodwork; the ecclesiastical context affected the imagery, but the same workshops made both. Its popularity is attested by the quantity that survives. Intarsia was expensive: Benedetto da Maiano (1442–after 1498) 'remained in Florence devoting his attention to productions in intarsia, because he thereby made larger gains than could be secured by the other arts' (architecture and sculpture).[38] Benedetto and his brother Giuliano (1432–90), sculptors and architects, supplied intarsia *lettuci* (small beds) to the royal house of Naples in 1473 and 1476.[39] According to Vasari, Benedetto experienced a disaster due to changes in humidity: 'he executed a pair of very rich coffers for King Matthias of Hungary, who had many Florentines in his court…the most delicate and beautiful workmanship, in coloured woods, inlaid…when the waxed cloths in which the coffers had been wrapped were opened, almost all the pieces…fell to the ground'[40] (the same thing happens in over-heated museums). This so disgusted Benedetto with the medium that he thenceforth concentrated on sculpture.

Despite such disadvantages, marquetry became the preferred way of obtaining refined pictorial effects in furniture [208].

The influence of antiquity on the Renaissance chest: sculptors, painters, and furniture-makers

Antique influences on fifteenth-century Italian furniture are manifest in the chest or *cassone*. Cassoni were practical pieces, customarily presented to bride and groom at a marriage; a cassone front decorated with gilded *pastiglia*, a refined form of gesso, is dated Florence 1507; it is adorned with large tempera portraits of the bride and bridegroom surrounded by coats of arms.[41] The greater the family the more ostentatious the cassone, which might come in a matching pair. The cassone often combined flat painted or inlaid surfaces with ornament in relief.

What influences transformed the 'old' style of cassone [92, 140] into the new [159]?

The role played by the painter, sculptor, engraver and goldsmith in the design of Italian fifteenth-century furniture ceases to be gleaned from hints given by Cennino Cennini (p. 81), chance references or inventories, and becomes well-established fact. Painters worked on rooms and furniture together; for instance, in the 1430s and 1440s Jacopo Sagramoro decorated rooms in fresco and painted and gilded marriage chests for the court of Ferrara.[42] Vasari says that the minor painter Dello (d. after 1455), who always worked in an apron of brocade (William Morris, wishing to be 'pre-Raphaelite', used a shepherd's smock!),[43] 'painted the entire furniture of a room for Giovanni dei Medici'. It was 'the custom at that time for all citizens to have large coffers or chests of wood in their chambers, made like a sarcophagus [159]…nobody failed to have these chests adorned with paintings; and in addition to the stories which were usually depicted on the front and cover of these coffers, the ends, and frequently other parts, were commonly adorned with the arms and other insignia of the respective families. The stories…were for the most part, fables taken from Ovid, or other poets; or narratives by Greek and Latin historians; but occasionally they represented jousts, tournaments, the chase, love tales…these chests were not the only movables adorned thus, since balustrades and cornices, litters, elbow-chairs, couches, and other rich ornaments of the chambers…were beautified in like manner.'[44]

The painted surfaces of chests were often more Gothic than their shapes. Sometimes the paintings were 'modern', since major painters decorated rooms and the furniture in them. They included that innovative genius, Uccello, who painted scenes on *lettuci* and beds,[45] Domenico Veneziano, Mantegna,[46] Botticelli, Giovanni Bellini, and Andrea del Sarto.[47] The furniture in the chambers of Lorenzo the Magnificent was 'depicted not by men of the common race of painters, but by excellent masters'. Vasari spoke of 'many of our old nobles…who will not permit these decorations to be removed for the purpose of being replaced by ornaments of modern fashion';[48] formerly 'even the most distinguished masters employed themselves in painting and gilding such things. Nor were they ashamed of this occupation, as many in our days would be.' It is hardly conceivable that innovative painters did not influence the form of this furniture as well as painting its surfaces. Less distinguished painters also painted furniture: Vasari says of the Florentine Andrea Feltrini, whose speciality was the new decorative grotesque, that 'It would not be possible to describe the vast number of decorations in friezes, coffers and caskets, with the numerous ceilings, wainscots and other works of similar kind executed by the hand of Andrea di Cosimo [Feltrini].'[49]

The influence of portable illustrated manuscripts on design in general stretches back into the Dark Ages, and amongst the most stylistically adventurous early Renaissance artists were miniaturists [193, 212], including Perugino and Pinturicchio in their number. Fifteenth-century Italian miniaturists frequently had connections with the making of furniture. Apollonio di Giovanni and Marco del Buono, who ran the largest of the workshops that made painted chests in Florence in the mid fifteenth century, painted book miniatures; Francesco Pesellino, who greatly influenced the painters of furniture, and who specialized in exotic figures in Turkish and Byzantine dress, was also a miniaturist; in the Casa de' Medici his father Giuliano 'decorated a balustrade with figures of animals, which are exceedingly beautiful, as also certain coffers, on which he depicted…jousts and tournaments'.[50] The antique innovations of the miniaturist are apparent in the decorative paintings of many cassoni [158].

Renaissance goldsmiths contributed significantly to the design of furniture. Line engraving, used for multiple prints, was a goldsmiths' technique; new designs came increasingly to be disseminated through prints (pp. 97–98). Many goldsmiths were also painters and sculptors: Antonio Pollaiuolo, Verrocchio, Pierino da Vinci, and Salviati, all of whom designed furniture or influenced its design, were trained as goldsmiths. This close interdependence of the arts facilitated the transition of motifs to furniture. Much of Mantegna's work became furniture decoration through prints, including an extraordinarily influential engraving of marine gods. The links between goldsmiths, other craftsmen, architects and sculptors continued for centuries, and were not confined to Italy.[51]

The art of the sculptor, ancient and modern, strongly influenced furniture. Cassoni often combined influences from two antique artefacts in particular, the sarcophagus and the frieze in bas-relief. People were excited by the antique bas-relief; flat, and easily adapted to the wooden board, it provided a convenient path for classical figure sculpture to enter furniture design. The *Hypnerotomachia* illustrates the concentration with which contemporaries 'read' the reliefs carved into the fronts of great Renaissance chests and cabinets. Bas-reliefs and three-dimensional figures had ornamented furniture in antiquity and thereafter, but the Renaissance employed them in furniture to a revolutionary extent, the beginning of an accelerating development. Ancient statues were imitated more or less 'straight' on

modern furniture; how could they not be, in an age so fascinated by antique statuary and so stimulated by periodic and spectacular discoveries? The small Paduan or Venetian bronzes made after the antique by such artists as Riccio (d. 1532) were the precursors of the plain and gilded bronzes that had a momentous future as furniture ornaments.

The process of assimilation is demonstrated in a Florentine walnut cassone of the second half of the fifteenth century decorated with the Virtues and Vices [160]; it shares its old-fashioned shape with the north Italian chest [92], but its decoration is unmistakably 'Renaissance'. The apron is decorated with winged heads and ribbons, the background with stamped flowers and leaves, but the principal panel imitates, in gilded *pastiglia*, a classical bas-relief replete with antique imagery such as garlands, centaurs, candelabra, and cornucopias; the dress of the four cardinal Christian Virtues – Prudence, Justice, Fortitude and Temperance – is of the high-waisted, 'wet-draped' classical variety deriving from the antique Roman Greek revival. The design is taken from a print by the avant-garde painter and sculptor Antonio Pollaiuolo (*c.* 1432–98), who was influenced by Donatello. The stimulating effect of a progressive painter becomes clear if one compares this Pollaiuoloesque 'bas-relief' with a less innovatory Florentine cassone front of more or less the same date;[52] its *pastiglia* polychrome scene, appropriately that of a wedding, is unclassical in dress, stance, and detail (a prominent goitre is displayed); more 'classical' are its gilded *pastiglia* frieze – an example of 'sculptural' grotesque executed before the rediscoveries of grotesque – and its candelabra-decorated pilasters.

The painted, carved and gilded 'Nerli Cassone' [159], of 1472, has the grandeur of the fully fledged early Renaissance cassone. Made before the exploration of the Domus Aurea was opening up new possibilities to artists and designers, it shows no grotesque influence. Its form is taken from a particular type of free-standing Roman sarcophagus[53] with an upraised back, transformed in the coffer into a dignified backboard; this is painted, beneath an entablature, with a scene glimpsed through a simulated drawn-back hanging covered with a pattern simulating textile. The heavy lid, decorated with the imbricated pattern imitating roof tiles that occurs on sarcophagus lids [185], surmounts a coffer whose massive three-dimensional acanthus scrolls and lion paw feet contrast strangely in their antique dignity with the Gothic miniaturism of the painted panels.

160 A cassone in pine with painted and gilded gesso, decorated with the Virtues and Vices after Antonio Pollaiuolo; Italian (Florentine), late fifteenth century.

IV *Chapter 2* Grotesque and arabesque

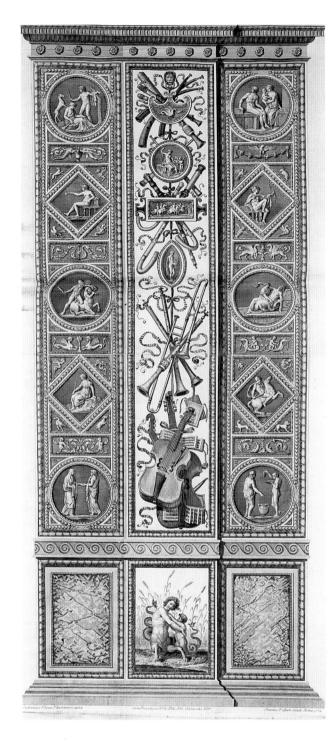

161 Details from the Logge in the Vatican Palace, Rome, executed under the supervision of Raphael and completed in 1519; the design includes a trophy of musical instruments in the centre; Italian, published in Rome in 1772 (from *Arabesques of the Vatican Loggie*).

opposite 162 The Loggetta in the Vatican Palace, Rome, executed under the supervision of Raphael; the airy grotesques are principally influenced by those of Nero's Domus Aurea, including the cryptoporticus (whence also come the Greek key patterns) and the Volta Grotta; Italian, 1519.

THE FIFTEENTH-CENTURY Italian revival of antiquity inspired an art that, reaching full maturity in the first years of the sixteenth century, has a wonderful freshness, purity and grandeur, the greatest 'classical' art since that of ancient Greece: Raphael's *School of Athens*, completed in 1511, marks its apogee. But just before that came the discoveries that encouraged the growth of quite a different kind of art, sixteenth-century 'mannerism'.

The seeds did not fall upon unprepared ground. Fifteenth-century ornament had held a strong vein of antique fantasy [150]. It was particularly evident in the paintings of the Paduan and Ferrarese schools, in Italian miniatures, and in artists' sketchbooks. One of the last, made, to judge from its binding, as a presentation copy to a great personage, remarkably anticipates the antique ornament (especially the ornament based upon candelabraform shapes and the baluster) that became so common in sixteenth-century furniture [163, 164] – not to mention the ornament that became again common in late eighteenth-century furniture! Fifteenth-century antique fantasy shows traces of the lingering influence of Gothic fantasy;[54] it is fascinating to notice, once again, a link between grotesque and Gothic (p. 276), a link so strong that the Gothic spirit appears at times to have infected rediscovered antique forms with the ancient caprices of grotesque well before the latter had been rediscovered. Ruskin (pp. 245–47) indignantly differentiated between 'true' or 'noble' mediaeval grotesque and 'false' or 'ignoble' antique and Renaissance grotesque – the latter was 'the most hopeless state into which the human mind can fall'.[55] He was on shaky ground in making such distinctions.

Antique grotesque was unearthed in great quantity and quality on the site of Nero's Domus Aurea in the 1480s and 1490s [33]. 'Grotesque' elements had entered antique Roman sculpture [38] and thence early fifteenth-century antique ornament; some grotesque motifs such as the velarium had persisted in use ever since antiquity [105]. But to all intents and purposes grotesque in painted guise was quite new. The early explorers mistook the buried rooms of Roman palaces for underground grottoes, or burial chambers, a misconception that helped to inspire a sixteenth-century 'grotto' romanticism that has affected decoration and furniture up to the present day. Raphael realized that the Domus Aurea site held an accumulation of superimposed buildings; the common error was to suppose that the later Baths of Titus, which had been built above part of the Domus Aurea, had covered the whole area, a mistake that led to all the remains being called the 'Baths of Titus'. It was as the Baths of Titus that the Domus Aurea was published in the later eighteenth century [33].

In a guide book to Rome of about 1499 or 1500 Bramante called the painted schemes *grotteschi*, 'grotesques', by which time the term was probably common. Artists flocked to see them and scribbled their names on the paint; the earliest graffito is dated 1493. It was easy to examine the ceilings at close quarters since the partially cleared rooms were still filled high with rubble. The paintings, which were in brilliantly fresh condition, were recorded by artists in drawings of which copies were passed from hand to hand. Those of the *Codex Escurialensis*, an Italian sketchbook of

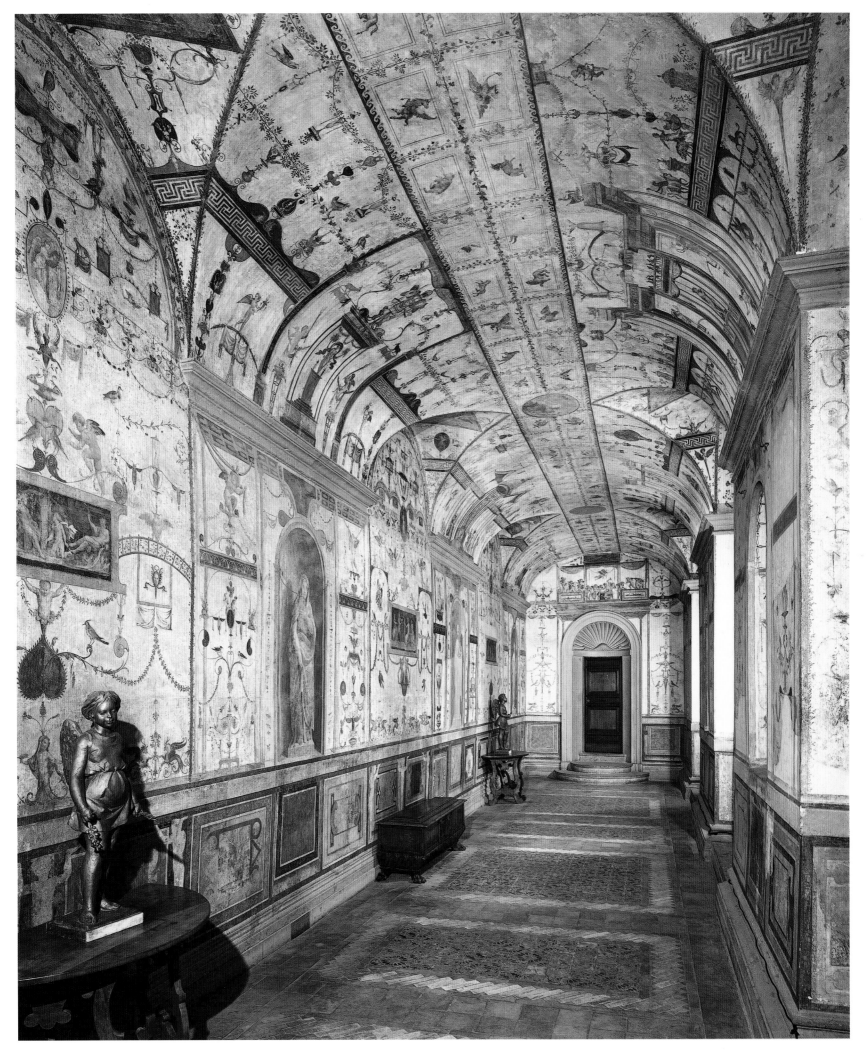

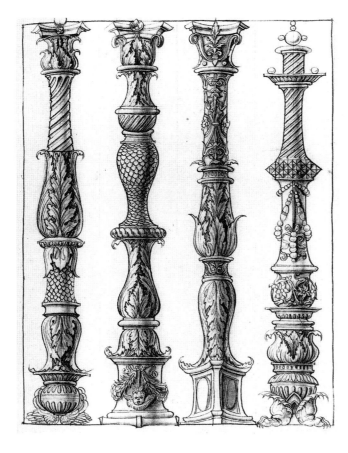

163 Baluster forms combined to become candelabraform and decorated with ornament taken from antique sources, from a late fifteenth-century Italian sketchbook, the *Codex Destailleur*.

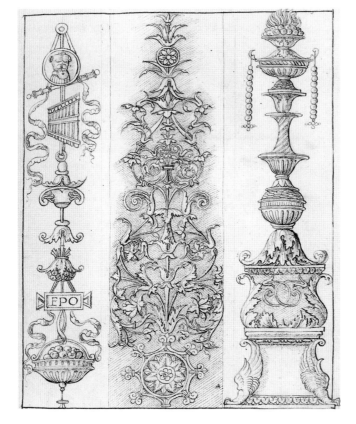

164 Trophy, candeliere and candelabro ornaments, from a late fifteenth-century Italian sketchbook, the *Codex Destailleur*.

about 1493–94, in which depictions of antique grotesque predominate over other material, are copies possibly after Ghirlandaio; they vividly illustrate the diverse sources from which late fifteenth-century artists drew inspiration for modern artefacts in antique style. The drawings include much that was to find its way to furniture: for example, a page of grotesque candelabraform ornament is followed by a page of modern 'antique' candelabra, trophies, the sarcophagus of Cecilia Metella, antique statuary including the *Nile*, a Roman throne, and Roman lettering; there is a sacrificial scene with a tripod and 'antique drapery'.[56]

The modern re-use of grotesque by painters

In about 1480, Pope Sixtus IV summoned a group of Florentine painters that included Pinturicchio, Perugino and Signorelli from Florence to Rome to decorate the newly built Sistine Chapel. All became important early practitioners of grotesque, Pinturicchio being the most influential. To polychromatic gaiety, Pinturicchio added antique references and motifs from all kinds of sources, including illuminations, and Gothic and Northern European art (whence probably came the burlesque element in his work). Nobody, before Raphael and his pupils, did more to set grotesque upon its centuries of development; the word itself appears in a contract for the first time in that for Pinturicchio's frescoes in the Siena Library (1502–9).[57] The mixture of ornament in his paintings prefigures similar mixtures to be seen later in furniture design. It includes interlaced knotwork[58] of a type common in Italian illuminated books,[59] scroll-shaped frames inspired by motifs from rooms in the Domus Aurea, pilasters decorated with candelabro motifs,[60] and so on. Signorelli freed grotesque decoration from the confines of pilaster, frieze or pendentive,[61] a development which would lead eventually to Berain and Boulle. With surprising speed, painters appeared who made the painting of grotesques their sole or main employment, such as Morto da Feltre, 'the first to discover and restore the kind of painting called arabesques and grottesche'.[62] There were distinct variations in grotesque style; the grotesque of Vasari, for instance, differed from that of Peruzzi, and the differences were reflected in furniture decoration.

Raphaelite grotesque

From its very nature, its caprice and irrationality, grotesque is peculiarly open to alien elements; it takes in other ornament, antique, exotic, and modern, with amazing ease. Its story from the sixteenth to the twentieth centuries is that of a series of chameleon-like changes caused by invasion and assimilation, sometimes to a point where the original grotesque becomes so transformed that it disappears – as it does from rococo (p. 170). Raphael, the most convincingly 'classical' genius of the Renaissance, took advantage of this receptivity to create a grotesque of such consummate beauty, vitality and versatility that it has been employed in more or less its Raphaelite form ever since [161, 162, 365]; besides acting as a catalyst for other European decorative styles, it deeply affected furniture, not least in the eighteenth century (pp. 194–201).

Vasari says Raphael had little interest in antique decoration, but it seems more consistent with what is known of him that he inspired highly talented assistants who developed their own specialities. The sequence of absorption and invention seen in Raphael's own paintings is clearly apparent in the evolution of Raphaelite grotesque. First

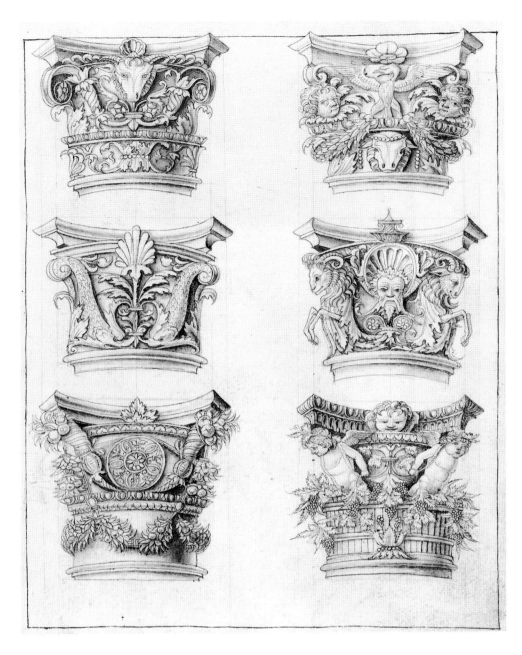

The motifs employed included medals, architecture, sarcophagi, shields, gems, still life and so forth, the range extending from a lyrical and feathery lightness to a heavy richness. The elements taken from antique sculptured ornament and Michelangeloesque 'modern' sculpture give certain of the grotesques something of sculpture's weight, a clear-cut vigour that led eventually to the 'classical' grotesque of Simon Vouet [272] and to aspects of the furniture designs of Jean Le Pautre [257].

Giovanni da Udine contributed the delightful birds, beasts and flowers that descended partly from those of Northern European and Italian illuminated manuscripts and embroideries. Other influential themes include baskets filled with flowers taken from antique grotesque, and jewels, beads, and ropes of pearls taken directly from Italian miniatures and, ultimately, from Byzantine and Sassanian art. All, sooner or later, were to find their way to furniture. Raphael also exploited the shot colour of antique painting in his grotesque, a feature which eventually greatly influenced the painted decoration of eighteenth-century furniture.

The grotesque of the Logge was significant for furniture design in three additional ways. The first was the organization of parts of its grotesque as vertical strips, an eccentric but effective arrangement that seems almost expressly made for extraction and use in interior and furniture decoration (often turned to the horizontal in the process). The second was the series of extraordinary little cupolas that influenced European architecture and decoration for centuries: they include a vine-covered pergola, birds and monkeys, a cupola with trellis and sky, owls and other birds, leafy arbours, curvilinear interlace, diminishing hexagons, and diminishing lozenges on a curved interlacing grid that forms pointed arches. The third influential innovation was the consistent 'archaeological' depiction of antique furniture types [180, 181, 391].

Grotesque prints

Prints were an outstandingly efficient way of spreading design. Design had always been international, remarkably so taking into account the hazards of travel; artists travelled far, but prints could travel further and were copied, adapted, and further disseminated by other printmakers. Engraving and etching on paper evolved from a simple technique of the metal-chaser, the engraved line on metal; it was much finer than the woodcut line, and permitted the reproduction of minute decorative detail. Vasari attributed the invention of engraving on metal to the Florentine goldsmith Maso Finiguerra, in about 1460. Influential printmakers might be unimaginative but technically brilliant artisans or great artists; the furniture-maker usually followed the printed image more closely than did the more adventurous painters and architects.

The connection between printmaking and metal-workers continued throughout the sixteenth century. Grotesque became very popular with goldsmiths, and grotesque prints by Netherlandish and German goldsmiths were issued in large numbers, thus influencing furniture design. Pre-Raphaelite, antique-style flat painted grotesque was quickly engraved by artists such as Giovanni Pietro da Birago, Zoan Andrea, and Agostino Veneziano. Raphaelite flat painted grotesque was also spread through prints, although strangely enough the Vatican decorations themselves were not engraved until much later (artists copied them direct). Especially influential were prints issued by three designers, Italian, French and German.

165 Capitals of a fantastic type invented in the second half of the fifteenth century, from a late fifteenth-century Italian sketchbook, the *Codex Destailleur*.

came a pastiche, in subject and handling; next a free variation that imported delightful new motifs; then a completely original creation that in splendour and variety surpassed its ancient original.

The Stufetta of Cardinal Bibbiena in the Vatican (1516), the earliest in the sequence of Raphael's grotesque decorations, is the first complete modern decorative scheme to imitate ancient grotesque; not without novelties, it is astonishingly archaeologically correct. Its paintings contain antique-type figures not precisely copied from the antique but probably inspired by literary sources[63] – amorini on black panels, very like those in the House of the Vettii in Pompeii [35, 36, 76], drive chariots drawn by eccentric mounts. The Stufetta was succeeded by the Loggetta [162], which bases an airy and delicate scheme, free and fanciful, on the 'Pompeian' Fourth Style (p. 31).

In the Logge [161, 365], the most famous of Raphael's grotesque schemes, an unparalleled variety was attained. Pinturicchio had previously synthesized grotesque with geometrical and curvilinear interlace and knots, a combination already seen in late antique mosaics. Raphael, also acting on hints from antiquity, now combined grotesque with ornament drawn from all manner of antique sources.

166, 167 A grotesque design and a grotesque title page, copied by Enea Vico from an unknown source and republished in 1541 together with his own designs; Italian (from *Leviores et…extemporaneae picturae quas grotteschas vulgo vocant*).

The Italian Enea Vico (1523–67) published a collection of grotesque prints in 1541 that quickly became known in southern Germany and France. Some of the grotesques, earlier borrowings[64] (the world of the print is a labyrinth – prints are confusingly inter-related), have an airy incorporeality; others are in Vico's own manner, stronger, more volumetric, and bizarre rather than pretty.[65] The artist's inscription on the title page makes (with a touch of self-deprecating humour) a virtue of a spontaneity that skirts skimpiness[66] – the figures and monsters, often enclosed in elaborate fictive architecture, are so elongated and boneless as occasionally to become almost scrolls. The prints contain fascinating rehearsals of later developments in furniture, illustrating at an early date the later influence of grotesque decoration on three-dimensional furniture forms: candelieri turn into burning candles [166], a motif that became three-dimensional in the eighteenth century; Empire-looking figures recline on couches under baldaquins, a motif used also in the Logge; the title page [167] shows little connected tables with candelieri at their back, their look almost like late eighteenth-century English sideboards.

The Frenchman Jacques Androuet Du Cerceau (1526–1604) published grotesque prints in 1550; influenced by Vico, they exhibit a delicate bizarrerie, small scale over the whole area, with figures that anticipate Jacques Callot. Light and airy, they 'set the note for all lighter French classicism down to the Empire'.[67] Vico and Du Cerceau together mark the half-way point in the line that leads from the cryptoporticus of the Domus Aurea through Raphael's Stufetta and Loggetta towards Berain, Boulle and the eighteenth century.

Hans Vredeman de Vries (1526–1604), born in Friesland, published a collection of influential grotesques in 1556 that was greatly influenced by both Vico and Du Cerceau. The sequence of publication dates tells its own story.

The use of flat grotesque in furniture

The obvious way of translating flat painted grotesque into flat furniture decoration was through paint, intarsia, or marquetry. Ghirlandaio, who made cassoni in his workshop, directly quoted a motif from the cryptoporticus of the Domus Aurea that appears in the sketchbook associated with him, the *Codex Escurialensis*,[68] in the fictive intarsia dado of a room shown in a fresco of 1488–90 in S. Maria Novella, Florence. The decoration of the real grotesque intarsia of the dado of the Cambio at Perugia (1499–*c.* 1500), designed by Perugino and executed by Domenico del Tasso, is similar in style [149].

Still life is not found in antique stone decorative sculpture, but is common in antique grotesque painting [169]. It is perplexing to find that intarsia still lifes precede the 'official' discovery of grotesque in the 1480s. A famous early example is in the Studiolo of the Ducal Palace at Urbino. Set into a rich but restrained architectural framework are intarsia still lifes; the subjects include human figures set in shell niches, scenes of classical architecture in perspective, books, candles, hour-glasses and so forth set in trompe-l'oeil cupboards with open doors, baskets of fruit, squirrels, caged birds, musical instruments, etc.[69] It has been pointed out that all these motifs are found in the Second and Fourth Styles of 'Pompeian' painting;[70] (the link between still life and grotesque was picked up by early critics[71]). Had designers somewhere, before 1475, either seen antique decorative paintings in Roman ruins or come across drawings of them? It has been thought that Giotto and Donatello might have

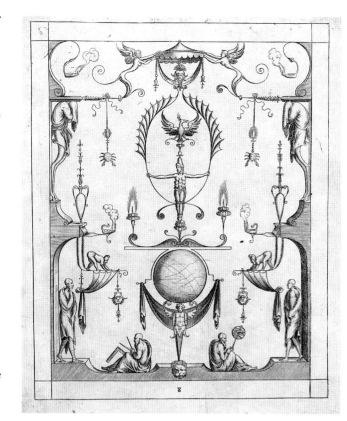

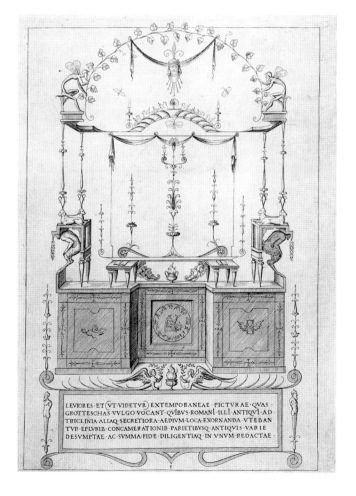

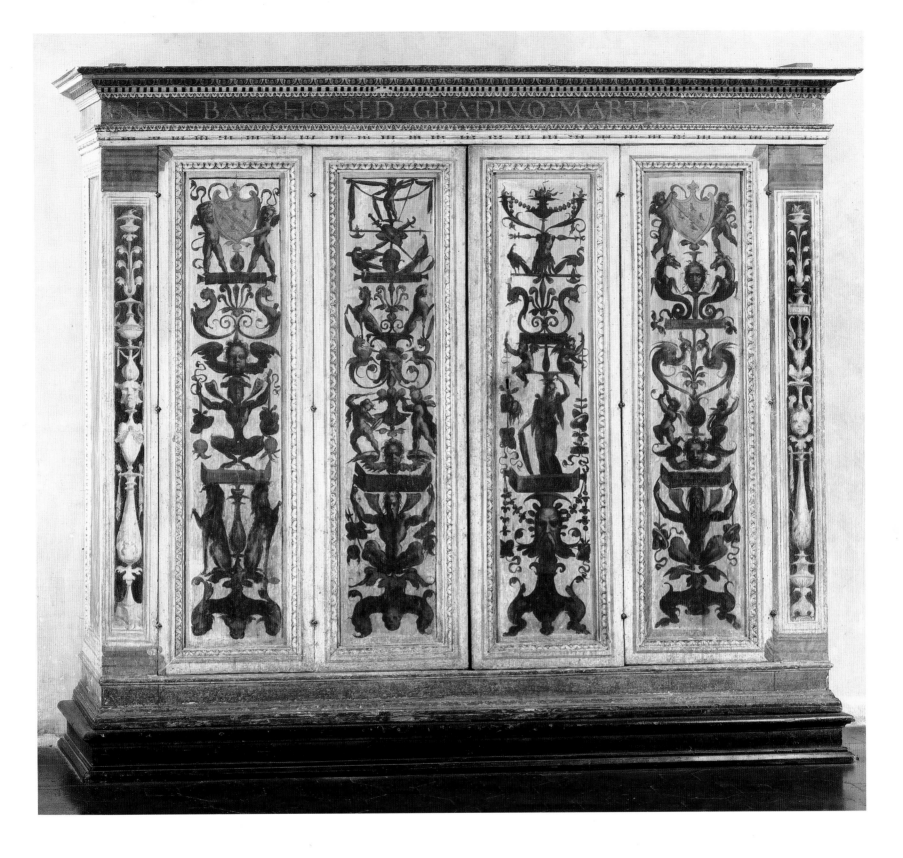

168 A cupboard with painted and gilded grotesque decoration, and with a motto in Roman lettering (see p. 100); Italian (Florentine), sixteenth century.

been influenced by them.[72] Trompe-l'oeil decoration is mentioned in antique literature, and this, so important as an influence in the Renaissance, could have inspired patrons and artists who resurrected such scenes.[73] It is, however, hardly possible that verbal descriptions alone could have led to such close re-creations.

Painters were quick to reproduce the subjects as easel paintings; their refinements and inventions were then drafted back into woodwork. A 'trophy' of dead partridge by Jacopo de' Barbari, composed like an antique still life, is signed and dated 1504; trophies of musical instruments from Raphael's Logge [161] were still being engraved in the late eighteenth

century.[74] The oldest independent flower painting known, a lemon tree, flowers, a vase decorated with a grotesque head, and a lizard – significant conjunctions – is dated 1538 and is after Giovanni da Udine, who painted grotesque for Raphael.[75] Thus began the line that was to lead to the Dutch flower marquetry of the seventeenth century and the French marquetry masterpieces of the eighteenth.

Grotesque motifs used on furniture rapidly followed its use in decorative painting; the modern versions of trophies, garlands, candelieri, monsters and so on that originated in antique grotesque are fairly easily distinguishable from modern versions of similar motifs originating in other antique

169 A detail of a Roman wall painting from Pompeii showing paintings of still lifes, with their shutters open, hanging on a wall in conjunction with garlands, fluttering ribbons, and fictive architecture; published in Naples in 1808 (from *Gli ornati delle pareti ed i pavimenti…dell' antica Pompeii*).

sources such as sculpture. Grotesque was frequently used to decorate panels and pilasters, as in a fine Italian cupboard [168]; the simple antique architecture is perfectly set off by capricious grotesque. The grotesque, a simple, 'pre-Logge' type, has elements that resemble earlier miniature decoration of the 'Paduan' type influenced by Mantegna; there is little hint of sculptural influence in the candelabraform decoration of the pilasters or in the panels, although the putti themselves do show sculptural traces. The stern motto, in the immaculate Roman lettering copied by the Renaissance from lapidary inscriptions (but with less than immaculate Ciceronian spelling), perhaps indicates that the cupboard contained armour rather than comestibles: 'Rather than to Bacchus, one addresses oneself to the warrior Mars' – and the grotesque contains armour, swords and a corselet, two putti appear to fight, and a lady holds a shield.

A walnut Florentine cassone of about 1550 [173] has scrolling grotesques in maple and plane in a simple and elegant linear pattern at first sight similar to that on the Bellini prie-dieu [156]. A closer look reveals that it is less tightly organized; the ends of the scrolls become grotesque heads or female acanthus-monsters with wings; the unseemly widespread legs of the winged monsters are typical of the bizarre grotesque. The grotesque heads on the central strapwork cartouche have the humorous coarseness typical of the Low Countries; Flemish grotesque painters were at about this time collaborating with Alessandro Allori on the grotesque ceilings of the Uffizi Corridor in Florence. The simple sarcophagus shape stands on lion paw feet; the base has intarsia 'gadrooning', a form of decoration found on the antique bronzes in which the Renaissance was so interested (a chest in Warsaw with almost exactly the same intarsia pattern has three-dimensional gadrooning).

Raphael's use of grotesque in the Logge cupolas was extended at the Villa Madama in Rome, where he introduced the first dome in a domestic interior. It could only be a matter of time before so splendidly pompous a feature as the architectural dome descended from the ceiling to the caparisoned bed, and so it happened. A carved and inlaid bed with a tester dome painted with grotesques is attributed to Bernardino Pocetti [171, 172];[76] reputed the best decorator in Florence, he painted splendid grotesques in the Pitti Palace. However, the velarium at the centre of the dome's grotesques is clumsily interrupted by radiating ribs, an infelicity not expected in a master ornamentalist. The domes of beds were also frequently covered with textiles and given an ogee curve, a form with both Gothic and Islamic affiliations.

170 A bench combined with a chest, a *cassapanca*, in carved walnut, designed by Adrián Lombart; Spanish, 1553.

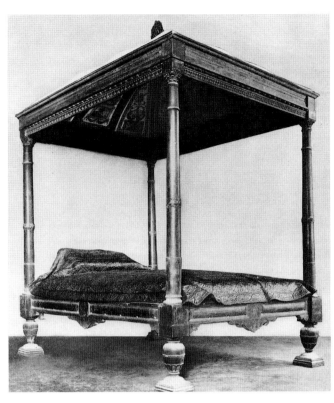

above and right **171, 172** A carved, inlaid and turned bed, its dome painted with grotesques attributed to Bernardino Pocetti; Italian (Florentine), mid sixteenth century.

below **173** A cassone in walnut with grotesque intarsia in maple and plane; Italian (Florentine), mid sixteenth century.

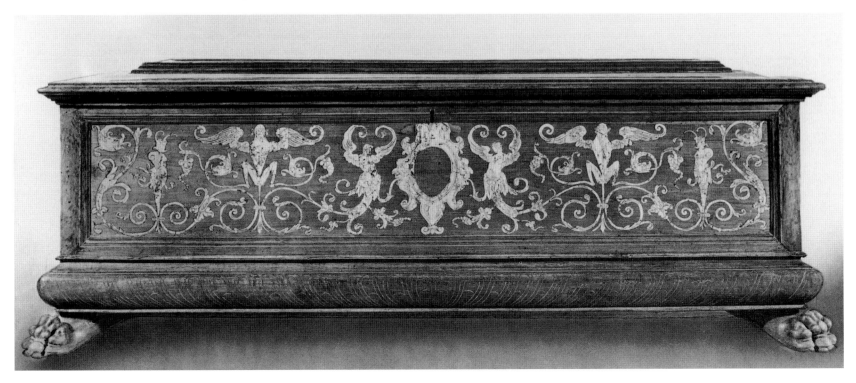

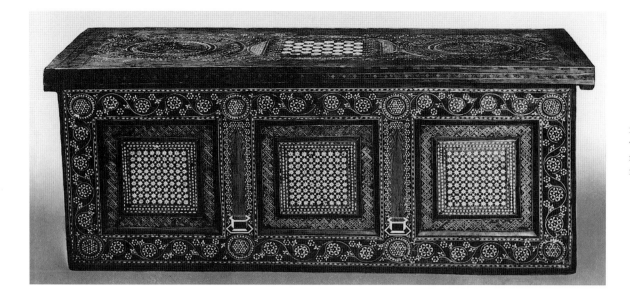

174 A cassone in walnut decorated with certosina work in ivory and mother o' pearl; north Italian, fifteenth century.

opposite 175 A canopied camp bed in ebony inlaid with moresques in ivory; German (Augsburg), *c.* 1580.

'Arabesque' or 'moresque'

In the early years of the sixteenth century one of the most fruitful marriages of history was being arranged, that between grotesque and arabesque (or moresque – the Renaissance tended to use the terms indiscriminately). High Renaissance classicism entered into its full inheritance just as they were about to destroy it. The 'anti-classicism' of Islamic arabesque, grotesque, and Gothic had family links, and as the last receded into history some of its qualities were taken over by the others.

Moresque motifs on Iberian (Hispano-Moresque) pottery, the first notable native European wares since antique times, had sparked off the development of Italian 'maiolica' in the early fourteenth century. A new wave of Islamic influence entered fifteenth-century Italy at the same time that architectural and sculptural classicism were being revived; it came from imported Islamic luxury goods and the ornament that decorated them. The influx had begun in earnest in the fourteenth century: a papal embargo on Islamic goods had been lifted in 1344, and the Venetians immediately began trading with Alexandria. Many went to Damascus in pursuit of the highly coveted 'damascened' metalwork; as a result its interlaced ornament often has some Western content. Eastern silks were traded in huge quantities: Islamic weavers settled in Italy and ornaments such as Turkish ogival motifs appeared in fifteenth-century Florentine silks. Islamic leatherwork was admired in Europe, one of the main agents of moresque influence being the portable bound book. In 1442 Alfonso V of Aragon became king of Naples and brought Spanish leather-workers to Italy. From about the middle of the century Neapolitan bookbinders imitated Persian and Mameluke bookbindings; the fashion spread to Rome and Venice, where Egyptian bookbinders also worked; in the sixteenth century 'morocco' leather became fashionable for book-covers.

It can be no coincidence that it was in the fifteenth century that the art of inlaying wood, which had survived in Islamic countries since the Dark Ages (pp. 68–69), became a staple Italian technique. A north Italian cassone of that date is typical [174]. The front is organized in three relief panels; the top is flat; there may have been a base, now lost. It is made of walnut inlaid with other woods, ivory, and mother o' pearl. Its ornament – 'stars', lozenges, a formalized running scroll (Islamic scrolls were not 'peopled') and geometric interlace – is typically Islamic. The extraordinary 'fountains' of rigidly disciplined flowers, emerging from containers, that decorate the two inner stiles containing the panels represent the petrification into formality of the ancient candelabro motif. The total effect is of brilliant, flat polychromatic gaiety and a complete lack of sculptural form.

By the late fifteenth and early sixteenth centuries, Islamic goods were entering Europe mainly via Venice, which had close contacts with Constantinople and the Near East. Painted arabesques decorate the picturesque chimneys that top Carpaccio's Venetian palaces,[77] and Turkey carpets hang over the balconies; Gentile Bellini went to the Sultan's palace to portray him, and Italians worked in Constantinople and Alexandria. Damascened metalwork influenced the ornament on European metalwork – a good source for disseminating ornament, since buffet vessels and armour were both conspicuous expenditure. The centres that specialized in it, such as Augsburg and Antwerp, extensively employed moresque on furniture and musical instruments.[78] Furniture-makers imitated the decorations on Islamic textiles, carpets, book-covers and leather hangings; in 1528 Pierre Roffet, a Parisian bookseller, acquired 'ung cabinet de cuir doré, a ouvraiges moresques…une boueste aussi de cuir doré, faictes à semblables ouvraiges de moresques, garnie de bandes de fer dorées' – 'a cabinet of gilded leather, with moresque work, and a box of gilded leather, with similar moresque work, ornamented with gilt metal bands'.[79] The oriental exoticisms of arabesque were an attraction, and its differences from European native ornament did not worry craftsmen.

Moresque prints

The distribution of arabesque or moresque motifs was greatly assisted by prints, in which the goldsmith played as significant a role as for grotesque. Because the cheap print became so important in spreading a knowledge of arabesque, and because the designs were often meant for embroiderers and lacemakers, many of the early published arabesque motifs were linear, whether geometrical, curvilinear, or mixed. In the 1520s a series of books containing influential moresque prints appeared in Augsburg, Cologne, Antwerp, Venice and Paris.[80]

Two may be taken as early and influential examples of the genre. Their patterns were frequently used for marquetry. The first, the *Essempio di recammi* by Giovanni Antonio Tagliente (*c.* 1465–*c.* 1530), was printed in Venice in 1527

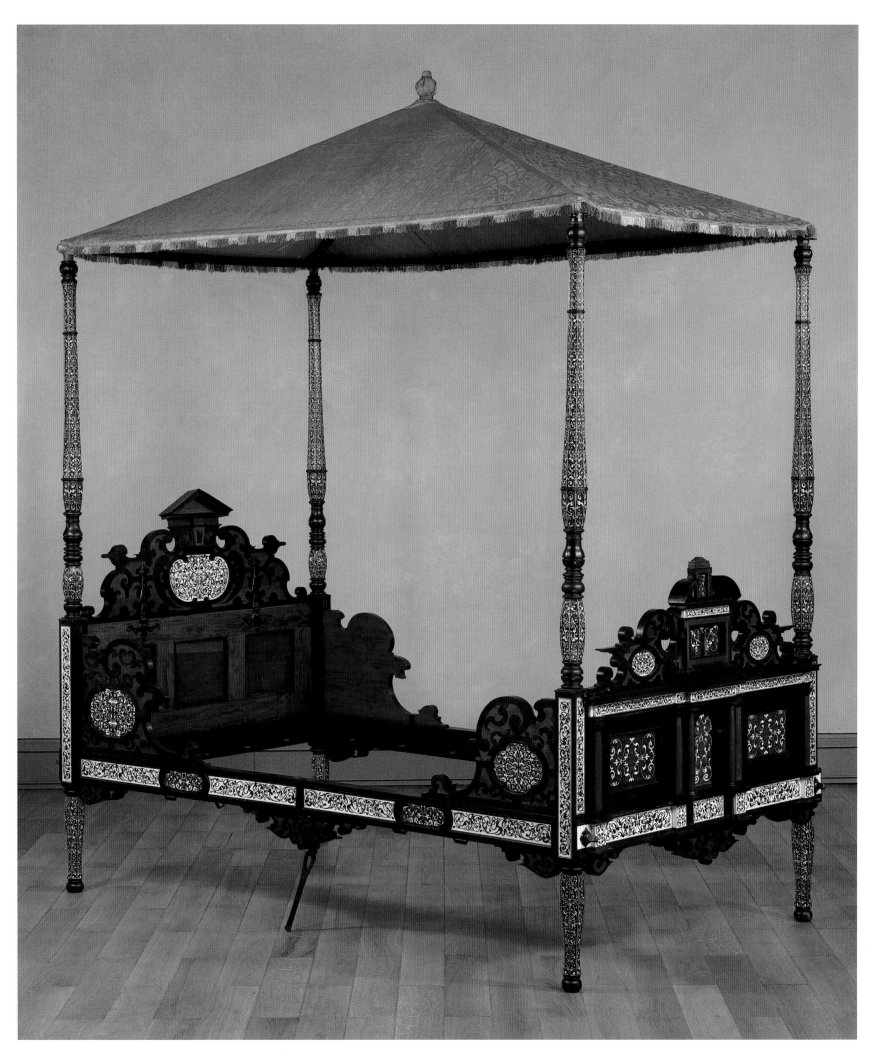

176 Moresque designs by Virgile Solis; German (Nuremberg), 1541.

177 Islamic interlace: a detail of ornament from the *Quran* of Sultan Mou'ayyed, dated 1411.

right 178 A two-tiered cupboard in walnut and other woods, inlaid with moresque intarsia and a perspective, by the monogrammist HS; Swiss (Thurgau), 1565.

and by 1535 had been reissued three times. This, the earliest Italian embroidery pattern book, contained 'groppi moreschi et arabeschi' of a type that had interested Leonardo and Dürer. Many are in white on black. In his text Tagliente emphasizes the intricacy of interlaced knots, saying that the cord should always pass alternately over and under the intersecting strands. Another book, published in Paris in 1530 by the Florentine Francesco Pellegrino,[81] contains embroidery patterns in the 'façon arabique et ytalique', including a splendid series of sumptuous, entirely moresque designs. Some pages consist only of scrolls; there are knots, interlacing, and banding with 'broken curves'. Pellegrino's designs were copied by others. In these moresque designs one sees furtive faces or grimaces reminiscent of those concealed in the Celtic interlace of the Dark Ages.

The middle of the century saw influential moresques published by others, including Peter Flötner (*c.* 1490–1546),[82] an outstanding designer of furniture and goldsmiths' work, Du Cerceau, and Balthasar Sylvius of Antwerp, who in 1554 produced one of the most most useful collections of moresques of its time.[83] Examples published by the prolific printmaker Virgile Solis [176] show clearly the close relationship between moresques and strapwork (pp. 120–21). As the sixteenth century wore on, naturalistic details were gradually introduced into European adaptations of the abstract scrolls of curvilinear arabesque.

All these sources, and many more, contributed to the use of arabesque as furniture ornament, where it was quite often associated with other genres: a cabinet of 1565 [178] combines Islamic moresque with a Gothic ruin perspective and antique candelabro motifs; in its original form, a sphinx

table [597] had a moresque cornice in silver. The almost neo-Attic elegance of the moresque inlaid decoration in ebony, ivory and purplewood of a sophisticated Augsburg travelling bed [175] reinforces the refined restraint of its forms. The bed's faceted and turned candelabraform pillars foreshadow late eighteenth-century designs; the scrolling architectural headboards and footboards provide its only pronounced curves, and these are kept within bounds. Nothing could be further from the extravagances of much Northern grotesque.

Arabesque interlace and knotwork became basic elements in the design of floors, ceilings – and gardens. The ceilings of Northern Europe were frequently decorated with arabesque geometric and curvilinear interlace in stucco, a form of decoration that eventually retreated before the fashion for heavy 'antique' coffering associated in France with the name of Jean Cotelle (1607–76) and in England with Inigo Jones (1573–1652). Its remnants were still being used by German and Italian stuccoists into the middle of the eighteenth century [289], and its influence pervades the interlaced backs of contemporary English chairs [288, 290]. It survived even longer in the flourishes of 'copper-plate'.

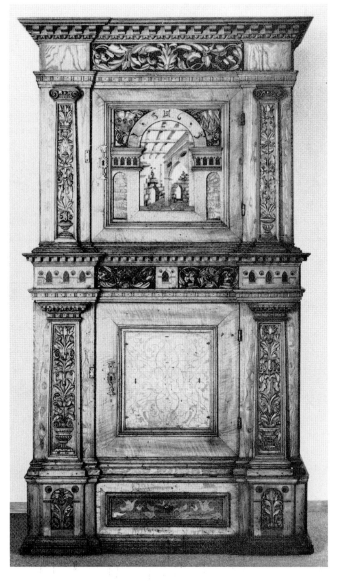

Chapter 3 High Renaissance classicism versus 'mannerist' expressionism

179 A four-legged table in carved walnut; Italian, sixteenth century.

THE TWO GREATEST ARTISTS of the Renaissance, Raphael and Michelangelo, were born within eight years of each other. The opposed nature of their temperaments and achievements has entered legend (had Raphael lived longer, they might have come closer). They profoundly influenced their own age, and their formative influence lasted the next four centuries. We do not know what Western furniture would have been like had they not lived, but it would have been very different. Raphael created a new and immensely influential type of grotesque; he looked closely at antique furniture and reproduced it in an 'archaeological' manner in his paintings. Michelangelo used the antique vocabulary to create a new expressionistic architecture, sculpture and painting. All subsequent developments in furniture design tended to follow (in the wake of the fine arts) one or another of these paths, the grotesque, the sculptural (which includes baroque and rococo), or the archaeological. The paths frequently converged, as they had in antiquity.

Raphael: furniture in antique style

Raphael's subject paintings set the standard for modern European classicism: the eclectic classicism of the Carracci in the seventeenth century, the post-rococo neo-classicism of the late eighteenth century, and the romantic classicism of the early to mid nineteenth century all drew on his work. The influences inescapably filtered down to furniture. Raphael also had an influence on furniture design of a more direct sort. Set in grotesque manner amongst the fantasies of the Logge are little paintings that are far from grotesque; executed by Raphael's pupils, they are in the classical mode of the famous tapestries Raphael designed for Pope Leo X. Despite the small size of the paintings, 'Raphael's Bible' became as famous as the tapestries, and both were taken for centuries almost as eye-witness records of biblical events. One of their minor virtues was that they contained scholarly depictions of ancient furniture – not the first attempts at 'authentic' antique furniture, but amongst the most convincing and objective. The paintings were often reproduced or plagiarized, and their realistically antique ambience influenced other artists, including such classically orientated painters as Rubens and Poussin; in many ways the later art of Poussin, which so greatly influenced 'archaeologizing'

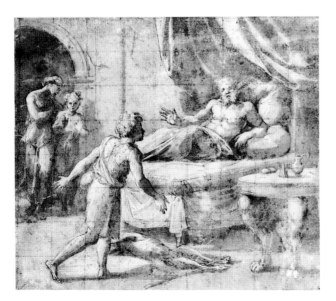

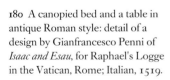

180 A canopied bed and a table in antique Roman style: detail of a design by Gianfrancesco Penni of *Isaac and Esau*, for Raphael's Logge in the Vatican, Rome; Italian, 1519.

eighteenth-century furniture, was founded on 'Raphael's Bible' and his tapestries. One can hardly doubt that it was Raphael's keen eye that prompted this accuracy; the same eye, applied to antique sculpture, 'may even have anticipated most of the conclusions that were reached by archaeologists only three or four hundred years after his researches'.[84]

The antique furniture depicted in Raphaelite grotesque includes a Roman three-legged table with animal feet taken straight from the antique [180];[85] klismos benches, an uncommon antique type but they do occur, as in in a Pompeian mural of erotes at play;[86] an authentic-looking Roman couch [181]; X-frame chairs; and some caprices, such as a klismos chair with back legs that are turned [391] – one says 'caprices', but some antique Roman furniture was capricious, and it is possible that a reputable source existed for the chair. Incidentally, pictured in the Logge grotesque panels is a boss with two centaurs that is virtually the Regency convex mirror. Raphael's tapestries also depict antique X-frame chairs.

After Raphael's death and the sack of Rome in 1527, his pupils and assistants, a cosmopolitan lot to begin with, scattered over Italy and Europe, carrying with them an interest in and knowledge of antique furniture. Copies were made of the Logge paintings [507]. Paintings by Raphael and his school, dispersed through engravings, were copied on to maiolica, which perhaps acted as a propagandist for antique style in sixteenth-century furniture in the same manner as did the wares of Wedgwood in the later eighteenth century. Painters were conscious of the appurtenances – a young maiolica painter depicted himself on a plate working on his trade seated in an 'antique' chair adorned with details drawn from Roman furniture, including candelabraform ornament and 'antique drapery'.[87]

The same basic type of 'antique' furniture as that of 'Raphael's Bible' is repeated in a whole range of Italian sixteenth-century 'archaeologizing' furniture, plain and often massive – far more than can be illustrated here. It seems likely that this furniture, which apart from the X-frame chair was not common outside Italy, owed much to Raphael's pupils and plagiarists. The animal-legged 'antique' type of table, massive and influenced by marble prototypes, became common during the sixteenth century, sometimes with three and sometimes with four legs; the top was round, square or polygonal. The form of the sturdy animal leg was not infrequently drawn upon a flat plank [179]; this was more economical of wood than a leg carved fully in the round, but the design may have been influenced as much by slab-ended antique tables as by the desire for economy: the profile of such legs often carries a strong hint of the curve of the slab-ended marble table [36] or the rounded sarcophagus [65:D], and their acanthus and scrollwork decoration is also often reminiscent of the sarcophagus. Frequently, such decoration was translated into a grotesque idiom.

The X-frame chair hardly needed revival; it had never disappeared. It retained its regality, although its details varied. In the fifteenth century dogs' heads and paws were adopted as an alternative to lions'; the back had tended to become higher during the Gothic period, and in the sixteenth century the X-frame became squarer, with legs

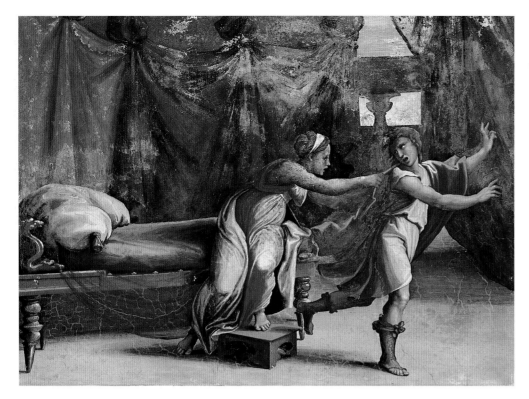

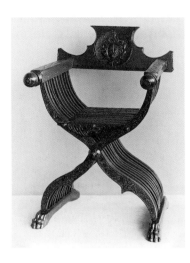

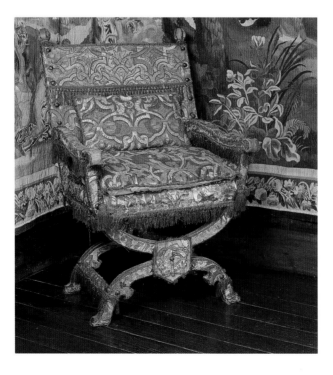

181 A bed in antique Roman style, with a Renaissance interpretation of 'antique drapery' behind: detail of a painting by Giulio Romano of *Joseph and Potiphar's Wife* in Raphael's Logge in the Vatican, Rome; Italian, *c.* 1519.

182 A multiple-legged X-frame chair in carved walnut that incorporates a Gothic ogee arch; Italian (probably Venice), *c.* 1550.

183 An X-frame chair covered in contemporary satin appliqué; English, probably *c.* 1685.

and arms vertical and many more 'turnings' to the knobs. The chair was made both of metal and, in its typical papal or seigneurial form, of wood covered with velvet and trimmed with heavy tassels and fringes. It appears more frequently than any other chair in grand Renaissance portraits, where, apart from the addition of un-antique integral upholstery, it approaches most nearly the antique type. The continued interest is shown most unambiguously in an English X-frame chair that is much in the tradition of the Renaissance despite its late seventeenth-century date [183]; probably from the palace of James II, it is covered in a contemporary upholstery of red satin which owes much to moresque design.

The multiple-legged X-frame chair was revived in archaeological form during the fifteenth and sixteenth centuries, little changed from the antique type; the Venetian example illustrated [182] retains Gothic cusping but combines it with gadrooning and other antique detail.

Sixteenth-century carved 'Michelangeloesque' furniture

Michelangelo exerted an almost totally anti-classical influence expressed in an almost entirely classical language. A judgment made by a noted English Regency antiquarian and furniture designer illuminates the subject, the critic, and the critic's own period: 'Michel Angelo…though possessed of mighty genius, wholly wanted taste; in pursuit of novelty he often lost sight of propriety; in seeking the grand, he frequently found the gigantic, the whimsical, the affected, the extravagant; even in sculpture, with the finest examples of the antique before him, he became *outré*, and a "mannerist"; what wonder then, that in architecture, with only the vicious models of ancient Rome for his models, he should have become still more licentious?'[88]

Michelangelo's influence came through his heroic sculpture, painting, architecture and interior decoration. No modern designer has, directly or indirectly, influenced furniture more than he. The 'licenza' of his architectural designs, inside and out, gave rein to inventive licence in others. His revolutionary interior decoration of the New Sacristy of S. Lorenzo in Florence introduced new combinations of antique motifs likened by Vasari to the fancies of the 'grottesche': 'he [Michelangelo] composed a decoration of a richer and more varied character than had ever before been adopted, either by ancient or modern masters: the beautiful cornices, the capitals, the bases, the doors, the niches, and the tombs themselves, were all very different from those in common use, and from what was considered measure, rule, and order, by Vitruvius and the ancients…this boldness on his part has encouraged other artists to an injudicious imitation, and new fancies are continually seen, many of which belong to grottesche rather than to the wholesome rules of ornamentation.'[89] Vasari was referring to Michelangelo's treatment of brackets, consoles, pediments, etc. as decorative and expressionistic appurtenances. Vitruvius' forebodings were prescient: it was largely the 'licenza' associated with grotesque that allowed modern baroque and rococo to develop as forms of art that used a classical vocabulary but disregarded all the Vitruvian rules. This 'licenza' rapidly infected furniture.

Michelangelo's sculpture was equally revolutionary. He translated the Hellenistic expressionism of the *Laocoön*, the *Farnese Bull* and the *Belvedere Torso* into a forceful and dramatic modern idiom which developed into the baroque expressionism of the seventeenth century. Interior decoration and furniture were deeply affected. The strenuous muscular effort exerted by so many of his carved or painted figures, even when they are inert or passive, gave a new language to furniture, ideal for upholding the heavy forms of cabinets and tables or for giving force and power to state chairs and torchères. Such uses were far from new, but he gave them new meaning, and, over the next few centuries, sculpture took furniture into realms hitherto foreign to it.

The asymmetrical nature of sculpture, and especially the heaped asymmetry of modern sculpture, which was combined with rockwork in the garden sculpture of the wildly imaginative Florentine architect, sculptor, and furniture designer Bernardo Buontalenti (1531–1608), encouraged the development of asymmetry and the use of rockwork in baroque furniture; this had links with the underworld naturalism of the grotto, with Michelangelo's slaves (placed within a Buontalenti grotto), with Giulio Romano's giants, with antique furniture [251] and with such

antique sculptures as the *Tiber* and the *Nile*. Michelangelo's influence extended in other directions. He assisted, for instance, in the development of the all-important cartouche (pp. 120–21).

Vasari describes how the painted gave way to the carved cassone: 'the custom prevailed, after no long time, of forming richer decorations, by carving in natural wood, covered in gold, which did indeed produce most rich and magnificent ornaments'.[90] The flat, vestigially Gothic, painted surfaces of the fifteenth century were largely superseded by assertive sculptural carved ornament which originated in antique stone ornament, in grotesque decoration, or, where the human form was concerned, in Michelangelo. The obvious antique models for carved chests were the numerous late antique sarcophagi – the Renaissance models were Roman, but the inspiration was Hellenistic [185] – carved with crowded, vigorous human figures; during the sixteenth century they inspired chests thronged with humanity. Furniture-makers came relatively late to the sarcophagus shape (as distinct from its ornaments) despite the ancient link between coffin and chest. The sarcophagus had been revived for funerary monuments by the middle of the fifteenth century: a tomb designed by Desiderio da Settignano for a Florentine monument [184] has lion paw feet, clear-cut acanthus decoration, and a bombé shape, all directly inspired by a type of antique sarcophagus. It resembles Italian chests of a hundred years later,[91] and even anticipates Boulle commodes [275]. Renaissance beds often combine a sarcophagus base with columns and canopy, all ingredients found in fifteenth-century tombs. The furniture that resulted from such stony origins, whatever its modern purpose, reflected the weight and solemnity of antique stone.

The antique intent of the carved cassone is unmistakable; sometimes carved walnut was tinted to resemble patinated bronze. The fashion for carved cassoni was led by Rome;

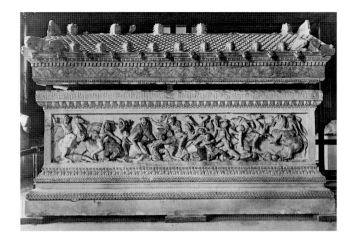

they were frequently executed by expatriate Florentine carvers (Michelangelo himself was Florentine). A fine example of the Roman type, a carved and gilded walnut cassone of the second half of the sixteenth century (one of a pair) decorated with scenes from the life of Julius Caesar [186], shows Caesar crossing the Rubicon and giving the order to break open the public treasury. The classical detail above and below the central panel is strong but static, acting as a framework for the vigorous action of the central bas-relief; the brooding corner figures, which have more or less abandoned the conventions of the bas-relief and stand free, emphasize the gravity of the piece. The style is strongly Michelangeloesque, with little trace of the softer graces of mannerism.

A particular type of cassone, characterized by corner caryatids and a shape that, sarcophagus-like, swells upwards from the base, has been associated on the strength of a drawing in the Uffizi with Buontalenti. A superb example in walnut from after 1550 [187] has female corner caryatids issuing from acanthus, that curve forwards to follow the bulge of the cassone; similar figures later became common as the free-standing but still bulging legs of seventeenth-century baroque tables. Its front is decorated with the tritons and nereids found on Roman sarcophagi and popular in the Renaissance, the most influential modern examples being Mantegna's engraving *The Battle of the Sea Gods* and Raphael's magical *Triumph of Galatea*, which recreates Hellenistic classicism with added graces. The cassone has a strapwork apron and lion paw feet.

Some palatial tables (centre tables were the only items of Renaissance furniture meant to stand in the middle of the room) followed the form of antique slab-ended marble tables. A particularly impressive and large example of a strongly classicizing type [189] – very different from French grotesque variants on the same theme [229] – was designed by the architect Vignola (1507–73) and made between 1565 and 1573 for the Farnese Palace in Rome. Michelangelo had worked on the palace, and early guide-books speak of the slabs (in fact worked by several hands) that support the top as 'by Michelangelo'.[92] It has been pointed out that their forms evoke the ornate vases, candelabra or pedestals seen in paintings by Salviati, Vasari and Zuccaro (all influenced by Michelangelo) rather than their antique sculptured prototypes [24, 36].[93] The bat's wings are an *outré* touch, probably of grotesque origin [217] (pp. 121–22). The top combines the old craft of marble inlay [44], revived in the sixteenth century, with inlay of hardstones or 'pietra dura'; it possibly re-used fragments of ancient marbles brought from the Baths of Caracalla.[94]

184 A detail of the sarcophagus of Carlo Marsuppini, by Desiderio da Settignano, in S. Croce, Florence; Italian (Florentine), before 1455.

right 185 The 'Alexander Sarcophagus'; Hellenistic, *c.* 300 BC.

below 186 A cassone in carved and gilded walnut, with scenes from the life of Julius Caesar; Italian (Roman), *c.* 1550–1600.

bottom 187 A cassone in carved walnut of the 'Buontalenti' type; Italian, *c.* 1550–1600.

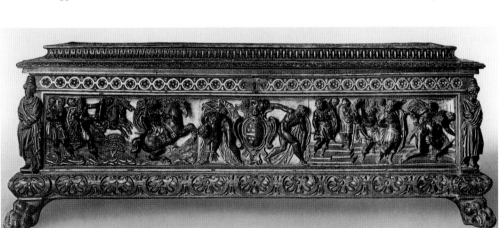

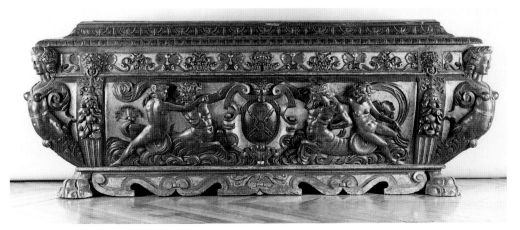

Variations on antique themes

The Italians were not slavish in their classicism. More or less 'correct' imitations of antiquity were outnumbered by new inventions that employed antique forms and ornament. These enormously expanded the furniture types available; within a short time the comparatively narrow range of Gothic furniture had grown into a variety that surpassed that of antiquity itself.

Antique coins and gems greatly influenced the decoration of Renaissance furniture, a process assisted by the multiplication of books depicting them. In 1517 Andrea Fulvio, the friend of Raphael, produced the first book to show coins;[95] its images supplied popular antique motifs that were adapted for all kinds of purposes for centuries. Sometimes images were abstracted from their contexts: in 1548 Enea Vico published the heads of Roman empresses, taken from gems and coins, and surrounded them with inventive and meticulous ornament, mostly mannerist but some highly classical.[96] A parallel but less elegant example is the heads of a hundred and fifty-seven Roman emperors published by G. B. Cavalieri in 1583;[97] he included Rudolf II (b. 1552). Similar publications appeared outside Italy.[98] These books were constantly reprinted; Agustín's book on coins and inscriptions of 1587 was still being republished in the eighteenth century, despite its crude execution. The most splendid of all was Goltzius' series of magnificent woodcuts of Roman emperors' heads[99] published in 1557. It was from such sources – and from antique busts, especially those in roundels – that furniture makers took the 'Romayne' heads that became so popular a motif on sixteenth-century furniture. A Portuguese cupboard of the first half of the century [188] mixes such heads with more contemporary types; in the centre of the top tier is an acanthus mask copied from the antique. Despite the Renaissance ornament there is much that is still Gothic about this piece, including the pattern of the ironwork, the panelled organization of the front, and the linenfold panelling of the sides.

The antique motif of a sphinx-supported table [596] was seized upon by European designers. A strongly sculptural example [597] stood in 1574 in the bedroom of the Grand Duke of Tuscany in the Palazzo Pitti. The marble top is a replacement: the inventory speaks of a top made of amethyst (almost certainly veneered) with a solid silver and ebony cornice, the silver being 'worked in the manner called "damaschina"' (of Damascus). The sphinxes[100] are of sandalwood – originally parcel gilt, but entirely gilded in the seventeenth century to conform with current taste.[101] Archival evidence makes its fabrication attributable to the woodcarver Dionigi Nigetti and its design to Vasari.[102] Vasari's motif of a vase placed upon a table base – the broken curves of its handle demonstrate how antique motifs could be employed in a 'modern' manner – became a commonplace in the seventeenth century and continued [674].

Urns, vases and ewers were a characteristic Renaissance innovation in furniture decoration, increasingly used as the years brought nearer the flamboyant rhetoric of the baroque. In the fifteenth century they had often been part of composite ornament; in the sixteenth they achieved independence. They easily accepted grotesque or other ornament. The most distinguished models available were yet another legacy from the enormously rich Raphaelite store, the vases, urns and ewers of Polidoro da Caravaggio (1490– c. 1535), a painter who had worked on the Vatican Logge with Giovanni da Udine (from whom came the interest in nature reflected in Polidoro's vases). From about 1540 Polidoro's paintings were issued as prints; the most influential were produced in 1582. His influence lasted for centuries.[103]

New types of table included small tables supported on a single baluster leg, sometimes elaborately adorned with fluting, strigillation and gadrooning derived from antique vases and other sources; rectangular tables with heavily carved slab ends, some of which looked antique save that a strapwork cartouche was applied at each end; extraordinary anticipations of the Empire pier table supported on sphinx monopodia; and tables of which the turned legs combined the concave/convex turning of Roman couches with a residue from Byzantine/Romanesque turning. Tables with dolphin legs probably existed by the 1490s.

A table was invented at this time that lacked any antique prototype but looked convincingly 'antique'. The top rested

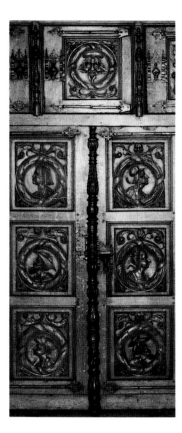

188 A detail of a cupboard in carved oak, decorated with an acanthus mask and 'Romayne' heads and a candelabraform column, and with mounts of wrought iron; Portuguese, c. 1500–1550.

189 The 'Farnese Table', in white and coloured marbles, alabaster, and semi-precious stones, designed by Jacopo Barozzi da Vignola; Italian, c. 1565–73.

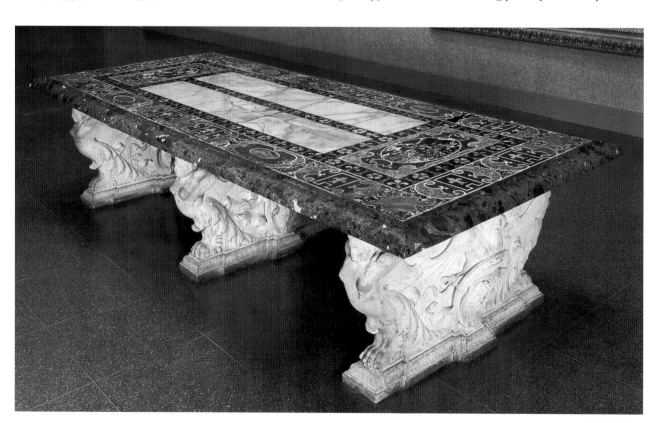

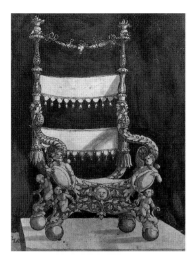

190 A design for a chair by Peter Flötner; German (Nuremberg), after 1535.

right 191 A state chair made of iron by Thomas Rucker; German (Augsburg), 1574.

192 The 'Guicciardini Table', in carved, parcel-gilt and inlaid walnut and other woods, probably designed by Jacopo Barozzi da Vignola and made by Fra Damiano da Bergamo; Italian (probably Bolognese), *c.* 1540–50.

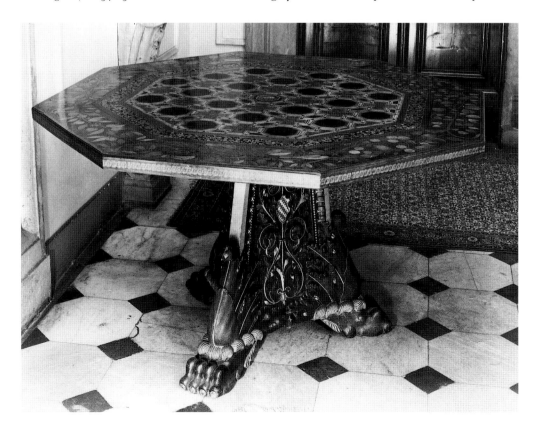

not on legs or slabs but on a solid base with three or four sides derived from antique altars or the bases of tripod candelabra. Revived at the end of the eighteenth century, it became a basic Empire 'type'. A particularly fine example, made probably in Bologna in the 1540s and associated with the intarsia worker Fra Damiano da Bergamo [192], is indeed almost early nineteenth-century in form [407]; the vitality of its carving and decoration proclaim its true date. The design of the octagonal top, decorated with intarsia in a mosaic-like geometrical design containing octagons, surrounded by naturalistic fruit and flowers and geometrical and curvilinear interlace, is traditionally attributed to Vignola, who together with Serlio had designed intarsia made by Fra Damiano. The base is carved with delicate acanthus scrolls, and has lion paw feet.

In complete contrast to the antique restraint of such tables, a design for a chair by Peter Flötner might serve to illustrate a fantastic tale by the Brothers Grimm [190]: it comes from the grotesque stable. Flötner, who lived in Nuremberg, was probably trained in Augsburg and may have gone twice to Italy. The back stiles of the chair begin with winged putto heads that hold in their mouths a garland reminiscent of those in fifteenth-century Italian illuminated manuscripts, an essay in the three-dimensional ornament that was to have such a field-day in the later eighteenth century; they proceed through candelabraform shapes, of which the detail is influenced by antique bronze couches, to foliated scrolls that form the arms. These are supported by figures carrying shields, themselves resting on putti and globes. Two strips with tasselled lambrequins are stretched across the back of the chair. It may be the chair that Cardinal Bernhard von Cles requested Flötner to design for him in 1531/32 – 'an amusing chair, made of wood and covered in leather, in which to rest and sleep during the day';[104] to put 'amusing' in context, it should be recalled that sixteenth-century critics applied the term to the paintings of Bosch.[105] Such elaborate chairs did not remain as designs on the drawing board. 'A chair constructed entirely of iron with many chiselled figures, histories and triumphs, executed with the most highly skilled and exceptional workmanship'

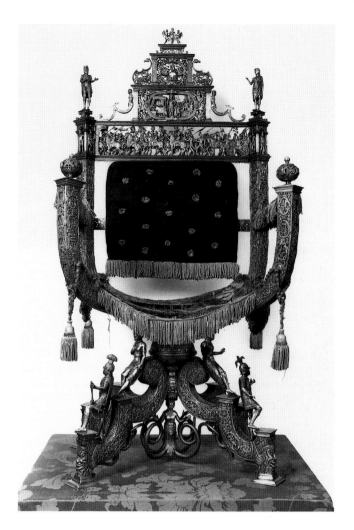

appeared in the 1607–11 inventory of the Emperor Rudolf's Kunstkammer in Prague; it has been identified with a chair signed and dated 1574 by Thomas Rucker, who worked in Augsburg[106] [191]. Its upper part is derived from a Renaissance variant of the X-frame, but the lower X is replaced by a table-like pedestal of scrolls made up of broken curves. The haphazard 'artisan' iconography of this triumph of the ironworker – Rucker also made cutlery, swords and scientific instruments – includes armour, the Trojan Wars, land and sea battles, and a Roman triumph. The scene of the Dream of Nebuchadnezzar in the iron back illustrates Daniel's interpretation of the Dream, 'And the fourth kingdom shall be strong as iron' (might this contain a zodiacal allusion?). The four Monarchies of the world have been traditionally supposed to be represented on the chair – those of the Persians, Greeks, Egyptians and Romans,[107] or of the Babylonians, Persians, Greeks and Romans, according to one's preferred interpretation. It has been deduced that the chair was made initially for 'a high city Council official'[108] – a martial citizen with an interest in empires?

The state bed

The Renaissance bed of state was inspired by four major antique sources; these cross-fertilized each other, resulting usually in a hybrid. They were: the antique, medieval and Renaissance canopy [193, 196]; the antique Roman couch or bed [21, 31]; antique and modern grotesque motifs, including candelabraform motifs; and antique architecture and other stone artefacts such as sarcophagi [10, 65].

An interesting and beautiful form associated with beds was the canopy, pavilion or 'padiglione'. Of antique origin, it had gathered other associations in the course of the centuries and by the time of the Renaissance it evoked antiquity, chivalry, amorous dalliance, and religious and secular state.

193 A canopy supported on candelabraform pillars: a miniature from a manuscript of the *Sonnets and Triumphs* of Petrarch; Italian (Urbino), 1474–82.

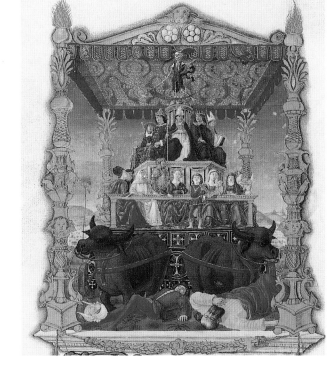

194 A canopied bed with lambrequins and 'archaeological' concave/convex turning, in a fresco of the *Birth of the Virgin* by Girolamo Santa Croce or Giulio Campagnola in the Scuola del Carmine, Padua; Italian, probably *c.* 1500.

A definition of 1611 runs: 'Padiglione: a Pavillion, or Tent for the field. Also a Canopie, or Sparvier [see below] for a bed. Also a Tabernacle. Also a cloth of state.'[109] The term thus included: the draperies that surmounted luxurious beds [180, 261]; the befringed or lambrequined religious ornament which reached its apotheosis in Bernini's immensely lofty catafalque in St Peter's [265]; the state or honorific canopy [193]; and the military tent (and hence the Roman and mediaeval general's headquarters, revived in the eighteenth century as room decoration). Elaborate examples of the padiglione's military and amorous use appear in Books of Hours and romances (military allusions crossed to the civilian bed). The padiglione had an aulic significance similar to that of the *sella curulis*, and in the regal throne beneath its canopy the two came together. Its honorary function was extended to the dead: antique and modern sarcophagi were both surmounted by winged genii holding aloft canopies; a fine example of 1423 surmounts the effigy of Doge Tomaso Mocenigo in SS. Giovanni e Paolo in Venice.

Unless it were hung from the ceiling, the padiglione, like the antique tent, always had a post or posts, and antique tent posts may have suggested bed-posts in antiquity. Exotic and oriental associations hung about it – a wall painting from

195 A canopied bed and chimney-piece en suite, a cradle and a table, in *The Birth of St John the Baptist*, a French copy of an Italian painting, *c.* 1550.

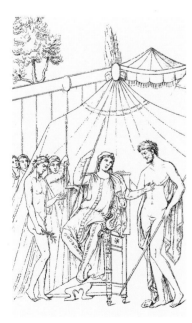

196 A Roman tent with lambre-quins and an enthroned figure in Asiatic dress, after a wall painting in the House of the Lutanist, Pompeii.

Pompeii shows a figure in Asiatic dress on a richly decorated throne beneath what appears to be a padiglione in some very light material; behind is a tent-like canopy with lambrequins and fringes [196]. A suspended padiglione something like the Pompeian example appears in a painting of 1510;[110] to judge from its context, this may be an attempt at historical reconstruction as imaginary as another 'antique' bed complete with canopy, lambrequins and baluster legs displayed in Raphael's Logge. From being used as motifs in antique grotesque decoration (prominent examples survived in the Domus Aurea), the padiglione and lambrequin became key motifs of modern grotesque. Their popularity tended to wax and wane with that of grotesque generally; it waxed with the late eighteenth-century grotesque revival [349].

The padiglione's lingering exoticism was reinforced by the theatrical exaggerations it underwent when used as a canopy or catafalque for fêtes and triumphs, real and pictured. Especially popular were manuscript illuminations of Petrarch's *Triumphs* [193]: triumphs seized the Renaissance imagination, and furthered the 'state' connotations of the padiglione. Exoticism was intensified by the presence of lambrequins – a fine orientalizing canopied and lambrequin'd grotesque bed was thought appropriate for Nebuchadnezzar – and both moved on into chinoiserie. Exoticism did not exclude usefulness; the word 'canopy' derives from the Greek for a mosquito net, and fifteenth-century *moschetti* were padiglioni of lightweight material. The suspended padiglione often had its curtains hitched back; their hovering appearance prompted the English nickname of 'sparver'

(a sparrow-hawk). The canopy with posts is a different matter. It has been said that bed hangings were virtually never attached to the bed itself until about 1490, when posted beds began to appear in Italy. This may be so, but it is difficult to be certain (p. 76).

The antique couch, usually canopied and often with posts, was re-created in fifteenth-century Italian paintings and prints. Mantegna is the prime example: his 'archaeological' approach anticipated that of Raphael. He pictured accurate Roman concave/convex turning in the legs of a canopied couch on which Judith slew Holofernes.[111] Candelabro forms probably taken from antique sculptural decoration appear in paintings by Piero della Francesca and other archaeologically minded painters, and are depicted in considerable variety, greatly elaborated, in surviving painters' sketchbooks of the late fifteenth century [163].[112] They easily blend both with concave/convex turning and with the candelabraform shapes of grotesque. A famous example of a bed with candelabraform posts was painted by Carpaccio in the 1490s;[113] St Ursula reposes in a bed which has a simple architectural headboard with a segmental pediment, a tester with chaste lambrequins, and excessively slender turned posts which must represent metalwork; the horizontally organized inlay on its platform approaches (save for the circular motif) horizontal grotesque of the Ghirlandaio type. The source for the posts could be ancient bronze furniture or, perhaps, some other antique bronze artefact; the resemblance to candelabraform grotesque is probably fortuitous. A bed illustrated in the *Hypnerotomachia Poliphili* during the same decade[114] has

197 A design for a canopied bed with lambrequins and candelabraform bed-posts that spring from mermaids and lion paw feet, by Peter Flötner; German (Nuremberg), c. 1530.

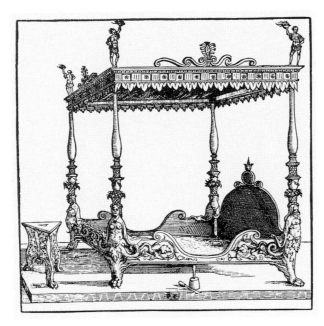

a heavy pawed footboard derived from an antique sarcophagus or slab-ended marble table, a lambrequin'd tester, and posts which look like a combination of the Renaissance baluster with features derived from concave/convex turning; the last influence is confirmed by the rudimentary 'foliage' that holds the base in two of the posts, a feature seen in antique couches (the illustrator has been careless, and omitted it from one of the bases).

The posts of the bed of a *Birth of the Virgin* at Padua [194] come quite close to real Roman turning. The date of the painting is disputed, but its location in Mantegnan Padua makes an early date for its archaeologizing bed completely credible – about 1500 or soon afterwards. Whether real beds existed like this painted bed is unknown, but seems probable.

The same may be said of a couch pictured by Giulio Romano in Raphael's Logge [181]. Its body and leg are each fairly accurately antique [12, 30], although a bronze original has influenced the arms and a stone original the legs. The body anticipates German archaizing furniture of the 1840s, which by then glittered with high French polish. Giulio pictured another 'antique' bed in a scene of Cupid and Psyche that, made up of sculptural ornament from antique and modern sources, is utterly unlike a real Roman bed – but represents an influential 'antique' variant that was reflected in contemporary furniture[115] and was to be made again in the early nineteenth century; its decoration (grotesque masks, acanthus, garlands, and an erotic composition of nymph and satyr against a background of 'antique drapery') is of an entirely Renaissance type. Giulio also pictured a bed with 'antique drapery' at its base and a bed-post of a turned Roman type [116] (not as convincing as Mantegna's); by that time such bed-posts were probably being made. Whether they were or not, the Giulio Romano examples show how one artist could provide prototypes for at least three distinct types of 'antique' bed.

The full-blown three-dimensional grotesque fantasy of sixteenth-century candelabro and candelabraform ornament was eagerly seized upon for bed-posts. They vary a good deal in type, including up-to-date realizations of fifteenth-century ornament, 'archaeological' imitations of concave/convex turning, and candelabraform bed-posts that, allowing for differences, remarkably anticipate beds of the later eighteenth century. Peter Flötner made a woodcut of a sumptuous bed [197] with candelabraform posts showing concave/convex influence and ornament drawn from various antique sources: classical architecture (the entablature of the tester), antique sarcophagi and sculpture (the hairy paw legs, the acanthus scrolls, the armoured figures with torches), and grotesque (the lambrequins, the mer-caryatids with baskets on their heads). Its distinct resemblances to the *Hypnerotomachia* bed have led to the latter being regarded as its inspiration. The scrolled profile of the rails is a bold innovation.

Bed-posts did not always support testers. A Florentine example of the first half of the sixteenth century has posts decorated with swirling strigillation held in acanthus 'cups' related to vases and balusters; they resemble the table and buffet supports mentioned above. The headboard is topped by an opposed scroll composed of grotesque-like dolphins with a cartouche in the centre. The urns on the posts are of a type that was to become ubiquitous.[117]

The hazards of pictorial evidence are demonstrated by two almost identical sixteenth-century paintings, French[118] [195] and Italian.[119] The French version has a bed and chimneypiece with elongated caryatids; the Italian has less attenuated caryatids with lofty baskets on their heads. The French interior has a small round table with goat legs based on an antique original; the Italian table has thicker legs. Children are playing on a cradle in the French painting, which in the Italian becomes a stool. Which painting came first? Probably the Italian rather than the French. The animal-legged table is more likely to have originated in Italy, based on an antique stone artefact, and been fined down by a French painter; the terms are of an Italian type that may be seen, for instance, in the gardens of Caprarola; they have lost their volumetric qualities in France. Each painting, according to its nationality, has been used by eminent furniture historians to illustrate French or Italian furniture; had only the French version survived, it would have been unchallengingly accepted as showing French furniture.

Two mattresses are on the bed; three or more are said to have been used in Tuscany[120] – a curious coincidence if then peculiar to that region, since its original inhabitants, the Etruscans, were noted for their piled-up mattresses. The painting reflects reality in the sparse furnishing that allowed dominance to the bed. Documentary evidence confirms that grandees slept in grandly bare surroundings; when Henry III of France stayed at the Palazzo Foscari in Venice in 1574 his bedchamber contained only the bed, one gilded armchair under a cloth of gold canopy, and a black marble table;[121] compensation for bareness was provided in the care with which each piece of furniture emphasized regal state.

IV *Chapter 4* Furniture and sixteenth-century architectural classicism

198 A carved and painted model of a design for the façade of Florence Cathedral by Bernardo Buontalenti; Italian (Florentine), *c.* 1587.

199 The Tempietto, S. Pietro in Montorio, Rome, by Bramante, 1502.

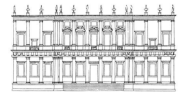

200 The Palazzo Chiericati, Vicenza, after a drawing by Palladio, *c.* 1550.

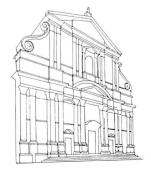

201 The façade of the church of the Gesù, Rome, by Giacomo della Porta, *c.* 1580.

ITALIAN SIXTEENTH-CENTURY architecture steadily moved away from the antique classicism represented by such buildings as the Tempietto of Bramante in Rome (1502) [199] towards baroque expressionism. The tensions are often contained within one building: the theatrical drama and vigorous rustication of Giulio Romano's Mantuan Palazzo Te of 1527–34 [230], for instance, is accompanied by refined classical detail. Heavy rustication strengthens Palladio's palaces, although his name is principally associated with cool porticoes of unfluted Ionic and Corinthian columns [200], topped by tranquil pediments and statues. The dynamic motif of Giacomo della Porta's façade of the Gesù in Rome [201], a development of Alberti's invention of the giant scroll supporting a central pediment [154], became part of the baroque (Part V); it is reproduced almost exactly in a splendid Augsburg table cabinet of about 1580–1600.[122] The close connections between architecture and furniture are apparent in a polychromatic wooden model of a design for Florence Cathedral by Buontalenti [198];[123] set on a stand and with the scale of the upper storey adjusted, the façade could almost be a grand late Renaissance cabinet. Some of its decorative motifs originated in Roman theatre decoration; others, such as the balustrade, or the strapwork cartouche beneath the pediment, crossed from contemporary interior decoration. The Gesù's swooping giant scroll has become a proto-rococo flourish.

France developed an architectural and sculptural classicism from the 1530s onwards which coexisted first with architectural grotesqueries and then with the rhythms of the baroque, eventually resurfacing as late seventeenth-century French classicism. It is not surprising that France became a vehicle of classicism: the High Gothic of Amiens or Bourges demonstrates that an interest in harmony and lucidity was nothing new there. The sculptor Jean Goujon evolved a style which has amazing similarities to that of ancient Greece. Goujon collaborated with Philibert Delorme (d. 1570), the greatest of sixteenth-century French architects and the first Frenchman to study antiquities in Rome, where he dwelt for three years (1533–36).

Delorme's illustrated architectural books became highly influential. Such books (as distinct from prints of ornament) became important sources of ideas for furniture-makers in the sixteenth century. They were published in Italy, France (for most of the sixteenth century, Frenchmen published the greater number of engravings of Roman antiquities), and elsewhere. Many Roman publications were for the tourist, but others were more weighty in both senses, depicting Roman buildings and other antique and modern artefacts in a manner circumstantial enough to be useful to scholars and designers. These books included: books on antique ruins, reconstructions and sculpture (often together); books on the principles of antique Roman architecture; books that used antique architecture as a springboard for original invention, usually in the grotesque mode (for these, see pp. 123–25); and books on antique artefacts such as coins, gems, altars, and sarcophagi.

Only a few of these numerous publications can be mentioned here. An excellent example of the book on antique ruins and reconstructions that includes detailed plans and elevations of ancient Roman buildings was published in 1552 by Antonio Labacco; within twenty-four years it had gone into seven editions.[124] To Labacco, ancient architecture 'seemed the work not of men, but of giants'.[125] A grand volume on antique buildings and sculpture was published in 1575 by Antoine Lafréry;[126] it depicts Roman buildings both in ruin and reconstructed; the large section on antique sculpture includes the *Nile*, and the bas-relief of the 'Visit of Bacchus' that eventually found its way into the Townley Collection in England and may have influenced the furniture of Henry Holland. In 1547 came the first French edition of Vitruvius; in 1548 Walter Rivius published an illustrated version in Nuremberg that expressly addressed itself to, amongst others, cabinet-makers.[127]

As might be expected, Italian books that expounded the principles of Roman architecture inclined towards Vitruvian 'classical' rather than grotesque 'anti-classical' idioms. Practising architects often included their own designs amongst the illustrations of antique buildings; the preeminent example is the greatest book on Roman architecture produced during the sixteenth century, Palladio's *Four Books of Architecture* of 1570,[128] which has an informative and coherent text and remained in use for centuries. The fourth book was especially valuable for those interested in Roman design: it pictured a large number of major temples, such as those at Nîmes (in Provence) and Tivoli; details of buildings in Rome include the frieze from the Temple of Antoninus and Faustina with its candelabra and addorsed griffins, which, reproduced and adapted many thousands of times over the following centuries, became one of the commonest of classical furniture ornaments; almost equally influential was a splendid frieze from the Temple of Fortuna Virilis depicting putti, ribbons and swagged garlands. The fourth book included a modern building, Bramante's Tempietto.

Sebastiano Serlio (1475–1554), who moved to France in 1541, published architectural books in Italy and France in an order confusingly at variance with their numbering.[129] One of the greatest sixteenth-century sources for architecture and decoration, Serlio's architectural classicism greatly influenced furniture design. Stylistically, architects and furniture-makers had much in common; in some cases, indeed, architecture was translated more or less directly into furniture – Italian ladies leant to pray at miniature Roman triumphal arches [202], hardly surprising when for years the Offices of the Church had been sung from choir books depicting them [212].

Doorways and chimneypieces in stone or wood often resemble grand furniture, or shared motifs with other prominent pieces of furniture in the same room; for instance, caryatids adorn both bed and chimneypiece in the French version of the Franco-Italian bedchamber [195]. Wooden monumental doorways were frequently designed by architects and made by craftsmen who also made furniture. Master craftsmen travelled – the Escurial in Spain has magnificent inlaid doorways made by German craftsmen – and travelling craftsmen meant travelling style. Serlio remarks that chimneypieces 'are truly grand [large] ornaments of dwelling places',[130] and illustrates many designs for strongly architectural ones, adorned with vigorous scrolls, caryatids, and boss-like octagons; the supports are plain,

202 A prie-dieu in walnut; Italian (Florentine), c. 1500-1550.

fluted, or ending in paws. A Serlio design for a curved chimneypiece [203] – the curve smoothed the transition to the flat wall behind it – uses a motif that also occurs on sarcophagi and on the chests derived from them. The curved tops of seventeenth-century case furniture [245] could have derived from sarcophagi or been influenced by such chimneypieces.

Such 'architectural' furniture not infrequently retained a stony appearance. A pietra dura table from the early seventeenth century [204], monumental, strong and simple, with strongly contrasting shapes and colour, is in general form almost like a chimneypiece, retaining the bosses and even the 'keystone' so often found there. The tapering legs, which derive from the base of a term or caryatid, lack the vertical uprights that would have backed them in a chimneypiece, and therefore appear more slender; they continued in use for centuries [248]. The pattern on the base continues the architectural theme in its resemblance to that of a ceiling or floor. This type of table occurs in variants that have more delicate proportions and decoration.

Furniture was frequently related in design to other features of 'architectural' interior decoration; details of the top of the Vignola table [189] correspond with those of floors and ceilings he designed for the Farnese villa at Caprarola.[131]

The square, rectangular, hexagonal and octagonal wooden compartments of the elaborate and heavily panelled ceilings of antiquity had been translated into stone, stucco and paint as 'coffering' and 'panelling' in antiquity itself [15]; coffering and panelling had been used to decorate antique and Byzantine [84] furniture, and the Renaissance followed the same path: what could be more in keeping than heavy cupboards and cabinets decorated with motifs allied to those on walls, ceilings and floors? Not infrequently, ornament such as gadrooning moved from furniture to ceiling [225]. Canopied beds had ceilings, and throughout the four hundred years of their use the design of the inner canopy frequently followed ceiling fashions. It is sometimes impossible to tell whether free-floating designs were intended for ceilings or furniture.[132] A London edition of Serlio of 1611 dedicated to 'Artificers of all sorts' commented that the ceiling designs it contained could be applied to furniture, and a Dutch cupboard of about 1640 followed this advice by using a Serlio ceiling design unaltered to decorate its doors (the same versatile design was used by Borromini for the dome of S. Carlo alle Quattro Fontane in Rome).[133] Another Dutch oak cupboard, dated 1607 [205], articulated with Ionic pilasters, has doors decorated in a manner that strongly resembles compartmented ceiling designs; the

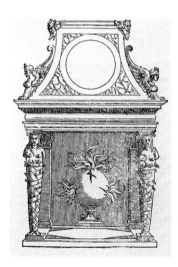

203 A design for a chimneypiece by Sebastiano Serlio, first published in Book IV of his *Architettura*, 1537; Italian, printed in Venice in 1584 (from *Tutte l'opere d'architettura di Sebastiano Serlio*).

right, above 204 A centre table inlaid with pietra dura in contrasting marbles; German (Munich), c. 1625–30.

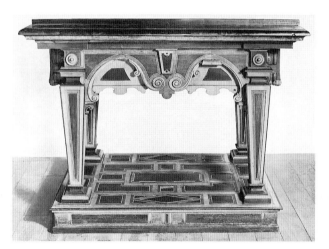

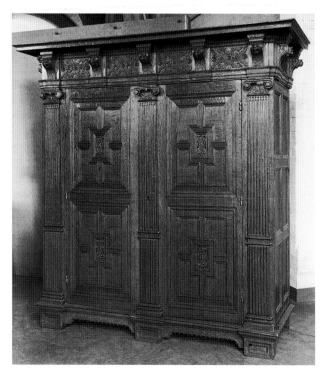

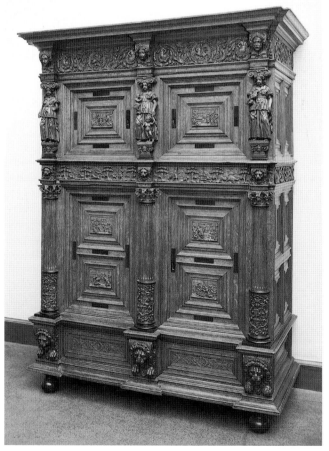

left 205 A cupboard in carved oak; northern Netherlands, 1607.

above 206 A two-tiered cupboard in carved oak and ebony; northern Netherlands, c. 1630–50.

entablature is decorated with carved consoles and interlaced strapwork. Despite the mannerist detail, the cupboard displays a classicizing restraint.

One of the commonest migrations from stupendous architecture to decoration [212] and domestic furniture [202] was the triumphal arch. Another was the orders arranged in their hierarchy, as on the exterior of the Colosseum: Corinthian above Ionic above Doric. Serlio's representation of the two stages of the interior of the Pantheon already looks much like the front of an 'architectural' cabinet.[134] A late Renaissance Dutch cupboard in oak and ebony [206] has heavy decoration that obscures the basically clear architectural articulation of the piece. The front is organized as a two-tier façade of Ionic above Corinthian (the Ionic caryatids, Faith, Love and Hope, are in the classical dress revived in the fifteenth century); the fluted Corinthian three-dimensional pillars are decorated with scrolls and birds: had the cupboard been earlier they might have been in a grotesque manner. The base on which the pillars rest is supported with consoles in a manner used by Michelangelo in the Laurentian Library, here ornamented with lions. The heavy panelling of the doors and sides is like that of coffered ceilings; the carved panels show scenes from the life of Susanna, taken from prints after the Dutch Italianate painter Maarten van Heemskerck published in 1563. The lower frieze is decorated with hunting scenes in a wood, the upper with peopled scrolls in a manner that approaches the auricular. The 'bun feet' are a form of truncated turning.

The rivalry with Raphael felt so keenly by Michelangelo (Raphael was classical in his unruffled calm, Michelangelo expressionistic in his angry scorn) was projected into the forms of cassoni; those in antique taste were frequently adorned with the orders and coffering combined with decorative architectural sculpture, quite different from Michelangelo's expressionistic versions of Hellenistic baroque; such çassoni exhibit an elaborate grandiosity and controlled richness that have much of the antique Roman spirit. The sculptor and architect Jacopo Sansovino (c. 1486–1570), a classicizing designer influenced by Raphael, arrived in Venice in 1527 and erected magnificent buildings in the latest style, after which the use of antique motifs in Venetian furniture increased. A Venetian cassone is accordingly decorated in virile relief in the manner of a Roman temple frieze [207]; the central motif of a wreath

containing a coat-of-arms edged with strapwork is supported by splendid winged male and female centaurs with acanthus scroll 'tails'; the centres of the scrolls contain animal and human torsos, and the detail includes snails, birds, ribbons and putti. The clear-cut scrolls reveal the same antique influences that helped the Lombardi to produce such beautiful work [157]. The ungilded carved work stands out from a gilded and tooled background. The frieze is supported on a strongly gadrooned base.

Architectural perspectives continued as an ingredient of the decoration of furniture, which was dignified as well as adorned by depictions of antique (albeit ruined) and grand modern classical architecture. The rules of perspective were introduced from Italy into Germany by Dürer, whose illustrated work on 'Measurement' was first published in 1525 at Nuremberg; by 1538 it had been reprinted four times, at Paris and Nuremberg.[135] A whole series of books, especially German and Italian, appeared in the sixteenth and early seventeenth centuries on decorative perspectives. The perspective painter Vredeman de Vries published in Antwerp in 1601 a reprint of earlier designs from various sources, *Variae Architecturae Formae*, which contained twenty horizontal and vertical oval designs of perspectives derived from a book by Du Cerceau;[136] these were meant for inlay and marquetry; the book also includes perspectives of ruins.

The *Geometria et Perspectiva* of Lorenz Stoer (Augsburg, 1567), another book specifically intended to provide models for furniture, has images of a different type [209], outlandish geometric forms combined with ruins that themselves partake of geometry and animated rollwork; in the midst of all hangs a spiked macehead of a particularly Germanic Gothic type. Stoer's images are reflected in the designs of German marquetry, which reached virtuoso heights. Two pieces give some idea of the achievement. The marquetry of the first, the 'Wrangel Cabinet', a table cabinet made in Augsburg and dated 1566 [208], shows the strong influence of Stoer – although it preceded what is thought to be the first edition of Stoer's book. The elaborately decorated doors (birds and monkeys) open to reveal compartments and drawers arranged in a stately two-tiered Corinthian architectural arcade (the columns are alabaster); to the highly coloured marquetry are added carved decoration in boxwood and antique heads adapted from coins. This, perhaps the first *Kunstschrank* or cabinet of curiosities, is certainly one of the most famous. The second example, a

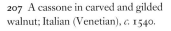
207 A cassone in carved and gilded walnut; Italian (Venetian), c. 1540.

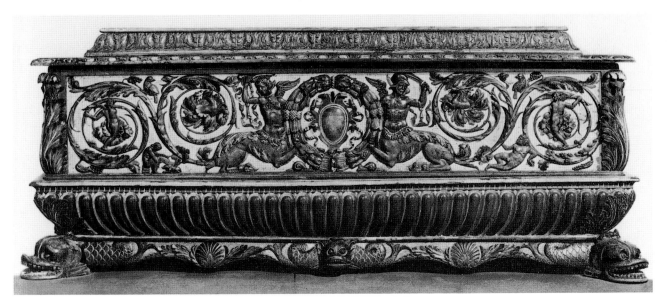

208 The 'Wrangel Cabinet', a table cabinet for curiosities, with marquetry and carving in boxwood and various other woods, some stained green and shaded by scorching, and alabaster columns; German (Augsburg), 1566.

below 209 A design for marquetry by Lorenz Stoer; German, published in Augsburg in 1567 (from *Geometria et Perspectiva*).

below right 210 A table cabinet with marquetry in various woods depicting perspectives; Mülhausen (Mulhouse), *c.* 1550.

two-tiered architectural cabinet signed and dated 1565 [178], is articulated with Ionic and Doric pilasters decorated with candelabra issuing from vases; dentils mark the entablatures of both tiers. Above a panel decorated with moresque intarsia is a fine perspective of a Gothic, rather than classical, ruin set into an adaptation of a triadic arch that itself has a little row of Gothic arches marching across it, repeated in a modified form above the pilasters at the lower stage. The basic formula of this piece was to be repeated for centuries; it occurs in Empire and Biedermeier furniture.

There were many kinds of perspective decoration. The often crude inlay seen on the well-known English 'Nonsuch chests', probably made by immigrant Flemish or German craftsmen, frequently has a Gothic flavour; its resemblance

to the fantasy architecture of Henry VIII's grotesque palace has given the chests their name. Serlio's well-known perspectives for Comic and Tragic scenery, published in 1584, approach the emblematic: Gothic (obviously thought undignified) architecture and open arcades were thought appropriate for Comedy, but the 'grandi personaggi' of Tragedy have houses in classical style.[137] Did perspectives once carry meanings now lost? Some are amazing in a severe, cubic way; simple as shapes, but so intricately involved in disposition as to approach archaeological excavations in appearance, they seem, with their flights of steps and superimposed landings, almost to anticipate the labyrinthine *Carceri* of Piranesi. It is difficult to accept that such enigmas were only decorative.

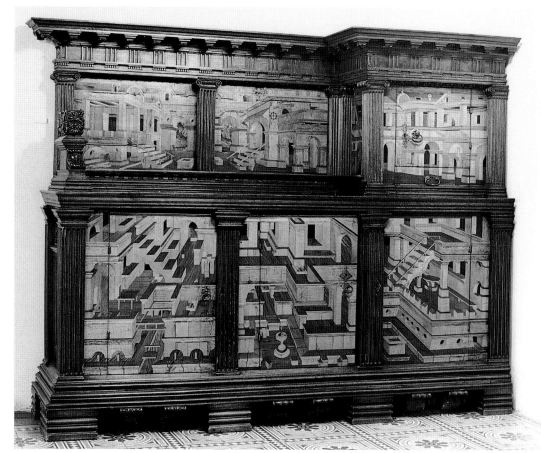

Grotesque and grotesque hybrids, 1530–1680

211 A term of the Composite order, by Hugues Sambin; French, published in Lyons in 1572 (from *L'Oeuvre de la diversité des termes*).

THE IDEAS AND ORNAMENT discussed above came together in an extraordinarily rich, often confused hybrid style[138] that promiscuously mingled motifs taken from antique architecture, sculpture, and ornament with those from grotesque and moresque; it was used for everything, from buildings, interior decoration and furniture to tombs and fountains. Aesthetically, it was the victory of the barbarians all over again (the influence of Flanders and Germany was strong) – but a victory ennobled by antique content and allusion.

Sometimes more than a dash of Gothic was added; even Giulio Romano indulged in a fully fledged Gothic design for a Bolognese church.[139] Gothic motifs entered the peopled scroll, which had a strong Gothic tradition. Northern prints lovingly depict such 'Gothic' plants as the cabbage, a plebeian vegetable in consort with the fig and acanthus of Arcadia. German and Flemish furniture monsters resemble the Gothic monsters of illuminated manuscripts. At the end of the sixteenth century Nuremberg and other Northern towns saw something of a Gothic revival. Grotesque was easily turned into 'Gothic' grotesque. [211]

The sixteenth century was not content merely to look backwards and exploit this enormously rich, mixed vocabulary (as did the nineteenth century). It invented highly important new ornaments, such as strapwork and the cartouche; before discussing them, a mention must be made of an intellectual and literary invention that intimately affected furniture and furniture textile ornament – the emblem.

The emblem

The Renaissance was passionately interested in the emblem, abstruse and trivial as it may seem to modern sensibilities (which are so taken up with the subtleties of the logo as to pay a fortune for an elf on a telephone box!). An 'emblem' consists of a picture that illustrates an accompanying pithy verse and motto. Its illustrations came from mixed sources in which antique mythology played a predominant part; its mottoes utilized ancient and modern proverbs and maxims.

In ancient Greece, cities and private persons employed emblems and mottoes. The beautiful and amorous general Alcibiades excited displeasure by his shield of gold 'which bore none of the usual ensigns of his country' (in Athens, this would have been Athena, the olive or the owl [413]) but in their stead a Cupid bearing a thunderbolt.[140] Antique wall paintings were accompanied by epigrams in a way that much resembled Renaissance emblems: an epigram was inscribed on a Pompeian wall accompanied by a painting illustrating it.[141] The influential Pompeian painting of Perseus and Andromeda is exactly reproduced in the words of a Greek poem;[142] the thrones of the gods [396, 452], repeatedly painted on Roman and Pompeian walls and revived by Renaissance painters of grotesque, are emblems without literary content.

The modern pictorial emblem began as a neo-classical literary conceit; its inventor, Andrea Alciati, had intended merely to produce epigrams,[143] but the printer had added pictures. Alciati explained the emblem's manifold uses in his *Emblematum Liber* of 1531, the most popular of emblem books: 'if anyone wishes to fill out what is empty, adorn what is bare…he may take from his emblem book, as from a well-stocked cupboard, something that he may inscribe or engrave on the walls of his house, the glass in his windows, on curtains, hangings, pictures, vases, statues, signet rings, garments, a table, the back of a couch, armour, a sword.…Then the things of common use will present on every side a form endowed with speech.'[144]

The other influence on the emblem was the Egyptian hieroglyph; emblems attempted to create a modern equivalent of the hieroglyph as it had been misinterpreted from the cryptic accounts of ancient authors.[145] The Italian hieroglyph fashion was fuelled by a book written probably in the fourth century AD by 'Horapollo' (Horus Apollo), thought to be an Egyptian priest. It was translated from Greek into Latin in 1517 by Filippo Fasanini, who mentions the decorative applications of hieroglyphs to beds, doors and ceilings.[146] Alberti, who knew Horapollo's book, said that 'the Aegyptians employed Symbols in the following manner; they carved an Eye, by which they understood God; a Vulture for Nature; a Bee for King; a Circle for Time; an Ox for Peace, and the like'[147] (one thinks of the bees scattered over Napoleonic furniture: a tunic embroidered with bees was found in the tomb of the Merovingian Childeric). An emblematic rather than aesthetic interest in Egypt is demonstrated in the delicate Egyptianizing fantasies, which include hieroglyphs, painted by Pinturicchio in the Borgia apartments in the Vatican: the Egyptian theme was an allusion to a Renaissance genealogical investigation of Firbankian outrageousness – a Dominican monk's 'proof of the descent of the Borgia pope Alexander VI from the Egyptian god Osiris-Apis (the Pope had identified the god carried on his litter with himself carried on his *sedia gestatoria* [2]).[148]

A passage in which a Renaissance writer speaks of the art of inlay helps to communicate the contemporary importance of emblems for the furniture of the Renaissance. It makes clear the immense distance between twentieth-century literal-mindedness and the sophisticated range of associations which affected seventeenth-century furniture decoration. The point from which the author departs is the derivation of the word 'emblem' from the Greek word for mosaic or inlaid and applied designs (a fact mentioned by Alciati in his preface): 'It is all skill of the intelligence and the hand, working the one to select, the other to weld together those different slices of wood, having a certain colour, a certain grain, a certain pattern, and alternatively so light and clear and so shaded and dark, that when joined together, whatever one intended comes out as an effect of their union: but with a shading from one leaf to another, with such mingling of colours, that it does not seem to be a grouping of many slices of various trees and of various woods…but a work born of a piece in one tree trunk, which quite by chance appeared when splitting it.…In such works of inlay, one wishes to make it appear as if nature had imitated art, contriving in such a way that art may not be distinguished from nature [208]. Is not the source of wonder, and therefore of delight in such works, the fact that one sees one thing used to express another? the deception being all the more

212 A torn-paper 'cartouche' superimposed upon a triumphal arch with an architectural superstructure: a miniature from a gradual written in Cesena; Italian, 1486.

innocent in that in the whole conception of a false thing there is yet no element which is not true. The same thing happens when we use anything taken from history [186], from fables [229], from nature and art [216], to represent something in the moral order which is not: in such a way that there should be so much appropriateness and correspondence of reciprocal proportion between truth and its likeness that the whole, so to speak, should not seem to be an artifice of the brain but the *philosophy of nature, as if nature had written, almost in cipher, her precepts everywhere.*'[149]

This is 'glamour', the magic dust thrown upon the eyes by the sorcerer, and it helps to explain the meaning to contemporaries not only of pictorial inlay but of precious stones, the last intensified by the Renaissance revival of Greek interest in their magical associations. It illuminates also the associations attached to metals, ebony, pearls, lapis lazuli, amber, hardstones like those used to decorate Renaissance cabinets, Palissy's concepts of Nature and Age (p. 123) and so on. Iconography was not confined to the high arts of painting and sculpture, it was extended to everything with which Renaissance man surrounded himself. The choice of furniture motifs (as of poetry) was influenced by considerations now forgotten (who now reads a sonnet with the thought that it is an emblem without a picture?).

This book concentrates on visual appearances rather than meaning. But when Mary Queen of Scots, who had time to reflect upon meaning, embroidered the counterpane of a grand bed, she included 'A Tree planted in a churchyard environed with dead Men's Bones, the word *Pietas recovabit ab Orco.* Eclipses of the Sun and Moon, the word *Ipsa sibi lumen quod invidet aufert*, glancing, it may appear, at Queen Elizabeth.…A wheel rolled from a Mountain into the Sea, *Piena di dolor voda de Speranza*; which appeareth to be her own, and it should be *Precipitio senza speranza*',[150] and so on – all, of course, emblematic of her own unhappy condition.

The grotesque particularly lent itself to emblems.[151] Pirro Ligorio (*c.* 1513–83) has much to say about the emblematic meanings of grotesque, which followed two main paths. The first was the general way its fantastic and dreamlike forms echoed biblical texts in shadowing forth the vanity of life; to Ligorio as to Alciati, grotesques 'represented something in the moral order which is not', 'ancient pictures…which have the significance of moral documents, amongst other things signifying immortality, sweet things changing to bitter, death, envy, hatred, lust, and all evils…'[152] The second was the emblematic meanings of grotesque subjects often found in furniture: the satyr [211] and the naked woman, which meant lasciviousness, the (deceptive) beauty of the siren, which meant the lover's treachery, the sphinx, which signified prudence [232, 597], and so on.[153] Monsters were emblematic of the gods,[154] and Ovid's monstrous metamorphoses symbolized mundane desires that end in vanity.[155] Ideas connected with Nature and metamorphoses found realization in the casts from nature practised by Paduan bronze sculptors, exploited by Wenzel Jamnitzer and his followers to create naturalistic ornament – insects, small reptiles, fruits and grasses – of which the counterpart was possibly found on sophisticated furniture [227]; and in the frogs, toads, butterflies and caterpillars that, living examples of metamorphosis, were introduced into the still lifes of flowers that in the seventeenth century were to become so conspicuous an ornament of furniture.

The influence of emblems lasted far longer than might be imagined, and merged with that of iconologies. The latter were the pictorial allegories of such ideas as the Virtues, the Vices, the Seasons, the Continents, the Senses, the Arts, the Rivers, the Muses, and so on, that, also derived from hieroglyphs, resembled emblems without any literary content. The first and most notable to be published are contained in the *Iconologia* of Cesare Ripa (1593 and 1603); his book went through many editions over many years; a monumental edition in five volumes was printed at Perugia between 1764 and 1767. In 1776 Winckelmann attempted to reform iconology according to his own brand of neo-classicism.[156] A version of Ripa was issued in 1778 by George Richardson, a pupil of Adam;[157] the images that people Richardson's pages are very like those from the House of the Vettii and other antique sources, and resemble motifs inlaid in marquetry and painted on 'Hepplewhite' and 'Sheraton' furniture. By that time, the distinction between emblems and allegories had been obscured. Sheraton suggested that as centaurs 'seem to have been a rebellious race, they may be introduced into such subjects as are intended to show the odium of such conduct'; griffins 'if you please, may be introduced into subjects intended to represent covetousness; or they may be placed over cabinets where treasure is kept'. However, 'in opposition to these vanities, I cannot well omit whispering into the ear of the reader, that "To us there is but one God, the Father, of whom are all things." 1 Cor. viii.6.'[158]

When emblemism could be put on its head and stigmatized as 'vanity' (what would Pirro Ligorio have thought!) it was doomed as a serious exercise of thought. But it staggered on. Whole pages of Thomas Hope's furniture book (p. 216) are steeped in emblemism, to the extent of decorating entire rooms, including the furniture, in accordance with an emblematic idea. He inscribed a cradle (presumably that of his son) with 'SPES' (Hope) and ornamented it 'in gilt bronze, with emblems of night, of sleep, of dreams', including poppy heads.[159] Percier and Fontaine travelled along the same path. The furniture of Napoleonic

213 The influence of Flemish expressionism on grotesque ornament: a strapwork frame that includes among its motifs broken curves, 'imprisoned bodies', and monsters of a Northern type, surrounds an overmantel painting of *The Tribute to Caesar* designed under the supervision of Philibert Delorme, in the château of Écouen; French, after 1547.

France was deeply emblematic: 'these warriors who brought home so many crowns that they stuck them even on the arms of the chairs, I must say I think it's all rather fetching!'[160] The pages of the issue of the *Art Journal* that describes the contents of the Great Exhibition of 1851 are drenched in the wettest, most simpering kind of emblemism. Emblemism enjoyed a minor revival with the Symbolism of Art Nouveau furniture (p. 310) and Surrealism (which added to it Viennese psychological theories, the twentieth-century equivalent of Renaissance witchcraft but lacking the background of religion).

This takes us far from the Renaissance, but it illustrates how far the emblem shed its light, growing dimmer as time went on.

Fantasy

The visual style of the early and High Italian Renaissance was rational. When they needed nasty monsters, Uccello or Raphael looked at Gothic monsters; Filarete included mediaeval 'grotesques' in the decoration of his bronze doors to St Peter's. Classical monsters were often beautiful or majestic: Verrocchio re-created harpies,[161] Antonio

Rossellino placed unicorns on his tomb of the Cardinal of Portugal, Andrea del Castagno employed impressive bench-end sphinxes.[162] Some Renaissance monsters – the angels of Botticelli, the winged putti of the *Sistine Madonna*, the mermaids of *Galatea*[163] – have become archetypes of beauty. But even beautiful monsters seem anomalous in the grandest High Renaissance art: there are no monsters in the *School of Athens*, and Michelangelo in the Sistine Chapel ceiling robbed his angels of their wings to create the famous 'ignudi'.

The monstrous was subjected to Renaissance realism. The intellectual authority for realism was Aristotle, who saw attractions in ugly veracity: 'All men, likewise, naturally receive pleasure from imitation…in viewing the works of imitative art…we contemplate with pleasure, and with the *more* pleasure, the more exactly they are imitated, such objects as, if real, we could not contemplate without pain; as, the figures of the meanest and most disgusting animals, dead bodies, and the like.'[164] Renaissance artists extended the attractions of veracity to ugly fantasy, and gave monsters conviction by compounding them from real parts, as advised by Cennini.[165] Leonardo painted a terrifying beast from disparate parts of lizards, hedgehogs, newts, serpents, dragonflies, grasshoppers, bats and glow-worms; he made it issue from a cavern, breathing fire and smoke;[166] he gives a recipe for a fabulous beast in his *Trattato*. Michelangelo approved of monsters where they were appropriate.[167]

Monsters were only one part, albeit an important part, of fantasy. The brief reign of harmonious rationality in the High Renaissance was followed by the fantasy of 'maniera'.

A sixteenth-century theorist, one of the many who thought fantasy a shaping force that affected the whole galaxy of the arts and design, identified an extraordinarily miscellaneous list of its manifestations 'in painting, sculpture and architecture, and in stucco, stone, marble, bronze, iron, gold, silver, *wood, ebony, ivory* [author's italics] or other materials…'; they included 'harpies, festoons, clocks, chimerae…all such things enrich art, and create very great beauty'.[168]

Furniture was greatly affected by the all-pervading influence of mannerist fantasy. As were other artefacts. Enea Vico claimed that his well-known twenty-four vases and ewers published in 1543 were after the antique, but they are exaggeratedly mannered. The swelling, sometimes serpentine shapes, balanced on disproportionately small bases, act as host to various monsters and metamorphoses: for instance, a female monster bends backwards from the bulging body of a vase, her hair turning into acanthus that forms the handles; a ewer[169] has a female in the same posture, with bat wings and two tails that unite in a complex knot; clamped to her breasts with cruel effect is a huge bird's claw; other motifs include satyr masks and a crab. The lips of Vico's vases often display the nascent auricular style (pp. 130–34), as do his candlestick designs. The motifs pictured in the vases reappear all over Europe in all kinds of media, including furniture [187].

Beauty and ugliness

Much sixteenth-century decorative fantasy has links with the grotesque. Grotesque developed two extremes, mingled to make intermediate types. The first, that of Pinturicchio, Perugino and Raphael, was blithely hedonistic, festive, capricious and irrational, brightly coloured, lyrical, epicurean. Some of its qualities are caught in an English description of 1612: 'The form of [grotesque] is a generall, and… an unnatural or unorderly composition for delight sake,

214 A 'Doric' cooking scene, by Wendel Dietterlin; German, published in Strasbourg in 1598 (from *Architectura*).

advocated a perfect chord followed by an 'unpleasaunt discord';[172] the madrigals of Gesualdo follow this precept explicitly. Ugliness did not exclude style: Bronzino portrayed the startling ugliness of the profile of the poetess Laura Battiferi[173] with beautiful results. Much of the later art of Michelangelo has an ugly beauty.

The union of ugliness with a derisive and perverse humour seen in much sixteenth-century grotesque has given the word 'grotesque' its modern pejorative meaning. This expressionist element, allowed ingress by the un-Vitruvian irrationality of grotesque, was primarily imported from Northern European art (although the Gorgon heads of archaic Greece are ugly enough). It is seen in concentrated form in the images of Wendel Dietterlin (1551–99). Flemish prints are usually more extreme than German, and it would be difficult to be more extreme than Dietterlin. In his savagely energetic, tortured prints the cruelty is vividly overt, usually in the form of hounds tearing at stags or unicorns [217]. Anti-classicism is explicit in the mockery of his Doric cooking scene, in which a caryatid cook has his belt hung with a cleaver and plucked birds [214]. There is play in all this, but the play has become nasty – 'grotesque'.

A modern German writer, in speaking of the Germanic 'old-world, underground neurosis', comments that 'always the crass, obscenely comic figure of the "divel" has been nearer [to the German folk] than the Eternal Majesty'. This 'crass, obscenely comic…divel' came from an underworld that spoke 'Deutsch' (German and Flemish); he was supported by other contemporary 'underworld' neuroses (it was in the 1490s that the real persecution of witches began), by 'fantastical, dark-corner, misanthropic, torture-chamber thoughts, Spanish black and the ruff, lust not love'.[174] He colonized grotesque with his progeny; his familiars may be seen in the Renaissance grotto [236], his spirit is in the cult of the ugly that entered grotesque ornament (Dietterlin and others sometimes used forms derived directly from Bosch), and his cruelty in the use of strapwork to imprison living forms [215]. The new grotesque – Ruskin called it 'a delight in the contemplation of bestial vice…this spirit of idiotic mockery'[175] – played the leading role in the sixteenth-century fashion for aggressively inharmonious decoration and furniture. Renaissance furniture in the grotesque manner often provokes dislike, and with reason: its ugliness, although alleviated by the classical spirit, is not infrequently intentional and obvious [223]: old Germanic devils grimace from amongst classical foliate ornament, classical caryatids and terms are themselves turned into devils [211]. Old Nick's bodily likeness to Pan completes the link between Hell and Arcadia.

Strapwork and the cartouche

The sixteenth century saw two new ornaments invented: strapwork, an assemblage of twisted and curling forms [176], and strapwork assembled into the framework of the cartouche [213]. Strapwork expired in the later seventeenth century, to be resurrected later; the cartouche lived on to become an essential part of the language of rococo. Both became dominant components of furniture design.

Strapwork cartouches were first extensively used to hold together the superbly original and influential decorations begun in 1534 in the palace of Francis I of France at Fontainebleau; the formula became ubiquitous. The scheme of 'medallions enclosing scenes from classical history or mythology or landscapes, set within elaborate strapwork cartouches interspersed with figures or animals…

of men, beasts, birds, fishes, flowres etc., without (as we say) Rime or reason, for the greater variety you shew in your invention, the more you please.…You may, if you list, draw naked boyes riding and playing with their paper-mils or bubble-shels upon Goates, Eagles, Dolphins etc., the bones of a Ram's head hung with strings of beads and Ribands, Satyres, Tritons, Apes, cornu-copias, Dogs yoakt, and drawing Cowcumbers, Cherries, or any kind of wild traile or vinet after your own invention, with a thousand more such idel toyes, so that therein you cannot be too fantastical.'[170] The description anticipates rococo and post-rococo neo-classical grotesque.

The second type of grotesque was sinister, menacing and ugly. A Ferrarese humanist who died in 1541 made an epigram:

Sunt quaedam formosa adeo, deformia si sint:
Et tunc cum multum displicuere, placent.

('Certain things are beautiful although they are deformed, and please by giving great displeasure'.[171]) This expresses a current idea which comprehended all the arts. For example, Castiglione, writing of music, thought it 'a verye great vice to make two perfecte cordes, the one after the other', and

[was derived] directly from the Roman grotesque'.[176] The Italian artists who invented it, Rosso (1495–1540) and Primaticcio (*c.* 1504–70), were inspired by the spirit of the Sistine Chapel ceiling. The Gallery of Francis I, executed in paint and stucco, is dominated by three-dimensional forms – figures, exuberant fruit, and strapwork. Turkeys, elephants and dragons contribute to the conscious exoticism; there are grotesque masks, little framed stucco scenes, caryatids, satyrs, putti, garlands, medals, etc.[177] Primaticcio's exquisitely Greek version of Giulio Romano's robust Roman figures entered French decoration [213]; the mannered elongations of his forms became part of that refined French preciosity seen hundreds of years later in the gilt-bronze figures that decorated the furniture of Riesener and others [377, 401]. The sharply broken curve, employed in three dimensions in strapwork, was taken into furniture design and became an important three-dimensional motif in baroque furniture (pp. 154–57).

Conjectures about the origins of strapwork have included the banderoles often used in fifteenth-century Gothic art, which assume waving and curled forms [147], and the torn and curling paper or parchment painted in trompe l'oeil in Italian illuminated books of the late fifteenth century [212]. More directly, the broken curves and 'holes' of strapwork must be a legacy of moresque [176], as are the swelling opposed scrolls [110], themselves related to antique scrollwork. Strapwork greatly intrigued the printmakers; Fontainebleau itself housed a school of graphic artists, and perhaps the most influential prints of its decorations were those by Antonio Fantuzzi, who between 1537 and 1550 had himself worked on them. Fontainebleau was strategically placed between Italy and Flanders, and its contributions towards ornament, including strapwork, were eagerly taken up by other nationalities, especially Flemings and Germans. It spread throughout Europe.

The 'imprisoned body'

It was in Flanders that strapwork was turned into bonds [215], the cruel and playful theme that has been called the 'imprisoned body' – as if the savage spectacle of the pillory had been carried over into decoration. An early hint of it appears in Fontainebleau strapwork;[178] at Écouen [213] the arms of the Primaticcioesque ladies and the bodies of male figures are, as it were, 'dipped' into strapwork. A Netherlandish artist, Cornelis Floris, played a major part in its development. An Italian referred to Floris as a 'great architect and sculptor…to whom is given the honour of having been the first to carry to this country [Flanders] from Italy the art of imitating the grotesque with conviction'[179] (he said much the same of Frans Floris and Jan van Scorel).

Whence does the 'imprisoned body' derive? The idea is a feature of sixteenth-century art, but it stretches further back. Some antique Roman lamps approach the idea: a sphinx, for instance, is held in by scrolls. Romanesque capitals show beasts and birds restrained by bonds of curvilinear interlace; lions bite their own limbs in attempts to free themselves. Barbarian knots entangle human figures in the initial letters of illuminated manuscripts [68], sometimes with menace (was Cornelis Floris inspired by these? the first unequivocal Renaissance examples of the imprisoned body similarly decorate initial letters[180]). Gothic scrolls wrap themselves around heraldic beasts [147], but without sinister intent; moresque has a hint of constraint in its overlapping and restraining sinuosity, but its scrolls are leashes rather than bonds.

215 The 'imprisoned body', shells, water, and proto-auricular ornament in a grotesque design by Cornelis Floris; Flemish, published in Antwerp in 1556 (from *Veelderleij veranderinghe van grotissen ende compartimenten*).

Whatever its origin, the 'imprisoned body' caught the sixteenth-century imagination, and appeared everywhere in decoration and furniture.

The grotto

The Italian Renaissance was the first culture to become totally absorbed in the art and way of life of a dead civilization. In re-creating the antique for contemporary purposes its artists could scarcely avoid melancholic associations, especially since the design sources were frequently sepulchral. For the Renaissance, the grotesque was an art that came from the past and the dead, not the objectionable modern orientalism it was for Vitruvius (witness the deathly nickname of a Renaissance practitioner who was steeped in it – *Morto* da Feltre).

Grottoes had existed in antiquity both as artificial garden ornaments and as the sacred cave of the oracle or god. Attached to caves was the fear of accidental imprisonment, the fear of the rocky sepulchre, the primaeval dread of death. The cave was also the mouth of Hell: in well-known lines Virgil, regarded by the Middle Ages as a magician, describes the entrance to Hell as 'a deep rugged cave, stupendous and yawning wide';[181] it appears as such in mediaeval and Renaissance art, often with teeth and eyes.

For the Renaissance the 'grottoes', the underground chambers of the grotesque, were not the scenes of active domestic life they had been for the Romans; they were places of mystery and terror, ancient places where the demons seen by Cellini and his apprentice in the ruins of the Colosseum lurked.[182] A sixteenth-century cardinal thought grotesques appropriate in churches only when they depicted Hell, the damned, or the vices.[183] The artists who explored the ruins for grotesque paintings encountered wild life of the 'creepy-crawly' type associated with necromancy; one such saw 'toads, frogs, screech owls and barn owls and bats'.[184] Hell, antiquarianism and creepy-crawlies came together in an

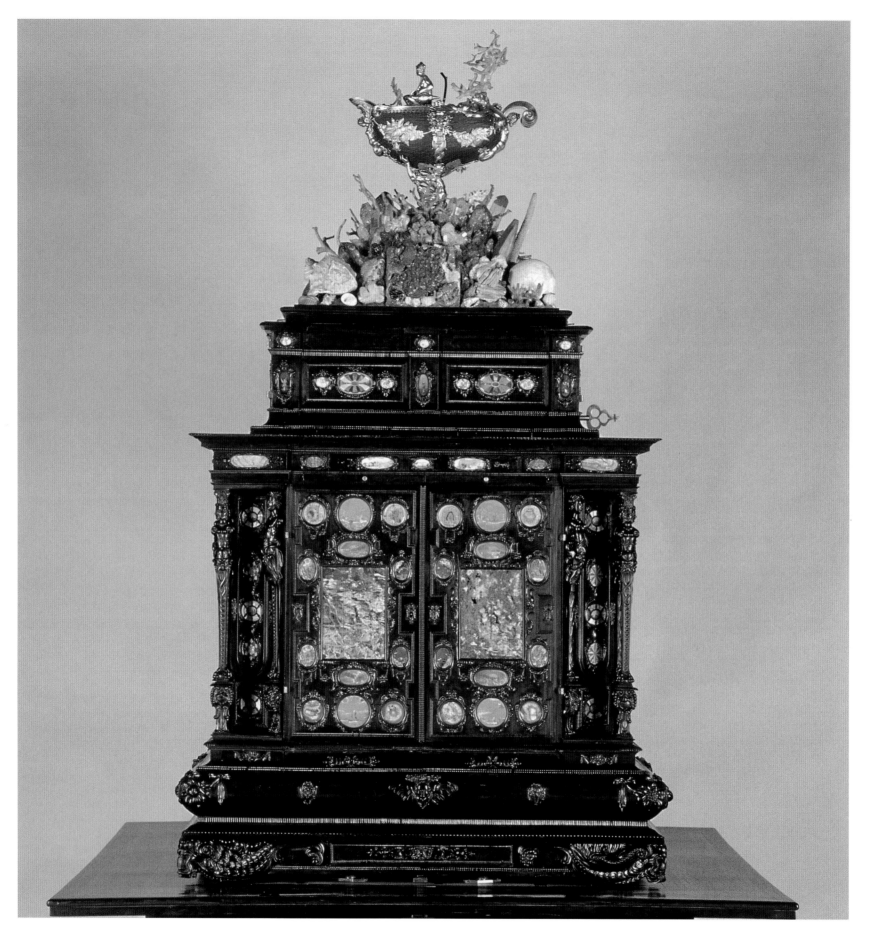

216 A curiosity cabinet in carved ebony with pietra dura inlay; German, presented by the city of Augsburg to Gustavus Adolphus of Sweden in 1632.

elaborate sixteenth-century Italian underground feast described by Vasari at which the guests passed through the mouth of a serpent to a chamber painted with the torments of the damned; there they consumed an 'infernal supper', concealed under a pastry which 'caused [the] eatables to appear as if they were nothing less than serpents, adders, lizards, newts, great venomous spiders, toads, frogs,

scorpions, bats…' The festival's subject was the rape of Proserpine, an underworld myth if there ever was one.[185]

Creepy-crawlies entered the arts associated with grotesque: they decorate the resplendent hardstone confections of the Renaissance goldsmith. It is unlikely that they decorated antique grottoes, but they were found abundantly in Renaissance ones [236]. Grotto extravagances

are vividly evoked in Bernard Palissy's description of his creations for the Duc de Montmorency and Catherine de Médicis.[186] He was entranced by romantic concepts of the aesthetic attractions of Time, and Time was set off by rocks, plants and natural forms; water, shells, marine and reptile life; beautiful and colourful semi-precious stones. These ideas, although not confined to grottoes, were encapsulated in them, and they gave the grotto a meaning that has enabled it to continue as an art form: grotto romanticism continued long beyond the Renaissance, played its part in the creation of the baroque and rococo, and has lasted to the present day.

Palissy portrays antiquity as Time-eaten: a grotto term 'would be like an old statue eaten by the air or dissolved by frost, to show its very great antiquity',[187] another would be in the form of a rough rock covered with vegetation 'to show a great antiquity'.[188] The antiquity would be rough rather than smooth: 'the great rock…would be shaped by an infinite number of protuberances and concavities, which would be enriched by certain mosses and several kinds of [aquatic] plants'.[189] The idea of Time-eaten roughness allied with statuary and architecture became common,[190] reaching

217 An arch in ruin, by Wendel Dietterlin; German, published in Strasburg in 1598 (from *Architectura*).

heights of expressionism in the work of German designers: a wildly ruinous arch, supported by a unicorn and stag savaged by dogs [217], is topped with Michelangeloesque reclining figures and goats that perch as on the top of cliffs. Its keystone is carved with a bat (has it flown in from the Domus Aurea? and did it alight, en passant, on the 'Farnese Table' [189]?).

The interest in the organic and in the idea of the earth as a 'womb' from which 'wonderful and monstrous' things emerge was not confined to grottoes or garden fantasies. The bases of hardstone goldsmiths' work were often treated roughly, with minutely worked forms emerging from them; palaces of the sixteenth and seventeenth centuries often grow from exaggeratedly 'rustic' ground stories; the Pitti Palace in Florence, entirely rusticated on its street façade, resembles a rocky outcrop that holds treasures within. Arched undercrofts were often painted in trompe l'oeil to resemble grottoes. Significantly, the potter Bernard Palissy extended the idea to interiors: 'I have set up a small room where I have put several wonderful and monstrous things that I have taken from the womb of the earth…'[191] It is not surprising that cabinets were given rocky bases, often peopled with deities and other mythological beings, which much resemble the decorations of grand gardens.

Palissy's grottoes were full of shells, including a figure made entirely of shells, anticipating Arcimboldo.[192] There was a general European trade in grotto ingredients culled from the teeming sea; they were employed not only by the Italian rocailleurs who travelled so widely making grottoes, but by goldsmiths and cabinet-makers. Palermo and Genoa supplied coral both unworked and carved.[193] Shells were imitated in metals and in hard and semi-precious stones but were extensively used 'raw'; the Dutch States presented the King of France with 6,000 florins worth of snail shells, and the Emperor had a room decorated with them.[194] Mother o' pearl scales and amber were immensely popular.

Palissy's grottoes were enhanced by the polychromatic gleam and glitter of semi-precious stones: 'as for the niches, columns, bases and pilasters, I would wish to make them of rare stones of different colours…porphyrys, jaspers, cassidoines and of several sorts of agates, marbles and speckled grey stones'[195] – much the same effect as made by a grand Renaissance cabinet! The coldly voluptuous appeal of such materials was an old one, but they now acquired an additional layer of associations. One of the consequences was the development of the cabinet to contain curiosities, which became an elaborate and costly item of furniture [216].

Printed books and printed furniture designs: grotesque and grotesque hybrids

Grotesque prints served furniture-makers and other trades; other important sources for furniture design were books that played highly inventive and elaborate grotesque variations – extravagant, incongruous, anti-classical, not infrequently coarse, but richly ornamental and capable of sumptuous effect – upon antique architecture. The motifs within their pages, Northern in spirit, sometimes wildly expressionistic, materialized on furniture throughout Europe. These books co-existed with the classically orientated books of Palladio and Serlio (p. 113). Three names are especially significant. They are Du Cerceau, whose multitudinous compositions[196] cover an enormous range of antique and modern architecture and include, from 1550 to the 1560s, the earliest large group of printed furniture designs [228]; Vredeman de Vries, a fine architectural painter whose splendid engravings, influenced

DORICA V 9

entablatures, and pilasters that could be easily adapted for furniture.[200] The books of all three exhibit cross-influences between stone architecture and wooden furniture: Serlio's 'rustic' doors and chimneypieces, and a wooden arch by Dietterlin[201] (which has a rustic Solomonic column held together by dowels), both relate to Vitruvian and Albertian architectural theory, which taught that primitive wooden prototypes had evolved into sophisticated stone architectural forms. This theory implicitly sanctioned the reverse process, by which stone forms turned into wooden furniture, doorways and buffets [225]. It also reinforced a self-conscious awareness of the dignity of construction shared by designers in wood with designers in stone; the innovatory furniture book of Vredeman de Vries symbolized the honour of the trade by arranging woodworking tools as antique trophies and panoplies on the title page; most of the plates proclaim the wood in which the designs were to be realized, and in some the dowel is so emphasized as to be an ornament.

A page of Vredeman de Vries' furniture designs [219] reveals how chairs and tables could be treated almost as a minor branch of architecture and yet, despite the fluted piers, arches with keystones, and consoles, not lose common sense. Two tables have outswept legs which must bear a relationship with the klismos. The 'turned' Roman leg is noticeable by its absence. A chair shows a connection with the Italian *sgabello* [231] and the *caqueteuse* [222]. Such designs demonstrate how useful furniture designers must have found the new architectural books, and ideas adapted from them expressly to the needs of the furniture-maker began to appear. An example is the *Architectura* of Gabriel Krammer, first published in Prague in 1600. The plates show architecture in process of transmutation into furniture; an illustration headed 'Dorica' [218] shows pediments, columns and pilasters overwhelmed by decoration: Doric capitals top pilasters that have turned into broken scrolls, niches turn into hanging cupboards, grotesque attics and obelisks sit on cabinets rather than buildings; in other plates,

218 A design for ornaments using the Doric order, by Gabriel Krammer; published in Prague in 1600 (from *Architectura*).

right 219 A design for tables, stools, a corner table and a chair, by Hans Vredeman de Vries; published probably at Wolfenbüttel, *c.* 1588 (from *Différents pourtraicts de menuiserie a scavoir…*).

by Du Cerceau's 1559 book, display antique architecture succumbing to the blandishments of grotesque with richly unclassical results, and who published, probably in 1588, the earliest furniture pattern book [219]; and Wendel Dietterlin, whose *Architectura*, ostensibly separated into different parts corresponding to the five orders, sometimes discovers amongst the welter of outlandish imagery a strangely accoutred Doric or Corinthian column [214].[197]

Despite his classicism, Serlio had crossed a boundary: as a nineteenth-century historian remarked, his style was sometimes 'no longer architecture but carpentry. In this, Serlio is the true forerunner of Dietterlin'.[198] The architectural books of Serlio, Vredeman de Vries and Dietterlin are indeed full of designs that show the dependence of carpentry upon architecture; for example, a plate of Dietterlin shows 'vases', an entablature and pediment, and fluted Doric pillars[199] resembling those that appear on luxurious contemporary cabinets; others show doorways, niches, windows,

6

rustication decorates the lower tiers of a cupboard rather than the ground storey of a palace. The result of such ideas might, in less than sure hands, be architectural delirium [225].

Within the pages of these grotesque architectural books several worlds met, and the sense of fecund, not to say rank growth is overpowering. It is difficult to select, but some motifs were especially important for furniture.

One is the overlaying of the antique forms of the orders, caryatids and terms with grotesque ornament and strapwork; they were frequently smothered in the most outlandish fancies, ornaments that were frequently touched by the 'grotto' concepts of Nature and age. Hugues Sambin (1520–c. 1601), who worked in Dijon, produced devilish satyr terms described as 'drawn after the antique, which always pleases';[202] they were obviously inspired by the famous 'Della Valle' Roman satyrs, casts of which were used by Philibert Delorme to support a chimneypiece at Fontainebleau.[203] Velaria, strapwork, monsters and tangled vegetation replaced sacerdotally significant antique garlands and bucrania on entablatures; the column was covered with grotesque motifs up a third of its length, or entirely stifled beneath them; it was adorned with decorated bands, a practice justified by Delorme on the mistaken grounds that Greek columns were monoliths, and joints needed concealment.[204] Such bedizened orders were still dignified by the august terms 'Doric', 'Ionic', 'Corinthian'.

Three-dimensional caryatids and terms were covered with a mass of picturesque accretions – a precedent for astonishing ornament existed in the many-breasted antique image of the Diana of Ephesus – carrying on their heads baskets seen in grotesque still life; the caryatids were frequently drawn out to extraordinary lengths. Classical monsters derived from stone sources were given three-dimensional details derived from grotesque paintings. All these fancies spread to beds and cabinets; especially common were caryatids [195] and vegetation-wreathed columns[221].

An architectural motif found plentifully in the books is the climax of pediments, scrolls, consoles, vases, figure sculpture, and obelisks frequently used to decorate the attic storeys of a façade; orders and entablatures, superimposed tier upon tier and supported from the sides by Gesù-derived scrolls converted into strapwork, make up a miniaturized façade more densely decorated than the façade itself. The motif underwent further miniaturization as bed-heads or as a cresting for elaborate armchairs and cabinets. It persisted well into the eighteenth century, the details changing as architectural fashions changed.

The orders were integrated with the bulbous shapes, so favoured by the sixteenth century, that swell aggressively from beds, tables, and other pieces of furniture. These had been foreshadowed in fifteenth-century candelabro ornaments [163]; the earlier motifs now blended with the newer, more volumetric 'architectural' grotesque to produce assertive forms influenced by the antique vase and the Renaissance baluster, from both of which came the fluting (frequently convex in the sixteenth century), strigillation, gadrooning and other classical detail that adorns the bulge. Coarse variations of these balusters supported the testers of Elizabethan and Jacobean beds and buffets. The order used was often the Ionic, occasionally rendered as simplified volutes that resemble the ancient Greek Aeolic capital [14, 51]. In simpler or more primitive pieces of furniture, the turnings, bulges and other motifs that give so barbarically sumptuous a profile to elaborate posts were smoothed out

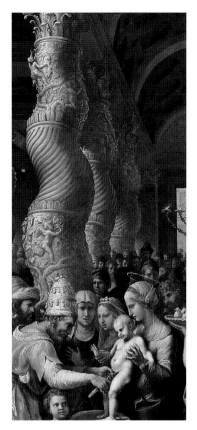

220 Strigillated and decorated Solomonic columns: a detail from *The Circumcision* by Giulio Romano, Italian, early sixteenth century.

right 221 A cupboard in carved walnut attributed to Franz Pergo; Swiss (Basel), 1619.

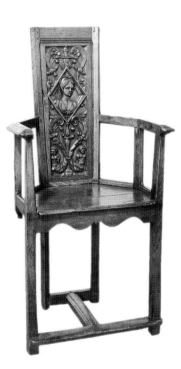

222 A caqueteuse in carved oak; French, 1535.

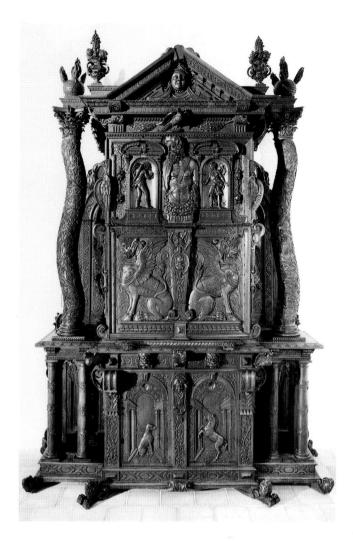

or simplified to produce the familiar seventeenth-century baluster column soberly enlivened by discreet ornament.

The elaborate embellishments applied to the orders were added also to the Solomonic column. The swaying and the straight twist had in antiquity already been subject to sophisticated variations and had been used in furniture [10]. The Solomonic column had survived throughout the Dark and Middle Ages: barbarians struggled to render its smooth twists in three dimensions [71]; the Cosmati bejewelled it; it often appears as a Gothic ornament, especially in Italy [141]; Raphael and other Renaissance artists made it a respected ingredient of High Renaissance classicism. As the column at which Christ was scourged, it had the double lure of religion and the East. Michelangelo and Giulio Romano were amongst the painters who depicted it inside the Temple of Solomon at Jerusalem. Michelangelo's painting is lost;[205] Giulio's survives, his columns [220] having a slack, plastic curve, quite unlike those with which he decorated the Ducal Palace in Mantua. It is in this form that the Solomonic column appears in the engravings of Du Cerceau, which so influenced furniture; it was later abandoned for the emphatic twist that became a dominant motif of furniture in the seventeenth and early eighteenth centuries. The vigorous twist occurs in sixteenth-century Italian furniture, but an elaborate late Renaissance cupboard attributed to Franz Pergo or Perregault [221], a Burgundian Protestant refugee who took the style of Hugues Sambin to Basel, is dominated by two Corinthian Solomonic columns in which the slackness of Giulio's columns becomes a positive sag. The cupboard betrays mixed influences, including Vredeman de Vries, Du Cerceau, Stoer and Dietterlin.[206]

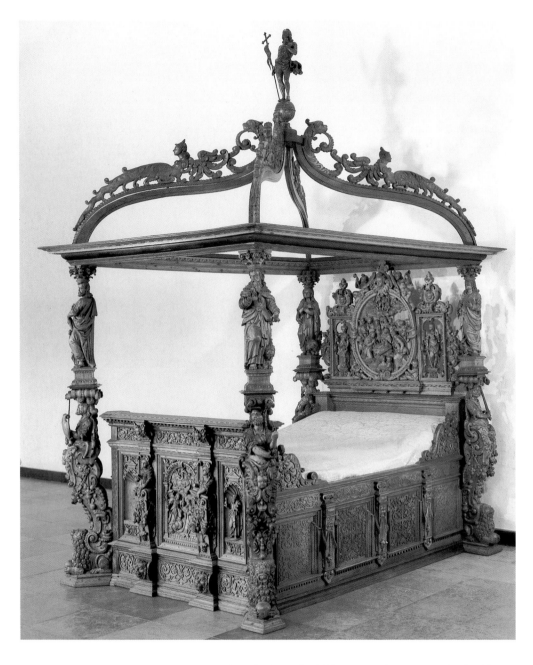

223 A canopied and carved ceremonial bridal bed from Clausholm, Jutland, by Peter Jensen Kolding; Danish, c. 1640–50.

right 224 A design for a bed with candelabraform Corinthian columns, shown partly to be executed in ash, by Peter Flötner; German (Nuremberg), c. 1540.

far right 225 An interior, by Bartholomäus van Bassen; Dutch, c. 1620.

Solomonic and other columns were frequently employed to support beds, more frequently as the baroque took hold. The design could be academically correct – Tuscan, Doric, Ionic or Corinthian. It rarely was; the sixteenth-century taste for magnificent elaboration was too strong. A woodcut of about 1540 by Peter Flötner [224] shows a comparatively restrained bed in which, despite the grotesque candelabra-form decoration (which is largely confined to the lower reaches) architectural motifs predominate: fluted and unfluted Corinthian pillars, Ionic pilasters between shell niches, a frieze of bucrania and garlands, and so on. The head

has architectural shell niches that a little later would probably have become mannerist 'attics'. The putti with cornucopias above the tester come from classicizing sculpture rather than grotesque, although the 'dolphins' with scrolls have a grotesque provenance. The woodcut indicates that certain sculptures are meant to display the showy grain of ash, a popular wood in sixteenth-century Germany.

A bed from Jutland, old-fashioned in its period due to Jutland's distance from the centres of fashion, dates from about a hundred years later [223]. It combines the influence of grotesque with that of sixteenth-century Italian sculpture.

The ogee dome is decorated with sinuously recumbent grotesques; the upper parts of the bedposts are 'Corinthian' draped figures of a Roman or Michelangeloesque type (the Michelangeloesque hand is unmistakable), and the elaborately carved headboard, footboard and base combine Italianate motifs with Northern European expressionistic grotesque.

Du Cerceau produced designs for ornately adorned four-poster beds which unite delicacy and strength in a manner characteristic of French taste. He also made extraordinary designs for strange objects that have been thought to be

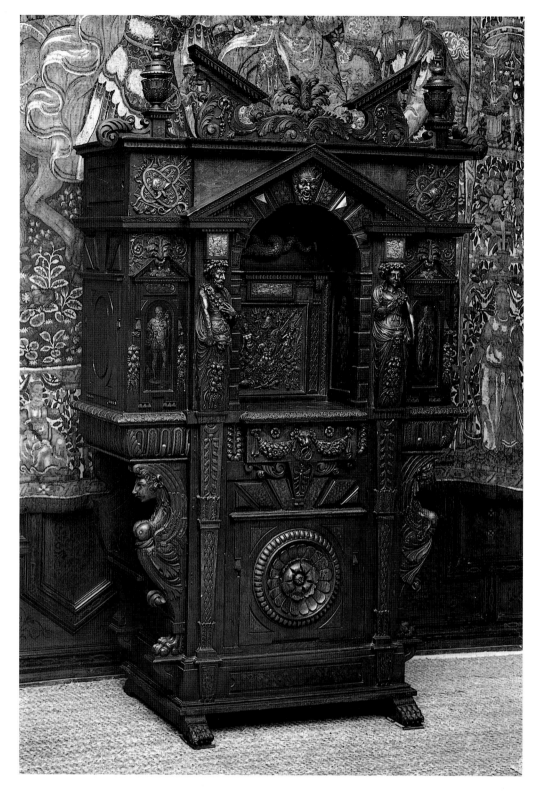

beds [228][207] – as they might be. Are they perhaps day-beds? As beds, the designs present problems. Would the mattress have been brought up to the level of the top rail? Did the truncated ornament at the foot carry some form of canopy or padiglione? Why confine one's feet within the bed in that peculiar manner? The 'beds' are not altogether unlike Roman chariots [65:C], which had sometimes been made in solid silver.[208] They also have similarities with certain antique baths; a Hellenistic example, for instance, although very different from the Du Cerceau designs, has a form that could well have suggested that of the 'beds' – and at its foot is a pair of mutilated sculptured feet revealing where a figure once stood in much the same position as in the Du Cerceau design.[209]

Could these designs be for 'antique' baths? If so, they are extremely elaborate ones – but there was something of a French cult of the bath (nobody can forget the aristocratic Fontainebleau ladies in their baths having their nipples pinched) and if Du Cerceau designed a bath it would be an elaborate one. Whatever the purpose, each bed or bath resembles an antique stone throne extended to a curved foot; each is decorated with ornament drawn from sarcophagi and other antique sources [10, 65]. The delicate garlands also resemble those in shallow carving on antique altars; one sees such garlands in Renaissance decorative painting. The monsters that 'draw' the 'baths' take their forms from grotesque but are treated as sculpture; indeed, the whole treatment suggests marble as much as wood.

A fine French cabinet at Hardwick Hall [226], which was mentioned in an inventory of 1601, has beneath its ornament a strong architectural foundation; it is dominated by a grotesque arch of the type found in Renaissance gardens. The arch was easily adapted to furniture requirements; the grotesque arch produced effects very different from those of the Italianate classical arch [202, 212]. The upraised hand of the term on the left, with its characteristic divided fingers, is derived from Michelangelo's *Moses*; the highly 'classical' rosette motif reminds one that France was the country of the classicizing Philibert Delorme. The cabinet is much in the Du Cerceau style, as seen in a design [227]; cabinet and

226 A cabinet in carved walnut in the manner of Jacques Androuet Du Cerceau, at Hardwick Hall, Derbyshire; French, late sixteenth century.

above right 227 A design for a cabinet by Jacques Androuet Du Cerceau; French, *c.* 1560.

right 228 A design by Jacques Androuet Du Cerceau for a couch or bath; French, late sixteenth century.

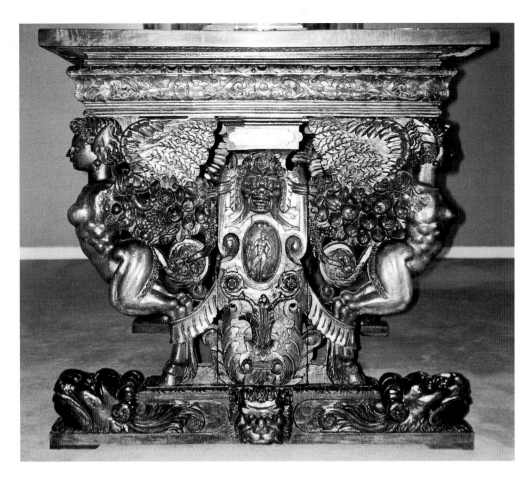

229 A table in carved walnut in the style of Hugues Sambin; French, c. 1575.

230 The Palazzo Te, Mantua, taken from a drawing by Giulio Romano, 1527–34.

design both have rich architectural ornament, broken pediments, grotesque terms or caryatids, trophies, and heavy garlands of flowers and fruit. The miscellaneous vegetation that hangs from the central pediment of the Du Cerceau design recalls Dietterlin's shaggy arch [217], and manifests the same interest in grasses as that shown by contemporary goldsmiths: were such effects, impractical in wood, possibly realized in perishable materials? They certainly were in later periods: the eighteenth and early nineteenth centuries decorated bed domes and chandelier stems with silk and paper flowers. There was much Renaissance use of cheap materials for temporary festive arches and triumphs; contemporary gardens were adorned in very fugitive materials.

Chests in sparsely furnished rooms invited the weary frame to repose, and the consequence was the *cassapanca,* a chest that doubles as a backed seat; appearing first in northern Italy,[75] it was used in Tuscany from the early fifteenth century onwards. A fine Spanish example, dated 1553 and designed by Adrián Lombart [170], has densely carved and boldly sculptural decoration that mixes grotesque monsters with bold acanthus and the 'Romayne' heads that were influenced by antique coins and busts. Another common type, the Italianate *sgabello,* played host to varied decorations: its flat back and front easily took the profile of the end of a sarcophagus, a baluster, or a capricious assortment of scrolls and grotesque masks. A *sgabello* chair of about 1625 [231] is attributed to Franz Cleyn (1582–1658), a Dane who had been to Italy and who in 1625 became designer at the Mortlake Tapestry works in England.[210] Its back is made up of a shell of the type common in Italian Renaissance architectural niches; the front is decorated with grotesque masks in profile, scrolls and garlands. Cleyn had obviously looked hard at the grotesque tapestries of Bacchiacca, whose lumpy putti and ornament passed into English decoration and furniture.

Tables frequently followed the antique marble slab-ended model decorated with grotesque ornament. A carved table in

walnut made in Toulouse [229] is upheld by two grotesque winged monopodia imprisoned at the feet, not very strictly, with lambrequins; the decoration includes grotesque masks and strapwork. It has similarities with the designs of Hugues Sambin (p. 125). The masks at top and base of the pier have gone some way towards the abstraction of the auricular style.

A table at Hardwick Hall [232], possibly French,[211] was described in the inventory of 1601 as 'a drawing table Carved and guilt standing upon sea doges inlayd with marble stones and wood'.[212] By this time the draw-leaf was common, the earliest published designs for draw-leaf tables having being made in about 1550 by Du Cerceau. The curved section beneath the draw-leaf is, as it were, a truncated section of a sarcophagus, a common feature of furniture of the period; it frequently appears on beds, which sometimes look uncommonly like tombs; cradles without canopies bear an even stronger resemblance to sarcophagi.

The table has points in common with three tables pictured by Vredeman de Vries.[213] The 'sea doges' closely resemble a design published in about 1560 by Du Cerceau for a dog-headed 'sphinx' begarlanded with fruit and flowers, wearing a diadem, and with floppy 'ears', two sets of wings and a fish's tail; they also resemble the supports of a chair on which Queen Elizabeth was portrayed.[214] It has been suggested that the 'fact that these speedy creatures are placed on the backs of tortoises must illustrate one of those punning Latin tags so dear to the Renaissance mind: *festina lente* (make haste slowly)'.[215] Possibly: the tortoise is certainly emblematic of considered sloth – one pictured on the Allori grotesque ceilings in the Uffizi has its shell equipped with a sail and the motto 'Festina Lente'. However, other possible interpretations come to mind. A frequently reproduced emblem of Alciati, 'Matrimonium', bears the motto 'Mulieris famam, vulgatum esse oportere' (A woman's reputation should be known to the world); it shows Venus standing on a tortoise; the verse attached to the emblem explains that the tortoise symbolizes the fact that women should stay at home and keep silence – the tortoise, according to Plutarch, symbolized 'ideal female domesticity'.[216] Coincidentally, in one early edition of Alciati this emblem faces another that pictures two erotes (probably Sacred and Profane Love) and a winged and tailed monster described as a 'harpy' that has hairy animal paws; it resembles the 'sea doge' save that its face is human: the motto is 'Bonis a divitibus nihil timendum' (There is nothing to be feared from good riches). The dog was used in emblem books as a symbol of faithful domestic attachment.

'Bess of Hardwick', the owner of Hardwick Hall, was the richest woman in England after the Queen, a matriarch who ruled with a rod of iron. Her granddaughter, Arabella Stuart, was a possible heir to the throne about whom it was necessary to be tactful; the last thing that Bess would have wished was to appear to be dangerously meddling in state affairs (she was loyally nasty to her imprisoned charge, Mary Queen of Scots). Emblems are shifting sands, but the 'domestic' interpretation makes more sense in the Hardwick context. It would have been quite possible for Bess of Hardwick to instruct a French furniture-maker to include certain emblems (after all, sixteenth-century magnates had their coats-of-arms put on porcelain in China). Did she by any chance leaf over the emblem books and conjure up something appropriate for the table that stood in the withdrawing chamber on the state floor of her house, the chamber into which she invited the most important guests? Did the table say to them: 'I may be rich, I may be powerful,

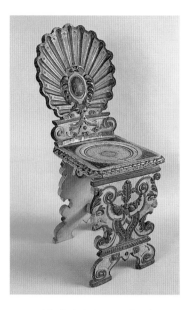

my granddaughter may be a possible tool for the anti-King James as heir to the throne party, but there is nothing to be afraid of, I'm just a little stay-at-home widow, I shall stay at home and keep quiet'?

Seventeenth century anti-classicism: the auricular style

A style that developed in the later sixteenth century uses shapes that resemble the fleshy, convoluted folds and crevices of the ear; this has given to it the name 'auricular'. The strange name only faintly adumbrates the strangeness of the style, in which the 'underworld' quality of Northern expressionism came to the surface.

Born of the grotesque and the grotto, the auricular style, which matured in the seventeenth century and took something of sixteenth-century mannerism into the eighteenth, added to the fleshiness inherited from strapwork a fluidity that subjects forms to a peculiar deliquescence, dissolving them to a point where their contours become completely irregular; it elongates the 'holes' derived from strapwork until they resemble the gaps in decaying skin. The auricular style has proto-rococo (pp. 285, 295) and proto-Art Nouveau [649] aspects; it is melting and lax like Art Nouveau, rather than lithe and bounding like rococo. Water and the sea supplied auricular motifs (as they did rococo motifs); the style was partly evolved in the sea-threatened Low Countries, and one of its most frequent images is a vast

gaping maw above which gleam two sinister little eyes, the whole looking somewhat like the underside of the head of a ray fish: the motif of the gaping mouth had been evolved in Italy but it was left to the Low Countries to give it watery menace. Dolphins, shells (the rippling profile of the murex was a frequent motif), rocks, coral and marine monsters were commonly used. Many such auricular motifs are exhibited in their 'home' environment in a drawing for a melancholic grotto designed for the Prince of Orange a little after 1620 by Jacques de Gheyn [236]. The constituents of the grotto – shells, marine fauna, salamanders, the stamp of age given by the entrapped bearded ancient – recall the grotto extravaganzas of Palissy, as the toads, serpents and owl recall the fears of the fifteenth-century grotto-visiting painter.

Motifs that were carried to creepy auricular excess had been invented in the sixteenth century. Italian artists had supplied much, inspired by antique grotesque acanthus masks that were already almost completely auricular [343]; these were taken as inspiration by Michelangelo for his proto-auricular masks. Auricular forms can be seen in germ in the designs of Enea Vico (including the sinister 'eyes'[217]). A head from the tomb of Pope Paul III (d. 1549) by Guglielmo della Porta in St Peter's at Rome is strongly proto-auricular [234]. Seventeenth-century Italian prints were influential in promoting auricular detail; a design for a cartouche by Agostino Mitelli (1609–60), which shows prominent 'ears', seems to have stopped at the auricular

231 A hall chair in carved and painted walnut, attributed to Franz Cleyn; English, c. 1635.

232 A table in walnut, fruitwood, tulipwood and marble, after Jacques Androuet Du Cerceau, at Hardwick Hall, Derbyshire; French or English, c. 1580.

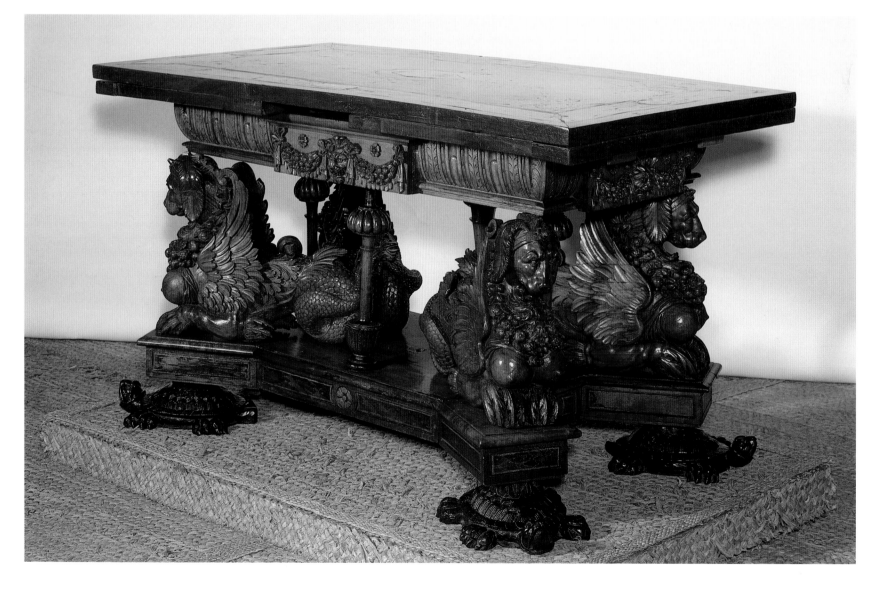

233 A cabinet on stand in spruce and oak veneered in pearwood, inlaid with ruin marbles, lapis lazuli and other stones, the inside inlaid in ash and walnut; Austrian, c. 1650–1700.

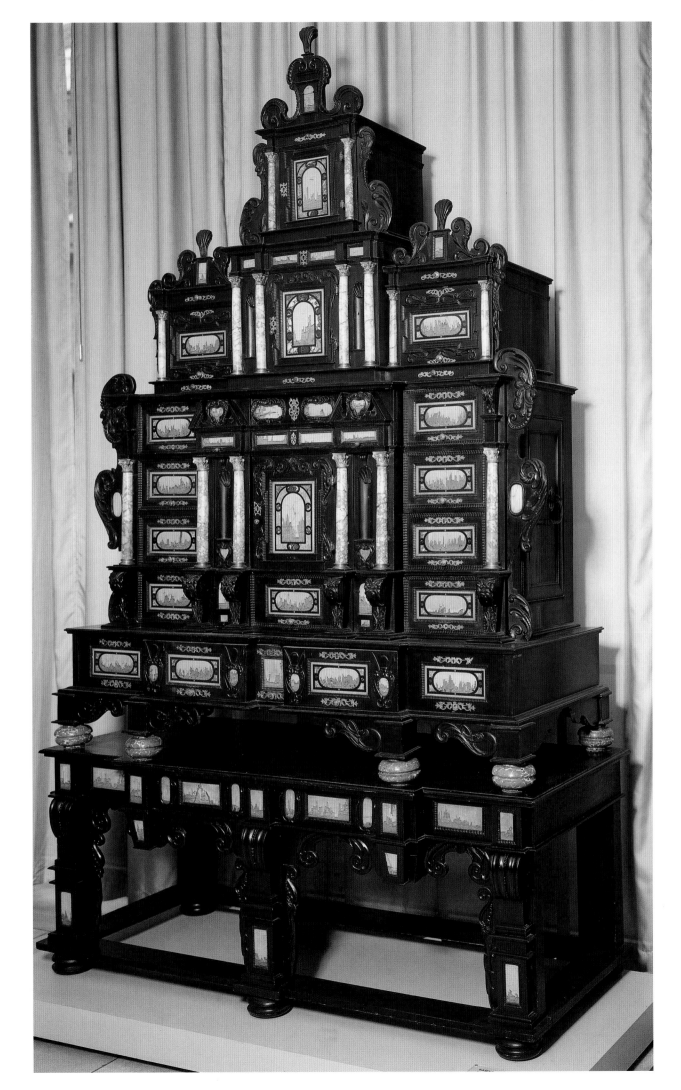

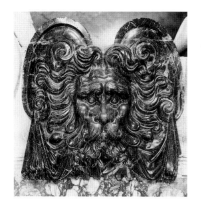

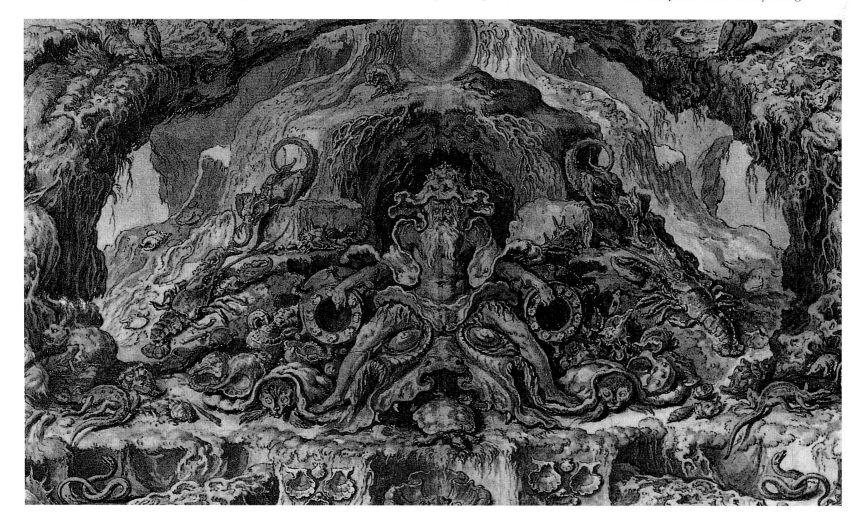

234 A mask in marble from the tomb of Pope Paul III in St Peter's, Rome, by Guglielmo della Porta; Italian, mid sixteenth century.

235 A cartouche from a title page, designed by Stefano della Bella, published in Paris in 1646/47 (from *Paisages maritimes*).

en route between strapwork and the rococo [237]. The same might be said for a very different design printed in Paris in 1646/47 by Stefano della Bella [235]; behind the fishy and shelly cartouche stretches the sea.

The nether-worldliness of the auricular style came not from Italy but from the Netherlands and from the necromantic court at Prague. Prime sources were Frans Floris [215] (who borrowed fleshy auricular strapwork from Vico), and Cornelius Bos; the old man imprisoned in shells in the De Gheyn grotto design [236] echoes Floris, and some of its monsters recall Vredeman de Vries' monsters, or the horribly squelchy creations of Erasmus Hornick, a prolific designer who drew directly from Bosch. The deathly associations of the grotto become overt, perhaps partly because of the strong Netherlandish interest in the 'Vanitas' (an offspring of ancient Roman painting and mosaics); after 1600, public dissections of human corpses began in Prague

236 A design for the grotto at The Hague, by Jacques de Gheyn II; Flemish, *c.* 1620.

and the Low Countries. Anatomical publications were used by designers and artists; a book published at The Hague in 1634 was directed not only to surgeons but to painters, sculptors and engravers.[218]

The aid of strapwork in articulating auricular liquidity is clearly shown in a design for an armoire [239] published in 1642 by Crispin de Passe II (*c.* 1593–after 1670). It gives choices: the cartouches contained within the panels beneath the shell on the left are auricular (eyes resembling those of the ray appear at the top of the upper panel); the equivalent panels on the right show strapwork above, and a motif derived from ceiling panels or floor parquetry below.

The Netherlandish auricular style first found complete expression in the work of an Utrecht goldsmith, Adam van Vianen (*c.* 1565–1627). The archetypal piece, a silver gilt ewer of 1614,[219] was 'composed of grotesque or *Schnakkerey* as it is called[220]…this ewer passes as an entirely strange

237 A design for a cartouche by Agostino Mitelli; Italian, *c.* 1630.

238 A design for an armoire, by Friedrich Unteutsch; German, published in Frankfurt *c.* 1640 (from *Neuen Zierathenbüchlein*).

piece'.[221] The comment shows that the style was thought outlandish; outlandish or not, the ewer caught the fancy of Dutch still life painters and appears at least ten times in their pictures. The style passed to London, where in 1623 auricular designs by a Dutch goldsmith were published.[222] A decade or so later, Adam's son Christiaen van Vianen became goldsmith to Charles I; he returned to London at the Restoration in 1660. His son-in-law John Cooqus made a silver state bed in 1674 which might well have been in a thoroughgoing auricular style – metalwork remained the medium[223] in which it most uncompromisingly showed itself, and extreme auricular deliquescence seems more likely to have materialized in metal than in wooden furniture. Charles II gave the bed to Nell Gwyn,[224] which somehow seems appropriate.

Little surviving wooden furniture displays the complete abandonment, the expressionistic extremism, of which the style was capable; in many cases the auricular ornament is discreet, as in a magnificent ebony cabinet of about 1640, which has touches of the auricular in the rectangular cartouches below the main panels of its front [246]. A few contemporary depictions of furniture indicate that radical transformations of form may occasionally have occurred – perhaps through the influence of painters; Rembrandt, who had orientalist and exotic leanings, depicts auricular furniture in an extreme style, and a Rembrandtesque painter, Gerbrandt van den Eckhout (1621–74), made designs for furniture of a similar nature. Some designs show unbridled auricularity, as seen in an armoire from the 1640s by Friedrich Unsteutsch, who was town cabinet-maker at Frankfurt [238]. It is adorned with swollen, tangled C-scrolls mixed with auricular ornament, and has prominent 'ears' on the side.

A Netherlandish table in gilt walnut of about 1660 [240] has melting legs that seem half animal, half vegetable; the mask, in the form of a cartouche, is formed entirely of

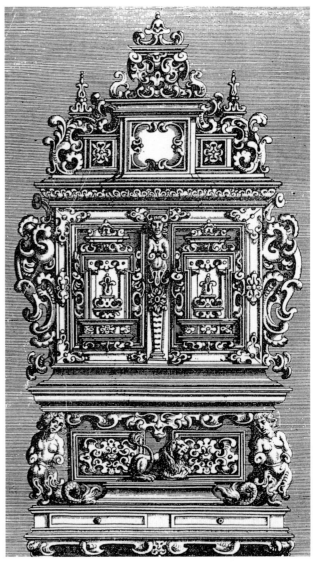

239 A design for an armoire, showing two alternative schemes, by Crispin de Passe II; Dutch, published in Utrecht in 1642 (from *Officina arcularia*).

far right 240 A table in carved and gilt walnut with a marble top; Dutch, *c.* 1660.

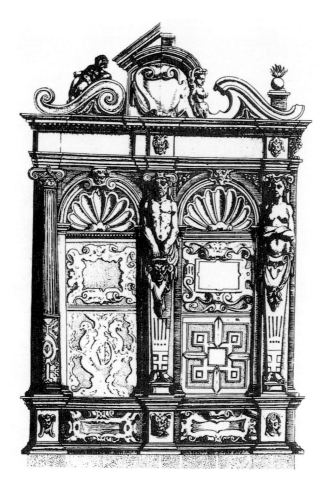

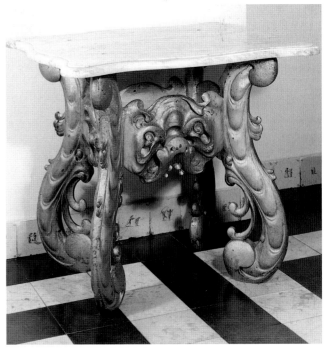

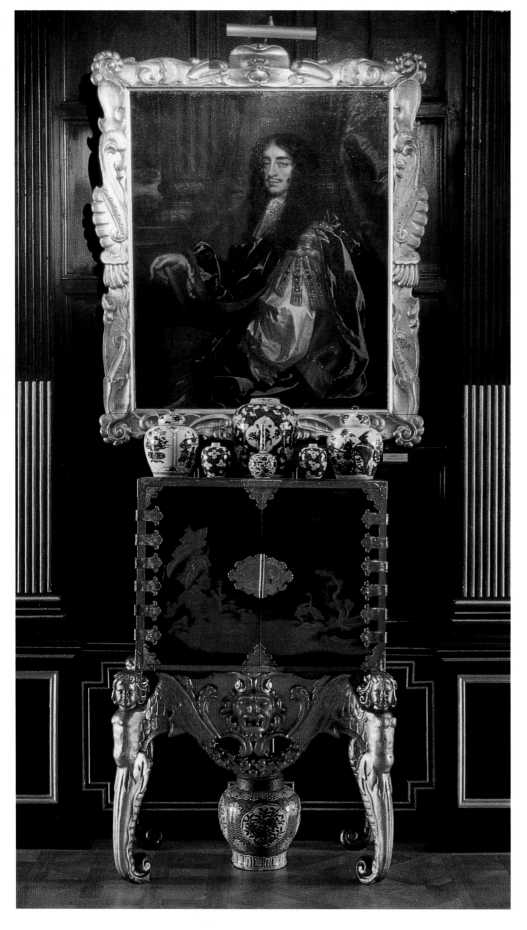

deliquescent scrollwork; the table has similarities with a design for a table by Van den Eckhout.[225] The wavy lines of the marble top are auricular rather than baroque, which was stiffened by the angles of the broken curve. A more restrained Anglo-Dutch auricular stand supports a Japanese cabinet at Ham House [241]. Above it hangs an auricular picture frame of a type that became common in fashionable English houses of the Restoration period; the motif at the top centre of the frame hints at a face without actually forming it. Also at Ham is a set of chairs of about 1673 in an 'auricular chinoiserie' style, two extravagances blending into one exotic whole [242]. Dutch craftsmen, some of whom worked in the auricular style, strongly influenced seventeenth-century English furniture: Restoration chairs often exhibit auricular features.

An Austrian cabinet on stand of the second half of the seventeenth century [233] has auricular 'ears' much like those of the Unsteutsch design [238]. Monumental and architectural, it has eighteen Corinthian pillars and an 'attic'. The continued ruin fancy is evident in the many small plaques of 'ruin marble' that cover the cabinet's front, extraordinarily disturbing natural 'pictures' which somehow recall the sketchy but lugubriously evocative prints of Roman ruins published by Étienne Du Pérac[226] in 1575. Auricular expressionism and grandeur make odd consorts.

241 A picture frame in carved and gilded wood, made by John Norris, frame-maker to the Court, and a Japanese lacquer cabinet on a carved giltwood stand, probably Dutch, at Ham House, Surrey; both c. 1575.

242 A chair in japanned beech, at Ham House; English, c. 1673.

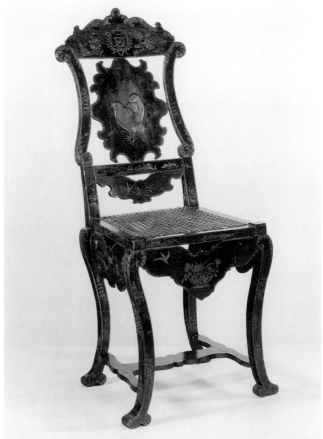

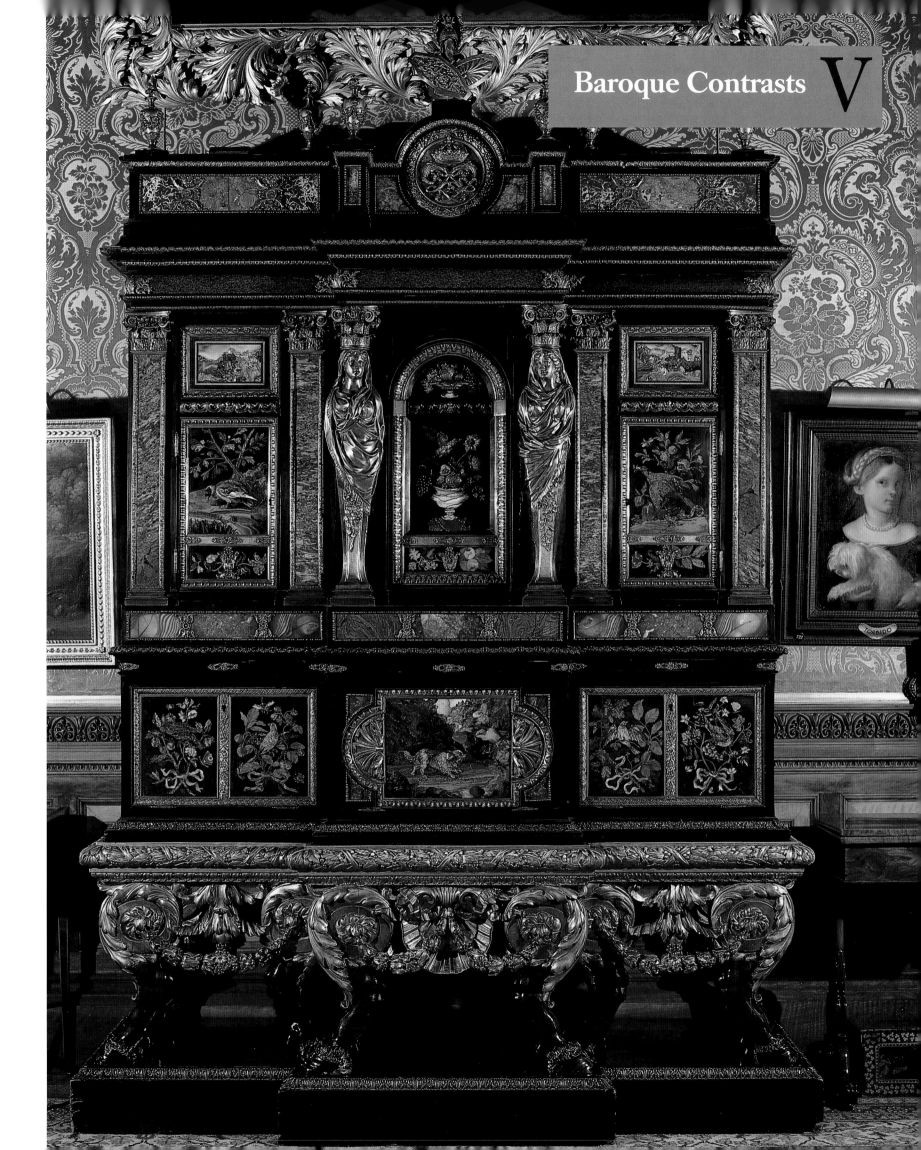

overleaf 243 A cabinet on stand in
ebony and pietra dura, decorated
with semi-precious stones, designed
by Domenico Cucci; French,
c. 1681–83.

The baroque tastemakers: Italy and France

Taste in Europe in the seventeenth century was dominated
by the art of the baroque. Baroque architecture and
decoration have aroused strong antipathies. André Félibien, a
French classicist, wrote severely in 1685 of the restless
movement and broken-up surfaces of baroque buildings: 'a
confused mass of advancing and receding shapes…with as
many heads as Hydra, and as many arms as Briareus…an
infinite number of angles and unevennesses'.[1] Thomas Hope,
an English Regency classicist, denounced Bernini and his
contemporaries, Fontana and Borromini, for 'their corkscrew
[Solomonic] columns, their architraves *en papillotte*, their
pediments curled and twisted into every unnatural
shape…[that] far outstripped in bad taste the worst examples
of the worst era of pagan Rome'; he went on to say 'still more
were those mouldings and details…destined to experience
every species of contortion…in the chair, table, chimney-
piece, chandelier, sconce, and picture frame'.[2] Hope
concentrated his strictures on architectural details; he had
less fault to find with the planning of interiors because grand
baroque interiors, unlike grand rococo interiors, are usually
articulated in a traditional classical way; they employ the
orders and organize spaces with clarity: the baroque Galleria
of the Palazzo Colonna at Rome has nothing of the fluid
ambiguity of the rococo Kaisersaal of the Residenz at
Würzburg.

The germs of seventeenth-century baroque architecture,
its curves and counter curves, its broken pediments and its
exterior use of the lambrequins and swags that originated in
draped textiles and interior decoration, existed in antique
Rome, and nowhere in such exaggerated and proto-baroque
form as in the *scaenae frons* of the Roman theatre, which
reappears in grotesque wall decoration. This link with the
antique theatre accords with the opulently rhetorical nature
of seventeenth-century baroque: 'Every object swells with
state, All is pious, all is great.'[3] Etiquette swelled with the rest:
grand state furniture was part of the theatre of etiquette
which distinguished the state apartments' decoration and
furniture from that of other parts of the house; pier tables,
candle-stands and mirrors became part of a great mise-en-
scène; the enfilade of sumptuous reception rooms was
dramatically graded from splendid 'public' spaces to even
more splendid, if smaller, private ones.

Much state furniture had no utilitarian function; the
utilitarian commode could never have evolved in Italy as an
item of 'state' furniture; French royal bedchamber etiquette,
however, had developed to a point where imposing 'state'
bedroom furniture such as the commode became essential.
The bedchamber of Louis XIV at Versailles, the inner
sanctum where the king was disrobed in public behind the
gilded balustrade of the bed alcove, was placed at the precise
point where the Sun King, semi-divine and, as Apollo, semi-
pagan (in his pagan days, the Emperor Constantine had
identified himself with Apollo), could watch the sun rise –
in theory. In reality, the king had by then escaped from his
public to his private bed. Life as theatre was strenuous for the
actors, and retreats were contrived that ranged from private
appartements to smaller palaces such as Marly (which was,
significantly, arranged as a series of private apartments in

separate buildings). The 'apartment', a sequence of private
rooms, was invented in the Renaissance (a proto-apartment
of about 1460 at Urbino is the first fully independent entity of
rooms set apart for private living since before the Dark Ages).
These informal retreats engendered distinct types of informal
furniture.

Sumptuous baroque interiors were created as a unit, often
by a team under one controlling designer. All rhetorical art
proceeds by accumulating multiple detail that explodes in
a grand crescendo; furniture, as part of the apparatus of
rhetoric, acquired a new importance. Grand baroque
furniture cannot successfully be taken out of its context of
design and scale; furniture that takes its part in the great
orchestra of the Palazzo Colonna or Holkham Hall is as
inappropriate in a modern Roman penthouse or New York
apartment as a roll of drums in a closet.

The console tables in the Galleria of the Palazzo Colonna
are as much sculpture as furniture; as ornament they could
afford to be sculptural, wildly sculptural. The new decorative
ideas exhibited in such ensembles produced new types of
furniture. Mirrors, which wonderfully amplified the
splendours, became 'architectural' – the invention of plate
glass in 1688 was the result, not the cause, of the fashion for
huge mirrors (the mirror craze was gently mocked in
unexpected quarters: 'Then said Mercy, *There is a Looking-
Glass hangs up in the Dining-Room*, off of which I cannot take
my mind; if therefore I have it not, I think I shall Miscarry').[4]
The French architect François Mansart was said by
contemporaries to have been the first to introduce mirrors
over chimneypieces; mirrors were also combined with pier
tables, first as associated entities and eventually as one unit,
the pier table often being attached to the wall as a console
table. Such combinations became usual in the early eight-
eenth century and continued into the post-rococo period.

The presiding genius of the baroque, a universal genius
who was primarily a sculptor, was Gianlorenzo Bernini
(1598–1680). Bernini's main interest lay in energetic
plasticity; he took to a hitherto unparalleled extreme the
'licenza' that had been introduced into sculpture, painting
and architecture by Michelangelo and his followers. The
sculpture-dominated art of the Italian high baroque was the
most anti-classical high art since the ending of Gothic
(it was later to be outdone by rococo). It was eagerly taken
up outside Italy, especially in Catholic Germany; German
expressionistic leanings help to explain why German baroque
and rococo are so extreme – the swooning ecstasies of
German and Austrian rococo sculpture often resemble those
of Northern late Gothic sculpture. Baroque expressionism
was not, however, universally accepted. Italy, at the height of
its extreme baroque extravagances, produced furniture and
decoration[5] that anticipate post-rococo neo-classicism. The
arch-baroque artist, Bernini himself, called the arch-classicist
Poussin 'the greatest and wisest painter who ever lived'.[6]
Raphael and his heirs exerted a classicizing influence that
counterbalanced Michelangeloesque 'licenza'; Raphael
joined Michelangelo in influencing the eclectic art of the
Carracci, and the Carracci and Veronese (a 'classical' painter)
influenced Vouet [272], whose Italian-influenced grotesque
made an important contribution to French 'baroque

classicism'. Moreover, the time lag suffered by countries far from creative centres held back even German decoration and furniture from reaching the limits of expressionist licence until the eighteenth century; English design suffered from provincialisms caused by distance until the later seventeenth century.

It was in the seventeenth century that France began to equal Italy as the taste-maker of Europe. A rich French tradition had been built up during the sixteenth century, and in 1608 Henri IV centralized creativity by establishing workshops in the Louvre for skilled French and Flemish workmen. Craftsmen played a more active role in France in evolving style in the decorative arts than in Italy, where the fine arts ruled the roost. France could not fail to be profoundly influenced by Italy; quite apart from anything else, the Italian Queen Marie de Médicis (1573–1642) had Italian tastes in decoration. The powerful minister Mazarin (1602–61), also an Italian, was one of the greatest of all collectors. A guide book of the 1680s gives the Italian and international flavour of the Hôtel Mazarin:[7] 'Most of the ceilings are exquisitely beautiful. They are by a certain Grimaldi, who was brought especially from Italy in 1648, as well as by Romanelli, a pupil of Pietro da Cortona, who painted the gallery';[8] the apartments on the ground floor were all 'full of *Germain* [Dutch?] Cabinets, and *China*, with Trunks of Japan, wonderfully light and sweet'.[9] Giovanni Francesco Grimaldi stayed in France until 1651, designing furniture amongst his other activities. Furniture of the Mazarin period was dominated by the Dutch Pierre Gole [244] and the Italian Domenico Cucci [243].

Italian baroque influence never overwhelmed French taste, and from the time Louis XIV assumed control in 1660 the establishment of a distinctive French style became official policy. For good and ill, this man of immensely strong will and decided ideas, 'Le Grand Monarque', set and directed his own programme, in the arts as in war. The taste of the autocrat was decisive and his eye infallible: Saint-Simon traces the disastrous outcome of his later wars to a chain of circumstances set off by the king's noticing that a window at the Trianon was a few inches narrower than the others.[10] As Pericles lives on in the Parthenon, so Louis XIV lives on at Versailles: the political achievements have gone with the wind. The 'style Louis Quatorze' has remained through succeeding centuries the criterion of excellence in French decoration and furniture.

Louis XIV strongly favoured the classical antique at the expense of the anti-classical baroque. Following Francis I in deliberately attempting to classicize French art, he rejected Bernini's design for the Louvre and banished his 'unseemly' equestrian royal portrait (after judicious alterations) to the outer fringe of the extensive gardens of Versailles. In 1666 Colbert founded the French Academy in Rome to cultivate 'le bon goût et la manière des Anciens'. The French Academy admired Raphael's Logge and the Carracci's Farnese Gallery; it restrained baroque excesses throughout the period, watching the baroque inclinations of Le Vau, Louis XIV's architect/decorator, with suspicion. Grotesque was not to the taste of the classicists: Félibien objected to it on Vitruvian grounds as 'tout a-fait barbare & ridicule'; he denounced Callot, an influence on Berain (p. 153), for his disjointed and deformed figures.[11] The Academy of Architecture was equally conservative; in 1710, after Louis XIV had himself embraced the nascent rococo, it expressed its disapproval of rococo tendencies in chimneypieces as 'gothic'.[12]

Louis XIV subsidized publications of antiquities as part of his programme: such books were the raw material of new classical design, and their influence can hardly be overestimated: in the seventeenth century they overtook circulated artists' drawings as the main source of knowledge of antique styles. The temper of the times aided the king; there were many scholars jostling for attention and eager for publication. The most significant movement was that towards antiquarian encyclopaedism. Its beginnings had been signalled by Pirro Ligorio's unpublished forty volumes of antiquities[13] and J.-J. Boissard's published encyclopaedia of 1597–1602: the latter profusely illustrated diverse types of heavily 'improved' antiques, some of which were later to be incorporated into Montfaucon's encyclopaedic early eighteenth-century collection; they included depictions of ancient furniture. Rubens's antiquarian friend, Cassiano dal Pozzo, assembled a huge collection of material, unpublished but vastly influential [477].[14]

In 1650, before the accession of Louis XIV, Fréart de Chambray (using Pirro Ligorio's drawings as a source) published a book on antique and modern architecture[15] which, illustrated with fine engravings, enjoyed a long and continuing influence – John Evelyn, who produced an English version in 1664, informed Charles II that it contained 'the Marrow and very substance of no less than Ten judicious Authors and of almost twice as many the most noble Antiquities now extant'.[16] Then came François Perrier's influential publications of antique sculpture;[17] Félibien's splendid *Statues et bustes antiques* of 1679, more hard-edged and imposing, and paid for by Louis XIV, displayed the brilliant results of the absorption by the king's own team of artists and craftsmen of the lessons taught by antique sculpture[18] – a group of modern sculptures, many designed by Charles Le Brun (1619–90), precedes the antique sculptures as if in conscious rivalry, and very fine they look.[19] The taste represented by Félibien's book is reflected in the superb gilt-bronze plaques that became so conspicuous an ornament of contemporary French furniture. In 1682 came the crown of Louis XIV's antique publications, the volume by Antoine Desgodetz on the antique buildings of Rome 'dessinés et mesurés très exactement'; its fame steadily increased and it continued in use well into the twentieth century. Other publications included examples of the 'thesaurus'; one such, published in 1690 by Michel Ange de La Chausse, included a volume devoted to two hundred gems.

The greatest French architect of the period was Mansart; he admired Palladio, Vignola, and Michelangelo, but his own work was superbly, often severely, classical. Popular and successful as was Berain's grotesque [273], he was never particularly favoured by Mansart.[20] Louis' main instrument in interior decoration was Le Brun, who dominated the King's immense works; from 1663 onwards he directed the Gobelins manufactory, set up in 1662 to make furnishings for the royal palaces. Le Brun had baroque proclivities, but he had been taught by Vouet and was influenced by Poussin [330], who himself had been influenced by Raphael; had Poussin 'painted in fresco on the ruins of an old wall…the world might as easily have been persuaded, that his painting had been the work of some famous antique Painter…there was such conformity between his Paintings and what have been really discovered in that manner, and are certainly antiques'.[21]

The tensions from opposing forces, classical and baroque, created an individual French style, which includes such masterpieces as the famous Galerie des Glaces at Versailles

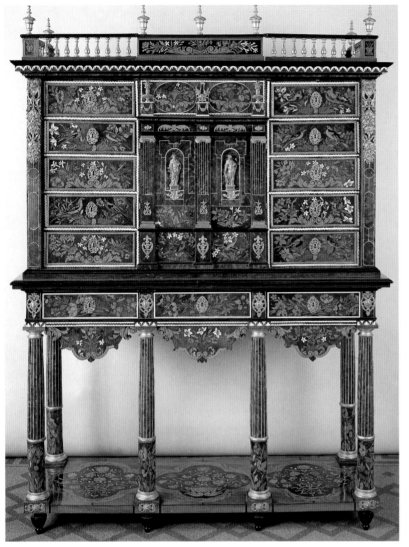

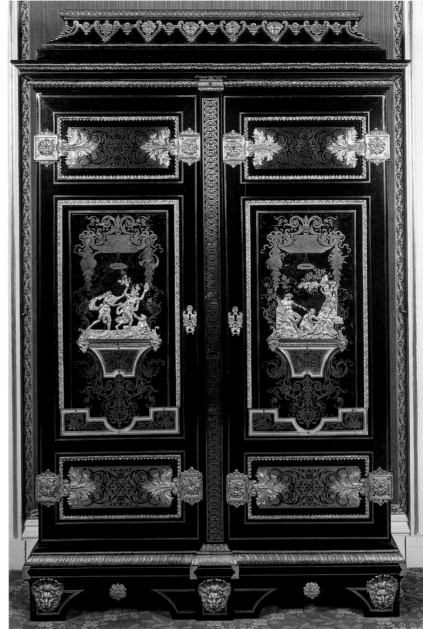

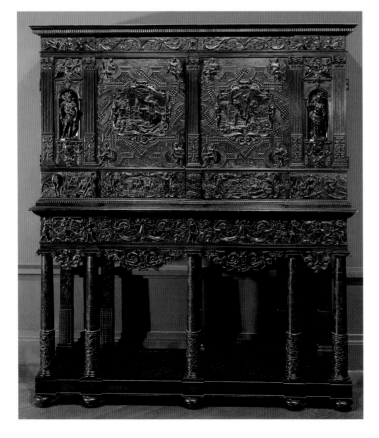

above **244** A cabinet on stand with marquetry of tortoiseshell, ivory, green-stained bone, ebony, boxwood, kingwood, tulipwood and other woods, and decorated with gilt bronze, attributed to Pierre Gole; French, *c.* 1660.

above right **245** A wardrobe in ebony, gilt bronze, and brass and tortoiseshell marquetry, attributed to A.-C. Boulle; French, *c.* 1700.

right **246** A cabinet on stand in carved and turned ebony; French, *c.* 1640.

of 1678, the designs of Jean Le Pautre [256, 257], and the furniture of Boulle [245, 275]. Percier and Fontaine, the great French decorators of the Directoire and Empire, summed up the situation in words that embody a leitmotif of this book: 'furniture and furnishings always strictly accord with the spirit that presides over the inventions of the architect, sculptor, and painter. The goldsmiths' work of the century of Louis XIV is permeated with the style of Le Brun. The armoire and guéridon of Boulle have the contours, outlines and decorative frames [cartouches] of Mansart.'[22]

Italy and France were the creative centres of the baroque. Less intense but attractive variants, affected by national differences, provincialism, and political and religious antagonisms, occurred elsewhere, including those that evolved in England and Holland. Watered-down the baroque might be, but no seventeenth-century 'high' style could quite escape it.

Baroque classicism

Swirling, often violent movement is an essential part of baroque art, but baroque (unlike rococo) is as much a volumetric as a linear art, its forms retaining some classical solidity; where movement is absent, classicism reasserts itself. Furniture may for convenience be divided stylistically into

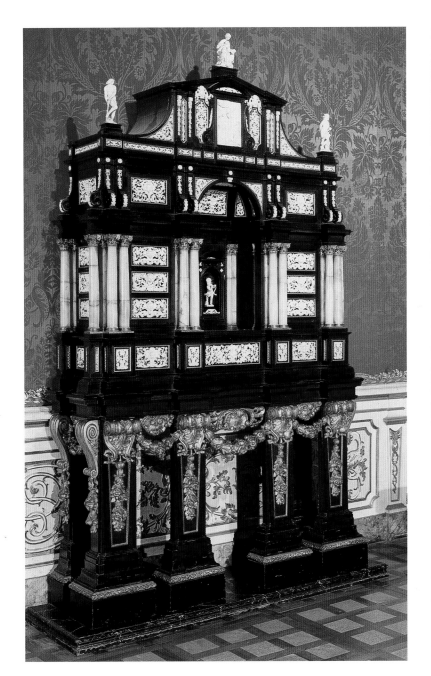

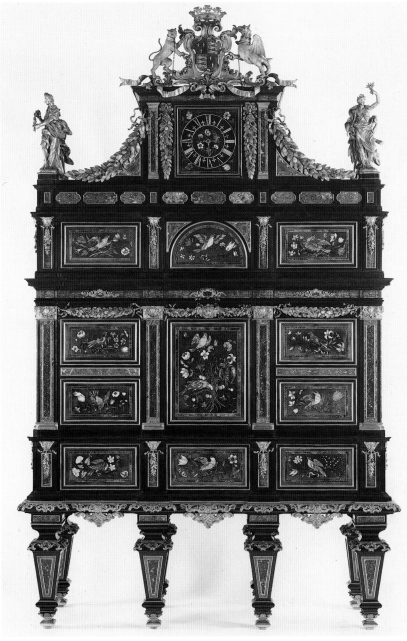

247 A cabinet on stand in ebony, alabaster, ivory and gilt bronze, designed by Giovanni Battista Foggini and made by Adam Suster; Italian (Florentine), 1704.

above right 248 A cabinet on stand in ebony, pietra dura, amethyst, lapis lazuli, jasper, agate, gilt bronze and other materials; Italian (Florentine), 1726–32.

'extreme' baroque and modified or 'classical' baroque. 'Extreme' baroque displays as a salient characteristic a dynamic and often contorted movement. 'Classical' baroque preserves many of the traditional attributes of classicism.

One of the characteristics of grand late Renaissance and baroque furniture is the emphasis placed on rich, precious surfaces, the liking for 'noble' materials such as ivory [249] and ebony [246]. Ivory was of immemorial repute: conjoined with gilt bronze it recalls the white and gold of antique 'chryselephantine' furniture. White and black contended in opinion as the most noble of colours. Aristotle had named white the most noble and black the lowest of colours, a statement qualified in 1584 (in a way that reflected the age's predilection for black) by the assertion that, despite Aristotle's opinion, people say that black is more noble than white, because 'il nero mantiene sempre il suo stato' – it is unchanging.[23] Is it coincidental that black and white 'nero antico' forms the background of the escutcheons, the badges of nobility, on the 'Farnese Table' [189]? The majestic blackness of ebony, a wood so hard and heavy that it has almost the qualities of stone, had a double value: it admirably complemented polychrome inlays [248], and used alone it set the tone for an age during which 'Spanish black and the ruff' established a European fashion for black and white

dress. Ebony was imported into Europe via Portugal from the late sixteenth century onwards. By the middle of the seventeenth century its use had become common, especially in the Low Countries, Italy, and Augsburg; its prestige is indicated by the Augsburg custom of marking it with the town pine-cone mark as a guarantee of authenticity.

The rich and powerful avidly collected antique hardstone vessels, which were remounted and embellished with gold, enamels and gems; modern versions, masterpieces of the jeweller's art, were made in antique taste. 'Pietra dura' or 'commesso' was an art in allied taste, similar to intarsia save that wood is replaced by stone: small sections of semi-precious stones were inlaid into black slate or another material and attached with adhesive; the whole was then highly polished. This polychromatic technique, perhaps the most flamboyant of all decorative finishes for furniture, was related to antique *opus sectile* [44], the difference being that the objects depicted were given natural colours. Although a Florentine inlayer of hardstones is mentioned as being in Padua as early as 1379,[24] Vasari refers to the manufacture of two tables with pietra dura tops to his design in 1562 as a remarkable novelty.[25] Hardstone workshops established at Milan supplied the European courts; the Florentine grand dukes recruited Milanese workers and in 1599 formally

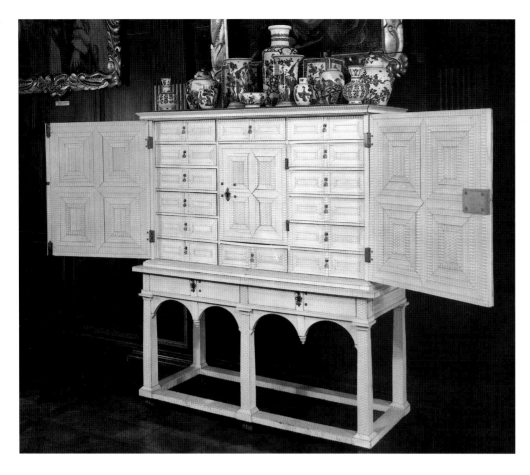

249 A cabinet on stand in cedarwood and turned and veneered ivory, at Ham House, Surrey; probably Flemish (Antwerp), c. 1665.

effect is classical rather than baroque: Corinthian pilasters on the chest and Ionic columns on the stand give a static dignity to the piece; its outline is disturbed by curves only on the apron. It nowhere employs monsters – acanthus or otherwise. French cabinets of this type establish the existence of French baroque classicism well before the reign of Louis XIV; they were at one time attributed to Jean Mace (1602–72), born in Blois and trained in the Netherlands, who had been recalled to France by Marie de Médicis. No authorship can be proved, but mixed antecedents shape many such cabinets, some of which were imported from Antwerp.[26] The techniques used in their making quickly became acclimatized in France, and from the later years of the century the craftsmen who employed exotic timbers became known as 'ébénistes' (from *ébène*, ebony), as distinct from the 'menuisiers' who made carved furniture. Flemish craftsmen also worked elsewhere in Europe: Gerrit Jensen, for example, served four sovereigns in England.[27]

A cabinet of ebony is succeeded by a cabinet entirely faced with ivory, probably made in Antwerp in about 1655 [249].[28] The ivory plaques are decorated with wave mouldings and rivetted in place. The sober coffered doors and pillared stand allow the opulent material to make its full effect and, once again, there is nothing of baroque movement about the piece – which did not prevent it from being placed in a principal state room (decorated with Solomonic columns) of an ambitious English house.

Similar in its static classicism, but gaily exuberant rather than solemnly splendid, is a cabinet on stand of about 1660 [244]. It has been attributed to Pierre Gole (1620–c. 1690), who, born near Amsterdam, came to Paris in 1643 and eventually worked for both Cardinal Mazarin and Louis XIV; his skilful tortoiseshell veneers (a revival of antique practice that began in the sixteenth century) and other types of marquetry provided a technique developed by Boulle. The elaborate floral marquetry here militates against an overall 'classicism' (pp. 151–52). The use of ivory to depict the fluting of pilasters and columns subtly emphasizes the 'architectural' effect, which is lightened by the gilt-bronze balustrade and finials. The patterns of the gilt-bronze ornaments have nothing of the antique grandeur of Boulle.

A cabinet on stand in ebony and pietra dura, made at the Gobelins by Domenico Cucci in about 1681–83 [243], exemplifies the Italianate baroque classicism that helped to form the Louis XIV style. There are no curved lines on the body of the cabinet; the caryatids are frozen, without the gestural arms seen on an earlier Cucci piece;[29] the pietra dura flowers and birds, although not as formalized as they tended to be earlier, are controlled enough. But the piece as a whole has an overbearing magnificence, and the complicated movement of the base, with its rich acanthus and intercrossed bulls' legs, is hardly classical. The cabinet's general air of sombre splendour resembles that of sumptuous Italian baroque chapels that use similar techniques. Cucci, trained in Rome, had come to Paris in 1660 and within four years was working at the Gobelins; his furniture set the tone for that of Boulle and for the Louis XIV style generally.

A stately wardrobe of about 1700 attributed to André-Charles Boulle (1642–1732) [245][30] owes its splendour to fine proportions, dramatic colour and magnificently fastidious, luxuriant ornament: it is completely static, with not a hint of baroque movement (the shape of the top resembles that of a Serlio chimneypiece [203]). Veneered with marquetry of ebony, engraved brass and tortoiseshell, it is dominated by gilt-bronze ornament; in this respect alone it makes an utterly

founded their own domestic workshop, the 'Opificio delle Pietre Dure': its products were given to foreign sovereigns and sold to private persons. Florentine and Milanese pietra dura workers were established at the court in Prague of the Emperor Rudolf II, who was obsessed by hardstones, some of which had magic properties (p. 53).

Pietra dura was used lavishly during the baroque period for all kinds of purposes, from floors to ceilings. Pictorial mosaic, an allied technique – the essential difference is that mosaic, unlike pietra dura, conceals rather than exploits its support – was developed in Rome from the early seventeenth century. Yet another revived antique technique that became important in furniture manufacture was the imitation of marble by powdering genuine coloured marbles and mixing them with gesso and glue into 'scagliola', a composition that was a much more flexible and 'painterly' medium than pietra dura. And 'ruin marbles', the mysterious markings of which suggest ruins or Mantegnaesque rocky landscapes, were inserted into the fronts of cabinets [233].

Six cabinets and a wardrobe – the grandest of all types of furniture – made over the course of about eighty years give an overall impression of controlled classicism, despite the occasional presence of prominent baroque elements. All are dominated by straight lines and cubic forms. Each employs 'noble' substances.

The sumptuous black glitter of the ebony surfaces of a truly magnificent Franco-Flemish cabinet of about 1640 [246] fully bears out the nobility of black. Its form, of cabinet on stand, combines the chest and the table; the ornament of this particular example has mixed origins, and includes mannerist and auricular elements; the square pillars of the back legs end in wave mouldings of a Dutch or German type; the interlaced decoration on front and sides that encloses the sculpted scenes is ultimately Islamic in origin, with much use of the broken curve. Despite these eclecticisms, the total

different impression from the slightly earlier Cucci cabinet. The fleur-de-lis and monogram indicate that it belonged to the French Crown. Pictorial elements are provided by gilt-bronze plaques of Apollo and Daphne and the Flaying of Marsyas, both subjects taken from Ovid's *Metamorphoses*; drawings by Raphael from the *Metamorphoses* are known to have been in Boulle's collection, and these mounts may be based on them, perhaps via versions by Rubens. The wardrobe originally had peg-shaped feet.[31]

A strikingly 'architectural' Italian cabinet on stand of 1704 [247] described in an inventory as made in 'la forma di tempio' (the form of a temple)[32] takes one even nearer to the baroque chapel than the Cucci cabinet, although exuberance is tempered by the underlying seriousness that marks much baroque art. It was designed by Giovanni Battista Foggini (1652–1725), a Florentine sculptor and architect trained in Rome who became court architect to the Grand Duke of Tuscany in the middle 1690s; one of his duties was to superintend the marble, ebony and metal workshops, the Galleria dei Lavori. The cabinet was made of ebony, alabaster, and gilt bronze, by Adam Suster; the ivory inlays, by Vittorio Crosten, reflect Foggini's naturalistic sculpture. It is adorned with ivories of German manufacture taken from the Medici collections: 'Charity' at its summit, by Balthasar Stockamer, is flanked by copies, after the antique on the left, after Bernini's *David* on the right; the central panel of ivory is also probably German.

The last of this group [248] was also the last of the grand cabinets made at the Florentine Opificio delle Pietre Dure; about thirty specialist craftsmen would have been needed to make such a piece (although the workshop closed in 1737, the tradition continued elsewhere[33]). The 'Badminton Cabinet', as it was known until its recent export from the house for which it was ordered and in which it had stood for two hundred and fifty years (perhaps the greatest of all the tragic losses of furniture from English houses since the last war), was made in 1726–32 for the third duke of Beaufort. It is eminently 'classical baroque': the shape of the legs goes back to Serlio and the sixteenth century [204], as the essential sobriety of the pietra dura inlays (save for the central bouquet) goes back to botanical illustration. Even the gilt-bronze swags have a resemblance to swags of the sixteenth century, such as those painted by Vasari on the walls of the Palazzo Vecchio in Florence.

Gilt bronze

The technique of bronze mercury gilding was ancient: that described in the treatise *Diversarum artium schedula* of the monk Theophilus in about 1100 was substantially the same as that described by Diderot in his Encyclopaedia of 1751–72.[34] Gilt bronze was much used in seventeenth-century Italy, especially in churches: for Bernini's great Solomonic construction in St Peter's [264] the Roman bronze roof of the Pantheon portico was sacrificed. Gilt bronze contributed to the polychromatic brilliance of grand Italian cabinets. Louis XIV himself had a taste for bronze, and the Italian and other artisans encouraged by Mazarin to come to France worked in it. Cucci himself, whom Mazarin brought to France (as he did Pierre Gole, also a bronze worker, and Philippe Caffiéri, 'avant tout sculpteur'[35]), is called first an 'ébéniste', then a 'fondeur',[36] in the accounts of the Bâtiments du Roi; he used bronzes abundantly in his cabinets [243].

The catalyst for the extensive use of ormolu in French furniture was the ruinous cost of Louis XIV's wars, which led in 1688–89 to the melting of his twenty tons of silver furniture, as splendid in design and craftsmanship as in material.[37] Lacking silver, gilt bronze was the poor King's only resource; its manufacture was pushed forward, and items made partly or wholly of gilt bronze replaced the melted silver items. Cucci made at least six ormolu chandeliers for Louis XIV modelled after the silver chandeliers they replaced.[38] In 1689 a royal order prohibited the use of silver in decoration and furnishings (for a short time, in 1691, even gilt bronze was forbidden, an edict that was ignored).

In one way, the use of ormolu augmented *luxe* – bronze increasingly replaced ironwork in interior decoration, and door handles, window fittings, and staircases began to be made in bronze. Mirrors were bordered with bronze. The Boulle wardrobe [245] displays fully developed the union of carcase furniture with gilt bronze that was the most characteristic and influential invention in furniture of the French 'Grand Siècle'; it dominated French and most European high-style furniture until the end of the Second Empire in 1870, and equally suited French baroque furniture, French, English, German and Italian rococo furniture, English, French and Swedish post-rococo neo-classical furniture, Napoleonic and post-Napoleonic French and European furniture, and international Art Nouveau. Where resources or craftsmanship did not stretch to the manufacture of gilt bronze, its style and placing were frequently imitated in gilt wood; much 'American Empire' furniture resorts to this expedient.

A valuable function performed by bronze corner mounts in the Louis XIV period and afterwards was that of protecting the vulnerable corners of 'Boulle' marquetry and other veneers; bronze sabots performed the same service for feet [275]. Marquetry in the manner of Boulle, one of the most characteristic inventions of the period, was yet another example of striking originality engendered by study of the past. The technique, which united the talents of the goldsmith or armourer with those of the cabinet-maker, combined brass, pewter, and other metals with wood (usually ebony) or tortoiseshell (the colour of which might be varied by the use of underlying foils). It had grown naturally from previous developments in marquetry, but must surely also have been stimulated by two other influences. One was the technique of inlaid metal as seen on remaining examples of Roman furniture [31]; the other was the mention in ancient writings of the luxurious tortoiseshell inlays favoured by Roman connoisseurs for furniture and doorways (pp. 35–36). Although the result seems to us the quintessence of 'Louis Quatorze', more especially when the marquetry employed Berainesque grotesque (p. 153), it must to Boulle and his royal clients have seemed impeccably 'antique'.

Extreme baroque: the influence of baroque sculpture

Despite its antique antecedents, extreme baroque was essentially a modern invention. In the 1730s French anti-rococo publicists were to complain that sculpture had become the mistress of architecture. They were a little out of date as far as Italy was concerned, where it had happened about a hundred years before: the result was baroque in its most exaggerated form. Effective as architecture may be in making volumetric gestures, it is far surpassed by sculpture. Sculptural values invaded architecture; as far as furniture was concerned they affected not only depictions of gods and martyrs and ornament such as drapery, acanthus and the cartouche, but fundamentally changed its shape.

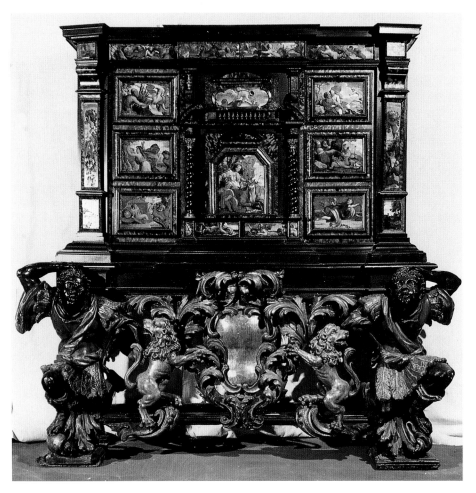

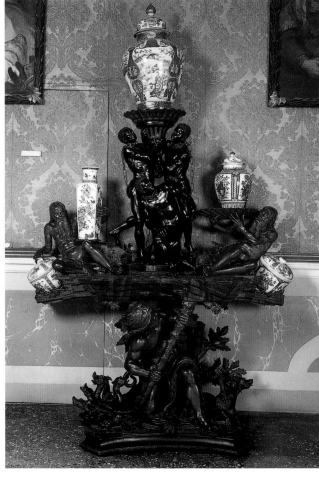

250 A cabinet in ebony and tortoiseshell, with painted panels under glass after Ovid's *Metamorphoses*, on a stand of carved blackamoor caryatids: Italian (Neapolitan), c. 1650–70.

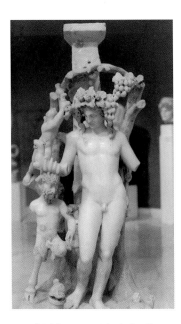

251 A table support depicting Pan and Dionysus, in matt and polished marble; Hellenistic (Asia Minor), c. AD 170.

The virtues of antique figure sculpture constantly pulled artists and craftsmen back to it: Rubens, for example (not exactly noted for the marble-like rigidity of his figures) recommended the antique as a model for all artists and wrote of its sculptures that 'we of this erroneous age, are so far degenerate, that we can produce nothing like them…'.[39] The baroque vigour of Hellenistic sculpture is already almost incompatible with classical values; its most famous example, the *Laocoön*, which profoundly influenced baroque art[40] and baroque furniture, was exceeded in gestural expressionism by its Italian baroque descendants. Hellenistic sculpture became part of proto-baroque Hellenistic furniture [25, 251]. The tradition was revived in pockets (p. 64). In the seventeenth century, stylistically advanced free-standing sculpture – as opposed to bas-relief – became part of furniture on a scale previously unknown.

Early antique sculpture – an Erechtheion caryatid for instance – is symmetrical and static, often meant to be seen primarily from the front. Hellenistic sculpture was frequently ingeniously composed to give various viewpoints and to have a sense of movement, and it encouraged not only asymmetry but pronounced asymmetry. The sculpture now introduced into furniture was emphatically of the latter sort. The lead was given by Bernini. A design for a looking glass for Queen Christina of Sweden [254] treats the mirror as a subordinate element in a piece of wall sculpture, wall sculpture that hints at the Counter-Reformation 'Vanitas' (which often contain mirrors): the subject, Time unveiling Truth, was a mordant message for a lady looking into a glass, and especially so for a Queen who was also a murderess. Bernini was a deeply religious man, and the figure of Time recalls the daemonic energy of God the Father on

Michelangelo's Sistine Chapel ceiling. A *Martyrdom of St Laurence* of 1618 stands on a sculptural wooden table representing a tree in flames, both designed by Bernini at the age of twenty.[41]

The difficulty with sculptural furniture is that so much depends on the quality of the carving; it has to be good, and the best sculptural baroque furniture moves into the realms of 'fine' rather than 'applied' art. The real test is the human figure. For example, the vigorously carved blackamoors that support a Neapolitan ebony and giltwood tortoiseshell-veneered cabinet on stand of about 1650–70 [250] are fine, but not superlative. This cabinet owes much to painting and sculpture: the glazed decorative pictures on subjects taken from Ovid are gaily painted with lapis blue and Venetian red; the stand, in the Roman baroque manner, has acanthus and a cartouche as well as blackamoors. The strong contrast between the 'architectural' cabinet, static save for the curved broken pediment and Solomonic columns in the centre, and the lively movement of the stand, is a feature common at this period, possibly partly due to the employment of craftsmen with different specializations. A similar contrast is seen in an early work by Boulle [255], almost certainly made at the Gobelins manufactory. This elaborately decorated but restrained cabinet is supported by carved wooden caryatids of Hercules and (perhaps) Omphale in Italian taste. The colour and gilding of the caryatids emphasize the stylistic divorce between figures and cabinet.

A table and chair [252, 253] by Andrea Brustolon (1662–1732) mingle influences from Bernini and Pietro da Cortona with others from the grotesque (the last particularly evident in the chair arms and legs). The sculptor has hardly succeeded in unifying his stylistic sources, which like those of

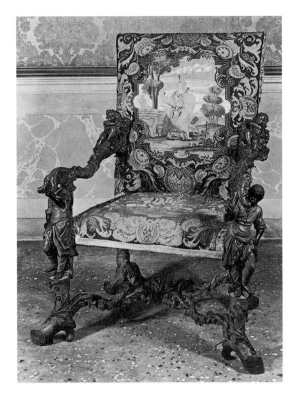

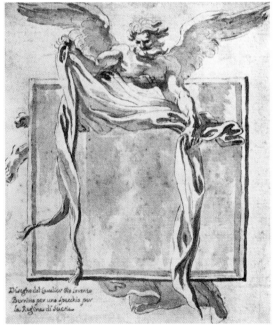

opposite and above **252, 253** A table for holding porcelain in carved boxwood and other woods, and a chair, in carved boxwood, by Andrea Brustolon; Italian (Venice), *c.* 1700.

254 A design for a mirror for Queen Christina of Sweden, by Gianlorenzo Bernini: Italian (Roman), *c.* 1670.

above right **255** A cabinet in ebony and marquetry of various woods, some stained, pewter, brass, and other materials, supported by carved, painted and gilded wood figures, by A.-C. Boulle; French, *c.* 1675–80.

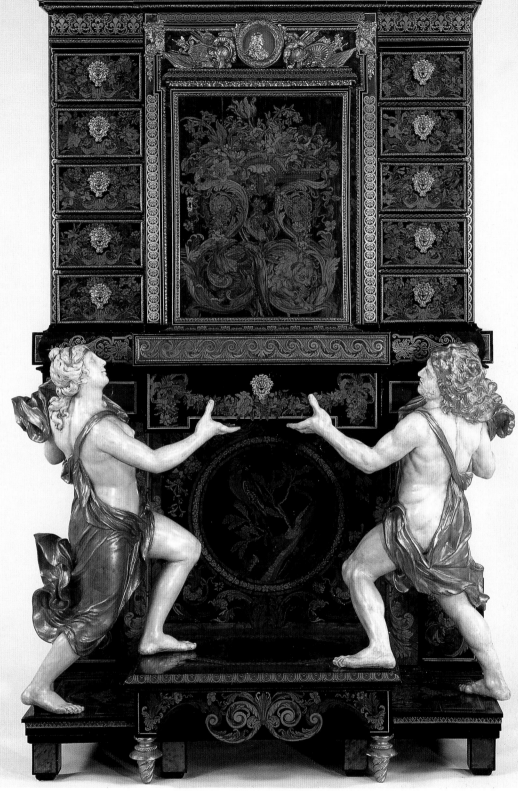

Bernini's mirror for Queen Christina [254] are principally sculptural. The table top supports a group surrounded by river gods of the type seen in Bernini's Roman fountains (a famed and easily accessible public spectacle, full of robust forms like those found in baroque and later furniture [263]). The ultimate origin of the table's gods lay in a literary conceit older than any visual image, already ancient when Ovid described a crowd of river gods accompanied by their urns:

Spercheus, crown'd with Poplar, first appears;
Then old *Apidanus* came crown'd with Years:

Enipeus turbulent, *Amphrysos* tame;
And *Aeas* last with lagging Waters came.
Then, of his Kindred Brooks, a num'rous throng
Condole his loss; and bring their Urns along.[42]

Brustolon's gods hold decorative porcelain, not gushing urns.

An Austrian state bed of 1711 [258] is uncanopied (did it possibly once have a canopy in which the spears of the figures at the bed's head played a part?). Austria was directly exposed to Italy, and the influence of Italian baroque sculpture is evident: the bed was made by specialists, a

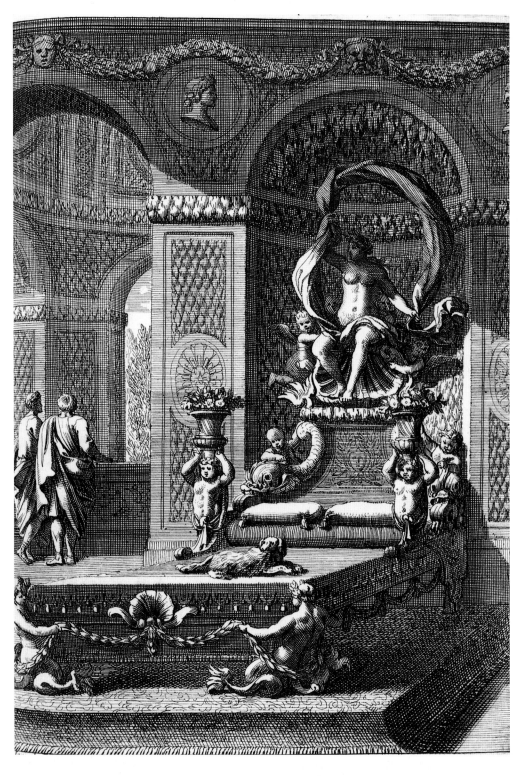

hangings being separate from a couch;[43] this may well be correct, but one should bear in mind that a couch of the kind illustrated, with separate hangings and without posts, seems to have been regarded as more 'antique', more 'Roman', than the posted bed – as indeed it was. Sculpted draperies and the free use of sculpture were a modern 'Roman' feature, and that may also have influenced the use of the term. A Le Pautre design for a cabinet [257] has the usual complement of sculptural garlands, griffins, herms, sphinxes, and acanthus. Many of Le Pautre's designs have, despite strongly moulded sculptural forms, the static quality that marks much French baroque classicism.

Baroque drapery

Draperies have always been subservient to general style. Greek sculptors, intent on the human body, used the superfine Egyptian linen that was their most luxurious material to reveal the contours of the form beneath it. In the later Gothic period draperies fell into sharp, angular, often agitated folds. Early Renaissance Italian painters such as Mantegna and Botticelli imitated the fluttering draperies of antique Roman sculpture and painting: in the High Renaissance draperies became ample, heavy and dignified, thereafter becoming acceleratingly animated until in the early seventeenth century their expressive forms billowed, blew and streamed all over Europe, in sculpture, in painting, in interior decoration – and in furniture.

Bernini played a decisive part in this development. People have been fascinated by Bernini's draperies, and with reason. His range was wide, as divergent opinions reveal: a nineteenth-century critic said he 'composes [drapery] …entirely according to painterly principles', whereas an eighteenth-century critic alluded to his 'Greek draperies [taken from Greek sculpture]…in natural and fine folds that seem wet'.[44] They vary from wind-blown insubstantiality to opulent heaviness. He carried his sculptural interest in expressive drapery into interior decoration – a famous example is the stucco drapery flung in 1656–57 around the arch of the Sala Ducale in the Vatican Palace. His design for

256 'Lit à la Romaine' a design by Jean Le Pautre; French, published in Amsterdam *c.* 1690 (from *Ornemens pour les maisons*).

right 257 A cabinet on stand designed by Jean Le Pautre; French, published in Amsterdam *c.* 1690 (from *Ornemens pour les maisons*).

opposite 258 A state bed carved by Leonard Sattler and painted by Matthias Müller, in the Abbey of St Florian; Austrian, 1711.

sculptor and a painter. Vividly polychromatic, it anticipates southern German rococo; symmetry is precariously maintained. The anti-Turkish iconographical scheme includes a bonded figure that descends from the chained barbarians seen on antique coins and sarcophagi; Vienna had only recently been relieved from the threat of Islamic conquest, and the bed (made for a rich monastery) is really a 'meuble parlant', conceived long before Romantic Classical architects (p. 178) evolved 'architecture parlante'.

A sculptural bed [256] designed by Jean Le Pautre (1618–82), an arbiter of Louis XIV decoration and furniture, a baroque classicist with a pronounced sculptural bias, uses nautical imagery, mermen at its foot, dolphins and a Galatea-like Venus with a shell at its head. It is of the type called 'Lit à la Romaine', a term that has been thought to refer to

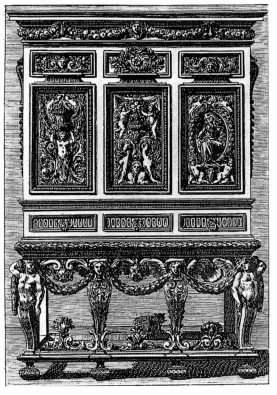

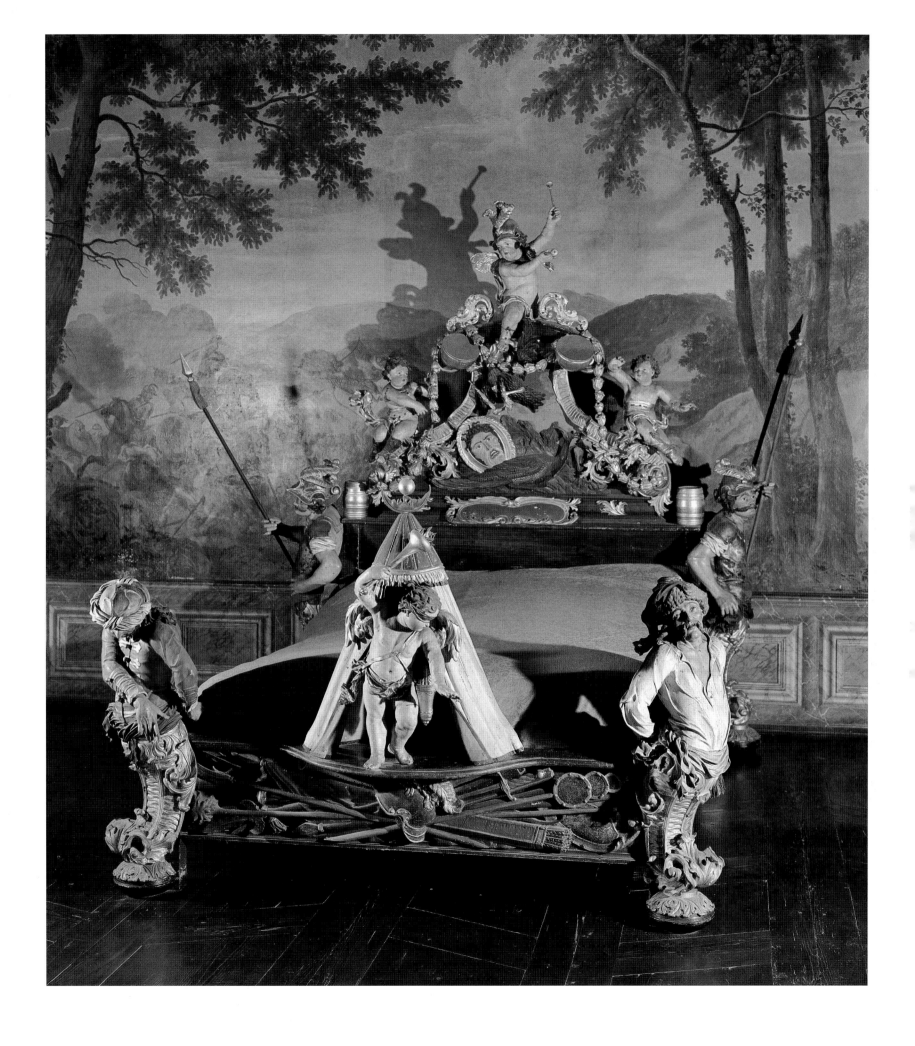

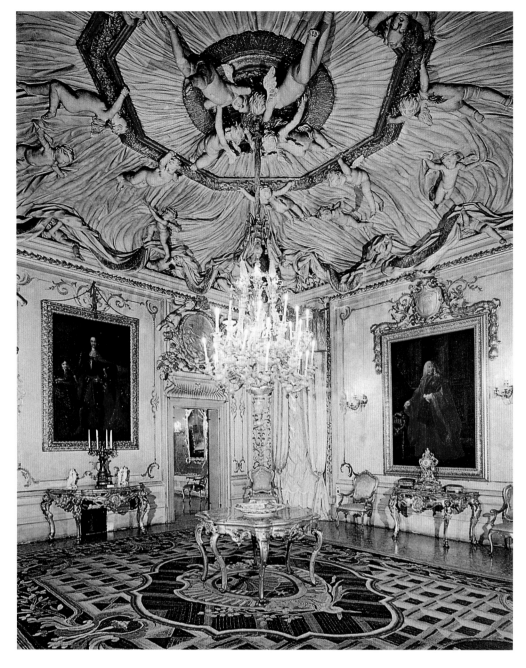

259 The Ballroom of the Palazzo Albrizzi, Venice; Italian, c. 1700.

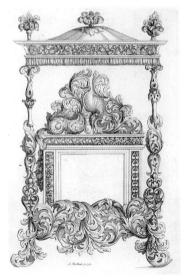

260 A bed decorated with acanthus, by Johann Unselt; German, published in Augsburg in 1690 (from *Neuen Zierathen-Buch*).

Queen Christina's mirror uses draperies as a unifying device [254]. His imitators carried the theme to a point where a room in a Venetian palace [259] resembles a voluptuously draped tent – or the interior of a domed bed. Curtained and draped beds were a natural vehicle for Berniniesque fantasy, and exaggeratedly draped, frequently far-flung fabrics became an accepted feature of late seventeenth-century state beds. Naturally, few have survived.[45] French state beds, following the French preference for classical restraint, tended to be cubically grave and box-like, although a confection of aerial frivolity was designed in 1672 [261] for an amour of Louis XIV: non bene conveniunt…Maiestas et amor'[46] (majesty and love go ill together!).[47]

Sculptural acanthus and the cartouche

Ornament was as affected by baroque sculptural volumetric movement as was the human figure; especially important were baroque acanthus and the baroque cartouche.

The various types of antique acanthus available as models were adapted for distinct purposes. The acanthus that most attracted baroque artists working in three dimensions – architects, sculptors, and woodcarvers – was the richly decorative acanthus of Hadrianic sculpture, broadly

modelled and with vigorous three-dimensional rhythms; surviving throughout the Dark and Middle Ages, especially in Italy, it had been revivified and given shot colour in the vertical acanthus scrolls of Raphael's Logge [365]. Italian baroque carvers imparted to this type of acanthus an extraordinary vitality; its sculptural values are apparent even in the flat media of wall tapestry, carpets, and marquetry. Acanthus became a furniture motif all over baroque Europe, characteristically different in its sumptuous congestion from the lucid scrolls of the Augustan type [52] that had been so popular with the artists and furniture designers of the Renaissance. Luxurious or lucid, both differed from the delicate, not to say wispy acanthus of Berainesque grotesque [273] and 'Boulle' marquetry [499], which was, as described above, derived ultimately from antique painted grotesque via Vico, Du Cerceau and others.

Bernini and other Roman or Rome-orientated baroque sculptors, such as his assistant Giovanni Paolo Schor (1615–74), had much to do with the development of baroque acanthus. Acanthus was particularly suitable for picture frames and mirrors. Antique wall paintings depict simulated frames that employ acanthus in a disciplined way[48](imitated pedantically in countless post-rococo neo-classical picture frames); acting on that hint, baroque carvers broke away

opposite **261** A design for a bed at the Trianon de Porcelaine, Versailles, 1672.

right **262** A carved giltwood mirror; Italian (Modenese), *c.* 1650.

below **263** A state bed in carved and gilded mahogany, probably designed by John Linnell and made by James Gravenor, at Kedleston Hall, Derbyshire; British, *c.* 1762.

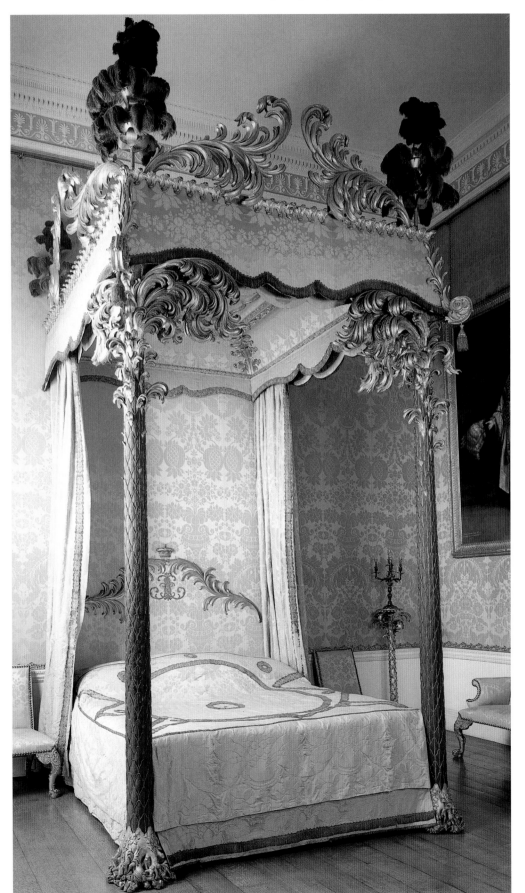

from the straight line to produce frames of extravagantly luxuriant acanthus that disposes itself expansively around the glass and upon the wall [262]. Splendid acanthus frames of this type were made at Bologna throughout the seventeenth century. Acanthus ornament decorated later seventeenth-century chairs throughout Europe; itinerant Italian stuccoists introduced baroque acanthus to German and Austrian decoration, and pattern books made it readily available to the artisan;[49] the designs of Johann Unselt, an Augsburg cabinet-maker, contain an armchair totally made up of acanthus. They also contain a bed dominated by unnervingly vigorous acanthus [260], its candelabraform columns partially enwrapped in it; a shell cowers amongst the acanthus decoration on the bedhead. Acanthus on this scale introduces yet another element of sculptural asymmetry into furniture.

Throughout the seventeenth century the cartouche, very often enclosed within acanthus, sometimes exaggeratedly so, was evolving towards the supreme position it achieved in the rococo period; cartouches occasionally became asymmetrical as if blown sideways [237], a prophecy of later developments.

Italian influence was strong in early eighteenth-century England, and is seen in furniture supplied to Kedleston Hall as late as the 1760s. John Linnell's flamboyant mer-sofas in the drawing room show Italian baroque influence (Bernini's Roman fountains influenced various works at the same house),[50] and a grandiloquent state bed [263] is supported on 'palms' that have much of the propensities of Italian baroque acanthus.[51] Made by James Gravenor, who worked on pier glasses and on alabaster Corinthian capitals in the drawing room,[52] it was carved locally in mahogany.

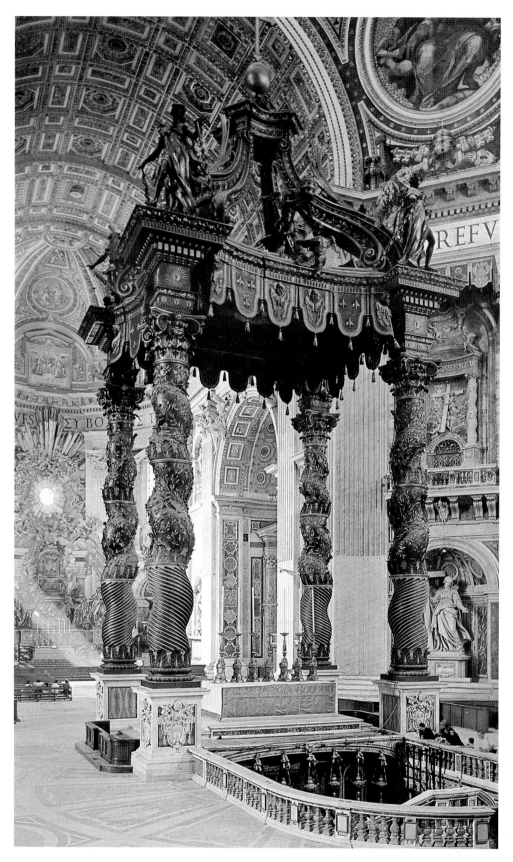

The Solomonic column and exaggerated turning

The motif that above all others expresses the baroque ideal is the Solomonic column. The sole regular motif of architectural origin that writhes, it gives an impression of a constant spiral movement that is halted only by capital and base; its popularity in baroque furniture derived from the perpetual agitation it communicated to such normally static components as table, chair and cabinet legs. It was frequently combined with exaggerated turning. In the seventeenth century, the baroque Solomonic column was incarnated in its grandest form in the supports of Bernini's baldacchino in St Peter's at Rome [264]. His vigorously energetic forms, decorated with vegetation and other ornament, combined the twisted form with surface strigillation. Bernini's baldacchino is a macrocosm of the reinterpreted antique motifs that reappeared in the canopy, lambrequins and ogee dome of the state bed. Twisted columns and gestural sculpture became common not only in state beds but in grand bookcases and cabinets; they were eventually transmuted into neo-Gothic forms.

Two cupboards exemplify the baroque Solomonic column. One, made probably in Amsterdam in the mid-seventeenth century, has lax Corinthian columns [265]. It is veneered with ebony and other exotic hardwoods, mother o' pearl and ivory; the mother o' pearl decoration of the columns is on the same principles as the luxuriant decoration of Bernini's columns, albeit much simpler. The deep coffering (influenced by Renaissance ceilings) is ornamented with multiple ripple mouldings. The second cupboard, a large Augsburg piece of about 1700 [266], is conceived as an architectural two-tiered façade; the 'attic' is a modified version of a type that had appeared in various local variants on buildings all over Northern and Central Europe. The twenty-seven Solomonic columns that enclose the aedicules, Corinthian above Ionic in the approved antique manner, twist in customary manner in opposite directions. The cupboard is stamped with 'gut' ('good') in Gothic letters, the mark of approval of the local cabinet-makers' guild.[53]

The Solomonic column smelt of popery to English Protestants (the porch with Solomonic columns added to

264 The baldacchino in gilt bronze in St Peter's, Rome, designed by Gianlorenzo Bernini; Italian (Roman), completed in 1633.

265 A cupboard, turned and carved and veneered with ebony and other woods, mother o' pearl and ivory on oak; Dutch (probably Amsterdam), c. 1650–75.

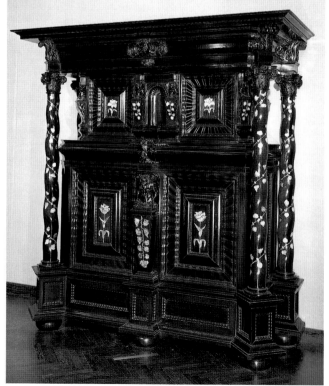

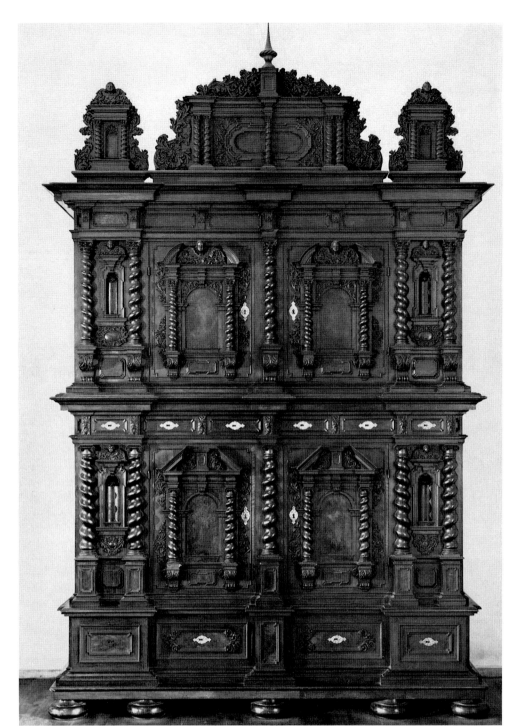

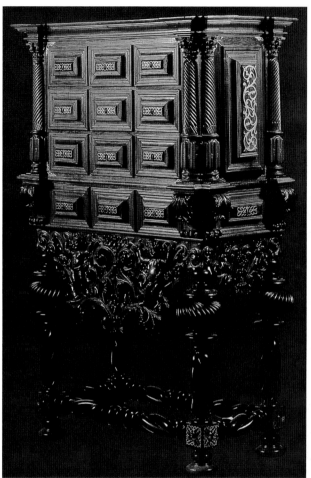

left **266** An architectural cupboard in walnut with turned
Solomonic columns; German (Augsburg), *c.* 1700.

above **267** A chest on stand in carved rosewood with gilded
copper mounts; Portuguese, *c.* 1725.

St Mary's Church at Oxford contributed towards Archbishop
Laud's losing his head). In the reign of the crypto-Catholic
King Charles II (1660–85) it entered the design of
'Restoration' English furniture in force, especially for chairs,
where it frequently appears together with versions of the
'Cecilia Metella' opposed scroll [477], horizontal and, with
Michelangeloesque 'licenza', vertical. The same type of chair
occurred in Europe, especially Holland, and was
manufactured in large numbers in the East Indies for export.
The architectural Solomonic column was also supplemented
or replaced by the use of twists, either with vestigial capitals
and bases or completely lacking them; divorced from
architectural restraints, such twists often became highly
fanciful. Open double twists occur frequently in ancient
grotesque painting [35]; some reach the heights of elaborate
fantasy.[54] A seventeenth-century English table, candle-stands,
candlesticks and wassail bowls [268], made of lignum vitae
and ivory, are decorated with restrained twists, plus ripple

moulding and rose turning. The multiple twist of the candle-
stand legs is found in antiquity; the rose motifs on the top of
the candle-stands curiously resemble ornaments employed
centuries earlier on Gothic chests, perhaps an example of
vernacular survival [128]. Twists were often combined with
turned ornament derived from other sources: the 'bobbin
turning' on the rim of the bowl is combined with wave
turning. Did other turned motifs cross from 'folk art' into
more rarefied realms? It seems likely: contemporary turned
country furniture boasted descent from antique [21],
Byzantine [82] and Romanesque [98] turning, before passing
in the Gothic period into the vernacular.[55] After all, the same
technique produced all kinds of turning. Much seventeenth-
century turned and twisted furniture hints at the vernacular: a
German table, for instance, displays an elaborate combination
of twists and bobbin turning.[56]

Impressively energetic furniture employing the twist and
the Solomonic column was made in Spain and Portugal.

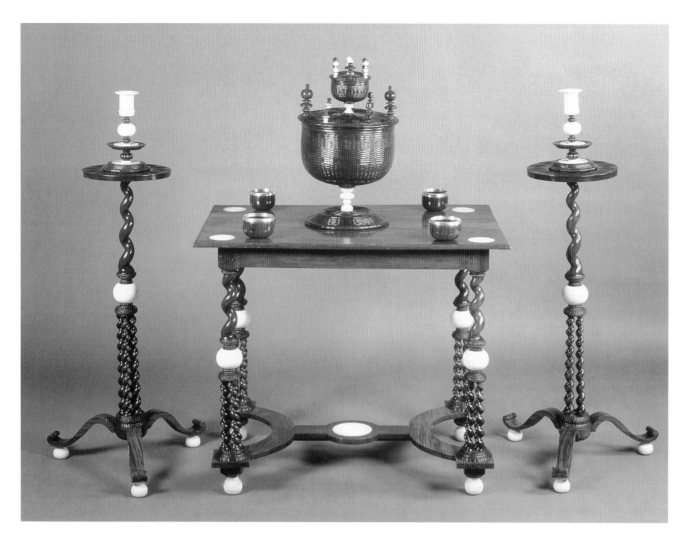

268 A wassail table, candle-stands, candlesticks and bowls in carved and turned lignum vitae and ivory; English, seventeenth century.

269 A detail of 'turning' on a chair (probably meant as a metal chair) depicted in a Roman wall painting, published in Naples in 1762 (from *Delle Antichità di Ercolano: Le pitture antiche d'Ercolano*)

270 A chest on stand in carved rosewood, with mounts varnished in yellow; Portuguese, *c.* 1650.

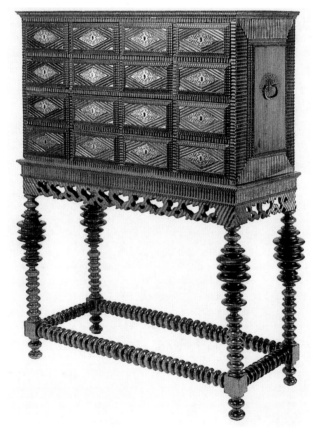

Some Iberian turning so strongly recalls exaggerated late antique turning [269] as to make one ponder its origins: the legs of a Portuguese chest on stand of about 1650 [270],[57] for instance, approach the neo-classicism of nineteenth-century Danish designers such as M. G. Bindesbøll [515], on whom indisputably direct late antique influences operated. Does the fact that the Portuguese chest is in 'vernacular' taste[58] increase the possibility of such a descent? Other Iberian examples mix Solomonic columns with bobbin turning, bulbous turning, and turning that resembles superimposed saucers, to make up a fine bravura display. A Portuguese chest on stand in carved and turned wood of about 1725 [267] with gilded copper mounts displays virtuoso turning and twists combined with plain 'ceiling-type' panelled drawers; the aprons are baroque in style.

The Solomonic column fell out of favour in French high-style furniture with the development of baroque classicism in the second half of the seventeenth century, and did not enter the vocabulary of French rococo (the vision of rococo with quantities of Solomonic columns added is dizzying!). It continued in use elsewhere until well into the eighteenth century and was revived at its end: Thomas Hope, who disliked rococo intensely, was interested in the twisted column; and Ruskin, oddly enough, liked it – although not as used in baroque art!

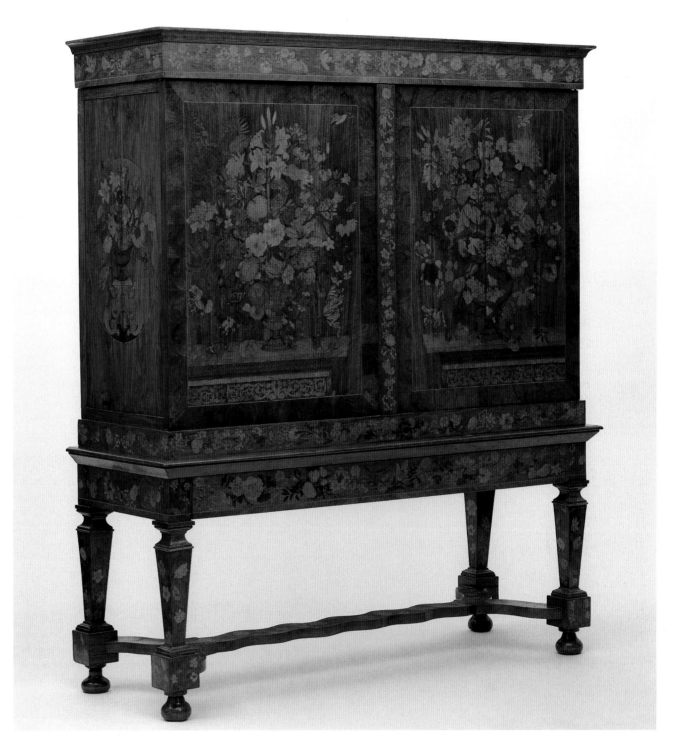

271 A cabinet on stand with marquetry of kingwood, ebony, rosewood, sycamore and other woods on oak, attributed to Jan van Mekeren; Dutch, *c.* 1700.

Flowers

It became fashionable in the seventeenth century to decorate furniture with profuse flowers and foliage; the application of this degree of naturalism to furniture was unprecedented. Antique taste had normally formalized and geometricized flower and foliage ornament; the 'anti-classical' complexion of Gothic had permitted the use of naturalistic flowers as architectural ornament and in miniature decoration; but they hardly began to enter furniture design until fifteenth-century cassone painters, many influenced by miniaturists, scattered flowers over their paintings. In the sixteenth century the interest in botany, fed by new plant importations from the East, prompted the production of flower prints, such as the panels of naturalistic mixed flowers and fruit published by Hans Leckner in 1560[59] that supplied craftsmen with new sources of flower ornament. The first picture of the tulip was published in 1561[60] – a mild prelude to the phenomenon known as 'tulipomania', which drove sober seventeenth-century Dutch merchants to expend fortunes on a single bulb.

The sixteenth century had witnessed the development of floral still-life painting; one of its pioneers was Giovanni da

272 An engraving of a grotesque
wall decoration designed by Simon
Vouet for the Palais Royal, Paris,
published in Paris in 1647 by
Michel Dorigny (from *Livre de
diverses grotesques*).

Udine, which underlines the strong connection of still life
of all kinds with the anti-classical art of the grotesque.
This connection continued: Hoefnagel, for instance, an
early painter of flowers, also specialized in grotesques.
Embroiderers and enamellers were early users of flower
motifs: in 1657, visitors to the cabinet in the Louvre of Anne
of Austria admired a table, guéridons and chair frames of blue
enamel painted with tiny flowers.[61] Flowers and birds, spare
and literal botanical specimens [265] as much as painterly
sprays diversified by acanthus and birds, became frequent
motifs on furniture, especially in the form of Italian pietra
dura, where the bright colours of the inlay contrasted
strongly with black marble [243, 248]. 'Botanical' furniture
decoration had a long life, coexisting with more carelessly
arranged compositions; the cabinet on stand by Pierre Gole
[244] shows the botanical spray loosening up. The eternal
appeal of flowers to embroiderers led to the inclusion of
botanical-type flowers in the silk-wrapped metal purl
embroidery employed on English cabinets.[62]

'Underground' auricular ornament was increasingly
displaced in Netherlandish furniture after about 1650 by
equally anti-classical but markedly 'aboveground' flower
motifs. The influence came from contemporary Dutch flower
painting, the great new art that stands halfway between
botanical stiffness and the sprawling and negligent luxuriance
that, culminating in the floral explosions of French painters
such as J.-B. Monnoyer (1634–99), persisted well into the
rococo period, when flower ornament on furniture became
three-dimensional [315]. Dutch flower painting was
assimilated into the ancient motif of a candeliera issuing from
a vase, flowers replacing antique ornament. Vases of flowers
were reproduced on furniture in marquetry; direct painting
was also used, especially in countries where skilled marquetry

workers were not so easily available. Today the colours of
most marquetry have faded to gradations of brown, but
protected areas show the bright stains that originally gave a
vivid polychromy. The wood was scorched with hot sand
to give chiaroscuro, and fine details were rendered in thin
incised and darkened lines. Some of the greatest masters
of this genre were Flemings, many of whom took their
skills to France.

A cabinet on stand [271] attributed to Jan van Mekeren
(1658–1733), who worked in Amsterdam, has large flat
surfaces intended primarily to display such 'paintings in
wood': the marquetry woods include kingwood, ebony,
rosewood, olive and sycamore; apart from the scrolling
pattern on the oddly placed tables on which the vases sit
(the asymmetry has an oriental cast) all the ornament is
floral. The interior contains a few drawers and plain shelves,
nothing like the elaborate architectural interiors of grand
French and Italian cabinets. The cabinet markedly lacks
baroque movement.

Monnoyer's work was disseminated in prints, and the
flowers mixed with baroque acanthus that decorate Boulle's
early work reached extraordinary heights of accomplishment,
splendid bouquets that, however opulently overflowing,
usually issued from a vase and were surrounded with
conventional ornament. Flowers were succeeded in Boulle's
later furniture by Berain-type grotesque and by the stricter
classicism of gilt-bronze reliefs in antique style.

The influence of grotesque decoration on baroque furniture

The different types of grotesque evolved during the course of
the seventeenth century influenced furniture design into and
throughout the rococo period, far beyond if one includes
furniture using the 'Boulle' technique. The stylistic cross-
currents during this long period are complex; one might
usefully simplify them by dividing French grotesque
influences into two main types influenced by two artists –
the 'sculptural' and 'classical' grotesque of Vouet [272], and
the 'linear' and 'anti-classical' grotesque of Berain [273].
To these may be added German grotesque; that of Paul
Decker, who was born in Nuremberg, is typical of the genre
(p. 156). All were widely circulated in the form of prints.

Christopher Wren wrote in 1655 from France that he had
'purchased a great deal of Taille-douce [copper-plate
engravings], that I might give our countrymen examples of
ornaments and grotesks, in which the Italians themselves
confess the French to excel'.[63] He must have included the
engravings after the well-known grotesques painted by
Simon Vouet (1590–1649) from 1643 for Anne of Austria at
the Palais Royal. Vouet had spent fifteen years in Rome,
returning in 1627 to Paris to become 'Premier peintre du Roi'.
The Palais Royal decorations, as seen in the engravings of
1647 that recorded them [272], were closely massed, grand,
sculptural, heavy, and symmetrical, containing antique
ornament such as garlands, goats, putti, sphinxes, and
censers. They have nothing of the airy, insubstantial quality
of Italian grotesque or of the later grotesque of Berain and
of Audran (p. 170): influenced by the Carracci, they are static,
earth-bound, sometimes by pedestals decorated with heavy
acanthus that foreshadow Louis XIV furniture. Although the
decorations are organized in the candelabro and candeliera
shapes of painted antique grotesque, they are dignified rather
than bizarre. The influence of antique sculptured ornament is
clear; the garlands and sphinxes come from a temple frieze
rather than the Domus Aurea, and the acanthus has the

refined line and crisp modelling of the chisel rather than the spontaneous flick of antique Roman paint: the design would bear execution as a marble or bronze bas-relief, or even in the round, with little adaptation. Indeed, the Vouet type of grotesque was, in accordance with French 'classical' preferences, often rendered in gilded relief in the Louis XIV period rather than painted flat in colours. Vouet's grotesques are less unlike late eighteenth-century neo-classical decoration such as that by the Rousseau brothers in Marie-Antoinette's apartments at Versailles (also echoed on furniture) than might appear at first glance.

It would be difficult for any grotesque to be more 'classical' than that of Vouet. It exactly fitted the predilections of Le Pautre, whose ceilings are composed in geometrical combinations of ovals, circles, and rectangles with much use of weighty classical ornament. Volutes often occur but (despite Le Pautre's having drawn plates for Desgodetz' *Édifices antiques de Rome*) he significantly tended to avoid the components of the orders, capitals, columns and pilasters. His design for a cabinet [257] has strong sculptural grotesque within the panels. His female type is that of Vouet (even in the black and white of Vouet's prints one senses the lambent flesh that is such a beauty of his paintings).

The grotesque of the other French master of the genre, Jean Berain (1640–1711), is at the opposite pole from that of Vouet; it is 'anti-classical' in the Vitruvian sense – even Dietterlin's caryatid cook [214, 273] reappears! Where Vouet is sculptural, Berain is linear, influenced by antique grotesque [33] and French grotesque of the sixteenth century; he articulates his fantasies with a bandwork of straight lines and scrolls conjoined, the last blossoming at their ends into a flourish of delicate acanthus. Theatrical and eccentric figures (reminiscent of the prints of Callot), cavorting birds and beasts perch on the bandwork, recline on it, and wrap themselves around it; the more prominent personages often stand or sit on some aerial structure, frequently a baldaquin. Berain's figures, unlike those of Vouet, inhabit an atmosphere – a foretaste of rococo, in the evolution of which Berain played a leading role. Caryatids, terms, sphinxes, cornucopias, trophies, masks, peacocks, putti, vine leaves, trellis, pyramids, fauns, satyrs, nymphs, gods and goddesses and the other decorative appurtenances of classicism are

273 A detail of a grotesque ornament by Jean Berain; French, *c.* 1700.

freely called into requisition. Occasionally one sees the personages of the Commedia dell'Arte. Berain often used garden motifs: in 1677 he became a designer of the royal gardens. What motifs did he not include in his grotesque? There are no grottoes, nothing that approaches the sinister or expressionistic.[64]

The Berain style was diffused by his engraved designs, which were copied in Augsburg and the Netherlands.[65] They included furniture designs, and panel designs that were adapted for use on painted or inlaid walls, inlaid floors, textiles, 'Boulle' commodes or armoires, and so on – this versatility was to become a feature of the decorative grotesque of later neo-classicists such as Adam, facilitating the production of unified schemes of interior decoration. One of Berain's furniture designs shows a commode decorated with delicate grotesque inlay and rich classical sculptural ornament; its heavy forms, and front that curves forward horizontally, are both derived from classical and baroque sarcophagi, the last being a modest foretaste of the voluptuous bombé shape that was to become so ubiquitous in the following century.[66] These designs closely resemble furniture made by Boulle, the most famous of ébénistes, and indeed some are known to have been executed by him.

Grotesque was employed in furniture in three principal ways: as flat over-all pictorial decoration; as flat individual acanthus scroll and banding motifs; and as three-dimensional versions of the forms seen in flat grotesque.

Flat Berain-type pictorial grotesque decorates two oak doors, veneered in ebony, engraved brass and tortoiseshell [499]. Caylus remarked that Boulle's 'deep studies, united with a natural taste, had made him the first of his profession',[67] and indeed the classically inspired furniture associated with his name was one of the most distinguished creations of the seventeenth century – distinguished enough to be made in essentially its original style throughout the eighteenth, nineteenth and early twentieth centuries. Grotesque marquetry is inseparable in the mind from such furniture, although furniture in the Boulle manner was in fact often designed without pictorial grotesque, perhaps because of the anti-grotesque prejudices mentioned above. The classical and sculptural aspect of the marquetry on the Boulle wardrobe [245], for instance ('Autumn' and 'Winter' were influenced by sculpture in the Parterre d'Eau at Versailles[68]), quite differs from the insubstantial whimsicalities of Berain's grotesque figures; the delicate curling marquetry acanthus is, however, of the Berainesque type, markedly contrasting with the sculptural gilt-bronze acanthus immediately contiguous to it. A similar contrast between delicate marquetry and bolder gilt-bronze 'sculptural' acanthus is seen in one of the few securely documented pieces by Boulle himself, a commode [275] made in 1708 for Louis XIV's bedchamber in the Grand Trianon at Versailles; it also has no grotesque, although the bold outlining banding with its broken curve of the marquetry originated in grotesque.

The broken curve; geometrical and curvilinear interlace

A feature of furniture in the seventeenth and early eighteenth centuries is the extension of use of the motif of the broken curve. From being a conspicuous element of surface decoration it became a structural element of the design. It was usually accompanied by curvilinear and geometric interlace.[69] The endless tergiversations of the motifs make simple exposition difficult; they have a duplicity that differs from the unambiguous frankness of acanthus or anthemion.

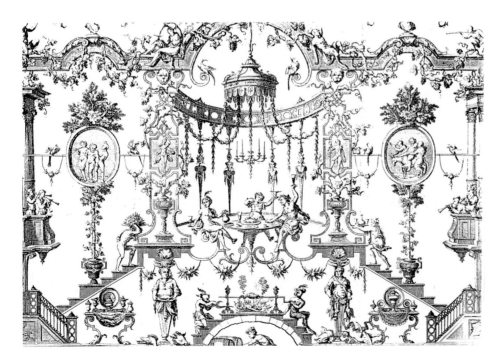

Broken curves are not, for instance, immediately obvious in the movement of the front of a chinoiserie bureau in the Boulle technique [274].

The line of the broken curve has moulded the body of the Boulle commode [275] (which also resembles Renaissance and baroque sarcophagi). The commode itself – stretched out to a slimmer length it would resemble the bureau plat, and was indeed called a 'bureau' on its delivery in 1708 – is one of the earliest examples of its type. The extraordinary way in which its body is, as it were, slung between the eccentric legs is somewhat reminiscent of carriage construction: the bodies of carriages frequently employed the broken curve. A Würzburg writing cabinet of 1716 [276] displays the broken curve rendered in three dimensions in the vertical scrolls that support the drawers at its sides and in the profile of drawers and base. Its elaborate marquetry employs walnut and other woods, tortoiseshell, ivory, pewter and brass;[70] the hodge-podge of motifs includes curvilinear and geometric interlace, baldacchinos drawn from grotesque, flowers, birds, and a lingering, half-hearted reminiscence of perspectives; around the panels is a repeated Turkish-type ogival pattern.

The persistence and ubiquity of the broken curve – baroque broken curves are still finely flourished all over the world in the violins and cellos of the modern orchestra – and geometric and curvilinear interlace is plainly demonstrated by a miscellaneous group of artefacts: an English Jacobean plaster ceiling at Speke Hall in Lancashire; a chair attributed to Franz Cleyn [231]; the floor of Bernini's 1648 sepulchre of Santa Francesca Romana at S. Maria Nuova in Rome;[71] a Boulle commode [275]; a pier table by William Kent [295]; an American bureau bookcase [280]. Broken curves and interlace were ubiquitous not only in the frames of furniture, but in the costly damasks and silks that covered walls and upholstered furniture. The motifs were easy to reproduce in the sumptuous textiles that embellished state beds (garden designs sometimes acted as patterns for such textiles – and vice versa). These fragile textiles have now usually disappeared, but where they remain one sees how large and bold were their broken curves and interlace, and how vital their role in the total effect.

274 A bureau decorated with chinoiserie polychrome 'Boulle' marquetry, its materials including mother o' pearl, stained shell imitating lapis lazuli, ebony, purpleheart, kingwood, brass and gilt bronze; the top is of parquetry; French, c. 1720.

275 A commode in tortoiseshell and brass marquetry, with gilt-bronze mounts and a marble top, by A.-C. Boulle; French, 1708.

right 276 A bureau cabinet in pine, with marquetry of walnut and other woods, tortoiseshell, ivory, pewter and brass, made in the workshop of Servatius Arend; German (Würzburg), 1716.

below 277 A table in solid silver, with a top engraved with a grotesque design of Venus and Adonis; Spanish or German, seventeenth century.

below right 278 A sofa in carved, turned, painted and gilded beech upholstered in contemporary Genoa velvet, made by Philippe Guibert, perhaps after a design by Daniel Marot; English, *c.* 1700–1705.

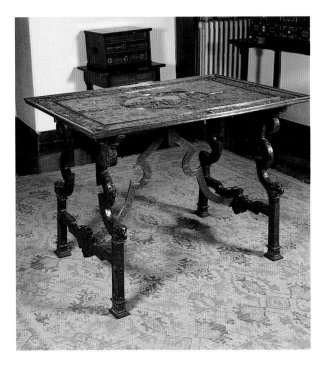

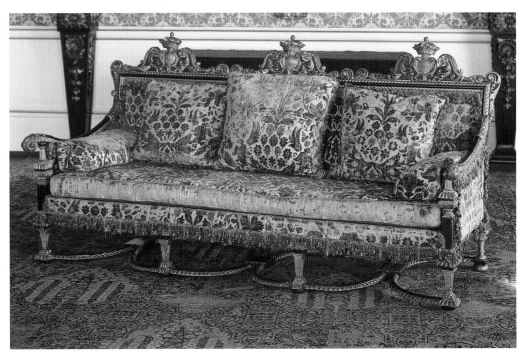

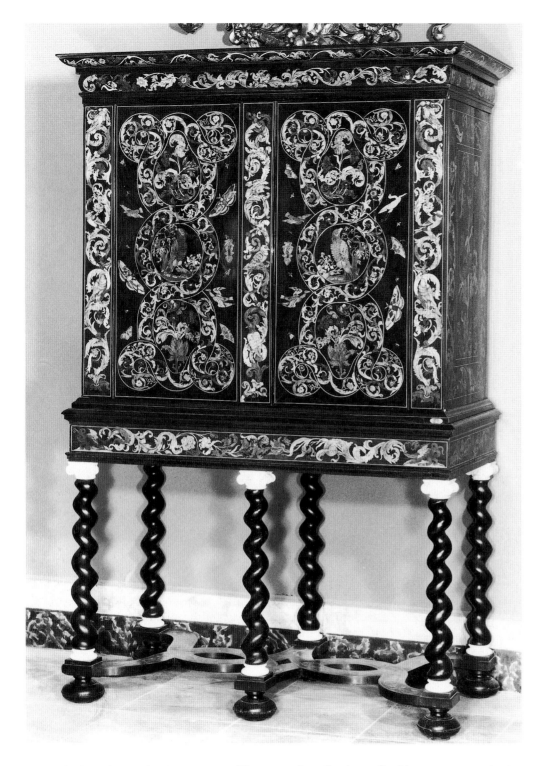

279 A cabinet decorated with marquetry in maple and stained bone on an ebony ground, on a turned and carved stand, probably made by Lorenz Corbianus; Danish, 1679.

dynasty of craftsmen and designers in royal service, Marot left France in 1685 after the revocation of the Edict of Nantes proscribed Protestantism; he became designer to Louis' enemy, William III, carrying the Louis XIV court style to Holland and England. The Huguenot persecution was not the only reason for the exodus of accomplished French craftsmen and designers; many Catholic craftsmen left France in the 1690s when severe retrenchments followed financial exhaustion and the Gobelins were closed. A sofa made by Philippe Guibert [278], who in 1697–98 supplied furniture to Windsor Castle and Kensington Palace,[72] is in the Marot style and was perhaps designed by him. In black-painted and gilded beech, it retains its contemporary upholstery of Genoese cut velvet on a satin ground edged with tasselled fringes. Its Frenchified forms have ornament of architectural origin, although beneath the fluting and gadrooning of the baluster legs lurks the phantom of antique convcave/convex turning – it becomes overt in the back legs.

Marot's designs for beds are amongst his most famous works – immensely, eccentrically tall constructions topped with ostrich plumes, heavily decorated with fringes and furbelows so that no wood shows.[73] The broken curve and interlace are often amongst their most prominent decorative motifs.

A particularly favourite type of curvilinear interlace, a simple antique pattern, had survived in constant use [107]; it was constantly republished in pattern books [281]. A fine bold version in flat marquetry on the doors of a Danish cabinet on stand of 1679 [279] has the geometric infilling frequent in antique examples [282] replaced by luxurious acanthus and two fine parrots; the inlay, in maple and stained bone upon an ebony ground, includes tulips, carnations, paeonies, moths and other insects, and two fine parrots.[74] The three-dimensional interlace of the stand stretchers is also a variant of a common antique pattern – it occurs within the scroll of a clumsy eleventh-century repair of a sixth-century mosaic pavement [282]. Related interlace [281] was especially popular for the simple flat marquetry decoration and three-dimensional stretchers of the restrained walnut and kingwood Anglo-Dutch furniture of the late seventeenth and early eighteenth centuries.

Broken curves and geometric and curvilinear interlace are prominent in the elaborate designs of Paul Decker (1677–1713); his grotesque was influenced by Berain and Marot but exhibits the intense interest in interlace and the broken curve that became a characteristic of German baroque. Much early eighteenth-century German decoration hangs halfway between baroque and rococo. The walls and floor of the early eighteenth-century Mirror Room of Schloss Pommersfelden [287], closer to Italian baroque chapels than to contemporary French rococo palaces, are completely covered with an elaborate interplay of broken curves and geometrical and curvilinear interlace, bewildering in their complexity; its ceiling contains such orientalizing motifs as lambrequins and ogival shapes; its elaborate inlaid wooden floor is made with the same techniques and patterns as those of its furniture, for instance the marquetry top of the pier table.

A few of the less costly emulations of the destroyed silver furniture of Versailles have managed to survive elsewhere in Europe, including England and Germany. A splendidly bold silver firescreen made in Augsburg [283] is dominated by a cresting of scrolls, but the broken curve and interlace are, once again, very evident. Designs for magnificently elaborate silver furniture, including a commode that has what appears

The connection of such motifs with grotesque remained close; many designs in the grotesque manner employ broken curves to construct little 'tables' [273] that are half pattern and half furniture. A splendid silver table at Madrid [277] looks much like such ornaments given solid form; its legs are constructed of broken curves, and the linear quality of legs and top, in both of which thickness is kept to a minimum, emphasizes the close links between ornamental pattern and actual furniture. The top itself is decorated with a grotesque design – 'Venus and Adonis' – of a Berainesque type. Taken as a whole, this table is as thoroughgoing a grotesque product as the chair designed for Cardinal Bernhard von Cles by Peter Flötner [190], albeit they are so utterly different from each other.

The work of Daniel Marot (1663–1752) makes prominent use of the broken curve and interlace; he took over some of Berain's engravings almost unchanged, and he was also influenced by Jean Le Pautre's son Pierre. Born in Paris of a

right 280 A bureau bookcase or block-front desk in carved, veneered and turned mahogany on pine, in the style of Nathaniel Gould; American (Salem, Mass.), *c.* 1779.

281 'Divers ornemens pour les tables', from *Dessins pour tables, bureaux et autres ouvrages de marqueterie* by Jean Langlois.

282 Curvilinear interlace of the sixth century (above) and of the eleventh (below) on a mosaic floor in the Abbey Church of Pomposa, Italy.

right 283 A firescreen of silver plate upon a wooden core, with a central relief, signed 'J. A. Thelott', depicting Mars, Venus and Cupid, the rest made by Philipp Jacob VI Drentwett; German (Augsburg), 1732–33.

to be crowned peacock heads jutting from the corners that might have satisfied even Ludwig of Bavaria, were issued by Paul Decker in 1705.[75]

The French craftsmen who worked for English court circles from the 1680s onwards imported specialized techniques, amongst which was water gilding, a refined method that allows burnished highlights but mercilessly reveals imperfections of surface; it was applied to a highly refined gesso, something like *pastiglia*. The shallow designs cut into the gesso heavily relied on flat curvilinear interlace, the broken curve, and Berainesque light acanthus; these motifs, mingled with grotesque acanthus masks, gadrooning, shells and a lappet of lambrequins completely cover an imposing gilt gesso wedding chest made for Sir William Bateman [286], the son of a rich City of London merchant; he married the granddaughter of the first Duke of Marlborough. Bateman seems to have shown an intelligent interest in what he saw on the Grand Tour,[76] and the chest may owe its form to that experience. The baroque sarcophagus form came via Berain and France, and indeed the whole piece is an approximation, in gilded gesso, to the type of Louis XIV commode in which the framing parts of the piece would have been in gilded bronze and the infill in 'Boulle' marquetry; a glance at a Berain design reveals the resemblances.[77] The feet of the Bateman chest are lion paws on balls, a Cosmati and Romanesque motif.

Baroque geometrical and curvilinear interlace, and the broken curve, had an eventful career in England in the first half of the eighteenth century. The broken curve is common in a muscular variety of baroque furniture designed by

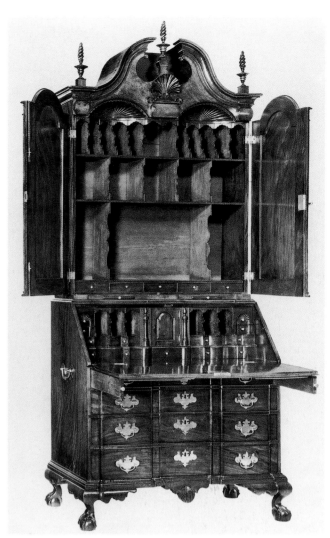

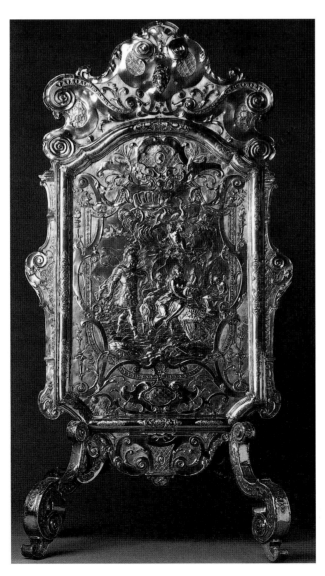

William Kent (*c.* 1685–1748) – not the only kind he designed (pp. 164–65). Kent had been trained as a painter, and this (although he was a flaccid painter, curiously at odds with his architecture and furniture) puts him in the grand tradition of the baroque painter/decorator, of which the most recent master had been the baroque classicist Le Brun (the later eighteenth-century pattern was to be that of the architect/decorator/furniture designer; despite the talents of eighteenth-century architects, something was lost). Most immediately noticeable in Kent's 'baroque' pieces is the forceful movement given by the scroll (often decorated with imbrication) and the broken curve, this despite the minor place assigned to the broken curve in the Palladian interiors that Kent himself designed. The bold scrolls, broken curves, and sphinxes of the splendid giltwood side tables in Houghton Hall [295] are as much 'Giulio Romano' as 'Le Pautre' or 'Marot'.

Thomas Chippendale (1718–79) used the volumetric broken curve to modulate commode fronts, writing tables and other furniture – his designs for 'French Commode Tables' [320],[78] for example, show rococo ornament (the 'French' ingredient) applied to a baroque broken curve (which remained common in Germany). This combination often occurs in the more ambitious Chippendale-style secretaires, highboys and so forth of English North America. A robust bureau bookcase made in Massachusetts [280] freely indulges in broken curves on pediment (the finials are replacements), 'block' front, pigeonholes, brasses, etc.; the shell motif within the cupboard has Kentian and antique antecedents. The bureau is in the manner of the only Massachusetts cabinet-maker recorded to possess a copy of Chippendale's *Director*, although it appears not to be his work.[79]

284 A cabinet on stand veneered with oysterwood, kingwood and ebony, with turned and carved detail and silver mounts, at Ham House, Surrey; Anglo-Dutch, c. 1690.

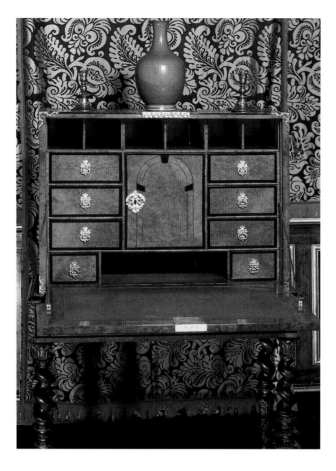

Dutch and English domestic baroque

right 285 A chair japanned in scarlet, with a split-cane seat, made by Giles Grendey; British with some Spanish features, c. 1735–40.

286 A wedding chest in carved oak and pine, with carved and gilded gesso, attributed to James Moore the elder; British, c. 1720.

The Protestant countries never abandoned themselves utterly to the extravagances of baroque, which was attuned to the altitudes of secular and religious absolutism. Their preference for classical quietude led at times to a use of a vocabulary so vestigial that baroque content was reduced to a trim or a flourish, or even to a total absence. Restraint is also evident in the big panelled cupboards [205, 206] and grand cabinets that were the major pieces of furniture in many Netherlandish interiors.

Seventeenth-century Dutch maritime greatness, and the accession of a Dutchman to the English throne in 1688, fostered an already existing Anglo-Dutch modified baroque style that allied itself in early eighteenth-century England

with Palladian classicism – not without some tensions becoming apparent, notably in the work of Kent, the pre-eminent designer of that alliance [292, 294, 295]. The underlying Anglo-Dutch attachment to classicism shows itself in the fact that when an even more anti-classical style than baroque presented itself – rococo – modified baroque tended to hold its ground. The Protestant colonies of North America were even more conservative, which is why the Massachusetts bureau-bookcase [280] could be made in an essentially baroque style as late as 1779, by which time post-rococo neo-classicism was poised to take over.

The Anglo-Dutch style is at its most distinguished in a walnut cabinet on stand of about 1675 [284], which gives an impression of domesticity despite the Solomonic legs (which were originally silvered[80]); the almost 'bun' feet were soon to retreat before the even quieter bracket feet [522]. The English liking for domestic simplicity culminated in the plain furniture of the days of Queen Anne and her immediate successor (the Queen herself was a thorough bourgeoise). The carefully chosen but unassertive veneers of a modest bachelor chest of about 1710 [522] do not disguise the fact that it is a utilitarian piece of furniture that would not easily collect patrician dust. The only lively note comes from the brass handles.

English domesticity was reconciled with baroque in the discreet broken curve that outlines the back of the typical Queen Anne or early Georgian chair [285], enclosing within it a flat baluster-shaped splat; such chairs usually have restrained hoof, pad or cabriole legs. They were popular over many years, and became common in English colonial

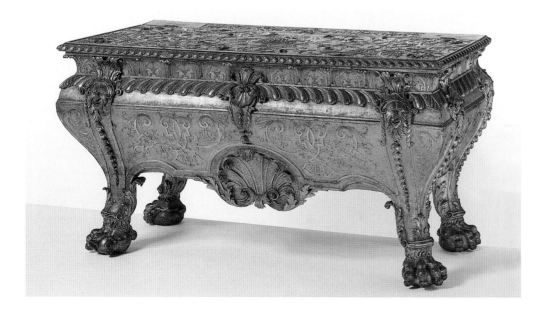

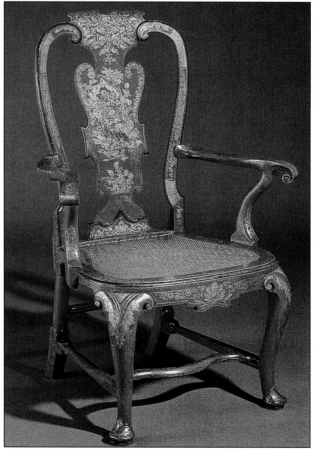

opposite 287 Broken curves and curvilinear interlace in the Mirror Room, Schloss Pommersfelden, with marquetry of an allied type on table tops and floor, all designed by Ferdinand Plitzner; German, 1714/18.

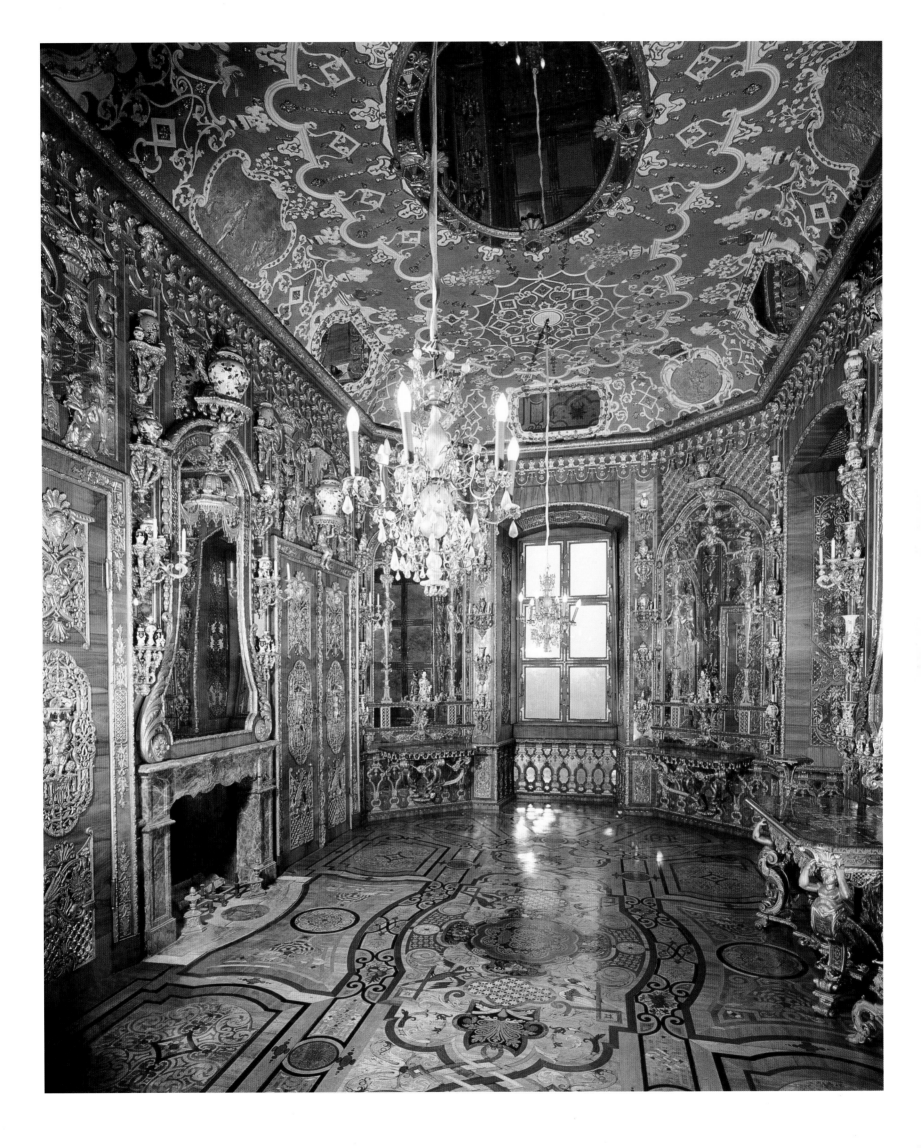

America and also in parts of Europe – large numbers were exported to Portugal and Spain. The London cabinet-maker Giles Grendey was heavily involved in the Iberian trade; a chair of about 1735–40 [285] was once part of a huge set of seventy-two articles that included armchairs, day beds, candle-stands and tables;[81] its shape is somewhat more animated than that of earlier chairs of the same type.

Curvilinear interlace manifested itself in various ways. It was used on the backs of chairs with rococo cabriole legs published in London in the 1740s by William de La Cour, a painter probably of Huguenot origin. It occurs frequently in elaborate parquet floors, and in decorations installed in English houses by Italian stuccoists: a modest English ceiling of the middle 1740s at Temple Newsam House in Yorkshire [289] consists of simple interlace ornamented with acanthus and garlands of flowers, disposed in a grotesque manner. Such interior decoration helps to explain why baroque interlace continually recurs in English furniture; a design of 1766 attributed to H. Copland [288], for instance, is to much the same basic recipe as the Temple Newsam ceiling.

Without doubt, curvilinear interlace was most memorably manifested in England in chair-backs published by Chippendale. The designs illustrated [290] appeared in 1762; the rococo legs of two of the chairs somewhat oddly consort with backs of the upright type (rather than the rococo cartouche [355]). A close approximation to the first design exists in a North American example:[82] the modesty and flexibility of simple interlace made it as perfectly at home in an American colonial setting as in a grand English interior. Curvilinear interlace easily accommodated Gothic and exotic detail [468], and – often combined with rococo cabriole legs – it continued common in English chair design during the 1760s and 1770s. It was still being used on a chair-back illustrated in the 1794 edition of Hepplewhite's *Guide*[83] – albeit disguised in neo-classical ornament: a tripod, and swags of drapery.

288 A design for a hall chair, probably by H. Copland; British, 1766 (from *The Chair Maker's Guide*, by Robert Manwaring and others).

above right 289 Detail of the ceiling of the Long Gallery, Temple Newsam House, Yorkshire; British, 1745–47.

290 'Chairs, No. IX', a design by Thomas Chippendale; British (from *The Gentleman and Cabinet Maker's Director*, 1762).

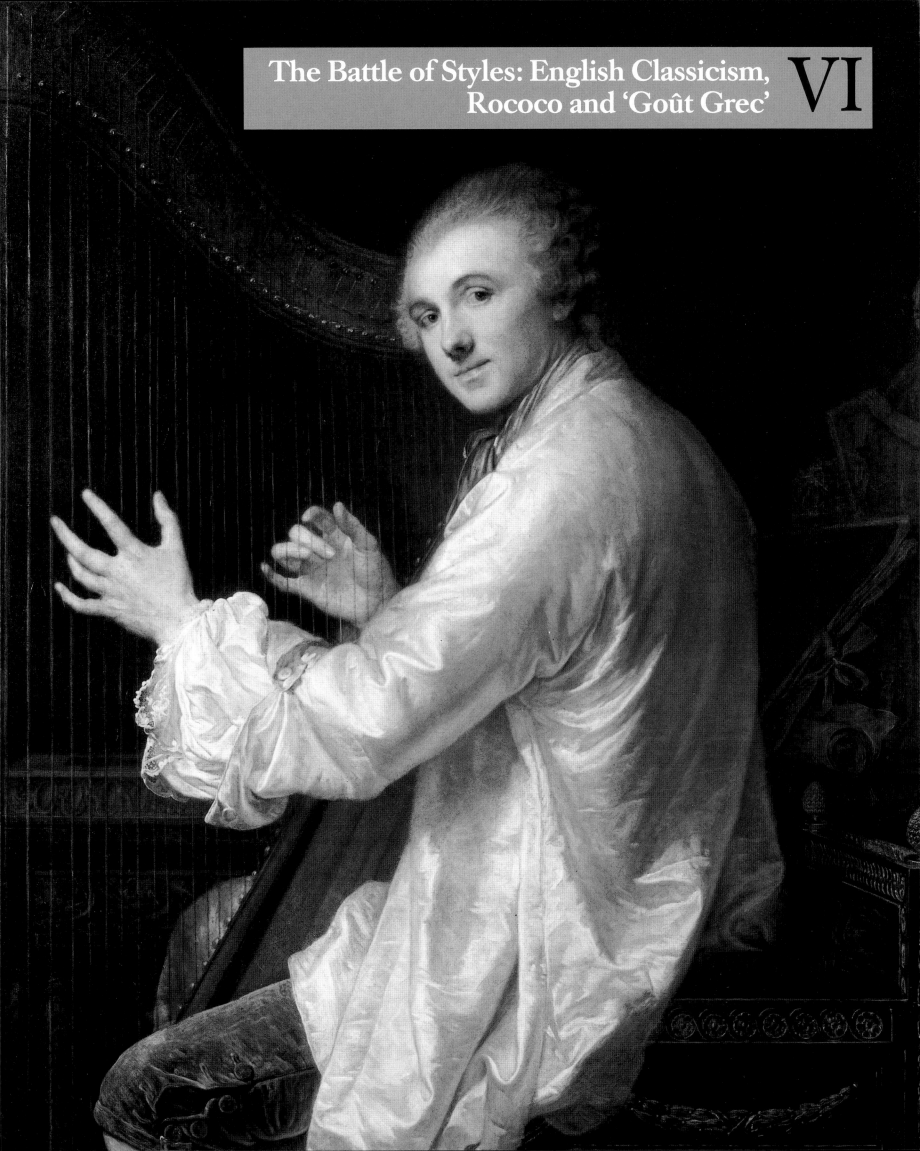

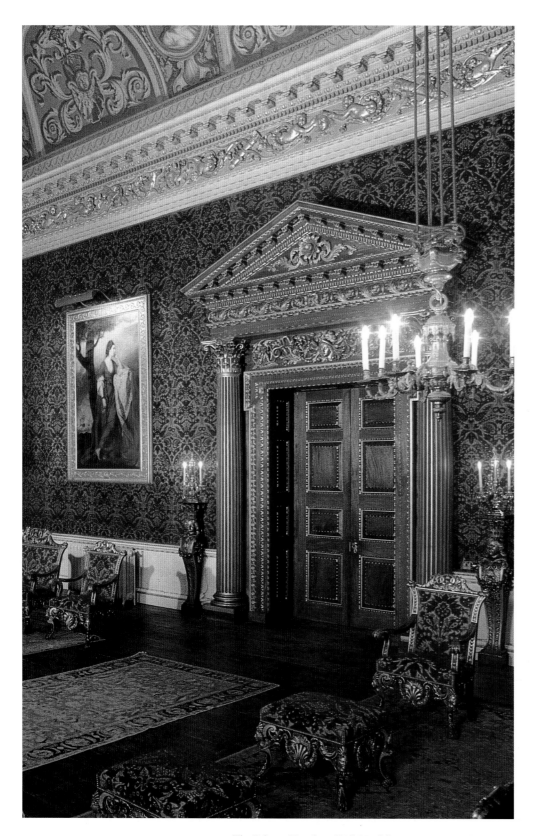

292 The Saloon, Houghton Hall, Norfolk, an interior entirely designed by William Kent, including an architectural doorcase and parcel-gilt mahogany chairs upholstered in the original silk and wool Utrecht cut velvet; British, *c.* 1730.

overleaf 291 The collector Ange-Laurent Lalive de Jully, with some of his his 'goût grec' furniture (see pp. 179–80), painted by Jean-Baptiste Greuze; French, *c.* 1759. In the background is his bureau plat [332].

Encyclopaedic classicism

Eighteenth-century European styles were dominated by rococo and by new forms of neo-classicism. These opposed styles, which came together in the 'rococo neo-classicism' of the latter part of the century, centred on two cities – Paris and Rome: the former spelled fashion and the rococo, the latter authority and antiquity. Other Italian cities had their attractions: Vicenza and the Brenta were centres of the Palladio cult, Florence and Venice were essential stops on the Grand Tour, and Naples became essential following the discoveries at Pompeii and Herculaneum. But Rome remained the mistress of classicism and the centre of antique studies; every painter, architect, craftsman or scholar of talent who was interested in classical antiquity either went there, wanted to go there – or, having got there, stayed there. Many antique works of art were carried off from Italy by collectors, but its buildings and collections remained unsurpassed and played a leading part in inspiring the genesis of new European neo-classical styles. Italy's own sons scattered to every part of Europe, taking with them the latest neo-classical gospel; not a few went to Russia.

The rococo style never reigned unchallenged. The years when it was at its strongest in France and Germany produced notable monuments and works of art in the antique tradition descended from that of the Renaissance, especially in England [292]. They also saw publications inimical to rococo. Time erodes the effect of polemical literature: even the *Essai* of the bogeyman Laugier (p. 177), that in 1753 caused a shudder to run through the frames of European architects and designers, quickly lost status as a shocker. The most long-lasting influence on the formation of new neo-classical styles came not from polemics but from books that pictured classical antiquities: these included many that had appeared in the sixteenth and seventeenth centuries, including those provided through the munificence of Louis XIV (p. 137); they remained in constant use throughout the eighteenth and nineteenth centuries. A list of 'the different works…which have been of most use to me in my attempt to animate the different pieces of furniture here described' is given by the didactically inclined Thomas Hope at the end of his *Household Furniture and Interior Decoration* of 1807, the most distinguished and influential of all English Regency furniture pattern-books (pp. 216–17).[1] The list speaks for itself (signalled in the Bibliography below): it concentrates on those works by scholars, antiquarians and architects that enlarged knowledge of antique artefacts and buildings and provided new exemplars, but also includes works containing new designs by talented contemporaries of Hope such as Percier and Fontaine, and Flaxman.

Such books served a multiplicity of purposes. Even at the height of 'archaeological' authenticity, architects did not restrict themselves to being inspired by ancient architecture, painters by ancient paintings, or furniture designers by ancient furniture. On the contrary, there were constant cross-fertilizations. Furniture designers took motifs from the entablatures of temples or the bowls of Roman lamps and placed them on commodes and sideboards; interior decorators articulated walls with borders taken from Greek vases, which were then repeated on furniture decorated en

suite; architects crowned buildings, and cabinet-makers cabinets, with vases, pyramids, and even miniature temples; shields became fire-screens (they had become a painted motif on antique Roman ceilings and walls); candelabra supported pedestal tables, tea was poured from cinerary urns, wine was kept in sarcophagi; ceiling designs were trodden underfoot on carpets and parquet and repeated on table tops. Nothing escaped metamorphosis: an Ovidian mythology of the inanimate might well have been created from these brilliant permutations and combinations. Sometimes metamorphosis was hardly needed: the difference between a Roman incense casket published by Montfaucon [64] and a Louis XIV commode is one of scale rather than anything else, as is that between George Smith's 'Dejeuné table' and a Pompeian brazier stand [459, 460].

Santi Bartoli, Montfaucon, and Caylus

Three compilers of the 'omnium gatherum' variety were especially influential; despite the later flood of volumes on antiquity, Santi Bartoli, Montfaucon and Caylus were never displaced as authorities, although their accuracy was later impugned by stricter neo-classical canons.[2]

From the late 1660s a series of immensely influential books by Poussin's pupil Pietro Santi Bartoli (c. 1635–1700) reproduced antique buildings, paintings, decorations and artefacts.[3] They were reprinted up to and beyond the end of the eighteenth century. A passionate antiquarian, Santi Bartoli possessed his own 'rare, and rich museum',[4] and 'in his old age neither corpulence, nor size, nor the fatigue of descending and ascending, nor any other discomfort could prevent him from going down into the excavations, driven

293 A cabinet in carved mahogany in Kentian architectural style; British, c. 1740–50

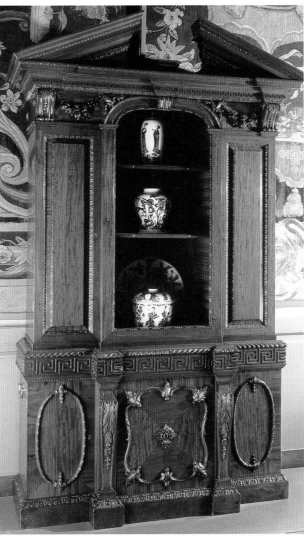

by his ruling passion, his taste, and, one might say also, by his instinct…'[5] On the death of the scholar Bellori, his collaborator, the Pope made Santi Bartoli 'apostolic antiquarian', an honour that descended in 1700 to his son Francesco. Father and son supplied coloured drawings of Roman decorations (rarely, since they feared the copying that would have destroyed their monopoly) to collectors and connoisseurs; for those engaged in decorating and furnishing houses such material was an invaluable supplement to the published works. English collectors were avid for such drawings.[6] Santi Bartoli's works possibly provided the incentive for Robert Adam's employment of Giuseppe Manocchi (p. 198).

Between 1719 and 1724 the learned Benedictine monk Bernard de Montfaucon (1655–1741) produced the most comprehensive survey of the antique world yet attempted. He drew freely on the work of Santi Bartoli and other earlier engravers for his huge variety and number of illustrations; they were organized in coherent subject groups, ranging from the gods of Greece and Rome to costume and funerary customs. Within these pages could be found all the 'various costumes of the Romans – arms, ships, victories, triumphs, sacrifices…temples, arches, mausoleums – types of leaf scrolls'[7] that a painter, stuccoist, or furniture designer could possibly need, and much else besides. The fifteen volumes of *L'Antiquité expliquée et représentée en figures* immediately became the most important pictorial source of all aspects of the life of European antiquity – eighteen hundred copies were sold in two months.[8] They remain invaluable [6, 20, 39, 40, 57].

The third member of the triumvirate, the socially prominent and aesthetically influential ancien régime nobleman, the Comte de Caylus (1692–1735), published between 1752 and 1767 his famous *Recueil d'Antiquités égyptiennes, étrusques, grecques, romaines et gauloises*. As its title implies, it was intended to cover the whole of known antiquity. It was profusely illustrated, although the quality of illustration varies. The text was almost as influential as the pictures.

British early eighteenth-century classicism

Books gave tools to designers, but the principal moving force for British classicism was the 'Grand Tour'.

The Grand Tour, the social obligation that began in the seventeenth century of sending the young British nobleman or gentleman to have his crust of native imbecility painlessly removed on the continent of Europe,[9] mercifully relieved the recurring tendency towards insular philistinism. The educational effect of the Tour made the eighteenth century the great century of British design; its decline in the late eighteenth and early nineteenth centuries was recognized by Regency connoisseurs as a major cause of growing bad taste and provincialism. Its influence was primarily antiquarian, and it helped to create strongly individualistic houses and furniture in grand classicizing style. It was institutionalized in the Society of Dilettanti, a benevolent dictatorship of taste founded in London in 1733–34 which made travel to Rome the pre-condition of membership and sponsored classical expeditions and publications. The Society was less regal and more bibulous than Continental patrons of publishing ventures – the club room rather than the throne room.

English houses were filled with Grand Tour spoils [348], antique sculpture being especially prized. Taste in paintings centred upon the modern classicism of Raphael, the Carracci, Poussin and Guido Reni, and in architecture upon the Renaissance classicism of Palladio. The 'Palladian' architecture of Lord Burlington (1694–1753) became fashionable amongst the English Whig aristocracy; its

294 A design for a table for Chiswick House by William Kent; British, 1744 (from John Vardy, *Some Designs of Mr. Inigo Jones and Mr. William Kent*).

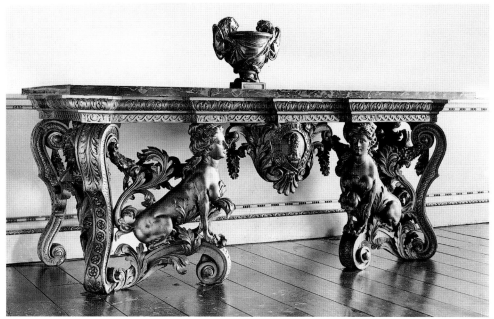

295 A giltwood side table with acanthus-tailed sphinxes and a cartouche that contains the motto and emblem of the Order of the Garter, at Houghton Hall, Norfolk, designed by William Kent; British, c. 1730.

296 A side table in painted and gilded pine; British, c. 1740.

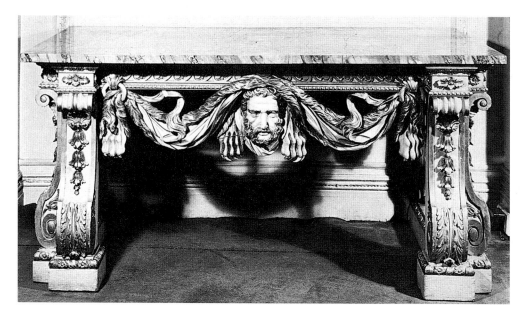

influence proved lasting and frequently resurfaced in Britain, in continental Europe, and in North America. The task of furnishing a Palladian house was not easy for the pedant, which Burlington tended to be, since Palladio, like Vitruvius, was silent on the subject of furniture. Burlington had met William Kent (p. 157) in Italy in 1715 whilst on his Grand Tour: they became close allies, and the solution to the dilemma was found in Burlingtonian Palladianism without and Kentian baroque classicism within, a combination that became the characteristic British grand style of the first half of the century. Kent's training as a painter in Rome by Benedetto Luti, a pupil of the Raphaelite classicist Maratta, chimed in with Burlingtonian taste; his architectural interior decoration was largely an amalgam of that of Inigo Jones, Palladio's early seventeenth-century British follower, and Burlingtonian Palladianism (which had Italian Renaissance antecedents; for instance, the ceiling and doorcases of the Blue Velvet Room at Chiswick House, Jonesian and Kentian in style, derive from a design by Cherubino Alberti, who died in 1615[10]). Kent's interior decoration [292] influenced his furniture to the extent of inspiring a 'classical' and Palladian strain that, dominated by antique architectural motifs [293, 294], was quite distinct from the grand, opulent pieces that prominently displayed the broken curve [295]. In whatever

style it was designed, Kent's furniture tends to have a certain aggressive quality.

Kent was the first English architect to take a serious interest in designing furniture; as Horace Walpole said later in the century, he 'could plan bookcases, cabinets and chimney-pieces…and in short do all, and more than all, that the upholsterer [furniture supplier] aspires to now'.[11] At Houghton in Norfolk [292, 295] , Kent designed 'all the ornaments throughout the house'.[12] It was the bookcases, cabinets and architectural mirrors, employing as they do the columns, pilasters, entablatures and pediments of Kent's doorcases and chimneypieces, that most clearly display the new neo-classicism. Kent was an early user of mahogany (a cheap wood, contrary to the legend of its costliness[13]) for both interior fittings and furniture; he used it solid, as if it were stone (his furniture was 'suggestive of stone rather than wood'[14]), and often heavily embellished it with gilding. A mahogany cabinet of about 1740–50 in the Kentian tradition [293] displays the 'nobility' that was to attract the French to mahogany when they returned to classicism after the rococo interlude. The cartouche that adorns the central lower portion is baroque rather than rococo. The strong Greek key is noticeable; it appeared in Kent's work (perhaps via Louis XIV furniture) well before 'goût grec' neo-classicism arose in France (pp. 179–80). He also employed richly expansive scallop shells, acanthus, and garlands. One of Kent's classicizing habits was to put marble or scagliola tops on his side tables, after the Italo-French pattern.

A small giltwood table designed for Chiswick House [294] derives all its components from antique stone prototypes, including the blank forward gaze of the head: much of its ornament comes from antique architecture. The fluted base of the 'vase' is closely related to a detail of the side of the 'Tomb of Agrippa', a famous Roman sarcophagus that stood in the portico of the Pantheon and was published by Desgodetz and others [65:D]: its profile resembles a motif which, often combined with the baluster, occurs on the centre back splats of so many 'Chippendale' chairs of the period. The solid stand increases its likeness to a vase; as executed, the carving remained open.[15] Other English furniture-makers, including Benjamin Goodison, followed Kent in producing furniture in a classicizing style partly based on antique stone artefacts. Matthias Lock (d. 1765) has been credited with an Italianate side-table from Ditchley Park in white-painted pine with gilt detail [296]; the table may,

right 297 A design for a 'Royal Bed' at St James's Palace, London, by John Vardy; British, 1749.

298 A medal cabinet in the form of an Ionic temple, of mahogany veneered in broomwood, attributed to George Sandeman, at Blair Castle, Perthshire; British, *c.* 1765.

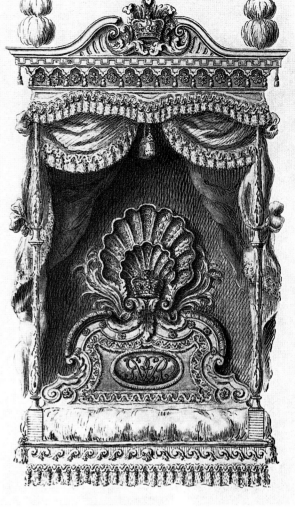

however, be by Henry Flitcroft, Lord Burlington's draughtsman, with whom Kent worked at Ditchley.[16] It is in the imposing Kentian architectural classical tradition; the apron is carved with a head of Hercules draped in the skin of the Nemean lion and the side aprons are decorated with shells.

The vogue for pompous heaviness associated with Kent – Walpole called his furniture 'incommensurably ponderous' – gradually gave way to a liking for lighter forms. A design of 1749 for a 'Royal Bed' [297] by John Vardy (d. 1765), who knew Kent well and published his designs,[17] was influenced by an imposing bed by Kent at Houghton. Vardy has, unhappily, attempted to lighten the Kent idiom by introducing candelabraform pillars and lambrequins to the Kentian scallop shell and broken curves; however, the pillars are topped by a heavy broken pediment instead of the expected light baldacchino. The grotesque introductions are prophetic of later developments.

The Kentian inheritance persists in two chairs designed in the 1750s and 1760s by English architects who were at the same time alive to Continental movements of taste (pp. 177–81). The first [301] was designed in 1759 by the architect William Chambers (1723–96), who thought himself 'really a Very pretty Connoisseur in furniture',[18] and who had known the 'goût grec' practitioners in Paris. Chambers's chair probably aspired to replace Kent's self-confident swagger with a refined 'French' neo-classicism; considering his talents, experience and contacts, its imperfections are surprising. Most unsatisfactory is the disjunction between its upper and lower halves; the arms, especially, are disproportionately thick compared with the legs (the spiral twisting of which is similar to 'advanced' spiral twists in designs by Neufforge and Delafosse). Chambers's chair is

gauche compared with a giltwood chair 'exceeding Richly Carv'd in the Antick Manner' designed by Robert Adam (p. 194) about five years later [302], which comes from the only set of Adam furniture known to have been made by Thomas Chippendale.[19] The basic shape is again Kentian [292], but the chair has a suavity absent from Kent's work, and its classical ornament is perfectly adjusted to its form. The back goes straight down to the seat in an 'English' manner (as does that of Chambers's chair).

Kent's 'antique' furniture was built up using miscellaneous antique ornament. An alternative method is demonstrated in an 'architectural' cabinet in mahogany [298] designed to accommodate gems, coins and medals. The cabinet fits form to contents by being modelled after an antique building; its Ionic 'portico' is based on that of the Temple of Septimius Severus in Rome – the side window is Burlingtonian Palladian. Source and proportions are Roman, but the choice of an Ionic rather than Corinthian model probably reflects the growing interest in Greek architecture and works of art that was shortly radically to change the appearance of much decoration and furniture. For during the 1750s and '60s the British search for a new antique style was stimulated by a rash of new publications on architectural antiquities (p. 202); it was given imaginative incarnation in the mythological paintings in Poussinesque style of Gavin Hamilton, a painter in Rome who dealt in Italian antiquities; they contained accurately observed ancient furniture, and were immediately reproduced in engravings.[20]

James 'Athenian' Stuart (1713–88), an architect, published his book on Athenian architecture in 1762 (p. 202). The result of his interests is seen in furniture he designed between

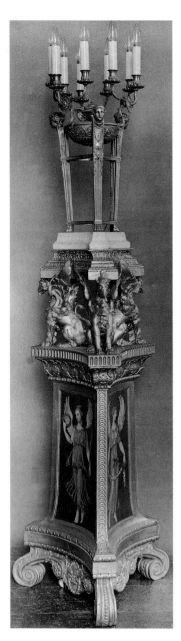

1759 and 1765 for Spencer House, the London palace in which he aired the new Greek fashion [367]. In its attempted return to the antique, this furniture is characteristically different from the French reaction to the rococo of the late 1750s, which blended Piranesian romantic stoniness with the antique fashions of Louis XIV.

A chair designed by Stuart for the Painted Room [300] comes from a different world from that of the Adam chair [302]. To a rococo cartouche-shaped back (pp. 175–76), and a curved horizontal seat rail, Stuart added antique ornament and uncompromisingly 'stony' animal legs. The sofas that accompany the chairs [367] were derived from antique stone thrones, but the lions were given the swan necks that appear most commonly in grotesque, the style employed for the painted walls. Included also were tripod pedestals that remarkably conjoin various 'advanced' antique motifs [299]; the candelabra, based on a reconstruction of the missing tripod from the summit of the Choragic Monument of Lysicrates in Athens, stands above griffins derived from a Roman marble tripod in the Capitoline Museum [10:O], upon a pedestal based on antique candelabra [10:B] that is decorated with Peruzzi-like 'antique' maidens above a base that has the inward-turned scrolls of baroque candle-stands. Quite a combination. Remarkable as these pieces are, two of the most significant in terms of the future have yet to be mentioned – a version made for the Painted Room of the Pompeian sphinx tripod, now about to experience its multiple reincarnation (pp. 195–96), and a severely 'archaeological' giltwood tripod of about 1760 [303] copied from the familiar Roman stone tripod. Many of its details were taken from a more elaborate Roman original grandiosely illustrated by Piranesi and dryly illustrated by others.[21] Adam followed hard on Stuart's heels in designing 'archaeological' furniture; the 'Tomb of Agrippa' [65:D], previously used by Kent [294], served him several times – virtually in its original form as a stool for Lansdowne House in 1768 (save that the space for the corpse was omitted) and titivated with fluting, gilding, painting and corner anthemions for stools made for Kedleston by John Linnell soon after 1775[22] [304].

England, indeed, was amongst the first to attempt an 'archaeological' style in furniture since the neo-classical

essays of Raphael and his followers in the sixteenth century. Patriotism may have affected taste: national animosities affected the arts, and English opposition to French influence was expressed in an 'Anti-Gallican' Society founded in the 1750s to oppose the insidious arts of the French nation (a little later the French were busy opposing 'anglomanie'!). However, the real roots lay in the English temperament. Most of the classically orientated furniture described above was made whilst rococo, chinoiserie, and gothick fashions flourished, but they hardly more than diverted a nation that maintained a steady disdain for one of the greatest of all English baroque buildings, Blenheim Palace. They were little more than froth upon the deep British current that ran for the antique throughout the eighteenth century.

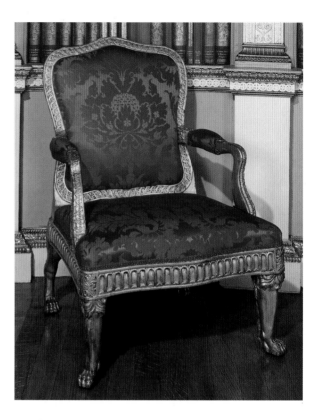

299 A tripod pedestal and candelabrum in carved, painted and gilded wood and gilt bronze from the Painted Room, Spencer House, London, designed by James 'Athenian' Stuart; British, 1759–65.

above right 300 An armchair in carved and gilded wood from the Painted Room, Spencer House, London, designed by James 'Athenian' Stuart; British, 1759–65.

right 301 The President's Chair of the Royal Society of Arts, in carved and turned mahogany, designed by Sir William Chambers; British, 1759–60.

far right 302 An armchair in carved and gilded beech 'in the Antick Manner', designed by Robert Adam and made by Thomas Chippendale; British, 1764.

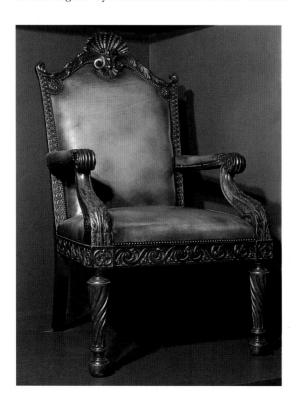

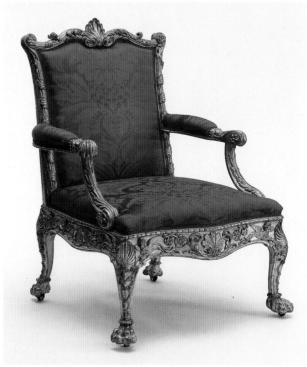

303 A tripod in carved and gilded wood from the staircase landing, Spencer House, London, designed by James 'Athenian' Stuart; British, c. 1760.

304 A carved, gilded and painted stool in the Marble Hall at Kedleston Hall, Derbyshire, designed by Robert Adam and made by John Linnell; British, c. 1775.

305 Rococo furniture, including a
side-table, overmantel mirror, wall
clock and candelabra, in *Le Déjeuner*
by François Boucher; French, 1739.

The social background

Voltaire, writing in 1751 of the grandeurs of Louis XIV,
identified a main social difference between that age and his
own: 'we have finally come to enjoy luxury only in taste and
convenience. The crowd of pages and liveried servants has
disappeared, to allow greater freedom in the interior of the
home. Empty pomp and outward show have been left to
nations who know only how to display their magnificence in
public and are ignorant of the art of living.'[23] This comment
on the new French invention of the 'art of living' had been
made on all sides since the beginning of the century; in
1713 Germain Brice, author of a repeatedly reissued and
amended guide book to Paris, had remarked of the new
installations in the Hôtel de Beauvais that modern taste was

'incomparably more convenient and agreeable than that
which we have in this hitherto followed....French architects
much surpass those who have preceded them, including even
the Italians.'[24]

The expression 'convenance' as applied to the apparatus
of living is recorded for the first time in 1702. Find a name for
something, and it flourishes. In the interests of 'convenance' –
the organizing of one's surroundings to minister to bodily
comfort and mental relaxation [305] rather than empty
grandeur – rooms such as boudoirs, dressing rooms, dining
rooms, and libraries were apportioned to distinct uses.
Their decorations and furniture became private even to
secrecy: nobody could guess at the interior character of a
rococo boudoir from scrutinizing its exterior architecture.
The smallest rooms became the most luxurious, and the
apartment was perfected.

The implications for furniture are obvious, and a host of
new types evolved, adapted for specialist uses. Sometimes
these involved mechanical contrivances, like the tables that,
ascending fully laden through the floor, enabled intimate
suppers to be enjoyed away from servants. Chairs became
organic, adapted to the human body: even case furniture
assumed an organic rather than organized look – the rococo
style that accompanied these changes was uniquely suited to
an organic treatment, being so organic in its own nature;
cause and effect are inextricably entangled. Seat furniture
became comfortable to a point that threatened the salvation
if its occupants – Madame Victoire, a daughter of Louis XV,
answered fears that she might follow her sister into convent
seclusion with: 'Make yourself easy, my dear....I love the
conveniences of life too well: *this couch is my destruction.*'[25] At
the advent of a new and generally accepted neo-classicism in
the 1760s, nothing was resisted so resolutely as the return of
seat furniture to antique style; every return to classical taste,
whether it were the 'goût grec' or Empire, meant a return to
classical discomfort. The comfort of rococo chairs was still
being regretted in the early nineteenth century (p. 219).

Women had much to do with the new attitudes. On all
sides observers, French and foreign, commented on the
influence Parisian women exerted on their surroundings.
Caylus asked, 'What is the cause of this amiable vivacity?...it
is that women set the style for all that happens in this great
city.'[26] The pace was set by the royal mistresses (the popular
identification of the rococo with the erotic has some basis);
their decorative hedonism contrasts with the gloomy piety of
Madame de Maintenon who, shown carp that had fallen sick
as a result of being transported to clear water, had said 'They
are like me, they regret their native mud.'[27] The most famous
of the mistresses, Madame de Pompadour, was keenly
interested in the arts, and exerted it in favour of post-rococo
neo-classicism (pp. 186–93) – as did Madame Du Barry
(originally a very muddy lady).

Stiff as eighteenth-century manners would appear to us
today, they had greatly relaxed from the superior stiffness of
earlier ages; those who persisted in the old ways attracted
ridicule, as did the 'Proud Duke' of Somerset in England:
when duchesses were portrayed as milkmaids there was a
new spirit on the wing, and it ill behoved old-fashioned dukes

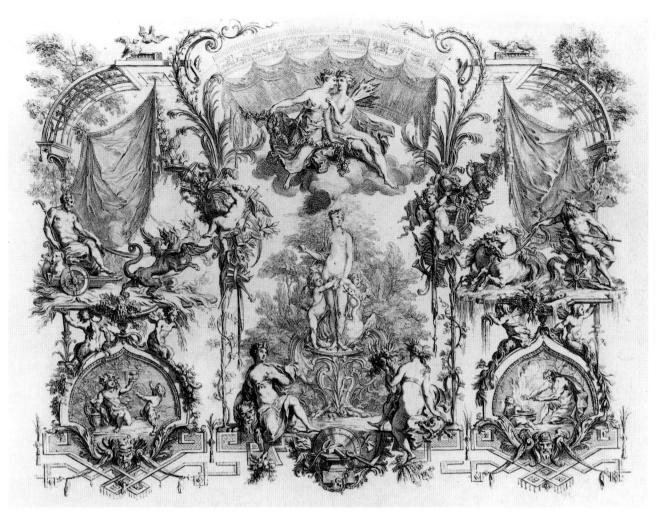

306 Rococo ornament including a velarium, palms, cartouches, pergolas, geometrical interlace and falling water, in a design for a tapestry by G.-M. Oppenord, engraved by C.-N. Cochin; French, 1720–30.

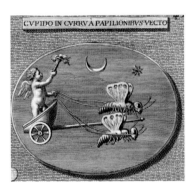

307 Cupid drawn by two butterflies, on an antique gem published in 1736 in Rome by Ridolfino Venuti (from *Collectanea Antiquitatum Romanorum*).

to resist it. The new spirit reached its height in France, as recognized by an English observer who 'must applaud the perfection of that inestimable art, which softens and refines and embellishes the intercourse of social life'.[28] This greater spontaneity in manners (which perfectly preserved politeness: liberty had not yet become licence) was reflected in a greater spontaneity in art; asymmetry is one aspect of it, as are the wayward rococo acanthus scroll, the rococo vignette, the capricious convolutions of 'rocaille', or, indeed, the interest in the spontaneity of antique Roman painting in which connoisseurs found 'a sympathetic and *effortless* handling, unsophisticated but pleasing colour, and, above all, an *enchanting artlessness and naivety*' (author's italics).[29] This *sprezzatura*, or deliberate naivety, extended to other forms of artifice in paint, even to the rouge on a woman's cheeks : 'I liked the way she had put it on, as the court ladies at Versailles put on theirs. The charm lies in the negligent way it is applied; no one tries to make it look natural.'[30]

The beginning of the French eighteenth century was the first period since antiquity in which a concern with the things of this world unashamedly dominated life. Any definition of rococo must include the adjective 'playful'. Its dominant motif in painting and decoration was Eros, a polite name for sex [349]; in Germany rococo took over churches as much as it did palaces, and both swarmed with erotes. Its attitude is encapsulated in the prettily turned verse sent by Caylus, connoisseur and roué, to accompany a gem [307] engraved with 'un petit amour' to 'Madame la D…D…D…D…' for her birthday: the little pagan god 'puts down' the Christian saint:

> J'apprends que c'est votre fête,
> J'ignore le saint du jour,
> Je croirai, sans plus d'enquête,
> Que c'est celle de l'Amour.[31]

('I learn that it is your feast-day:/I do not know which saint's day it is;/I believe, without further enquiry,/ It to be that of Cupid.')

This sceptical, witty, secular, spontaneous and comparatively informal new age invented a genre of decoration and furniture utterly different from any that had gone before.

The influence of grotesque

Rococo style was the most anti-classical since the extravagances of fifteenth-century Gothic. It was no accident that it made extensive use of the exotic extravagances of chinoiserie (pp. 276–89), nor that the first overt and extensive revival of mediaeval Gothic accompanied rococo decoration. That happened in England (pp. 234–37); France and Germany's rejection of overt gothicism at this period may be tied up with their acceptance of a heathen 'gothicism', Gothic without the pointed arch. Even the terms were interchangeable (p. 276). Many of the creators of rococo (like those of mediaeval Gothic) were French, not directly exposed to the strong antique influences of Rome and Italy; not a few, including Berain, Pierre Le Pautre, Audran, and Watteau, never went to Italy.

The anti-classicism of the French rococo style is shown in four principal ways: in its rejection of classicism based on antique stone artefacts; in its asymmetry; in the way it turned ornament into form; in its restless and flickering (rather than energetic) movement. Not only were rococo's principal creators painters, sculptors and craftsmen, rather than architects (this was true also of baroque), but the style was ruled by painterly and sculptural values to a hitherto unprecedented extent. This was remarked upon by many commentators, including a later hostile critic who (discounting his hostility) described rococo accurately, picking out three key figures as inventors of the 'genre

308 A garden room with grotto furniture, designed by J. M. Hoppenhaupt; German, c. 1755.

309 A design for a shell fountain, by Pierre-Quentin Chedel; French, 1738 (from *Livres des fantaisies nouvelles*).

right 310 A console table in carved and gilded wood with a marble top, designed by Ferdinand Dietz; German, c. 1765.

pittoresque' (the style founded on painting): 'About fifty years ago [c. 1727]…regular forms were abandoned and we applied ourselves to tormenting interior decorations in every possible manner under pretext of varying, lightening and enlivening suites of rooms. Men like Lajoux [Lajoue], Pinault [Pineau], Meissonnier and their copyists made architecture talk nonsense….Into our decorations were admitted only extravagant contours, a confused assemblage of motifs placed without selection and combined with eccentrically fanciful ornaments in which one finds an absurd heap of cartouches placed sideways, rocailles, dragons, reeds, palms, and all sorts of imaginary plants which have for long been the delight of our interior decorations, to such an extent that sculpture had made herself mistress of architecture.'[32]

Some of these ingredients – dragons and palms join geometric interlace and the ambiguous moresque/Gothic ogee arch [465] – are displayed in a print after the influential designer Gilles-Marie Oppenord (1672–1742), who had in Italy been influenced by Bernini and Borromini [306]. Cochin said ironically of 'The great Meissonnier' that he 'had studied in Italy and hence was not completely one of us…since, while there, he had wisely preferred the taste of Borromini to the tedious taste of the Antique…he banished symmetry'.[33] The Italian contingent that helped to create the rococo style shared the craft-orientated preoccupations of the French. Almost all the influential rococo printmakers worked in three dimensions: J.-A. Meissonnier (1695–1750) was a goldsmith, the Slodtz brothers were sculptors, Jacques Caffiéri was a sculptor, goldsmith and *fondeur*;[34] all designed furniture. The centres for rococo ornament prints were the same as those for goldsmiths: Paris, Nuremberg and Augsburg; French rococo prints were reissued in Augsburg, increasing the number in circulation.

Despite the anti-classical character of rococo, perceived and insisted upon by eighteenth-century critics – and indeed it blurred or obliterated the structural elements of antique decoration – it owed its origins to antiquity. High rococo art was created by releasing ornament from its antique stone straitjacket, a release stimulated by the most anti-classical of antique arts, grotesque – of which rococo was merely the most astonishing progeny, by Vitruvian standards a monstrous birth indeed. Caylus explained that the designer and painter Claude III Audran (1658–1734), a prime creator

of rococo, had derived his style from the decorations of Raphael in the Vatican [161, 365] and Primaticcio at Fontainebleau, adding that Watteau imitated Audran's ornament and the light touch that demanded white or gilded backgrounds.[35] Into the 'very delicate grotesque painted on a white ground' were 'introduced flowers, birds, and an infinite number of other whimsies, which make a most agreeable effect. The idea comes from the ancients, who lived again in Raphael'[36] [162]. In other words, completely and wonderfully original as rococo decoration appears, especially in its wilder German manifestations, its roots lay deep in the underground chambers of the Domus Aurea.

The other great contribution to rococo was made by Islamic arabesque, and its shaping influence was recognized in the change of nomenclature that from the 1690s onwards accompanied the birth of French rococo: 'grotesque' became 'arabesque'. This usage was later to be deplored by post-rococo neo-classicists such as Robert Adam (p. 194; it has also given modern art-historians not a little trouble[37]). Proto-rococo features are seen in the grotesque of Berain [273] and the liberated late baroque of Pierre Le Pautre (1648–1716):[38] the latter's designs of 1699 for Marly[39] contain panels bordered by bandwork frames incorporating C-scrolls, acanthus, cornucopias, flowers and garlands. Berain and Le Pautre both inventively developed the frame; Le Pautre's rococo frames contributed to the rococo cartouche, all-important for furniture (pp. 175–76). From 1701 to 1713 the new decorative style was introduced into Versailles and the Grand Trianon.[40]

The steps from Berainesque grotesque to the rococo may be counted in remarks made by contemporaries. In 1693 Audran was recommended for the imaginative novelties he brought to grotesque.[41] By 1713, he was considered supreme in his field, 'above all for arabesques and for grotesque ornaments in the manner of the celebrated Raphael'[42] – this differentiates between 'arabesque' and Raphaelite grotesque. Berain fell out of fashion, and with him went the taste for darkly glittering furniture; Louis XIV grandeur was quite out of place in the new world where the most beautiful colour was the white that 'augments the light and rejoices the eye'.[43]

Grotto ornament

The new style's basis in grotesque renewed interest in the grotto and its appurtenances – rockwork, springs, fountains, reeds, and other watery motifs. The sinister creepy-crawlies of the sixteenth and seventeenth centuries remained in their lairs; although rococo designers looked directly at auricular and proto-auricular work,[44] rococo shells and dolphins had nothing of the underground qualities of the auricular style. Rococo brought the auricular style out into the sunlight.

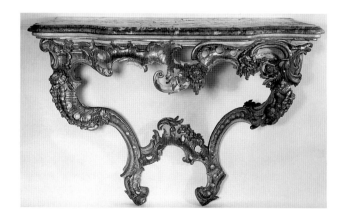

On the other hand, grotto and garden ornament, and the ruin, moved indoors – sometimes together. The results were *outré*: a print of about 1755 [308] shows a room that, halfway between a grotto and a drawing room, has completely abandoned the pre-rococo articulation of interiors with pilasters and other architectural ornament in favour of grotto sculpture; petrified water forms 'pilasters' (what price associationalism?), the mirrors are topped with shells on which perch putti who pour water from dolphins and urns upon the rock sofas below, the asymmetrically matching backs of which are covered in imbricated scales; the clock stands beneath a fountain upon a rock chimneypiece.

Shells had provided motifs for ornament, architecture and the decorative arts from antiquity onwards: they had ornamented Pompeian bronze candelabra, they had tenanted Renaissance grottoes and curiosity cabinets [216]; they now dictated form, becoming a vital ingredient of rococo decoration [309]. The Gersaint for whom Watteau painted his famous shop sign announced from 1734 that he would journey to Holland in 1735 and 1736 to seek shells for French collectors; his sale catalogue of 1736 mentioned the use of shells as inspiration for artists, a practice by then well established: 'they are able to inspire new forms in architects as well as sculptors, and even in painters'.[45] In 1742 the first systematically illustrated book of shells was published;[46] significantly, the conchology section was reissued alone in 1760.

Shells, dolphins and other marine motifs were reproduced in delightfully allusive chairs and tables [311]. Shells also contributed to an utterly unprecedented concoction that became a leitmotif of rococo. Murex shells from Libya and the Arabian Gulf have fascinatingly and elaborately irregular undulations and curls, fleshy folds that have much in common with some features of the auricular style [237, 235]. The shelly features were abstracted and synthesized with rockwork and coral; 'rocaille' prints were being produced in the 1720s by Oppenord and Meissonnier; the term itself was probably first published in 1736[47] and it passed into use as a noun that described a style. Another term for this ornament, also drawn from shells, was 'chicory' (*chicoreus* is a type of murex): a designer disparagingly referred in 1803 to rococo as the 'poor, incoherent style that designers named "rocaille" and "chicorée"'.[48]

Whatever one calls it, rocaille was one of the most imaginative and alluringly beautiful ornaments ever invented. Some side tables appear positively to foam [310] – the foam-like holes pierced through the rocaille are survivals of the moresque 'hole', itself descended from the 'pipes' of late antique acanthus decoration [113]. The same ghost haunts the entirely organic forms of 'root' chairs; their 'holes' sometimes take the shapes of commas, also a moresque form.[49] The abstract nature and lack of any controlling framework of rocaille ornament gave imaginations every licence – taken especially by German designers, who once more gave free rein to their bent for expressionist fantasy, this time in a genre that almost completely excluded darker forces. Not entirely: for instance, sinister 'faces' at times reminiscent of auricular masks emerge from the rococo ornament of J. Wachsmuth.[50]

A console table by Ferdinand Dietz of about 1765 [310] is decorated with rocaille, petrified water and a few stray flowers. The interest of Dietz's table lies in the beguiling ornament; the table itself is basically simple, just two legs and a connecting stretcher. Although elaborately wrought, rococo was not a formal style; it created not only the

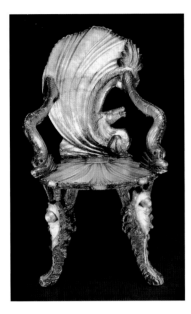

311 A chair made up of shells, dolphins, and rocaille ornament with two 'pearls', in carved and gilded wood; French, *c.* 1760–70.

right 312 A candle-stand in stained and painted pine designed by Thomas Johnson, its candle branches of iron; British, *c.* 1758.

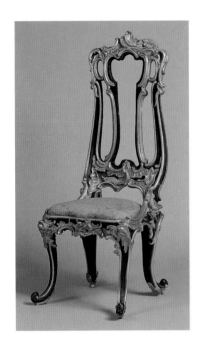

313 A chair in carved and parcel-gilt wood, at *S*chloss Fasanerie, Fulda; German (Fulda), *c.* 1760.

right 314 A casket on stand in mother o' pearl, gilt bronze and gilt copper, designed and made by Pietro Pifetti; Italian, *c.* 1745.

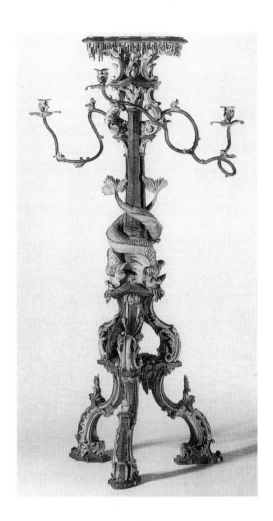

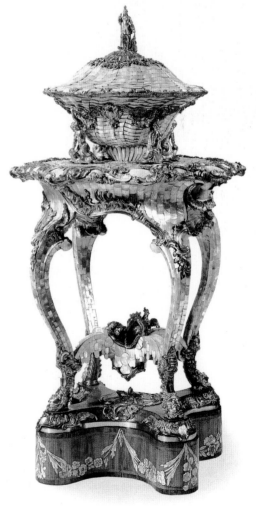

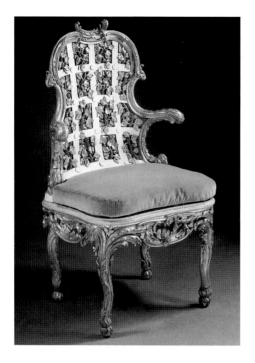

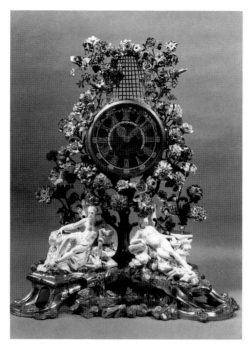

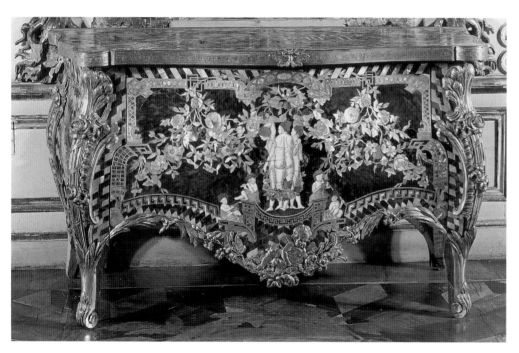

Did another casket once exist topped with her frequent adversary? The splendid rocaille gilt bronze was made by a Frenchman and an Italian.[52]

Aquatic motifs dominate a candle-stand [312] that (save for the candle branches) follows a design published in 1758 by the English cabinet-maker Thomas Johnson,[53] whose work had been directly influenced by Hoppenhaupt [308]; the candle-stand was one of four made for the Palladian Long Gallery of Hagley Hall in Warwickshire, together with pier tables, girandoles and wall brackets en suite – grotto imagery invading one of the grandest rooms in the house.[54] The motifs include water, rocaille, dolphins, acanthus, and interlace; the candle branches simulate twigs (they are of iron covered with composition; on the Continent they would probably have been gilt bronze). The whole is painted brown and 'stone' colour. Johnson's design is strongly reminiscent of a design, itself influenced by late seventeenth-century French taste, by François Cuvilliés (1695–1768), the Munich court dwarf who became one of the most brilliant of all rococo designers. A scholar comments that Johnson 'may fairly be said to have ruined a design by Cuvilliés…in attempting to adapt it'[55] – comparing Cuvilliés' inevitability with Johnson's uncertainties, one agrees.

Nature and gardens

The grotto taste ran in tandem with the interest in naturalism and gardens that grew throughout the eighteenth century; it has been said that the end of the ancien régime came when Louis XV ordered formal avenues at Versailles to be cut down.[56] Be that as it may, a taste for the new type of artificially informal 'English garden' influenced by Chinese 'sharawaggi'[57] had correspondences with the artificial informality of rococo, and by the end of that period 'English gardens' had made inroads even in classically oriented Italy.

The use of naturalistic ornament in European art had been increasing for centuries; oriental silks and other Eastern textiles were covered in flowers [580]. The French classical-baroque attitude is encapsulated in the well-known saying attributed to Le Nôtre, the great formal gardener, that 'flowers were for nursemaids'; in any case, it cannot be said that the seventeenth century used flowers and leaves as furniture decoration naturally. The flowers and plants that everywhere adorn rococo art are quite differently organized. They appear to be in complete disorder. Roses, carnations, and other plants are strewn amongst rococo scrollwork and acanthus; they stray far beyond the confines of the scrolling line, often across mirrors [308]; sometimes they form thick masses of petals, sometimes the twigs are bare [312]. This disorder may appear more naturalistic than the voluptuous bouquets of seventeenth-century marquetry, but the naturalism is more apparent than real; a flower-strewn painting by Fragonard is as artificial as a Monnoyer flower piece. This is, as Rousseau defined it, the art that conceals art.[58] It was later to be denounced – for its artificiality.

Not only was the new 'informal' naturalism 'art', it was rooted in antique art. Not, however, the tightly organized swags of antique stone sculpture; the loosely organized rococo assemblages that appear ready to disintegrate into their constituent parts recall more the free-floating festoons of painted grotesque [32, 33, 559]. Grotesque and rococo festoons are often accompanied by the treillage that also ornamented baroque and rococo gardens and the fronts of princely rococo commodes [315, 317]. The baskets of flowers that appear so inevitable when set next to a country maid in a Boucher landscape or placed in gilt bronze at a

top left **315** A chair made in carved and gilded limewood and naturalistically painted, made for the garden room in the Franckenstein Pavilion at Schloss Seehof; German (Bamberg), *c.* 1763–64.

top right **316** A clock in gilt bronze and Vincennes or Mennecy porcelain; French, signed 'Gauron 1754'.

above **317** A commode veneered in mother o' pearl, ivory and tortoiseshell, with silvered bronze mounts, by H. W. Spindler; German, 1769.

breathtakingly fantastic interiors, secular and ecclesiastical, that open the gates of Heaven, it also suited simple furniture and simple settings. Rococo simplicity is most evident in the routine French rococo chair. Even when elaborate, rococo furniture is rarely formal – an instance is an asymmetrical German chair of about 1760 [313], which is decorated with rocaille ornament that remarkably anticipates the Art Nouveau boudoir chairs of Georges de Feure.

An opulent mother o' pearl and gilt bronze casket on stand was designed for a palace in Turin at some time in the 1740s by Pietro Piffetti (1700–1777) [314]; mother o' pearl had for long been a 'grotto' material, but had been used also in other contexts (the only other work of Piffetti's completely covered with mother o' pearl is an altar frontal).[51] The base is veneered in kingwood and engraved ivory; the latter was probably originally coloured naturalistically. Most of the forms and emblemism are marine, which suggest Neptune rather than Minerva, the figure that tops the shell casket.

right 318 A cradle in carved and painted wood; Italian (Venetian), *c.* 1750.

focal point on a commode are precisely those that had been taken over by Italian painters in the early sixteenth century from the painted walls of ancient Roman palaces and tombs. The many proto-rococo and rococo artists who designed gardens amongst their other activities (they could design practically anything connected with court life) would have looked at ancient depictions of gardens with attention and knowledge (as did Humphry Repton in the early nineteenth century).[59] Berain designed gardens at Versailles, the Slodtz family designed both ornamental trellis for the Orangery[60] and furniture for Louis XV's bedroom [324].

Flowers and garden motifs were rendered in three-dimensional form in carved and painted or gilded wood, in gilt bronze and porcelain; they were pictured flat in marquetry, frequently in naturalistic colours (now embrowned), and painted in naturalistic colours in oils or on porcelain. This naturalism had some affinities with Gothic naturalism: the 'architect of Bourges Cathedral liked hawthorn, and…the porch of his cathedral was therefore decorated with a rich wreath of it;…he did not at all like *grey* hawthorn, but preferred it green…people would have been apt to object to any pursuit of abstract harmonies of colour, which might have induced him to paint his hawthorn blue'.[61] Like the architect of Bourges Cathedral, the eighteenth century would have objected to blue hawthorn (it would have gladly accepted it gilded). The fashion for naturalistic flowers spread everywhere in Europe; the few examples given here range from Venice [318] to Paris [316], and southern [315] and northern [317] Germany.

A Venetian cradle of about 1750 [318] resembles a shell run aground on a miniature 'tree' which is encircled with leaves and flowers; on its branches perch little birds. The cradle has lost the drapery that originally depended from the empty finial, but possibly this too was decorated with flower-covered fabric. A splendid gilt-bronze clock of 1754 [316] is surrounded by Vincennes or Mennecy porcelain flowers, with a white porcelain naiad and river (both ultimately taken from the antique) contemplating a rocaille pool.[62] Chandeliers were reduced to completely skeletal and asymmetrical frameworks, smothered in porcelain flowers and leaves. Large sets of furniture were given garden ornament: in 1761 the court painter of the Prince-Bishop of Bamberg decorated the audience chamber in the Franckenstein Pavilion of Schloss Seehof as a garden room with trellis and flowers, and a splendid set of furniture in carved, gilded and painted limewood was provided [315]; the backs of the sofas and chairs simulate trellis through which grow leaves and flowers.[63] Much of this furniture decorated with flowers and foliage was far from bucolic. An example is a magnificent commode of 1769 from Potsdam [317] made by Heinrich Wilhelm Spindler, member of a family of Bavarian cabinet-makers, who may have worked in Paris in his early years. The commode's central ornament of the Three Graces bound at the ankles – a subject probably prescribed by Hoppenhaupt, designer of the room in which the commode stood (the Graces are carved on the chimney-piece[64]) – is disposed with roses in a medley of tortoiseshell, mother o' pearl and silvered bronze; the central part of the design is contained within trellis. A series of Franconian commodes that has been associated, possibly incorrectly, with the Spindlers, has marquetry decoration that reflects the romantic naturalism of Sanspareil, the rock garden of the Margravine Wilhelmina of Bayreuth.[65]

Furniture was also made up of twigs and roots, sometimes real, sometimes skilfully simulated, sometimes gilded. Such

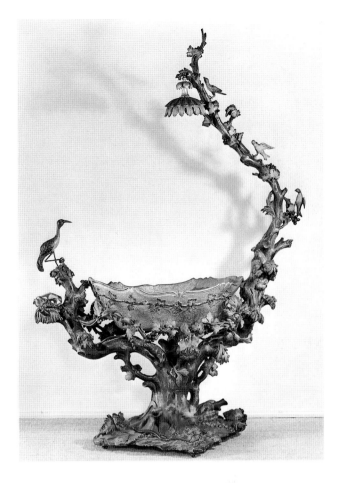

grotto and 'grotesque' garden furniture, often touched with chinoiserie [571], was produced throughout the eighteenth and nineteenth centuries, and is still being made.

The vignette

A beautiful invention that breathes the elegant pastoralism of rococo was the pictorial vignette or capriccio [319], a little scene usually framed in feathery trees, grasses and flowers that contains ladies and gentlemen trifling away their lives with a swing, peasants diverting labour with dalliance, monkeys acting as humans, and so on.

The origin of the capriccio lay in antiquity. 'The capriccio as an artistic genre appears to be rooted in the decorative grotesque evolved by Italian artists in the early sixteenth century.'[66] It was enriched by motifs evolved in decorating the fêtes and theatrical performances fashionable in Italy in the sixteenth and seventeenth centuries, and especially by the pantomimic antics of the Commedia dell' Arte, the columbines, harlequins and punchinellos descended from the buffoons, jugglers and musicians who had followed imperial Roman triumphs.[67] These Italian influences, together with the 'Petites Arabesques' of Du Cerceau, contributed towards the art of Callot, himself taught at Florence by an Italian.[68] Callot influenced Stefano della Bella: both created 'grottesche', scenes framed in cartouches or trees [235], and both influenced the art of Berain, Boulle and Audran.

Thus was laid the train to the rococo vignette, but the spark that ignited it came from Watteau, who bathed it in light and air and gave it 'pittoresque' naturalism and the melancholy that 'tantum mortalia tangunt'. The return to France of the Commedia dell'Arte, exiled after an unlucky satire on the 'old witch' (as Saint-Simon called Madame de Maintenon) had caused Paris to fall about with mirth, furnished Watteau with a topical motif. Others came from the fables of La Fontaine, which had in the late 1690s been

319 A vignette after a design of *c.* 1730 by Antoine Watteau.

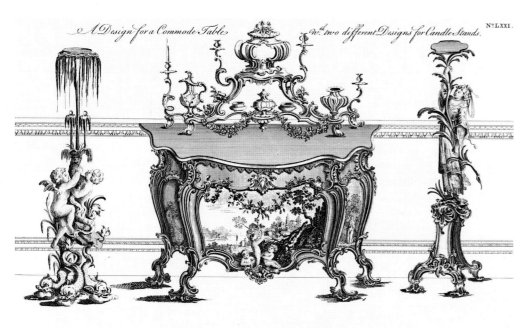

A Design for a Commode Table. Or two different Designs for Candle Stands.

320 A design for a 'Commode Table' and two 'Candle Stands', by Thomas Chippendale; British, 1761 (from *The Gentleman and Cabinet Maker's Director*, 1762).

used by Audran in his charmingly informal grotesque decorations on a gold ground painted for the thirteen-year-old Duchesse de Bourgogne. Women's pets and the exotic furnished other subjects. As did miniaturizations of the elaborately composed and exaggerated scenes of architecture and ruins, often baroque in detail, that had been created by specialist Italian architectural, ruin and landscape painters – the *quadraturisti* and the *vedutisti* – who had gained status as decorators when serious history paintings became unfashionable. Still lifes, baskets of flowers, trophies of arms, musical instruments, little antique temples and fantastic constructions of various kinds, all became subjects for the vignette. Humour, a constituent of ancient grotesque, also entered it.

The immense importance of the vignette for furniture lies in its sweeping success used in pictorial marquetry and painted decoration [320]; it often assumes the shape of a feathery cartouche. Additionally, it found three-dimensional realization in wood, gilt bronze, and porcelain in furniture such as girandoles [325], clocks, and mirrors.

Bombé surfaces; the cabriole leg; asymmetry

One consequence of 'sculpture [having] made herself mistress of architecture' was that rococo interior decoration and furniture reduced architectural motifs to residual mouldings – pilasters and capitals; when used entire they became insubstantial, swamped in rococo ornament. The tendency had become apparent before the rococo proper commenced its career; for instance, the orders are noticeably absent from the furniture designs of Jean Le Pautre [257]. The vestiges of classical architecture that were employed in high rococo decoration and furniture were treated with disrespect (save for the classical ruins depicted in marquetry, on girandoles, etc., which are usually more or less 'correct' save for their curved entablatures).

The designer of a Dresden writing cabinet of the 1750s [322] has allowed rocaille decoration not only to stray from three 'Corinthian' capitals and cut short the flutings of the pilasters, but so rudely to break the flutings in the middle as to increase their number from four (itself an offence against classical rules) to five. Such indignities were to committed neo-classicists a licentious outrage. This disregard for correctness was inevitable, since correctness was irreconcilable with the concept of decoration as an organic growth. 'Organic' decoration had been anticipated in the sixteenth century, in Enea Vico's title page [167] and in the vegetation-encrusted orders and arches of mannerist

grotesque [217]. Everything now yielded to the concept of decoration as a free-flowing, harmonious whole. It was complained that 'the clocks that are now so much in fashion …seem to leap out of the panelling to which they are fixed',[69] as also did candelabra and girandoles [305]; handles start out from the surfaces of commodes and bureaux [322, 324]; wall furniture at times virtually disintegrates in the hope of becoming one with its background – even in presbyterian Edinburgh, a mirror frame was only prevented by the rectilinear borders of its glass from flying off into a thousand pieces.[70]

The only straight line on many rococo console tables and commodes occurs at the meeting with the wall: clocks [316], candelabra, and chairs [313] often completely abandoned it. Flat surfaces in high-style work succumbed not only to the serpentine curve that undulates in two directions, but to the bombé curve that undulates in four [320, 322, 352]. The importance of the curve in rococo art is encapsulated in Hogarth's theory of the serpentine 'Line of Beauty'.[71]

The French-influenced rococo chair has cabriole legs and round, oval, or cartouche-shaped seat and back; in beauty and utility it is, at its best, the only rival to the ancient Greek klismos. Cabriole legs were one of the most distinctive features of the rococo style. They have been thought to have been influenced by Far Eastern furniture. However, they occur in antiquity; the marble throne of the priest of Dionysus in the Theatre of Dionysus at Athens has fully developed (if monumental) fluted cabriole legs that end in paw feet [23]. It seems likely that West and East both evolved the form by abstracting the antique animal leg [26] and absorbing it into the scroll [20]; the broken curve of the animal hock became one with the abstract broken curve or scroll, and the specific animal reference disappeared. Some late seventeenth-century chair and table legs show the process well advanced. The final stage occurred when the line of the whole leg was smoothed out to become a simple return curve. The cabriole leg frequently retains indentations along its length that *might* be taken as a phantom of the vanished muscle; however, a similar indentation is seen on other rococo scrolls…! The leg of the piece of furniture at the extreme left of a painting of a rococo interior [305] shows a variation: the hoof remains as termination to a series of rococo scrolls; anatomical hock and hair have disappeared.

A peculiarity of rococo is its fondness for asymmetry [311, 313, 322, 325]; the two were so identified that the contemporary term 'le genre pittoresque' could mean rococo style in general or asymmetry in particular. Many examples of asymmetry in art precede its general adoption during the rococo period. Ancient examples of asymmetrical design include trophies and panoplies [62]; grotesque decoration sometimes seems deliberately asymmetrical (a feature emphasized in the capriccio and vignette); Japanese lacquer, so popular in the later seventeenth century [577], is always asymmetrical. Shields placed asymmetrically on their sides had appeared in fifteenth-century Gothic furniture. Free-standing sculpture is asymmetrical, and sculpture had brought a decided element of asymmetry into antique furniture [251]; the restrained sculpture of Renaissance furniture became highly gestural with Bernini [254]. In its general fluidity, the auricular style was frequently asymmetrical (flowing water is never symmetrical). The cartouches of Mitelli [237] include asymmetry among their proto-rococo features. The admired murex shell is asymmetrical in every respect. Another factor that may have encouraged asymmetry was the designer's habit of giving alternative patterns by changing details halfway across an

engraved design; this can, unintentionally, create intriguing effects. The unsophisticated workman might even be deceived into taking the two designs as one; this happened in the case of a ridiculous Irish mirror of about 1760 [321] that followed two conjoined rococo designs in Chippendale's *Director*[72] (was the client as artless as the carver?).

The rococo scroll and the cartouche

The motif that later critics found most characteristic of the rococo style was the scroll, the 'meaningless Cs and Os' and 'tangled semi-circles', as hostile critics from Isaac Ware to Soane and Hope called them.[73] Two features of rococo scrollwork demand special attention: the scrolls themselves, and the way in which they were used to make up frames or borders.

The ingredients had been around a long time in non-rococo guise: simple opposed scrolls [477] and continuously winding scrolls [111] had existed in antiquity; broken curves had entered Western decoration through arabesque or (a less confusing term in the rococo context) moresque; opposed and broken scrolls were combined in strapwork [213]. Sixteenth-century decoration contains much scrolling ornament of this type; an instance occurs in some of the repeated decorations that head the pages of Serlio's influential books on architecture and decoration – thickly congested broken scrolls with a strapwork element, and graceful, more open acanthus scrolls, a female swagged mask and acanthus diadem. Proto-rococo in one way, these decorations are far distant from it in another: for one thing, they lack vivacious movement.[74]

Movement came with the baroque, as did the further development of the cartouche, which concentrated ornament on the border or frame. Amongst the most interesting seventeenth-century cartouche frames are those of auricular or auricular-influenced cartouches, which curvaceously conjoined scrollwork and other motifs, often marine motifs. They sometimes enclosed landscapes or other scenes, in the same way that rococo cartouches were to enclose scenes in lacquer or marquetry. The designs for cartouches of Stefano della Bella (with his feathery handling [235]) are very suggestive of rococo. The rococo cartouche was fully developed in the extraordinary decorative cartouches of Bernard Toro (1671–1731), published in Paris in 1716. Toro also designed tables, vases, and other artefacts.

321 A mirror in carved and gilded wood made after two conjoined designs by Thomas Chippendale; Irish, *c.* 1760.

right, above 322 A bureau cabinet made for Augustus III of Saxony, with marquetry of kingwood with other woods and mother o' pearl, ivory and brass, decorated with gilt-bronze mounts, attributed to Michael Kummel; German (Dresden), *c.* 1750–55.

right, below 323 A multi-purpose table in carved Brazilian rosewood, inlaid with tulipwood and ivory and with silver handles; Portuguese, *c.* 1770.

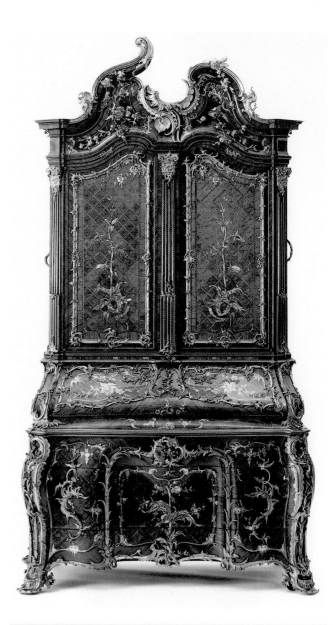

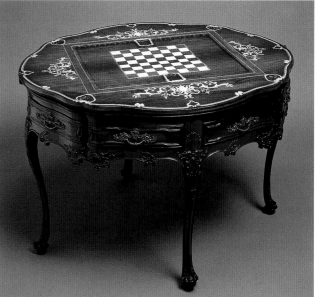

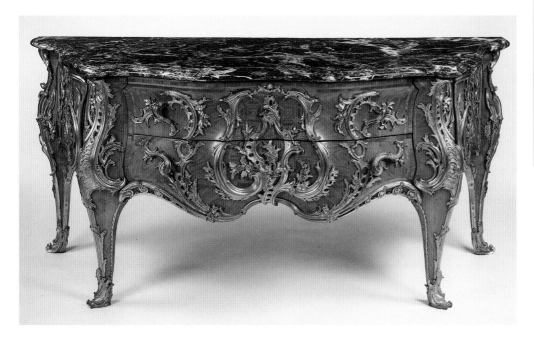

left 324 A commode veneered in kingwood and mahogany on oak, with a top of breccia marble, designed by one of the brothers Slodtz and made by A.-R. Gaudreau, with gilt-bronze mounts by Jacques Caffiéri; French, 1739.

Rococo scrollwork was created by conjoining opposed and broken curves in continuous, flowing lines that twisted and turned back upon themselves; it included C-scrolls, broken scrolls, acanthus, rocaille, flowers, etc., in winding lines that owe much, ultimately, to the abstract winding lines of Islamic arabesque. These rococo lines both provided frameworks for other decorations and, adventurous and spontaneous, invaded other spaces as tendrils. The scrollwork acted as a decorative framework within which subordinate decoration – marquetry or lacquer 'pictures', for example – was restrained; attention, in effect, was concentrated on the periphery, especially if it were in bright gilt bronze. The contour or border therefore became a dominant element: decoration was concentrated on the edges of picture frames and chairs (the all-over busily carved chair backs of the previous century were replaced by smooth upholstered surfaces), or was organized over the surface of a commode in cartouches; each face might become one huge cartouche, or a juxtaposition of cartouches, side by side or one within another. The pre-eminence of the cartouche necessitated the attempt to disguise, by an ingenious and distracting use of gilt bronze, the intrusive straight line of the drawers on the face of a commode. Not only were the details of a commode ruled by the cartouche; its form – front, sides and top – adopted and followed it.

Rococo scrolls and cartouches used in furniture range in complexity from the simplicity of those that adorn an enchanting blue and white commode made in 1742 for Madame de Mailly, one of Louis XVs many mistresses [581], to the staggering virtuosity of the Dresden bureau cabinet [322]. The Mailly bronzes are silvered, a fashion of the early eighteenth century. The motifs employed include acanthus, rocaille, flowers and leaves disposed in C-scrolls and broken curves; the handles to the drawers twist up from the ends of the scrolls. The front is gently bombé, the edge of the marble top undulates in sympathy.

A commode delivered in 1739 to Versailles [324] shows how magnificently impressive a piece of furniture completely lacking architectural features but decorated with scrolls and rocaille organized as cartouches could be; the front has scrolls that return upon themselves to form asymmetrical cartouches; each asymmetrical cartouche matches its twin, thus giving overall symmetry. Each side of the commode has a matching asymmetrical cartouche; one cannot see both sides at the same time, but one has the satisfying knowledge that symmetry is present. The commode has not a single straight line or cubic section – even the legs, as on so many rococo commodes, are triangular in section. The design has been attributed, on the basis of a drawing,[75] to the brothers Slodtz, descendants of Cucci (p. 140): in execution, the line of the legs has been straightened. The gilt-bronze mounts are by Jacques Caffiéri (1678–1755). This commode stood in Louis XV's bedchamber – its dimensions exactly correspond with those of a panel beneath a mirror.[76] It was immediately removed on the accession of Louis XVI, who disliked rococo furniture.[77] A problem sometimes arose from differences between various types of gilding: in 1754 Louis XV found the gilding of the *boiserie* in his Cabinet Intérieur too 'vive', as it did not accord with the gilt bronze; it was rectified and 'S. M. en a paru satisfaite'.[78]

The cartouche was frequently used for mirror frames – a large cartouche was sometimes surrounded by smaller cartouches, each enclosing an irregular area of glass. It provided a convenient shape for clocks: a single large, almost symmetrical cartouche encloses the face of a fine French

325 A design for a girandole, by Thomas Johnson; British, 1755 (from *Twelve Girandoles*).

326 A gilt-bronze clock in the form of a cartouche, with porcelain flowers, the dial signed C.-S. Passemant; French, *c.* 1750.

gilt-bronze clock of about 1750 [326].[79] Girandoles were often designed in the shape of asymmetrical cartouches that made up a symmetrical duo; a cartouche-shaped girandole of 1755 by Thomas Johnson contains a vignette of a wild boar snuffling amongst ruins [325]. Such girandoles, which were peculiar to England, were a speciality of one of the finest English practitioners of rococo, Matthias Lock. Both were influenced by the cartouches of Bernard Toro.

A single large cartouche dominates the front of a 'Commode Table', published together with an épergne and two candle-stands in Chippendale's *Director* of 1762 [320]; its scrollwork was, English-style, as likely to have been executed in carved wood as gilt bronze. No allowance is made for drawers, and the commode may have been conceived as a dummy, as are existing commodes by Adam at Osterley Park. The epithet 'French' so frequently attached by contemporary English rococo designers to their designs is misleading. The Chippendale commode reflects both French and German rococo designs; in its depth and spread-out feet it is reminiscent of published designs by François Cuvilliés, who influenced also the accompanying candle-stand with dolphins[80] (a London catalogue of 1762 offering 'Books of Ornament' for sale includes Cuvilliés amongst others[81]). The earliest rococo pattern book produced in England (1736) was by an Italian, Gaetano Brunetti; his clumsy patterns are far removed from French virtuoso rococo chic.

Chippendale propagated English design through his books; no fewer than nine copies of the *Director* are recorded in North America before 1786.[82] A copy was owned by Catherine the Great of Russia.[83] Portugal had strong trade and familial links with England, and Portuguese furniture reflected English design well into the nineteenth century. A splendid multi-purpose table [323] in Brazilian rosewood, inlaid with tulipwood and ivory and with silver handles, shares the English interest in ingenuity. Its several folding tops can be turned over like pages in a book; it can be a games table (for chess, draughts and backgammon), a pier table, or a dressing table with an adjustable mirror. Its curvaceous shape, rococo scrolls and cabriole legs are Chippendale seen through Portuguese eyes, and none the worse for it.

French and Italian antique influences

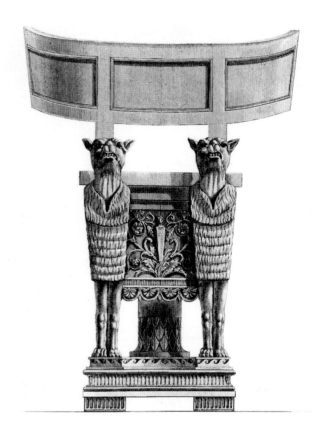

327 A klismos chair with two wolves, by G. B. Piranesi; Italian, published in Rome in 1762 (from *I Fasti…*).

Whilst England was pursuing its own form of classical antiquarianism based on a synthesis of Renaissance classicism, baroque classicism, and antique archaeology, new aesthetic creeds were evolving on the continent. Most influential were the French critic Laugier and the Italian designer and artist Piranesi, the first revolutionary in his Greek primitivism, the second revolutionary in his Roman romanticism. Laugier's two books, the *Essai* of 1753 and the *Observations* of 1765, caused rare flutterings in the architectural dovecotes, and were still being hotly debated in the early nineteenth century. Piranesi was one of those rare people whose talent unleashes forces of extraordinary power: lacking the transcendent genius of Michelangelo, his effect on design in the eighteenth century (admittedly a less mighty century) parallels that of Michelangelo on the sixteenth.

The architectural theories of the Abbé Laugier (1713–69) were based upon the premise that structural logic and beauty are indivisible. Naturally, he rejoiced in rococo's decline: 'Happily…this dangerous plague is on its last legs.'[84] He asserted that all form that was not founded upon the logic of primitive construction, and all decoration that did not originate in construction or in Nature, should be expunged: his notorious *Essai* reviews columns, entablatures and façades and repeatedly lets the word 'Défaut' fall with a dull thud, like earth upon a coffin lid, upon many of the most universally accepted (and most beautiful!) ancient and modern architectural usages. Pilasters are 'never necessary';[85] the 'effect of arcades is always feeble';[86] balusters are bad; arches carried upon columns are 'vicious…a usage against nature';[87] pediments placed one upon the other are absurd, and they should never be curved. For Laugier, the free-standing column was supreme. He much preferred Greek to Roman architecture,[88] and showed himself fully aware of the Augustan Greek revival: 'genius reached the height of perfection under the sway of Alexander, its imitation under that of Augustus produced copies equal almost to their models'.[89] His Greek taste was Hellenistic; he much preferred Corinthian to Doric, than which 'nothing was less magnificent, more dry and more poverty-stricken'.[90] In this bias, he reflected his period (Burke revered the nobility as 'the Corinthian column of polished society';[91] republican extremists preferred Doric).

Laugier's views on interior decoration had important implications for furniture. He thought the orders inappropriate used in apartments (except for vestibules): columns 'should never be used merely as decoration' because from their nature they must constitute a principal part of a building. This dogma had even greater logic applied to furniture; Laugierian theory therefore implicitly rejected the use of three-dimensional 'architectural' decoration in furniture design. Softer counsels prevailed in other matters – he accepted architecture depicted in painted decoration,[92] rejecting painted surfaces only when placed next to white stone, which kills the colours[93] (a solecism frequently committed today by gallery directors who hang paintings, old and new, on white walls). Laugier's doctrines therefore implicitly admit both painted furniture and furniture decorated with the frivolous 'architecture' of painted grotesque, such as candelabraform columns. Laugier also liked textile hangings and advocated the use of draped 'pavillons' in interiors[94] – which would allow elaborately draped beds. He has been claimed as a forerunner of twentieth-century functionalism (p. 270), but this has little justification. His taste, refined and French-orientated, was dogmatically rigorous but not inherently puritanical.

It is impossible to tell how far furniture was affected by Laugier's opinions – rococo furniture had abandoned fully-fledged orders, pediments, and columns long before he began to write – but it is unlikely that they were ignored: they undoubtedly had a powerful effect on architecture. Certainly, a glance at the post-rococo furniture of Adam, Percier and Fontaine and many others reveals the paucity of 'architectural' features (save where they come via antique artefacts [304]); it was not until the Empire style of the early nineteenth century became fashionable that three-dimensional columns and pediments again became common on furniture (the 'vicious arcade' took even longer to return).

The other great propagandist, Giovanni Battista Piranesi (1720–78), a passionate devotee of ancient Rome, was as much a romantic as an antiquarian. His antiquarianism was not so progressive that he dropped the term 'arabesque' – for him, the scrolls of the Ara Pacis [52] would have been (they were not discovered until the nineteenth century) 'arabeschi'.[95] Piranesi was most moved by stone, the more gigantic, overweening, august and battered the better; his antique frenzy strangely contrasts with the mechanistic aridity of J.-N.-L. Durand [10, 65]. He was excited by volume; even his depictions of ancient subject paintings look like marble bas-reliefs.[96] His original designs [371] resemble the magnificent assemblages of antique stone fragments 'restored' by dealers and sculptors [328]; his depictions of

328 Three 'candelabri di marmo', published in Rome in 1778 by G. B. Piranesi (from *Vasi, candelabri, cippi, sarcofagi*).

329 The house of Mademoiselle Guimard, Paris, designed by C.-N. Ledoux in 1770; French, published in Paris by Ledoux in 1804 (from *L'Architecture considérée…*).

impressive candelabra, half Hadrianic and half conjectural modern, had an extensive influence on furniture [328]. His publications provided a host of images for designers of various kinds; the suggestive power of his romantic images of Rome is revealed in the way the incomplete arc of half-buried triumphal arches was taken over for use in modern architecture and furniture – it is true that velaria were depicted within arcs, and columbaria were often in the form of depressed arches [39], but the Piranesian contribution is sometimes unambiguous, as in the flattened niche decorated with Piranesian coffering of a house designed by Ledoux in 1770 for Mademoiselle Guimard [329].

Piranesi's sculptural ornament – dolphins, sphinxes, griffins, acanthus and erotes – is monumental. He designed decorations and furniture in a highly mannered form of grotesque [366, 371] and, like Borromini before him, 'made use of a bizarrerie which [he] had seen in ancient things'.[97] However, he reproduced in his books only five grotesque stucco ceilings,[98] which with one ambiguous exception are of the non-bizarre type. His influence was decisively in favour of the 'classical', stone-based variety of neo-classicism. His widely influential Egyptian ornament is also volumetric [598], despite the fact that it is disposed in the grotesque manner.

Mid eighteenth-century French classicism

The rococo, that enchanting sculpturesque welter of scrolls, was still at its height when the architects took their revenge and invented a furniture style unprecedentedly stony, unyielding and 'antique'.

During the late 1730s and the 1740s a group of French artists in Rome absorbed ideas from which they created a revolutionary new Parisian classicism. The time was ripe. In 1749, the same Caylus who had regretted the loss of Watteau's rococo decorations at Meudon[99] successfully pushed through a rule that forced the pupils of the French Academy to draw from the antique.[100] The French School in Rome, already biased in favour of classicism, had been for some time encouraging a more thorough study of Roman monuments; the new group found powerful inspiration in Piranesi's romantically daemoniac interpretations of Roman antiquity and invented a style in furniture that, for the first time since the end of the fifteenth century, drew form and ornament almost exclusively from antique stone artefacts, completely bypassing the grotesque. This change is the most obvious effect of the new neo-classicism, but it was accompanied by two less obvious – indeed 'abstract' – effects that long outlasted the new neo-classicism itself.

First, the Piranesian interest in stony weight and solidity [327] encouraged the static and cerebral at the expense of the dynamic and organic – movement and spontaneity gave way to immobility. Secondly, the great masses, the cube, the sphere, the pyramid, and other elementary forms that lay beneath the luxuriant decorations of Roman antique architecture came to be appreciated in their own right as elementary forms. In 1753, Laugier threw off a witty remark (to refute the criticism that he had reduced architecture to almost nothing!) to the effect that all that was needed for good architecture was genius and a little geometry: 'du génie, & une légère teinture de Géométrie'.[101] One of those mysterious, irresistible 'somethings' was in the air.

Interest in elementary forms was not entirely new. The English architect Wren (and later, Robert Morris) had praised them; Kent's architecture, and perhaps his case furniture, had displayed a feeling for them; that enigmatic genius Hawksmoor had used them infused with the same dark romanticism that permeated the work of the French Romantic Classical architects of the 1770s onwards, a school dominated by the un-rococo features of flat surfaces, straight lines, and geometric curves. Laugier and Piranesi were the midwives of the new school, which gave birth to monumental buildings and designs dominated by elementary forms. Its most famous exponents are Boullée and Ledoux [329]. Incorporated into furniture, 'elementary forms' produced effects into the present century [666, 676].

Architects did not make all the running. Painters also contributed. A greatly respected French painter from an earlier age – Poussin – was very influential. His 'antique' pictures (he lived in Rome) contain accurately depicted ancient furniture [330]; they were recommended as inspiration by a French cabinet-maker in 1768.[102] In 1764 a painter influenced by Poussin depicted more fanciful 'antique' furniture, such as a chair which simulates polychrome marble: a stony chair indeed [331].

Roman influences were overpoweringly important, but others are perceptible. One was English Palladianism. The letters of the Abbé Le Blanc to Caylus, written from England between 1737 and 1744, are amusingly chauvinistic, but beneath his denigration of things English lies an interest in what was going on in England. He held Vitruvian values –

right 330 A Roman stool and sofa: detail from *Moses trampling on Pharaoh's Crown* by Nicolas Poussin; French, *c.* 1645.

331 A detail of an X-frame chair, from a painting in the series *The Life of St Ambrose* by L.-J.-F. Lagrenée; French, 1764.

332 A bureau plat and cartonnier in ebony, with gilt-bronze mounts by Philippe Caffiéri, designed by Joseph Le Lorrain for Lalive de Jully's Cabinet Flamand; French, 1756–58.

he mentions an anti-grotesque remark by Horace with approval[103] – and he praises Inigo Jones and Lord Burlington. English Palladianism, a kind of half-way house to the harder neo-classicism of the 'goût grec', influenced the buildings of Soufflot, an early opponent of rococo and an architect highly praised by Laugier. Soufflot took the Marquis de Marigny (1727–81), brother of Madame de Pompadour and Directeur Général des Bâtiments (from 1751), to admire Palladio at Vicenza during their educational trip to Italy in 1749; in 1768–69 he designed Marigny's house at Le Roule in Palladian style.

'Goût grec'

In 1756–58 Joseph Le Lorrain (*c.* 1714–59), a painter who had spent eight years in Rome in the 1740s and on his return been taken up by Caylus, decorated a 'cabinet à la grecque' for the collector Ange-Laurent Lalive de Jully [291]. His bureau plat and cartonnier [332] demonstrate a new, startlingly different neo-classical style, rigid and rectilinear and weighted with gilt-bronze ornament that in its solidity strongly recalls architectural stone ornament. The Greek key fret, rope-like garlands,[104] Vitruvian scroll and Herculean lion mask in gilt bronze were made by Philippe Caffiéri (1714–74), the first bronze-founder to adopt classicism. All became leitmotifs of 'goût grec' (the cartouche was banished into the empyrean). Piranesi and Roman volumetric stoniness were the only influences: the dramatic colour, ebony and gold, typical of 'goût grec's' emphasis on 'nobility', is that of Boulle, and furniture in the new style looked back not only to antiquity but to the great furniture-

maker who served the 'Grand Monarque'. To the 'goût grec' revivalists, the 'golden age for letters and the fine arts in France'[105] was the age of Louis XIV and Boulle.

Boulle had never became outmoded during the rococo period. After his death in 1732, ébénistes trained in his workshops continued to to make 'Boulle' furniture, using the same mounts and marquetry templates. Lalive himself highly esteemed Boulle furniture,[106] and his own furniture was said by Mariette to be in the taste 'formerly followed by Boulle'. The boldly magnificent Greek key had been much used by Boulle. There was still a general interest in the great age of

333 A Sèvres celadon and gilt-bronze vase; French, 1765–70.

334 A Greek key illusionistic pattern from a Roman mosaic pavement, published in Naples in 1808 (from *Gli ornati delle pareti ed i pavimenti…dell'antica Pompeii*).

335 *Jeune moine à la grecque*, from *Mascarade à la grecque* by E.-A. Petitot, published in Parma in 1771.

the seventeenth century, and craftsmen used a wide range of sources; for example, the sculptor and *fondeur* Philippe Caffiéri, who executed the bronzes on Lalive's desk, collected the designs of Marot, Vignola, and Jean Le Pautre together with those of Palladio, Vitruvius, the Greek adventurer Le Roy, Caylus and Vien. In 1751, before the creation of Lalive's 'cabinet à la grecque', the designs of Le Pautre had been reprinted by a Parisian publisher.[107]

A splendid object that did not have to observe the utilitarian requirements of a desk will perhaps help to illuminate the ideals of 'goût grec' [333]. Under a fir-cone inspired ultimately by the vast ancient Roman example in the Belvedere of the Vatican, and a lid that has the same shallow curve as the Pantheon dome (the lids of baroque and rococo urns normally have a baroque swell), a vase of 1765–70 displays the heavy swags of Hercules' lion skin, the thick Greek key, disciplined acanthus and other 'goût grec' motifs. Translated from the precious materials of porcelain and gilt bronze into stone, and eight feet high, this object might confidently stand at the end of a tree-lined avenue. It has been said that 'as a motif, the urn offers as much scope for invention as, for instance, the arabesque or the rocaille',[108] and some of the most striking 'goût grec' designs were for the urn-shaped clocks and vases that adorned chimneypieces, commodes and walls in the same taste.

The new French neo-classicism was sometimes called 'le style antique' (Lalive's *cabinet* was designed 'dans le style antique').[109] The French term for the Greek and Roman fret [334] is *grecque*;[110] Horace Walpole probably used 'Grecque' in this sense when he said that in France 'Everything must be à la Grecque, accordingly the lace on their waistcoats is copied from a frieze'.[111] However, 'à la Grecque' also means

'in the Greek fashion'; this made for ambiguities, and in any case the terms 'goût grec' and 'à la grecque' meant more than just Greece or the Greek fret. The architect E.-A. Petitot, in Rome from 1746 to 1750, shows in his amusing skit of 1771, the *Mascarade à la grecque* [335], a massive assemblage that has nothing specifically 'Greek' about it (the pyramid emphatically not); there is only an insignificant *grecque*.

The antique artefacts that principally inspired 'goût grec' tended to be Roman Greek revival, which sometimes deceived connoisseurs into thinking them Greek (Caylus described a Hadrianic Greek revival tripod as 'Greek'; in England the term 'Grecian' was a little later indiscriminately used to include 'Greek' style that was actually Roman). People knew that many artists working in ancient Rome had been Greek; and it is evident that Greek architecture was being noticed: J.-F. de Neufforge (1714–91), whose furniture designs are emphatically 'goût grec', said that he wished to imitate the 'masculine, simple, and majestic manner of the ancient architects of Greece'.[112] The picture changed when 'goût grec' was extended to describe the slightly later fashions inspired by Greek ('Etruscan') vases (pp. 202–8); there is all the difference in the world between the linear, truly Greek style derived from Greek vases and the volumetric style of the Romanized 'goût grec'. There were confusions: in 1767 a letter asked 'Does your excellency know that everything today had to be made à la grecque, which is the same as à Erculanum?' (p. 186–87). Of course, it wasn't.

The propagandists of 'goût grec' articulated the aesthetic rules of classicism more clearly than ever before. Many of its practitioners were architects who also designed furniture; they included Neufforge (who never went to Rome), Charles de Wailly, and Jacques Gondoin; Gondoin also designed chair covers and silks.[113] One of the most distinguished designers of interiors and furniture in the new style was the architect Jean-Charles Delafosse (1734–89). His 'Grande

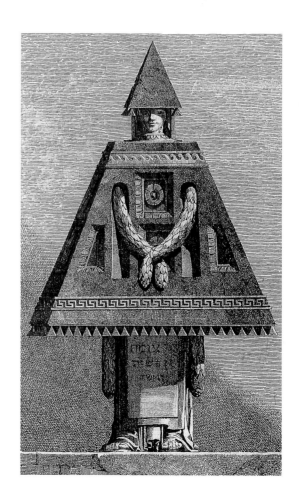

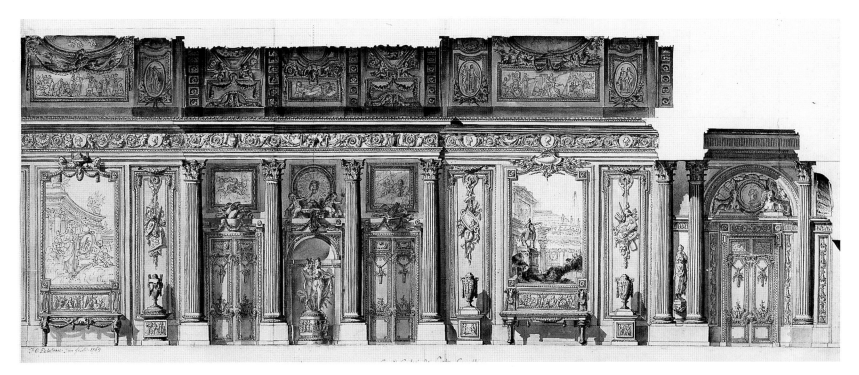

336 A design for a 'Grande Galerie', by J.-C. Delafosse; French, 1769.

337, 338 Designs for a picture frame and a console table, by J.-C. Delafosse; French, published in 1768 (from *Nouvelle iconologie historique*).

Galerie' of 1769 has a monumental grandeur that recalls the style of Louis XIV [336]; its 'goût grec' benches have a weight that assimilates them into the architectural decorations. Designers who were not architects had similarly to contrive furniture and objets d'art in harmony with the new style of interior decoration. The heavier furniture that resulted – to which Egyptian weight soon began to contribute [601] – was to persist as a strain throughout the flimsier 'rococo neo-classicism' of the 1790s.

Designs by Delafosse for a picture frame and side table [337], both items of furniture intimately connected with wall decoration, have the uncompromising 'masculine' vigour frequently mentioned as a virtue of the Louis XIV style, of which 'profiles and ornaments were invariably of the most masculine kind'.[114] 'Masculinity' carried to excess aroused objections: heavy garlands of oak and laurel (the latter is seen on Delafosse's frame) were, according to Blondel, more appropriate for triumphal arches. Delafosse's table also has garlands of roses and a mask that approaches the grotesque; such motifs helped 'goût grec' to avoid appearing over-'archaeological'. It exaggerates the proportions of a motif seen in Boulle's furniture which combined Greek key and broken curve – a *grecque* turns a rounded corner to become the table leg.

'Goût grec' quickly spread throughout Europe. A giltwood armchair bearing the arms of an Elector of Trier approaches the designs of Delafosse [339]; perhaps by a French craftsman working in Germany, it has the oak and laurel ornament denigrated by Blondel, the Greek key in a broken curve, a Vitruvian scroll and heavy garlands of roses, the petals of which are carved in virtually straight lines. Le Lorrain went in 1754 to Sweden for Count Carl Gustav Tessin and attempted to ship 'goût grec' furniture to Russia, although it never got there. Eighteenth-century Sweden was a rich country and could afford luxuries. A commode by Garnier and Durand at Gripsholm Castle of about 1762–65 [346][115] is a fine example of 'goût grec' and functional 'masculinity'; the only curved lines are in the gilt-bronze Vitruvian scroll and the garlands of the handles which combine a *grecque* with a burning lamp. No architect would have permitted the equal number of flutings in the pilasters.

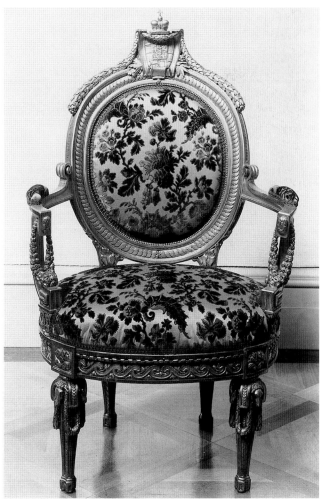

339 A carved and gilded wood armchair with the arms of Clement Wenceslaus, Elector of Trier; French or German, *c.* 1770.

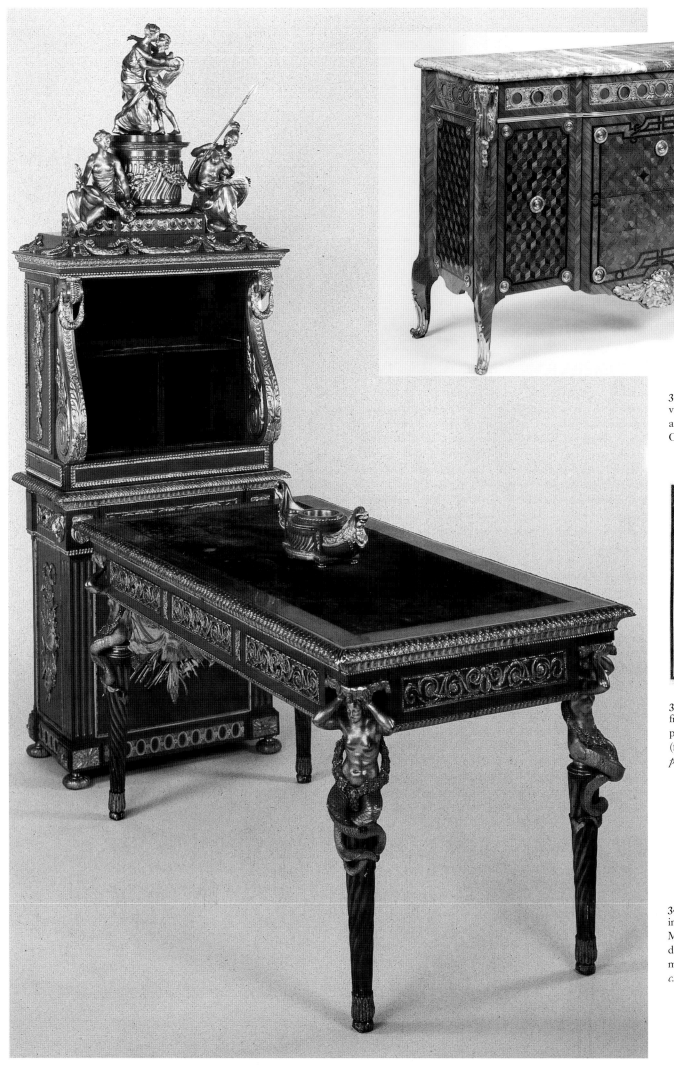

340 A commode with marquetry of various woods, gilt-bronze mounts and a marble top, made by J.-F. Oeben; French, *c.* 1760.

341 An illusionistic pattern from a Roman mosaic pavement, published in Naples in 1808 (from *Gli ornati delle pareti ed i pavimenti…dell'antica Pompeii*).

342 A cartonnier, bureau plat and inkstand in oak lacquered in vernis Martin and parcel gilt, possibly designed by Charles de Wailly, made by René Dubois; French, *c.* 1770.

343 An acanthus mask from a frieze of the Temple of Bacchus, Baalbek, Lebanon, *c.* AD 200.

right, above 344 An encoignure veneered with marquetry of tulipwood and other woods on oak, with gilt-bronze mounts and a top of griotte marble, probably by P.-A. Foulet; French, 1773.

right, below 345 A mineral cabinet in marquetry of various woods and gilt bronze, presented by Gustav III of Sweden to the Prince de Condé, designed by Jean Eric Rehn and made by Georg Haupt; Swedish, 1774.

'Goût grec' undiluted was too strong for most tastes, and less aggressive variants were made. It has been suggested that a type of breakfront commode with discreetly cabriole legs is identical with that of a group of seventeen commodes by Jean-François Oeben (1721–63) described in Madame de Pompadour's inventory as 'à la grecque'.[116] Perhaps, but it is strange that apart from an air of restrained luxury these commodes lack overt signs of 'goût grec', including the Greek key itself. The marquetry pattern on the example illustrated [340] is taken straight from Roman mosaics [341].

Gilles Joubert (1689–1775), an ébéniste who who had grown up in the reign of Louis XIV and who turned away from rococo in about 1755, became the leading supplier to the court during the second half of Louis XV's reign; he delivered a magnificent corner cupboard to Versailles in 1773 for the apartment of the Comte d'Artois, brother of Louis XVI [344].[117] He was eighty-four at the time, and the cupboard is attributed to Pierre-Antoine Foulet (master 1765).[118] It is in an advanced but not eccentric style: all its lines are straight, or at the most canted; the forceful gilt-bronze ornament, placed on a background of non-pictorial marquetry (the woods include tulipwood, purplewood, and holly) is martial in character – it includes a trophy, laurel leaves and corner ornaments of helmets and banners (the blank gilt-bronze oval originally contained a trophy with a lion-skin and quiver). The extraordinary grotesque mask made up from acanthus and scrolls was influenced by stone ornament rather than grotesque painting [343]; it also closely resembles a cartouche of Federico Zuccaro (*c.* 1543–1609), in which the eyes are similarly formed from the edge of the scroll.[119]

A magnificent cartonnier, bureau plat and inkstand in 'vernis Martin' (p. 282) by René Dubois (1737–99) [342] has trophies and scrolls that recall the interior decoration of Ange-Jacques Gabriel [356]; the thinnish rope-like garlands and twisted legs hint at a watered-down 'goût grec'; strigils decorate the base of the inkstand and the pedestal of the drum that supports a 'Cupid and Psyche' after the sculptor Falconet; the voluptuous curves of the caryatid mermaids are rococo rather than neo-classical. It has been suggested that the designer may have been Charles de Wailly (1730–98), who

left 346 A commode veneered in tulipwood and amaranth, with gilt-bronze mounts and a marble top, by Garnier and Durand; French, *c.* 1762–65.

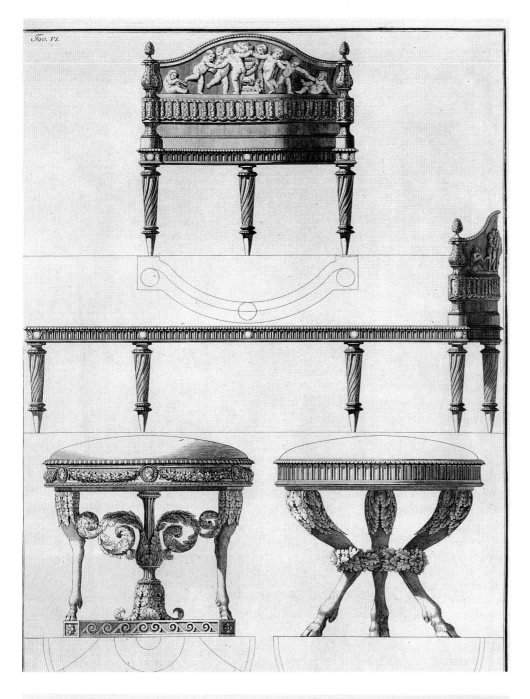

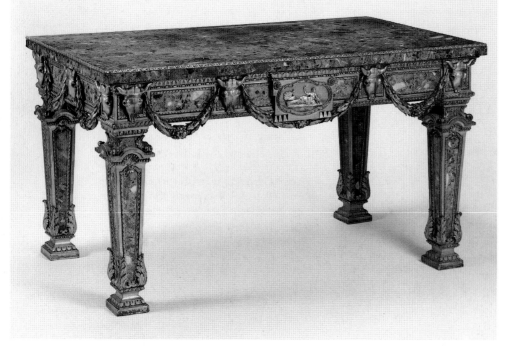

made designs for Catherine the Great,[120] and aspects of whose style have affinities with this piece.

A cabinet for minerals [345], a present from Gustav III of Sweden to the Prince de Condé, was made by Georg Haupt (1741–84), who worked in Germany, Paris and London and became ébéniste to the King of Sweden in 1769. Haupt was influenced by Oeben and Riesener, the makers of the 'modified rococo' 'Bureau du Roi Louis XV' [353], but the cabinet, designed by Jean Eric Rehn (1717–93), is in a modified 'goût grec' taste – Rehn had studied design in Paris between 1740 and 1745. All lines are straight save the concave curve to the top, a motif used by Boulle amongst others [245]. The gilt bronzes are not so massive, the heavy garlands are less rope-like than those of earlier 'goût grec' furniture (they also look less uncompromising in marquetry than in gilt bronze – as does the *grecque* itself). The duster is humorously represented in pompous ostrich feathers, fitting for the exalted rank of the recipient who may well have dusted the specimens himself.

The spread of 'goût grec' and classicism in general was assisted by antique influences emanating directly from Italy, especially Rome. These are exemplified in a Roman centre table of about 1770 [348], of giltwood and verde antique marble – the latter probably salvaged from ancient sites – which is much in the Grand Tour taste cultivated by English patrons. The table bears ornament that reveals some links with that of 'goût grec', although the broken curve at the top of the legs (basically the same as on the arcades of Hadrian's Canopus at Tivoli and of Diocletian's Palace [16, 17]) and the curled acanthus leaves at the base recall baroque usage.[121]

More advanced 'antique' furniture was designed by an eminent Italian practitioner, Giocondo Albertolli (1742–1839). Albertolli was influenced by Petitot, who had become ducal architect at Parma, and in his work 'goût grec' influences fused with the new 'archaeological' classicism. He taught ornament at the Milan Academy up to 1812, the high-water point of academic neo-classicism; in 1781 he wrote explicitly recommending as models 'the excellent originals which present themselves in antique marbles'; advising against grotesque, he hoped that the great number of good examples he had given would assist young men 'not so easily and foolishly to abandon themselves to the false and dry style which we see in the caves of the ancient baths of Rome, in the ruins of Herculaneum and elsewhere, which some have wished to introduce amongst us'.[122] Included in his illustrations is a page of furniture designed and made for the Royal Palace at Monza [347] which compares interestingly with the chair painted by Lagrenée more than twenty years earlier [331]. The seat on the left is influenced by the Pompeian 'sphinx' tripod [42], that on the right by a marble tripod table: a variant of the latter was made for an archbishop of Milan,[123] and by the late 1790s the design had (anonymously) entered general circulation.[124]

347 A design for 'Two seats in the form of a tripod, and a sofa made for a little room of the Royal Villa at Monza', by Giocondo Albertolli; Italian, published in Milan in 1787 (from *Alcune decorazioni di nobili sali ed altri ornamenti*).

348 A centre table in carved and gilded wood and verde antique marble; Italy (Rome), *c.* 1770.

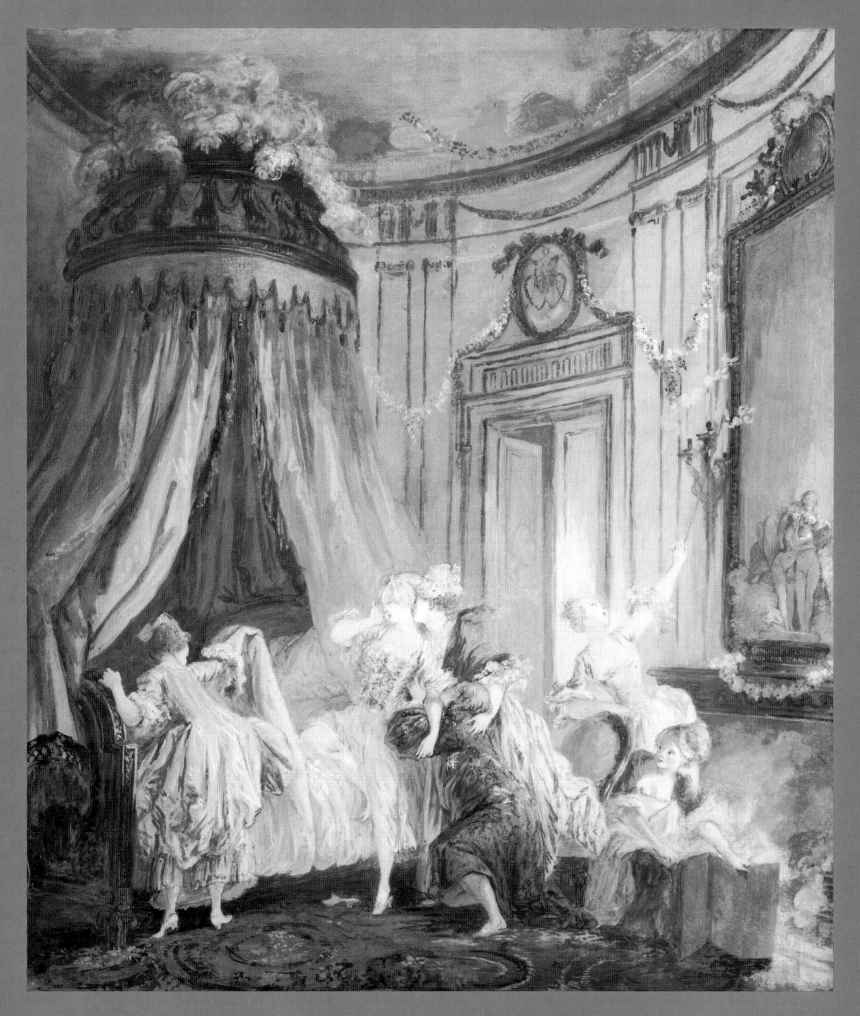

overleaf 349 'Louis XVI' furniture
in an interior touched with the
'goût grec': *Bringing the Bride to Bed*,
a drawing by Pierre-Antoine
Baudouin; French, 1767.

THE ANTIQUE REVIVAL that gathered force after about
1760 lasted until well into the nineteenth century; it is usually
referred to as 'Neo-classicism' *tout court*. However, because
so much Western art, before and after the Renaissance, has
been 'neo-classical', the clumsier but less misleading term
'post-rococo neo-classicism' is substituted for it in these
pages.[1] Post-rococo neo-classicism assumed four main
shapes, which commingled but also existed more or less
'pure'. These (in no particular order) were 'modified rococo',
in its various manifestations, which blended antique and
rococo forms; 'Greek' and 'Etruscan' neo-classicism;
'grotesque' neo-classicism, which frequently retained
a rococo spirit within antique forms; and finally the
'archaeological' neo-classicism that based itself on antique
Greek and Roman furniture (Part VIII). The picture is further
complicated by the increasing influence of pre-rococo
neo-classical styles.

New antique sources

The decline of full-blooded rococo ushered in a period when
invention in decoration and furniture, always fertile, ran riot.
In the 1750s revivalism began to be a force: 'goût grec' was
itself a form of Louis XIV revivalism. Gothic revivalism in
England became as serious as Horace Walpole could make it
– not very! The revival of Raphaelesque grotesque began in
England and France; furniture designers like Albertolli [347]
were beginning to look at the Cinquecento and be influenced
by its versions of antique classicism; the 'archaeological'
antique was on the move. The pace for the European
furniture style that succeeded rococo was set by France,
but England and Italy made important contributions.
Everywhere, new neo-classical interior design styles
shaped furniture.

New antique sources provided exciting material for
designers. Louis XIV had given a royal lead to the publishing
of antiquities; the Enlightenment brought with it a shift in
emphasis that led to 'institutional' publication. Royal,
princely and papal collections were turned into museums
with intentions loftier than self-aggrandizement; the
illustrated book or catalogue describing a collection was
seen as a tool to elevate the mind and encourage the arts and
crafts. Individual collectors remained important, as did
antiquaries – the latter often served institutions, as Gori[2]
served the Grand Dukedom of Tuscany, and Winckelmann
and the Visconti served the Papacy.[3]

Classical sculpture provided motifs for marquetry and
furniture bronzes; a notable publication of 1733 by Leplat
illustrated the collections at Dresden;[4] its impressive though
slightly crude engravings include bronzes and four pages of
'Etruscan' vases (pp. 202–3). The dazzling collections of the
Capitoline Museum in Rome, for long a source of inspiration
to furniture designers, were superbly illustrated by Bottari
and Foggini in a series of volumes issued from 1750 to 1782;[5]
the engravings showed famous sculpture and busts of Roman
emperors and empresses; one of the volumes has the 'Cupid
and Psyche', a favourite motif often used on clocks and
furniture.[6] Another type of sculpture publication was
represented at its most lavish in Bartolomeo Cavaceppi's
three expensively printed volumes[7] devoted to sculpture he

had restored – or made; some pieces, such as a copy of the
centaur from Hadrian's Villa, were confessedly modern. His
books are really a trade catalogue of sculpture, much already
sold to England and Prussia. Included were examples of the
splendidly grandiloquent stone candelabra that were so
popular during the eighteenth and early nineteenth centuries
[424]; Piranesi also had made much of these examples of
'ancient magnanimity', and they appeared again at the end
of the century in C. H. Tatham's book of ponderous Roman
artefacts (p. 220).

In the middle years of the eighteenth century the more
distant parts of the Roman Empire received attention: 'the
Iliad has new beauties on the banks of the Scamander, and
the Odyssey is most pleasing in the countries where Ulysses
travelled and Homer sung'. Thus Robert Wood, in the
preface to his fine volume on Palmyra published in 1753,[8]
which contained a headily grandiose mixture of motifs from
that city of a cosmopolitan and sophisticated people: 'Their
funeral customs were from Egypt, their luxury was Persian,
and their letters and arts were from the Greeks.'[9] Wood
published Baalbek, with its sumptuously decorated
orientalizing Graeco-Roman temples, in 1757. Robert Adam
produced a careful volume on Spalatro (Split), the gigantic
late Roman fortress-like palace to which Diocletian
withdrew to grow cabbages, in 1764. The building, said
he, furnished 'the only full and accurate designs that
have hitherto been published of any private Edifice of the
Ancients'.[10] All three books proved highly influential.

Amongst the most important and influential publications
were those on Herculaneum and Pompeii, 'one of the noblest
curiosities ever discovered'.[11] The great eruption of Vesuvius
proved fortunate for art-loving posterity; it is as if the
eighteenth century suddenly found on its doorsteps the latest
issues of the *Art Journal* for the year AD 79. The entombed
cities had slumbered until 1684, when a well was sunk into
the Herculaneum theatre. Marbles discovered there were
sent in about 1706[12] to France and Vienna. The King of
Naples forbade further excavations, and everything stopped
until 1736. In 1748 further digging began at nearby Pompeii,
which had been smothered in ash and cinders more easily
removable than the petrified lava of Herculaneum. The two
sites yielded, generally speaking, different types of artefacts –
architecture and decoration at Pompeii, paintings and
household objects at Herculaneum. The towns became a
tourist attraction: everybody who went to Naples visited them
and some published a record of their journey; one of the
most popular, the *Voyage Pittoresque* of 1781–86 of the Abbé
de Saint-Non, contains rococo-style views which form
strange contrasts with its 'neo-classical' illustrations
of artefacts.

Between 1757 and 1792 the authorized volumes of the
finds were published[13] [45, 269, 392, 400, 452, 459, 558, 559];
the books, not sold but sent by the King of Naples to
favoured recipients, illustrated paintings, mosaics, furniture,
and other artefacts of all kinds. In 1767 the need for
translations into French and English prompted the comment
that 'all the goldsmiths, jewellers, painters of carriages, of
overdoors, upholsterers [furniture-makers], decorators, need
this book....I have seen more than ten copies of that woman

350 Designs for the Palais Royal, Paris, for a door panel (the horizontal line indicates it would be much taller) and a sofa, by Pierre Contant d'Ivry; French, *c.* 1755–57 (from Diderot and Alembert, *Dictionnaire des Sciences*, Paris, 1762).

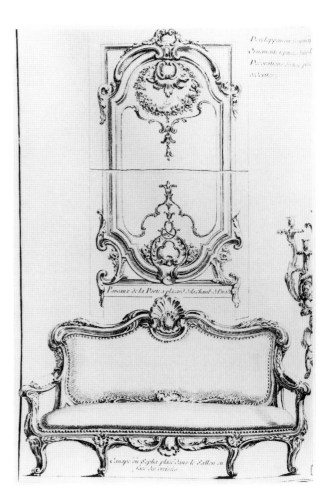

selling cupids like chickens'[14] [379]. The craze for Herculaneum and the 'Pompeian' style swept Europe and Russia from end to end; the books supplied an extensive new repertoire of ancient painting, decoration, ornament and household objects; illegitimate and inaccurate sketches by Caylus and others were similarly exploited. Painters gave a lead: to Anton Raphael Mengs, an apostle of the new neo-classicism, 'the paintings of Herculaneum manifested…the true fountain of Beauty'.[15] Between 1796 and 1820 the 'Stamperia Regale' of Naples published the most princely of all volumes, certainly amongst the biggest, in which the 'walls and floors' of Pompeii were pictured in sumptuous black and white engravings [32, 169, 315, 334].[16]

However, the provincial paintings of Pompeii and Herculaneum could not vie in quality with the Neronic sophistications of the long-discovered Domus Aurea. In the 1770s and 1780s Cameron, Ponce, Smugliewicz and Brenna reproduced its wall and ceiling decorations as from the 'Baths of Titus' [33].[17]

The miniaturism characteristic of post-rococo neo-classicism found the carved and engraved gem [445] congenial. Gems had enjoyed high favour since antiquity, and had often been published [49, 307]; they were 'comparable in all respects with the finest statues of antiquity';[18] there could be no higher praise. They combined the brilliance of semi-precious stones with minute workmanship and difficulty of execution; their subjects embraced the whole of antique myth and life. Their quality stimulated the engraver, as the thirty-four beautiful small engravings in Enea Vico's *Ex antiquis cameorum* of 1550 show; these were republished in 1730 with a new commentary.[19] Gems appeared both in sumptuous volumes[20] and in workaday journeyman's books.[21] The captivatingly light-hearted scenes of cavorting putti, fauns and satyrs, and graceful females in chariots drawn by swans or butterflies,[22] inspired artists of all kinds; they were often enclosed in cartouches and surrounded by rococo arabesque. They remained popular well into the nineteenth century; their continued use, given a further impetus by similar themes painted on the walls of Pompeii and Herculaneum [35], helped to ensure the survival of rococo sportiveness throughout the reign of austere Greek revivalism.

The tight line and pedantic attitudes of the later books may have encouraged the academic and etiolated character of some late neo-classicism. Early Renaissance art, which culminated in the classical art of Raphael, has a delicacy, virility and apparent spontaneity that bring it at times close in spirit to ancient art itself, much closer than the somewhat mechanized (although still beautiful) neo-classicism of the later eighteenth century.

'Modified rococo'

The rococo style was long a-dying. Merely perusing the few illustrations given within these pages will make it clear to the reader that 'goût grec' in its doctrinaire form must have been a considerable shock for most people, like Yahweh after Baal. Indeed, most people who inhabited interiors in the 'goût grec' manner [349] did not fill them with 'goût grec' furniture [337, 339]; the rococo style had been easy to live with in the most literal sense. Nevertheless, the impulse to follow fashion was strong, and even where 'goût grec' was not wholeheartedly adopted it managed to leave its traces. Compromises were found, and two somewhat differing types of furniture came into existence, modified rococo and modified 'goût grec'.

As with most innovations in French design, the process was given rational expression: 'the masculine style [the 'goût grec'] which the majority of our architects strive nowadays to give to their ornaments has yet…not necessitated that character of heaviness which our ancestors [Louis XIV, etc.] affected in their interiors, nor that prodigality of small members for which we have already criticized the majority of our [rococo] woodcarvers, but rather a just medium between these two excesses.…They [the architects] also realized that too much symmetry in its turn often produced compositions which were merely cold and monotonous'.[23] The subject of these remarks was the innovatory rococo designs of Contant d'Ivry for the Palais Royal of the late 1750s [350]. The door panel and sofa illustrated show the 'just medium' – an increased heaviness, symmetry in ornament and form, loss of organic spontaneity and reduction in curvaceousness. The sofa bears odd resemblances to contemporary English attempts at rococo in which the substitution of architectural mouldings for French banding produced furniture resembling a leaden baroque.

Some 'modified rococo' furniture was superb. The 'Bureau du Roi Louis XV' [353], designed to stand in the centre of the King's private cabinet at Versailles, a room that already contained rococo furniture, maintains a golden mean between rococo and the new neo-classicism. Begun in 1760 by Oeben and completed by Riesener (p. 192), it was delivered in 1769. The desk retains a rococo serpentine shape and subtly cabriole legs, with some straight lines; the candle branches, the most rococo feature, are not wildly so. The rest of the gilt bronze is in antique taste, but retains some movement; the ribbon-tied garlands do not have the frozen rigidity of 'goût grec'. The marquetry by Oeben, of still lifes and flowers, is casually disposed; the interior woodwork is decorated with marquetry imitating antique mosaic. The small terms that stand next to the interior drawers were

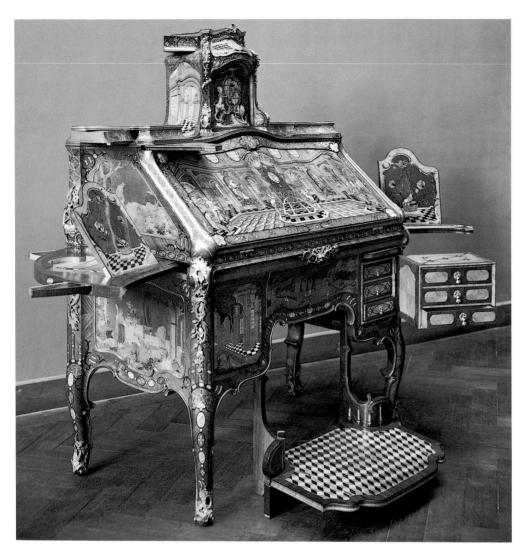

351 A fall-front desk with marquetry that includes bone, mother o' pearl, tortoiseshell, silver and brass, and with gilt-bronze mounts, by Abraham Roentgen; German (Neuwied), *c.* 1765.

352 A commode veneered in fustic with marquetry in various woods, designed and made for Nostell Priory, Yorkshire, by Thomas Chippendale; English, *c.* 1770.

described in 1763 as 'quatre Termes, dans le goût grec'.[24] This bureau compares with another magnificent desk of the same decade, by the Rhineland cabinet-maker Abraham Roentgen (1711–93) [351]. Again, the serpentine lines are considerably modified, and despite the presence of some bombé surfaces, rococo movement is subdued. The marquetry decoration includes naturalistic outdoor scenes and interior perspectives in classical taste.

An English commode of the same date made for a bedchamber at Nostell Priory [352] has a subtly curved bombé front with concave sides; the simple classical ornament of vases, husks and garlands is perfectly placed: another commode, made for the dressing room, has the same form but vases and flowers are placed within two unsymmetrical but balanced rococo cartouches. The execution of some English pieces in this style may be not of the finest,[25] but the pleasing design enabled this variety of 'modified rococo', given straight rather than curved legs, to continue into the next century; subdued rococo designs were included in the last edition (1794) of Hepplewhite's *The Cabinet-Maker and Upholsterer's Guide*.

'Louis XVI' furniture

A type of late eighteenth-century French furniture usually called 'Louis XVI' had emerged before the death of Louis XV in 1774 and survived until the 1790s. The term covers several strains, intermingled and distinct. First comes latter-day tamed 'goût grec' furniture, which continued to be made for the French court and aristocracy and to influence European furniture in general into the 1780s. For more general use, however, people preferred something sweeter, lighter and

opposite **353** The 'Bureau du Roi Louis XV', veneered on oak with various woods including pearwood, holly, burr walnut, purplewood, tulipwood and stained sycamore, by J.-F. Oeben and J.-H. Riesener, with gilt-bronze mounts designed by Duplessis, cast and chased by Hervieu; French, 1760–69.

more genial. They found it in the furniture style associated with the interior decoration of the architect Ange-Jacques Gabriel (1698–1782), who became First Architect to the King in 1741. Gabriel's architectural style combined the rich Corinthian of Louis XIV with the cool Palladianism of Italy and England; he articulated his rooms with panelling enlivened by crisp but unassertive 'architectural' decorative motifs – Vitruvian scrolls, acanthus; the use of the orders is minimized; flowers, wreaths and garlands are frequent but disciplined. The ornament is 'feminized' by being unobtrusively miniaturized, but this miniaturism never becomes fussy or trivial, as it did in the later ornament of Adam; the taste is perfect. Gabriel's later interiors, such as that of the Salon de la Reine in the Petit Trianon at Versailles, are of surpassing beauty [356], restrained, serene and lucid. Chairs were still customarily placed against the walls when not in use, although Louis XIV's dislike for rooms disturbed by a chair pushed forward would now have seemed hopelessly *vieux jeu*. White, 'French' grey, or other soft colours were preferred; this was the age which considered that the colours 'most appropriate to beauty, are the milder of every sort: light greens, soft blues, weak whites, pink reds, and violets...'[26]

The vocabulary and virtues of these interiors are repeated in the furniture, especially the seat furniture. Seat furniture resisted classicism longer than any other type: innumerable chairs exist in rococo form with classical decoration, and chairs hardly began to become thoroughly antique until the reign of horsehair and hard seats began in the 1790s. Louis XV, who accepted some neo-classicism, never liked chairs with straight legs, modelled after the fluted column rather than the scroll. Rococo cartouche-shaped chair backs were replaced by circular or oval backs (the circle was Roman taste, the oval Greek, as Owen Jones was to notice).[27] A chair by Jacques Pothier of about 1765 suavely adopts classical features [355]; the horizontal seat rail is decorated with the

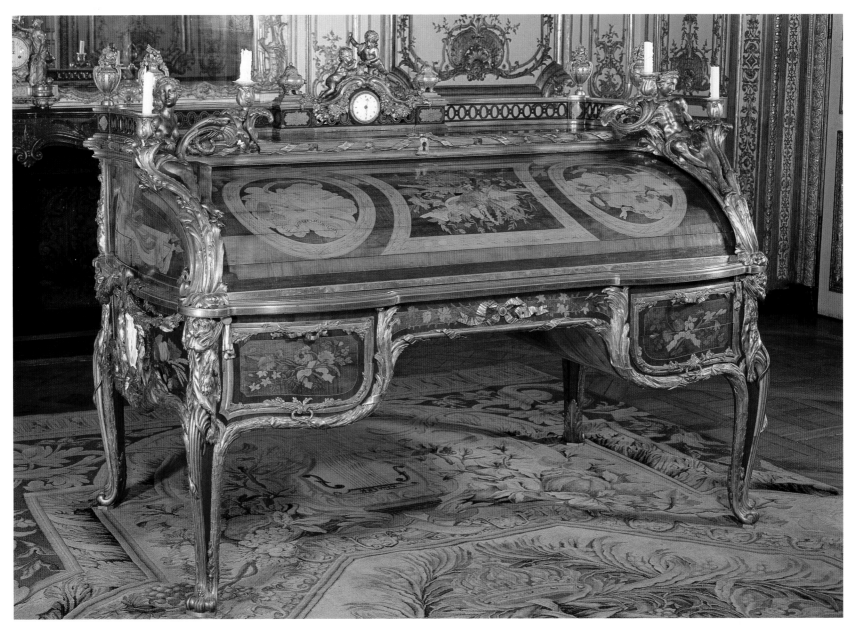

354 A design for a chair by Matthias Lock; British, *c.* 1770.

right 355 A chair in carved wood by Jacques Pothier; French, *c.* 1765.

Greek key, but the chair retains the rococo cartouche-shaped back (bordered, however, with a continuous and sedately carved frame) and the cabriole legs are gently curved. An English design by Matthias Lock for a chair of about 1770 [354] has an oval back, and offers as an alternative to the modified cabriole a straight leg which approaches the 'Pompeian' candelabraform rather than the fluted architectural leg.

Furniture in this reasonable and usable style was made all over Europe long after high fashion had moved on. France exported luxury furniture directly, and designers of various nationalities who had been trained in Paris returned to their own countries and adapted French style to suit native tastes – thus confusing furniture historians. For instance, the French or English nationality of the chairs in the Tapestry Room at Osterley Park in England has been a subject of dispute [359]. The room, designed by Robert Adam after a pattern repeated elsewhere,[28] is French in conception; its Gobelins tapestry panels are dated 1775. There was so much interchange between the two countries that to categorize the chairs on the grounds of supposed 'English' or 'French' characteristics (the English client's preferences may have gone either way) is risky: one can only say generally that the French tradition as it had developed and was developing was more likely to have produced the chairs than was the English.

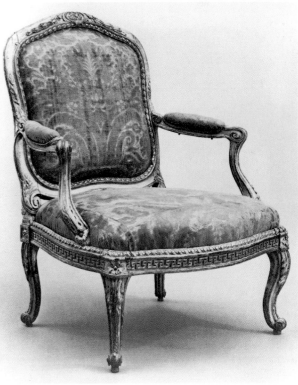

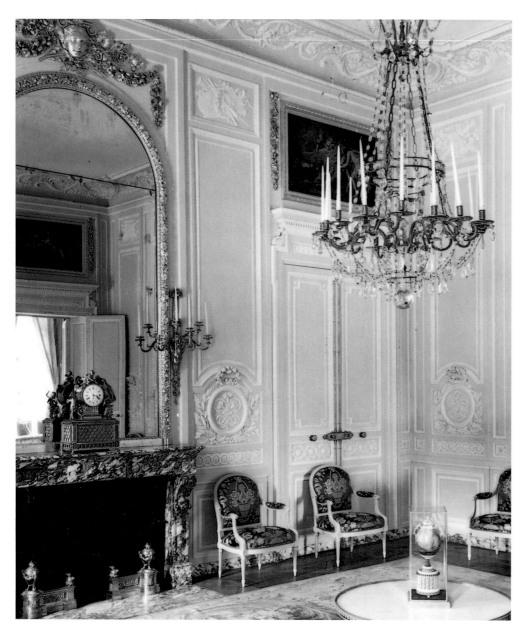

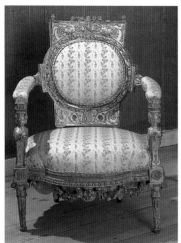

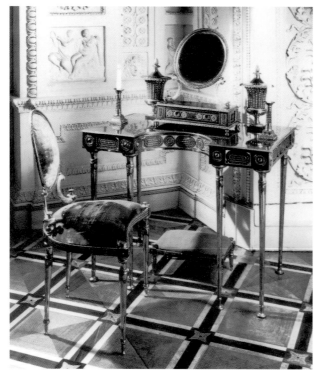

357 An armchair in carved, painted and gilded wood; Russian, *c.* 1790.

358 A dressing table and its appurtenances, and a chair, of Tula steel, gilt bronze, and silver, at Pavlovsk; Russian, 1789.

356 The Salon de la Reine in the Petit Trianon, Versailles, designed by Ange-Jacques Gabriel; French, 1762–68.

A late eighteenth-century Russian armchair [357] combines an oval and a rectangular back; the rich carving in antique style is largely of the miniaturized 'architectural' type; the fluted legs are of the Ionic order. Some versions of 'Louis XVI' were singularly eccentric. An attenuated Russian dressing table, toilet appurtenances, chair and footstool made of Tula steel, gilt bronze, and silver and decorated with steel 'diamonds' [358] was sold in 1789 to Catherine the Great;[29] it adapts French style to a foreign type of manufacture developed during the eighteenth century from the imperial armoury at Tula. Furniture in Tula steel fetched exorbitant prices. One cannot imagine how much a Parisian would have been prepared to pay for it.

'Anglomanie'

The hegemony of France in matters of taste did not exclude the influence of other countries, especially Germany and England. Many of the finest ébénistes working in Paris were Germans. England exported to France a whole way of life. 'Anglomanie', in the words of King Louis-Philippe, was 'prevalent among the wealthy clan of the French nation during the reign of Louis XVI. It was even so by the end of the reign of Louis XV, who was disturbed by its progress'; especially Anglophile was 'M. le Comte d'Artois, who had built Bagatelle and laid out an English garden'.[30] The Comte d'Artois, a close friend of the Prince of Wales, assiduously imported French ideas into England. English exports possibly included the 'Etruscan' style (p. 203),[31] as well as individual motifs such as lyre-shaped backs for chairs. The highly influential pattern books of Hepplewhite, Sheraton and others blended grotesque detail with the 'Gabriel' style and in their turn gave ideas to France. A chair of the 1780s by Georges Jacob (1739–1814) [471] shows the influence of the 'Hepplewhite' shield back [394].

The Jacob chair is in mahogany, and the English liking for mahogany made serious inroads into French taste. As early as 1768 a 'Magasin Anglais' sold English mahogany furniture in Paris.[32] The French adoption of mahogany brought with it the English 'dining' table – François de La Rochefoucauld wrote in his memoirs that after English dinners 'the cloth is removed and you behold the most beautiful table that it is possible to see. It is indeed remarkable that the English are so much given to the use of mahogany.'[33] The attempts made to resist English fashions seem at times half-hearted: Marigny, an arbiter of French taste, in 1779 wrote to the cabinet-maker Garnier that ebony and gilt bronze were far more 'noble' than mahogany[34] – although he himself had bought mahogany games tables in London the previous year and given them to Garnier to copy.[35] His admiration of things English was not confined to mahogany furniture: 'These chairs are English. How beautiful is your manufacture of horsehair for the bottoms.' Marigny bought over one hundred chairs and some tables from James Wyatt (1746–1813), a notable but lazy pioneer of English antique design[36] who would probably have received much more notice had he produced a pattern-book; as late as 1826 a furniture designer praised him for his good influence 'on our domestic movables'.[37]

In 1786 a commercial treaty between France and England permitted import of English goods at moderate duties. Partly via France, the mahogany taste was

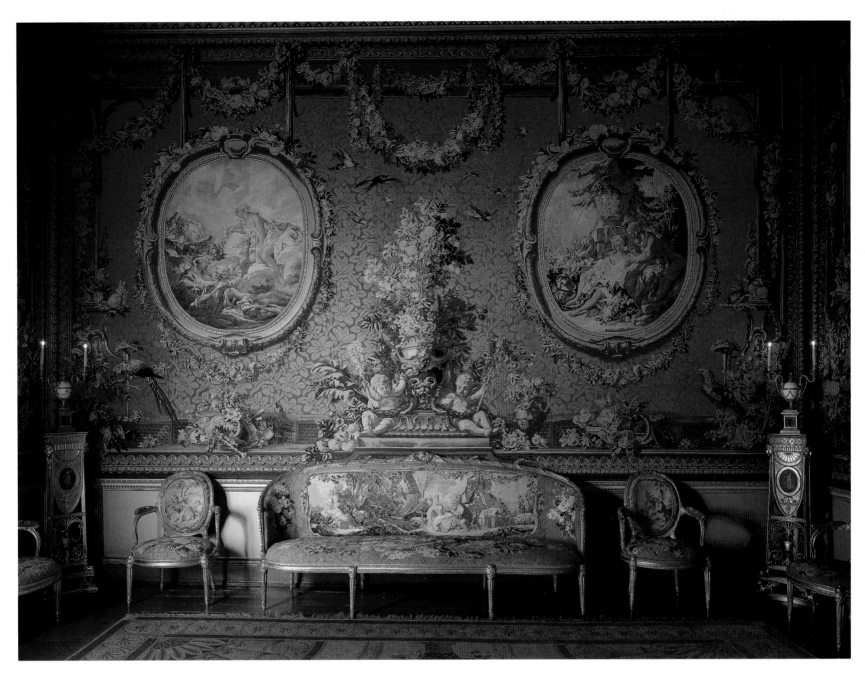

359 The Tapestry Room, Osterley Park, near London: Gobelins tapestries on walls and seat furniture, French, 1775; chairs, French or British, 1776; tripod candelabra, pedestals, and carpet designed by Robert Adam, British.

360 A semi-circular commode, veneered in mahogany with brass mounts; Russian, c. 1800.

exported to Russia; David Roentgen (1743–1807) – himself a sufferer from 'anglomanie' – who was praised in 1779 for a mahogany table with 'so perfect a polish that to eye and hand it gives the illusion of marble'[38] made magnificent furniture for Catherine the Great in mahogany and gilt bronze that anticipates the columnar style and strong colour of Empire taste; it inspired native cabinet-makers [360]. Ironically enough, English fashion was the ultimate origin of the dark mahogany from which some of the most splendid Napoleonic furniture flaunts its aggressive military emblemism in gilt bronze. But this was 'after the deluge'.

French royal and court furniture

Meanwhile, the grasshoppers enjoyed the Indian summer. The 'Louis XVI' furniture made for the French royal family and court should be set apart from everything else. It had achieved by the 1780s an exquisite refinement of form and preciosity of finish that remain unequalled. At times it looks like jewellery on an enormous scale [362]. Four pieces by two makers, a table and three secretaires, illustrate the 'splendeurs' (and possibly the 'misères').

All completely lack architectural embellishments such as columns, pilasters, and entablatures. The first two, by the

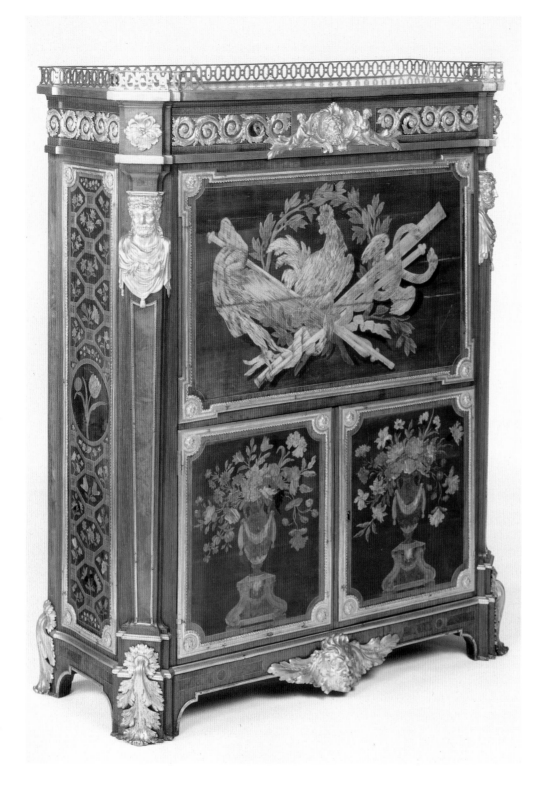

Two secretaires by Jean-Henri Riesener (1734–1806), a Westphalian immigrant who became one of the most famous of French ébénistes, show how pieces made within five years of each other could widely diverge in style. Both were royal commissions. The first [361] was delivered to Versailles for Marie-Antoinette's Cabinet Intérieur in 1780.[41] It is veneered on oak with purplewood, tulipwood, holly, burr maple and sycamore; the mounts are strongly modelled gilt bronze; the flowers are formal bouquets in vases. Floral marquetry had re-entered France in about 1750 through German immigrant ébénistes such as Oeben, whose style developed towards a naturalism that extended over a whole piece; the secretaire may owe its old-fashioned air to work done to it by Oeben before his death in 1763. The burnished finish of the mounts was replaced by matt in 1788, a comment on changing tastes.[42] The emblemism – Hercules and the French cock – seems hardly appropriate for the Queen. The second secretaire [363], which is more characteristic of Riesener's post-1770s work, reflects Marie-Antoinette's romantic and sentimental tastes; at St Cloud she set a clear pane of glass above a chimneypiece to frame an untutored landscape, and she loved flowers, roses and cornflowers being said to have been her favourites.[43] Furniture made for her has some of the finest flower decoration in existence. The mounts of the secretaire, in the manner of Pierre Gouthière (1732–c. 1812), one of the most accomplished of craftsmen, are of great delicacy; the flowers that 'people' the acanthus scrolls are realistically modelled and in full relief; ribbons come forward as drawer pulls. The gilt-bronze plaques are in the manner of Clodion,[44] and the emblemism is discreetly amorous. The decussated marquetry pattern in 'infinite rapport' is derived from Roman motifs;[45] it encloses sunflowers.

Another masterpiece produced by Riesener for Marie-Antoinette, a commode [362], came from her Cabinet Intérieur at St Cloud: the group, which re-used old Japanese

361 A secretaire veneered on oak with marquetry of various woods, including purplewood, tulipwood, green-stained holly, burr maple and sycamore, made for Queen Marie-Antoinette by J.-H. Riesener; French, 1780.

362 A detail of a commode in Japanese lacquer, ebony and gilt bronze, made for Queen Marie-Antoinette by J.-H. Riesener; French, c. 1787.

eclectic René Dubois (p. 183), differ enough from each other to show the versatility of a maker perhaps working with different designers. The modified 'goût grec' cartonnier, bureau plat and inkstand [342], said to have been made for Louis XV and later acquired by Catherine the Great[39] (p. 183), is utterly different from a huge armoire-secretaire in Japanese lacquer and gilt bronze made by unproved repute for Catherine in about the year of Louis XV's death, 1774[40] [579]. The secretaire, which recalls Boulle as well as the rococo (Dubois included pastiches of Boulle in his work) is of bombé shape decorated with symmetrical classical ornament – acanthus, bay-leaves, and trophies. The ornament lacks the rigidity of 'goût grec': its garlands are loosely organized, and Jove's eagle naturalistically flaps his wings and elevates his beak at the top of the grandiloquent structure.

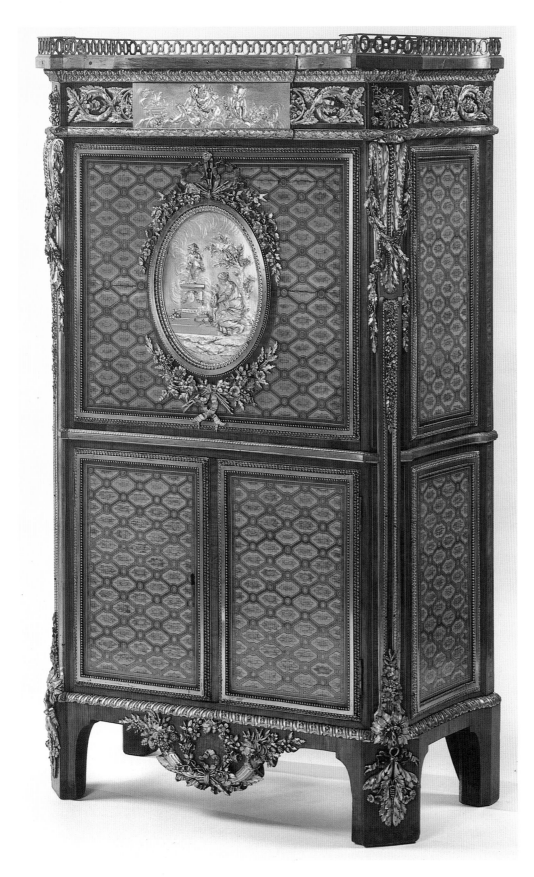

lacquer,[46] included a secretaire and an encoignure, all probably dating from 1787.[47] The combination of grandeur and delicacy is quite extraordinary. The curve of the sides and the subtle break of the front give movement to the massive shape; nothing could be more beautiful than its contrast with the completely naturalistic profusion of flowers that hangs in gilt-bronze garlands; on the apron the flowers issue as sprays from cornucopias. Another masterpiece, the jewel cabinet of the Comtesse de Provence [401], is a miracle of cabinet-making, 'rococo neo-classicism' to perfection: the frivolous emblemism of the period is exemplified in the use of the feathers of Cupid's arrows as 'capitals' of the supports of the stand. The stand itself looks back to the seventeenth century [244] – as the elegantly elongated caryatids look back to the sixteenth, to the grave maidens of Primaticcio at Fontainebleau.

Some of the most enchanting of all pieces of furniture were being made at this time – small, mobile, infinitely luxurious pieces that satisfied every social requirement of a hedonistically sophisticated aristocracy; they ranged from diminutive tables to gueridons, jewel cabinets, bonheurs-du-jour and night tables. Small tables of this type were rectilinear, sometimes oval, and often retained subtle curves on legs and and body. Many were decorated with porcelain plaques: Sèvres panels had been introduced into furniture by the *marchand-mercier* Poirier, an arbiter of taste, by 1763 (*marchands-merciers* were a kind of combined antique-dealer and decorator). A small table designed by Poirier for Madame Du Barry and stamped by Martin Carlin (*c.* 1730–85), a German from Baden who had settled in Paris by 1754, will have to represent an abundant variety [364]. Its Sèvres plaque of a Turkish scene is signed by Dodin and dated 1771.[48] This table subsequently belonged to Queen Maria-Carolina of Naples, a sister of Marie-Antoinette. Such light pieces of Carlin furniture were almost all made for women;[49] the Duchess of Saxe-Teschen, another sister of Marie-Antoinette, also bought an assemblage of porcelain-mounted furniture from Poirier.[50]

By 1785 tastes in interior decoration had changed: the royal family was buying from Weisweiler (p. 285) through the *marchand-mercier* Daguerre, who in 1777 had taken over Poirier's business. Riesener's career had begun its distressing decline; the 'style arabesque' (grotesque) had come into favour.

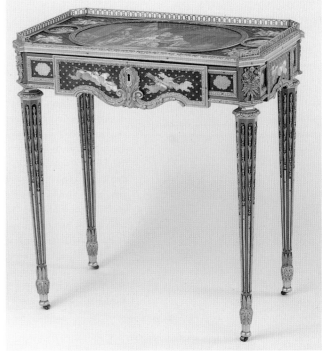

363 A secretaire veneered on oak with marquetry of various woods, including purplewood, holly and casuarina wood, with gilt-bronze mounts in the manner of Pierre Gouthière, plaques in the manner of Clodion, and a Carrara marble top, made for Queen Marie-Antoinette by J.-H. Riesener; French, 1783.

364 A table in gilt bronze with Sèvres plaques, the centre plaque of a Turkish scene signed by Dodin and dated 1771, designed for Madame du Barry by Poirier and made by Martin Carlin; French, *c.* 1772.

365 Detail from the Logge in the Vatican Palace, Rome, including a large acanthus scroll in shot colour, executed under the supervision of Raphael and completed in 1519; Italian, published in Rome in 1772 by Marco Pagliarini (from *Arabesques of the Vatican Loggie*).

366 A pier table and other furniture designed for Cardinal Giambattista Rezzonico by G. B. Piranesi; Italian, published in Rome in 1769 (from *Diverse Maniere d'adornare i cammini*).

THE REVIVAL OF GROTESQUE throughout Europe in the later eighteenth century deeply affected furniture design. Antique-style grotesque had survived during the first half of the century but not as high fashion. In France, it had been largely subsumed into the rococo.[51] In England, Palladianism had disdained it (Palladio had ignored the Domus Aurea in his guide to Rome)[52] although Kent had painted several ceilings of jejune quality in 'ye grotesk manner…as what ye Ancients used'.[53] In Italy, grotesque had continued in fashion; Kent's dry and listless patterns shrink before the magnificent grotesques of the Palazzo Doria-Pamphili in Rome, painted in 1734. C. H. Tatham wrote in 1796 that 'to this day an Italian never modernizes his House without arabesque [grotesque] being the principal decoration'.[54]

The Italophile British embarked on grotesque decoration in the late 1750s, coincident with a growing animus against the heavy formality of 'temple' interior decoration. Major grotesque schemes were put in hand at Spencer House in London by 'Athenian' Stuart [367], and at Hatchlands by Robert Adam;[55] the first was flat-painted, the second painted stucco. The panels and vertical acanthus scrolls of the Painted Room at Spencer House are in Raphaelesque grotesque [365]; the painter was possibly an Italian immigrant, Biagio Rebecca.[56] Adam had evolved his own grotesque style by the early 1760s; it proceeded from Alessandro Algardi's sculptural grotesque at the Villa Pamphili through Raphaelesque grotesque to 'antique' grotesque and finally to the inclusion of 'Etruscan' motifs; his furniture follows much the same order, using marquetry, paint, scagliola, gilt bronze (and composition) in place of the paint or light stucco used on the walls. Tatham wrote in 1795 that 'The late Messrs. adams' were the children of the Arabesque'. Adam acquired working drawings of ornament that include grotesque in all its guises: numerous ancient ceilings, many redrawn by Giuseppe Manocchi in the 1760s; the Raphael grotesques from the Vatican;[57] the stuccos by Algardi from the Villa Pamphili; furniture from Pompeii; and so on. But they also include much carved stone ornament, such as the splendid scrolled pilasters from the Arch of the Goldsmiths, Medusa's head and scrolling acanthus from the Temple of Vespasian,[58] ancient sarcophagi and curvilinear interlace. All was grist to Adam's mill.

The French revived grotesque in the 1760s and 1770s,[59] and exported designers and executants to England and Sweden (p. 206); the Scot Charles Cameron (*c.* 1743–1812) took his grotesque style to Russia, as did the Italian Brenna. Adam regarded France with a jealous eye. He reprimanded the French for using 'arabesque' as a synonym for 'grotesque': 'By grotesque is meant that beautiful light style of ornament used by the ancient Romans found in "grotte," which was imitated in the Renaissance in the loggias of the Vatican [161, 162, 365], and in the villas Madama, Pamphili [by Algardi], and Caprarola [by the Tibaldi, Zuccaro, etc.]…the French, who till of late never adopted the ornaments of the ancients [a claim for British primacy in the grotesque revival]…have branded those ornaments with the vague and fantastical appellation of arabesque, a stile which, though entirely distinct from the grotesque, has, notwithstanding, been most universally confounded with it by the ignorant.'[60]

This statement signalled taste turning towards the 'archaeological' approach of nineteenth-century neo-classicism; it also implied a high esteem for Italian Renaissance grotesque, which was now revived and published. A straw in the wind was Charles-Antoine Joubert's issue of sixteen engravings of the Logge decorations, and in 1772 a magnificent set of coloured engravings of the Logge [161, 365] was published which Schinkel and others thought worthy of the walls of palaces. Nicolas Ponce included some of Raphael's grotesques in his book. Catherine the Great had the Loggia itself reproduced entire in the Hermitage in St Petersburg (glazed…!). Antique and Raphaelesque strains tended to merge; presumably Catherine knew one from t'other, but she described Cameron's highly individualistic Tsarskoe Selo grotesques as 'plus ou moins de Raphaélisme'.[61]

Later eighteenth-century architects and interior decorators often lumped all grotesque together as 'Pompeian': the epithet particularly signified the modern method, copied from antiquity – and not, of course, confined to Pompeii – of articulating walls into compartments marked by candelabraform and other grotesque motifs [37]. Paintings were frequently inserted within the compartments in the ancient manner. The light-hearted 'print room', in which prints and coloured engravings were stuck directly on to painted walls and surrounded with trompe-l'oeil frames and grotesque decoration, was really a cut-price form of grotesque. The same mode was applied to furniture: English 'Sheraton' furniture exhibits such motifs painted on a satinwood ground. Prints themselves were stuck directly upon furniture.

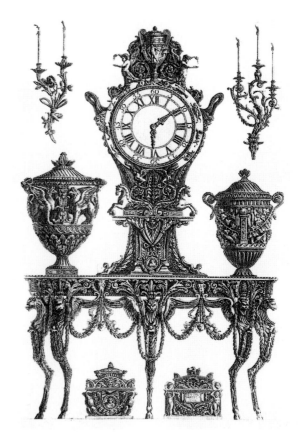

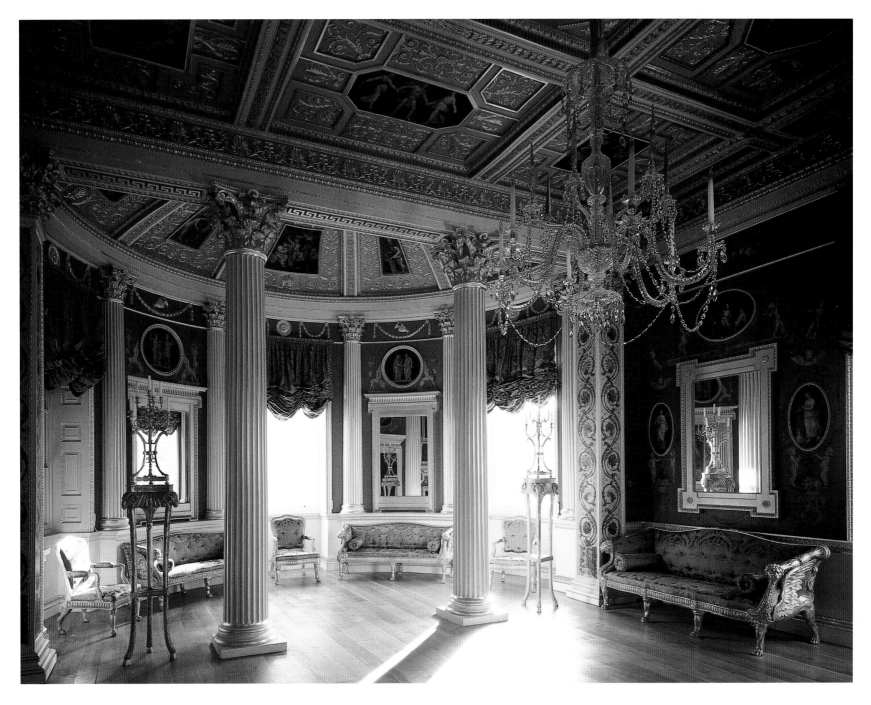

367 367 An interior with acanthus scrolls and other Raphaelesque grotesque decoration on the walls, and with carved, painted and gilded wood furniture, all save the chandelier designed by James 'Athenian' Stuart: the Painted Room at Spencer House, London; British, c. 1759.

The revival of three-dimensional grotesque motifs in furniture

The grotesque revival put the witty, 'anti-classical' spirit of rococo into antique dress. In 1769 Piranesi produced designs for grotesque wall decorations that are so 'antique' that they could almost have come from one of the Roman tombs illustrated by Santi Bartoli or Montfaucon; they were accompanied by designs for furniture that demonstrate how rococo sensibility could survive the loss of rocaille and cartouches and pass into pieces composed principally from antique stone ornament and ancient bronze furniture. Piranesi was an ornamentalist, and argued for profuse ornament against 'people, the poorness of whose ideas renders them above measure lovers of simplicity...it is not the multiplicity of ornaments that offends the eyes of the spectator, but the bad disposition of them'.[62]

The ancient furniture discovered at Pompeii within ancient grotesque-painted rooms played a leading role in the formation of the new furniture style, and Piranesi's highly ornamented 'rococo neo-classical' pier table designed for Cardinal Rezzonico [366] was influenced by the sphinx

tripod discovered in 1765 in Pompeii [42]. His print of the Rezzonico table remained influential for many years, as a French pier table of the Louis XVI period influenced by it [369] and a Swedish table of 1810 modelled directly after it demonstrate.[63]

Piranesi published the sphinx tripod as an antique,[64] but in designing used it as a jumping-off point for his own improvization. It was quickly to be used 'pure' (it was itself, indeed, a kind of antique rococo 'Gallicism'). It would be interesting to know 'Athenian' Stuart's thoughts when he considered how best to furnish his innovatory 'Painted Room' at Spencer House [367]. Contemporaries found his solution seemly: in depending upon antique stone sources to furnish a grand room decorated with Renaissance-type grotesque he adopted much the same stratagem as had the Italian sixteenth century. However, he also introduced into the Painted Room a piece of quite a different type, an 'archaeological' copy of the sphinx tripod. This instance became one of thousands; the tripod was increasingly reproduced in more or less its original form in all kinds of materials: wood, gilt bronze, ceramic, with tops of mosaic,

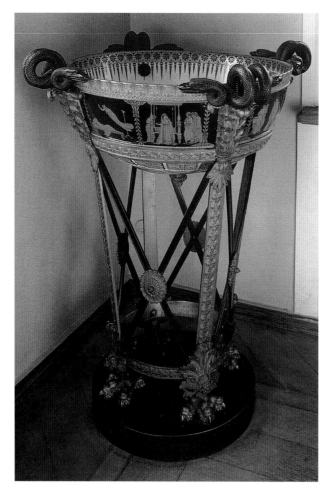

368 An *athénienne* in patinated and gilt bronze and Russian porcelain, designed by Alexander Brjullov; Russian, 1839.

Imperial porcelain bowl decorated in the 'Etruscan' palette with an 'Etruscan' scene. Tripods had been 'objets de luxe' in antique times, sometimes in silver and gold, and ancient luxury was now emulated in modern materials.

Most furniture made after about 1760 grew progressively lighter until the end of the century: a dictum made in an influential English book on aesthetics of 1790 applied to the *athénienne* would apotheosize it as the most beautiful example of modern furniture – as, indeed, it perhaps was: 'all…furniture is Beautiful in proportion to the smallness of its quantity of Matter, or the Fineness and Delicacy of the Parts of it. Strong and Massy Furniture is everywhere vulgar and unpleasing'. Moreover, 'the lightest and most beautiful of [the Forms of Grecian and Roman Furniture] are almost universally distinguished by straight or angular Lines'.[67]

An antique elegance analogous to Piranesi's and Vien's is reflected in designs for two[68] tables [370] by a 'goût grec' designer, Charles de Wailly (p. 183). These, influenced by Boulle but far removed from the gravity of the master, show the new frivolity and lightness in their hanging garlands, tripod supports and swooping curvilinear interlace; the bases must have been intended for execution in metal. Lightness also struggles to emerge from a pair of chairs that Piranesi placed beside one of his extraordinary chimneypieces[371]; stony in the Piranesian way, they are, so to speak, stone standing on tip-toe.[69] The spirit expressed in this design is developed in a captivatingly sprightly Italian side chair in the style of Michelangelo Pergolesi (fl. *c.* 1760–*c.* 1800) [372]; it

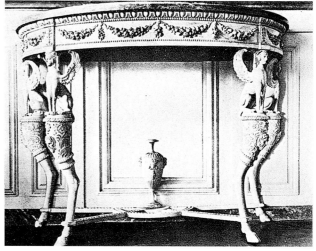

369 A pier table in carved wood; French, *c.* 1780.

370 A design for a table by Charles de Wailly; French, 1760.

lapis lazuli, malachite, and porcelain. It was especially suitable, being small, sculptural, and originally in bronze, for the exceedingly rich treatments of small spaces which so delighted cultivated courts. It occupied a prominent place in the boudoir [400] of Pauline Borghese, the sister of Napoleon of whom public rumour spoke lightly. It exists in a comparatively modest Swedish version of about 1800[65] made in gilded wood, as it might have been in England; in France or Russia it might well have been gilt bronze. This omits the scrolls, a self-denial that became common in the early nineteenth century.

Other pieces of ancient bronze furniture that had survived the volcanic conflagrations contributed much to the new furniture style. They were pictured in scenes of the daily life of pre-eruption Pompeii by the popular French artist J.-M. Vien (1716–1809), who had lived in Italy in the 1740s and witnessed the stir created by the excavations. His images made a gracefully antique existence seem accessible to modern Parisians – not the severe discipline of the 'goût grec', but the hedonistic 'rococo' classicism of Hellenistic pleasure resorts. His widely reproduced *La Vertueuse Athénienne* ('The virtuous woman of Athens') contained an antique tripod of the folding criss-cross type [519]; it prompted the invention of a completely new item of furniture, the *athénienne*.[66] Adapted to all kinds of modern uses, ranging from cassolettes to flower-stands, it remained popular for eighty years. An example of about 1839 [368] was probably made for the Pompeian Dining Room at the Winter Palace in St Petersburg, designed by Alexander Brjullov (1798–1877), a Russian of French Huguenot origin; in gilt and patinated bronze, it has been equipped with a base, claw feet and serpents, and bound with a circle of gilt bronze; all pretence that it folds has been abandoned. It holds a fine Russian

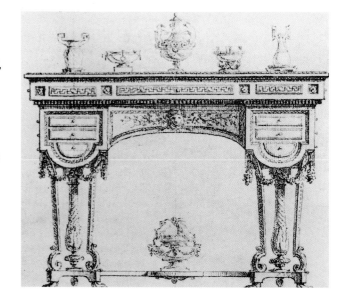

371 A design for a chimneypiece and two chairs, by G. B. Piranesi; Italian, published in Rome in 1769 (from *Diverse Maniere d'adornare i cammini*).

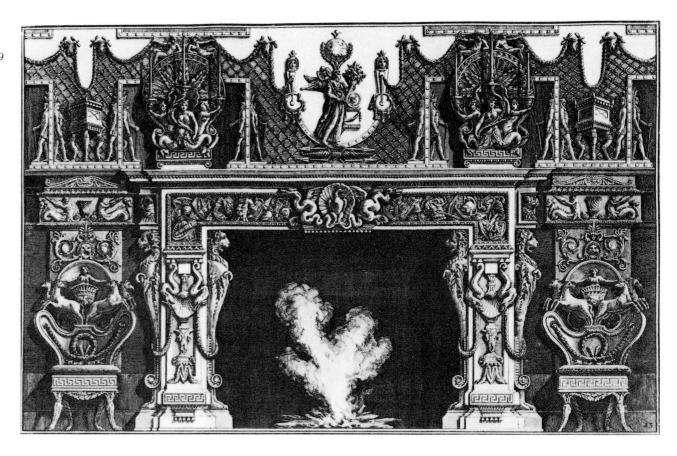

372 A side chair in carved, painted and gilded wood, in the style of Michelangelo Pergolesi; probably Italian, c. 1780.

takes all its motifs from the antique, including the back's combined X-frame stool and cornucopias [86], the legs' outward curve (also influenced by the antique X-frame stool), the eagles' heads, husks, acanthus, baldacchino (which has an ogee curve), and paterae. The weight of antique reference does not inhibit the total effect from being thoroughly 'rococo'. Pergolesi worked much in England, and designs close to his manner, unphlegmatic and un-English, were made by the Gothicist John Carter and others in the late 1770s[70] and early 1780s.[71]

Flat patterning from antique and Raphaelite grotesque

The new grotesque ceiling and wall decorations were immediately taken over by furniture. Adam's pupil George Richardson remarked in 1766 that his own Adamesque grotesque ceiling designs 'may also be serviceable to several proffessions…as the figure, the ornaments and the enrichments can be introduced with propriety in other subjects that require embellishment'.[72] In 1794 Thomas Sheraton (1751–1806), whose publications spread his influence throughout Europe and America, added, after describing the sphinx, centaur, and griffin, that such ornaments may be studied in 'the painted walls in nobleman's houses'.[73] A more direct injunction to seek inspiration in painted grotesque would be difficult to find.

Flat-painted and stucco grotesque inspired much three-dimensional furniture. Examples of the correspondences between flat and three-dimensional grotesque are provided by Adam himself. A comparison of the richly decorated grotesque walls of the Drawing Room at Derby House, London[74] [373], with the overmantel mirror, girandoles and commode designed for the same room [374] shows the extent of the interchange (mirrors and girandoles, practically part of the wall already, were particularly susceptible to this sort of treatment). The Derby House grotesque attempts

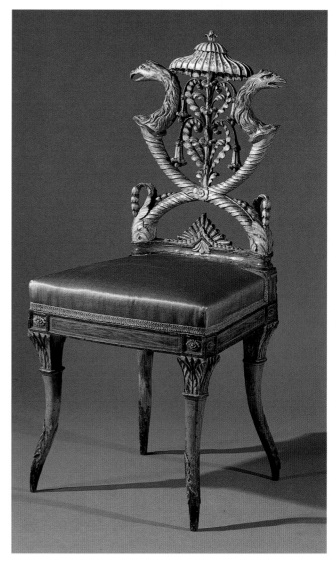

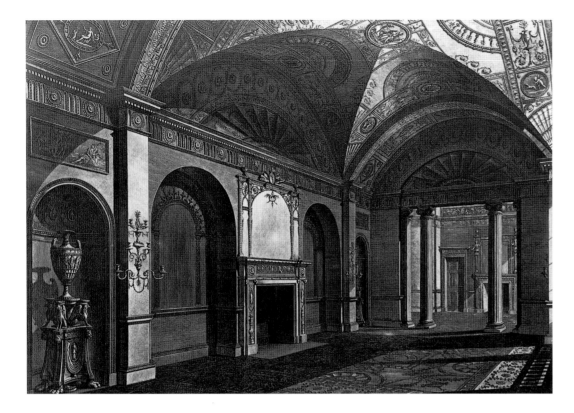

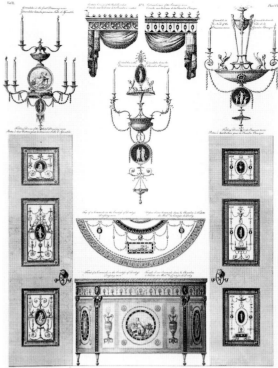

373, 374 The Drawing Room, Derby House, London, an interior in 'archaeological' grotesque style, with furniture and fittings that included a mirror, a commode, girandoles, door panels and curtains, all designed by its architect, Robert Adam; British, 1773–74, published in London in 1777 (from *The Works in Architecture of Robert and James Adam*).

375 An 'Arabesque' that approaches a girandole, a design by 'Michel'; French, *c.* 1780–85 (from *Le Cahier d'Arabesques*).

376 A grotesque design for a ceiling or table top, by Giuseppe Manocchi; Italian, 1766.

antique authenticity; there are no Raphaelesque mannerisms and no banding or Berainesque 'moresque'.

Manocchi, the artist who copied ancient and modern grotesque for Adam, probably himself participated generally in the work of design [376]. A design of about 1780–85 by 'Michel' vividly illustrates the effect of grotesque on three-dimensional design [375] – virtually the whole design is a girandole, with burning candles. A French 'Arabesque' by Dugourc (see below) – and here we see a French designer using the term to which Adam objected! – might easily be realized three-dimensionally as a candlestick.[75] A design by Adam of 1769 for a giltwood mirror for Harewood House shows grotesque wall decoration in three-dimensional form; it includes trellis in receding perspective.

Flat patterning was the most direct way of decorating furniture with grotesque, and Adam's followers used it extensively. A superb 'dressing-commode' of 1773 designed and made by Thomas Chippendale for Harewood House [378] contrasts with an earlier Chippendale commode design [320] to show the effects of the neo-classical revolution. The marquetry, in various woods on a satinwood ground with details emphasized in engraved penwork, extends to the top (which in France would have been marble – Chippendale supplied marble slabs on only two known occasions[76]); the motif of the velarium in an exedra (used in three dimensions by Adam in interior decoration) is a feature of ancient grotesque [39:D], as are the half-velaria and garlands of husks

of the frieze.[77] The roundels of Diana and Minerva are inlaid in ivory. Flat patterning on furniture in paint and marquetry taken from antique grotesque became a common feature of English pattern-books, especially those of Hepplewhite and Sheraton. The latter shows the principle extended to clock cases; his grotesque, of the somewhat over-refined later type, would probably have been painted on his preferred 'straw-coloured' satinwood.[78]

The use of flat-painted grotesque on high-style furniture was rarer in France than in England. A jewel cabinet made by J.-F. Schwerdfeger in 1787 to designs by J.-D. Dugourc (1749-1825) [377] includes amongst its rich decoration Raphaelesque gouaches by Degault, touched by French delicacy and surrounded with mother o' pearl; the form, that of a cabinet on stand, looks back to the seventeenth century but the ornament, forms and caryatids are stiffening into Empire. The Sèvres biscuit plaques imitate Wedgwood, an influence also perceptible in the palette and crowning vases of an armoire-secretaire of odd proportions designed between about 1780 and 1790 by G. M. Bonzanigo (1745–1820) [383]; its finely carved tall panels owe as much to the lighter forms of Renaissance grotesque as to any other period. Bonzanigo worked for the court at the 'Italo-French city of Turin',[79] and his furniture is curiously hybrid; Millin (p. 203), whose taste was severely Greek, said in 1811 that 'in many of his works [he] shows more dexterity than taste'.[80]

opposite, above 377 A jewel cabinet in mahogany, Sèvres plaques, verre églomisé, mother o' pearl and gilt bronze, designed by J.-D. Dugourc and made by J.-F. Schwerdfeger, given to Queen Marie-Antoinette; French, 1787.

opposite, below 378 A dressing commode in satinwood and other woods, ivory and gilt bronze, designed and made for Harewood House, Yorkshire, by Thomas Chippendale; British, 1773.

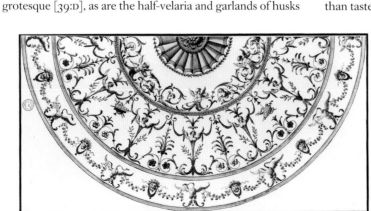

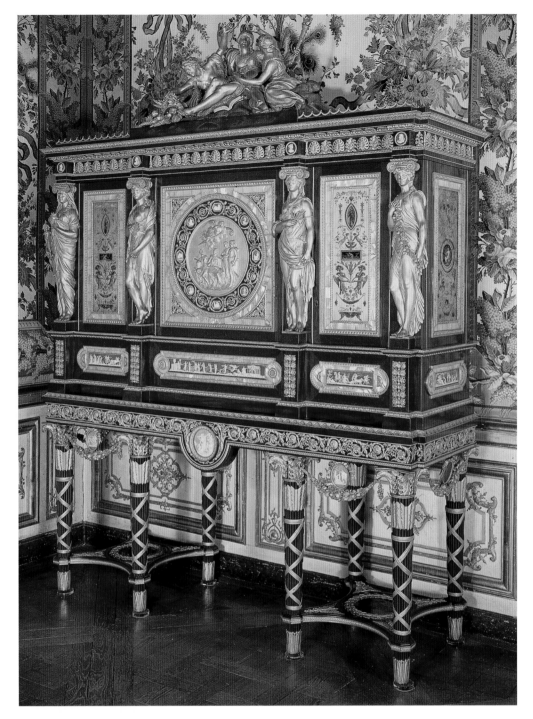

Other grotesque motifs used in furniture

The grotesque revival opened the pastures of 'rococo neo-classicism' to the monster: once again artists could with fashionable approval 'place Eros next to a Dragon, and a shell to the wing of a Bat…we have returned to Gothic barbarism'.[81] Not quite: the Renaissance cult of the ugly and deformed no longer obtained; Northern European expressionism had been tamed and held on leash (later to be released by nineteenth-century Romanticism). The monsters that newly decorated furniture were charming and playful: smiling sphinxes with butterfly wings, and griffins enwreathed in fluttering ribbons and flowers, happily accompanied the hovering cupids who accompanied graceful maidens sacrificing before bijou temples in Arcadian landscapes.

Sheraton described grotesque monsters in some detail: 'In the Vatican are figures whose upper part is female, and the lower of foliage.…Other female figures have their lower part of a fish, and some of a greyhound. Others show only a human head, with foliage springing from it…a lion's head and an eagle's leg and talons brought into a smooth outline by the help of foliage…partly a horse with wings and two fore legs, and partly the tail of a fish; all of which are now a nameless generation.…These are still, and ever will be retained in ornaments less or more. The most tasty of these were selected by Raphael, and painted by his pupils on the walls and ceilings of the Vatican Library at Rome, and which are handed down to us, by the Italians, in masterly engravings; which, in the course of this work, I have consulted, and from which I have extracted some of my ideas, as well as from some French works.'[82]

The elongated caryatid had been around for a long time [591], but now enjoyed new life: Adam employed it exaggeratedly and extensively in his mirror designs; Weisweiler turned it into an inhabitant of the Celestial Empire [592]. The influence of Pompeian paintings was reflected in smaller decorative objects such as vases of gilt bronze and porcelain flowers. One in particular became ubiquitous, in ancient and modern guise. In 1763 Vien painted a delightful version of a Pompeian mural that shows an old woman selling cupids to young women; the graceful eroticism of Vien's version [379], the tasteful appurtenances, and the fact that each of the young ladies (wearing the high female waist of antiquity, 'pitiless…for those whose bust line was not perfect'[83]) could have been 'one of us' (the old woman definitely wasn't), explains what inspired so many people who furnished their houses in the neo-classical fashions of the latter half of the eighteenth century. It was sold in innumerable engraved versions, as were painted copies of the Pompeian original, and was repeatedly used to ornament furniture in the form of marquetry, paint and applied prints.

The famous painted 'dancers' from the *Antiquities of Herculaneum* supplemented those long in the repertoire, as long ago as the dancing Muses of Mantegna's *Parnassus*,[84] which had become amazingly 'antique' in the hands of Peruzzi; the famous sculptured reliefs of dancers reproduced by Santi Bartoli, Montfaucon and many others continued to be influential. All helped to populate the fronts of commodes, many painted in an 'Angelica Kauffmann' manner. Pompeian paintings added to the store of erotes [36], to which neo-classical exactitude gave more slender proportions; especially enchanting were those that showed the remorseless little monsters being carried in chariots by grasshoppers, butterflies, griffins, swans and other natural

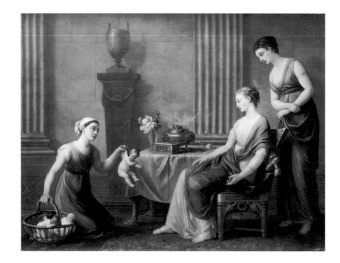

379 *The Seller of Cupids*, a modern adaptation of a Pompeian painting, by J.-M. Vien; French, 1763.

380 'Legs for Pier and Card Tables', designed by Thomas Sheraton; British, 1794 (from *An Accompaniment to the Cabinet-Maker and Upholsterer's Drawing Book*).

right 381 A design for a sofa (see p. 228) and two conversation chairs, by Thomas Sheraton; British, 1793 (from *Appendix to the Drawing Book*).

and monstrous fauna. The gilt-bronze plaques and other decorations in the manner of Clodion that were applied to furniture often employed such motifs; gems [307] provided similar or identical compositions, influencing the depiction of subjects not taken from gems, such as the charming scenes on the Wedgwood and Sèvres plaques used to ornament furniture [385].

The discoveries of Pompeii and Herculaneum revivified furniture motifs that had been in circulation since the late fifteenth century. One of the most important was the candelabraform column, now everywhere employed as a decorative adjunct; miniaturized architectural ornament was often grafted on to it. Sheraton's 1790s books charmingly played with it; it is hybridized with balusters, elongated caryatids and other motifs and elaborated with reeding, spiral turning, and classical ornament drawn from a variety of sources. Sheraton used it flat as chair splats, rounded for chair legs and 'elbows', bed-pillars, long-case clocks, cabinets, and (in brass) for the galleries of sideboards. The likeness of

some of this candelabraform ornament to that of the late fifteenth century is striking [163, 380]. Sheraton frequently employed the half-velarium and the shell. Even his tripod stands echoed those painted and carved on walls, and ornaments such as girandoles everywhere imitated the airy scrolls of grotesque; he depicted 'girandoles' next to a flat grotesque 'Ornament for a Painted Panel' as if to emphasize affinities between furniture and wall decoration pointed out in his text.[85]

An exquisite small table designed by Cameron and decorated with gilt bronze, blue glass, white opaline glass and silver leaf [382] discloses grotesque influences of an order different from those of other designers. Cameron, whose tastes seem to have been naturally 'Russian', was particularly fond of coloured glass, 'precious' finishes, and plain and coloured mirrors. Was he perhaps also inspired by Roman literary sources? In his book *The Baths of the Romans* he quotes Statius on the effulgence and luminosity of 'Etruscan' baths: 'Light does not yield in splendour, the vaults glow, the whole of the roof glitters…the glad wave is poured from and falls into silver; marvelling at its own beauty it stands poised on the gleaming brim.'[86] And after that radiant description he translates Seneca: 'That Person is now held to be poor and sordid, whose house does not shine with a profusion of the most precious materials…unless they are covered with a laborious, and variegated stucco after the fashion of Painting; unless the chambers are covered with glass.' And as for baths: 'What a profusion of Statues? What a number of Columns do I see supporting nothing, but used as an ornament…? We are come to that pitch of luxury that we disdain to tread upon anything but precious stones.'[87] These descriptions perfectly concord with the silvery and gleaming surfaces of Cameron's beautiful and distinctive grotesque interiors and furniture.

382 A table in blue glass, white opaline, gilt bronze and silver leaf, designed for the Catherine Palace, Tsarskoe Selo, by Charles Cameron; Russian, *c.* 1790.

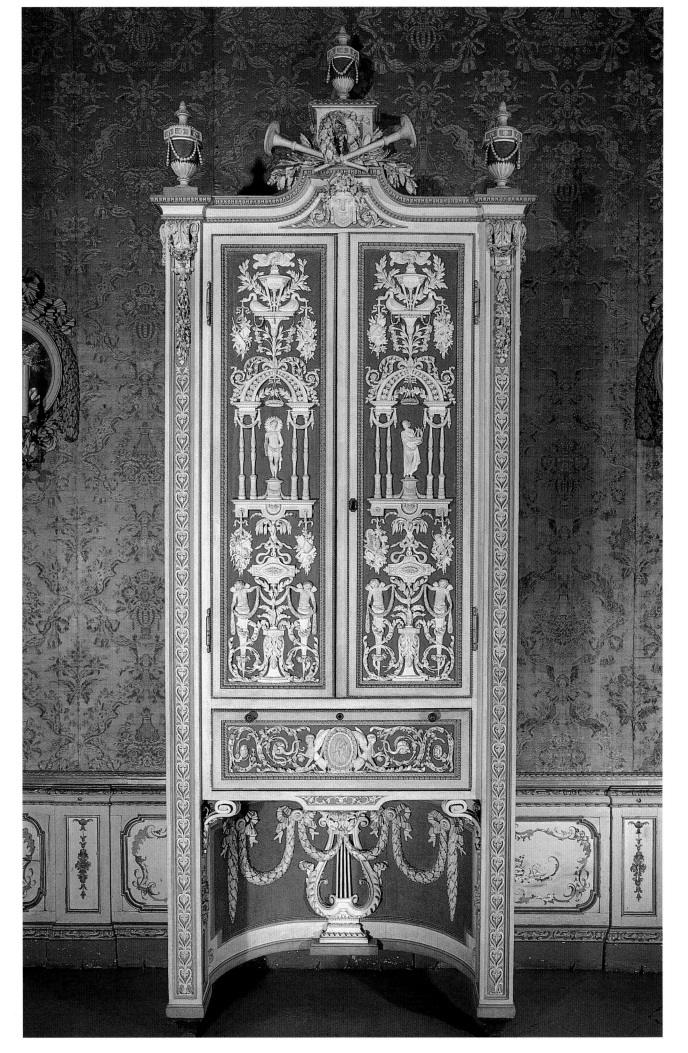

383 An armoire-secretaire in carved and painted wood, designed by G. M. Bonzanigo, in the Palazzina di Caccia, Stupinigi; Italian, c. 1780–90.

384 A pedestal and urn in carved and turned wood painted with 'Etruscan' ornaments in terracotta and black on a pale green ground, designed by James Wyatt for the Etruscan Room at Heveningham Hall, Suffolk: British, *c.* 1784.

Sources of Greek Revival and 'Etruscan' design

The supremacy of Greek art had been generally acknowledged by savants and connoisseurs since the time of Vasari: 'It is well known with what care *Raphael, Julio Romano, Giovanni da Udine,* and *Poussin,* studied after these sort of monuments [Greek vases]';[88] Poussin was so Graecophile that he 'wanted in every way to vilify the Latin manner'.[89] It was, however, for long difficult to translate admiration into imitation, since representations of Greek artefacts (with a few exceptions, such as gems) were few and inept. Greek influence had principally been exercised on modern arts through the filter of the numerous and beautiful objects produced by ancient Roman revivals of Greek art (p. 22).

In 1764 Johann Joachim Winckelmann (1717–68) published his *History of Ancient Art,* which is to antique art what Ruskin's *Stones of Venice* is to Gothic. Winckelmann divided antique art into four periods, all dominated by Greece – the Antique (archaic Greece), the Sublime (the fifth century BC), the Beautiful (the fourth century BC) and the Decadent (the last centuries BC up to and including the Roman period). His books contained ecstatic purple passages on what he categorized as Greek sculptures; his *Monumenti antichi inediti* (1767–68) was included in Thomas Hope's list of the works that were 'of most use' to him as a designer of classically inspired furniture.

The profoundly influential concept of the 'Sublime' had itself been developed from antique literature – primarily from a treatise attributed to Dionysius Longinus (AD 213–273). Longinus' main subject was poetry, but in the seventeenth century his principles were extended to painting,[90] and following an English translation in the 1740s[91] they were elaborated by Edmund Burke in 1756 to include landscape and architecture.[92] The 'Sublime' thus grew to full maturity, and, supported by the romance of the 'Picturesque', powerfully assisted the appreciation of fifth-century BC Greek architecture and art.

In the 1760s, new publications put the means of concocting a style based on Greek architecture and vases into the hands of every designer. The pioneers in developing the Greek taste were English: Palladian England was not as distant from Greece as was rococo France. Many of the influential monuments of Greek architecture were first published in England, or for Englishmen; a main instrument was the Society of Dilettanti. Investigators, armed with instruments to measure and record, left Europe for distant and often plague-ridden territories inhabited by bandits and bureaucrats. Greek publications began in 1762 with Stuart and Revett's books on the later and more graceful buildings of the Acropolis; in 1787 the major monuments, including the Parthenon itself, were pictured, and the series continued well into the nineteenth century.[93] Accuracy became a matter of competition, and academic acerbities invaded the texts of the books (an amusing instance is seen in 'Athenian' Stuart's and J.-D. Le Roy's rival books on Athens[94]). The disagreements were not of academic interest alone, since rival and differing depictions such as those of the famous Temple of the Winds prompted different modern versions. In financing the exploration and publication of Greek antiquities, the Society reinforced the existing strong British classical tradition. Amateurs of the new taste at first cautiously restricted it to their shrubberies and glades, placing re-creations of Greek buildings adjacent to Gothic and Chinese 'confectionery'.

In 1778 Piranesi succumbed to Greece and published his magnificently lowering etchings of the most splendidly primitive of Greek temples, those at Paestum; they were less dramatically published by others.[95] However, the volumetric austerity of classical Greek architecture had fewer immediate attractions than the anecdotal charm and linear elegance of vase painting. Fifth-century Greek architecture, 'so magnificently and blithely severe', was rejected by many as brutal and primitive. People objected that ancient Greece was a society much less complex than modern societies; any attempt to return to strict classical simplicity was bound to provoke incongruities. As far as decoration and furniture were concerned, there was a further barrier – Laugier's prohibition of the irrational use of 'architectural' features (p. 177). Eventually, Greek architecture was accepted, and, as Percier and Fontaine complained,[96] the brutal baseless Doric order became in the early nineteenth century 'l'ordre des boutiques'. White marble Doric columns were employed as furniture decoration, by David Roentgen amongst others – although their proportions remained slender even when Doric.

Vases acted as the principal catalyst for the Greek fashion; the general use of vase motifs preceded those of early Greek architecture by almost forty years. Scholars in the seventeenth and early eighteenth centuries had called Greek vases 'Etruscan' in error; the mistake was soon realized but the misnomer remained,[97] and throughout the eighteenth and nineteenth centuries people who knew perfectly well that the vases were Greek persisted in calling them, and the decoration and artifacts they inspired, 'Etruscan'. This makes it difficult to discard the term, although its continued use by writers (including this one) obscures the fact that 'Etruscan' decoration and Greek Revival architecture were both Greek, and both were employed in 'Etruscan' decoration and furniture.

In 1766 and 1767 came the most influential of all 'Etruscan' publications, the splendid collection of vases assembled by Sir William Hamilton, envoy to the Court of Naples; 'Etruscan' vases became the rage throughout Europe.[98] The text, by the art historian 'd'Hancarville', extolled the vases as models for artists and craftsmen; the volumes captured something of the strength and elegance of Greek line, which became the basis of the art of Flaxman and Ingres. The motifs seen in the borders and decorations – linear renderings of architectural ornament, Greek key patterns, anthemions, rosettes, strings of bay leaves, stellate motifs, interlaced ovals, circles, and arches, and decussated squares and lozenges – attracted much attention, as did the wonderful figures and furniture. The borders themselves, rectangular, square, and circular, seemed expressly made for forming the compartments that were so prominent a feature of 'Pompeian' decoration; they were to be transferred entire to furniture [414]. The discovery of a table on which Philip of Macedon and his son Alexander the Great might well have rested their golden rhytons [410] revealed a black marble top

385 A secretaire veneered in satinwood and sycamore and decorated with Wedgwood plaques; Dutch, *c.* 1780–95.

inlaid in ivory that is very close indeed to 'Etruscan' versions conjured up from vase decorations.

The linear nature of vase ornament ideally suited it to reproduction in marquetry or penwork. The red, black, ochre and white of the painted terracotta provided a striking and immediately recognizable palette.

In 1791–95 Wilhelm Tischbein published Hamilton's second collection of Greek vases. Significant differences from d'Hancarville's edition included the omission of borders and decorations: the new publications were confined 'to the simple outline...no unnecessary Ornaments, or colouring have been introduced'.[99] Sir William asserted that the purpose was to make the work cheaper, more accessible to the 'young Artist'. Perhaps, but there was also a change of taste, a new emphasis on reproducing the Greek line exactly, which meant acceptance of archaisms. This cannot have been cheap: Hamilton explained that 'the Artists employed in this work [i.e. the book]...have often been obliged to make three of four copies from the same Vase before they could arrive at giving an idea of the purity in the outline of the figures in the original'.[100]

Towards the end of the century people were ready to take Greek anfractuosities undiluted by modern suavity, as can be seen from Greek sculpture pictured in a minor publication of 1794, the *Museum Worsleyanum*,[101] and from two sumptuous and scholarly French volumes on Greek vases published by A. L. Millin in 1808–10 [24, 26].[102] The latter omitted the borders and did not flinch from the archaic Greek figure style; Millin, indeed, criticized Tischbein for over-finishing his figures and for adding grace and elegance.[103] Millin's claims on behalf of the vases were as lofty as those of Hamilton (and Millin was not trying to sell them!); in an age which had an unbridled passion for fireworks and diamonds,[104] he preferred Greek vases in terracotta to Greek vases made of gold and silver.

'Etruscan' interior decoration

The Greek style made its first significant appearance in decoration in the ceramics of a canny English industrialist, Josiah Wedgwood; his wares – 'rosso antico' (before 1763), black basaltes (from *c.* 1769), and jasper (from 1774) – were all produced by a factory named 'Etruria'. They quickly gained European markets and celebrity. Wedgwood copied some Greek vases almost unchanged; he also rendered Greek motifs in relief, after the model of the Roman 'Portland Vase' or of grotesque stucco. Wedgwood wares often depict Greek furniture such as the klismos. The propaganda value must have been considerable. Continental factories imitated Wedgwood reliefs, and originals and copies quickly found their way on to furniture – witness an elegantly plain Dutch secretaire [385] veneered with sycamore and satinwood and decorated with Wedgwood plaques; the large oval is after a famous antique cameo of the marriage of Cupid and Psyche, the 'Marlborough Gem': the vestigial inlaid decoration is Greek in character.

The 'Etruscan' style entered furniture through English and French interior decoration. Adam asserted that his design for the Countess of Derby's dressing room (1773–74) introduced 'A mode of Decoration...which differs from anything hitherto practised in Europe...imitated from the vases and urns of the Etruscans'.[105] The room was certainly in 'the colouring of the Etruscans', but the decoration contains no 'Etruscan' motifs. The Etruscan Room at Osterley of 1775–79 does contain 'Etruscan' motifs, but they are disposed in the manner of antique grotesque (the painter

was an Italian, Pietro Maria Borgnis). The painted chairs from the room are decorated with 'Etruscan' motifs – anthemions, husks, Greek key and rosette. An 'Etruscan' design of 1775 by Adam for the Countess of Home departs from the grotesque: the husks on the walls form compartments, and the line of interlaced circles above the dado is unmistakably taken from the vases, as are the skinny and almost Gothic sphinxes; the couch is decorated en suite. A French variant of 'Etruscan' decoration was quickly developed by F.-J. Belanger (1744–1818) and Dugourc at Bagatelle (1777), possibly through the English predilections of the Comte d'Artois, its builder.

James Wyatt designed an 'Etruscan' anteroom at Heveningham Hall between 1780 and 1784, and no doubt a pedestal and urn from the house [384] were also from his hand. The urn takes its shape from Greek vases which, as d'Hancarville said, provided more than two hundred new forms.[106] The maidens imitate the manner of black-figure vases, the anthemions and ornaments on the base imitate those on Greek vases in general. Only the form of the base comes from a stone source [10:B]. The neo-Greek chastity of the design is remarkable for its presumed period; the introduction of expressive vacancies, part of 'Greek' frugality, into furniture design was a new departure that paved the way for Thomas Hope. 'Etruscan' wall decoration evidently remained uncommon until well into the 1790s – as late as 1796 Tatham wrote from Italy to tell the architect Henry Holland of 'a modern invention', a 'new and tasty method of fitting up rooms' by applying to the walls printed strips of ornament 'in the Etruscan style' sold by Tischbein.[107]

386 A settee in carved, painted and gilded walnut, with verre églomisé panels; Sicilian, *c.* 1790–1800.

'Etruscan' influence on furniture: the klismos

The Greek style affected furniture in two principal ways: in the application of Greek ornament, and in the employment of Greek furniture forms. The last became part of the movement towards 'archaeologically' accurate furniture (Part VIII). The fashionable obsession with vases identifies earlier modern Greek-style furniture as 'Etruscan', although most of the furniture seen on the vases was to be found also in Roman bas-reliefs, grotesque paintings and statues. Ancient Roman men and women occasionally sit on Roman Greek revival klismos chairs, and such a model was used by Canova for his statue of Napoleon's strong-minded mother, 'Madame Mère'.

As might be expected, 'Etruscan' motifs first entered modern furniture as decorative detail. In 1787 Jacob delivered a set of X-frame chairs 'of a new pattern in the Etruscan style'[108] designed by the painter Hubert Robert (1733–1808) for Marie-Antoinette's Dairy at Rambouillet [387]. The involvement of an avant-garde painter who specialized in decorative paintings is not surprising. The form of the chairs has nothing specifically to do with Greece, but the ornament – elongated lozenges decorated with paterae, strings of bay leaves, and an anthemion enclosed within an oval – all comes from 'Etruscan' vases. 'Etruscan' decorative detail also occurs on a Sicilian carved, painted and gilded walnut settee of the 1790s [386]; it is decorated in reverse painted glass imitating

below 387 An armchair in mahogany in 'Etruscan' style, designed by Hubert Robert and made by Georges Jacob for Rambouillet; French, 1787.

below right 388 An armchair in carved wood from the Turkish Room at Bagatelle, probably designed by J.-D. Dugourc; French, 1777.

lapis, agate, and marble; its 'Etruscan' interlaced ovals, with the characteristic slightly pointed ends, are taken from vase ornament.

It is remarkable that the three-dimensional revival of the klismos had to wait until the later eighteenth century. Klismos legs and chairs had been depicted in Roman contexts by Raphael and Poussin. Even at the height of the 'Etruscan' fashion, the association of the klismos with Rome continued: Hope shows a klismos, of a Greek as much as a Roman type, in his picture of a 'Roman Study'.[109] In or before 1760, a chinoiserie Aubusson tapestry after Boucher was woven in which, amazingly enough, a klismos chair and klismos-legged table were thought appropriate for an amour between a Chinese lady and gentleman.[110] However, when interest in the klismos really awakened soon after the middle of the eighteenth century, it became firmly identified with the Greek or 'Etruscan' taste.

The revival of the klismos preceded the publication of Hamilton's vases: chairs with klismos legs were designed between about 1760 and 1764 by Louis-Félix de La Rue, and published some time after 1771 by P.-L. Panzeau. However, Dugourc's claim to be the first to revive the 'Etruscan' style is strengthened by a chair made for the Turkish Room at Bagatelle in 1777[111] [388]: its decoration is entirely 'Louis XVI', but the outswept legs and back put it firmly into the klismos camp. A more accurate version of the klismos was designed in about 1780 as part of Antonio Asprucci's grotesque decoration at the Villa Borghese; it has been attributed to a German, Gaspare Seiz.[112] The blunt forms of its legs are Roman rather than Greek; its velarium-decorated back, a flight of fancy lacking antique precedent, was used a little later in Italian-inspired chairs designed for Catherine the Great, whence it entered Russian furniture. Another early, and much more elegant, klismos was designed in 1787 in England by Joseph Bonomi (1739–1808), whose style – despite working for the Adam brothers for eighteen years – conformed to Italian taste (he worked from England for Italian clients). Bonomi, who had numbered Antonio Asprucci amongst his teachers, decorated the Gallery of Packington Hall in Warwickshire with black and red grotesque imitated directly from the Domus Aurea.

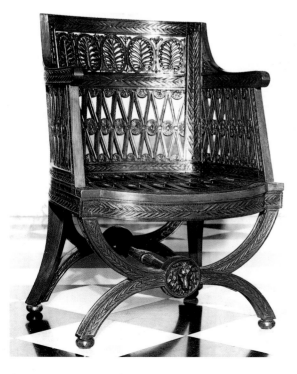

opposite 389 The Grand Salon, Haga, the walls painted by Louis Masreliez and the klismos chairs designed by Masreliez and made by Eric Öhrmark; Swedish, *c.* 1790.

390 A design by Louis Masreliez for the King's chair in Gustav IV Adolf's Council Room in the Royal Palace, Stockholm; Swedish, 1796.

391 A chair with klismos front legs and turned back legs, as depicted in a sixteenth-century copy of a painting by Gianfrancesco Penni, *Joseph interprets Pharaoh's Dream*, from Raphael's Logge in the Vatican; Italian.

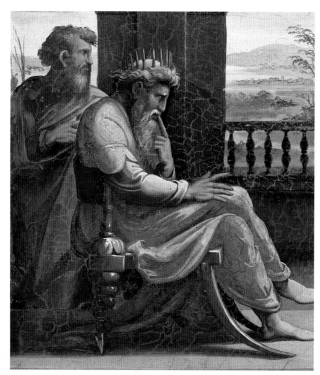

His approach was precociously 'archaeological'; the grotesque approached 'authenticity', including its use of the ancient encaustic method,[113] and his klismos was much more accurate than earlier attempts:[114] its form follows that of the 'flared' klismos, perhaps inspired by a consecutive series pictured in the *Pitture antiche di Ercolano* [392]. The circumambient grotesque decorations provided the ornament on the squab cushions; however, the paintings along the backs of the chairs were taken from 'Etruscan' vases.

These three early versions of the klismos, French and Italian, or Italian-inspired, were made in association with non-'Etruscan' interior designs. The same thing happened in Sweden. An advanced Swedish neo-classicism was favoured by King Gustav III, who had studied in Paris and been to Pompeii and Herculaneum. He employed Louis Masreliez (1748–1810) to design at Haga the first post-rococo grotesque interior in Sweden, the Divan Room. Finished in 1786, it was inspired by Renaissance, not antique, grotesque –

by Giulio Romano's Sala degli Stucchi in the Palazzo Te at Mantua. The Grand Salon, the most splendid room in the pavilion [389], is decorated with Raphaelesque grotesques devoted to Apollo, Jupiter, Juno and Minerva. Its klismos chairs, which like Bonomi's imitate the 'flared' antique type, were designed by Masreliez and made by Eric Öhrmark (1747–1813), the most gifted Swedish chair maker of the period. Another Masreliez klismos design, for chairs for Gustav IV Adolf's Council Room at the Royal Palace in Stockholm [390], may also have originated in the designer's interest in Raphael's grotesque. Surely the strange combination of turned and pointed back leg, and klismos front leg, derives from Pharaoh's chair in 'Raphael's Bible', the little subject paintings included in the decorations of Raphael's Logge [391]. It was probably in studying the Logge that Masreliez came across his source of inspiration – he had lived for eight years in Rome. The sphinxes that support the King's chair, to which the designer has given a tall seventeenth-century back, are, as explained in a note on the design, 'attributes of Prudence and of the Sun, from which nothing is hidden. Augustus had a sphinx on his seal…' (it was later to be replaced by the sun, the device adopted by Louis XIV).

In 1794 John Flaxman (1755–1826) published his imaginative reconstructions of episodes from the *Iliad* and the *Odyssey*; these, rendered in 'Etruscan' outline and called by Hope 'the finest modern imitations I know of the elegance and beauty of the ancient Greek attire and furniture, armour and utensils',[115] had a European vogue. They contain many illustrations of the 'archaeological' klismos, and it was in that same year that the klismos was designed in its purest eighteenth-century version [393] by the learned Danish painter and architect N. A. Abildgaard (1743–1809). Commissioned to decorate the new residence of the Crown Prince in Amalienborg Castle, Abildgaard chose a strong, pared-down 'architectural' style; the blue and yellow walls were articulated with Ionic pilasters and decorated with bas-reliefs and sculpture.[116] For chairs, sofas and tables he turned to antiquity, and produced highly distinguished 'archaeological' furniture that established a Danish neo-classical tradition that has persisted into the present century (pp. 268–70). As well as the klismos he produced a version of the Greek 'cut-out' chair [395]; its frame is studded with

far left 392 A Roman klismos with a flared back, from a Pompeian wall painting, published in 1760 in Naples (from *Delle Antichità di Ercolano: Le pitture antiche d'Ercolano*).

left 393 A klismos chair in gilt beech, designed by N. A. Abildgaard; Danish, *c.* 1790.

since to them it represented Republican virtues; the emigrant English architect Benjamin Henry Latrobe designed furniture for the Capitol and White House that included klismos chairs made in Baltimore.

The klismos curved leg was divorced from its original context and used in modern furniture as 'Greek' detail. Examples are legion, ranging from wash-hand stands to flower containers. Klismos legs attached to chairs of which the rest of the design has nothing to do with the klismos are to be seen in the pages of Hepplewhite [394]: the front legs of two shield-back chairs are so subtly curved that the klismos allusion is almost lost, but the design allows the grace of a curved leg that is neo-classical rather than rococo. Such chairs were extensively copied on the Continent,[117] and probably contributed to a common Biedermeier pattern of twenty-five years later in which the chair has a pinched-in back and slightly splayed legs. Jacob's shield-back chair [471] has these features, perhaps due to English influence.

Greek vases very occasionally show tables with klismos legs,[118] so there was some slight precedent for their reckless multiplication on tables, desks, and other types of furniture. The English dining table of the 1790s often stood on three or four klismos-derived legs in tripod fashion, attached to a circular column – a superbly elegant, functional, and popular invention: from about 1800 the leg was frequently 'hipped' [399]. The sofa table was frequently given klismos legs; a design by Sheraton [398] equips the klismos leg with paw feet and a cluster column of ultimately Gothic derivation, panels it, and places above it a body derived from the sarcophagus hung with a drapery derived from the 'antique drapery' seen on vases and other antique artefacts. The same outward-splayed leg was frequently combined with a delicate rounded and turned ornament derived principally from Greek and Roman table and chair legs [29], a beautiful and lively synthesis that was generally employed for light chairs.

The daintier types of boudoir and drawing room furniture – small tea tables, sewing tables, étagères, and so on – were especially suited to the klismos leg. The choice of monumental or light depended to some extent on function: bookcases or desks could be massive; small tables, stands, ladies' secretaires were better light and mobile. Light items

394 A design for two shield-back chairs by George Hepplewhite; British, first published in 1787 (from *The Cabinet-Maker and Upholsterer's Guide*).

bolts that allude to the bronze technique of the Greeks. The gulf between Abildgaard's lucid, hard-edged primitivism – his furniture seems to breathe the bright, clear air of Greece – and the sumptuous opulence of French 'Empire' yawns wide.

The lines of Abildgaard's klismos – he chose wood that was already curved to achieve the sweeping lines of the legs – make commercial versions such as the English 'Trafalgar' chair look hopelessly banal. The latter, which appeared in the early 1800s, became ubiquitous throughout the English-speaking world. It settled in India, where it was made, and is still made, in silver. A popular variant, the 'Trafalgar' with added scroll arms, may have been assisted by a type of Greek throne that has winged arms ending in bold scrolls and curved scrolled legs ending in paw feet. An English chair that has back legs of a klismos shape and turned and reeded front legs (Masreliez' Council Room chair design in reverse) was designed in the 1790s by the francophile English architect Henry Holland for Samuel Whitbread. It served as the proto-type for innumerable variations over the next forty years.

Kings, princes and brewers were not the only people interested in 'archaeological' neo-classicism – the revolutionaries of France and America liked the klismos,

395 A chair of 'cut-out' form in gilt beech, designed by N. A. Abildgaard; Danish, *c.* 1800.

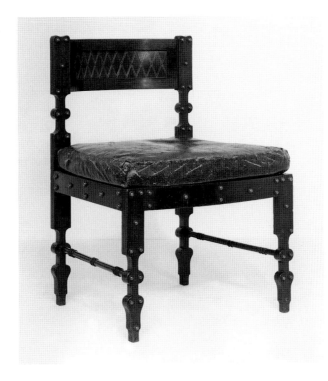

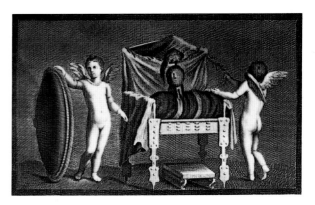

396 The throne of Mars, draped in 'antique drapery', from a Roman wall painting published in Naples in 1757 (from *Delle Antichità di Ercolano: Le pitture antiche d'Ercolano*).

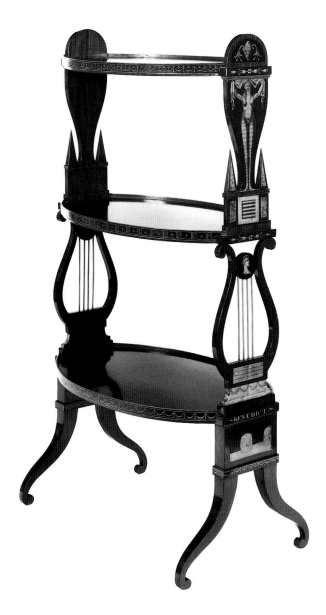

397 An étagère veneered in mahogany, maple and stained maple, with white paste incrustations and penwork; Austrian (Viennese), 1807.

influenced by ancient 'Pompeian' metal furniture gravitated towards 'feminine' drawing rooms and boudoirs. This kind of furniture, civilized, unpretentious and charming, was favoured by the English fashion for Picturesque 'intricacy' – furniture huddled together in confusion (this even led in England to a passing fashion for sets of 'harlequin' chairs, all different). An 'Etruscan' Viennese étagère of 1807 is typical of the type [397]; the upper tiers are formed from a lyre, an instrument identified at this period with Greece (p. 225). The klismos curve ends with a turned-under scroll; this leg was unknown to antiquity, and its use here is perhaps an early indication of a renewed interest in the seventeenth century. The elongated 'Greek' figure remarkably anticipates those of the Viennese Secession.

In the hands of early nineteenth-century designers the klismos leg became massive and stumpy to conform to the new taste for weight – yet managed to preserve the elegance of the Greek line. It was attached to the ends of antique-style sofas and chairs in a way quite foreign to antiquity; a chair by Hope that owes much to Percier has it [411] (astonishingly enough, the klismos-legged sofa was anticipated, fully fledged, in seventeenth-century France).[119] The sofa klismos leg was frequently reeded, an instance of ornament derived from the fluted column or pilaster being attached to a leg that was never (unlike straight legs) so decorated in antiquity. A thickened klismos leg was given paw feet by many designers, including Pelagio Palagi [418]. At the turn of the century, the nascent interest in the seventeenth century and 'Louis Quatorze' resulted in the klismos-derived leg being combined with a scroll, recreating the broken curve.

Rococo, 'rococo neo-classical', 'Etruscan', and late eighteenth-century grotesque furniture had charms of an order extinct since the end of the old Roman Empire. The ambience of civilized life had been immensely enhanced by an array of chairs, tables, sofas, secretaires, étagères and other inconsequential pieces that, devoted to frivolously pleasant purposes, were clothed in forms and decoration – some simple, some extraordinarily rich – of captivating charm and perfect utility. Simple or rich, they spelt comfort and elegance – qualities not easily to be surrendered. Buffeted by the assaults of the stony sarcophagi, four-square altars and pylonic ramparts that influenced fashionable furniture during the forty years' rule of classical archaeology that followed 1800, the essential forms of the earlier styles substantially survived.

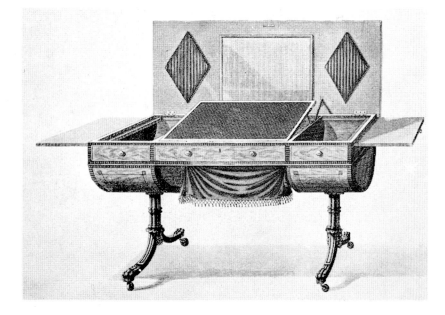

below 398 A design for a sofa table by Thomas Sheraton; British, 1804 (from *The Cabinet-Maker, Upholsterer, and General Artist's Encyclopaedia*).

399 A dining table in mahogany and brass; British, *c.* 1800.

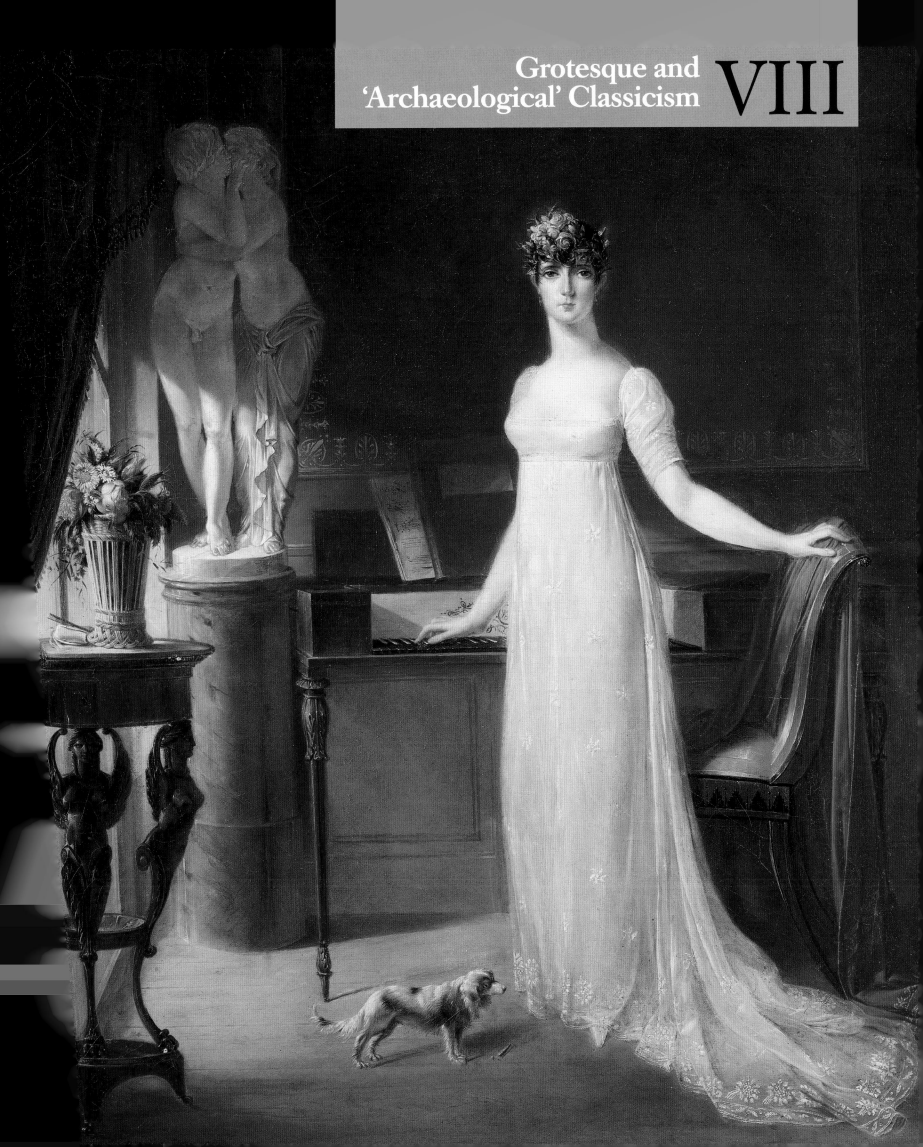

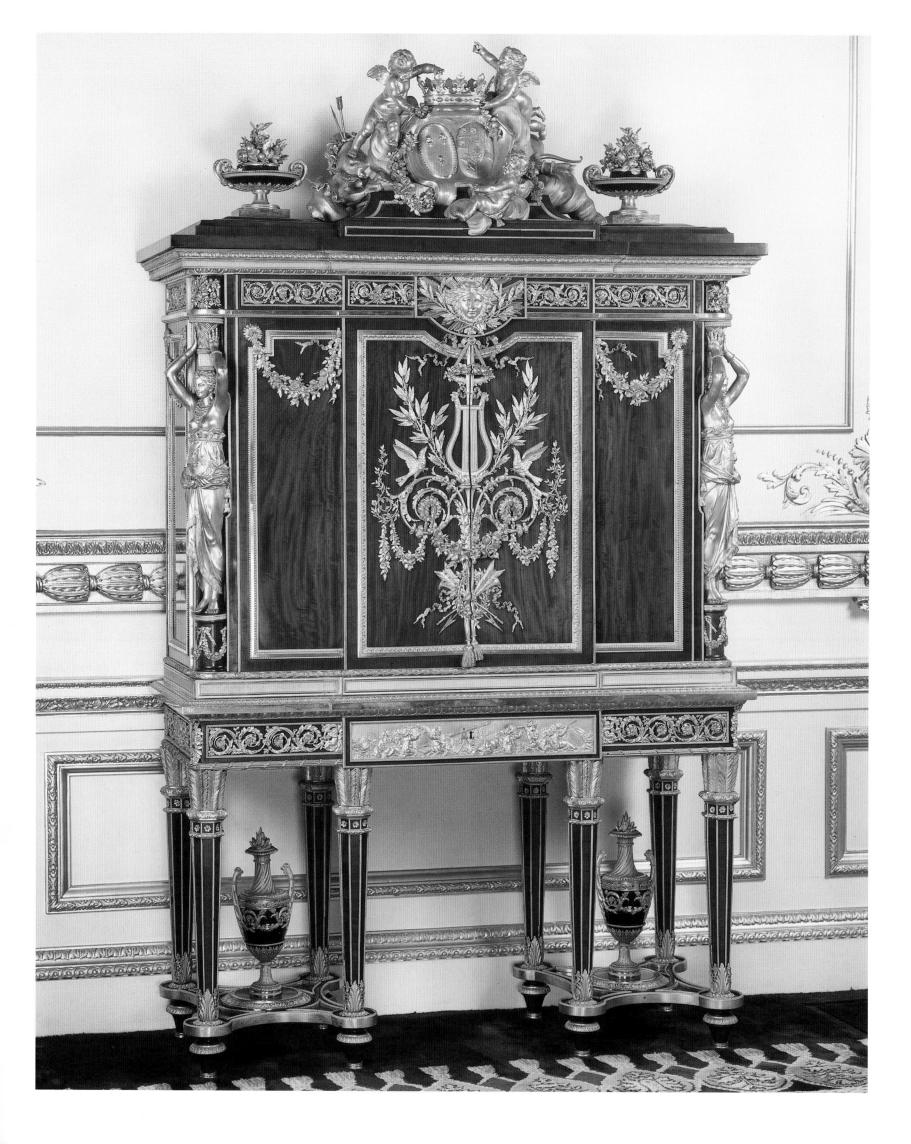

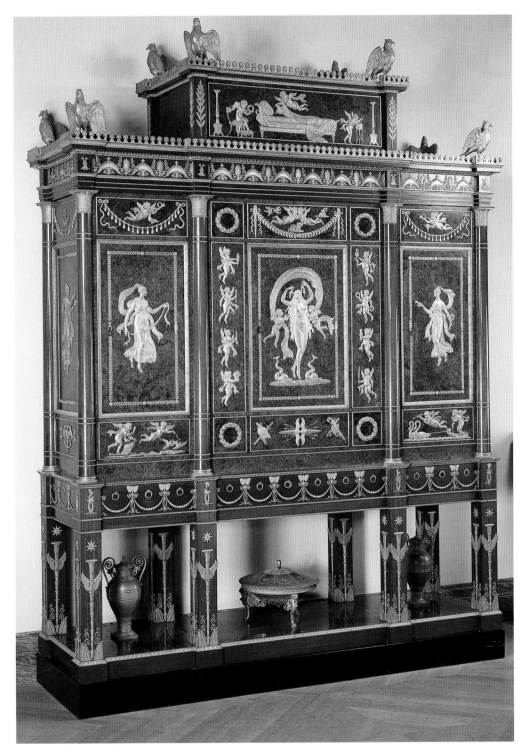

on page 209

400 'Archaeological' furniture, and a sculpture by Canova after an antique model, in a portrait of Pauline Borghese, Princess Borghese, by Jean-François Bosio; French, *c.* 1805.

opposite **401** A jewel cabinet in mahogany veneered on oak, and gilt bronze, made for the Comtesse de Provence by J.-H. Riesener and bought by King George IV of England after the French Revolution; French, *c.* 1785.

above **402** A jewel cabinet in yew, amaranth, gilt bronze and mother o' pearl, made for the Empress Josephine by Jacob-Desmalter; French, 1809.

The 'archaeological' fashion; general influences

Antique furniture was resurrected in the early nineteenth century in an accurately spectacular manner. European images of 'archaeological' furniture had been sharpened by hundreds of years of international activity by antiquaries and dealers: as early as 1629, for instance, correspondence between Nicolas-Claude de Peiresc, Rubens and Cassiano dal Pozzo concerning an antique bronze tripod [27] had involved drawings and casts of antique tripods being sent from Rome to France.[1] An English collection given to Eton College in 1736[2] contains drawings of a type of folding tripod [519] that was to be copied and adapted in huge numbers after the 1760s. Interest in scholarly exactitude grew steadily; 'encyclopaedic' publications of antique artefacts became self-consciously academic in texts and illustrations; antique casts and models decorated studies and libraries; newly founded or opened public and private museums contained antique artefacts that artists and craftsmen were urged to study. Painters accurately depicted antique furniture over a long period: Raphael, Rubens, Poussin, Mengs, Gavin Hamilton and Vien were joined in the 1780s by Jacques-Louis David (1748–1825), Vien's pupil, whose pictures contained furniture ranging from austere Roman Republican to voluptuous 'Pompeian' confections. By the beginning of the nineteenth century an unprecedented number of design sources was available: the result was synthesis on a grand scale. For the moment, the digestive system coped; by the 1840s, dyspepsia had set in.

Caylus declared in 1757 that Nature knew 'no distinction between men save that given by herself by her unequal distribution of talents, and she paid no attention to nobility of blood, or fame of ancestors, in creating a man of genius'.[3] The French 'philosophes' espoused the art and architecture of the ancient Greek republics as products of a 'free' society. From these innocent beginnings, a sinister link was forged between 'archaeological' fashions and judicial murder. David designed 'antique' furniture for the Duc de Chartres, son of Philippe Égalité, and painted 'archaeological' pictures for the Comte d'Artois, a few years before enthusiastically attending the Duke's father and the Count's brother and sister-in-law to the guillotine. He designed 'republican' antique furniture for the Revolutionary Convention. In singular contrast to the nonchalance with which human heads were daily tossed into baskets, the concern for free humanity (provided it had no shoes) was carried to extremes: in 1794 a jury in pursuance of 'political correctness' ordered the designers of Savonnerie carpets not to allow human figures to be trodden underfoot, monsters and chimeras excepted. Percier and Fontaine followed this dictum in their early work.[4] In about 1800 the Prince of Wales – the future George IV – denied himself French furniture in the antique style in case it were accused of 'Jacobinism'.

In 1804 the French régime switched from republic to empire, and from ancient Greece to ancient Rome. Napoleon commanded impressive talents and resources and 'believed…that the French are attracted by the glitter of external pomp'.[5] Alexander the Great had kept a copy of Homer under his pillow; Napoleon studied his Plutarch, who dilates on Alexandrian luxury. Elaborate decoration gave

the Napoleonic state a prosperous aspect; Parisian buildings were adorned with luxuriant Roman Corinthian rather than chaste Greek Doric and Ionic, and the imperial palaces were filled with extraordinarily rich decorations and furniture, more glittering (if less august) than those of the court of Louis XIV. Napoleon liked militaristic exhibitionism (he made much of parades) and military emblemism was scattered over Napoleonic furniture; modern armour was incorporated into trophies and reproduced in pattern-books.[6] The capitals that came under French influence, such as Madrid and Naples, adopted the French 'Romanized' version of antiquity – an unprecedentedly widespread politicization of decoration and furniture. In reaction, the capitals of the legitimate monarchies, especially London and St Petersburg, came to accept Greek motifs in architecture, decoration and furniture, despite their fearsome democratic associations. Germany itself (once the Napoleonic nightmare had passed) saw a conscious attempt to 'present the significance and practical application of Hellenism for the politics of the present day'; this entailed bridging the gap 'between classical antiquity and the attitude of a bourgeois in a free German fatherland'.[7] It may easily be conceived how such ideas fostered 'Biedermeier-Greek' decoration and furniture.

Whilst the designers of new furniture were following antiquity, a handful of adventurous spirits – such as the Prince of Wales and certain members of the nobility and gentry in England, and Denon and Girodet in France – were inaugurating a new taste of a different kind – that for French furniture of the 'ancien régime' (a term first recorded in 1789). Napoleon, for obvious reasons, was denied that taste – he refused a wonderful piece later acquired by George IV [401]: 'Sa Majesté veut faire de neuf et non acheter du vieux'.[8]

New methods of production

The new decorations and furniture were made in ways that augured profound change. From the mid-eighteenth century onwards,[9] papier-mâché and other compositions had been used increasingly to simulate carved wood; from the 1780s more and more English friezes, mouldings, medallions and ornament were mass-produced, a development that impaired the quality of Adam's mirrors. Compositions that originated in early industrial England were adopted on the Continent, such as a chalk paste mixed with wax and oil that had reached Vienna by 1810; another recipe, which consisted of ash kneaded with flour paste and paper pulp, may have been invented in Vienna itself.[10] Chalk, wax, oil and ash – hardly 'noble' substances!

Casting and impressing tended to replace sculpting and chiselling, gilt bronze to replace marquetry (the fashion for marquetry in a simpler form returned after 1815); ornament began to be 'applied'. Symmetry produced by old methods of craftsmanship had demanded a meticulous care which spoke of costly luxury; it now expressed economy. The weakness and the strength of Napoleonic France are seen in the 'mixture of admiration of greatness in architecture and of the appreciation of mechanical repetition of small units of decoration in ornament',[11] an observation that applies to furniture – as evinced in two jewel cabinets. The massive forms of the Empress Josephine's cabinet [402] are relieved only by stolid doves, gilt-bronze ornaments on the cornices and vessels on the stand; a repetitive pattern of small gilt-bronze ornaments replaces the flowing and graceful decorations of the Comtesse de Provence's cabinet [401], which are topped by a lively flurry of putti around the

coronet. The earlier piece has a spring in its step; the later is weighed down by grandeur. Undeniably fine as the Napoleonic piece is, one might yet feel that something has been lost.

The Paris Exhibitions of 1798 and 1801 demonstrated methods that were denounced by Percier and Fontaine: 'Plaster takes the place of marble, paper plays the part of painting, pasteboard imitates sculpture....But the most grave abuse is that of the prostitution imposed upon works of art and taste, the economy of work, the imitation of materials, and the systematic or mechanical processes that take away the perfection of execution and the touch of delicate feeling that…are inseparable from [conception and creation]'.[12] Thomas Hope complained that 'Throughout this vast metropolis [London], teeming as it does with artificers and tradesmen of every description, I have, after the most laborious search, only been able to find two men, to whose industry and talent I could in some measure confide the execution of the more complicated and more enriched portion of my designs'; he found himself 'under the necessity of procuring…models and casts from Italy, for almost all the least indifferent compositions which I have had executed'.[13] One has a sense of living on borrowed time: marvellous things were still being produced, but architects and artists of the late eighteenth and early nineteenth centuries were a lesser breed than their predecessors: even brilliant painter/ architect/designers such as Percier and Fontaine or Schinkel had not the stature of Giulio Romano, Rosso or Primaticcio – not to mention Raphael and Michelangelo.

Available styles

Two tastes, sometimes opposing, sometimes complementary, dominated interiors and furniture designed in the antique manner between about 1790 and 1840 (after which came the maelstrom of eclectic Revivalism). The first employed grotesque and 'Etruscan' motifs, pure and intermingled; the second opted for Roman and Greek 'archaeological' interiors and furniture. The first, decorative and linear, was founded on grotesque painting and Greek vase painting; the second, architectural and volumetric, was founded largely on antique stone artefacts, such as those pictured by Percier in 1796 in a design for a museum [423]. The two tastes frequently co-existed in one house – in different rooms, or combined in one room. Three interiors demonstrate the possibilities.

The first, the 'Platinum Room' (so called because of the precious metal included in its inlay) at the Casa del Labrador at Aranjuez [403], was installed in Spain after having been made in Paris. Walls and ceiling are covered with grotesque ornament skilfully blended with 'Etruscan' motifs, mainly in paint and cast metal; the use of mirror extends the spaces and adds 'Pompeian' ambiguities. The paintings are by Girodet (p. 214).

The second is the very different Entrance Hall in the same building [404] – such distinctions between entrance halls and boudoirs were common. It is a colourful, sumptuous, and masterly example of the 'archaeological' style, Roman rather than Greek. The walls are articulated with unfluted Corinthian pilasters, bas-reliefs in sculptural style, and niches containing statues; the mirror over the chimneypiece is contained within an architectural 'aedicule' and has a panel of figured marble above it. The barrel-vaulted ceiling is coffered in three dimensions as well as being painted. The marble (or scagliola) floor includes real Roman mosaics. The marble pier tables are heavily Roman, flanked by

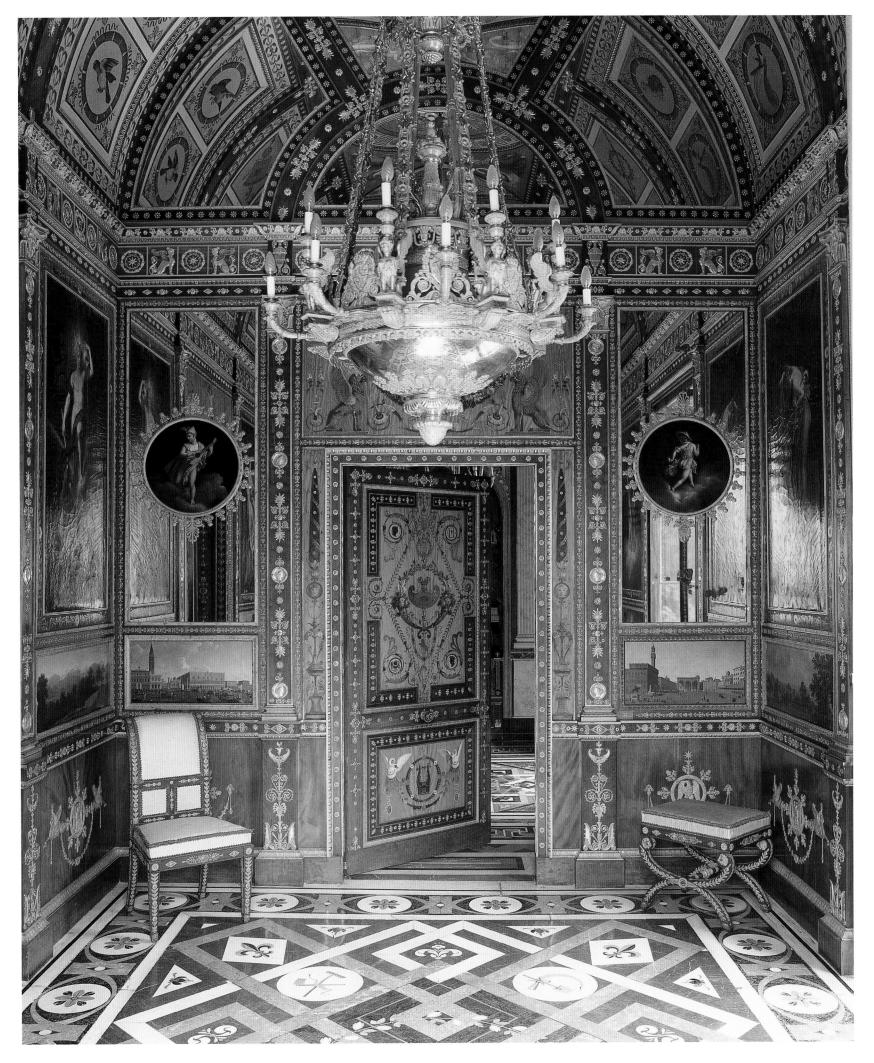

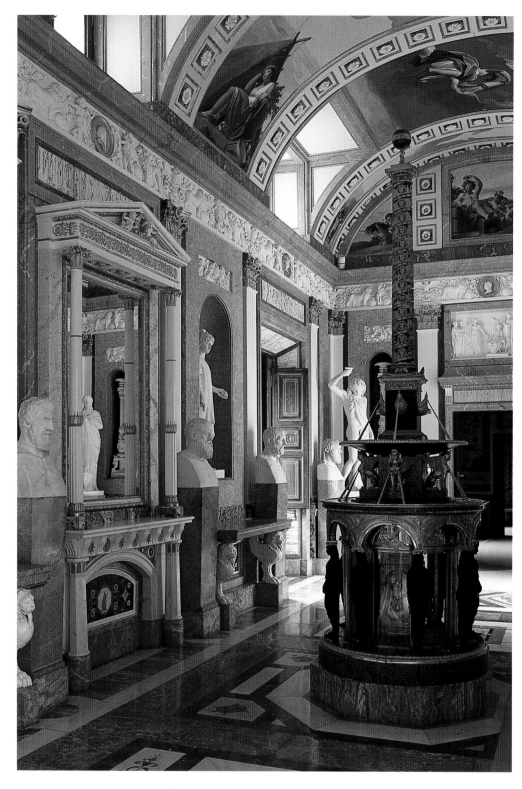

404 The Entrance Hall of the Casa del Labrador, Aranjuez, designed by Percier and Fontaine, *c.* 1800.

forward-gazing busts on heavy plain pedestals. (The fountain was not part of the original scheme.) Such 'archaeological', massively forceful furniture drawn from stone sources tended to congregate in 'stony' and 'architectural' areas of the house, 'masculine' in character, such as halls, dining rooms, and libraries, although some did invade drawing rooms, as seen in the next illustration.

This, a New York interior in strict Greek Revival fashion [407], is the work of Alexander Jackson Davis (1803–92), a designer, architect and journalist who later became a protagonist of Gothic. The threat of bleakness or solemnity that hung over 'archaeological' interiors and furniture, especially after the Greek fashion brought in bare, unadorned walls and fireplaces, is manifest in this chilly room, of which the fluted Ionic columns are the only pronounced architectural feature.

Various permutations and combinations of these styles were generally popular during the first forty years of the century, and furniture followed suit. The primary influences on antique-inspired modern furniture were antique stone artefacts – architecture, sculpture, sarcophagi, furniture, and so on; grotesque painting; ancient metal furniture; and ancient wooden furniture as depicted on vases and bas-reliefs. Modern adaptations of ancient wooden furniture that looked heavy in the original – the 'cut-out' couch [13], for example – were often employed in 'architectural' interiors.

There was an ideological contest between the 'archaeological' style and grotesque. Taking his standards from stone artefacts, Winckelmann had implicitly consigned the grotesque to 'decadence'. Its revival in the later eighteenth century had not been unaccompanied by dissent. Adam's finicky later ornament had prompted Horace Walpole's denunciation in 1773: Adam's gate at Syon was 'all lace and embroidery, and as *croquant* as his frames for tables....From Kent's mahogany we are dwindled to Adam's filigree....Wyat has employed the antique with more judgment.'[14] Mengs, another powerful voice, 'could not endure...the ridiculous grotesque, and Arabesque, of which he thought like Vitruvius, Pliny and other ancients'.[15] The theorist Francesco Milizia thought that the grotesque was a 'disgusting taste'.[16] A Spanish writer of 1788 was equally condemnatory.[17]

On the other hand, 'decadence' has its pleasures, and the coldness of the 'archaeological' style was ameliorated by a boneless eroticism, a peculiar mixture of sweetness and frigidity that easily degenerated into archness, which owed something to sixteenth-century mannerism and Correggio. It was common in sculpture – Canova set the tone – and it also affected Empire furniture ornament [402] in which the human figure appears. It permeates a painting of 1799 (which ruined the career of the unfortunate lady depicted in it) by Anne-Louis Girodet (1767–1824) [405].[18] Girodet worked with Percier and Fontaine [403]; his influential '*poésies* and ...taste for allegories' were the antithesis of David's 'majestic and brutal' early archaeological force.[19] Girodet's manner, shared by the influential Pierre-Paul Prud'hon (1758–1823), appeared throughout Europe on furniture, clocks, and ornaments.

Percier and Fontaine, who were fully aware of the anti-grotesque lobby, themselves perfectly reconciled grotesque with the 'stone' style. They opined that if 'gaiety' were the only want, grotesque would become 'the universal ornament'.[20] Many clients preferred gaiety to dignity, even for state apartments.

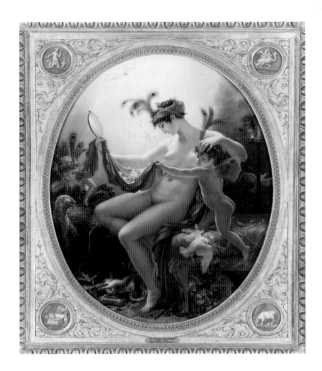

405 *Mademoiselle Lange as Danae*, by Girodet; French, 1799, in a contemporary frame.

406 'View of the Bedroom of Cit. V. at Paris', by Percier and Fontaine; French, 1801 (from *Recueil de décorations intérieures*).

407 A design for a New York drawing room, by Alexander Jackson Davis; American, c. 1826.

Grotesque and 'Etruscan' decoration and furniture

Charles Percier (1764–1838) and Pierre Fontaine (1762–1853) orchestrated the highest triumphs in decoration and furniture achieved by grotesque since the Renaissance; their influence on early nineteenth-century furniture design surpassed that of any other modern designer. They began their partnership in 1793 by helping to design furniture made by Jacob for the Convention, evolving over the next few years a style that synthesized severe, often stone-derived forms with luxuriance of decoration. Motifs from antique decorative sculpture were mixed with grotesque and 'Etruscan', the linear emphasis common to the two last making combination easy. 'Classical' and 'anti-classical' achieved balance; frigidity and opulence were united. The Percier and Fontaine style was shaped by their two principal tenets – that the art of Pompeii and Herculaneum was, in its refinement, Greek and not Roman, and that the High Renaissance, a new shoot of antiquity, surpassed all subsequent styles.[21] Was their grotesque influenced by

Adam's published works [374]? It is difficult to believe it was not, despite the obvious differences.

In 1801 Percier and Fontaine published the *Recueil de décorations intérieures*, frequently reprinted after the second edition of 1812; its monochrome plates lack the splendid colour of the real thing [403]. The 'Bedroom of Cit. V.' [406] – some of Percier and Fontaine's ornate but simply designed bedchambers date from the immediate post-Revolutionary days of 'Citoyen' and 'Citoyenne' rather than those of 'Monsieur' and 'Madame' – illustrates the designers' early mixture of antique and Renaissance grotesque with 'Etruscan': 'Etruscan' predominates on furniture and doors, grotesque infiltrates into the upper part of the walls. The armchair combines the klismos and the stone throne, but its ample surfaces are enlivened with ornament; the pillar topped by 'La Bonne Déesse' – the many-breasted Diana of Ephesus (such pillars occur in antique furniture [3 *upper right*]) – is 'une armoire où se renferment les effets de nuit' – whatever such 'night things' may be. The side table is modelled on an antique sarcophagus, the 'Tomb of Agrippa' [10:D].

Percier and Fontaine's furniture frequently combined substantial forms with grotesque/'Etruscan' ornament; even where the furniture decoration came from stone artefacts, delicacy was retained. Typical examples of their work are designs for two commodes and a table [409]; the uncompromising four-square aspect of the commodes is lightened and given 'gaiety' by exquisite ornament. The table gains in grace what it loses in majesty. Different as are the results, there is often a likeness between the Percier and Fontaine recipe and that of Boulle, a union of massive, 'masculine' shapes and delicate, often 'feminine' ornament. Boulle served a magnificent autocratic, Percier and Fontaine dignified the undignified autocracy of the Empire.

The frigidity of the Percier style is relaxed and the changes wrought by the passage of twenty years are revealed in a jewel cabinet of 1826 [408] for which a design exists.[22] The shape is still severe, but the decoration has become opulently florid. The peacock, emblem of Venus, presides over a piece covered with hard-paste Sèvres porcelain that has a character at once voluptuous and 'hard-edge'.

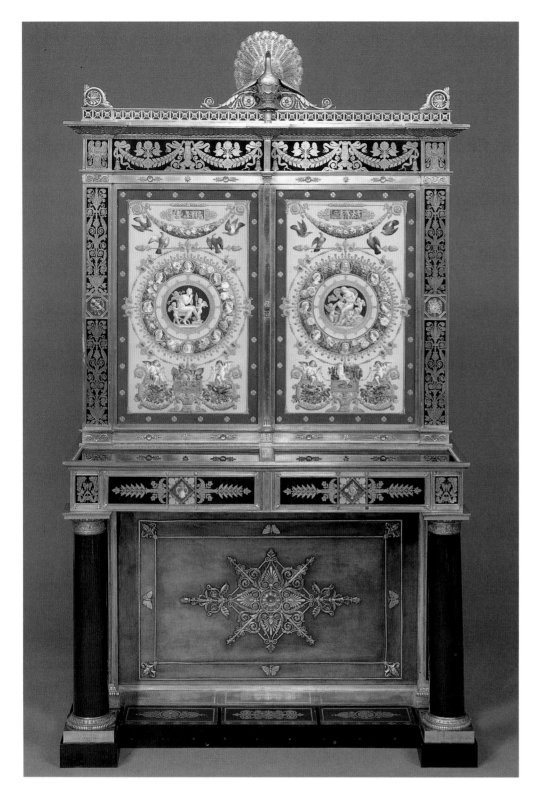

grotesque. Greece was his main source – Greek vases, Greek stone ornament, or Roman Greek revival motifs. Hope often employed ornament from stone originals in places where, a little earlier, grotesque might have been used: for instance, a baluster of the fifteenth-century Renaissance type performed the same function for his pier tables as did the grotesque candelabraform motif in grotesque-inspired furniture. He also adapted motifs that did not originate in stone artefacts to look as if they did. Instances occur in designs for a 'narrow pier table' and two 'mahogany chairs, inlaid in metal and ebony' [411]: the table is made up of cunningly transposed forms influenced by the Greek cut-out couch and the volute-calyx [13], with a tablet interposed in the centre of the leg; of the chairs, one is an elegantly massive variant of the klismos invented by Percier and Fontaine, here decorated by Hope with 'Etruscan' ornament and a Greek lyre; the other, again influenced by the klismos, adapts Aeolic scrolls for the back. The thing is brilliantly done. He played variations on the old Aeolic volute-calyx, which tops the fluted legs of an 'upright piano-forte'.[25]

A monumental bronze-mounted and brass-inlaid mahogany desk of about 1810 [414] has affinities with the Hope style; all its ornament is Greek. Precedents for its bold architectural Greek key ornament existed in Greek furniture, Louis XIV, 'goût grec' and Kentian furniture; the owl within a laurel wreath with the Greek letters that signify 'Athena' was an emblem of the goddess frequently seen on coins [413]; examples existed in all the princely collections and the image was frequently published. The capital of the pilasters is a version of the volute-calyx. The sides of the desk have a lion mask set within four inward-pointing anthemion motifs placed in the corners of the compartments exactly as they were by Greek painters on 'Etruscan' vases and by Regency decorators on modern walls.

The New York drawing room designed by Davis in the late 1820s [407] is pervaded by Hope's influence – in its general style, in the disposition of the paintings and mirror

408 A jewel cabinet in mahogany, gilt bronze and glass, with Sèvres porcelain mounts; French, 1824–26.

409 Designs for two commodes and a table, by Percier and Fontaine; French, 1801 (from *Recueil de décorations intérieures*).

The imitations of antique cameos, especially favoured by Louis XVIII,[23] have already acquired something of 'Victorian' pulpiness; those in the outer rings are set amongst ravishingly painted flowers; the heaped-up still lifes between the erotes have the suffused colour and luxurious disorder of passages in Girodet's *Mademoiselle Lange* [405].

There are correspondences and differences between the Percier and Fontaine style and that of Thomas Hope (1769–1831), a rich Regency connoisseur who devised perhaps the most distinguished pattern-book of the period – *Household Furniture and Interior Decoration*, published in 1807. Many similarities arise not from plagiarization but from the common antique prototypes used; one exception is Hope's sofa with massive klismos legs, which shows Percier's influence.[24] A major difference is that Hope's furniture and interiors were noticeably deficient in ornament derived from

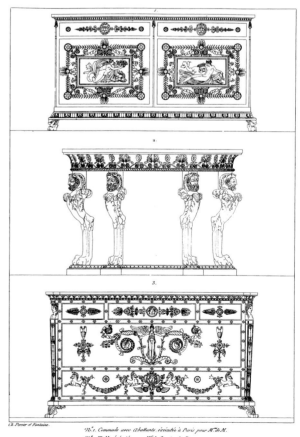

410 A detail of a round table top, of black marble inlaid with ivory; Macedonian, *c.* 350–300 BC.

411 Depictions by Thomas Hope of furniture in his house in Duchess Street, London; British, published in 1807 (from *Household Furniture and Interior Decoration*).

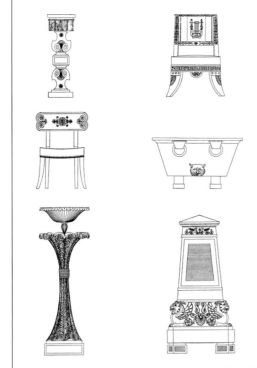

far right 412 A secretaire-bookcase in ebonized, painted and gilded mahogany, attributed to Joseph Meeks & Sons of New York; American, *c.* 1825.

below 414 A desk in mahogany and bronze, with brass inlay; British, *c.* 1810.

below right 415 A cabinet in oak, ebony, ebonized wood, gilt bronze and brass, with a Mona marble top, by George Bullock; British, *c.* 1816.

413 The owl of Athena, on a silver Athenian coin, *c.* 520–510 BC.

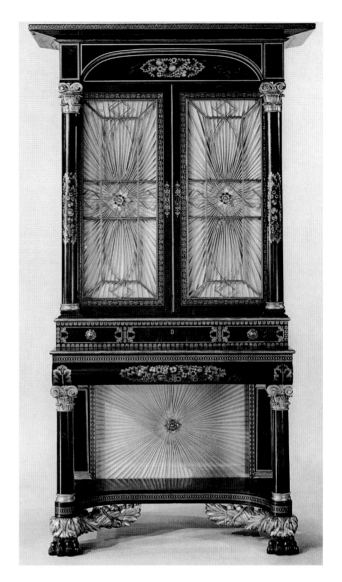

on the walls, and in the furniture. The side table, chairs and torchère are old-fashioned by European standards, and resemble examples in Hope's pattern-book of 1807.[26] The sofa, however, with its pronounced 'Etruscan' three-dimensional ornament, is distinctly Italian and 1820s in style, somewhat reminiscent of the furniture of Pelagio Palagi [418]. The two round centre tables – which have Renaissance prototypes [192] – plagiarize a famous design made for Hope in several versions.[27]

Sometimes all or most of the ornament of a particular piece came from 'Etruscan' sources. A splendid German giltwood pier table designed by Andreas Gärtner between about 1806 and 1810 [438] has a French shape and richly combines grotesque (the candelabraform motif) with 'Etruscan' primitivism, much in the manner of Percier and Fontaine. The Regency cabinet-maker George Bullock (d. 1819) based much of his finest furniture upon 'Etruscan' ornament. In 1816 and 1817 a series of plates of his furniture was published in Ackermann's *Repository*; those showing furniture in situ often show it accompanied by 'Etruscan' 'panelling out'[28] on the walls and 'Etruscan' ornaments on curtains and furniture.[29] A Bullock cabinet [415] decorated

with brass marquetry and gilt bronze has the corners of its glazed panels marked with 'Etruscan' anthemion motifs in the same way as the Greek Revival desk [414]; the shape and ornament of the feet are taken from the borders of Greek vases (the identical motif appears on the walls of Osterley's Etruscan Room, in Hope's and Percier's furniture designs, and so on); the thyrsus that adorns the corners is a frequent vase ornament. Different as their furniture is, Bullock often echoes Percier.

A resplendently coarse secretaire-bookcase in ebonized and painted mahogany of about 1825 [412], attributed to

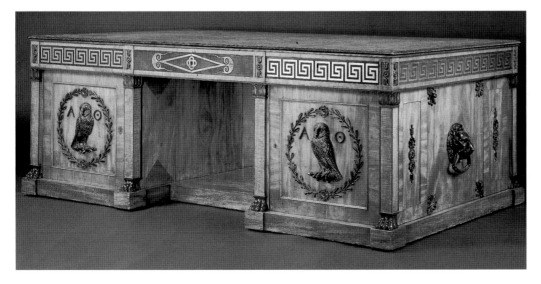

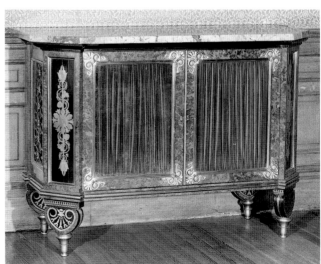

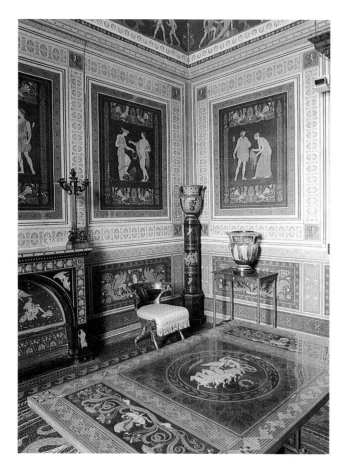

416 The Etruscan Room at Racconigi, designed by Pelagio Palagi; Italian, early 1830s.

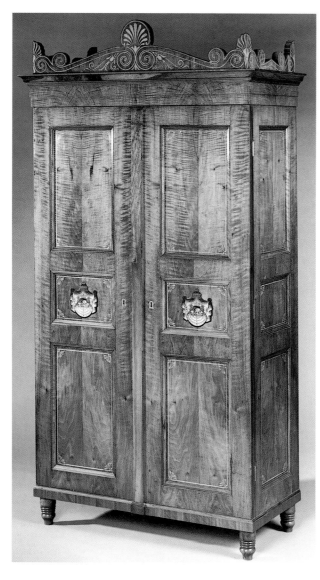

417 A cupboard veneered in walnut and beech, designed by Leo von Klenze: German (Munich), 1834–35.

Joseph Meeks & Sons of New York, is covered with gilt 'Etruscan' ornament. The drawers are outlined with 'Etruscan' 'panelling out' exactly as used in 'Etruscan' wall decoration, and beneath the line of anthemion decoration that surrounds the drawers is a horizontal band of 'Etruscan' interlace. The columns are topped with Aeolic capitals of the type seen on the Greek cut-out couches pictured on the vases [13] – but beneath them is placed Corinthian acanthus, a conjunction that would certainly not have occurred to the Greeks nor, indeed, to the Romans.[30]

The use of 'Etruscan' motifs encouraged a sensitive discrimination in the use of ornament, sparse or profuse, that is part of the aesthetic appeal of the original Greek artefacts. This quality is evident in furniture by two talented designers – one German, Leo von Klenze (1784–1864), and the other Italian, Pelagio Palagi (1775–1860). A cupboard of the early 1830s [417] by Klenze, who was taught by Gilly, Durand and Percier and subsequently became the leading architect and designer in Munich, is topped by an antique opposed scroll [477]; its ornament, influenced by vase painting, is linear rather than sculptural. The doors are 'panelled out' in the same way as 'Etruscan' decorated walls.

Palagi, a painter and universal man, had a 'mania' (his own word) for antiquities; his style reflects influences from his former colleague Albertolli [347], from Flaxman, and from Percier and Fontaine: he may have worked in Count Carlo Aldrovandi's factory at Bologna, which from 1794 onwards produced 'Etruscan' wares in emulation of Wedgwood. In the 1830s and 1840s Palagi designed interiors for the King of Sardinia at Turin and Racconigi [416], the furniture being made by Gabriele Capello of Turin, in a new technique that allowed extremely intricate inlay.[31] 'Etruscan' inlaid ornament dominates a sofa that came from Racconigi [418]; its upholstery was originally adorned with blue and silver harps and rosettes. Palagi's habit of outlining forms and ornament by a thin line of dark veneer is taken directly from the painted line of Greek vases. His 'Etruscan' furniture won a medal in 1851 at the Great Exhibition in London, where it was described as 'enriched by the ornaments of the best period of Grecian taste'.[32]

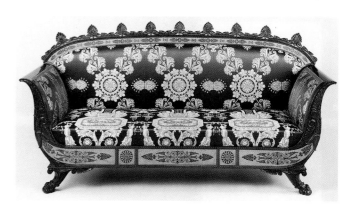

418 A sofa in mahogany with maple inlay, designed by Pelagio Pelagi and made by Gabriello Capello and Carlo Chivasse; Italian, c. 1832.

right **419** An urn on a tripod, all in cut and moulded clear and blue glass and gilt bronze, designed by Andrei Voronikhin; Russian, *c.* 1810.

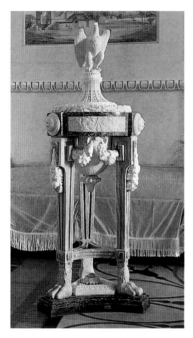

420 A perfume burner in white and polychrome marbles, carved by Ferrero; Italian (Turin), *c.* 1780–90.

421 A stool from the plate 'Antique Seats of white marble from Originals in Rome' by C. H. Tatham, published in London in 1799 (from *Ancient Ornamental Architecture Drawn from Originals in Rome*).

422 A pedestal table in white marble, at Monticello, Virginia; nationality uncertain, *c.* 1820.

Furniture influenced by antique stone artefacts

The antique stone furniture – sarcophagi, ossuaries and altars – that provided models for modern 'archaeological' furniture lacked Pompeian graces but was unrivalled for dignity, splendour, and majesty. Metamorphoses from stone into wood had their perils: the early nineteenth century lacked its predecessor's sure touch. Many found its archaic Medusa-like petrifications repellent; the 'solemn foppery' of Hope's furniture was lambasted as 'exquisitely bombastic, pedantic, and trashy…too bulky, massive, and ponderous, to be commodious for general use', it 'weigh[s] down the floor'.[33] The Egyptian fashion (pp. 292–96) increased the weight; the bodies of Empire swans are sometimes so thickened as to look like geese. Stone monsters marched on to furniture; their numbers and aspect excited sarcasms.[34] Some found stone-inspired furniture lugubrious, not surprising when one's bookcase could be terminated by virtually unaltered funerary monuments;[35] one could stretch one's legs on an ottoman and rest them on a tombstone.[36] Solemnity was mitigated by the new fashion for rich, bright textiles. Where these were absent, severity became painful, literally so: Lady Holland preferred 'les ris et les amours' of the eighteenth century to 'the goût sévère' of the nineteenth, and a 'well stuffed sofa to a small, hard one'.[37]

The general trend towards heaviness affected even lighter models: Percier and Hope placed their versions of the sphinx tripod on a massive base as high as itself; Hope omitted its festive scrolls.[38] Light-hearted decoration that came largely from ancient painted sources, such as 'Pompeian' scrolls and dancing maidens [55], was turned into rigidly sculpted bas-reliefs, in gilt or patinated bronze in France [402] and carved wood in England. Greek sculpture supplied sturdy, frontally facing, grave caryatids that looked as if they could indeed bear weights – young matrons as distinct from the gracious gilt- bronze maidens of Louis XVI furniture [401]. Furniture that, derived from stone antique sources, had been converted by modern designers into wood, was frequently turned back into stone: an austere marble version of the Hope table (p. 217) stood in the library of Thomas Jefferson's house, Monticello [422].[39]

The English, whose long-standing Palladian obsessions resurfaced in Regency architecture, took naturally to 'archaeological' furniture; the early essays of Adam and Stuart were the forerunners [303, 304], and the traditionally massive shape of the British desk [523], which had survived throughout the reign of skeletal fragility, was easily converted into the new antique idiom [414] (as it had been into Gothic [472]). The native antique bias of the Italians, reinforced by Piranesi, put them early into the field [600]. Tripods gave much scope for invention. An Italian 1780s version of the stone tripod, a perfume burner carved by Ferrero of Turin in white and polychrome marbles [420], has travelled far from its models; it retains some 'goût grec' mannerisms, but its fleshy opulence anticipates the late nineteenth century. Almost as distant from its originals is a tripod and urn of about 1810 [419] designed by Andrei Voronikhin (1760–1814), a Russian who had travelled in Europe and worked with Brenna, the recorder of the Domus Aurea, at Pavlovsk.[40] Made in cut and moulded clear and blue glass and gilt bronze, its legs are thinner than they would have been in the antique original: could the conceit of making in glass an object originally in stone be connected with Cameron's interest in antique 'effulgence' (p. 200)? The entwined serpent (emblematic of peace) appears on antique tripods [10:J], vases, wall paintings and mosaics.

423 A project for the interior of a museum, by Charles Percier; French, 1796.

above right 424 A torchère in carved mahogany designed and made by Vulliamy & Son; British, 1807.

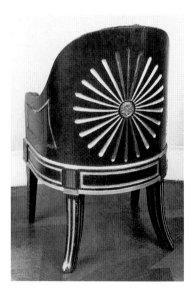

425 An armchair in parcel-gilt mahogany and brass, in the palace of Pavlovsk; Russian, *c.* 1800.

right 426 An eagle 'dal naturale', by Giocondo Albertolli; Italian, published in Milan in 1796 (from *Miscellanea per i giovani studiosi*).

The architect and furniture designer Charles Heathcote Tatham (1772–1842), sent to collect examples of grotesque in Italy for Henry Holland, made instead the drawings that were first published in 1799 as *Ancient Ornamental Architecture Drawn from Originals in Rome*; they pictured (mostly) stone artefacts. Tatham's depiction of a stool [421] has led to his being assumed to have designed its wooden equivalent[41] that simulates marble and copies his antique original almost exactly (it omits the fringe). This is very possible. However, many of the images contained in Tatham's book, including the stool, were already commonplaces, and the dangers of assuming a connection that seems obvious are illustrated by two torchères in carved mahogany with bronze mounts [424] that follow an antique original [10:B], also illustrated by Tatham; these are inscribed 'Designed and executed by Vulliamy and Son, London A.D. 1807'. Without the Vulliamy signature, Tatham would certainly have been given the credit.[42] Such antique stone candelabra, especially the splendid Hadrianic type pictured by Piranesi and Tatham, were frequently copied or adopted for modern use; there are wonderfully imperial Russian examples in gilt bronze.

Tatham and Hope both acknowledged their debts to the sculptor John Flaxman, whose classicizing line illustrations, which had a vogue throughout Europe, included furniture drawn from antique marbles. Where a form was thought beautiful, there was often little or no attempt to alter it: the Dowager Duchess Anna Amalia of Weimar had a copy made in Germany after an antique stone seat she had occupied at Naples [430]; the same type was depicted by Flaxman, and Hope's 'Third Room containing Greek vases' contained it appropriately embellished with 'Etruscan' ornament.[43] Similar repetitions attend the console table supported on an eagle, a motif associated since before 1750 with Kent. The eagle was a truly 'Roman' emblem; it hovers over a variant of

the 'Tatham' stool [421] in a print published by Boissard and over a couch published by Santi Bartoli.[44] Horace Walpole had owned a 'glorious fowl' dug up near the Baths of Caracalla, to which he gave pride of place at Strawberry Hill.[45] The Kentian eagle side-table enjoyed a renewed surge of popularity in Regency England, when early eighteenth-century examples were given new up-to-date stands and slabs.[46] The greatly increased naturalism of the early nineteenth-century examples, their waving pinions and fierce beaks – an improvement on the barnyard fowls of the early eighteenth century – was probably encouraged by a magnificent series of eagles 'from life' published by Albertolli [426], whose work was recommended as a model by Sir John Soane to his Royal Academy pupils.

The antique stone throne with rounded back was frequently used by designers, either in a form approaching the original or adapted as a lighter armchair. Percier and Fontaine conjoined it with klismos legs; a Russian version is in mahogany and gilded wood [425]. Such chairs, on klismos, turned or reeded legs, became common. Or the stone throne

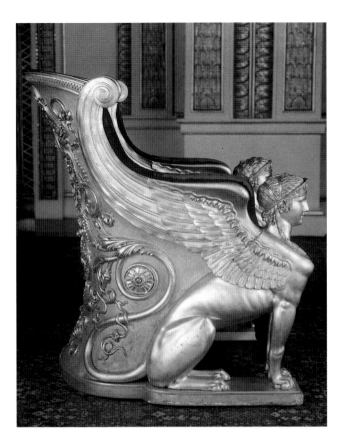

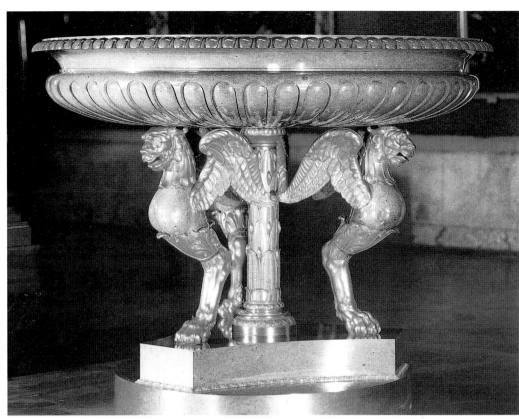

427 A Council chair in pine, and gilded lime and beech, originally with a caned seat, made for the Council Room of Carlton House, London, possibly designed by C. H. Tatham; British, 1812.

above right 428 A large bowl on stand in Korgon porphyry and gilt bronze; Russian (Kolyvan), 1809–11.

429 A design for 'A Cheval Dressing Glass' by George Smith; British, dated 1804 (from *A Collection of Designs for Household Furniture*, 1808).

was taken over entire – as seen in a 'Council chair' of 1812 [427] made up largely from two ancient thrones in Rome, at S. Gregorio Magno [22] and the Vatican. Its back, which recalls the Roman chariot [65:C], is decorated with bold scrolls, its front with two large sphinxes.

Antique stone furniture, especially rectangular and round tables, had frequently employed monster monopodia as supports [24, 61]; one consequence of the 'archaeological' fashion was the return of monsters unimproved by rococo or 'rococo neo-classical' Parisian finishing schools. Sometimes stone furniture was adopted virtually unaltered: Hope made a wine cooler out of an 'antique bath or lavacrum', and 'imitated …an Etruscan altar in the Villa Borghese' for a formidably bemonstered 'sideboard pedestal'[47] [411]; the latter had a few years earlier been illustrated by Durand, one of Hope's named sources.[48] An impressively monstrous Russian vase in Korgon porphyry and gilt bronze of 1809–11 has a base taken from Roman stone candelabra or tripods [428]. Excitingly grand as such furniture is, its monsters can seem slightly pushing. Swans on the arms of a chair are one thing, griffins another, and any lady who surveyed herself in the glass of an 'archaeological' assemblage by the English cabinet-maker George Smith [429] might be excused a tremor.

Romantic Classicism and monumental forms

The imitation of assertive antique stone models was supplemented or replaced by more abstract antique influences, resulting in furniture of a singularly timeless classicism.

The early nineteenth century inherited the feeling for the weight and power of of antique stone artefacts and disconnected elementary geometric forms – the cube, the cylinder, the half-cylinder, the globe, the pyramid, the cone, the monolithic obelisk – that had been engendered in the eighteenth (p. 178). The cult of elementary forms that now spread throughout Europe was not the least

430 *The Dowager Duchess Anna Amalia of Weimar in Naples*, by J. H. W. Tischbein; German, 1789.

remarkable of the offspring that sprang from Piranesi's sowing of stones.

Basic geometric forms may be employed by designers in several ways. Baroque art used them as ingredients in designs that read as a whole: a baroque building or piece of furniture looks as if the separate components of which it is composed have fused; it has dynamic rhythms that build up to a climax. Romantic Classical architects used elementary forms in a completely different way, being interested in them for their own sake; the distinguishing characteristic of Romantic Classical architecture is that the cubes, cylinders and semi-cylinders of which it is composed remain as separate, inert, recognizable entities, even in the more suave examples [329]. Elementary forms possess inherent strengths, and buildings which present them undiluted can have great emotional power; their originality does not disguise their debt to antique Egypt and Rome. Their mystical force also had antique origins: d'Hancarville observed, 'The Greeks took this cult of Stones, Trees and Pillars from Asia, and Pausanius tells us that formerly Stones in Greece, received divine honours, and that even, the most ill shapen ones were the most revered.'[49] Goethe, an arbiter of antique taste, erected an astonishingly volumetric 'Altar of Good Fortune' in 1777 [431] drawing upon a Renaissance emblem that pictured a sphere and a cube: spheres roll, but cubes remain immobile, therefore 'as Fortune [Destiny] rests on a sphere, so Hermes [Art] sits on a cube'.[50] The message was that 'Art is unaffected by the fluctuations of Fortune'. An emblem exactly like that of Goethe's altar appears at the feet of the enthroned Zeus in a grotesque wall painting (obviously influenced by Phidias' statue) at the House of the Dioscuri in Pompeii. Designers such as Ledoux were as aware of such meanings as were poets such as Goethe.

As 'rococo neo-classicism' receded, basic furniture shapes were gradually taken over by a self-conscious geometry, the

431 The Altar of Good Fortune, Weimar, designed by Goethe; German, 1777.

right **432** The dressing table of the Empress Josephine, veneered in ash, with gilt-bronze mounts, by Antoine-Thibaut Baudoin; French, 1809, the gilt-bronze candlesticks added in 1837 by P.-P. Thomire.

433 Napoleon's 'bureau mécanique', in mahogany and gilt bronze, designed by Giovanni Socci; Italian, 1807.

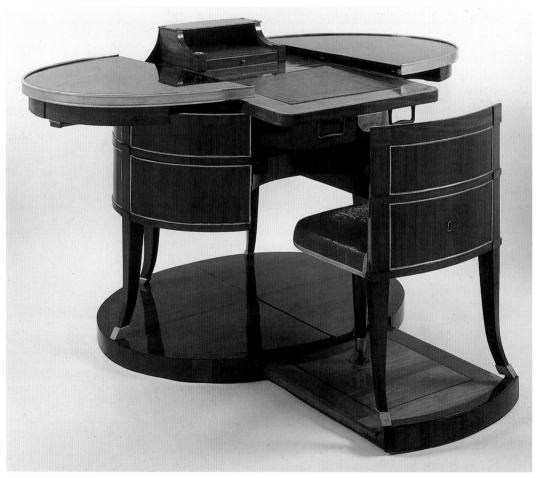

French roots as the Russian commode, and Socci may have seen Sheraton's library table design,[51] which has an orthodox desk set into demi-lune ends. He might also have been influenced (despite the differences) by the imperial appropriateness of a Piranesi design for a chair placed on a platform [327], a practice usually confined to a throne.

In the early nineteenth century, North American furniture began to enter the mainstream of design. Pattern-books such as those of Chippendale had disseminated English style in America, but pattern-books cannot establish a sophisticated native tradition. Immigrant craftsmen and designers in large numbers most efficiently perform that service: French craftsmen and designers in the later seventeenth century had done it for England, and French and Italians in the eighteenth century had done it for Sweden. The British, French and Germans now implanted their talents in North America; throughout the nineteenth century, some of America's finest furniture was made by immigrants. India did not require such assistance: the splendid refinements of Mughal culture gave eighteenth-century Anglo-Indian furniture a sophisticated beauty denied to furniture made in provincial New World colonies. To some extent, quality was a question of money; eighteenth-century America could not, for example, afford the cost of painted grotesque decoration.

Sheraton's designs had a considerable success in Europe and America; he was interested in elementary and disconnected forms. His pattern-books of 1791–94, for example, contain a bookcase flanked by tall semi-cylinders and the library table mentioned above. His utilitarian corner wash-stands are quarter-cylinders. His severe design for a 'Sisters' Cylinder Bookcase' in the *Cabinet Dictionary* of 1803 was the source for a desk and bookcase in mahogany, satinwood, and maple made in Baltimore in about 1811 [434].[52] The bookcase is built up of rectangles and ovals topped by two globes; the turned members hover between baluster and candelabraform; the verre églomisé panels depict the familiar 'Pompeian' dancers.

Architectural motifs – the full rounded column, the pediment, the heavy base, imbrication – had never been banished entirely from furniture design, but they now returned in full measure (Hope, perhaps influenced by Laugier, avoided the column and pediment). The Empress Josephine's jewel cabinet [402], veneered in yew and amaranth with mounts of gilt bronze and inlays of mother o' pearl, has massive cubic forms: the columns on the front are its only rounded forms, even the stand has rectangular piers. The strength and simplicity of elementary forms did not exclude them from the feminine boudoir, perhaps a reflection of the frequency with which spurs went clanking into it. In 1808, the year of Wagram and Talavera, a dressing table was delivered to the Empress [432]. It is made up of cylinders and cubes, with round and oval shapes prominent in mirror, base, and marble top. Few things could be simpler (the candlesticks were added in 1837). The plain forms allow full expression to the beauty of the pale ash veneers. Native woods, as employed in Josephine's dressing table and jewel cabinet, were now high fashion; ash, walnut, unstained sycamore, beech, elm, fruitwoods such as pear and cherry were used in large quantities; the elaborate grain of burr wood was popular. The frequently repeated statement that the blockade of Napoleon's Empire in 1806 compelled the use of indigenous woods may have some truth, but fashion was stronger than blockades: Landon had ardently advocated the use of native woods in 1801,[53] and the same early interest is

434 A desk and bookcase in mahogany, satinwood and maple, with verre églomisé panels, after a design by Thomas Sheraton; American (Baltimore), *c.* 1811.

process culminating in the early nineteenth century. 'Goût grec' was the forerunner: it restored cubic shapes to furniture. Most French secretaires of the 1770s and 1780s are simple cubes; the 'demi-lune' commode, a semi-cylinder (sometimes slightly flattened), became popular in England, France, and elsewhere; the surface of the semi-cylinder often lacks any relief ornament that might interfere with the simple shape. The 'encoignure', a quarter-cylinder, also became popular; it also was frequently given almost uninterrupted surfaces. The semi-cylindrical Russian commode in mahogany of about 1800 [360] is in this late eighteenth-century Anglo-French tradition; its two demi-lune shapes sit one above the other, and it is simply inlaid with straight brass 'fluting' on carcase and legs. Another striking use of elementary forms is seen in Socci's 'bureau mécanique' of 1807, of which Napoleon possessed an example [433]. When closed, the desk makes up a perfect (Greek) ovoid into which the three-legged chair is absorbed; in order to achieve the desired shape the designer produced that nightmare for the orderly, a desk with curved drawers. The brass inlay is composed in simple rectangles; the only overt antique feature is the Greek

influenced by Sheraton's *Drawing Book*, which was published in Leipzig in 1794, but the continuance of Romantic Classical architecture in Northern Europe and Scandinavia after its expulsion from Paris by Napoleon ensured a powerful immediate volumetric presence. Friedrich Gilly (1772–1800), an architect deeply affected by Romantic Classicism, taught the young Schinkel at the Berlin Academy; the result is evident in an uncompromisingly 'architectural', although astylar, secretaire designed by Schinkel in 1811 [436].

Karl Friedrich Schinkel (1781–1841) was one of the most interesting designers of the first half of the nineteenth century. Painter, architect, interior decorator, and designer of glass, porcelain and metalwork, he was primarily influenced by the antique and the Renaissance (although much attracted to Gothic and beguiled for a time by functionalism (p. 267)). This early secretaire has the overweening monumentalism of Romantic Classical architecture: the façade is articulated in squares and rectangles, and above the 'Cecilia Metella' pediment [477] is placed a severe vase of the same shape as the flared baskets seen on Greek vases; a perfect circle sits at the centre of the composition. Its richly dark burr-birch veneers are decorated with mounts in austere cast iron. Hardly yet 'Biedermeier', the piece has Biedermeier's elementary forms but lacks the extraordinary reconciliation with the flat plank that is the style's most striking characteristic.

435 A writing bureau veneered in mahogany and ebonized pearwood with gilt-bronze mounts; Austrian (Viennese), *c.* 1820.

436 A secretaire veneered in burr birch with mounts of cast iron, designed by Karl Friedrich Schinkel and made by Bernhard Wanschaff; German (Berlin), 1811.

evident in England (many George Smith designs of 1805 employ pale woods, *bois clair*). Their use continued until fashion changed again in the 1840s. In some areas of the house, such as the English dining room, mahogany refused to be displaced.

Geometry ruled a 'French Sofa' illustrated in April 1815 in Ackermann's *Repository*: 'The outline of the seat and back are described by equal radii, and are intersected by small ovals, that combine with them and form a long ellipse or oval…a portion of this severity is essential to the character of beauty, dignity and greatness.'[54] The sofa is described as French, but looks more German; Ackermann periodically visited his native Germany. It was in Germany and Central Europe that the most signal triumph of elementary forms occurred.

A Viennese mahogany writing bureau of about 1820 shows the Biedermeier style fully developed into its union of elementary forms and flat surfaces [435]. The design is dominated by a perfect circle of pearwood stained black, which contains within itself a rectangle that looks at first glance like a square. The geometrical severity of the piece is relieved by griffins and lion paw feet; these particular feet are realistic, but many Biedermeier animal feet are broadly modelled in a way similar to the abstracted animal feet on Greek vase furniture.

Whence came Biedermeier flatness? It was evidently thought highly important: 'this tendency towards flatness even outweighed the concept of honest craftsmanship…thus providing evidence that the interior dynamic [*sic*] of a style is always ultimately more powerful than any striving for truth to materials'– this even though much Biedermeier furniture was designed by practical craftsmen whose 'outlook…was…one of the most important constituent elements of the Biedermeier style'.[55] The origin of Biedermeier flatness was therefore purely stylistic. Flatness dominates the large unadorned surfaces of cubic Romantic Classical architecture, but is also noticeable in furniture depicted on Greek vases [3]. Vase furniture tends to look flat because the painting technique, essentially linear and decorative, lacked shadows and had little perspective. Apart from that, stylistic flatness was inherent in much actual Greek furniture. The Greek chest, for example, expresses flatness [9], and its flatness was not just a vase-painting convention – the construction of ancient surviving chest-coffins from Egypt and Russia, which are directly related to contemporary Greek chests, emphasizes the board or plank in a Biedermeier way [441]. Another highly influential Greek invention, the cut-out couch, was startlingly ruled by the boards from which it was manufactured. Its primitive flatness, utterly foreign to the conventions that ruled European seat furniture before the advent of the 'Etruscan' fashion, was now taken up with zest. It even affects Biedermeier seat furniture that does not quote the cut-out

437 A worktable in the form of a globe on a tripod, in mahogany and maple with gilt-bronze mounts; Austrian (Viennese), *c.* 1820.

438 A pier table in gilded wood from the Queen's Drawing Room in the Königsbau of the Munich Residenz, probably designed by Andreas Gärtner; German, *c.* 1806–10.

439 A secretaire veneered in mahogany and maple with ebonized pearwood, and gilt carved ornament; German (Hanover), *c.* 1815.

idiom: for example, a sofa [440] that little resembles the Greek cut-out couch strikingly reproduces its flatness from one viewpoint – the side.[56]

A form that recurs in post-rococo neo-classical furniture is that of the ancient lyre. The lyre is Roman as well as Greek, but its frequent appearance on Greek vases made it a leitmotif of the 'Etruscan' style. It often occurs in secretaires, for emblematic reasons – Apollo, god of the lyre and the arts, was also god of literature. A Viennese secretaire in mahogany with carved and giltwood details and gilt-bronze mounts of about 1810 owes its basic shape to the lyre[57] – the giltwood acanthus and paw carving is sculptural and vigorously executed, as are the abstracted cornucopias that decorate the sides. Lyre strings appear as mounts on the front of another example.[58] The fully developed Biedermeier version of the lyre form, in which volume has surrendered to flatness, is seen in a secretaire of about 1815 made in Hanover [439]. All its ornament is Greek, and the paw feet are splayed outwards in the manner of ancient Greek tables.

A superb table of about 1830 by a Parisian specialist in *bois clair*, L.-F. Puteaux, is supported by lyres that have a volumetric weight derived from lyres realized in ancient sculpture [442].[59] The inlaid ornament (inlay now tended to replace marquetry) has 'Etruscan' motifs in plenty; the top has a pattern imitated from antique mosaics; swans, a favourite antique Roman motif that also appears in Greek

furniture, are also included. The style has some affinities with that of Pelagio Palagi. In 1830 Puteaux abandoned his craft for industrial production,[60] a sad exchange.

Smaller items of furniture followed the same fashions as larger. A lady's worktable [437] balances a perfect globe (awkward to construct in wood); it is decorated with signs of the zodiac and sits upon a tripod – celestial globes in antiquity always stood on tripods. A Pompeian painting reproduced in several publications [444] may have inspired a small table [443] that is a highly refined example of a type that recurs with a more solid stem resembling more closely the mural. Volume combined with slenderness appealed to Biedermeier designers, and the same combination informs a 'tulip' chair of which the upper half is influenced by the scroll-ended couch [551].

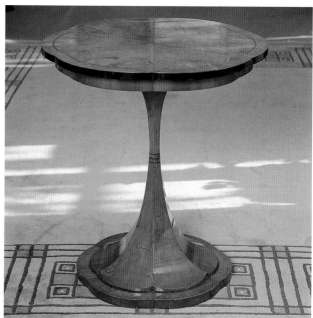

440 A sofa veneered on pine with birch, burr birch and other woods; Austrian (Viennese), c. 1825.

441 A wooden chest-coffin from Abusir, Egypt; Hellenistic.

442 A table veneered in ash, sycamore and amaranth, by L.-F. Puteaux; French, c. 1830.

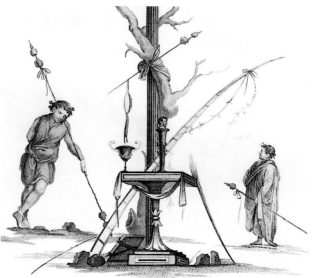

top 443 An occasional table veneered in walnut and cherrywood; Austrian (Viennese), c. 1820.

above 444 A sacrificial table, after a Pompeian wall painting, 'A Ceremony in Honour of Bacchus', published in Naples in 1765 (from *Delle Antichità di Ercolano: Le pitture antiche d'Ercolano*).

Chapter 3 The play of fancy

445 A throne with cornucopias and winged sphinxes, emblematic of fecundity and prudence, on a chalcedony cameo with Augustus and Roma; Roman, first century AD.

right **446** The cradle of the King of Rome, in silver gilt, by J.-B.-C. Odiot and P.-P. Thomire; French, *c.* 1810.

447 An X-frame chair in 'perspective', on a Roman coin, 44 BC.

448 A sofa in mahogany and split cane, attributed to Duncan Phyfe; American (New York), *c.* 1820.

STRONG as the 'archaeological' impulse was in the early nineteenth century, most furniture adventured beyond the boundaries set by its antique prototypes.

The simple antique X-frame stool and chair, the curule chair, was subjected to inventive variations. Its republican associations had made it part of the fierce iconography of the French Revolution. They may have encouraged the New York cabinet-maker Duncan Phyfe (1768–1854), a Scot who worked in a variant of the Hope style, to make a set of mahogany and cane furniture with X-legs [448]; the sofa's alignment of the legs arises from a misunderstanding of the perspective conventions of antique coins that show the legs of X-frame stools apparently ranged on one plane [447]. The label describes the X-frame as an American innovation!

Napoleon took to the X-frame for other reasons: his revival of court ceremonial gave new life to the X-frame palace stool: some *tabourets* made for his court can be classed as 'Louis Quatorze', as the revival style was known (it combined elements of both Louis XIV and Louis XV). For his military campaigns he used a utilitarian form [523]. The imperial associations of the X-frame must have encouraged its use for the cradle of the King of Rome [446], on whom the hopes of the new dynasty rested; the X is formed from crossed cornucopias, probably taken from the fructifying symbol seen on ancient thrones and consular diptychs [86, 445]. Crossed cornucopias occur in emblems in the sixteenth and seventeenth centuries with the motto 'Virtuti, Fortuna comes' – 'Good Fortune attends Virtue'.[61] The addition of the imperial eagle, Victory and laurel [65] crown holding the canopy reinforces the message; perhaps only the youth of the occupant prevented the addition of an associated motif, the trophy. Napoleonic fondness for such military associationalism prompted the invention and widespread dissemination of a stool the legs of which are crossed sabres – not, at the time, historical relics, but contemporary weapons (sabres were still being used in the First World War). The X-frame construction was also used for 'archaeological' re-creations; the excavations at Pompeii and Herculaneum introduced variants of the type, including an X-frame stool of which the legs ended in birds' heads [10:D]; this is similar to a modern variant popular in the 1790s, an X-frame with a round section that tapered to the foot.

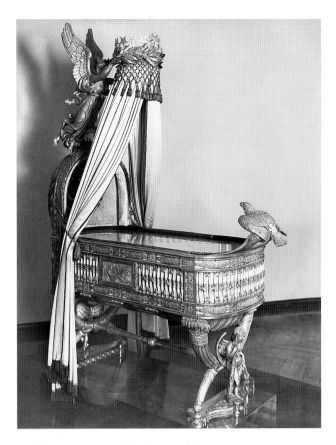

The appearance of the fashionable couch was transformed between about 1795 and 1805.[62] The typical English sofa of the 1790s, upholstered in fabric that prominently displays the velarium, is seen in a Sheraton design of 1793 [381]. The sofa employs a variant of the slender convex-turned antique leg that tapers down to a point or near point, a Greek and Roman form which had been adopted for tables and small pieces of furniture by the 1780s. Over the next twenty years, such dainty seat furniture was replaced by much heavier types based on antique models. Design tended to coarsen further as it moved away from its place of birth: a particular type of scroll-ended couch made in the United States, a variant of English and English-influenced German styles), that had already lost its fine edges, became quite beastly by the time it got to Peru.[63]

The three main antique types of couch – scroll-ended, square-ended, and the couch with gracefully tapering and turned-out ends that resemble a lyre [10:L, 20, 450] – had already been freely revived in the Renaissance, but re-creations and free variations now occurred on an unprecedented scale, far too many to begin to describe here.

A maquette for a scroll-ended couch in antique style [454], probably made in about 1800, illustrates the practice of supplying rich or exacting clients with a designer's or upholsterer's model; these might be made of wood, terracotta, wax, textiles, or a mixture of materials. This example is highly unusual in its extraordinary richness and perfection of finish; the couch is of superbly carved mahogany, its panels in verre églomisé bear allegorical devices and antique scenes, its gilt-bronze mounts have grotesques, palms and roses, its green velvet draperies are embroidered with silver and finished with scallops. The collars of the winged dogs that crouch within the couch's scrolled arms bear the inscription 'Fidelidad conyugal' and the initials 'C' and 'M': this identifies the clients as Charles IV of Spain and his notoriously unfaithful Queen, Maria Luisa, perhaps the most unsavoury royal pair to sit on a throne in modern times; their squalid features are immortalized in the

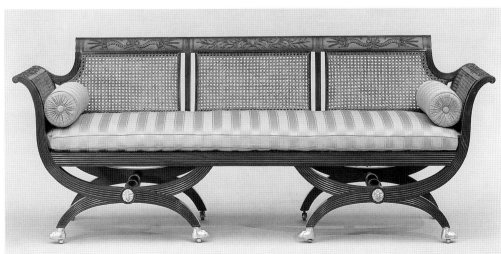

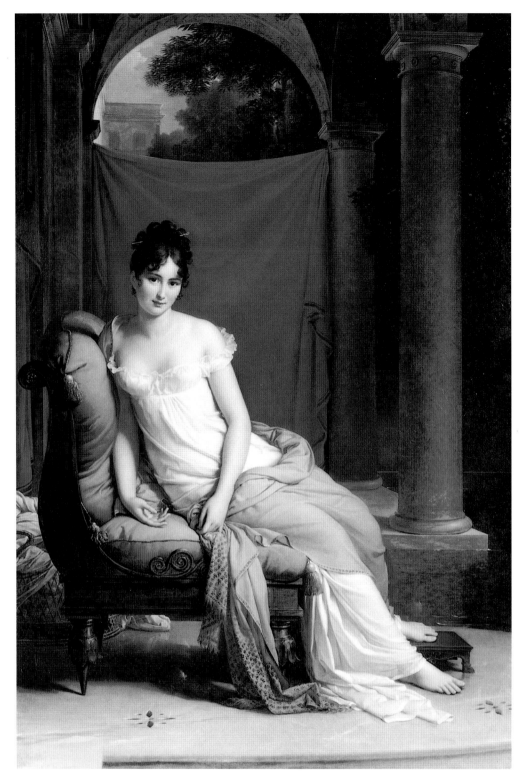

canvases of Goya. The dog is an old emblem of fidelity (p. 129); antique sphinxes [7] are at the couch's feet: does the association of dog with sphinx, as on Bess of Hardwick's table two centuries earlier [232], indicate an associated emblemism – perhaps fidelity and wisdom? The present dog might well have carried an extra meaning, since after Charles became king 'his one serious occupation was hunting'.[64] The royal hunting lodge, the Casa del Labrador [403, 404], was superbly furnished by a phalanx of artists of whom many were French; do the hint of eccentricity and the nature of the ornament in this design of great distinction perhaps point to Dugourc [377]?

An early English instance of the lyre-ended sofa was designed by Henry Holland;[65] he was influenced by French architecture and interior design and employed French designers and craftsmen. The couch ending in a scroll or lyre, with klismos, turned, or animal legs, became especially popular in the early nineteenth century in English and German-speaking countries: Sheraton published an influential design for such a 'Grecian squab' in 1802. A graceful scroll-ended couch with bobbin-turned legs and pointed foot based on the antique [21, 450] supports Madame Récamier in her famous early portrait by David; it may have been part of the studio furniture made in 1787 by Jacob. Thirty years later, the ageing beauty was pictured reclining on an eight-legged version of the same model, in pathetic and impecunious (but not unvisited) retirement in the Abbaye du Bois.[66]

In 1805, at her meridian and clad in antique dress of the most diaphanous texture, she was painted by Baron Gérard [449] sitting in a chair that has scroll ends and an accurate version of an antique turned Roman leg decorated with 'leaves'; the leg was still in fashion well into the 1830s. Turning in general now became fashionable: the exaggerated rounded or concave/convex turning seen on many antique couches, and some chairs, was extensively revived for all kinds of furniture, including tables, sideboards, and desks, the turned sections tending to become steadily heavier up to the 1840s. The turned baluster as it had developed in the Renaissance from hints dropped in antiquity was also revived; it became the preferred 'archaeological' alternative to the candelabraform column. A mannered armchair designed by Abildgaard in about 1790 [453] contains all three main types of turning – round, concave/convex, and baluster.[67]

Antique influences of a somewhat different order are apparent in Schinkel's highly accomplished sofa and chair of

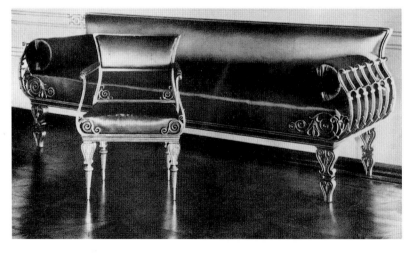

above left **449** A scroll-armed couch in antique style, in a portrait of Madame Récamier by Baron Gérard; French, 1805.

far left **450** A Roman scroll-ended couch with turned legs, from a bas-relief of the 'Death of Meleager', published in Rome in 1783 by J. Barbault (from *Monumens antiques*).

left **451** A sofa and chair in wood, iron, and gilded iron, designed for Prince Wilhelm's Palace, Berlin, by Karl Friedrich Schinkel and made by Karl Wanschaff; German, 1829.

1829 [451] which combine Greek Aeolic scrolls with wiry scrolls related to those depicted on chairs on Greek vases [3], the Pompeian 'sphinx' tripod [42] and Pompeian decoration [35]. The sides of the sofa even hint at a Gothic allusion! Large sofas, usually accompanied by a sofa table or a large round table, had become the lynchpin of the drawing room and were meant to focus the attention. Grandeur became a desirable characteristic of sofas: the revived square-ended couch had it in full measure, and Percier and Fontaine designed superb examples for Napoleon. The desire to

452 The throne of Venus, from a Roman wall painting, published in Naples in 1757 (from *Delle Antichità di Ercolano: Le pitture antiche d'Ercolano*).

453 A turned armchair in parcel-gilt beech, designed by N. A. Abildgaard; Danish, *c.* 1790.

454 A three-dimensional model design for a couch, in mahogany, gilt bronze and verre églomisé, and with contemporary fabric draped as 'antique drapery', about 15 in. (38 cm) long, made for Charles IV and Maria Luisa of Spain; probably French, *c.* 1800.

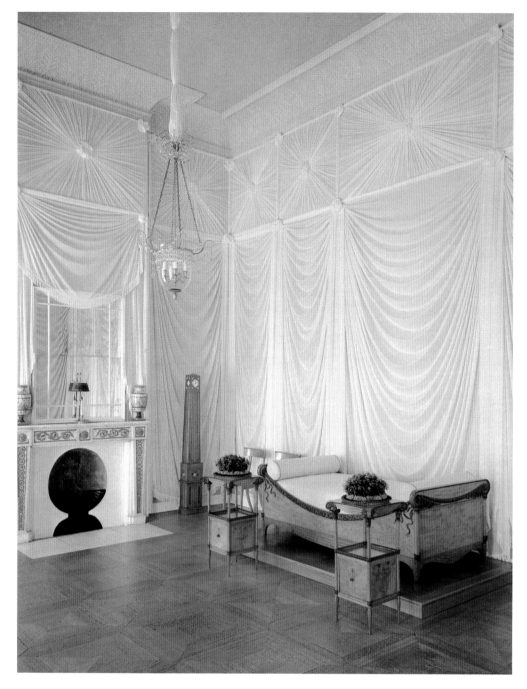

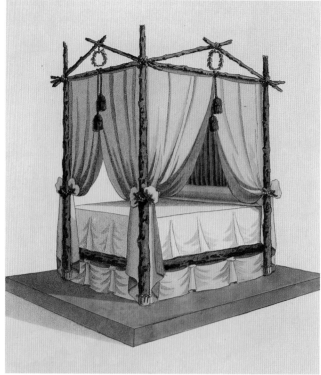

make sofas monumental and architectural led to the addition of a rectangular tablet or frieze to the back rail and to the combination of scroll end and square foot.[68]

The sofa also entered the bedroom, where it often displaced the traditional bed. Ancient bas-reliefs and Greek vases were amongst the main sources for the innovation, but it had been anticipated in sixteenth-century paintings [181]. The change was dramatic. In place of the pillared bed with prominent headboard and footboard, hung with elaborately festooned curtains, came a couch lacking all the traditional appurtenances. The new simplicity invaded royal bedchambers: Schinkel's design for the bedroom of Queen Luise of Prussia at Charlottenburg [455] is luxuriously, fastidiously simple. The walls were hung with white mousseline over rose-pink wallpaper in the chaste folds of 'antique drapery' [39:E], the whole emblematic of morning mist and sunrise.[69] The bed ends are topped with an ornament derived from an elongated and be-garlanded

455 The bedroom of Queen Luise of Prussia, with furniture of carved pearwood, in the Neue Pavilion, Charlottenburg, Berlin, designed by Karl Friedrich Schinkel; German, 1810.

above right **456** A design for a 'Field Bed', by George Smith; British, dated 1805 (from *A Collection of Designs for Household Furniture* , 1808).

right **457** A sofa in carved and veneered woods; Spanish, *c.* 1850.

opposite **458** A dressing table and chair in cut glass, steel, verre églomisé and gilt bronze, designed for Madame Desarnaud-Charpentier by Nicolas-Henri Jacob; French, 1819.

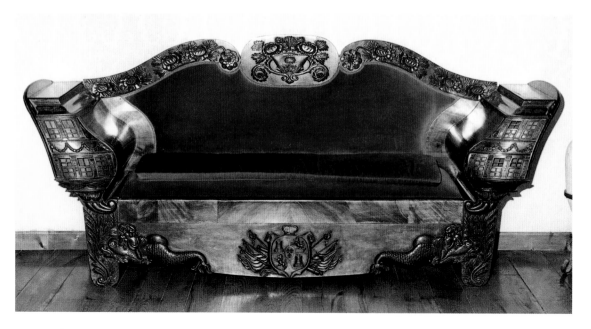

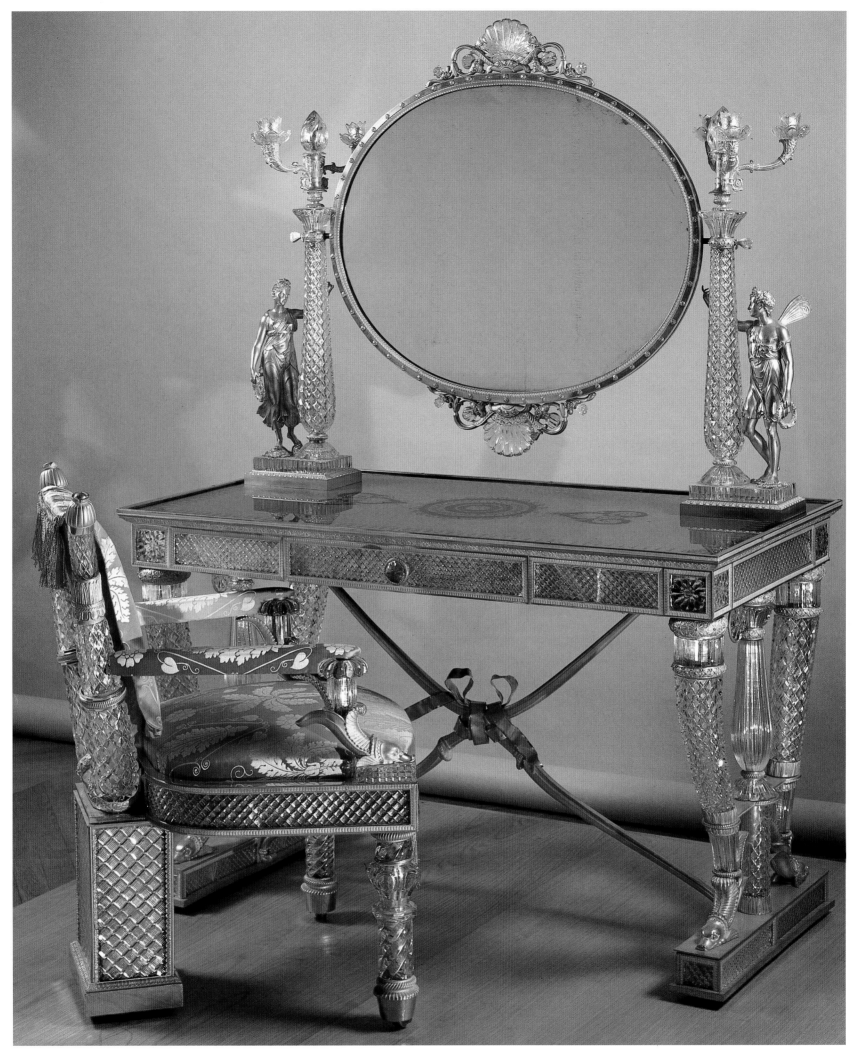

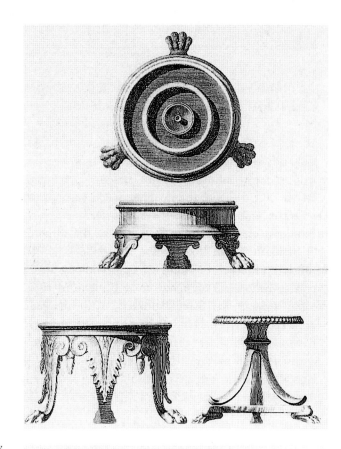

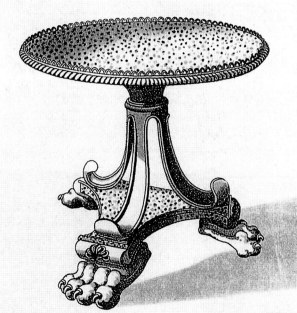

459 Bronze stands for lamps, excavated from Herculaneum, published in Naples in 1792 (from *Delle Antichità di Ercolano: Le lucerne ed i candelabri d'Ercolano*).

460 A 'Dejeuné Table' designed by by George Smith, with a top meant to be porphyry; British, dated 1805 (From *A Collection of Designs for Household Furniture*, 1808).

Ionic capital; does the bed owe anything to Lodoli's theory of the gondola as the supreme example of functionalism (p. 262), in which Schinkel was interested? It sits on a platform, a device also used by Percier and Fontaine; Schinkel hung the room with the plainest 'antique drapery' which everywhere replaced festoons as decoration. Not everybody desired their bed to appear naked and antique; a design by Percier and Fontaine for 'Madame de B. …à Paris' shows a compromise, a free-standing couch derived from the antique scroll-ended couch dressed up with 'antique drapery', a profusion of ornament, and crowned in muslin and passementerie.[70]

Roman bronze free-standing candelabra [45], of a type that went back to Etruscan times, were revived and employed for a variety of objects, ranging from academic copies of the originals to firescreens, tea-chests, and work tables. Hanging lamps copied antique bronze chandeliers and other antique bronze and alabaster hanging lamps; the graveyard lustre of their dark bronze was a striking departure from the glitter of other models – chandeliers draped with a magical web of festooned brilliants influenced in form by the hanging garlands of grotesque paintings, or made up of massed volumetric pendants influenced by the fashion for weighty elementary forms. Antique models also influenced gilt-bronze confections of the type seen in Percier's chandelier at Aranjuez with its winged horses [403]; the design recalls a well-known model by Boulle.

Ancient metal artefacts of diverse types were used by designers for objects far removed from the original; for instance, George Smith published in 1808 a design of 1805 for a 'Dejeuné Table' [460] that, apart from acquiring a porphyry top and base, was taken unchanged from a Pompeian brazier stand illustrated in the *Antichità di Ercolano* of 1792 [459]. A stand supported on three dolphins (a symbol of Aphrodite) illustrated in the same volume widely influenced table design. And did yet another depiction from the same source, that of a Roman 'rustic' torchère [45], influence the design of Smith's extraordinary 'Field Bed' [456]? The idea of the skeletally rustic pediment and wreath may have come partly from Laugier's insistence on the primitive wooden temple as the archetype of Greek architecture.

Percier and Fontaine always kept grotesque 'gaiety' under control. Other designers allowed free rein to the imaginative excesses inherent in grotesque, and high fantasy rendered the sofa a theatre of experiment it had never (in that sense!) been before. Animal legs, dolphins, cornucopias, swans, roses, all the armoury of pagan mythology found a place on the sofa. Fantasy is prominent in the broadsheets of La Mesangère (1761–1831), who from 1802 to 1835 issued a *Collection de meubles et objets de goût* as a supplement to a fashion magazine. The same genre of fantasy occurs in designs by the Viennese Joseph Danhauser (1780–1829), in which the fanciful use of draperies, elaborated versions of the baldacchinos of grotesque, is carried to imaginative extremes. A Spanish sofa of the mid nineteenth century adds maritime romanticism to a depraved antique shape [457]. Sometimes fantasy and gaiety lay in the materials of which furniture was composed as much as in its form. An audacious dressing table and chair of 1819 [458] designed by Nicolas-Henri Jacob (1782–1871), a pupil of David, was sold from 'L'Escalier de Cristal' in the Palais Royal in Paris, the shop of Madame Desarnaud-Charpentier. The furniture is mounted on steel frames and made of gilt bronze and glittering diamond-cut glass, a genre that Madame Desarnaud-Charpentier claimed to have inaugurated. The table top is verre églomisé in black and gold on blue, the chair's back is in a lyre shape made up of dolphins, and the legs of the table suggest both the X-frame and the cornucopia. It seems likely that they were part of the furnishings of the Duchesse de Berry's château of Rosny, described in 1828 as 'également recherchées et soignées'.[71] Antique luxury and 'effulgence' had been surpassed.

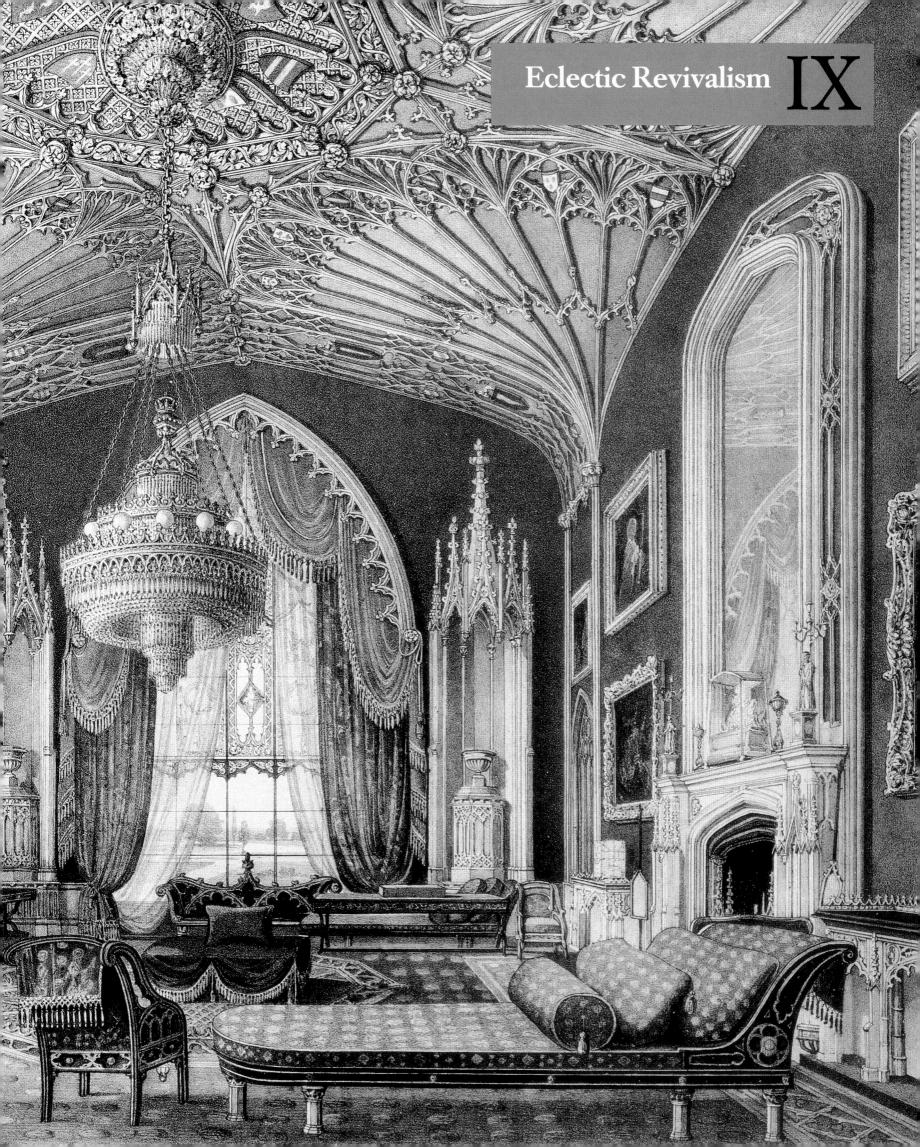

overleaf **461** The drawing room,
Eaton Hall, Cheshire, by William
Porden; British, 1826 (from
J. Buckler, *Views of Eaton Hall*).

Early Gothic revivalism: sources and publications

Building in Gothic style practically stopped in the course
of the sixteenth century, and knowledge of its principles of
construction waned. There were notable exceptions, such
as the scholarly reconstruction in the earliest years of the
seventeenth century of the ruinous Gothic east end of
the Abbaye aux Hommes at Caen – classicism having
been argued away. Notable examples of Gothic survival
(or revival?) occur in later sixteenth-century German art:
Dietterlin's *Architectura*, for example, displays antique motifs
overlaid by grotesque and suffused with the heady fin-de-
siècle atmosphere of late Gothic; Victor Hugo and Notre
Dame would have felt quite at home with his deranged,
intensely wrought beasts. Despite the revivals, Gothic
ornament steadily lost ground in fashionable furniture,
although traces persist in vernacular furniture up to and
beyond the eighteenth-century Gothic Revival.

The association of Gothic with grotesque fantasy
continued intermittently in the seventeenth and eighteenth
centuries. Ladies in fifteenth-century dress stray occasionally
into Berainesque grotesques; it was probably through
grotesque that Gothic ornament entered rococo. The
Berainesque grotesque/chinoiserie tapestries designed for
Beauvais in the 1680s contain whimsical Gothic vaulting,
pendants and cusping [569]; another tapestry from the same
set is dominated by large-scale cusped Gothic ogee arches
framing Gothic vaults beyond, supported on exiguous
grotesque pillars.[1] The Gothic element in rococo often hints
rather than states; for example, Oppenord elongates the
antique velarium into a cobweb that foreshadows the
velarium's later synthesis with the Gothic fan vault.[2] In
England, the relationship between grottoes and Gothic led to
Gothic and grotto garden furniture becoming virtually
synonymous. As English interest in Gothic increased, its un-
Vitruvian irrationalities attracted praise rather than censure:
the Regency arbiter of taste, Richard Payne Knight, whose
interests were centred in antiquity, averred that the 'crowded,
capricious, unmeaning [exactly the grounds of Vitruvius'
objection to grotesque] ornaments' of King's College Chapel
in Cambridge made up a whole 'more rich, grand, light, and
airy, than…any other building known, ancient or modern'.[3]

A Gothic architectural resurrection occurred in
seventeenth-century England, and generally speaking the
Gothic Revival in architecture, decoration and furniture for
the next hundred years was an English phenomenon.
Literature and romantic associationalism played a decisive
part: 'It was the revival of classic letters which induced the
imitation of classic art. It was the love of mediaeval lore, of
Old English traditions, of border chivalry, which by the
magic power of association, led the more romantic of
our sires and grandsires first to be interested in Gothic
architecture, and then to discern its beauties.'[4] The
conventual ruins left by Henry VIII, regarded as romantic
almost from the time of their creation (p. 90), forged an
alliance between Gothic ruins and the antique ruin cult.
From the 1730s onwards, English gardens were littered
with fake (and real) Gothic ruins.

New buildings in Gothic style appeared in England from
the 1650s onwards: Wren's essays [462] are well known. In

462 Tom Tower, Christ Church,
Oxford, designed by Sir Christopher
Wren; English, 1681–82.

1699 the *London Spy* declared that Henry VII's Chapel at
Westminster 'justly claim[s] the admiration of the whole
universe' and that old Northumberland House had 'much
more beauty than…any modern building'.[5] Sir John
Vanbrugh reproduced Gothic castellations; Nicholas
Hawksmoor's Gothic towers in a Gothic quadrangle at All
Souls ('the most debased travesty of Pointed Architecture in
Oxford'[6]) achieved a dreamlike beauty. Apprehensions were
voiced in 1711 that 'our immediate Relish' for Gothic, which
had led to the hasty proliferation of '*Gothick*' spires on
London's skyline – the spire is a Gothic form, however
classically clad – would result in later censure;[7] the writer
hardly foresaw that, on the contrary, the taste for Gothic
would grow until complete Gothic interiors [461] would
be installed in houses crowned with a forest of cast-iron
pinnacles (and Wren's spires would be censured for
not being Gothic enough!).

Most early Gothic Revival buildings employed the style
decoratively rather than structurally, but some French critics
appreciated its architectural qualities.[8] The Abbé de
Cordemoy in 1714 praised Michelangelo for having entered
into the taste for ancient architecture whilst retaining what
was good in Gothic,[9] and wrote that it was impossible to
enter certain Gothic churches without being seized with
admiration 'and a secret joy compounded of veneration and
respect'.[10] The joy, be it noted, had to be 'secret'! Soufflot and
Laugier both thought highly of the structural system of
Gothic; the former imitated it. Nonetheless, French interest
in Gothic remained cerebral long after the English had
covered their land with Gothic houses and follies, inserted
Gothic windows into Palladian houses, installed Gothic
drawing rooms, galleries and libraries, and put their
dowagers' rumps into Gothic chairs.

What sources existed in the early eighteenth century for
those wishing to design Gothic decoration and furniture?

A multitude of impressive ecclesiastical and secular
Gothic buildings still stood, the latter more plentiful and rich
in Flanders and Germany than England. Gothic paintings
survived, especially of the fifteenth century [146], and
illuminated miniatures [138] were a genre that greatly
interested collectors. There was little Gothic furniture, and
by the time of Horace Walpole (1717–97) confusion
prevailed – mediaeval, sixteenth-century and seventeenth-
century furniture was thoroughly mixed up in people's minds
The great Regency Gothicist and connoisseur, William
Beckford, was very shaky on this point. The paucity of
scholarly books illustrating Gothic style was a major
handicap for architects, artists, and designers; those that did
exist were meant for antiquarians rather than designers.
Two early examples were Wenceslas Hollar's illustrations to
William Dugdale's *Monasticon Anglicanum* (1655–73) and
Dugdale's *History of St Paul's Cathedral* (1658), the second
better illustrated than the first; there was also Montfaucon's
Les Monumens de la monarchie française (1729–33), a mixed
bag that was short on spiky Gothic. The contrast between
these lonely pioneers and the crowd of publications on
antiquity is striking, although Gothic books increased in
number as the century wore on.[11]

463 'A Gothic structure Not only Ornamental...', a design by Paul Decker, published in London in 1759 (from *Gothic Architecture Decorated*).

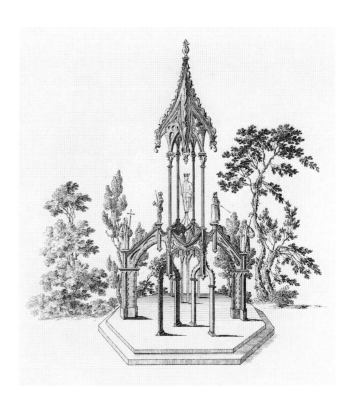

By 1670 Gothic woodwork had begun to be imitated: 'Perpendicular' choir stalls were installed within the Norman architecture of the cathedral at Durham. A lady said of Longleat that 'when my father died [in 1708], I still remember his lamenting that my grandfather had taken down the Gothic windows on the first floor…the present Lord Weymouth…ordered…the old windows to be restored.'[12] By 1724, Gothic was being canvassed for English domestic interiors: 'I judge for a gallery, library or the like, 'tis the best manner of building, because the idea of it is taken from a walk of trees, whose branching heads are curiously imitated by the roof', wrote the antiquarian William Stukeley,[13] who later (1740) asserted that York Minster surpassed the Pantheon and St Peter's,[14] the two supreme masterpieces of antique and modern architecture. English Gothic design (which means also continental European Gothic design) was created by Kent, Chippendale, Walpole, Wyatt and Beckford; Walpole launched and Beckford sustained Gothic interior decoration, the essential prerequisite for a widespread revival of Gothic furniture.

The first fashionable interior that might have seemed to demand Gothic furniture was that of the thatched 'Merlin's Cave' at Kew, a garden building designed by Kent for Queen Caroline and completed in 1735. Its room had Gothic vaulting supported on tree columns; the two bookcases in a Kentian classical style with pediments that stood in it were 'Gothic' only in that they were twiggy (although Kent designed silver for the Cave in Gothic mode).[15] Kent's Gothic activities were multiple; he designed Esher Place in Surrey in Gothic style from the 1720s onwards and installed a Gothic dining room in the late 1730s for Rousham. By the 1740s the English Gothic Revival was becoming a general fashion.

Kent's most influential follower, the engagingly named Batty Langley, built on Kent's work by publishing in 1742 the earliest Gothic designs, *Gothic Architecture Improved by Rules and Proportions*; the scorn of a growing band of would-be purists did not impede its republication up to after 1787.[16] Langley owes much to Kent; he attempted to synthesize Gothic with the antique by applying the ogee arch and quatrefoil to classical structures, and tried to create Gothic 'orders' in ways analogous to the sixteenth-century creation of grotesque orders. He recommended the 'Saxon' style for 'all parts of private buildings; and especially in Rooms of State, Dining Rooms, Parlours, Stair-cases, &c. And in Porticos, Umbrellos, Temples and Pavillions in Gardens, Parks, &c.': despite this clear invitation to interiors that might need Gothic furniture, he shows none. Another useful manual, which included 'Designs of the Gothic Orders, with their proper Ornaments', was published in London in 1759 by Paul Decker the younger;[17] it was directed towards

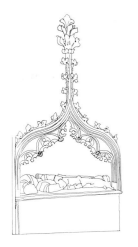

464 A cusped and crocketed ogee arch on the tomb of Lord Berkeley in St Mark's, Bristol, 1461.

465 A design for chairs in Gothic style, by Matthew Darly; British, 1750 (from *A New Book of Chinese, Gothic and Modern Chairs*).

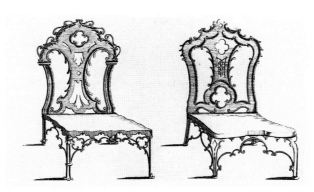

gardeners, but the garden buildings depicted were versatile: 'A Gothic Structure Not only Ornamental as in the figure But by different Coverings may be easily made a Tent, Temple or Umbrello'd Banqueting House etc.' [463] – or a gueridon or looking-glass. The whole of the second part of the book was devoted to Gothic palings, 'to which are added, Several Designs of Frets for Joiners and Cabinet-Makers'. Many of these could as readily be Chinese as Gothic (p. 277). Frets, indifferently Chinese and/or Gothic, became a positive obsession of furniture designers. Decker's book made much of twigs: 'Many [garden buildings]…may be executed with Pollards, Rude Branches and Roots of Trees…Being a taste entirely new.' Designers who set themselves to resuscitate a past style have a difficult task. The Gothic Revival of the 1750s, however, was not a serious, high-minded affair like the revival of antiquity at the Renaissance; it resembled the Chinese fashion (pp. 278–89) in its capricious inconsequence. It merely grafted 'Gothick' (the addition of the 'k' has become a rococo flourish) upon current fashionable forms. Rococo Gothic was succeeded by neo-classical Gothic, in which architectural Gothic motifs were imposed on antique forms such as the tripod; then came the Gothic of the turn of the eighteenth and nineteenth centuries, in which Gothic ornament was applied to forms (often antique) that shared the growing vogue for heaviness. It was not until the 1830s that true 'archaeological' Gothic made an appearance.

The earliest published Gothic furniture designs appeared in Matthew Darly's *A New Book of Chinese, Gothic and Modern Chairs* (1750, 1751) [465]. The chairs – confused, disproportioned, and inept – display cabriole legs, a cluster column leg, acanthus, elongated 'moresque' holes of which some have turned into Gothic, quatrefoils, ambiguous Gothic cusping/rococo C-scrolls, curvilinear and geometrical interlace and fretwork, and so on. This welter of ornament makes the first truly Gothic designs, those of Chippendale in the 1754 edition of the *Director*, look controlled and orderly, quite an achievement. Chippendale skilfully applied Gothic, Chinese, and rococo ornament to current furniture forms: his artful combinations (which indeed hardly bear close

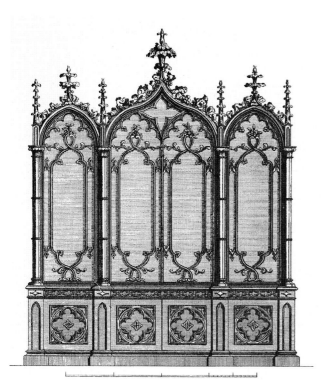

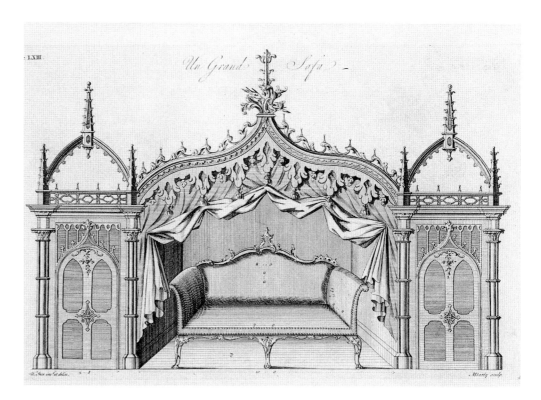

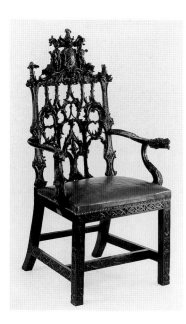

466 A design for a Gothic bookcase, by Thomas Chippendale; British, dated 1753 (from *The Gentleman and Cabinet-Maker's Director*, 1762).

467 A design for 'Un Grand Sofa', by William Ince; British, *c.* 1762 (from *The Universal System of Household Furniture*).

468 The Master's chair of the Joiners' Company, London, in mahogany, carved by Edward Newman; British, 1754.

analysis) were open to ridicule from solemn aesthetes. His popular pattern-books showed furniture divorced from any context, a practice that encouraged growing tendencies towards stylistic fragmentation (they greatly intensified in the next century).

Amongst the best-known of Chippendale's Gothic designs are his richly capricious chairs, which freely combine pointed arches, ogee arches, lancets, arcades, crockets and cusping with rocaille and rococo scrolls; they make much use of the ambiguous Gothick/Chinese fret.[18] Their backs are often based on Gothic windows and arcades, an 'architectural' motif common in mediaeval Gothic furniture [118, 131]. 'Chippendale' Gothick fantasy is beautifully illustrated in a magnificent confection made in 1754 (the year of the first edition of the *Director*), for the Joiners' Company [468], a complex hybrid of Gothic, antique, rococo and Chinese motifs; the Gothic tracery of the back includes cartouches. Chippendale also made designs for Gothic bookcases; an example first published in the 1754 book [466] is equipped with the ogee arch, an accommodating and hugely successful motif – it is both Gothic [464] and oriental, and its return curve made it easy to integrate with rococo. The glass doors are treated as lancet windows within cluster columns, and have interlaced panels inserted (Gothic gave plenty of opportunities for the broken curve); there is much use of cusping. All is profusely garnished with foliage and crockets; the capitals display branches, grapes and vine leaves that have been endowed with the rounded ends of the conventional acanthus. Rococo details accompany the Gothickry. Despite such mixtures, Chippendale's Gothic bookcases are less idiosyncratic than his chairs, and, tidied up, set the pattern for the drier 'architectural' Gothic bookcases of the later eighteenth and early nineteenth centuries.

Ingredients similar to those used by Chippendale occur in a less accomplished but quite beguiling 'alcove ornamented in the Gothic Taste; with a sofa adapted to the whole side of a room', published in about 1762[19] [467]. Lambrequins are added to the ogee arch, and the interlace on the doors resembles that on 'Chippendale' chair backs. The whole is

organized in the manner of an architectural façade [462]. The rococo sofa has nothing Gothic about it. This association of Gothic and rococo was to last well into the nineteenth century.

Horace Walpole's gothicization from 1747 onwards of Strawberry Hill concentrated Gothic-disposed minds: in 1764 he published *The Castle of Otranto*, the first Gothic novel, a trashy but zestful production that seduced the most jaded sophisticates into Gothic joys. It set a fashion, and henceforth the Gothic Revival in England was to be powerfully aided by literary effusions (it is surprising that it took so long for Gothic narrative furniture to evolve, since carved furniture easily tells a story). In the 1820s, Walter Scott was to transform the buckram and pasteboard of the Gothic novel into flesh and blood, a prelude to 'archaeological' Gothic.

Walpole had 'a strange ingenuity peculiarly his own, an ingenuity that appeared in all he did…with the Sublime and the Beautiful [he] had nothing to do, but…the third province, the Odd, was his peculiar domain'.[20] Strawberry Hill, a country house near London called by the classicist Sir William Chambers 'a barbarous den'[21] and by the rival Gothicist Beckford a 'gothic mousetrap', was for Walpole 'My gothic Vatican of Greece and Rome' – an adaptation of Pope's *Dunciad*: 'A Gothic Vatican! Of Greece and Rome/Well purged'.[22] Well purged or not, the house contains backwashes from the antique. The Library bookcases [470], taken from an illustration in Dugdale of old St Paul's, are certainly unequivocal architectural Gothic; they have the ogee arch, as do Berain's tapestries, but lack Berain's, or even Chippendale's, sense of fantasy. But elsewhere… the Gothic fan-vaulting of the Gallery glitters with mirror glass; the Library ceiling, painted in 1754 by Andien de Clermont (who specialized in grotesque) is in Gothic mode, and yet…? It is understandable that artists trained in antique styles retained lingering traces of their training, but Walpole himself did not bother overmuch about consistency: antique ossuaries squat beside the Gothic bookcases, and he sits in a contemporary chair. It has been suggested that the chair might have belonged to the artist,[23]

but Muntz must surely have gone to Strawberry to depict the Library, and why not paint client (and chair) in situ? The most likely explanation of the modern chair is that, as Walpole's friend, the poet Gray, wrote, 'every chair that is easy is modern, and unknown to our ancestors'.[24]

In fact, the scarcity of especially designed free-standing Gothic Revival furniture at Strawberry is surprising. The chairs for the Great Parlour were delivered in 1755; like some of Chippendale's chairs, their backs imitated those of 'architectural' mediaeval chairs, using curvilinear tracery influenced by the Decorated style. They are agreeable enough, but lack the inventive charm of Chippendale's 'Gothick' published the year before. They are ebonized, probably in homage to the highly prized late seventeenth-century East Indian ebony furniture that Walpole thought was Tudor (Beckford shared the delusion). The chief significance of Strawberry's furnishing is that it seems to have been the first extended example, an immensely influential one, of deliberate eclectic furnishing: this is the fashion that, justified by the Picturesque doctrine of 'intricacy' and espoused by influential figures such as Beckford and the Prince Regent, eventually swept the world. It is typical of English taste that its most all-pervasive gift to the furnished interior has been confusion.

A splendid library table in mahogany and pine [472] was made in about 1758 for the Countess of Pomfret's Gothic Revival house in central London, 'Pomfret Castle'; the designer may have been Henry Keene or Sir Roger Newdigate, both Gothic enthusiasts.[25] Most of the detail – cluster columns, quatrefoils, etc. – is unambiguously Gothic. Only the cusping on the large rosettes identifies that dominant motif as Gothic; otherwise, substantially the same interlaced motif appears on antique Roman ceilings as it does on a grotesque ceiling by Robert Adam at Mersham le Hatch (the central feature, placed within a velarium[26]) and on grotesque ceiling designs by Adam's assistant, George Richardson, which he expressly said 'may also be serviceable to several proffessions' (p. 197).[27] The shape of the table and its articulation with columns, frieze and plinth correspond almost exactly with the equivalent parts of the neo-classical Chippendale desk formerly at Harewood House in Yorkshire.[28] The kneehole arch is round, not pointed.

In singular contrast with the 'Chippendale' Joiners' chair of 1754 [468] is Robert Adam's earliest furniture design [469], an armchair conceived in 1761 but actually made in 1777–80. The two chairs measure the difference between Gothic furniture liberated by eclecticism and Gothic furniture guided by historical research. Adam's chair has

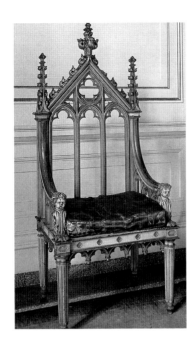

469 An armchair in carved, painted and parcel-gilt wood, designed by Robert Adam in 1761; British, made in 1777–80.

right 470 Bookcases, a chair and an ossuary in the Library at Strawberry Hill, in a portrait of Horace Walpole by J. H. Muntz; British, late 1750s.

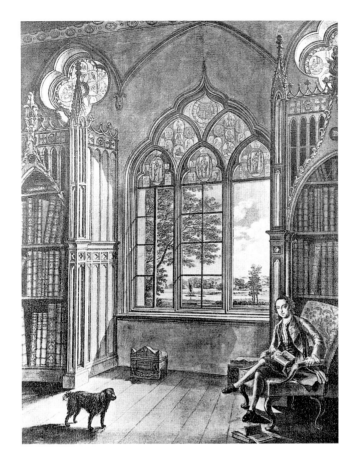

taken from the Coronation Chair in Westminster Abbey its general shape, arcades, quatrefoil and the forward sweep of the arms: apart from a few details, including the acanthus putti and perhaps the cluster column legs, it might have been made a hundred years later than its actual date. This genre of Gothic was taken up and forwarded by the architect and designer James Wyatt (p. 190), a highly influential figure in the Gothic Revival, who not only preserved Gothic when, towards the end of the eighteenth century, it seemed to be faltering, but whose family carried the Gothic flambeau well into the succeeding century. Had Wyatt not died in a coach accident, the Royal Pavilion at Brighton would have been Gothic (it has some Gothic detail).[29]

During the later eighteenth century the English Gothic Revival began to colonize Europe, including Russia. Italy showed herself indifferent: the Italian attitude is probably exemplified in the words of Bonomi (p. 204), who referred in 1807 to the 'thickest gothic clouds [of the fourteenth century]' and added 'I cannot help lamenting the revival of such absurdities in this Country [England], which had adopted a good taste…'[30] France gave signs of an interest

471 A chair in mahogany by Georges Jacob; French, c. 1795.

472 A library table in carved mahogany and pine, made for 'Pomfret Castle', London; British, c. 1758.

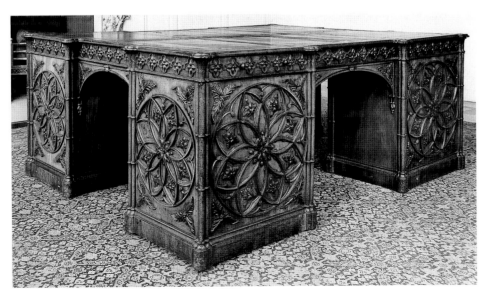

473 A rose window from the south front of Amiens Cathedral, France.

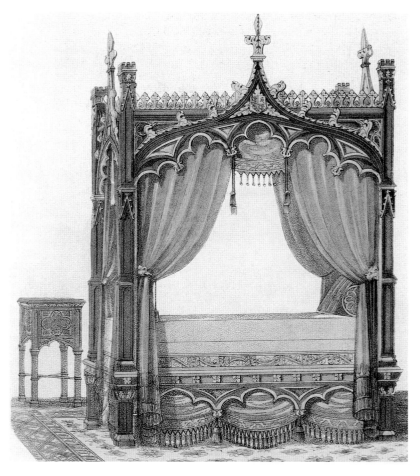

474 A design for 'A Gothic Bed'; British, 1827 (from Ackermann's *Repository*).

475 A design for a 'Cribb Bedstead', by George Smith; British, dated 1807 (from *A Collection of Designs for Household Furniture and Interior Decoration*, 1808).

prompted probably by 'anglomanie'. In 1780 Queen Marie-Antoinette's brother-in-law gave her a fete and tournament with fifty knights in mediaeval array; in 1791 the Théâtre du Marais in Paris was rebuilt in the 'gothic style…just like the architecture of our old chapels'.[31] A mahogany chair by Jacob [471] discreetly flirts with Gothic ambiguities: the shield with pointed corners was a Gothic and not an antique form, and occurs on fifteenth-century Gothic furniture; Jacob has exaggerated the arcs to make them even more 'Gothic'. The equivocal rosette recalls the Gothic rose window [127]. The form is probably based on shield-back 'Hepplewhite' chairs with modified klismos legs [394]. However, such exceptions proved the rule; the French attitude to the Gothic fashion is encapsulated in Madame du Deffand's tart comment: 'natural enough in a country which had not yet arrived at true taste'.[32]

In the 1790s, the remnants of French Gothic sculptures destroyed in the name of liberty were reassembled in the Gothic museum in Paris and attracted much attention, but by and large French hostility continued. The two greatest designers of Imperial France disliked Gothic: Percier rejected it as not created for 'us' ('cela n'est pas fait pour nous'!), regretting the English export of 'the taste for Gothic arches, little clusters of columns, stained-glass Gothic windows', and Fontaine considered 'that it was all too long ago for modern ways' (he was probably right).[33] This left England possessed of the Gothic field, not an unmixed blessing for either.

The dissemination of the Gothic Revival

Two English patrons of extraordinary abilities and outrageous character ensured the success of early nineteenth-century Picturesque Gothic. From 1797 the millionaire William Beckford (1760–1844) was building, with Wyatt as architect, the incredibly lofty Fonthill Abbey, an object of general astonishment throughout Europe and of emulation in England. The King, George IV, turned Windsor Castle during the 1820s into the greatest monument of castellated

Gothic Revival in Europe (his work has been recently compromised by the infiltration into St George's Hall of 'modern' style, an anomaly instigated by architects, politicians, 'political correctness', ignorance and indifference). Regency castles proliferated in England, and the fashion was exported to the Continent. Both George IV and Beckford had eclectic tastes, and neither Windsor (save for a few rooms) nor Fonthill was singlemindedly Gothic in its furniture. They hardly provided models for Gothic furniture.

English publications supplied modern Gothic furniture designs for amateur and professional; two had a European circulation. George Smith's *Household Furniture* of 1808 has many Gothic designs; his 'Cribb Bedstead' in Tudor architectural Gothic [475] contrasts strikingly with the cradle made a few years later for the King of Rome [446]. The second publication, Ackermann's *Repository*, was periodically stimulated by peaks of activity from notable Gothicists to show Gothic designs; between 1825 and 1827 its Gothicism effloresced in a series of wildly spiky designs by the elder and younger Pugins; these mark the apotheosis of early nineteenth-century 'architectural' Gothic. A more sober 'Gothic Bed' of 1827, meant to be executed in 'rosewood and or-moulu' [474], conforms 'as much as possible' to the style of Henry VII; however, 'the posts at the four angles are of an earlier date, and resemble the carving on the tomb of Crouchback in Westminster Abbey'.[34] This was the period when people sat at a ' Gothic Whist Table' or 'Gothic Upright Piano-Forte' ('this instrument being totally unknown to our ancestors…we can merely decorate the given forms by traceries and other Gothic ornaments best calculated to assist the sound'[35]) before retiring to a 'Gothic Bed' in a room that held a 'Gothic Toilette' and a 'Gothic Looking-Glass' – the last supported by 'flying buttresses, which, while adding to the strength of the frame, detract nothing from the lightness of its character'.

The examples of Fonthill and Windsor led to other Gothic enterprises of which some, notably the extraordinary Eaton Hall, were filled with thoroughgoing Gothic furniture.

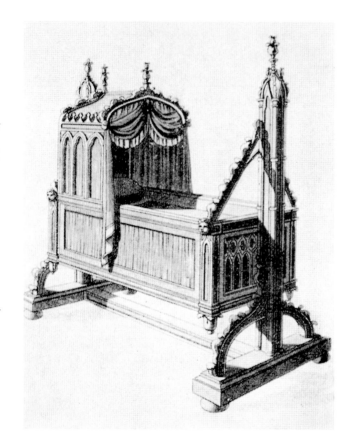

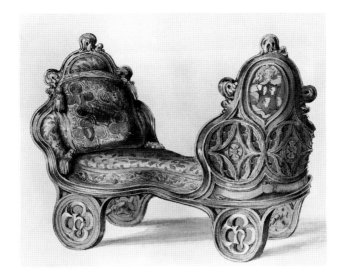

476 A design for a conversation settee, by L. N. Cottingham; British, c. 1842.

above 477 A Roman strigillated sarcophagus, the 'sarcophagus of Cecilia Metella': a drawing attributed to Pietro Testa, from the Paper Museum of Cassiano dal Pozzo, early seventeenth century.

below 478 A bed in carved mahogany; Swedish, c. 1830.

Eaton shows revived rococo picture frames hanging on the walls of rooms otherwise entirely Gothic [461]; this, the old association of the two great 'anti-classical' styles, rococo and Gothic, continued well into the new archaeological age; whole sets of revived rococo furniture were deliberately designed in concordance with Gothic Revival rooms.[36] An attempt at synthesis between Gothic and rococo is seen in a design for a massively squirmy 'conversation settee' [476] by L. N. Cottingham; the wheel-like legs prompt the fancy that the object is about to make its lumbering progress across a room.

The furniture of Eaton is one of the many examples of Gothic decoration applied to antique forms. The delightful impurities of 'Gothick' had been accepted in the same spirit as the stylistic melanges of Picturesque architecture inspired by the paintings of Claude and Gaspard Poussin which, as Payne Knight said in 1806, constantly showed 'a mixture of Grecian and Gothic architecture employed with the happiest effect in the same building; and no critic has ever yet objected to the incongruity of it'.[37] Gothic furniture frequently clings to remnants of antique form and ornament; people saw

nothing untoward in eclecticism if the result were agreeable. A charming Augsburg design of the early 1800s conjoins Gothic tracery with sprightly klismos legs [479]. In 1826 the *Repository* explained how 'from their vertical form' antique candelabra were 'well adapted to the Gothic style', and illustrated an example that resembles a Gothic pillar surrounded by an Eleanor Cross; in 1825 it said of a sofa very like the Eaton drawing room sofa [461] that it preserved 'the modern form…so as to combine the peculiar features of Gothic art [Gothic tracery] with the form that is now considered to afford the best accommodation for its purpose'[38] – in other words, non-archaeological comfort prevailed over Gothic accuracy.[39]

Gothic was also blended with the 'archaeological' antique. The influence of English design on Biedermeier encouraged the use of Gothic as a decorative trim: cathedral and classical sarcophagus combine in a Swedish mahogany bed of about 1830 [478], the head of which is topped with an 'opposed scroll' above a Greek fret, both abstracted from the 'sarcophagus of Cecilia Metella' [477]. Above the scroll is a floriated Gothic ornament that retains something of the late antique [74] and Romanesque acanthus; the foot is decorated with finials of flaming antique lamps with antique wreaths and columns below – antique flummery cheek by jowl with Gothic arches and cusping.

After the Bourbon Restoration in 1815, Gothic became fashionable in France as the monarchical and Catholic antidote to the imperial classicism of Percier and Fontaine. French Gothicism was encouraged by Chateaubriand, a tiresome poseur but a great writer who had seen modern Gothic in England. In the later eighteenth century France had produced both the 'troubadour' style of painting (probably yet another result of 'anglomanie') and a cult of Henri Quatre (d. 1610); troubadour painting became part of the general Gothic movement (even recruiting Ingres), and the cult of Henri Quatre was encouraged by Louis XVIII.[40] At the King's funeral in Notre Dame in 1824, the royal princes wore 'the violet mourning of the court' and 'costumes

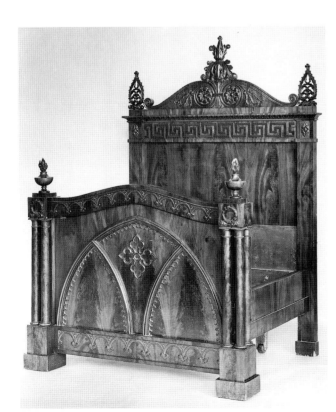

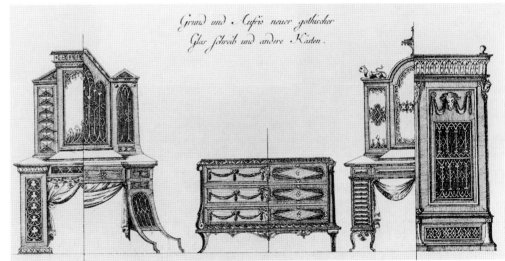

above 479 A design for Gothic furniture, by J. A. Dusch; German (Augsburg), c. 1800 (from *Entwürfe zu gothischen Möbeln*).

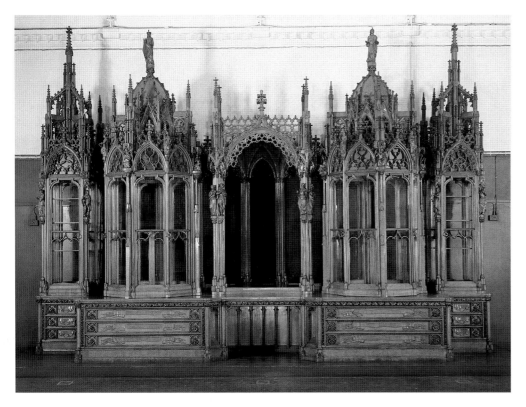

480 A bookcase and chest of drawers in carved oak given by the Emperor of Austria to Queen Victoria, designed by Bernardo de Bernardis and Josef Kranner, made by Carl Leistler and Son; Austrian (Viennese), 1851.

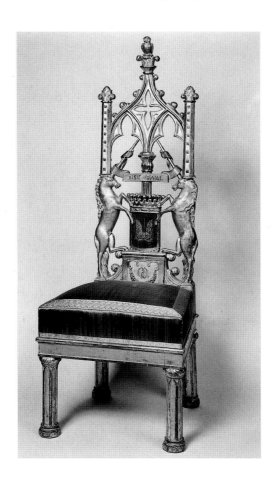

481 A clock in gilt bronze in the shape of Rheims Cathedral, by Bavozet frères et soeurs; French, c. 1835.

482 A chair in carved and painted giltwood from the 'cabinet gothique' of the Osmond family, by Jacob-Desmalter; French, 1817–20.

which recalled those of the last Valois kings'[41] (a dynasty that had ended in 1589); this dress, like that worn at the coronation of George IV in 1820 (and like the eclectic furniture of Fonthill), signalled the entry of 'Renaissance' motifs into the Gothic Revival.

English influence is obvious in a pair of fine giltwood chairs made between 1817 and 1820 for a 'cabinet gothique' of the Osmond family by Jacob-Desmalter [482].[42] Apart from the anomalous garland that hangs from the interlaced cusping at the base of the back, the Osmond chairs could have come from the pages of the *Repository*. Similar chairs

exist at Laxenburg near Vienna, bearing witness to an international English influence.

The French Gothic fancy led to some odd metamorphoses. One was the cathedral west front rendered in gilt bronze and reduced to fit the chimneypieces of Gothic drawing rooms [485]. The example illustrated depicts Rheims [481], and was reputed to have been composed of more than four hundred and fifty separate pieces. The fashion was probably encouraged by Victor Hugo's novel *Notre Dame de Paris* (1831) – in 1836 he was offered a clock that reproduced Notre Dame.[43] The idea was not confined to Gothic cathedrals; it embraced the Vendôme Column and other 'antique' monuments.

The Germanic nations had their own brand of 'architectural' Gothic. An oak Viennese bookcase and chest of drawers adorned with bronze figures was a present from the Emperor of Austria to Queen Victoria [480]; its cluster of domed and turreted apsidal chapels appeared in the 1851 Exhibition beneath Paxton's innovatory iron roof. No mediaeval domestic furniture ever looked like this. Ruskin must have been particularly annoyed to see the intercrossed and 'broken' tracery of the astragals: 'the point…of the German tracery consists principally in…cutting [good traceries] in two where they are properly continuous. To destroy at once foundation and membership, and suspend everything in the air, keeping out of sight, as far as possible, the evidences of a beginning and the probabilities of an end, are the main objects of German [Gothic] architecture, as of modern German divinity'![44] Broken tracery and banderoles, both of Gothic origin [108], occur also on a piece presented in 1850 to Ludwig I of Bavaria [484]; its free-wheeling romanticism is of a type that led inexorably to the Wagnerian drama of Ludwig II's impossibly romantic and Romanesque Neuschwanstein, begun in 1869.

The Gothic style was more than an affair of gay pointed arches and crockets; it encompassed *Der Freischütz* and the Haunted Glen. The mid nineteenth-century dining room of the Ohrada hunting chateau, an annexe of the opulently neo-Gothic/Renaissance/baroque Hluboka Castle in Bohemia, illustrates the aristocratic German fashion for antler furniture [483]. Stylistically, antler furniture is nearer to eighteenth-century twig furniture than anything else, but twiggy innocence is replaced by the savage spikiness of sixteenth-century German expressionism; one is reminded of some particularly ferocious Dietterlin prints. 'Anti-classicism' could go no further.

Later nineteenth-century Gothic Revival: the background

Although the light-hearted 'Gothick' of the eighteenth century persisted into the 1830s, it was doomed to die of seriousness at the hands of the new century.

Mario Praz categorized the nineteenth century – on which he had profound and disconcerting insights, and for which he had a great love – as 'That century which made use of every kind of exoticism and eclecticism to distract the restlessness of its exasperated senses and to make up for its lack both of a profound faith and of an authentic style'.[45] The restlessness and lack of authentic style were recognized by contemporaries, as was the prevailing bad taste of the buyer: 'if an article is of simple and good design…the ordinary furniture salesmen only call it "neat"'.[46]

The buyer often came from a class that had previously had little to do with the forming of taste – a class called by the English 'commerce'.[47] 'Commerce' used pejoratively did

483 Antler furniture in the banqueting hall of the Ohrada hunting lodge on the estate of Hluboka Castle; Bohemian, c. 1850.

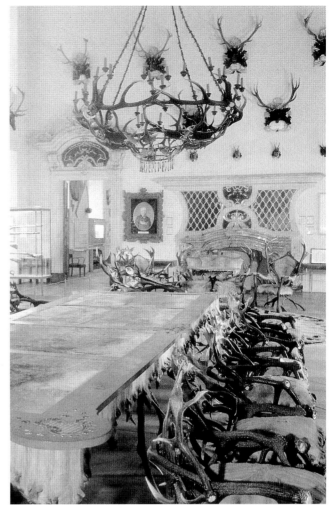

not mean industrialization, with which it has become confused:[48] it meant the new rich, people who had money but little taste or knowledge, who preferred gaudy ostentation to rich restraint and novelty to sound design. Hope had deliberately dissociated himself from 'commerce' and fashion, saying emphatically that though of merchant stock, he was not a merchant, and his furniture was designed to last for generations. He was fighting against the tide. English decadence of taste was bolstered by an assertive middle-class philistinism that disdained overt interest in decoration; Sydney Smith remarked of Hope's furniture book: 'A man of taste, if he be a man of leisure, will show it, no doubt, in his furniture, as well as in his dress: but he will infallibly make himself ridiculous, in this country, if he make a study and an occupation of such frivolous concerns.'[49] An ill wind blows when ignorance, self-confidence and wealth march hand in hand with mechanized execution. And so it was that England came to lead Europe (and North America) in bad taste. An Englishwoman who had lived on the Continent wrote in 1845–46 that 'the English surpass in folly all the nations of God's earth, and are more abject slaves to…the desire to keep up a certain appearance than the Italians are to priestcraft, the French to vainglory, the Russians to their czar or the Germans to black beer…frugality in dress, food and furniture [are] synonymous with vulgarity.'[50]

In France, a powerful bourgeoisie and a parvenu aristocracy wallowed in luxury: Mazois, 'one of the most learned pupils of M. Percier', compared contemporary French taste in 1824 with the decadence that followed Nero, when people sought not to be charmed, but to be dazzled and astounded, and when 'the noble and elegant simplicity

484 A carved desk in oak inlaid with palisander, ebony, mother o' pearl, mahogany, tin, brass and tortoiseshell, with gilt-bronze and enamel ornaments, presented by the art-workers and craftsmen of Munich to Ludwig I of Bavaria, designed by Peter Herwegen, made by Leonard Glink and Franz Xaver Fortner; German (Munich), 1850.

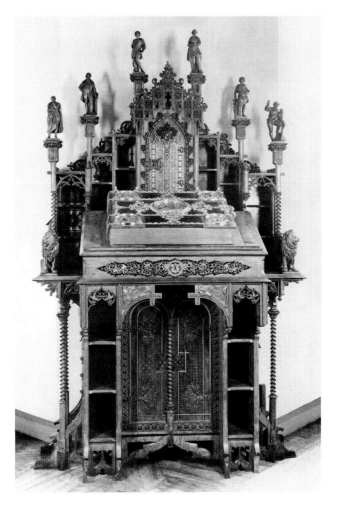

of the Greeks was replaced by a magnificent barbarism of which Asia offered the models'.[51] The ancien régime nobleman, Talleyrand, wrote that 'The luxury of these [European] courts founded by Napoleon…was absurd…neither German nor French; it was a mixture, a species of learned luxury; it was copied from everywhere. It had some of the gravity of that of Austria, with something European and Asiatic belonging to St Petersburg. It paraded some of the mantles taken from the Caesars at Rome; but, in return, it showed very little of the ancient court of France where the magnificence of dress was so happily concealed under the spell of all the arts of taste. That which this luxury set off above all, was the absolute lack of propriety; and, in France, where propriety is too much lacking, mockery is near at hand.'[52] Talleyrand died in 1838, but might well have mocked from hell an insanely luxurious French dressing table of silver, silver-gilt, enamels, garnets and emeralds [486] with which a Mephistopheles of stylistic impropriety, the French designer F.-D. Froment-Meurice (1802–55), tempted the Duchess of Parma. Its 'Louis Quatorze' table contests with 'Great Exhibition' naturalism and rococo and Gothic detail; the mirror has a Gothic arch, the two caskets are almost entirely Gothic, the candelabra are post-rococo neo-classical, and the ewer and basin Renaissance Revival.[53] Made between 1845 and 1851, the dressing table was shown in the Great Exhibition in London (p. 244).

Academic copying provided a safe if unexciting refuge from such anarchy: it came in all styles – antique, Gothic, Renaissance and rococo. In 1856, Owen Jones spoke of his age as 'an age of copying…when the works of the past are reproduced without the spirit which animated the

THE GOTHIC REVIVAL 241

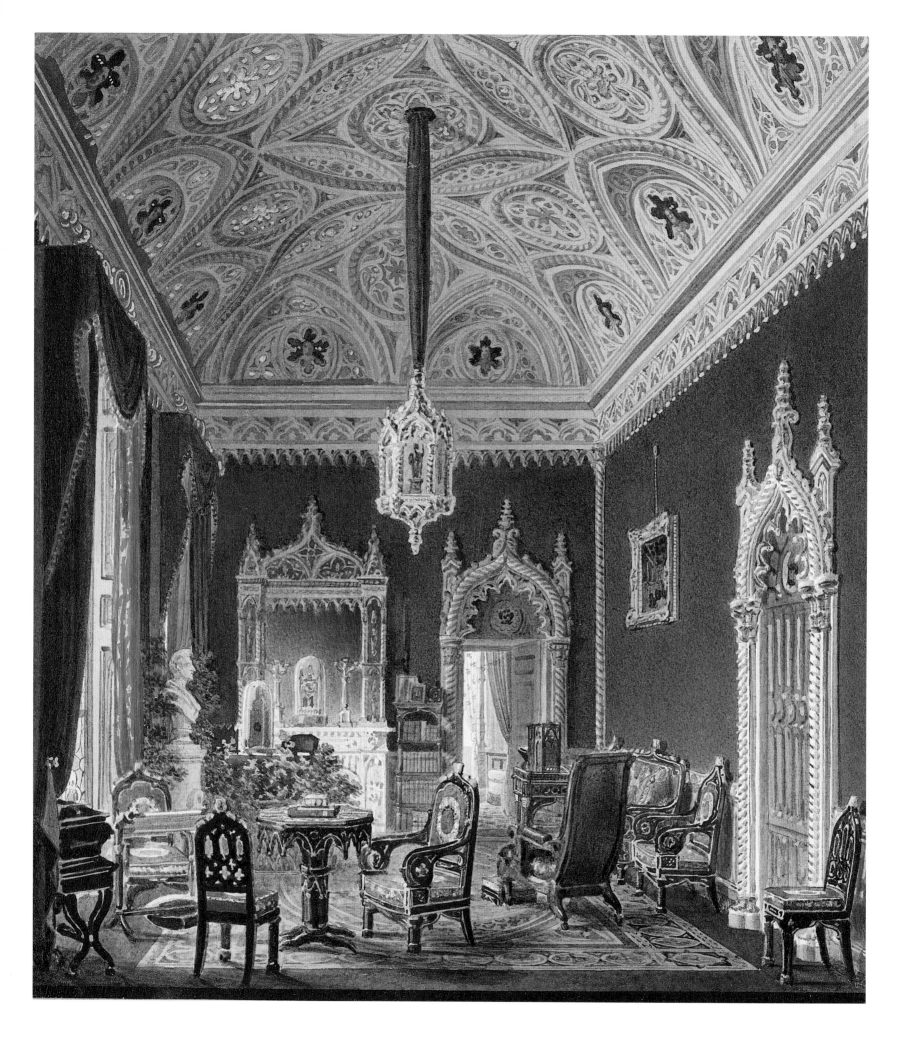

opposite **485** A drawing room in Gothic style; French, *c.* 1836.

originals'.[54] 'Servile' reproductions were made so brilliantly accurate (where the skills of the craftsman permitted) as to class as forgeries; some 'Renaissance' and 'Louis Quatorze' examples still reside in museums masquerading as originals, often assisted by the incorporation of old carved detail or panels of 'Boulle'.[55] Minutely accurate revivalism of this type will not be dealt with in this book, for reasons apparent in the one example given [510].

Designers had been exhorted from the eighteenth century onwards to learn from sculpture and works of art in museums. In 1802, Bonaparte's Minister of the Interior had had 'the idea of establishing museums in each department, and afterwards in Paris, for the purpose of exhibiting, at stated periods, the produce of national industry. This happy idea was immediately carried into effect.'[56] Napoleon paraded his loot from the private and public museums of Europe in procession through the streets of Paris before installing it in the Louvre. Everywhere the museum influence on design increased as the nineteenth century wore on; more public museums were founded, and the collections came to be studied by industrial designers who picked and chose motifs and historical styles according to fancy – much like going around a design supermarket and putting miscellaneous packets into a basket.

It was, unfortunately, not enough to look at great works of the past. Europe reached a point in the early nineteenth century when even the power to reproduce antique ornament with vitality and conviction, which had become

486 The dressing table of the Duchess of Parma, in silver, silver-gilt, enamels, garnets and emeralds, by F.-D. Froment-Meurice; French, 1845–51.

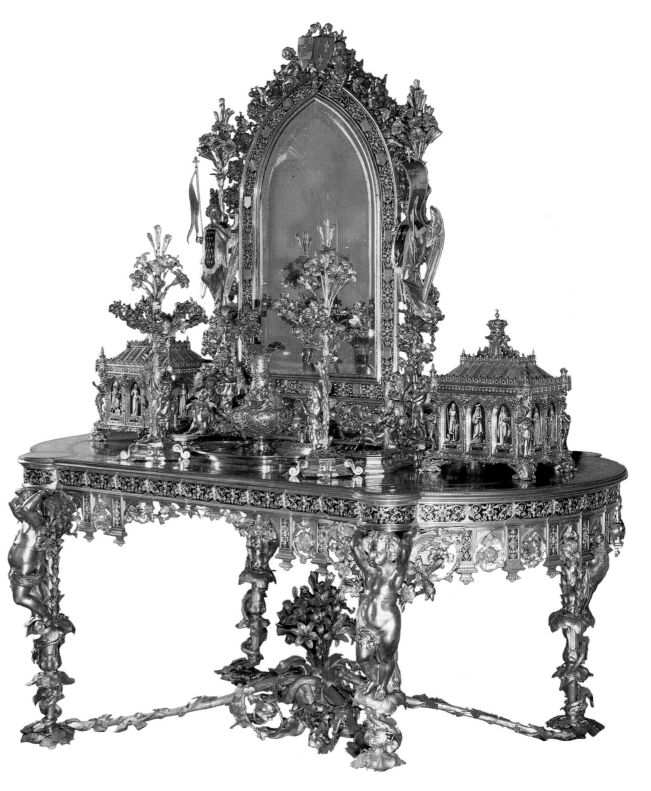

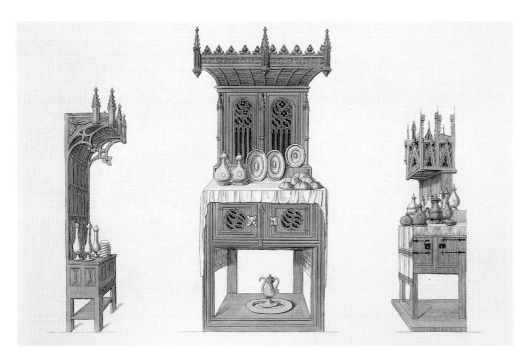

487 Fifteenth-century Gothic buffets copied from illuminated manuscripts, published in London in 1836 by Henry Shaw (from *Specimens of Ancient Furniture*).

second nature to designers and craftsmen in all media, faltered and faded. Familiar motifs were no longer rendered with the old mastery: a nineteenth-century historian remarked the inferiority of Napoleonic versions of the famous addorsed griffins from the Temple of Antoninus and Faustina to Renaissance interpretations: 'The fifteenth century had preceded the First Empire in a predilection for this motif, but where the latter has introduced heaviness and boredom, the Renaissance had distinction and charm.'[57]

Architects sometimes produced vigorously innovatory furniture, but their lack of interest in decoration was the subject of comment. The furniture reformer Charles Eastlake (p. 248) opined in 1878 that 'there is an intimate connection between the falling off in the excellence of our manufactures, and the tame vapid character which distinguished even our best painters' work in the early part of the present Victorian age'.[58] Great painters such as the Impressionists and Post-Impressionists stood aside from the official art of their century. Natural designers (like Ingres) concentrated on painting. This estrangement largely destroyed the painters' traditional role of giving a lead to the decorative arts. Painters who did deign to design furniture tended to be minor and/or eccentric, usually both: people like the Pre-Raphaelites [493], Alma Tadema [514], or Stuck [645, 659].

The tastes of the typical English Regency decorator John Gregory Crace may be gathered from remarks made in 1829 about Soufflot's Ste Geneviève of 1757 and the late rococo Opéra Comique: the former was 'very light and beautiful', but 'great fault could be found with the details'; the eclectic riot of the latter was 'the neatest I have yet seen in Paris…'[59] The Craces' own style was eclectic: the Duke of Devonshire said that the new grotesque decorations installed by the Craces in 1844 in the Lower Library at Chatsworth were 'something between an illuminated MS and a café in the Rue de Richelieu'.[60] It is hardly surprising that where they lacked a decent outside designer their furniture, however technically accomplished, is nerveless; they could not even copy old decoration without taking the guts out of it – *vide* their version of the Villa Negroni grotesques at Ickworth. This was one of the better decorating and furniture-making firms of nineteenth-century England.

The British on all sides recognized by 1850 that their design was catastrophically bad. After twenty years of attempts at reform, William Morris said in 1878 that 'I must in plain words say of the Decorative Arts, of all the arts, that it is not merely that we are inferior in them to all who have gone before us, but also that they are in a state of anarchy and disorganization'.[61] Complaints were focused on 'commercialism' and the decline in craftsmanship. The latter was not an inevitable accompaniment of industrialization (Wedgwood had improved standards of craftsmanship) but it was allowed in by the wane in taste and creative power – which, oddly enough, was general in the nineteenth century, reaching even the Far East. In England, Hope's search for craftsmen would have been even harder by the 1870s, when according to a contemporary, joinery was 'neither so sound nor so artistic as it was in the early Georgian era', brasswork was much inferior, and 'the ordinary furniture-carver has long since degenerated into a machine…a great deal of plain work is literally done by machinery'.[62] Five patents for carving machines were taken out in England between 1843 and 1845; in the latter year the most commercially successful of all, that of Thomas Jordan, was patented; it could produce undercut carving, and was chosen by Barry to make the acres of carving designed by Pugin for Westminster Palace – it reduced costs by sixty per cent.[63]

The industrialism of the furniture trade encouraged a phenomenon that had considerable influence on furniture design, for good and ill – the gargantuan Trade Exhibition, the fashion for which lasted up to and beyond the 1925 Paris Exhibition. France and England led the world in this development. The idea began in Napoleonic France; French design was stimulated by competitive craftsmanship, and between 1845 and 1880 the 'Union Centrale des Arts Décoratifs' was evolved with the aim of founding a museum of decorative arts orientated towards industry.[64] The desire of Prince Albert and the British government to improve British design led to the first international exhibition, the 'Great Exhibition' held in London in 1851; it financed a public museum of ornament (a serious subject in the 1850s) which eventually became the 'Victoria and Albert Museum'.[65] In 1864 the British example was imitated in the Vienna Museum of Applied Arts; other nations followed suit.

Another and completely different approach to the challenges of industrialism was the institution of trade 'guilds', which exerted a considerable influence on design (p. 249): the co-existence in one period of huge industrial exhibitions and a resuscitation of the mediaeval guild measures the yawning gulfs in contemporary society.

Gothic reform: Pugin and Viollet-le-Duc

In this new world, 'Gothick' became an anachronism; loss of frivolity meant the loss of its raison d'être; when it ceased to be entertainment, it had to become something else – and whatever it might become, it would have to be serious. Early attacks on stylistic latitudinarianism were unsuccessful; for some years 'Gothick' was protected by the uncertainties of the purists themselves: 'if we ask what they mean by *pure Gothic*, we can receive no satisfactory answer: – there are no rules – no proportions – and, consequently, no definitions'.[66] This gap was now filled.[67] As Charles Eastlake (1836–1906), an informed and progressive critic and designer who became a principal propagandist of Gothic reform (and Keeper of the National Gallery), later wrote, the 'publication of practical and accurately illustrated books on Gothic architecture may be considered as the main turning-point in the progress of the Revival'.[68] As was the publication of such books as Henry Shaw's self-consciously scholarly *Specimens of Ancient Furniture* in 1836 [467]. The temper of the age was bound

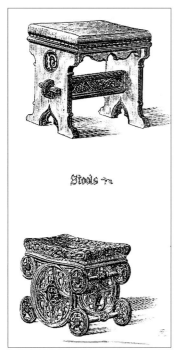

488 Illustrations of Gothic stools, by A. W. N. Pugin, the upper example approved, the lower disapproved, published in London in 1835 (from *Gothic Furniture in the Style of the Fifteenth Century*).

489 A bookcase in oak and brass, designed by A. W. N. Pugin and made by the Crace firm; British, *c.* 1851.

to lead to attempts to reincarnate academically 'correct' Gothic furniture.

The 'Gothick' butterfly was eventually pinned into the specimen box by the fingers of two architects, English and French, A. W. N. Pugin (1812–52) and E. E. Viollet-le-Duc (1814–79).

Pugin bent his considerable energies in the 1830s and afterwards to restoring an academically correct and unified Gothic to a dominating position in British national life. Eastlake said of him: 'Pugin was the first who deftly expounded the true principles of what he not inaptly named Christian art'.[69] His Gothic theories were moral, puritanical and radical, clad in the evangelical language of nineteenth-century religion; they had something in common with the theories of Laugier, who had used the language of eighteenth-century rationalism (p. 177). Pugin came of French stock; Continental influences are apparent in his designs and he worked for European clients.[70] The vision that inspired him was most dramatically expressed in the extended, rhapsodic eulogy of mediaeval Paris in Victor Hugo's famous novel. Hugo's picture of the beauty of Gothic Paris is echoed in Pugin's comparisons between Gothic and contemporary townscapes, greatly to the latter's disadvantage.[71]

Viollet-le-Duc, an archaeologist and encyclopaedist who published works still standard, including a dictionary of French Dark Age and mediaeval furniture (1858–75),[72] and who taught at the newly reorganized École des Beaux-Arts in Paris, was intellectually Pugin's superior.[73] However, as a designer he lacked Pugin's febrile brilliance: he produced no building to match the Picturesque vitality of the Houses of Parliament in London, for which Pugin designed the Gothic ornament and furniture.[74] Unlike Pugin, Viollet-le-Duc did not believe that Gothic surpassed all other styles, but like him

(and Morris) he advocated unity in the arts and interior decoration; he deplored the wish to disguise or ignore the machine and foresaw the 'honest' (un-Gothic) use of metal in architecture, thus sowing the seeds of a plentiful harvest. Viollet-le-Duc 'restored', or more properly re-created, many major Gothic buildings from the 1840s onwards, including (from 1858) the castle of Pierrefonds with its decorations and furniture. The results are leaden: assiduity and intelligence are no substitute for creative talent.

Pugin's radical morality applied to furniture emphasized 'honesty' of construction and materials [488]; he rejected deceitful veneers and urged that furniture's construction should once again be revealed .[75] Applied to ornament, Puginesque morality insisted that: 'All ornament should consist of enrichment of the essential construction' – this, of course, was the dictum of Owen Jones (p. 37).

In 1851, Pugin designed the contents of the 'Mediaeval Court' of the Great Exhibition, the only part organized by style rather than manufacture or nationality. A bookcase in oak and brass [489] – plain oak was favoured as more 'authentic' than the gilded veneers of Regency Gothic – is typical of a particular strand in his work. The piece is articulated in the familiar eighteenth-century tripartite divisions, and the Gothic equivalent of dentils runs along the top beneath the cresting; sufficient unadorned wood is left to allow the ornament its full effect. The ornament is rich but not quirky: the use of accumulated small lancets as a kind of 'background' to curvilinear Gothic lozenges, a device that gives flat decoration an impression of rich superimpositions, had already been evident in designs by the Pugins in the *Repository* of the 1820s. Pugin's Gothic furniture was much imitated, degenerating eventually into 'Stockbroker Tudor'; Puginesque Gothic architecture underwent the same debasement. Charles Eastlake said in 1878, in words as applicable to furniture as to architecture, that 'it is lamentable to see how many monstrous designs were perpetuated under the general name of Gothic…'[76]

British and French 'Reformed Gothic'; Pre-Raphaelitism

Pugin was the St John the Baptist, Ruskin the St John the Divine, and William Morris the Christ of the 'Reformed Gothic' and 'Art and Crafts' movements that appeared after 1850. Indeed, Morris and Edward Burne-Jones first wished to become clergymen, then to to found a brotherhood devoted to beauty and truth; eventually Morris decided to become an architect (and atheist!) and Burne-Jones a painter. The influence of Ruskin and Morris grew steadily in the 1870s and 1880s.

John Ruskin (1819–1900) was, like Pugin, a radical moralist; 'ethical and political considerations have never been absent from [Ruskin's] criticism of art'.[77] To genius Ruskin added bigotry: 'I was wearied and bored and in a rage with the whole humbuggy thing. Asses people must be, to come forty miles from Naples to see this' – Paestum![78] Nevertheless, he was the greatest art critic of his or any age, and expressed his opinions in magical prose. The first volume of *The Stones of Venice*, 'one of the very few necessary and inevitable utterances of the century',[79] was published in 1851, the year of the Great Exhibition. Ruskin enumerated six qualities characteristic of Gothic art: they were 'Savageness' (or rudeness), 'Changefulness' (or love of change), 'Naturalism' (or love of Nature), 'Grotesqueness' (or disturbed imagination), 'Rigidity' (or obstinacy), and 'Redundance' (or generosity). Without going deeply into

491 A chest on stand, the 'Backgammon Players', designed by Philip Webb, made by Morris and Company, and painted by Edward Burne-Jones; British, 1861.

left **490** A cabinet in stencilled and gilded pine and mahogany, designed by William Burges and painted by Edward Poynter and others; British, 1858.

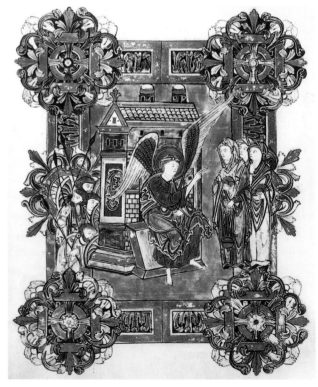

492 The Marys and the Angel at the Sepulchre, from the *Benedictional of St Aethelwold*; English, *c.* 975–80.

493 Chairs and other accessories designed by William Morris, and figures by Sir Edward Burne-Jones, in a Morris and Company tapestry, *The Knights of the Round Table summoned to the Quest by the Strange Damsel*, British, *c*. 1890.

494 A round table in painted pine, designed by William Morris; British, *c*. 1856.

495 A round knock-down table: detail of *The Death of St Augustine* by the Master of St Augustine; Flemish, *c*. 1500.

exactly what he meant, one perceives the absence of Elegance, Frivolity, Artificiality, Exuberance, Skittishness, the principal qualities of eighteenth-century Gothic.

Nature provided form and ornament to the Gothicists. Hope had in 1807 urged the 'young artist' to 'ascend to those higher, those most copious sources of elegance, whence I myself have drawn all my ideas, and which alone can offer an inexhaustible store of ever varied and ever novel beauties. I mean…those productions of Nature herself.' He gave second place to 'monuments of antiquity'.[80] William Morris said much the same thing: 'your teachers…must be Nature and History'; he defined 'History' as 'ancient art' and recommended museums as an aid to design.[81] Pugin and Ruskin emphasized the study of plant structure as well as flowers and leaves, but substituted Gothic art in place of Hope's 'antiquity'. Ruskin's insistence on Gothic naturalism was opposed by Owen Jones and Christopher Dresser (pp. 37–38), who preferred antique geometricized natural ornament. Inherent in these creeds was the far from novel idea that Nature manifested the divine: 'To see…a Heaven in a Wild Flower', as Blake had put it.

British Gothic after 1850 takes us into a confused world where mediaevalizing romance [493], utilitarianism, moral and aesthetic puritanism, functionalism, and eccentricity contended for mastery. William Morris (1834–96), noble, utopian, and cranky, drove home in his mediaevalizing verse and evangelistic prose the message that found material expression in the company he founded in 1861. It designed furniture, wallpaper, and textiles.

The design of post-1850 British furniture in advanced taste was influenced by a peculiar British school of painting – 'Pre-Raphaelitism', which aimed to record nature, accurately and minutely, in a style derived mainly from Italian fifteenth-century painting; it had been preceded by the similar German movement of the 'Nazarenes', founded in 1809, which amalgamated painting and prayer. The Pre-Raphaelites were more talented than the Nazarenes, but their creative period lasted only from 1848 to the late 1850s; their decline into quaintness persisted well into the twentieth century. Of the first eight members of Morris's company, five were Pre-Raphaelite painters.[82] All painted furniture.

The Pre-Raphaelite interests of the founding members of the Morris firm ensured that its furniture was influenced by the painted Italian cassone [140, 159], mediaeval North European painted furniture [101], fifteenth-century painting [144, 495], and illuminated manuscripts [122]. A chest on stand, the 'Backgammon Players' of 1861 [491], has the amateur charm characteristic of much of the firm's early

furniture. It was designed by Philip Webb (1831–1915), whom Morris had met when both were articled to a leading Gothic Revival architect, G. E. Street, and decorated with an oil painting on leather by Edward Burne-Jones (1833–98). The painting on the chest gives no measure of Burne-Jones's stature (Time has unveiled him as the creepy genius of Victorian painting) and the composition sits awkwardly in its place – deliberate gaucheness, one of the more annoying characteristics of Pre-Raphaelitism, was extended to its furniture, as was remarked in 1861: 'This studied affectation of Truthfulness, in placing ironwork in the middle of a picture, is one of the many sins that have to be purged from the Mediaevalists'[83] (would a 'goût grec' critic ever have referred to the 'sins' of rococo?).

Gothic threw up some maverick eclecticists, a category that includes Gaudí (pp. 311–12) and Burges, designers who were original to the point of eccentricity, fantasists rather than revivalists. William Burges (1827–81), a neo-Gothic architect of the 'Savage' or 'Rude' variety, designed 'architectural' furniture from 1858 onwards. English Victorian painted furniture never came gaudier or more eventful than this [490], the illuminated manuscript as opposed to the moated grange of Morris. It has been suggested that the cabinet pictured was inspired by a Gothic armoire from Noyon Cathedral,[84] which Burges saw in 1853. The Noyon armoire is not unlike the Burges cabinet in general concept, and their painted decoration bears some slight resemblances. However, the Burges cabinet is articulated horizontally, not vertically, and apart from the pointed arches on its lower tier its form and ornament are as much Romanesque as Gothic: even the lettering is in uncial rather than Gothic script. The painting of the roof tiles resembles the Romanesque convention that had been influenced by the aspect of cloisonné metalwork (the method employed, transparent glazes over metal leaf, 'found by Burges in the eleventh-century manuscript of the monk Theophilus',[85] was a common eighteenth-century and Regency technique). In its roof, its finials, and in general effect the cabinet resembles furniture and buildings seen in Romanesque illuminations [492]. The style of its decorative paintings by Edward Poynter (1836–1919) is as near to French 1840s 'primitive' neo-classicism as anything else.

Charles Eastlake, a moderate – 'I do not see exactly how veneering is to be rejected on "moral" grounds'[86] – criticized the painted furniture produced by the Morris firm on the grounds that the paintings made the furniture costly, and that furniture 'ought to be artistic in itself'.[87] Eastlake's commonsensical books were read by everybody with

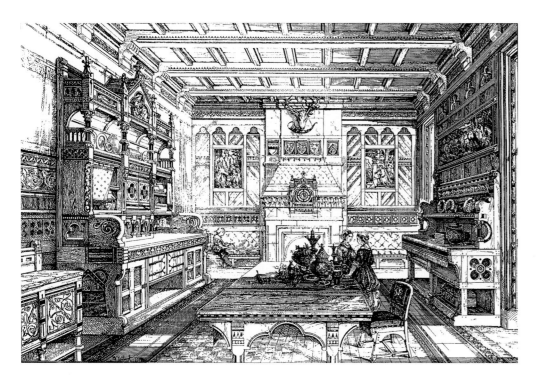

496 'Interior view of a Dining-Room', designed by Bruce Talbert; British, 1867 (from *Gothic Forms applied to Furniture, Metal work and Decoration for Domestic Purposes*).

pretensions to taste, and their influence extended to America: his seemly variations on modern vernacular Gothic were misused, and he was goaded to write 'I find American tradesmen continually advertising what they call "Eastlake" furniture, with the production of which I have had nothing whatever to do, and for the taste of which I should be very sorry to be considered responsible.'

A 'Dining Room' of 1867 [496] displays an elephantine, commercialized use of 'Eastlake' ingredients: predating by a year the publication of the first edition of Eastlake's *Hints on Household Taste*, it was prefaced by its author and designer, Bruce Talbert (1838–81), with the words 'Let us labour with love'. Talbert, who began life as a woodcarver, spoke with knowledge: whether he darkened counsel or not is a matter of opinion [516]. The sun of a hundred and forty years has rendered his furniture less formidable than his designs, the forms and decoration of which mix Gothic and Romanesque, with the latter predominating; some plates in his book have a Celtic flavour.[88] The 'aim of the author has been to keep the construction as simple and true as possible',[89] and the dowels and the framed construction are shown clearly in the engraving (Talbert had studied Dietterlin and Vredeman de Vries). Talbert rejected 'architectural' Gothic as 'a lavish display of ornament, which is usually but a repetition of the tracery, buttresses and crocketting used in stone work…the use of these forms gives a monumental character quite undesirable for Cabinet Work'.[90] By 'monumental' Talbert meant not 'big' – he was not daunted by mere size! – he meant 'grand and pretentious', the sense in which he qualified the word in speaking of the Fourdinois cabinet [512].

Talbert rejected veneering and polish: 'It is to the use of glue that we are indebted for the false construction modern work indulges in; the glue leads to veneering, and veneering to polish…the Ancients did not understand the mysteries of the glue-pot'[91] (they did, although they did not always use it). Suspicion of veneering had been around for some time: in 1836 Dickens made a chair expostulate: 'that's not the way to address solid Spanish Mahogany. Dam'me, you couldn't treat me with less respect if I was veneered.'[92] Despite his wariness, Talbert admitted veneering in small ornamental panels (sixteenth-century Germans had followed the same practice). He gave a receipt for 'dead polish…without the glitter of

French polish'. It is paradoxical that such puritanical precepts led to such grandiosely High Victorian design. One wonders exactly how far nineteenth-century British propagandists of 'honesty' in furniture were prepared to go. A novel of 1879 (admittedly by a paradoxalist) permitted a character to say of that then source of national pride, the English countryside: 'The prettiness is overwhelming. It is very pretty to see; but to live with, I think I prefer ugliness. I can imagine learning to love ugliness. It's honest.'[93] It was nice to have had the choice.

Arts and Crafts; the vernacular

Schinkel had found functionalism and constructionalism 'dry and rigid, and lacking in freedom' and missing 'two essential elements: the historical and the poetical' (p. 267). He died too soon to see a development in England that would surely have intrigued him – the evolution from Gothic reform into a constructionally 'honest' style that made new ventures into the historical and poetical by borrowing from the art of the people, the vernacular. Twentieth-century furniture styles really began with British vernacular Gothic in the 1860s, which as 'Arts and Crafts' was to cross to Europe in the late 1880s and be combined in Vienna with Greek, Byzantine, 'Etruscan', and Biedermeier motifs in a high style that, both functional and luxurious (pp. 270–71, 317–20), itself acted as a stepping stone to twentieth-century ascetic functionalism.

The British had shown an interest in vernacular literature in the eighteenth century; they collected ballads which Regency poets such as Scott, Wordsworth and Coleridge imitated; meanwhile the genuine ballad continued uninterrupted in new guises into the Victorian period – as did certain types of vernacular furniture. Chairs in vernacular style that employed a variety of turning descended from Romanesque and Byzantine turning were collected by Walpole as 'Gothic'. Vernacular furniture had been ignored by the Goths of the early nineteenth century, but they then changed direction and looked for inspiration not only to non-spiky examples of mediaeval furniture but also to old and contemporary vernacular furniture – a revolutionary course.

Morris's first venture into designing vernacular Gothic furniture came in the 1850s, when he shared rooms with Burne-Jones in London: Rossetti described him in 1856 as using a local joiner to make 'some intensely mediaeval furniture…tables and chairs like incubi and succubi'.[94] A table perhaps designed by Morris at this time [494] has sturdy Gothic 'revealed construction', with an emphasis on the plank; it is a pastiche of the simple furniture seen in mediaeval paintings [495] and illuminated manuscripts. The table found its way into a village hall, where, no doubt, it felt at home. Contemporary vernacular furniture also influenced the popular Morris 'Sussex chair', so 'vernacular' in design (inheriting something from chinoiserie on the way) as to be another – more elegant – pastiche. The English vernacular movement stuck neither to English furniture nor to vernacular furniture; one of the forms it helped to revive was the caqueteuse of the sixteenth and seventeenth centuries [222], which deeply influenced avant-garde furniture designers, including Mackintosh; another was that of the Spanish Renaissance bargueño [117].

The Arts and Crafts movement began in 1859 when Philip Webb designed Morris's own dwelling, the Red House. Morris, Burne Jones, Webb and Rossetti furnished the house, over which Pre-Raphaelitism cast its dreamy spell. Pre-Raphaelite paintings and tapestries show the ideal

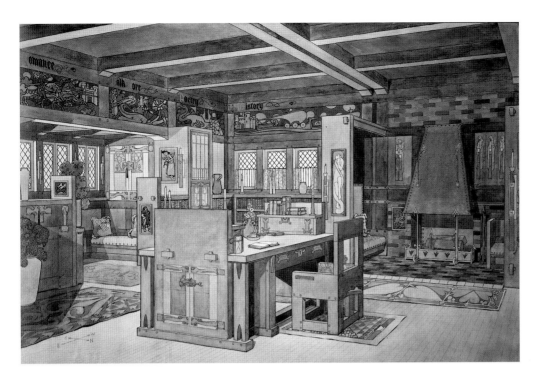

497 A design for a library, by Will Bradley; American, 1901 (from *The Ladies' Home Journal*, 1902).

towards which its devotees yearned; they contain furniture of indeterminate date and vernacular character, suited to the depiction of fables such as Malory's *Morte d'Arthur* [493]. Morris's plain furniture needs the boldly patterned textiles with which he (from 1856 onwards) intended it to be accompanied. The first public display of the firm's work was made at the Exhibition in London of 1862, and it was soon noticed and imitated; Eastlake helped to make mediaevalizing furniture generally popular. The homely 'Old English' and 'Queen Anne' architectural styles that came in the 1870s in the wake of the Red House influenced Voysey and Mackintosh.

The term 'Arts and Crafts' suits the nostalgic idealism that aspired to supply well-designed hand-made furniture to the working classes and to give pleasure in their work to the craftsmen who made it. As early as 1807, Hope had intended his designs to have a good influence on the 'mere mechanic trades', and (in language as weighty as his furniture) to 'afford to that portion of the community which, through the entire substitution of machinery to manual labour, in the fabrication of many of the most extensive articles of common use, had for ever lost the inferior kinds of employment, a means of replacing the less dignified mode of subsistence...by a nobler species of labour...one in which...the powers of mere machinery never can emulate, or supplant the mental faculties of man'.[95] Ruskin had added prophetic ululations in *The Stones of Venice*; as Morris said, the 'lesson which Ruskin here teaches us is that art is the expression of man's pleasure in labour'.[96] Morris's remedy for aesthetic and social ills was that 'the artist must unite with the "handicraftsman"' – 'no real living decorative art is possible if this is impossible'.[97] The cause of good design led to political action: 'Mr. Burne-Jones...is one of those Radicals whose Radicalism is first cousin to Socialism...the dear and intimate friend of one or two who have an almost sinister celebrity by reason of their enthusiasm for some very doubtful causes; Mr. William Morris, for one.'[98]

Idealism fell short on cost, and hand-made morally uplifting objects proved impractically expensive for all save the well-heeled. Morris was fully aware of this, but never

accepted the conclusion that only the well-designed industrial artefact could supply decently designed and inexpensive People's Furniture. Few items produced by Morris himself were cheap; the 'Sussex chair', one of the cheapest, cost about eight shillings in 1865;[99] in 1910 it cost seven.[100] Ironically, the interest thus fostered in vernacular furniture turned it into 'antiques' and inflated its prices: when Jude the Obscure sold his aunt's 'venerable goods' in about 1895 to the gentry, the auctioneer called 'this antique oak settle – a unique example of old English furniture, worthy the attention of all collectors!' "That was my great-grandfather's," said Jude, "I wish we could have kept the poor old thing."'[101]

The English Arts and Crafts movement organized itself into 'guilds'; the other-worldly name did not prevent them from efficiently selling artefacts designed and made by their members, partly through effective journalism. Various foundations of this kind[102] promulgated British design on the Continent through exhibitions and through magazines, notably *The Studio* which, founded in 1893,[103] wholeheartedly espoused advanced design in the applied arts. The skilful promulgation of aesthetic theories by Morris, Owen Jones, Dresser, Ruskin, and others helps to explain the prestige of British late nineteenth-century avant-garde decorative arts on the Continent – as does the strong British economic and political position: as Tatham had said in the 1790s, the arts of a 'prevailing' nation attract imitation whether worthy of it or not.[104] C. F. A. Voysey (1857–1941), an architect who joined the Art Workers' Guild and in the 1890s designed furniture, enjoyed a European reputation in the early twentieth century. He disowned his disciples, disliked William Morris's atheism, rejected Mackintosh ('the spook school'), and thought 1930s buildings in the modern style hideous. Believing in the instruction of Nature, Voysey's true master was Pugin. He was one of those who helped to revive Celtic ornament.

Commercialized British modern design, sold most notably by the London shop of Arthur Lazenby Liberty (from 1875), extended British influence further. 'Liberty Style' played for the British Arts and Crafts movement the part played by Samuel Bing's Paris shop 'À l'Art Nouveau' for French 'japonisme' and Art Nouveau.

The English 'Domestic' style of architecture encouraged the 1880s development of American 'Shingle Style' architecture, which relied heavily on wood within and without and opened up spaces within. A woody design of 1901 for a library [497] by Will Bradley (1868–1962) sums up many of the stylistic tendencies in furniture and decoration of the previous forty years, displaying the influence of Baillie Scott,[105] Carl Larsson [539], Voysey, Mackintosh, the Secession (p. 317), even the painters and wood-engravers Nicholson and Pryde (not surprising, since Bradley was a wood-engraver). Elegance and distinction have gone, cosiness and charm remain. The chunky forms of the furniture, the almost embarrassingly 'revealed' construction, the prominent ironwork, the 'peasant' murals, the rugs with their formalized patterns, the Voyseyish fireplace, the diamond-paned windows, the heavily beamed ceiling, all go to make a room in which Goldilocks and the Three Bears might have enacted their drama. Interior and furniture are Northern and barbarian rather than Latin and classical: they descend from the world of *Beowulf* rather than that of Ovid.

'Louis Quatorze' and other 'period' revivals

The background

498 A design for a giltwood sofa for the Ballroom, Windsor Castle; Anglo-French, late 1820s.

Unlike the nineteenth-century Gothic Revival, which had eighteenth-century roots, the Louis XIV, rococo, and Renaissance (which included Renaissance moresque) revivals were largely generated within the nineteenth century itself.

France had never forgotten Louis XIV, and furniture substantially in that style had continued to be made. After the Revolution, French connoisseurs, including Denon and Girodet, bought Louis XIV furniture: even Napoleon, who wished to create a style to match his court – 'it is not a court, it is a power'[106] – ordered Jacob-Desmalter to make a faithful copy of a Louis XV commode in seventeenth-century taste.[107] The necessary techniques continued to be practised. England materially assisted the revival of all these styles; signs of interest had appeared in the 1790s, when English collectors, led by the Prince of Wales, William Beckford (the 'richest commoner in England'), and Lord Hertford, bought copiously of the furniture that flooded out of the desecrated palaces of France. Their taste included French baroque classicism, high rococo, modified rococo and rococo neo-classicism; it prompted the reproduction in English Regency furniture of the techniques and motifs of 'Boulle' or 'buhl'. By 1801, Jean Le Pautre was receiving high praise from the classicist Tatham in terms that indicate a general approval of his work.[108] Tatham's sketches show interest in the broken curve depicted in furniture painted in the sixteenth century by Veronese,[109] and the motif appears in a table made in about 1800 for Southill Park in Bedfordshire. Accurate copies of Louis XIV furniture were made by London cabinet-makers, notably Thomas Parker and Louis Le Gaigneur; a mazarin desk by the latter bought by George IV was accepted as late as the 1930s as genuine Louis XIV. Old work was re-used; a 'Boulle' cabinet that entered the Wallace Collection [499] has old doors set – the wrong way round, the two horn players would have faced each other – into a new carcase of French construction.[110] Bullock was greatly

influenced by the cubic solidity and Boulle marquetry of Louis XIV furniture [245].

As was to be expected, 'Louis Quatorze' interior decoration succeeded the collecting of old French furniture. It was preceded by pastiches of English seventeenth-century interiors, early pioneers of which had appeared in the 1760s;[111] by 1820, Wren, Jacobean and Tudor interiors were common. At Windsor Castle, the state apartments were remodelled in baroque style between 1805 and 1812 for George III, ceilings and carvings being installed in the styles of Verrio and Grinling Gibbons. Beckford created 'Anglo-Italian' ('Renaissance') interiors at Fonthill Abbey which disappeared when the Abbey collapsed, leaving only a brief mention and no visual record.[112]

George IV was a decided revivalist. In 1815, as Prince Regent, he revived post-rococo neo-classicism in chinoiserie form at the Pavilion in Brighton (p. 285).[113] He had first ventured on 'Louis Quatorze' at Carlton House two or three years earlier in the Golden Drawing Room[114] of 1813, which displayed decided Grand Monarque proclivities in mirror frames, furniture and objets d'art; elsewhere in the palace, blue carpets were strewn with gold fleurs-de-lis; old French furniture abounded. However, he most resplendently realized English 'Louis Quatorze' revivalism in his refurnishing during the 1820s of the restored castellated Gothic shell of Windsor Castle. Contrary to much other work in the style, it was well designed and superlatively executed. One of the principal designers employed, J. J. Boileau (d. after 1851), was a veteran master of his craft who had been employed by George IV for over thirty years; born whilst the original rococo style still lingered, he had first come to England from France in the late 1780s, and had worked for Holland and Beckford. The interiors and furniture of Windsor were in a French classical baroque style touched with Inigo Jones and Kent, Louis XIV, Louis XVI and Empire: the huge Gothic windows were adorned with heavily sumptuous 'Louis Quatorze' lambrequins. Into Windsor the King, neither a romantic associationalist nor a devotee of hats worn by Queen Elizabeth I or cooking pots used by Meg Merrilies, poured magnificent baroque and rococo furniture and objets d'art of all periods, together with new furniture of the highest quality. The whole is splendidly imposing, but, tinged as it is with a musky Regency vulgarity, has nothing of the aulic pomp of true Louis XIV.

In the 1820s the full-blown revived 'Louis Quatorze' style entered British ducal castles, London mansions, and Crockford's gaming house;[115] the style was described by a German visitor as 'tasteless excrescences, excess of gilding,

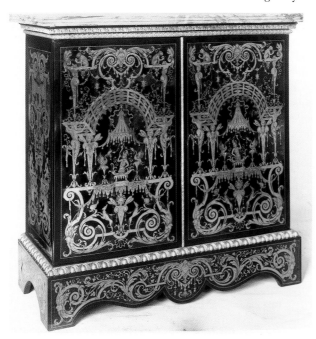

499 Two doors in brass and tortoiseshell marquetry, perhaps by A.-C. Boulle and *c.* 1700, inset into an early nineteenth-century carcase; French.

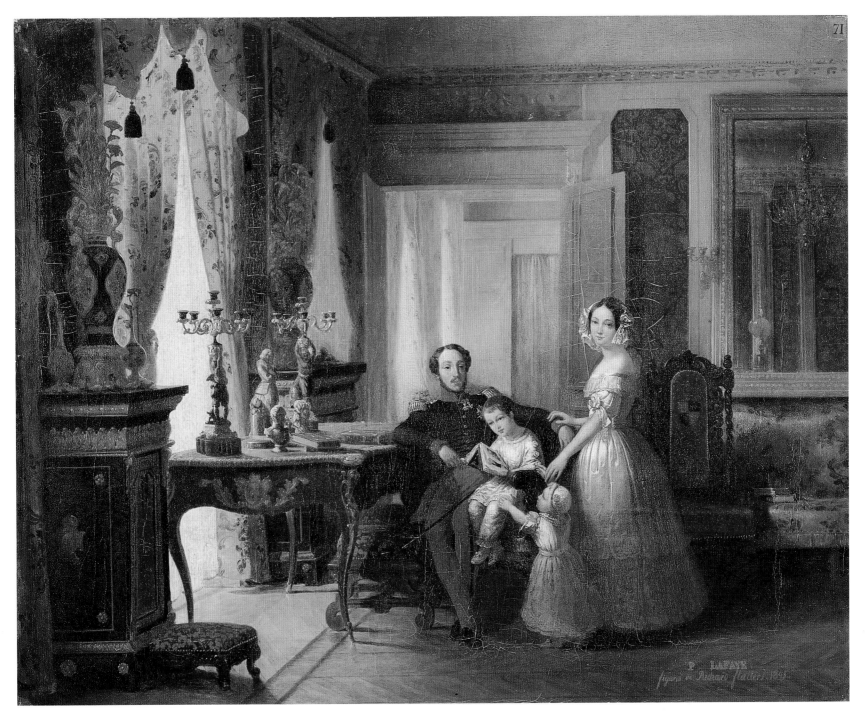

500 Revived rococo French
furniture and a revived Renaissance
chair, in an interior of the Duc
d'Orléans and his family by Prosper
Lafaye and Richard Flatters;
French, 1845.

confused mixture of stucco painting, etc.'[116] Observers
complained that the ornament employed was not 'correct': it
was 'erroneously termed that of Louis XIV, but…in fact is the
debased manner of…Louis XV'.[117] From the very beginning,
the poor quality of design and manufacture was condemned
– carving was simulated in coarse papier-mâché or 'Jackson's
Putty', and attached to a wooden framework. The same
techniques were used for wall decoration and furniture.
Where possible, architects and decorators obtained real
eighteenth-century *boiseries* and furniture, which they
recognized as much superior. Designs that depended on
spontaneous and vivacious ornament did not work when
spirit and talent had fled, and no calling would bring it back –
especially when 'the intelligent decorator will see that any
clever boy may produce them [papier-mâché ornaments]'.[118]
Oh, Cuvilliés!

The revivals were accompanied by the reprinting of
mannerist, baroque and rococo designs; an English
publication of 1845, for example, advertised itself as 'a series
of designs selected from the works of Dietterlin, Berain,
Blondel, Meissonnier, Le Pautre, Zahn, Boetticher, and the

best French and German ornamentalists'.[119] The title
shows a broad historicism, but the unidentified plates give
an impression of indiscriminate eclecticism. Sometimes the
reprints gave birth to 'amusing' modern versions of old
designs [509].

Rococo Revival

A major room at Windsor Castle, the Ballroom, was
decorated for George IV in an accomplished revived rococo
style with intricate 'Louis XV' scrollwork and Gobelins
tapestries. The London firm of Morel and Seddon made
designs for the furniture, probably in conjunction with
Boileau and the King; in 1826 Morel went to France for
inspiration and patterns.[120] A sofa [498] in immaculate
'Louis XV' style (save that the straight Regency fringe
oddly consorts with the curvilinear legs and frame)
was designed for it.

The French ruling classes favoured 'authentic'
reproductions of the type made by Louis Le Gaigneur in
England. A painting of 1845 [500] probably pictures the
apartment in the Tuileries Palace of the Duc d'Orléans

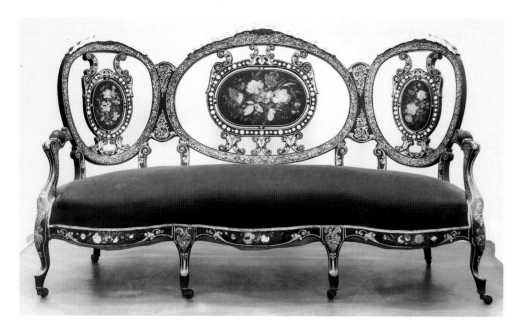

501 A sofa made of wood and papier-mâché on a steel frame, painted black and decorated with painting, gilding, and inlaid mother o' pearl; British, c. 1855.

502 An armchair and footstool in carved and gilded wood; Spanish, c. 1860.

The first furniture to be made of papier-mâché with wooden supports had been produced in the late eighteenth century in England;[124] improvements made between 1836 and 1851 made the material suitable for chairs and sofas. Papier-mâché furniture was a particular speciality of Jennens and Bettridge, a Birmingham firm which patented its own method of inlaying mother o' pearl. A revived rococo sofa [501], the back of which is held together by the reversed C-scrolls so disliked by the anti-rococo lobby, is made of wood and papier-mâché and decorated with profuse mother o' pearl and gilded ornament and bouquets of flowers. The painter Richard Redgrave called such ornamented papier-mâché 'a mass of barbarous splendour that offends the eye and quarrels with every other kind of manufacture with which it comes in contact'.[125] He was a little severe; the effect has some of the attractions of the oriental inlaid lacquer that must have partly inspired it.

By the middle of the century, revivalism was producing furniture that was ill-designed by any standards. This was especially true of rococo, a style more organically licentious than Renaissance by its nature. A Spanish carved and gilded chair and footstool of the 'Isabelline' period [502], which retains its original covers, illustrates the clumsiness of much Rococo Revival furniture. Mixing 'Louis XV' with a style that approaches the Venetian baroque of Brustolon [252, 253], the chair is alive with putti, who hold aloft at its apex the doves of Venus; the putto to the right of the back has usurped the stance of a Bacchante or Pompeian dancer. Despite the chair's curvilinear forms and ornament, it quite misses the easy flowing lines of true rococo.

An American bed [505] in laminated rosewood, an expensive form of plywood, was made in the factory of the German immigrant J. H. Belter, who began working in New York in the 1840s.[126] Plywood had been used in eighteenth-century England, for example in chairs designed by Robert Adam for the Library at Osterley;[127] in early nineteenth-century Austria it was employed extensively by Biedermeier

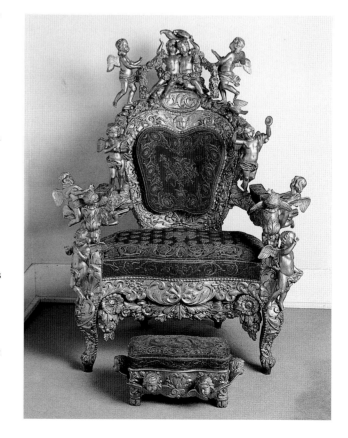

(1810–42), a cultivated man who also ordered furniture in a modern idiom from makers such as Bellangé [528]. The furniture mixes a 'Louis XV' desk (on which stands a figure of Joan of Arc) and 'Boulle' cabinets, all almost certainly high-quality reproduction, with an oak chair in seventeenth-century style; lambrequins hang at the window.

Rococo Revival quickly became commercialized. Much is coarse and graceless, oddly recalling Contant d'Ivry's eighteenth-century 'modified rococo' [350]. Some of the most aesthetically successful was produced in mass quantities. The prime example is the hugely popular English 'balloon back' chair, which spawned versions throughout Europe and America. The most harmonious variant combined delicate cabriole legs with a back shaped as an empty round cartouche (a horizontally elongated cartouche was evolved during the 1830s and 1840s that preceded the fully developed balloon back). The legs were sometimes – rather less happily – heavily turned and reeded, or charmingly ornamented with delicate adaptations of antique concave/convex turning combined with the slight outward splay derived ultimately from the klismos leg. Comfortable, light, practical, and pretty, the balloon back chair was used in both drawing and dining rooms, its ornament varying according to its location: drawing room chairs tended to be in walnut or satinwood decorated with carved flowers in 'Louis XV' style, dining room chairs to be in mahogany or rosewood, built in a slightly heavier style and decorated with debased classical ornament. The chairs were gilded for grander surroundings.

Revived rococo designs lent themselves to the deep buttoning made easy by the use of the coiled spring which, employed in the eighteenth century for carriages and gymnastic chairs, was patented for furniture use in 1826 and 1828.[121] It encouraged the exaggerated interest in curves that, characteristic of high Victorian taste, is seen as clearly in the curve of a pictured lady's elbow, in her dimpled fingers and swelling throat, as in the bursting contours of a sofa [476]. Eastlake complained that 'the word "elegant" was applied to any object curved in form',[122] saying of 'Louis Quatorze' that 'bad and vicious in principle as it was, [it] had a certain air of luxury and grandeur....Its worst characteristic was an extravagance of *contour*; and this is just the characteristic which the tradition of upholstery preserved'; sofas and chairs had 'not a straight line in their composition...this detestable system of ornamentation was called "shaping."'[123]

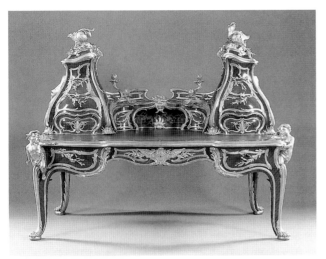

503 Furniture designed in oak by William Beckford for Lansdown Tower, Bath; British, pictured in 1844 (from English and Maddox, *Views of Lansdown Tower, Bath*).

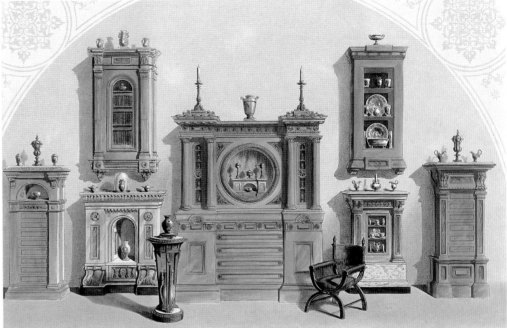

504 A bureau veneered in tulip-wood, with gilt-bronze mounts, by François Linke; French, *c.* 1890.

505 A bed in laminated and carved rosewood, by J. H. Belter; American (New York), *c.* 1856.

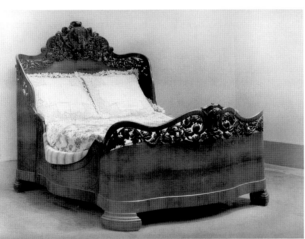

craftsmen, whence Belter no doubt brought the technique which he refined in patents taken out in 1847 and 1858.[128] The bed is in a baroque rather than rococo style – the character and motifs of the carved woodwork, the curves and counter-curves, are seventeenth-century rather than eighteenth-century in character. The extensive plain areas relieve it from the formidable *horror vacui* that afflicts so much of Belter's work. The glossy surfaces of 'French polish' contributed much to the pushy bourgeois opulence of this type of furniture.

Furniture in revived rococo style continued to be made up to and beyond the end of the century. A tulipwood bureau with gilt-bronze mounts made by François Linke (1855–1946) in about 1890 [504] received a gold medal at the Exposition Universelle of 1900 in Paris; the citation described it as 'an example of what can be done by seeking inspiration among the classic examples of Louis XV and XVI [furniture] without in any sense copying these great works'.[129] The bureau looks like a French bureau plat that has wandered into a room and been seduced by the top half of a German secretaire; its sagging gilt-bronze curves completely lack the taut vivacity of eighteenth-century work. In this showy piece stirs the spirit of Art Nouveau, but it has failed to get out.

Renaissance Revival

Some of the earliest and most distinguished revived Renaissance English furniture was made for Lansdown Tower, a house built for Beckford above Bath in 1824–27 from 'designs arranged according to the classic taste of the owner';[130] the style is a controlled Italianate/Renaissance. A book of 1844 tells us that 'the first embellishments [presumably furniture] of this charming edifice were sold a few years ago, with the view of finishing the whole more classically, as it now stands'.[131]

The decoration of the rooms may have been partly inspired by interiors as depicted in Italian paintings of the late fifteenth and early sixteenth centuries[132] – Beckford was passionately interested in pictures, and had a most distinguished collection – and the character of his furniture [503] bears out that conjecture. Complementing the house itself, it somewhat resembles the Italian antique-inspired sixteenth-century furniture associated in these pages with the 'Raphaelite' tradition (pp. 105–6): the cupboards include hanging cupboards like those seen in the paintings of Carpaccio and others, and the wall furniture has the square-set forms and architectural pillars and pilasters of Renaissance furniture. The arched wall table, for want of a better description, that stands to the left of the large central cupboard, appears to have no function save that of decoration; its form resembles that of an Italian sixteenth-century prie-dieu [202], and its inspiration by a prie-dieu – Renaissance paintings are full of them [156] – would explain its non-functional role in its new incarnation. The ebony X-frame chair is directly inspired by Renaissance and seventeenth-century furniture. Revived Renaissance furniture in Raphaelite style was unmarred by the frequently coarse 'Jacobethan' detail of so much nineteenth-century Renaissance Revival furniture.

Beckford's revived Renaissance furniture did not owe all to the Renaissance. Some of its details, such as the bolts and tablet of the hanging cupboard to the right, the Doric capitals of the central cupboard, the form of the tripod, are Greek or Graeco-Roman Revival; the nailed and fringed single chairs that stood in the drawing rooms cunningly synthesized seventeenth-century form with pointed 'Grecian' legs and a back of which the curve was influenced by the klismos.[133]

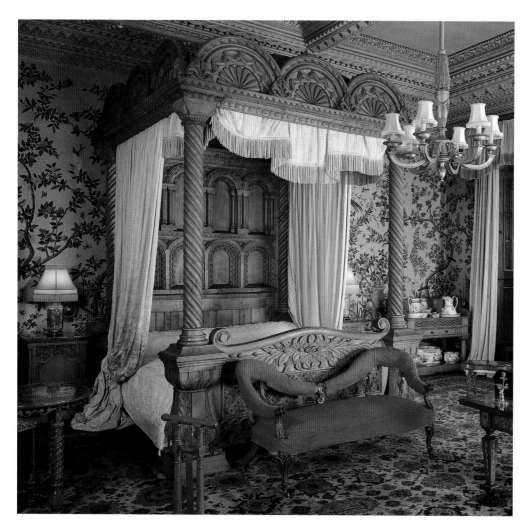

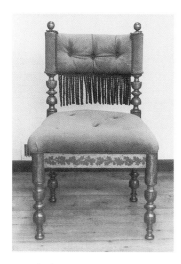

506 A bed in turned and carved oak, designed by Thomas Hopper, in Penrhyn Castle, Gwynedd; British, c. 1825–30.

507 A chair in turned oak painted with oak leaves, designed by M. G. Bindesbøll after a detail of a chair depicted in Raphael's *Madonna della Sedia*: Danish, c. 1840.

opposite 508 A Renaissance Revival room and furniture in Park Avenue, New York, designed by Léon Marcotte in the 1840s and depicted in *The Brown Family* by Eastman Johnson; American, 1869.

Incongruous in context are the finials of the central cupboard; these have some resemblance with the finial of the lantern of the campanile of Lansdown Tower, which was 'after a pure Grecian model'.[134]

In the same decade that the Lansdown Tower furniture was being made – furniture that one suggests may have been influenced by Renaissance paintings – the Dane Michael Bindesbøll (1800–1856), who designed the 'Pompeian' interior of the Thorvaldsen Museum in Copenhagen, designed a chair [507] indisputably inspired by a detail of a chair depicted in a Renaissance painting, Raphael's *Madonna della Sedia*.[135] Bindesbøll's chair was destined for the hall of a house in Copenhagen which held a copy of Raphael's *Sistine Madonna*.[136] Furniture of this same general 'Renaissance' type was designed by three Danish painters, Constantin Hansen, G. C. Hilker and Jørgen Roed. A close connection between an interest in Renaissance painting and the remaking of Italian sixteenth-century 'classical' furniture is present in the case of both Beckford and the Danes.

During the 1830s, English 'Jacobethan' forged an alliance with 'Norman'. An interest in Romanesque furniture had shown as early as George Smith's 1808 Gothic designs; most were intended for the gilding and veneering of high-style Regency furniture, but others were for plain oak chairs of a Romanesque character. Smith's fumbling concern for authenticity emerges in his opinion of 1826 that it 'has been a great mistake' to think that Gothic furniture had been designed after the style of Gothic architecture (he was wrong): 'in those days the furniture for domestic use was massive and heavy, consisting chiefly of bold and highly relieved mouldings, with other members partaking of the round and cable form. Many of the ornaments…may be called arabesque [the Romanesque acanthus scroll], and in

some cases they partook very much of the grotesque [Gothic monsters].'[137]

Not unexpectedly, 'Romanesque' interiors and furniture began to appear in the 1830s. However, it was difficult or impossible to revive upper-class furniture of the Norman period: little had existed or survived, and then not in the form of bedside tables, dressing tables, chiffonniers, and so on. English Romanesque Revivalists therefore took advantage of the fact that Romanesque had used many of the same antique motifs as did 'Jacobethan', to apply Romanesque detail to Renaissance Revival forms. The process is seen at work in Penrhyn Castle, a mock castle erected between 1821 and 1841 for a 'simple country-gentleman, whose father very likely sold cheeses'.[138] The taste displayed is undoubtedly that of 'commerce' (pp. 240–41). Romanesque architectural motifs of the type seen on furniture in manuscripts and on surviving pieces [94, 96] – cable mouldings, multiple facets, and jagged dog-tooth ornament – were reproduced in oak, limestone, and Penrhyn slate. A bedroom, beneath a ceiling in late seventeenth-century manner but with Romanesque detail, has a fearsome oak bed [506]; its twisted columns (which recall those of the aedicules that enclose beds in Byzantine-influenced mosaics [133]) have bases in the form of Romanesque capitals supported on massive balusters influenced by Italian Renaissance tables. The bedhead and canopy make obvious Jacobean and Norman references.

'Jacobethan' detail is prominent in a painting of 1869 that depicts a room in upper Manhattan [508]. In the late 1840s, a prosperous American family had commissioned the French designer Léon Marcotte (1824–87) to execute the interiors and furniture of its new house in an extravagantly eclectic Renaissance Revival style. The painting shows Mrs Brown watchfully surveying her surroundings; the painter was assisted by photographs taken within the house, including one of the fingers of the chatelaine. Shortly afterwards the Browns moved to a huge house on Park Avenue (which is still in parts lined with frowning Renaissance palazzi), carrying this entire room with them.[139] Marcotte had set himself up in New York in about 1849, becoming the most prominent designer in his field. A finely executed bedstead in bird's-eye maple attributed to him [511] might have come from a bedroom in the house, or it might have come from the Marquand house (p. 258); its details include crisply carved ribbons, swags, early Renaissance balusters and a cherub's head, giving a total impression that is as much 'Adam' as 'Renaissance': the combination of strigillation and oval paterae in the footboard recalls Adam's furniture designs, and there are late eighteenth-century echoes in the rectangular carved panel of the footboard.

Utterly different, but still Renaissance Revival, is a cabinet on stand of 1867 made by the Parisian firm of H.-A. Fourdinois [512]. Its form (such as the columned legs) and ornament are influenced by late sixteenth/early seventeenth century Franco-Flemish cabinets [227, 244]; it is decorated with fine, crisp carving and a new technique called 'marqueterie en plein', in which lighter woods were inlaid into ebony and then carved. Despite much mannerist detail, there is a strong late eighteenth-century flavour in the placing of the plaques and in the precision of the carved ornament (the helmet and cornucopias beneath the central plaque look particularly 'Louis XVI'). The figures of Minerva, Painting and Architecture have an early nineteenth-century neo-classical air; the Four Continents, elongated caryatids, manage to combine mannerist, Louis XVI and early nineteenth-century neo-classical traits in the one ornament.

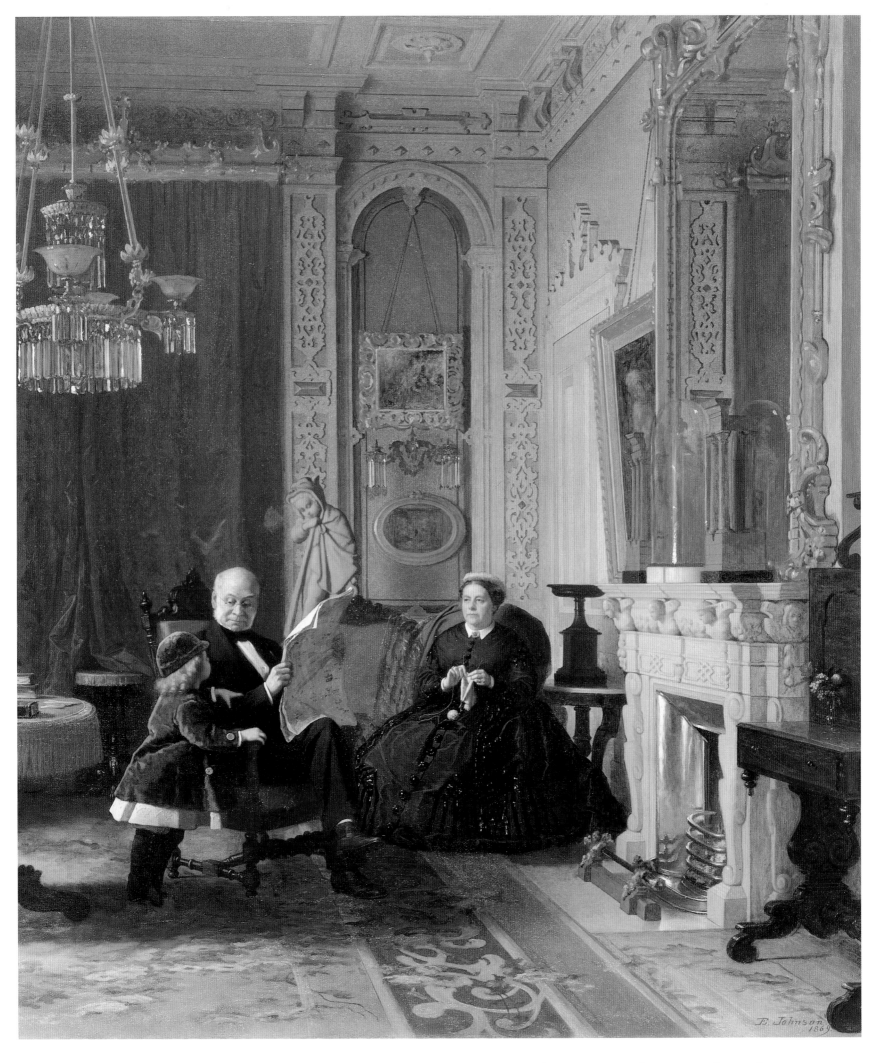

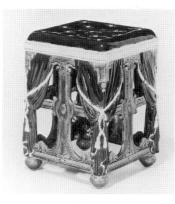

509 A stool in coloured earthenware, made by Josiah Wedgwood and Sons after a design by Vredeman de Vries; British, 1875.

right 510 A cabinet on stand in baroque style, veneered in ebony and inlaid in ivory; northern Italian, *c.* 1880–90.

511 A bed in carved bird's-eye maple, plain maple, and American tulip poplar, attributed to Léon Marcotte; American, *c.* 1878–84.

In the year of its appearance the Fourdinois cabinet [512] was compared by Bruce Talbert to an English late Elizabethan or Jacobean buffet with bulbous balusters illustrated in Shaw's *Specimens of Ancient Furniture,* the Conishead Priory cabinet: 'When this work is compared with the Fourdinois Cabinet…, the contrast is great. The oak of the English work has rightly…not been wrought with the exquisite delicacy of the French work. That delicacy may, however, be overdone.…Its [the Fourdinois cabinet's] cost was £2,700, an amount that would trouble even a millionaire.…It is a structure without a use, monumental in feeling.…Let [furniture for our daily wants] be familiar in feeling without trying to be grand and pretentious, and let there be as little aping of a building style as possible.'[140] Arts and Crafts restrictive puritanism in action – and the pot [496] calling the kettle black!

A reprinted Renaissance design first published in 1630 by Vredeman de Vries inspired a jolly Wedgwood glazed earthenware garden seat of 1875 [509]; its lively and colourful trompe l'oeil – although one would have to be half-blind to be 'tromped' – is more attractive than the treacly varnish stained with burnt umber that one sees on wooden 'antiquarian' furniture.

A northern Italian cabinet on stand of 1880–90 [510], a skilful pastiche of the baroque, employs the baroque contrasts of ebony and ivory or alabaster [247]; its late date is betrayed most clearly in the figure style of the ivory plaques that adorn the front, especially that of the voluptuous Victorian nymph (Hebe?) on the extreme right; the plaques remind one a little of those in pâte-sur-pâte by the French ceramicist Marc Solon, who in 1866 had published designs based on sixteenth-century prototypes.[141]

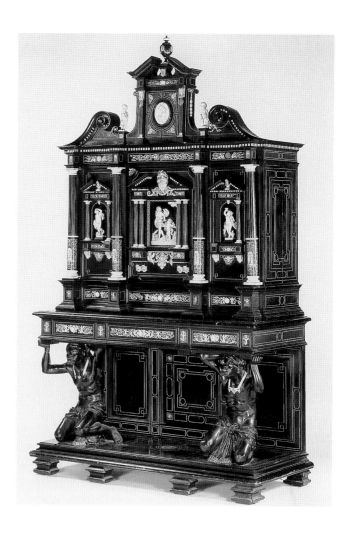

Neo-classical revivals

A refuge from revived Renaissance and rococo was sought both in antiquity itself and in the neo-classical styles of the late eighteenth century.

Sometimes the last were translated into the vulgar opulence characteristic of the nineteenth century, as in a 'rich and brilliant' cabinet made in England for the 1867 Paris Exhibition in a revived 'Adam' style. Its makers, Wright and Mansfield, over the next generation installed elaborate neo-Adam interiors in British houses; the firm was a 'leader of that pleasing fashion which has happily brought back into our houses many of the charming shapes of the renowned eighteenth century cabinet makers. The best forms of Chippendale, Heppelwhite, and particularly Sheraton, have been made to live again under the renovating influence of these able manufacturers.'[142] Such revivals were not confined to England (which had the largest middle class in proportion to its population): the Empress Eugénie made a cult of Marie-Antoinette, and furnished rooms at St Cloud, Compiègne and the Tuileries in 'Louis XVI' style, mixing real pieces and copies. Towards the end of the century old Biedermeier furniture was employed in avant-garde circles in Scandinavia [539] and Vienna, and copies began to be made.

Some styles never entirely died out, 'Etruscan' and 'Pompeian' amongst them. French early nineteenth-century furniture never committed itself entirely to the 'archaeological' fashion, frequently leavening Greek frigidity and Roman heaviness with Pompeian elegance. Schinkel in Prussia relied heavily on the Pompeian style. The publication of new books such as the *Pompeiana* (1817–19, 1832) of Sir William Gell, whose works 'found their way, not only to

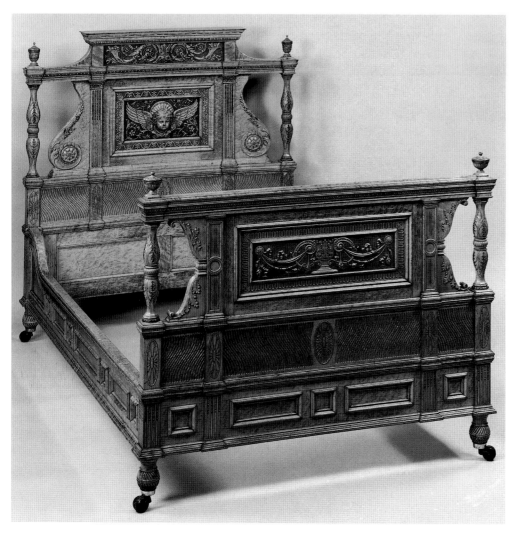

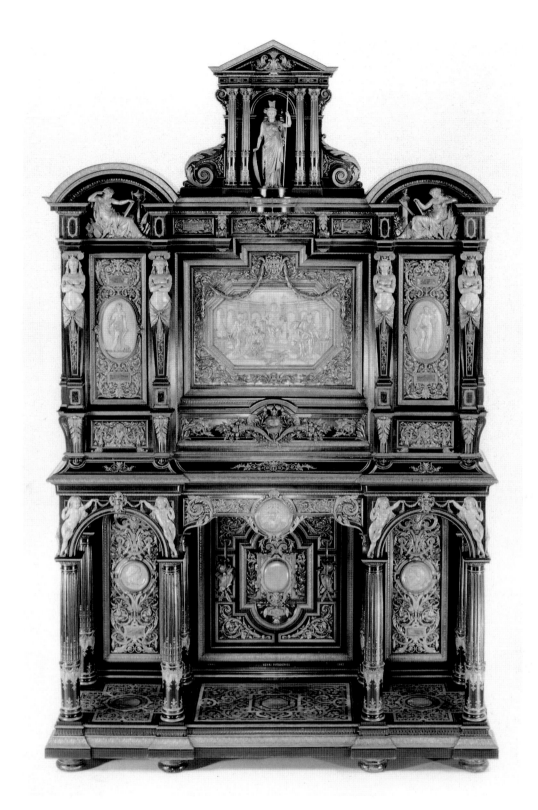

512 A cabinet in oak, ebony, box, lime, other woods, and hardstones, by H.-A. Fourdinois; French, 1867.

every part of Great Britain, but even to the Continent,'[143] helped to provide new motifs. Gell asserted that 'the subject of ancient art itself is exciting more of the public attention, and meeting with merited though tardy admiration, through the zeal and industry of M. Ternite'.[144] Ternite's overblown volumes (1839–59), with calligraphic thick-and-thin outlines of the kind castigated by connoisseurs, had texts in German, French, and English. They met a continuing need, and were being used by Stuck (p. 317) at the end of the century. The 'Pompeian' style provoked much hostile criticism: Owen Jones said in 1856 that it was 'so capricious that it is beyond the range of true art….It generally pleases, but, if not absolutely vulgar, it oftentimes approaches vulgarity.'[145]

In 1860 Alfred-Nicolas Normand built the 'Maison Pompéienne' in Paris for Prince Napoleon; the design was influenced by the villas of Diomedes and Pansa at Pompeii, and the interiors were decorated in the Third 'Pompeian' style. The house has gone, but its completion was celebrated in a painting [513] that shows performances from works by Théophile Gautier and Émile Augier in the atrium. Antiquity was re-lived: from his plinth the Emperor Napoleon, disguised as Augustus, surveys figures in Roman dress that include a languid personage sitting on an 'archaeological' concave/convex turned sofa; the room also contains 'Roman' jardinières. Did one not know that the painting recorded reality, one would take it for a reconstruction of the type painted by Sir Lawrence Alma-Tadema (1836–1912), whose meticulously 'authentic' scenes of antique life, painted with a superbly transparent handling of paint, are emptily banal in every other way. Many depict grotesque interiors,

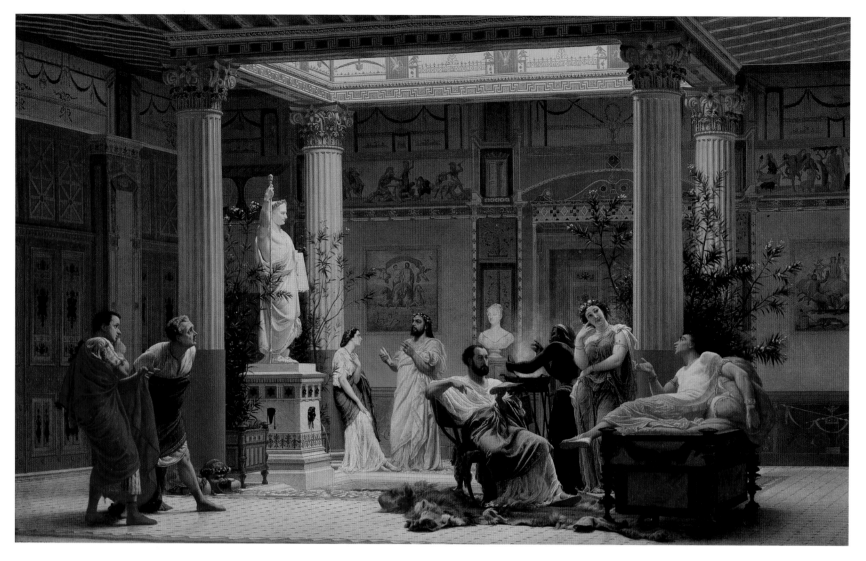

513 Furniture in the antique style in the atrium of the Maison Pompéienne, Paris, seen in a painting by Gustave Boulanger; French, 1861.

right 514 A chair in cedar and ebony inlaid with ivory, mother o' pearl and abalone shell, designed by Sir Lawrence Alma-Tadema for an American client; British, 1884-87.

below 515 A chair in turned and gilded wood, painted in red, white and blue, designed by M. G. Bindesbøll; Danish.

and Alma-Tadema designed for use in his paintings a couch that was archaic Greek on one side and 'Pompeian' – with concave/convex turning – on the other.

Such turning was also used creatively [515]. Bindesbøll, inspired by Abildgaard [453] and Greek and 'Pompeian' art, successfully applied turning to embellish what seems at first sight to be an intentionally seventeenth-century type of frame – until one looks at his 'Raphaelite' chair [507]. Furniture based on the antique can be curiously ageless – some Bindesbøll furniture even has fascinating affinities with the seventeenth-century Iberian furniture that surely drew on similar sources.[146]

Antique turning also adorns the legs of an accomplished ebonized cabinet by E. W. Godwin (1833–86) [517]. Its decoration, incised in gold on black, is a linear and attenuated version of largely 'Etruscan' motifs; such decoration became common in English furniture of the late nineteenth century, often similarly incised in gold on a black ground. In general appearance the cabinet's simple temple pediment and Graeco-Roman concave turned legs somewhat recall German high-style 'Etruscan' furniture of the 1840s.

The use of 'Etruscan' decoration continually resurfaced. The Marquand house in New York, whose owner possessed paintings by Vermeer, Rembrandt, Van Dyck and Hals, contained a Japanese room, a Moorish room, and a dining room in English Renaissance style. It also had a 'Grecian' parlour or music room designed, together with its furniture, by Alma-Tadema. An accomplished armchair [514] is in 'Etruscan' colours derived from inlays of ebony, ivory, mother o' pearl and abalone shell on a (brownish-red) cedar ground; its ornament (and the original upholstery pattern,

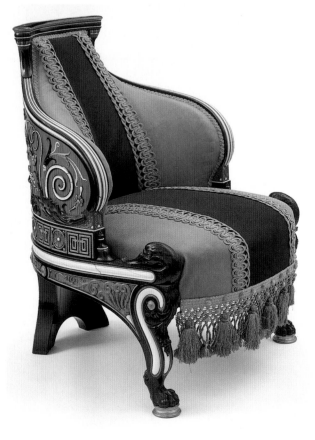

516 A turned, carved and inlaid cabinet in ebony, boxwood, myrtle,
mother o' pearl and ivory, designed by Bruce Talbert; British, 1878.

different from that shown)[147] came from 'Etruscan' vases. Its form recalls that of antique stone thrones. The duck's head is reminiscent of the feet of the only surviving complete piece of ancient Greek wooden furniture, now in Brussels. The Marquand house probably also contained the eclectic bed by Marcotte [511].[148]

The familiar 'Etruscan' palette resurfaces in the ebony, boxwood, myrtle, mother o' pearl and ivory employed in a cabinet by Bruce Talbert [516]. Replete with antique goddesses and their emblems, it became known as the Juno Cabinet when shown in the International Exhibition in Paris in 1878. Its inlaid ornament, largely Greek in origin, compares with that of Pelagio Palagi's sofa and Klenze's cupboard [417, 418]. The strips that border the lower shelves resemble the repetitive decoration that borders the panels of Palagi's Etruscan Room at Racconigi [416], and in both cases squares of ornament end the run; the figure style resembles Palagi's save that the latter retains traces of the fluid elegance of the Greek line that Talbert, 'always inept in figure drawing',[149] has completely lost. The scrolls above and beside the peacock feathers at the apex of Talbert's cabinet alternate black and white in a way similar to that of the scrolls that top Klenze's cabinet; the 'Etruscan' compartmentalism around Talbert's small rectangular drawers parallels that on Klenze's cupboard doors. Talbert's cabinet has much else from quite different sources, including the 'Jacobethan' buffet; unlike the masterly furniture of Palagi and Klenze, it is compromised by competing historicisms.

517 A turned cabinet in ebonized and parcel-gilt wood, designed by E. W. Godwin: British, *c.* 1876.

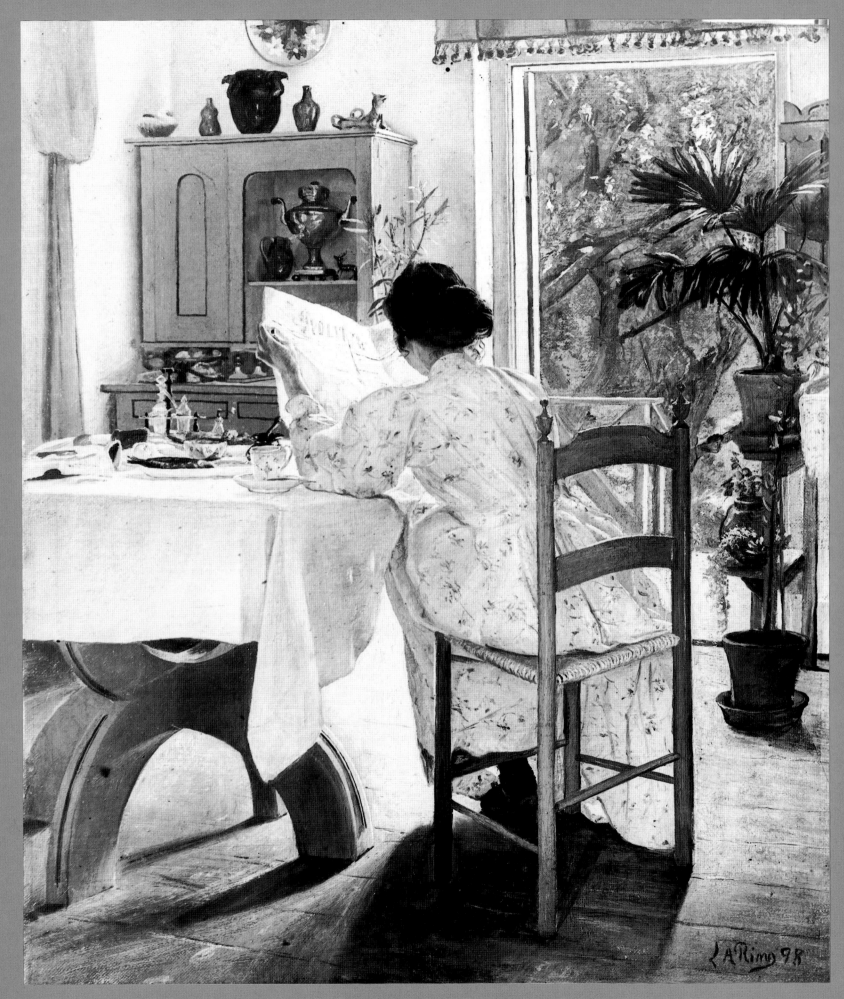

overleaf **518** A interior with a
'vernacular' Gothic table and
'vernacular' furniture: *At Breakfast*
by L. A. Ring; Swedish, 1898.

Antique and eighteenth-century theoretical frugality and functionalism

The idea that frugality, functionalism and beauty are close allies goes back to ancient Greece. Greek philosophers and politicians paid homage to all those qualities. Aristotle held that 'the good of man resides in the function of man',[1] a view he supported with an illustration from aesthetics that was taken as self-evident: 'just as for a flute-player, a sculptor, or any artist, and, in general, for all things that have a function or activity, the good…is thought to reside in the function…'[2] He related 'the good' with beauty and function. Frugality was a Greek virtue: statesmen contrasted Greek frugality with the oriental ostentation of Persia. Persian furniture was 'designed not for use but for luxurious display': when Alexander the Great, a small man, scrambled upon the lofty throne of Darius [6], his feet did not reach its lowest step, and a page had to place a table beneath them.[3]

Greek and Persian values came together in Hellenistic art, whence they influenced two thousand years of furniture design. As did Greek frugality and functionalism alone. Greek functionalism differs from the theoretical utilitarianism of the nineteenth century, which spurned ethics and aesthetics: it is what might be called 'designer functionalism', which thinks aesthetic quality and fitness for purpose of equal importance and does not consider beauty an inevitable corollary of functionalism. 'Designer functionalism', although often (by no means invariably) frugal, need not be brutalist or primitive: rather, it has 'elegance', a term that meant originally something that has been 'chosen' or 'selected'. The opposite to 'chosen' in this context is 'undesigned'. The designing and the making of a piece of furniture are separated in the modern mind, but this duality has an unreality which may adversely affect the thing produced. The Greek attitude was quite different, and is revealed in language: Greek has not two words for 'arts' and 'crafts' but one alone, *techne*, which is best translated as 'technology'. The 'technological' Greeks produced furniture at peace with itself, beautiful and useful.

Little approaching the conscious, frugal, elegant functionalism of the Greeks resurfaced until the beginning of the eighteenth century. France, Italy and England led this development; a powerful catalyst was the Greek neo-classicism of Vitruvius. Cordemoy, whose innovatory theories influenced Laugier and Lodoli, the two arch eighteenth-century functionalists, said that the ancients approved only that which, as Vitruvius said, 'conformed to reason and truth'[4] – a dictum extended in the eighteenth century to gardening: 'Who builds or plants, this rule should know/From truth and use all beauties flow.'[5]

In the late 1750s the neo-Greek functionalist writings of Laugier caused a furore amongst architects (p. 177). At about the same time, Carlo Lodoli (1690–1761) applied functionalist principles to furniture. Lodoli said that 'shoulders should shape the backs of chairs and bottoms should shape their seats'.[6] He did more: he experimented with functionalist designing. He 'had made a new pattern for a chair more or less based upon an ancient Roman chair. This chair did not become universally adopted then, but soon we saw a similar one brought to Paris by [a]…patrician of Venice. The Lodoli chair, besides having a concave back as the French have, was remarkably concave in the seat also. This fashion was soon adopted by the English. One day he placed that chair of his invention next to one of those grand chairs upholstered with calf-skin which are square-shaped, heavy, and loaded with metal studs and reliefs exactly at that point on the arm-rests where one could no longer rest one's elbows without pain; if

one wishes to sit in such a chair one has to throw oneself upon it – only to slide off again, due to the height and the hard pointed mound of the seat.'

Disliking discomfort, and favouring functionalism but not frugality, Lodoli is not the precursor he is often asserted to be of twentieth-century ascetic functionalism (the etiolated neo-classicism of Winckelmann's followers has a greater claim – 'Beauty should be like the purest water drawn from a spring, the less taste the better'[7]). Lodoli's functionalism was of a more genial and expansive kind. Chairs might be '"carved, painted and gilded as you wish, to satisfy your taste for luxury, as long as the demands of comfort and strength are not overlooked. Sit upon one, and then the other, and reflect whether it is wiser to follow ancient authority or the authority of common sense."' The perfect combination was '"solidity with apparent lightness, and comfort with ornament."' Lodoli 'was [not] opposed to fashion – he rather favoured it – without affecting the essential inherent usefulness of useful things, it gives that enchanting variety which so much delights us'. He thought fitness for purpose of fundamental importance, and the gondola (he was Venetian!) perfectly functional and perfectly beautiful: 'the final objective of things [pure Aristotle!]…caused the perfection of the nautical parts of the Venetian gondola…each piece of wood was shaped in accordance with its particular nature, and put in its place with thought.'[8] Lodoli's theories – known from 1753 onwards;[9] Chippendale used his plans and Hogarth cited the gondola in explaining his theory of the 'line of beauty'. They recall the passage on the beauties of functionalism in Proverbs: 'There be three things which are too wonderful for me, yea four….The way of an eagle in the air; the way of a serpent upon a rock; the way of a ship in the midst of the sea; and the way of a man with a maid.'

The Greek Revival of the second half of the century emphasized nobility and austerity; it idolized the 'noble simplicity and sedate grandeur' of antique statues;[10] it rejected the imperial sophistications of Virgil and the flamboyant luxury of Rome, preferring the true primitivism of Homer and the phoney primitivism of 'Ossian' (a favourite poet of Napoleon). The numinous quality of rough stones was again appreciated, and was extended to regular shapes; Ledoux, an influential designer [329], said that elementary forms followed natural laws and had the geometrical purity of natural phenomena, best appreciated when the surface of a form was plain. All these influences combined to encourage a new volumetric and astylar architecture and a new functionalist neo-classical theory. Vitruvius' own neo-Greek advocacy of reason and truth was in harmony with later eighteenth-century idealism. The idea of 'truth' was closely connected with that of 'virtue', and both were thought close to the sublime, as celebrated in Sarastro's hymn to Reason and Virtue in Mozart's *Magic Flute*. This lofty idealism had nothing in common with the nineteenth-century idea of 'virtue', which was compromised by the moralistic puritanism later inherited by twentieth-century dogmatic Functionalism.

Greek and eighteenth-century frugal, functional, and mechanistic furniture

Greek furniture frequently unites functional efficiency with extreme simplicity. The klismos itself, the most elegant chair ever invented, is superbly functional; it openly displays its dowels [521]; it owes its comfort to the brilliantly 'organic' curve of the back; the mannered spread of the legs was not a

519 A Roman folding table in bronze from Pompeii, from an early eighteenth-century drawing.

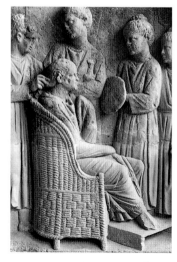

520 A Roman basket chair, from a marble relief found at Neumagen.

521 A satyr carrying a klismos, from a Greek vase.

designer's caprice but the device of a genius to ensure steadiness on uneven ground. The portable Greek table is usually spare and without ornament; its legs sometimes increase in width towards the ground, a feature shared with milkmaids' stools, which like Greek tables have three legs for stability on uneven ground. The X-frame stool and tripod are often of the utmost simplicity. Greek simplicity is connected with the Greek tendency towards abstraction, which was applied consistently to ornament drawn from plants and frequently imposed even on such vigorous naturalistic ornament as the animal leg [26]. The delight in abstraction and geometry is seen strikingly in the depictions of cubic table altars. All this is hardly surprising; the discovery of classical geometry was made by a Greek; in one's schooldays one's geometry book, with its circles, triangles and rectangles, was called quite simply 'Euclid'. It is not surprising that functionalism has always had a close relationship with Greek values.

Greek aesthetic functionalism survived in the teeth of Roman ostentation [494]; even the Romans did not disdain to picture in marble the humble form of a basket chair [520]. Byzantine illuminations show, sometimes next to bedecked confections, simple furniture of antique antecedents. Mediaeval 'knock-down' functionalism has an aesthetic appeal of the 'fitness for purpose' variety; its spareness is not the deliberate, sophisticated spareness of Greek design (which survived in the long-lived X-frame stool [122]), although people obviously found aesthetic pleasure in revealed construction and unpainted surfaces [95, 143, 519] – over a long period, as the sixteenth-century furniture designs of Vredeman de Vries [219] show.

The evolution of eighteenth-century functionalist theory was preceded and accompanied by the consciously designed and beautifully veneered but simple and functional domestic furniture that became fashionable in early eighteenth-century England – the modest chest [522], the 'Queen Anne' chair, and so on. The frugality of this furniture can be startling. The type persisted throughout the century, brought up to date in detail by influential pattern-books. Chippendale, for example, published a design for a 'Library Table' [523] in the 1760s that, apart from a simple band of ornament that could be discarded without prejudice, is functional simplicity itself; its singular contrast with his 'Commode Table' [320] emphasizes the deliberate nature of its simplicity.

This early eighteenth-century English 'empirical' functionalism is different in kind from the interest in Greek elegance that began in about 1760. The 'goût grec' fashion encouraged a simpler type of commode, the 'commode à la grecque' [340], high fashion but functional in the Lodolian sense; some are luxuriously furnished, some almost completely unadorned. The lavish bronzes and elaborate veneers that distinguish high-style French furniture have obscured its frequent functional simplicity, as exemplified in a satinwood secretaire delivered by Daguerre in 1787 to the Duc d'Harcourt, the Dauphin's tutor [527].[11] In that same year Hepplewhite, whose pages are full of plain designs, showed two chests of drawers [524] that are both 'empirical' and 'elegant'; the pared-down form of the lower chest is almost – not quite – worthy of being placed next to the klismos that has influenced the shape of its legs. Hepplewhite's frugality continued in many of Sheraton's early utilitarian designs; his camp chair of 1803 'made to fold up'[12] could almost have come straight off a Greek vase. The 'Etruscan' fashions of the 1790s spread Greek frugality to Scandinavia [393] and elsewhere; they also produced that

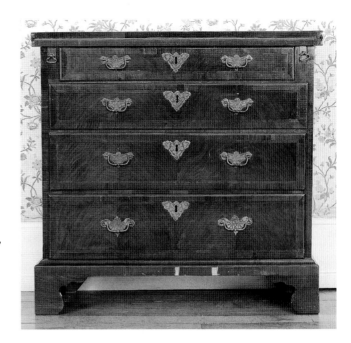

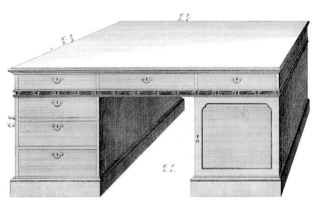

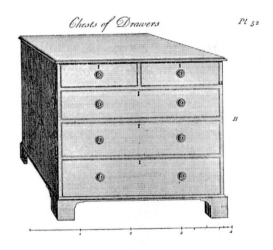

Chests of Drawers Pl 52

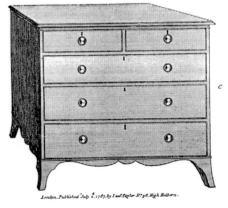

right, top 522 A chest of drawers veneered in walnut, with brass handles; British, c. 1710

right, centre 523 A design for a 'Library Table' by Thomas Chippendale; British, 1753 (from The Gentleman and Cabinet-Maker's Director, 1762).

right, below 524 A design for two chests of drawers by George Hepplewhite; British, 1787 (from The Cabinet-maker and Upholsterer's Drawing-Book).

525 A longcase clock in mahogany, kingwood and boxwood, signed by J. J. Merlin; British, c. 1780-90.

526 An X-frame camp chair in beech and red morocco, used by the Emperor Napoleon; French, 1805-10.

right, above 527 A secretaire veneered in satinwood, stamped by C.-C. Saunier and sold by Daguerre; French, 1787.

right, below 528 A banquette in mahogany and mahogany veneer, designed and made by A.-L. Bellangé for the Louvre; French, 1834.

brilliant invention, the English klismos-legged dining table [399]; early examples are sometimes so restrained as not even to indulge in reeding (dealers have reeded others).

In England, stylistic frugality and functionalism went together with an interest in applied science and mechanical ingenuity. The general interest in science affected artists and poets everywhere in Europe, from minor painters such as Joseph Wright of Derby and P. J. de Loutherbourg in England to the great Goethe, who corrected Newton's theory of optics. English and French designers devised furniture with multiple uses and ingenious mechanisms; craftsmen such as James Cox made clocks and mechanical toys, some highly elaborate. Locks had always attracted attention: in the seventeenth century wonderfully complex and ornate locks had spread themselves over the surfaces of strongboxes. Clocks were the supreme example of machinery as domestic furniture: 'skeleton' clocks were allowed to flaunt their bony mechanisms plain. A longcase clock of about 1780-90 [525] by John Joseph Merlin (1735-1803) is placed in a case the frugal design of which anticipates Viennese design of the 1820s – not to say Viennese design of the early twentieth century (its incongruous feet are probably later[13]). Its functionalism is apparent only – it violates all the usual practical conventions of clock construction.[14] Merlin's career illustrates the internationalism of mechanical circles: a Fleming, he was in Paris in the early 1750s, perhaps invited by the Académie des Sciences; there he saw a mechanical gouty chair[15] which he successfully reproduced in England. In 1760 he settled in England.

Sheraton published ingenious and influential designs for functionally adaptable furniture; his 'Library Table', although elaborately decorated, is simple in form and shows a readiness to accept unsightly mechanisms in use plain; his washhand tables positively bristle with useful devices.[16] Sheraton's designs were circulated throughout Europe well into the nineteenth century. The English preoccupation with mechanical ingenuity influenced French furniture before and after the Revolution. The great ébénistes Oeben, Roentgen and Riesener specialized in beautiful and ornate multiple-use furniture; Riesener often worked for Marie-Antoinette.

The association of early Greek styles with republicanism, which had led Louis XV to reject 'history painting' and George III to reject the Doric order, triumphed in the austere French furniture of the Directory, which was more truly 'Greek' or 'Roman republican' in form and spirit than anything hitherto attempted: it set the scene for the experiments in frugality and functionalism that characterized the nineteenth century. Despite his fondness for rich decoration and furniture, Napoleon used for his campaigns a utilitarian X-frame chair [526] that recalled those depicted in use by emperors on Roman triumphal arches. A version of Socci's 'bureau mécanique' of 1806 [433] belonged to Napoleon; its utility is something of a sham.

The antique style remained capable of restraint even as taste was moving to the extremes of 'profusion'. A banquette in mahogany and mahogany veneer [528] was designed in 1834 by A.-L. Bellangé, who was respected for his severe style;[17] it was part of a large set made for new antiquities galleries at the Louvre that had been designed in a rich neo-classical style by Pierre Fontaine. No doubt Fontaine approved the banquette's union of functionalism with fastidious ornament – the lyre shape is sturdy but suave, and although the reinforcing stretchers recognize the stresses of heavy wear, the turning that 'stops' their ends adds a nice touch of discreet refinement.

Biedermeier and Shaker frugality and functionalism

During the first three decades of the nineteenth century, a certain type of Biedermeier furniture carried abstraction and simplicity to an extreme which attracted Austrian designers of the late nineteenth century, thence making it a potent influence on twentieth-century design.[18]

The idea that Biedermeier furniture is 'bourgeois' is true only in that the bourgeoisie, a class greatly enlarged in the nineteenth century, bought a lot of it. The fact that countless elaborately designed, heavily draped interiors stuffed with Biedermeier furniture were lived in by the middle classes does not make Biedermeier a 'bourgeois' style. In common with other major styles of the period, Biedermeier was a royal style, an aristocratic style, a gentry style, a merchant style: it could be whimsical, it could be lunatically mannered, it could be elaborate, it could be modestly simple. It could

right **529** Furniture designed and
made by Joseph Danhauser, in the
Archduchess Sophie's Music Room
in the Laxenburg Palace near Vienna,
from a watercolour by J. S. Decker;
Austrian (Viennese), 1820s.

530, 531 Two designs for étagères
by Joseph Danhauser; Austrian
(Viennese), 1815–20.

right **532** A design for a rocking
sofa by Joseph Danhauser; Austrian
(Viennese), c. 1815.

533 A bedside table in mahogany
and brass; Austrian (Viennese),
1827.

also be exaggeratedly, eccentrically simple in a manner
less calculated than any other to appeal to the aspirant
bourgeoisie of the garishly exhibitionist early nineteenth
century. It learnt this aristocratic simplicity from Greek
vases and their 'precision of Contour, that characteristic
distinction of the ancients'[19] (Aristotle had adumbrated the
principle[20]), from the 'elementary forms' of Empire furniture
[432], and from English eighteenth-century empirical
functionalism.

The furniture of the Archduchess Sophie's Music Room
at the Laxenburg Palace [529], designed in the 1820s by
Joseph Danhauser (1780–1829), a Viennese trained as a
sculptor who founded a large furniture factory, is palace
furniture despite its austerity. No cosy bourgeois clutter here:
despite the fact that the furniture was veneered, Mr and Mrs
Veneering would have thought it totally unsuited to their
station in life. The elevated simplicity of the Archduchess's
Danhauser furniture was as much a deliberate choice as was
the neo-Greek austerity of the King of Denmark's Abildgaard
furniture [393]. Archduchess and King both liked Greek
frugality, in the Danhauser spirit or the Abildgaard letter.
Many Biedermeier bourgeois shared the Archduchess's
tastes, as is evident in the quantities of frugally plain
Biedermeier furniture still in existence. The aesthetic appeal
of frugality at a lower social level is brought out in a haunting
painting of 1814 [534], where even the line for lowering the
window curtain is given its full significance. The result is
'Greek' beauty of a high order.

Deprived of its cushions, fringes, tassels and the surface
decoration of the wood, a rocking sofa by Danhauser of
about 1815 [532] would be reduced to a simple scroll; a little
inlay apart, minimal allusions are made to antique ornament.
The point of the design lies in its daring elegance, its
(presumed) comfort, and a nice calculation that precluded
the immediate tipping of its occupant upon the floor.
Virtually no historical allusions are made in a bedside table
of 1827 in veneered and solid mahogany [533], which would
look at home in a 1930s bedroom; it is hardly 'bourgeois' in
style – and indeed its underside bears a German legend:
'This table was used by Emperor Francis I of Austria and on
it he wrote his last words.'[21] Danhauser's designs for étagères
include quite astonishingly uncompro-mising examples;[22]
one, made to hold paper [530], is similar to but even more
exiguous than that shown on the right in the painting by
Kersting [534] (it lacks the moulding and the classical taper
of the latter's leg); another [531] is a series of discs
superimposed to make up an egg-shaped dumb-waiter that is
exactly similar to a 1930s pared-down design; the simply

opposite 534 North German furniture, in a painting of a man reading by the light of a Bouillotte lamp, by G. F. Kersting, German, 1814.

535 A chair in gilded bentwood made by Thonet for the Palais Liechenstein, Vienna; Austrian (Viennese), 1843–46.

536 A cradle in bent beech, designed by J. & J. Kohn and made by Thonet; Austrian (Viennese), c. 1904.

curved foot betrays the influence of the base of the classical column, the sole such reference. Despite the lack of overt antique allusions, classical proportions are observed (in the same way as twentieth-century Modern Movement architecture often preserved them). The abstract functionalism of such pieces must have been part of a deliberate programme: one even sees Biedermeier furniture in which a decorative feature has been made of Greek-style 'revealed construction'. Pugin and Reformed Gothic were not the only avenues by which revealed construction reached later nineteenth-century Vienna and Munich.

In about 1835 Schinkel wrote of his own aesthetic odyssey in terms which cast light on the swings between fantasy and functionalism in Danhauser's furniture: he tells how 'prompted by dislike of the arbitrary use in modern buildings of past forms', he 'fell into the error of pure arbitrary abstraction, and developed the entire conception of a particular work exclusively from its most immediate trivial function and from its construction. This gave rise to something dry and rigid, and lacking in freedom, that entirely excluded two essential elements: the historical and the poetical.'[23] The historical and the poetical are certainly missing from the Danhauser étagères. Schinkel then says, 'I pursued my researches further, but found myself trapped in a great labyrinth [of historical allusionism]…' That labyrinth also trapped Danhauser's fantasy furniture,[24] which resembles that of La Mesangère – eccentrically exciting but often clumsy and inelegant.

A far-reaching development began with the establishment in 1819 of a furniture workshop at Boppard-am-Rhein in Germany by Michael Thonet (1796–1871). During the 1830s Thonet successfully experimented with bentwood, for which he took out a patent in Vienna, to which he had moved, in 1842. Bentwood, an ancient and mediaeval technique (p. 16), had been the subject of a British patent for carriage wheels in 1769 and of French experiments in 1778; Sheraton

mentioned the technique in his *Cabinet Dictionary* of 1803.[25] In the early years of the nineteenth century, bentwood was sometimes used for making the legs of curved X-frame chairs and tables. In the mid 1840s, Thonet made a chair for the Palais Liechenstein in Vienna of gilded bentwood [535]; it has an interlaced back and discreetly rococo legs; gilding apart, it set a pattern for the mass manufacture of innumerable cheap, light, easily transportable chairs, often with a vestigial outward-turned klismos leg and curved back. By the 1850s, such chairs were to be seen everywhere in Europe.

The bentwood technique had its own possibilities and made its own demands, both of which conspired to produce a new style that was functional, frugal – and decorative. The bentwood leitmotif is an abstraction of the classical scroll, largely based upon Biedermeier scrolls. A cradle of about 1904 [536] unites functionalism and abstraction with historical allusionism; it turns three-dimensional antique ornament, the scroll and gadrooning (the latter basically the same as that on the seat of Rubens's antique couch [1]), into the linear 'Contour' so admired in Greek art. The cradle's body echoes an 'organic' rococo shape [318]. The famous Thonet bentwood rocking chair has the organically shaped back of the Greek klismos. Bentwood was to be utilized by the Austrian designers of the early twentieth century.

There is occasionally a curious resemblance between the two extremes of the intellectually cogitated 'modernistic' furniture of Danhauser and the religious renunciations of Shaker furniture. This must be because Greek values were prominent in the ancestry of both, and because styles based on frugality or self-denial from the same period might be expected to share stylistically similar plainnesses.

The Shakers were an American primitivist sect founded on the English 'Quakers' and 'Shakers' of the seventeenth century, both known for ecstatically religious bodily convulsions. The 'Testimonies' of Mother Anne, collected in 1816, admonished against 'costly and extravagant' furniture, advising that 'you may let the moles and bats' have 'superfluities'.[26] A Shaker document of 1823 united functionalism and frugality with a spare aestheticism: 'Anything may, with strict propriety, be called perfect, which perfectly answers the purpose for which it was designed. A circle may be called perfect when it is perfectly round [elementary forms again!]: an apple may be called perfect, when it is perfectly sound…'[27] Laws of 1845 prohibited brass knobs and flower-painted furniture, advising that previously fitted brass knobs should be removed.[28]

Not everybody liked the result. In 1842 an English visitor to a Shaker settlement 'walked into a grim room, where several grim hats were hanging on grim pegs, and the time was grimly told by a grim clock, which uttered every tick with a kind of struggle.…Ranged against the wall were six or eight stiff high-backed chairs, and they partook so strongly of the general grimness, that one would much rather have sat on the floor than incurred the slightest obligation to any of them.'[29] This judgment was conditioned by over-blown, over-upholstered, over-decorated contemporary English furniture, the elegant 'powdered-head and pig-tail'[30] furniture having by then largely been consigned to attics. The latter, as pictured in the designs of Hepplewhite and Sheraton, passed to Shaker furniture something of neo-classical restraint and 'Etruscan' frugality: for instance, a Shaker circular tripod stand in cherrywood dated 1837 has legs derived from the antique curved X-frame stool; a table of about 1850 in cherry, pine and maple is a simplified and adapted version of a Sheraton sofa table, again with legs derived from the curved

Scandinavian classicism; 'Arts and Crafts'

The grip of antiquity on Danish furniture (pp. 206–7) never relaxed, and was considerably to subdue the curves of Danish 'Jugendstil'.[34] The most common chair between 1840 and 1900 was a version of the klismos designed by a pupil of Schinkel, G. F. Hetsch. Influential neo-classical furniture was designed for mid-century classicizing Danish interiors, the spirit and style of which were continued by the designers' descendants and disciples throughout the period up to 1900 and beyond.

One such designer was Jørgen Roed, who copied Raphael's *Sistine Madonna* for the Copenhagen house for which Bindesbøll designed 'Raphaelite' Renaissance furniture [507]. His bookcase [537] could, lacking its sinful painted decoration, almost be of Shaker manufacture. The decoration, inspired by 'Pompeian' and 'Etruscan' styles, it in the green and cream of English late eighteenth-century 'Hepplewhite'. The small paintings of female heads, frugal descendants of 'Angelica Kauffmann' motifs, are isolated within 'Etruscan' circles in the centre of empty 'Pompeian' compartments [32]; they are copied from well-known Pompeian paintings, the lady on the right being commonly called 'Sappho'. The painted ornament includes 'Etruscan' wave patterns, interlaced circles with circles within, and linear scrolls. The considered restraint of the whole design is very 'Greek'. Its links with Secession and twentieth-century Scandinavian designs are obvious; with a few omissions, Roed's bookcase could stand without remark in a twentieth-century kitchen or, polished, in a twentieth-century living room.

Like Greek and Shaker furniture, Arts and Crafts furniture made a conscious virtue of frugality and functionalism; Morris and Burne-Jones were apostles of Gothic functionalism [494]. Arts and Crafts worthiness was leavened by 'japonisme' (pp. 300–302). Japanese buildings and furniture, like the Reformed Gothic and vernacular movements, emphasized constructional virtues and the craftsman's spontaneity. Godwin, the most accomplished British exponent of japonisme, required certain qualities of

537 A bookcase in painted pine, designed by Jørgen Roed, painted by G. C. Hilker; Danish, *c.* 1850.

538 A sewing table of cherry, maple and poplar, made by the Shakers; American, *c.* 1860.

X-antique frame stool; a chest dated 1827 is close to a 'Hepplewhite' chest with its typical scrolled apron. Such English designs had greatly influenced Biedermeier, and indeed the form and decoration of a Shaker sewing table of about 1860 [538] (the footrest is later), which is primitively nailed together rather than dovetailed, are related to sophisticated Biedermeier [617] and English types.[31] Many techniques used in Shaker built-in furniture are Germanic,[32] and Shaker and Biedermeier furniture shared the use of transparent colour stains.[33] There is apparently not much evidence of a Germanic presence in the Shaker communities; this is odd, since to an English eye much Shaker furniture has, despite the English influences, a continental European rather than English sensibility.

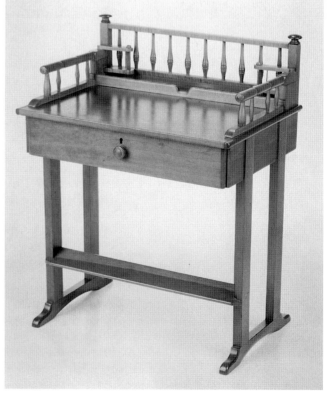

539 Eclectically mixed furniture, in
Mama's and the Little Girls' Room, by
Carl Larsson; Swedish, c. 1894–97.

his furniture. First, it was to be cheap and functional: he
wrote in 1876 of his famous sideboard [629], conceived in
1867, that 'with a desire for economy, I desired it to be made
of deal, and to be ebonized. There were no mouldings, no
ornamental metal work, no carving. Secondly, it was to be
easy to clean'[35] – an aesthetically neutral and somewhat
bourgeois virtue; was Greek frugality influenced by the fear
of dust? Thirdly, it was to be soothingly modest: 'It is
essential for true domestic comfort in these high-pressure,
nervous times, that the common objects of everyday life
should be quiet, simple and unobtrusive in their beauty.'[36]
Godwin has been described as 'the first nineteenth-century
designer to be concerned primarily with function and not
with superficial style [he wasn't], and it was for this reason
that his work was admired particularly by the Austrian and
German designers at the end of the last century'.[37] Function
without style is a poor thing, and Godwin, like Danhauser in
the early part of the century, was concerned with both; in
common with other very stylish (and unstylish) designers, he
happened to talk a good deal about function, but the most
striking element in his furniture is its highly original style,
which united Egypt, Greece and Japan [624].

The fashion for vernacular furniture, Gothic and non-
Gothic, that spread across Europe in the latter part of the
nineteenth century joined hands with the French white-
painted 'Louis XVI' furniture of the 1890s (p. 320) to
influence avant-garde Scandinavian interiors. The Swedish

painter Carl Larsson (1853–1919), who had lived in France
for some years, put into his house a mixture of recently
fashionable furniture;[38] an attic bedroom in the mid 1890s
[539] contained two primitive beds with 'revealed
construction', an X-frame table, white-painted neo-classical
chairs of indeterminate date (the backs decorated with the
curved X-frame taken from Scotland to America by Duncan
Phyfe [448]), and a rustic Biedermeier painted bed. The
vernacular style was not confined to self-conscious artists: a
delightful Swedish painting of 1898 [518] shows the lady of
the house – not the housekeeper – having breakfast in a
room furnished in up-to-date manner with a 'Gothic' table
and a modern vernacular chair and dresser, all painted blue.

In Denmark, the native neo-classical influence continued
into the twentieth century; the most influential designer,
Kaare Klint (1888–1954), was, amongst others, influenced by
the furniture of Bindesbøll. Klint was appointed furniture
designer at the Royal Academy of Art in Copenhagen in
1924; to him was largely due the continued popularity of the
Danish arc-backed armchair, a form directly influenced by
the klismos. Edvard Thomsen, who also taught at the
Academy, in 1923–24 created furniture influenced by the
classical furniture designed by Bindesbøll for the
Thorvaldsen Museum; he continued the klismos tradition
with a chair intended as a Danish version of the Thonet
chair. In 1930 he designed a chair [540] that combines the
arc back and outswept back legs adapted from the klismos

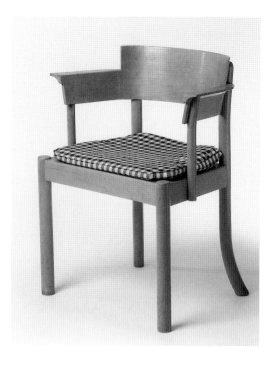

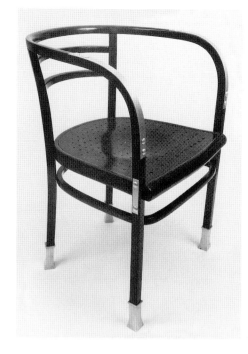

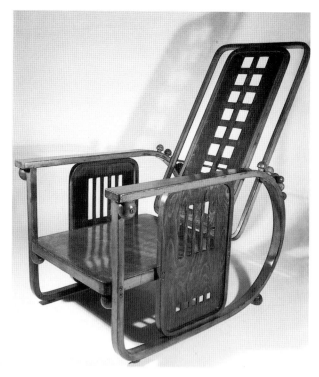

540 A chair in beech, designed by Edvard Thomsen; Danish, 1930.

above, centre 541 A chair in bent beech, plywood and aluminium, designed by Otto Wagner and made by Thonet for the Postal Savings Bank, Vienna; Austrian (Viennese), 1904.

above right 542 An armchair in stained beech, the 'machine for sitting', designed by Josef Hoffmann for the Purkersdorf Sanatorium and made by J. & J. Kohn; Austrian (Viennese), 1904.

with a straight perpendicular back, perpendicular front legs, and horizontal arms on perpendicular supports abstracted from the famous sphinx-armed chair that, pictured in the *Antichità d'Ercolano* in 1765 and frequently thereafter [10:E], had inspired Abildgaard in 1794,[39] Schinkel in 1828,[40] and Bindesbøll in about 1840[41] – to mention only three examples of many. The Thomsen chair absorbs its historicist influences to become an accomplished twentieth-century example of frugality and functionalism.

Early twentieth-century doctrinaire frugality and functionalism: the influence of the machine

Early twentieth-century classicism was strong enough to survive in strength in Germany, Austria and France (pp. 317–27). However, it was attacked head-on by fashionable new doctrines (or rather old doctrines re-dressed) that caught public attention through being couched in terms of revolutionary impersonality or expressionist violence.

The propagandists replaced the Aristotelian idea of the good residing in function, as interpreted by the Greeks, Laugier, and Lodoli, with the idea of the impersonal machine as an exemplar of furniture form. The 'new gospel [of machinery] was first preached by poets and writers' such as Zola (including, oddly enough, Oscar Wilde, as early as 1882[42]) – and H. G. Wells, a populist machine-addict who referred in 1905 to that 'laboured inane which our mad world calls ornament'.[43]

Adolf Loos (1870–1933) returned to Austria from America in 1897, and the same year saw Vienna's first 'modern, functional' interior, in which 'graceful and yet logical forms are adapted, as far as possible, to today's functionalism' – as a contemporary[44] described a ladies' drawing room exhibited in the Austrian Museum of Art and Industry (it was later categorized by Loos as 'our dear old German Renaissance fancy dress room with a modern top-dressing'[45]). Loos, who was called a product of American culture by a contemporary writer (and indeed one influence on his 1898 designs was that of the 'craftsman's furniture' of Gustav Stickley (1857–1946)), began a campaign against bad taste in the *Neue Freie Presse*, expressing ideas at the opposite pole from those represented in their purest form by the work of Josef Hoffmann (1870–1956), who demanded that

interiors should be 'total works of art'.[46] An idealistic contest eventually developed in which the existing matured concepts of classical frugality and functionalism were outvied by savage denunciations of ornament. The new ideas deeply influenced attitudes to furniture design, but the sound and the fury were miraculously and inevitably muted in the realized designs. One cannot sit in comfort on an explosion. Their attainment in a classical rather than mechanistic form may be clearly seen in three pieces of furniture, one by Wagner and two by Hoffmann [541, 542, 544].

Otto Wagner (1841–1918) was an architect who taught at the Academy of Fine Arts in Vienna from 1894; he followed the doctrine that ornament must be part of structure, and his students included Hoffmann. In 1899 he joined the Secession, an avant-garde Viennese society of artists founded in 1897. As an architect Wagner was steeped in classicism, fascinated by functionalism and technology, and influenced by large cast-iron buildings such as the Crystal Palace and railway terminals (did he know that the huge vaults of the Baths of Caracalla had been supported by iron girders?). The structural framework of his Vienna Postal Savings Bank of 1903–6 was made of aluminium, and its piers were patterned with the heads of rivets; the feet and arm claddings of the chair made for the Bank by Thonet to Wagner's design [541] are aluminium, with exposed rivets, a translation of 'revealed construction' into the new metal (Abildgaard's wooden chairs had copied the exposed bolts of Greek bronze furniture); its front legs and rail are continuous pieces of bent beech. The slightly concave feet are probably a lingering reference to Greek concavities (the curve is purely decorative, as is that of the legs). A comment has been made that the 'holes in the plywood seat are drilled in a pattern of diminishing diameters, but they are merely restrained decoration and have no historical design reference';[47] in fact, little circles (derived ultimately from the ends of beams [19]), were a motif of the 'Etruscan' decoration to which Vienna owed so much – an English cast-iron lobby chair described in 1833 as 'Etruscan' is similarly decorated with plain pierced round holes on seat, legs and seat rails.[48]

A small table designed in 1902 by Josef Hoffmann in his version of geometric modernism [544] consists of a marble circle set upon a square maple base; the shapes are pure

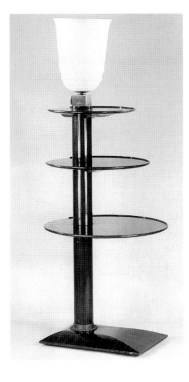

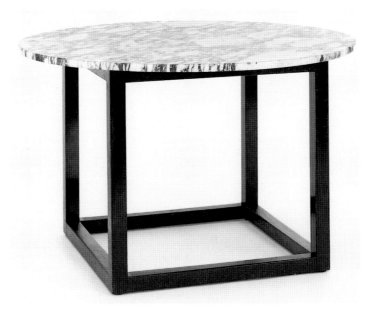

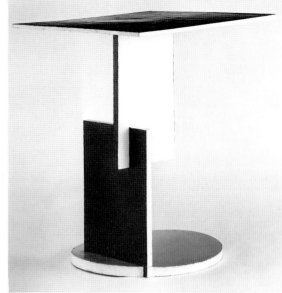

above **543** A bedside table in macassar ebony, with an alabaster lamp, designed by J.-É. Ruhlmann for a viceroy of India; French, designed in 1921.

above centre **544** A table in marble and dark brown maple, designed by Josef Hoffmann; Austrian (Viennese), 1902.

above right **545** 'End Table' in painted plywood, designed by Gerrit Rietveld; Dutch, 1923.

546 A sideboard veneered in walnut and coromandel ebony, designed by Serge Chermayeff and made by Waring and Gillow; British, 1928–29.

geometry and completely without ornament – Hoffmann's penchant for straight lines and geometry led to his nickname 'Quadratl-Hoffmann' ('Little Square').[49] The table observes Hoffmann's dictum, published in 1901, which declared that angular forms fitted the nature of wood (presumably marble had no 'nature' in that sense, and could therefore be round). However, rounded wooden forms (in bent stained beech) are seen in a 'machine for sitting' that he designed in 1904 for a sanatorium; it was made by Jacob and Josef Kohn [542]. Certain of its features originate in Biedermeier style: these include the decorative squares and rectangles (the latter distantly evolved from fluting – or even lyre strings?) and the radical curves introduced by Danhauser before the bentwood era. The chair also has 'Bauhaus balls' – the irreverent term is Osbert Lancaster's[50] – which in the guise of plugs allow the angle of the back to be altered; others appear as ornament below the arm rests and seat. 'Bauhaus balls' probably derived from Egypt, and might be described more accurately as 'Biedermeier balls' (p. 297): taken over from Biedermeier by Otto Wagner, Hoffmann and others, they eventually became 'fun' in the 1951 Festival of Britain style of furniture associated with the British architect Sir Hugh Casson. Notwithstanding its historicist references, Hoffmann's chair appears uncompromisingly 'modern', not least in its clear revelation of the affinity between bentwood and metal furniture. It is not surprising that the Thonet firm eventually made the transition to all-metal furniture.

Bearing these three pieces in mind, one turns to two violent diatribes. The first, 'Ornament and Crime', written in 1908 by Adolf Loos, said that all ornament was of erotic origin and resembled scatological graffiti; it likened an ornamented building to a tattooed man – a 'modern man who tattoos himself is either a criminal or a degenerate' (did Loos know that primitive Man decorated himself before he wore clothes?). This doctrine, founded in hysterical disgust – far removed from the frugality of ancient Greece, which was accompanied by tolerance – reminds one that contemporary Vienna was the city of Egon Schiele. In 1923 Loos went to Paris, where the essay was translated and republished. Similar in nihilistic puritanism is the Italian Futurist Manifesto of 1909, which proclaimed the virtues of the machine and advocated an iconoclastic and intolerant anti-historicism that

involved the blowing up of all ancient monuments (this was also a period of violent political Nihilism[51]). The fuss was largely unnecessary; the aims of the radical movements had already been partially attained, or were well on the way to attainment, before spluttering pen had been put to deeply gouged paper. However, the doctrines influenced the design of furniture and architecture, and 'accompany Modernism like a dark shadow in all its later phases'.[52] They were not without influence on the 'Cultural Revolution' of Chairman Mao.

The impulse towards frugality and functionalism was not confined to the aggressive theorists. The French Art Deco designer Jacques-Émile Ruhlmann (p. 324), included by Le Corbusier amongst the 'buffoons who believe in decorative art' (he found Ruhlmann's rare veneers 'as astonishing as humming birds'),[53] was greatly influenced by Biedermeier [435, 676]. Sometimes Ruhlmann's furniture takes long strides towards abstract functionalism; three tubular steel chairs he exhibited in 1925 anticipated Le Corbusier himself;[54] his bedside table [543] in macassar ebony closely resembles an ascetic design by Danhauser.[55] The lamp is alabaster, a substance favoured for hanging lamps in the Empire period and for windows in ancient Rome. A table of 1925 by Gerrit Rietveld [545], composed entirely of 'elementary forms' set one into the other, could almost

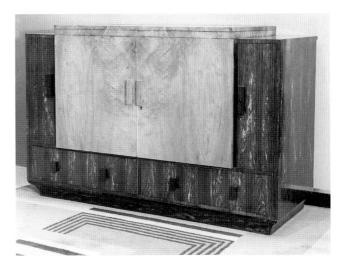

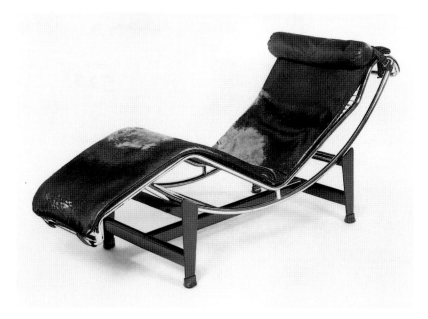

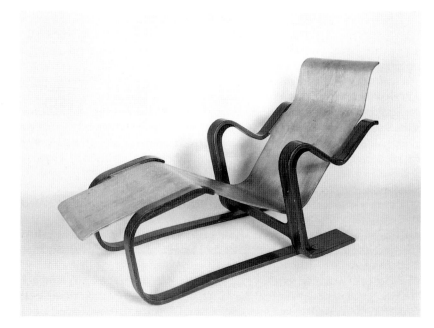

top **547** A chaise longue in chromium-plated tubular steel, painted sheet metal, and pony skin, designed by Le Corbusier, Pierre Jeanneret and Charlotte Perriand and made by Thonet, 1928.

above **548** A chaise longue in laminated birch, zebrano veneer and plywood, designed by Marcel Breuer and adapted by Isokon; the chair was meant to have a cushion; British, 1936.

right **549** The 'Barcelona' chair, in chromium-plated steel and leather, designed by Ludwig Mies van der Rohe; German, 1929.

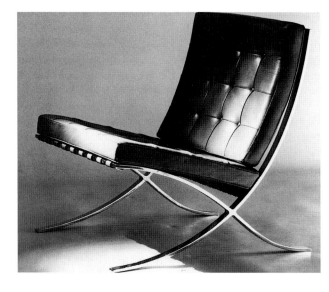

have been designed by Danhauser – except for its colour, which it shares with the abstract paintings of Mondrian.

A more work-a-day 'Modern' cubic style is seen in a sideboard [546] designed by Serge Chermayeff (1900–1996), a Russian educated at Harrow. In 1928 he and Paul Follot (p. 322) organized an exhibition of French and English decoration and furniture at Waring and Gillow's in London; this sideboard was in the dining room. The veneers are in walnut and coromandel ebony, and the handles are wooden, perhaps as a result of a lingering 'vernacular' influence. Chermayeff explicitly rejected ornament and advocated 'as pure a style as was finally achieved by the ancient Greeks in the age of Pericles.'[56]

Twentieth-century use of metal, plywood and fibreglass

Metal had been employed for the frames of chairs and tables since remote antiquity. In the eighteenth and nineteenth centuries fine rococo and neo-classical console tables and sofas had been made entirely of steel, often ornamented with gilt bronze; Russia had manufactured elaborate metal furniture [358]. Cast-iron garden furniture was everyhere in the nineteenth century. The nineteenth-century brass or iron bed was a commonplace; the iron 'campaign bed', a functionalist piece that folds into flatness, often has aesthetic qualities not dissimilar to those sought by twentieth-century functionalists. Cast-iron framing in building developed from the late eighteenth century onwards, and iron was used profusely by Nash at Brighton (inside, disguised as bamboo [590]) and by Schinkel in Berlin.

Given these circumstances, it is surprising that twentieth-century avant-garde metal furniture was greeted with something approaching consternation.[57] Perhaps it was partly because it looked so different from the large slabs of oak wielded by the vernacular lobby, partly because people disliked the deliberate association with machinery, and partly because taste had been corrupted by bad reproduction furniture. Certainly, bright chromium plate 'made a statement' – still bad manners in many circles. Whatever the reason, as late as 1929 it was said that 'In 1925 we do not remember having seen a single piece of furniture made of metal and we will not enter into any controversies as to whether the first piece was made in Germany or France… metal furniture has appeared simultaneously in so many places at the same time that it can be considered as a collective production, the invention…of society as a whole'.[58]

The German interest in metal furniture was forwarded by Hermann Muthesius (1861–1927), an anti-historicist German architect, civil servant and journalist who, never a designer, much influenced furniture design. He argued the case in Germany for the British Arts and Crafts movement[59] and for the acceptance of the machine, passionately advocating the standardization of parts. 'Unit furniture' had been used in America for bookcases; in 1910 *Typenmöbel* was produced by a Dresden firm.[60] Muthesius's views led in 1907 to the foundation of the Deutsche Werkbund, an alliance of artists and industrialists for the promotion of commerce. Its ideals were embodied in the Bauhaus, founded in 1919 by the merging of two Weimar art schools into one State school directed by the architect Walter Gropius. The Bauhaus taught fine arts, crafts, industrial design and architecture. It moved to Dessau in 1925; both it and the Werkbund succumbed to Hitler, the first in 1933, the second in 1934. The collectivism and standardization embodied in these German movements were hotly opposed by the later

individualism of Henry van de Velde (p. 313), Gropius' predecessor in Weimar: 'The artist is essentially and individually a passionate individualist....Never will he, of his own free will, submit to a discipline forcing upon him a norm, a canon.'[61]

The German cult of the machine and the use of metal in furniture was supported by French theorists, especially by 'Le Corbusier'.[62] In his youth Le Corbusier (1887–1965) had read the inflammatory works of Ruskin, Owen Jones and Viollet-le-Duc. He and the painter Amédée Ozenfant (1886–1966) were early devotees of Cubism: however, 'omnipotence itself cannot escape the murmurs of its discordant votaries', and in 1918 their *Après le Cubisme* accused Cubism of 'degenerating' into decoration; they advocated in its place 'Purism', an impersonal art stripped of ornament and individuality and inspired by the machine. Ultimately, the source of Le Corbusier's ideas lay far back in Platonic idealism and Greek frugality. To that must be added the heritage of Romantic Classicism: in Le Corbusier's own words, 'Cubes, cones, cylinders, and pyramids are the primary forms',[63] words that might have been uttered by Ledoux. 'Futurism' had said that 'a house is a gigantic machine'; Corbusier added a gloss slightly more human in its emphasis: 'a House is a machine for living in'.

One effect of the Modern Movement has been to limit the range and vocabulary of the furniture designed to occupy pared-down interiors. Apart from deliberate standardization, the reason is simple: furniture lives off interior decoration and the fine arts, depending upon them for sustenance; a puritan creed that eschews decoration and ornament may well eliminate the grosser elements that have made for much ugly furniture, but it also dramatically reduces the range of expression available to it. This partly explains the unresisting acceptance of the fashion for fitted cupboards and multi-purpose fitted shelves, which has increasingly eliminated ambitious large items such as wardrobes and armoires, dressing tables, bookcases and sideboards – even desks are now largely confined to offices. Design interest was forced to concentrate on chairs and tables or smaller items of case furniture.

However, some beautiful furniture – now hailed as 'modern classics'! – has been made under these restrictive auspices. The finest examples fit easily into interiors of many types, including, paradoxically, highly 'decorated' ones. One of the most successful is the chromium-plated steel chair

designed by Ludwig Mies van der Rohe (1886–1969) for the Barcelona Pavilion of the 1929 World Fair [549]. Mies had, like Le Corbusier and Walter Gropius, been apprenticed to Peter Behrens. He began as a devotee of Schinkel, and throughout his life had a passion for sumptuous marbles, bronze and tinted glass. His oft-quoted maxim 'less is more' breathes the essence of Greek frugality. The 'Barcelona' chair (which occurs also as a stool) has antique echoes; even the Pavilion in which it was housed recalls the Pompeian 'open plan' house. At first sight the chair seems to be a classicistic essay that synthesizes the klismos with the antique X-frame stool, and it can certainly be regarded in that light; however, a frequently published Egyptian chair [605] that combines the hieratic X-frame seat with a back in something of the same way as does the throne of Tutankhamun [4] contains, plainly delineated amidst all the surrounding ornament, legs that are essentially duplicated in those of the 'Barcelona' chair.[64] Undoubtedly beautiful, and frugal in design if not materials, Mies van der Rohe's chair is not comfortable (in this respect, Robsjohn-Gibbings' academically 'archaeological' klismos (pp. 323–24) is far more 'functional').

Two other 'modern classics' played variations on the chaise longue theme. The first [547] is in chromium-plated tubular steel, a material that offers the plasticity of bentwood and superior strength, together with a bright, hard glitter. Designed by Le Corbusier and others, it was made by Thonet in 1928, the year after the firm had first begun making metal furniture. Different as each is from the other, there are affiliations between this chaise longue, the Danhauser rocking sofa [532], the Thonet cradle [536], and a bentwood rocking chaise longue of about 1880.[65] The curved line of Corbusier's 'undercarriage' somewhat resembles Danhauser's, save that Le Corbusier has tilted up his seat at the knees; all the elaboration of the cradle's scrollwork, especially that of the base, does not disguise the similarity of its forms to those of aluminium and tubular steel. The bentwood rocking chaise longue comes close to the Le Corbusier chaise longue.

The second chaise longue [548] was designed by Marcel Breuer (1902–81), who graduated from the Bauhaus to teach furniture as head of its carpentry works. In 1925 he was inspired by his bicycle to design his first tubular steel chair. Mechanistic impersonality had been turned on its head: the end had been replaced by the means, and forms that were functional in machinery had became decorative in furniture – the chair inspired by the bicycle is immobile! The 'impersonal' chair was even given a name, the 'Wassily', after Kandinsky, who admired it.

Breuer began to use aluminium for chairs in 1932, and the chaise longue illustrated was designed first in aluminium and steel. In 1936 a bent plywood version (thought more acceptable to insular taste[66]) was put on sale by 'Isokon' (Isometric Unit Construction), a British firm of which Walter Gropius had in the previous year become director of design; the seat of the adapted design consists of a single piece of plywood mortised into the arms and 'legs'. Plywood is encountered in ancient Egypt (p. 16), but had been developed from the 1870s onwards by the inventions of sawing techniques and glues; by 1912 Finland was the principal supplier, and the strength and lightness of the material prompted its use in aeroplanes during the First World War. The plywood version of Breuer's chair closely resembles its steel and aluminium prototype, save that modifications made under the influence of the flowing lines

550 A tea table in maple plywood, glass and brass, designed by Carlo Mollino; Italian, *c.* 1950.

551 An armchair veneered in walnut; Austrian (Viennese), c. 1820.

552 An armchair in moulded plastic reinforced with fibreglass, and enamelled metal wire, designed by Charles Eames and made by Herman Miller; American, 1951.

553 Two armchairs in plastic, fibreglass and aluminium, designed by Eero Saarinen and made by Knoll; American, 1957.

right 554 A chair in welded steel wire, designed by Harry Bertoia and made by Knoll; American, 1952.

right, centre 555 A stacking chair in moulded polyester and fibreglass, designed by Verner Panton in 1960, first made, by Herman Miller, in 1967; Danish.

far right 556 The 'Superleggera' (super-light) chair in ash, designed by Gio Ponti; Italian, 1952.

of a plywood chair of 1931–32[67] by Alvar Aalto give it a quite different effect. Aalto's chair is nearer to 'functional' Biedermeier,[68] Thonet bentwood and Wiener Werkstätte furniture than are the rigid forms of the original Breuer chair; its plywood seat has deeply scrolled ends (cut short in Breuer's plywood chair) and its frame has curvilinear lines. Isokon's plywood version – Breuer himself was keenly involved in the project[69] – was badly designed at the point where the seat was attached by mortise and tenons to the frame, and its frame has had to be reinforced; the design was modified in the 1950s and 1960s to make it more practical. These chairs are usually photographed in 'functionalist' literature without their fitted upholstered seats, which would make them horribly unyielding – a comment on 'functionalist' aesthetics?

The visual sources of a curvilinear tea table of about 1950 by Carlo Mollino (1905–73) [550], which exploits the flexibility of bent plywood and glass, are most easily discerned in the floating planes and curvilinear forms of abstract paintings and sculpture: some twentieth-century furniture owes more to painting and sculpture than to interior decoration – although such distinctions become meaningless in an age when so much painting and sculpture have become primarily interior decoration.

A new material, reinforced fibreglass, offered flexibility and strength without the burden of metallic weight or the frangibility of cross-grained wood. The first designer to use glass fibre commercially for a chair was Charles Eames (1907–78).[70] An example of 1951 in fibreglass-reinforced plastic and exiguous black-painted metal [552] harmoniously unites two traditions – that of the Biedermeier 'tulip' chair [551], derived ultimately from the ancient woven chair via the stone throne and the scroll-ended couch, and that of the steel electricity pylon, which itself recalls the skeletal elegance of the folding metal tripod [519]. A chair designed in 1952 by a sculptor and teacher of metalwork, Harry Bertoia (b. 1915), in welded steel wire and rods [554] has a functional sparseness relieved by the organic, almost flower-like lines of the seat. Bertoia knew Eames, and their chairs have complementary aspects.

The chairs and table of 1957 designed by Eero Saarinen (1910–61) in white plastic and fibreglass on a cast aluminium base [553] is yet another design that has been called a 'modern classic'. Comments made by Saarinen a few years after it was conceived illuminate contemporary attitudes (in so far as one can follow the journalist's syntax): the 'pedestal chairs and tables designed by the American architect Eero Saarinen embody a revolutionary concept in furniture design....By the elimination of legs, which as Saarinen says "become a sort of metal plumbing" that in moulded chairs of

this type leads to a separation of seat from legs, a new spatial concept and a new organic unity was created...after many dozens of drawings quarter-scale models were made...Saarinen has said "I wanted to make the chair *all one thing again*. All the great furniture of the past, from Tutankhamun's chair to Thomas Chippendale's have always been a structural total."'[71]

It depends what one means by 'structural total' – one chair of Tutankhamun's [4] was made in two stages. One wonders why Saarinen left unmentioned the Biedermeier furniture from which his design principally derives – it is difficult to believe that he, especially given his Finnish background, conceived it in isolation. A Biedermeier table illustrated here [443] has 'metal plumbing' within its wooden stem – as, almost certainly, has the 'tulip' chair [551]. Saarinen's design is beautiful and functional, but there is nothing 'revolutionary' about it; the only really new thing is the material. A more complete 'structural total' was designed by the Danish architect Verner Panton (b. 1926) in 1960 [555]: this, the first chair moulded as an 'organically' continuous fibreglass shell, was, significantly enough, a stacking chair – the ultimate unhierarchical chair form.

The novelty of such materials and forms has over-excited the heirs of the nineteenth century's ingenuous belief in the spiritual powers of new materials. A reviewer of a book on plastics commented in 1997 that 'plastic has performed the role of a fundamental metaphor within modern American culture....Its increasing ubiquity and its complete integration into, and role in the determination of, the nature of everyday life has empowered it to represent our deepest fears and hopes.'[72] What art is produced by a culture that has its 'deepest fears and hopes' represented by plastic – or by any material? The deepest fears and hopes of the Egyptians who made the furniture of Tutankhamun in ivory, ebony and gold were certainly not 'represented' by those luxurious substances – as neither were the angelic aspirations of the Shakers represented by the plainest pine or cherry in which they made their furniture.

Perhaps the most brilliant of achievements is to use a completely traditional material – wood – to create something completely new – and yet old! The Italian designer Gio Ponti (p. 326) produced in 1952 a chair made of ash [556]; its fastidiously elegant forms are almost completely traditional save for the slightly bent back; it is so light that it can be lifted with a finger. Had Ponti read Lodoli on lightness? Had he seen the Greek vase paintings that show chairs and stools lifted with careless nonchalance – with one hand [521]? Whether he had or not, in his 'Superleggera' chair Greek and twentieth-century frugality and functionalism came full circle.

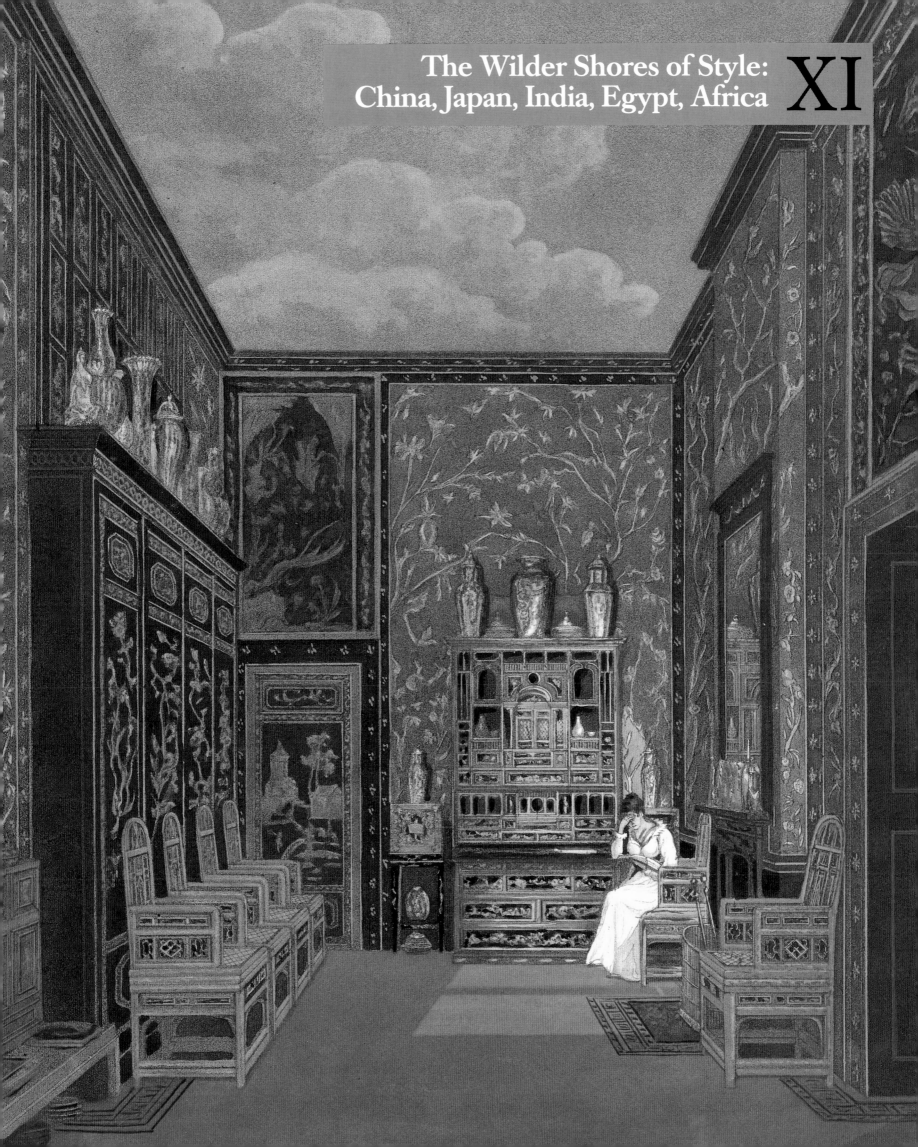

overleaf 557 A Regency chinoiserie room in Frogmore House (p. 287); British, published in London by William Pyne in 1817 (from *Royal Residences*).

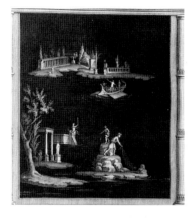

558 A fishing scene, from a Roman wall painting published in Naples in 1760 (from *Delle Antichità di Ercolano; Le pitture antiche d'Ercolano*).

559 An architectural capriccio, from a Roman wall painting published in Naples in 1757 (from *Delle Antichità di Ercolano; Le pitture antiche d'Ercolano*).

THE ADJECTIVE 'gorgeous' attached itself as by right to the East over many centuries – even the greatest poets did not find the repetition stale. Splendiferous general ideas, however, were accompanied by vaguenesses and errors that were only partly to do with distance. They had also to do with the ambiguities of ornament.

Fruitful ambiguities

Motifs have always wandered in space and time, acclimatizing themselves in lands far distant from their original homes: the same motif travelled through more than one channel and ended up in the same place in different variants. Western motifs followed four principal paths. The first came through a shared archaic inheritance – for example, many Greek motifs originated in Egypt; some motifs shared by Greece and China probably came from the area now called Romania.[1] Quite different from these involuntary and leisurely transmissions were the deliberate assumptions of alien styles by sophisticated cultures in search of frissons (such as the Egyptianizing essays of ancient Rome), or the copying by less advanced societies of the art of developed cultures (such as early Islamic borrowings from Byzantium, or European borrowings from Byzantium and Islam in the Dark and Middle Ages). Different again were the haphazard, sporadic borrowings that followed trade routes – for instance, the Chinese folding chair probably came thus from the Roman X-frame chair before AD 200.[2] The most violent way was through conquest: Hellenic motifs found their way into Egypt and India via Alexander's campaigns.

Egyptian, Greek, Roman, Islamic, Chinese, Japanese, and Indian arts share many motifs in common, and eighteenth-century designers and writers noticed and recorded the striking correspondences.[3] The fact that many alien motifs were already more or less domiciled in the West made deliberate imitations of alien styles easy. Indeed, motifs from different sources can be so similar that terminology becomes interchangeable: for instance, similarities between the frets, interlaced circles and decussated lozenges [561–568] on Greek vases and those of Chinese and Japanese ornament led in the 1780s to the architect Charles Cameron proposing that the central building in the Chinese Village at Tsarskoe Selo should be decorated with 'various Chinese ornaments' including 'cornices and ornaments *à la grecque*'.[4] Such ambiguities enabled the eighteenth-century painter Thomas Jones to speak of the recently discovered Hadrianic frescoes of the Villa Negroni in Rome [37] as 'painted ornaments much in the Chinese taste',[5] and Horace Walpole to say that 'the discoveries at Herculaneum testify that a light and fantastic architecture of a very Indian [meaning 'Chinese'] air made a common decoration of private apartments'. Diderot spoke of grotesque as 'a bizarre variety, without rapport or symmetry, as in "Arabesque" [rococo] or in the Chinese Taste'.[6] Close affinities of this kind cannot occur with the black African or South Sea Island artefacts which became fashionable in Europe in the early twentieth century – which is why European furniture that employed such motifs can look so 'unassimilated' [642, 644].

Gothic threw another term and another ambiguity into the stylistic whirlpool. The writings of Cordemoy illuminate contemporary opinion of the relationships between Gothic, moresque, rococo and grotesque. Cordemoy was influenced by a Jesuit, the 'erudite Father Tournemine',[7] who had proposed that 'Gothique Moderne' should be renamed 'Moresque'.[8] Tournemine repudiated the idea that the Goths had invented Gothic architecture; he divided Gothic into 'Gothique ancienne' (comprehending Late Antique and Romanesque) and 'Gothique Moderne', which drew its poetic fantasy from the Moors 'or what is the same thing, the Arabs, whose taste in their architecture has been the same as in their poetry. Both have had a perverted delicacy, been charged with superfluous ornaments, altogether removed from simplicity. Fancy…has made the buildings of the Arabs as extraordinary as their opinions.' Cordemoy, following Tournemine, defined 'Gothic' as 'Ordre Gothique ou Arabesque';[9] a startling marriage between the cloister and the harem. There is much truth in all this.

Cordemoy, in preferring the term 'Arabesque' to 'Moresque', added yet another ambiguity, since by the time he wrote 'Arabesque' generally signified in France the synthesis of arabesque and grotesque that had turned into rococo (p. 170). One's head whirls.

These confusions contained the paradisial poetry of dreams induced by the hookah or the opium pipe; they gave much more licence than the 'archaeological' pedantries that were to follow more exact knowledge and terminology. The pedantries already existed in embryo. The word 'Gothic' was employed as a (usually abusive) umbrella term for 'anti-classical' excess in general; it was associated by hostile critics not only with mediaeval Gothic but also with grotesque, chinoiserie, and the new great anti-classical style of rococo. For instance, the conservative French Academy of Architecture expressed in 1710 its opinion on nascent rococo fashions by saying that 'The Company has disapproved of many of the new styles, which are faulty and which have much of the gothic about them';[10] an English writer of 1728 referred to Vitruvius' denunciation of grotesque as 'a Censure upon those Painters of His Time, who were addicted to what at present are called *Gothick* ornaments';[11] the Président des Brosses wrote in 1739 of rococo: 'The Italians [obviously the conservative classicists] reproach us that in France…we are returning to the gothic taste, and that our chimneypieces, our gold snuff-boxes, our silver plate are twisted and distorted as if we had lost the way of using the circle and the square, and that our ornament has become entirely irregular.'[12] A French writer rejoiced in the success of 'goût grec' and the abandonment of 'gothic': 'The Comte de Caylus has revived the Greek taste amongst us, and we have at last renounced our gothic forms'. By 'gothic', he meant rococo.[13] He spoke too soon: Gothic (meaning Gothick) had already colonized England!

This fluidity of terms and ambiguity of ornament affected some of the most widely used motifs. Grotesque decoration afforded many examples: a twentieth-century description of the black or red backgrounds, sparse, asymmetrical decorations, trees and bijou temples isolated in space of Roman wall painting [558] makes them sound exactly like Japanese lacquer: 'The fact that the spatial recession of the schemes is immeasurable and the visual relationships of the

560 The idol 'Matzou', published in Amsterdam in 1675 by Olfert Dapper (from *Gedenkwürdige Verrichtung…in dem Kaiserreich Taising oder Sina*).

561 Frets from the coffers of the ceiling of the Propylaea, Athens (after Owen Jones, *The Grammar of Ornament*).

562 Fret from a Chinese painting (after Owen Jones, *The Grammar of Ornament*).

563 Frets from the coffers of the ceiling of the Propylaea, Athens (after Owen Jones, *The Grammar of Ornament*).

564 Border ornament from a Greek vase published in 1766 by P. F. D'Hancarville.

565 Fret from a Chinese painting (after Owen Jones, *The Grammar of Ornament*).

566 Ornament from the Propylaea, Athens (after Owen Jones, *The Grammar of Ornament*).

567 Fret from a Chinese painting (after Owen Jones, *The Grammar of Ornament*).

568 Ornament from a Greek vase (after Owen Jones, *The Grammar of Ornament*).

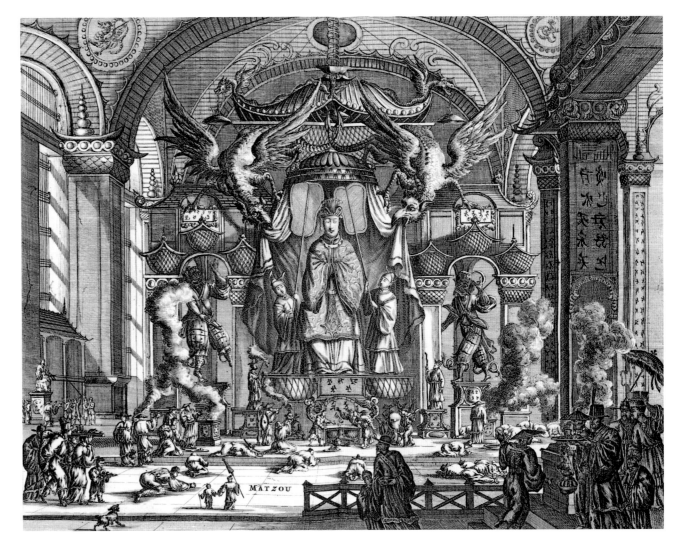

different elements one to another is ambiguous gives them an ambiguous, almost dream-like quality.' Another description recalls the 'Willow Pattern' plate: 'A man crossing a bridge is nearly half the height of an adjacent two-storeyed tower.'[14] Mature Roman art bears traces of what may be imported chinoiseries (p. 36): little temples with upturned 'pagoda' roofs, capricious compositions [559], serpents and dragons; bronze candelabra closely resembling bamboo existed at Herculaneum [45]. The parasol occurs in Greek vases, Roman paintings, oriental lacquer and European chinoiseries. Padigliones and lambrequins, those staple ingredients of rococo and chinoiserie, had both been associated with exoticism in antiquity, as in a Pompeian mural that contains a figure in Asiatic dress sitting on a richly decorated throne [196]. Chinese rockwork strikingly resembles such painted antique rockwork as that of the famous and often copied 'Barberini landscape';[15] rockwork frequently appears on clocks, console tables, and other furniture. Simulated bamboo can look almost exactly like the more slender forms of Greek and Roman concave turning [29]. The antique velarium has resemblances with Gothic fan-vaulting, and advantage was taken of this by architects and designers to incorporate Gothic detail into grotesque decorations. Antique and moresque geometrical interlace were sometimes identical, as were Gothic and Mughal cusped lozenges, a fact noted by Humphry Repton and George Smith. Such freedoms contributed mightily to the fact that the furniture of the most rational of centuries has a greater degree of 'poesie' than any other. Stylistic ambiguities facilitated mixed marriages that produced enchanting

offspring, including Chinese/Gothic Chippendale chairs [468] and French Chinese/Etruscan/Pompeian pier tables [592]. Such ambiguities explain why George IV in the 1820s hung Audran's grotesque tapestries in his Gothic Dining Room at Windsor – and why a Sotheby's cataloguer fell in 1970 into the trap of describing the tapestries as 'fantastic panels showing the influence of the Chinese style'![16]

The nineteenth century's attitude to stylistic mixtures was different, either moral outrage, racial intolerance (a new phenomenon – 'the civilised mind revolts', as a British painter-decorator wrote of chinoiserie in 1827[17]), or cultural servility, an extension of 'archaeological' pedantries to 'ethnography' (a word first used in English in 1834). For Christopher Dresser, 'my success in the production of [an Arabian, Chinese, Indian or Moorish] pattern depends largely upon the extent to which I become, in feeling, for the time a Chinaman, or Arabian, or such as the case requires.… I often find it necessary to inform myself of the religion, mode of government, climate, and habits of a people; for it is only by understanding their faith and usages that I can comprehend the spirit of their ornament.'[18] Such literalisms would have made rococo creativity impossible.

Early European contacts with China and Japan

'…oh do tell me something about the Chinese ladies whether their eyes are really so long and narrow always putting me in mind of mother-o'-pearl fish at cards and do they really wear tails down their back and plaited too or is it only the men, and when they pull their hair so very tight off their foreheads don't they hurt themselves, and why do they stick little bells

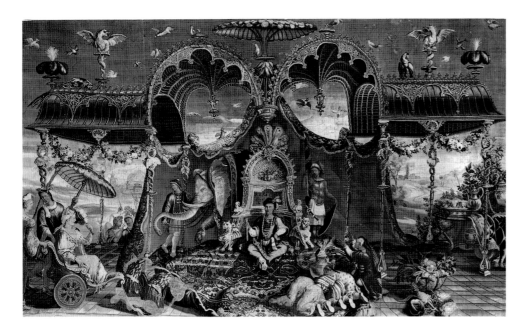

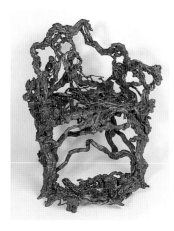

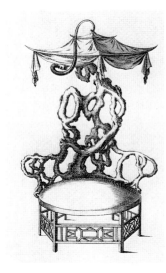

569 'The Audience of the Emperor', a Beauvais tapestry; French, designed *c.* 1685–90.

570 A 'twig' chair; Chinese, Qing dynasty, eighteenth or nineteenth century.

571 A garden table designed by Edwards and Darly; British, 1754.

all over their bridges and temples and hats and things or don't they really do it!'

Thus an excitable and perhaps slightly drunk English lady in 1855.[19] Europeans born before about 1850 saw oriental countries, impossibly distant for ordinary travellers, as exotic in a way they never can be again. Their arts were luxurious and excitingly different: their peoples, rarely seen in the West until the nineteenth century, had intriguingly outlandish customs. Imprecision (from the sixteenth century onwards the term 'Indian' was often used of Chinese and Japanese artefacts) added mystery to distance, allowing legends and idealizations to flourish. China combined an unmetaphysical philosophy with a refined, almost dixhuitième sensuality: Voltaire preferred the Great Cham to Le Grand Monarque, setting the perfect heathen society of China against the imperfect Christian society of Louis XIV[20] (Louis XV twice imitated the Chinese Emperor in the spring religious ceremony of driving the plough). Even classical antiquity might suffer by comparison: the famous Porcelain Pagoda at Nanking was described by a Dutchman in 1665 as surpassing 'in neatness, in prettiness, in variety, in enamelling, and in magnificence all the highly praised works of our ancients…it is so delicately enamelled and glazed in green, red and yellow that one would declare it made only of gold, emeralds, and rubies.'[21] The writer was predisposed to see emeralds and rubies rather than glazed pottery by what he had heard of China before setting foot in it.

Roman trade contacts with the Far East were affected by Dark Ages chaos, and it was not until the thirteenth century that the Mongol conquest of China allowed regular trading to resume. A Franciscan friar sent by Louis IX of France to the Great Khan wrote in 1254 the first of the accounts that fed the European appetite for the marvellous.[22] Other early books included the imaginary travels in China of 'Sir John Mandeville', which appeared between 1357 and 1371; once printed, it was reprinted up to the seventeenth century. As late as the nineteenth century, Marco Polo and opium conjured up that magical evocation, 'Kublai Khan'. Marvels were sustained by further mysteries: in about 1350 the new Ming dynasty closed the borders of China to Europeans until the early sixteenth century.

The sixteenth century saw trade re-established, principally through the Portuguese, who in 1517 reached Canton and in 1542 Japan. More accounts were released upon the Western

world; that of Juan González de Mendoza went through sixty-six editions in seven different languages.[23] In the seventeenth century trade accelerated: the British East India Company was founded in 1600 and the Dutch in 1662; religious zeal took the Society of Jesus into China and Japan; the Jesuits designed palaces for the Chinese Emperor. When the French West and East India companies were established in 1664, 'The king [Louis XIV] gave more than six millions of present-day [written in 1751] money to the company and urged wealthy people to interest themselves in it. The queen, princes and all the court provided two millions.'[24] A serious check occurred in 1639, when Japan closed its borders to foreigners, remaining inaccessible until forcibly opened by the Americans in 1854. One result was a complete dearth of illustrated books on Japan.

The influence of illustrated books

Of all exotic styles, chinoiserie and japonaiserie[25] exercised the most influence over the longest time. Designers in chinoiserie style were assisted by illustrated books that depicted grandees, mandarins and peasants, buildings, dress, plants, boats, animals, gardens – all the details of Celestial life.[26] Such books stimulated architects who needed more than a panel of Japanese lacquer from which to work; without such assistance Perrault could hardly have planned, as he did in 1671–72, to join the Louvre and the Tuileries with apartments 'in the manners of all the most celebrated nations of the world, the Italians, the Germans, the Turks, the Persians, the Mughals, in that of the King of Siam, of China, etc.'[27] Buildings and interiors inspired by illustrations or by designers' prints based on them were often seen as demanding chinoiserie furnishings.

Jan Nieuhof went on a Dutch East India Company embassy to China in 1655; ten years later he published a book in Dutch that was quickly translated into English, French and Latin;[28] it was profusely illustrated, and many of its images reappear in other publications. The figure on Nieuhof's title page was used for the central figure of the Berainesque Beauvais tapestry depicting 'The Audience of the Emperor', designed in about 1685–90 [569].[29] Nieuhof's book was followed in 1667 by that of the Jesuit Athanasius Kircher,[30] which was translated into French in 1670; it also contributed to 'The Audience of the Emperor'. Other informative books included the *Atlas japannensis* and *Atlas chinensis* by Arnoldus Montanus of 1670 and 1671, each containing more than a hundred illustrations. In 1675 Olfert Dapper published a book on China[31] that contained rich pickings for the exotically inclined artist or decorator [560]; gardens, costume, and genre scenes of various kinds were all given an airing. Designers quarried such books for their own publications: for instance, Peter Schenck (the younger) reissued the illustrations in Dapper's book in 1702; textile designers also reissued them.[32]

The multi-tiered pagoda, one of the most exotically bizarre of oriental motifs to Western eyes, was often illustrated. The Porcelain Pagoda at Nanking, depicted by Nieuhof, was imitated in Louis XIV's famous Trianon de Porcelaine at Versailles. Kircher's oddly pared-down pagoda, the 'Turris Novizonia Sinensium' (his depictions are Westernized, a feature that made assimilation easier), may have influenced the dignified neo-classical pagoda at Chanteloup,[33] and is depicted large on the walls of an appealing late seventeenth-century chinoiserie room at Troia near Prague.[34] Fischer von Erlach's heady collection of 1725[35] included his version of the pagoda at Nanking, significantly

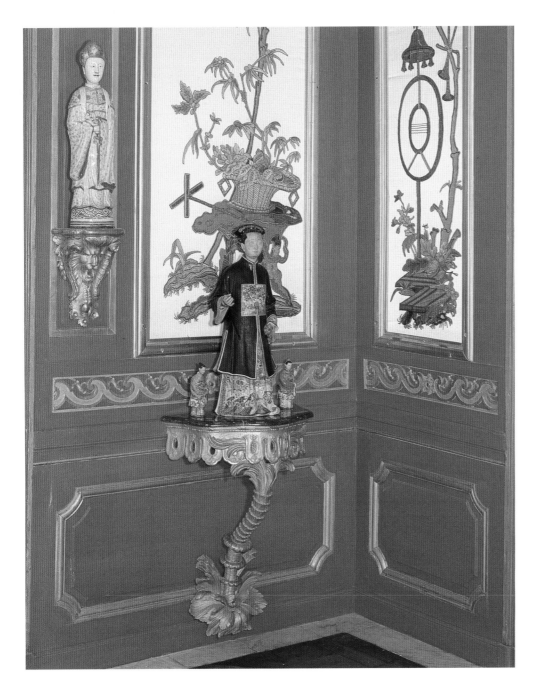

[570] and tumbled Chinese rockwork gave a further impetus to the rustic furniture and rockwork that had accompanied the grotto fashion (pp. 170–71); Chinese frets in garden fences and furniture became common [571]. Chinoiserie garden imagery came indoors; it pervades the figures, 'parasols', and flowering candle branches of the 'garden' girandoles of Thomas Johnson [325]. Some chinoiserie garden buildings were extremely sophisticated; the Pagodenburg at Nymphenburg outside Munich of 1716–19 is an early example. Other splendid examples include Frederick the Great's chinoiserie garden capriccio at Sans Souci, the exuberant palm-like columns of which were possibly inspired by Kircher's picture of the stately 'Ficus Indica Arbor Paradisi';[39] the same source may also have inspired the supports, topped by lambrequins, of console tables in the Chinese Pavilion at Drottningholm [572].

One of the most generally useful of all books on China was published in 1757 by the English architect William Chambers [573];[40] it influenced furniture [557] and interiors throughout Europe, including those of the pavilions at Drottningholm and Brighton [572, 590]. It came late enough to be affected by neo-classical dryness. The effect of French Romantic Classicism on chinoiserie was more disastrous – how *could* a style that resembled tents be adapted to the cube?

Chinese paintings assembled in European collections supplemented the illustrated books: forty-nine volumes of paintings had been presented to Louis XIV in 1697, and Watteau's chinoiserie designs reveal his acquaintance with real Chinese paintings.[41] In the later eighteenth and early nineteenth centuries, small gouaches made for export supplied motifs for decorations and furniture, and were themselves applied to walls in chinoiserie 'print rooms'. Chinese furniture itself was imported: a sixteenth-century Chinese folding chair with footstool attached that belonged to Philip II still stands in the Escurial, and a Medici inventory of 1598 contains what it almost certainly Chinese or Indian

572 A console table and a wall bracket in carved and gilded wood, designed by C. F. Adelcrantz or J. E. Rehn and made by Johan Ljung, in the Embroidered Room of the Chinese Pavilion, Drottningholm; Swedish, *c.* 1760.

573 Chinese furniture, from *Designs of Chinese Buildings, Furniture, Dresses, Machines and Utensils* by Sir William Chambers; British, published in London in 1757.

different from earlier versions by Nieuhof and Dapper. Thomas Hope was misled by (correct) Vitruvian theories of temple evolution to suppose that Chinese architecture recalled its nomadic origins: 'The palaces only look like a number of collected awnings, and the very pagodas, or towers, in their loftiness, are nothing more than a number of tents, piled on the top…the aggregated dwellings…resemble nothing but a camp'.[36] In fact the curved Chinese roof, facilitated by an old structural tradition that made curves an easy choice, derived primarily from aesthetic preference.[37]

Decorators and designers now had authentic sources not only for pagodas but for chinoiserie versions of the canopy, baldacchino, or padiglione, with its concave curves and antique associations (pp. 110–11) (the geographer Richard Hakluyt records that 'canopies' were amongst wares captured by Queen Elizabeth I's English pirates from the Spaniards in 1592[38]).

The admiration for Chinese gardens as described and illustrated by travellers led in the early eighteenth century to the fashion for the 'Anglo-Chinese' garden, which spread throughout Europe. Innumerable chinoiserie garden buildings followed; they demanded matching garden furniture, and the contorted forms of Chinese 'twig' furniture

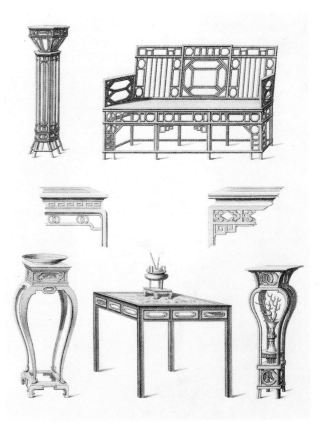

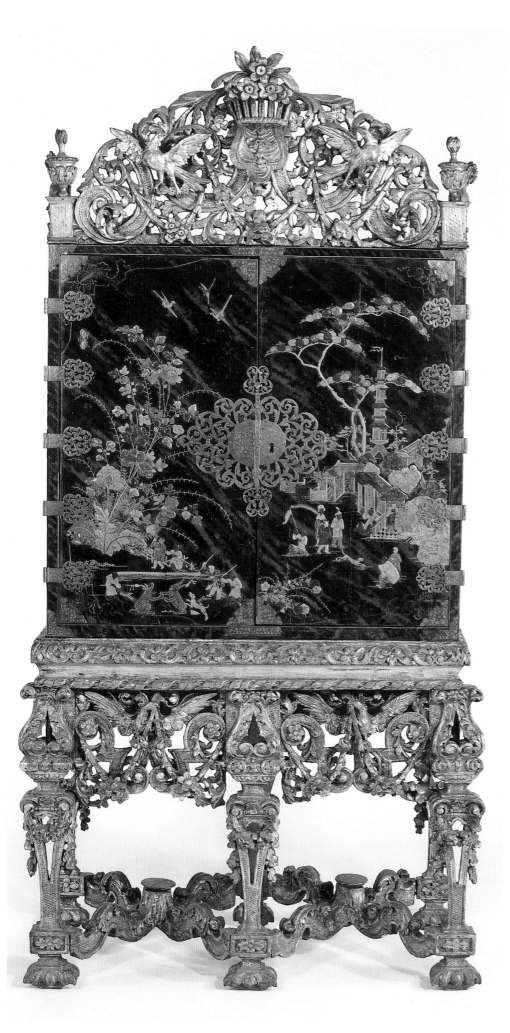

furniture.[42] The English pirates in 1592 mentioned above captured ebony beds bound for Spain.[43]

Through whatever conduits the arts of China and Japan travelled to become 'chinoiserie' and 'japonaiserie', the results always remain firmly attached to the prevailing style – be it baroque [574], rococo [581], neo-classical [592] or Art Deco [637]. The influence of Chinese and Japanese colour combinations should not be ignored. Chinese and Japanese buildings were, unusually, designed in colour as well as form; this was both functional, to protect timbers from decay and parasites – for instance, the brilliant red mercuric oxide was used from about 1100 BC – and aesthetic. Oriental artefacts used colours that varied from intense contrasts of black, gold, scarlet, blue and 'Chinese' yellow to the lighter complementary hues seen especially in certain fabrics, wallpapers and porcelains – lilac and yellow, pink and blue, green and pink – sophisticated juxtapositions that sometimes resembled the 'grotesque' colour schemes employed by Italian mannerist painters. The whole range was reflected in Western decoration and furniture, from the black, red and gold of the Chinese Pavilion at Drottningholm to the (originally) lilac and gilt chairs of the Royal Pavilion at Brighton [589].

Three magic substances – silk, porcelain, and lacquer[44] – provided some of the most influential motifs.

Lacquer and lacquer techniques

Lacquer provided motifs for use in textiles and wall decorations. One of the most esteemed of oriental products, it was easily adapted for use in Western furniture. The finest lacquer, technically and artistically, came from Japan, often as large screens that European craftsmen cut up and applied to other uses. Japanese lacquer had a flat, usually black glossy surface decorated in raised gold; Chinese Coromandel lacquer was incised, and its frequently fierce, congested compositions belong to a different world from the elegant, spaced-out lacquer idylls of the Japanese; the contrast is between profusion and economy. Oriental lacquer was costly, and was much imitated.

Unequivocal signs of a general European fashion for chinoiserie had appeared by 1600: whole rooms were being decorated in oriental style, chinoiserie furniture was being made in large quantities, and costly oriental lacquers were being imitated in European 'japanning'. In about 1615–16 a room panelled in green 'japan' was installed at Rosenborg Castle in Copenhagen, possibly the earliest European example extant. In 1616 the first chinoiserie prints – always a sign of demand from craftsmen – appeared;[45] in 1623–26

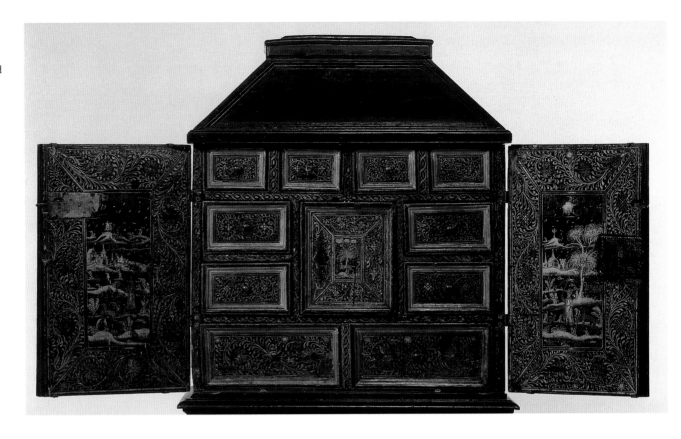

opposite, left 574 A cabinet on stand in pine and oak, the cabinet japanned and the stand silvered; English, *c.* 1690.

opposite, right 575 A design in the Chinese taste by Valentin Sezenius; German, 1623–26.

right 576 A japanned cabinet in oak, with gilded and silvered painted chinoiseries; English, *c.* 1620.

577 A cabinet on stand, with four Japanese lacquer panels framed in English aventurine japanning set upon a carved and gilded English pine stand, perhaps designed by James Moore; British, *c.* 1715.

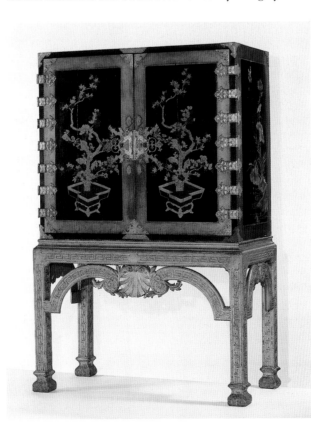

Valentin Sezenius issued prints that united chinoiserie with grotesque, the beginning of a long partnership [575]. An English cabinet of about 1620 [576], originally a table chest, is japanned in gold and silver leaf on a black ground (another cabinet from the same group imitates Japanese lacquer inlaid with mother o' pearl); the decoration mixes chinoiserie figures and foliage with European details such as a windmill, a gibbet and a church, an early instance of the inconsequence that remained a feature of chinoiserie decoration. The drawers, which are painted scarlet inside, are outlined in ribbon interlace. The chinoiserie is confined to flat decoration; the shape of the piece is Western.

European japanning varies in quality from the crudest imitations that would deceive nobody to highly accomplished imitations of Japanese lacquer undetectable by the eye. Almost from the beginning, japanning became the province of the amateur as well as the professional; Sezenius's prints could have been used as well for amateur japanning as for any other purpose. The detailed technical instructions given by the most famous of the instruction manuals, the *Treatise of Japanning and Varnishing* by Stalker and Parker of 1688, could be followed with ease by amateur or professional. The authors boldly asserted that 'the glory of one Country, Japan alone, has exceeded in beauty and magnificence all the pride of the Vatican at this time and the Pantheon heretofore'. The success of the treatise must have been assisted by the charms of its prose, which pays parodic homage to the organ notes of Sir Thomas Browne.

The large doors of the Japanese and Chinese chests that were imported in quantity into Europe from the later seventeenth century onwards made a good display of lacquer; the chests were imitated in 'japan', and originals and imitations were alike hoisted up on Western-made stands. Three cabinets on stands [241, 574, 577] represent a type found across most of Europe. One cabinet [574] is in English lacquer, its gold and silver decoration being applied to a ground of trompe-l'oeil tortoiseshell; the others are Japanese, and the differences in style are immediately apparent. As are the differences between the stands, of which two are English and one probably Dutch: they share only the metallic finishes that admirably complement the black and gold lacquer. One [241] is in the Anglo-Dutch auricular style. The English cabinet [574], of about 1690, has a stand and crest (the latter have usually disappeared, and this has lost ornament) that display the broken curves and rectangular baluster legs of French baroque; the birds, single lambrequin and flower basket are orientalizing allusions, although the last two occur in antiquity. The third cabinet [577], of about 1715, has a stand of carved softwood decorated with gesso that, despite the acanthus and cockleshell, is orientalizing both in shape and in its ambiguous Greek key decoration. Its interior is veneered with walnut in the understated Queen Anne style.

Chairs were frequently japanned. An English chair of about 1673 is japanned on a frame that shows Chinese and

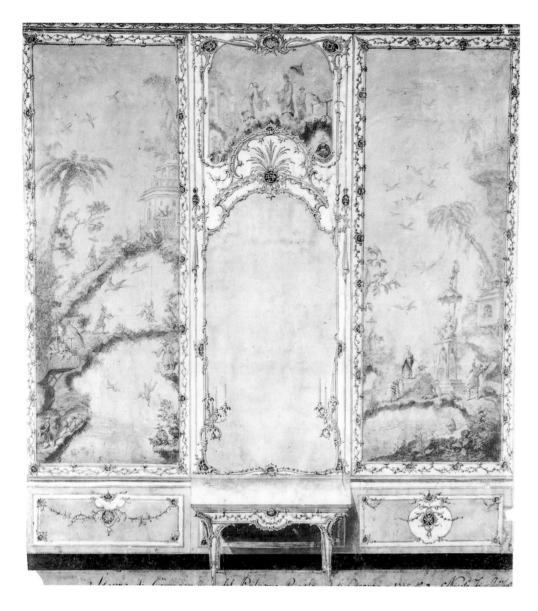

eighteenth-century Venice, where the spirit of carnival was strong. Venice's counterfeit lacquer furniture – *lacca contrafatta* or *lacca povera* – is in a class of its own; crude it may at times be, but the combination of exaggerated bombé curves (in which the broken curve is often prominent) with applied chinoiserie decoration, often on a light ground – green, duck-egg blue or yellow – is enchantingly frivolous. Chinoiserie decoration was also frequently carried out in paint and infrequently in *tôle*, a novelty that, perfected during the 1760s, became a speciality in the 1770s of certain French ébénistes.[49]

Lacquer, real and simulated, continued to be used as a sumptuous decoration for post-rococo neo-classical furniture: the exquisite refinement of Japanese lacquer appealed to French and French-influenced taste more than did the vigour of the Chinese. The most obvious way of introducing pictorial chinoiserie details to furniture, it was frequently the only chinoiserie element in a piece, the rest of the design being occidental in style.

The influence of silk and porcelain on furniture

Chinese and Japanese silks and porcelain exerted as strong an influence on European design as did lacquer.

Chinese silks have always been famous, and from the end of the thirteenth century their motifs appeared on Italian silks: from about 1350, Italian silks made in Lucca combined Chinese with Islamic and Italian ornament, which rapidly invaded other media; textile manufacture itself moved from

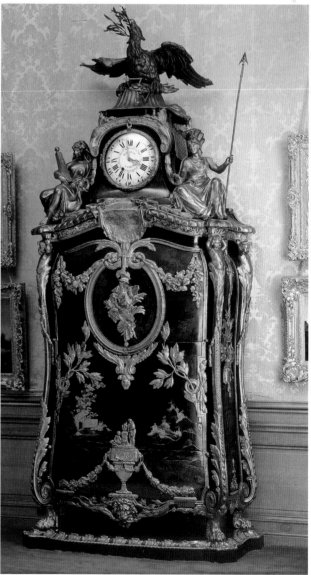

578 A design for wall decoration for the Ante-room to the Queen's Bathroom in the Royal Palace at Caserta, by Nicola Fiore; Italian, 1775.

579 An armoire-secretaire in Japanese lacquer and gilt bronze, made by René Dubois and J. Boyer; French, *c.* 1774 (see p. 192).

auricular influence [242]; another of the later 1730s in red and gold lacquer [285] represents a type of which large numbers were exported, especially to Portugal, where the style influenced native production. Chairs were made in much the same style in China specifically for export.[46]

The secrets of lacquer manufacture had been discovered by a Jesuit in the time of Cosimo III of Florence. The generic name 'vernis Martin' given to the highly successful lacquer imitations produced during the eighteenth century [342] derives from the name of the French brothers who perfected the technique;[47] they copied oriental lacquer by applying forty or more coats of an especially lustrous varnish, often green in colour. They were not the only people in the field: in October 1713, letters patent were issued in favour of Pierre de Neufmaison, Claude Audran and Jacques Dagly 'to establish a manufactory of varnish for application on all sorts of linen and woolly stuffs, silk, leather and other flexible materials and in all kinds of colours, suitable for making furniture'; their atelier was established at the Gobelins.[48]

Cheaper and easier ways of decorating furniture with imitation lacquer included applying prints, cut out, painted and varnished. Various craftsmen produced prints especially for the purpose: Gabriel Huquier (1695–1772), for instance, produced in 1737 twelve sheets for cutting out. Remondini of Bassano, in the Veneto, also produced prints especially designed to be cut up. Chinoiserie was highly fashionable in

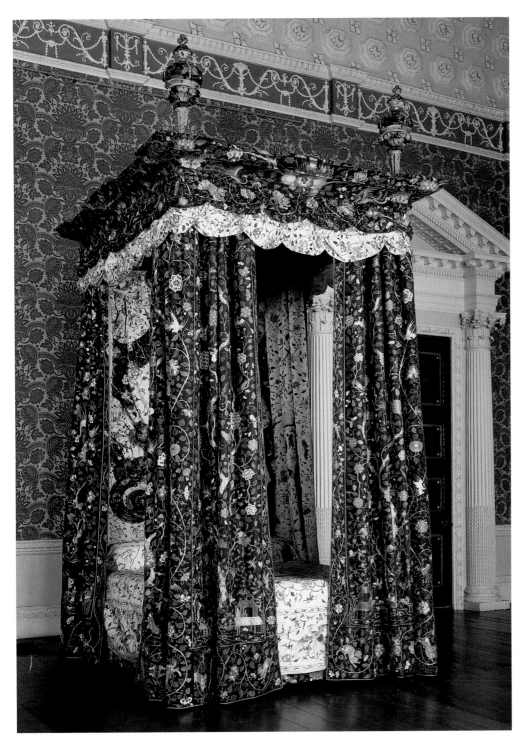

order – the Emperor Charles V possessed plates with his cipher and badge, and his son Philip II of Spain owned over three thousand pieces. Oriental porcelain became a furnishing fad in the later seventeenth century, covering cabinets and chimneypieces; in 1687, the Hôtel Mazarin in Paris contained '*Germain* [meaning Flemish [249]] Cabinets, and *China*, with Trunks [meaning chests] of Japan, wonderfully light and sweet';[51] the fashion continued in favour indefinitely, oriental wares being imitated first in European faience and then in European porcelain.

Orientalizing textiles frequently accompanied chinoiserie furniture and were used to upholster it, but comparatively few examples have survived. Beds were an obvious vehicle; as early as 1615, Lady Arundel was busy matching curtains to her 'bedde of Japan'.[52] Real Chinese textiles were used for the grandest furniture. By extraordinary chance, an eighteenth-century state bed preserves its Chinese embroidered silk hangings in pristine condition [580]. It was probably the marriage bed of the English princess who married the hunchback Prince of Orange in 1734; the survival of large extra panels suggests that the royal bedchamber was entirely hung with the same fabric. The bed is designed in the Marot tradition, somewhat old-fashioned by 1734; immediately after the marriage it was given to a bridesmaid as a perquisite,[53] never to be re-erected until 1985.

Splendid as baroque chinoiserie is, it never entered into the heart of European style as did rococo chinoiserie; even the most accomplished complete baroque schemes present chinoiserie applied to baroque forms rather than the seamless garment of the best rococo chinoiserie. The grotesque of Berain and Audran, which offered a host of unifying expedients, easily accommodated chinoiserie and the two fused in rococo chinoiserie; decorations and furniture became one [578]. rococo and chinoiserie so commingled that the origins of rococo have been (vainly) sought in chinoiserie (for instance, it has been thought that the asymmetry of chinoiserie bizarre silks between 1690 and 1725 contributed towards rococo asymmetry). Rococo unity– and style! – was frequently carried over into neo-classical chinoiserie [590].

A rococo commode [581] illustrates how furniture was designed in concordance with chinoiserie interiors, and how porcelain and textiles could influence its appearance. The commode was made by the ébéniste Matthieu Criaerd for Madame de Mailly, a mistress of Louis XV, and was delivered to her château at Choisy in 1743. There was currently a fashion for blue and white interiors designed to match blue

580 A state bed in oak and pine hung with Chinese embroidered silk, at Calke Abbey; British, early eighteenth century.

581 A commode made by Matthieu Criaerd, painted with blue and white chinoiserie designs probably by Alexis Peyrotte, with silvered bronzes; French, 1743.

Lucca to Venice. European textiles also copied the patterns and motifs of oriental porcelain and lacquer, and added Indian motifs to the mixture. A Medici inventory of 1553 mentions 'tela di Portugallo pinta', almost certainly an Indian chintz design[50] (the Chinese-sounding word 'chintz' has nothing to do with China, being derived from the Hindustani *chint*, meaning 'coloured'). In 1625 an English company was founded to weave hangings with Indian motifs. The oriental flowers taken into textile design from Japanese lacquer and Chinese textiles, porcelain and wallpapers encouraged the use of flowers on furniture; they became international and persisted for centuries. In the eighteenth century many people could not distinguish oriental textiles from the excellent French imitations.

Chinese porcelain was widely owned in Europe by the sixteenth century, and potentates were having it made to

engraved prints designed to be cut out and pasted on to much cheaper items of furniture by society ladies and others; Peyrotte had issued such 'découpures' himself.

From the 1730s onwards the walls of rooms were being entirely covered with Western imitations of Chinese porcelain, the most stupendous example being installed in 1763 at Aranjuez in Spain; Giambattista Tiepolo probably had a hand in its design. Smaller items of furniture such as clocks, candelabra, girandoles and light tables were ornamented with oriental and chinoiserie porcelain and pottery throughout the eighteenth and into the nineteenth century. A torchère and candelabrum from Brighton Pavilion, both made in about 1818, illustrate some of the possibilities. The torchère, from the Banqueting Room, has a Spode column ornamented with chinoiseries in gold [585]; its dark blue copies Sèvres blue, which in its turn had copied monochromatic Chinese porcelains. It is topped by an Indian lotus; its dragons are in gilt bronze but the dolphins, probably a royal afterthought, are in carved and gilded wood; they have an antique origin. The candelabrum, on the other hand, rises from a column of Mason's ironstone that imitates 'famille jaune' Chinese polychrome export wares.

Porcelain, in this case Sèvres porcelain, is used extensively in an ambitious 'cabinet chinois' of 1843–44 [582] that resulted from a brief but fruitful collaboration between Sèvres and the *architecte décorateur* (as he called himself) Léon Feuchère. Trained, amongst other things, as a designer for the theatre, Feuchère produced designs of noted virtuosity in most available styles, including 'moresque' – he had in 1842 adapted for Sèvres, in an inordinately expensive and splendiferous form, a 'vase arabe' from a Granada museum.[54] It is not surprising that despite the ostensible thoroughgoing chinoiserie of the cabinet – amongst the painters who worked on its plaques of Chinese scenes and frets was Émile Borget, who had actually studied in China[55] – other civilizations intrude. Antiquity influenced the tripartite division of the 'façade', whiffs of Islam, born of the ogival ambiguities between Chinese and Turkish ornament, emanate from its 'crests', and the cluster columns at its corners recall both Pompeii and the Alhambra.

The use in furniture of pagoda roofs; bamboo; frets

The most common way of imparting oriental glamour to furniture was to add chinoiserie motifs to occidental forms. The chinoiserie influence could be subtle – the seventeenth-century fashion for ebony and black-stained beech, for example, may have received added support from the attractions of the greatly coveted glossy black Japanese lacquer. The furniture pattern-books that followed Chippendale's contained chinoiserie furniture designs and motifs that, like his, could be used ad lib.

In the seventeenth century, chinoiserie had been mainly a matter of decorated surfaces. In the eighteenth, it invaded form. Chinoiserie furniture now employed three-dimensional motifs abstracted from Chinese buildings, monsters, exotic animals and plants, bamboo, frets, figures in native costume, and so on. A material closely associated in the Western mind with Chinese buildings of the lighter sort was bamboo or cane: Marco Polo recorded 'a Palace built of Cane…gilt all over, and most elaborately finished inside…stayed on gilt and lackered columns, on each of which is a dragon all gilt, the tail of which supports the column whilst the head supports the architrave, and the claws likewise are stretchd out right and left to support the architrave'.[56] Bamboo was easily assimilated into Western furniture design as 'simulated

582 A cabinet in Sèvres porcelain and gilt bronze, designed by Léon Feuchère; French, 1843–44.

and white porcelains; Madame de Mailly hung a bed and covered chairs with blue and white silk influenced by porcelain decoration; the furniture was painted en suite, including this commode. The painter was probably Alexis Peyrotte (1699–1769), appointed 'Peintre du Roi' in 1749, who designed furniture and textiles for the royal palaces, specializing in chinoiserie. The paintings within the silvered bronze cartouches not only imitate Chinese porcelain: they also, by a sophisticated legerdemain, imitate 'découpures', the

China Case.

T. Chippendale inv. et del. Pub.ᵈ according to Act of Parliam.ᵗ 1753 M.Darly sculp

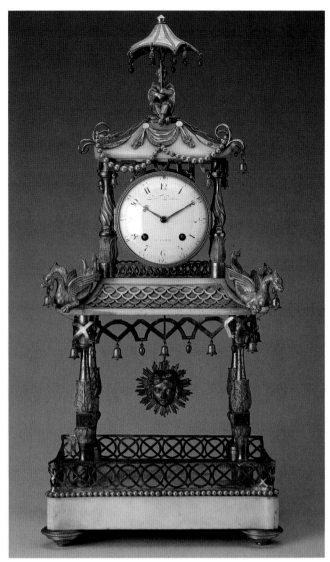

583 A 'China Case' designed by Thomas Chippendale; British, 1753 (from *The Gentleman and Cabinet Maker's Director*, 1762).

584 A clock in gilt bronze, marble and enamel, by D. F. Dubois; French, late eighteenth century.

bamboo' through its resemblance to types of antique turning [29]. Cane, as a material for chair seats and backs, had become popular after 1660; it always retained chinoiserie associations, although a caned chair might otherwise have nothing oriental about it: Hepplewhite wrote that 'Japanned chairs should have cane bottoms'.[57] Chinoiserie patterns were sometimes painted on chair cane. Complicated Chinese frets were reproduced in bamboo and cane, three-dimensionally in wood or gilt bronze or flat painted, and used to decorate furniture.

Three-dimensional pagoda roofs, canopies, parasols and the like, combined with simulated bamboo and frets, became frequent ingredients of chinoiserie furniture and decoration – a canopy tops a twig garden table, which is supported on Chinese frets [571]. Did such twig furniture consciously copy the writhing contortions achieved by the systematic forty-years' torture to which Chinese furniture-makers subjected living trees [570]? The relationship – which must surely exist – between European and oriental 'grotto' fashions is intriguing; it probably stretches back to antiquity; a kinship has been observed between Hellenistic rock landscapes and mediaeval oriental paintings.[58]

By the 1750s, chinoiserie was high fashion in England, and pagoda forms are combined with Gothic in the Master's chair of the Joiners' Company, carved in 1754 [468]. Chippendale's rococo chinoiserie designs are packed with such ornament: his 'China Case' [583] – chinoiserie intended to hold 'china'! – has no fewer than five concave 'roofs', two of them 'layered'; the central part looks almost like the beginning of a pagoda, complete with the dragons that were drainpipes in the original building. Several of the 'roofs', the feet, the apron, and the curvilinear, interlaced astragals are decorated with rococo scrolls; some of the astragals are Chinese frets (those either side of the central feature could almost equally be 'Etruscan', save that this is early for the 'Etruscan' fashion). The feet hint at a rococo/Gothic cartouche. These combinations of ornament, especially when applied to lighter sorts of furniture such as what-nots and small tables, continued – with fashionable adaptations – well into the nineteenth century, and were revived before its end (the twentieth century saw a fashion for chinoiserie radiograms).

Two concave pagoda roofs, plus a parasol, occur in a marble and ormolu neo-classical French clock, probably of

the 1790s [584].[59] Decorated with dragons, bells, and a figure, all of impeccable Chinese credentials, the clock also has frets beneath the clock face and a 'fence' along the base that could be interpreted as 'Etruscan', imbricated roof tiles as on the tops of pagodas and antique sarcophagi, and neo-classical candelabraform columns decorated with acanthus and strigillation; the columns perhaps justify the sunburst pendulum, which otherwise might seem unlikely to be original to the clock.

A sample of the variations that could be played on neo-classical/chinoiserie themes is illustrated in a pier table and two chairs.

The pier table [592] is one of two models that were placed in the 1790s in the Chinese Drawing Room at Carlton House; both combined oriental, 'Etruscan' and 'Pompeian' ornament and were made by Adam Weisweiler (c. 1750–c. 1810), a talented Parisian designer in the 'rococo neo-classical' manner. In 1819 they were moved to one of two 'Etruscan'/chinoiserie drawing rooms set up at Brighton Pavilion,[60] in both of which the walls were decorated with ornamental motifs inspired by the tables. The gilt-bronze fretwork on both types of table is ambiguously Chinese or 'Etruscan'; both have pointed feet influenced by the antique, decorated with a spiral motif derived from strigillation. Other than that, they differ. The one illustrated has Chinese 'mandarin' caryatids; the other has 'Pompeian' candelabraform gilt-bronze columns; the upper part of the column turns into simulated bamboo and is draped with a gilt-bronze tasselled curtain similar to a motif seen in ancient grotesque painting.[61] The central tablet bears an orientalized

velarium 'supported' by dragons, a chinoiserie version of such famous antique motifs as the candelabrum and griffins of the frieze of the Temple of Antoninus and Faustina.

An armchair of the early 1790s [587] by François Hervé, a French emigrant cabinet-maker, also travelled in the fullness of time from the Chinese Drawing Room at Carlton House to Brighton Pavilion. The chair is a striking example of 'Pompeian'/'Etruscan'/chinoiserie ambiguities. Much of the ornament – frets, serpents, and so on – could have had classical origins. The fret around the chair seat inclines to the 'Etruscan', that around the back to the Chinese; the sharp angle of the back is also Chinese. The birds' heads that end the arms resemble, in their smooth modelling and general character, the Egyptian falcon. The Chinese figure that sits in the middle of the back was probably an afterthought.[62]

The Hervé chair compares with a red and gold armchair [588] supplied by Charles Cameron in 1784 for the Great Chinese Drawing Room at Tsarskoe Selo in Russia; the maker was Jean-Baptiste Charlemagne.[63] It retains its original silk covers painted with Chinese scenes; on the upper back another Chinese scene is painted in grisaille, a classical rather than chinoiserie mode; serpents adorn the back and and lizards slither down the arms; leaves twine in and out of the ambiguous frets; the round seal or monogram at the base of the arms and on the legs is Chinese, but similar motifs also occur in Greek art [663]. The decoration on the arms was perhaps suggested by the scaly, skeletally ribbed breasts of Chinese dragons.

Genuine Chinese artefacts and motifs were linked not only with rococo chinoiserie: even at the height of the rococo period, Chinese monochrome porcelains and Sèvres imitations were mounted in 'goût grec' bronzes, a combination that sounds odd and looks wonderful. De Wailly published vases in neo-classical Chinese taste in 1760. Neo-classical chinoiserie appears in a secretaire stamped by Dubois [586], which may be linked with a Parisian advertisement of 1772 for 'secretaires in the Chinese taste decorated with paintings and mounts'.[64] This example has a European form and unmistakably occidental decoration; beneath a concave 'pagoda' top (exceptional in French furniture, and probably derived from Chambers's book) is

585 A torchère in porcelain, gilt bronze, carved wood and painted glass, designed for the Banqueting Room of Brighton Pavilion, probably by Frederick Crace; British, c. 1818.

right 586 A secretaire in gilded and japanned oak, by René Dubois; French, c. 1772.

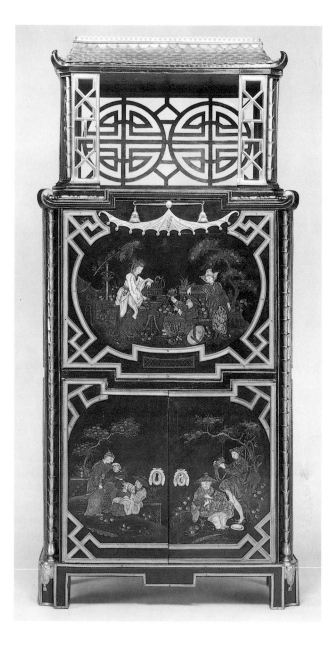

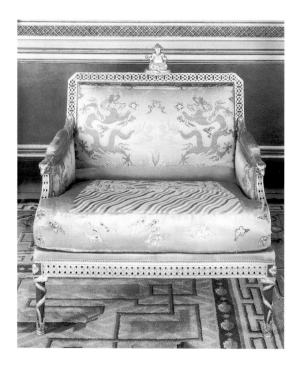

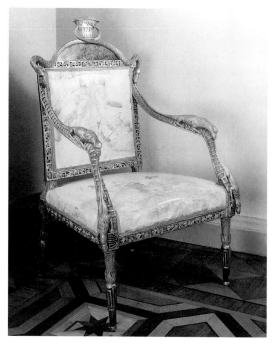

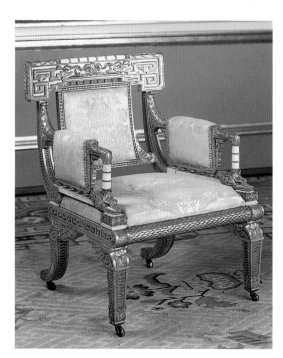

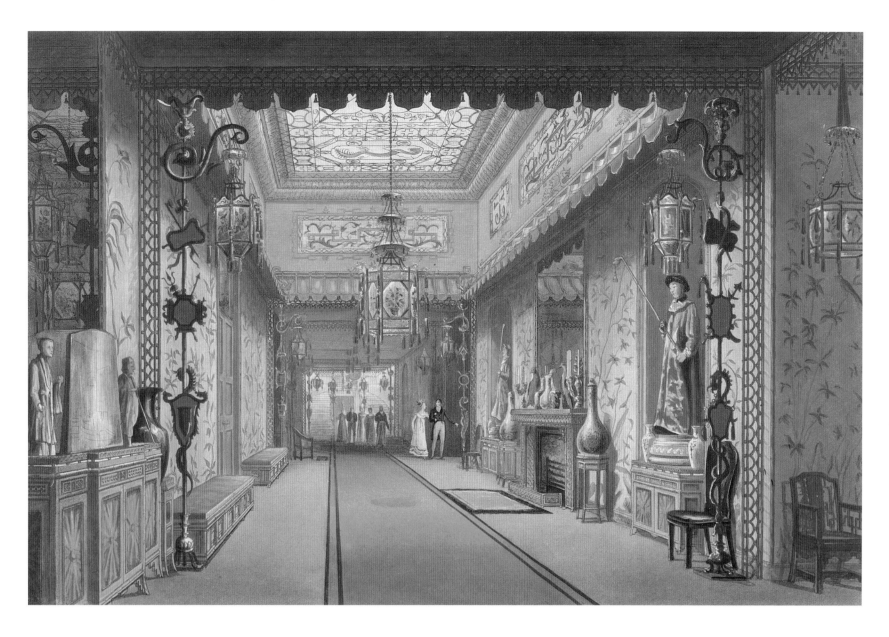

590 The 1815 decorations and furniture of the Corridor in Brighton Pavilion, designed by Frederick Crace; British, dated 1826, published in London in 1827 by John Nash (from *Views of the Royal Pavilion, Brighton*).

opposite

left 587 An armchair in carved, gilt and painted beech, by François Hervé, from the Chinese Drawing Room at Carlton House, London; British, *c.* 1790.

centre 588 An armchair in carved, gilt and painted wood, designed by Charles Cameron for the Catherine Palace, Tsarkoe Selo, with the original chinoiserie painted silk upholstery; Russian, 1784.

right 589 An armchair in giltwood, originally painted partly in lilac, from the Music Room of Brighton Pavilion, probably designed by Robert Jones, made by Bailey and Saunders; British, *c.* 1822.

fretwork composed of seals or monograms; the front has charming japanned scenes after Boucher and Pillement,[65] bells, a parasol and more fretwork. The gilt-bronze decoration that edges the corners of the base might have been taken from Roman bronze torchères [45].

Chambers illustrated real Chinese furniture [573], which helped designers who wished to abjure fancy for 'authenticity'. Authenticity was assisted by the importation into Europe in the later eighteenth century of Chinese 'rattan' furniture in huge quantities; chairs of this type stand in a room in the elegant neo-classical English royal retreat at Frogmore, of which nothing (apart from the lady, and even she has a 'Chinese' top-knot) is not chinoiserie or oriental [557]: the walls were lined with real Japanese lacquer and the 'china' was either Chinese export (facing the spectator) or European faience (that on the cupboard?). The secretaire looks like an export piece made in China to European requirements. Such bamboo chairs and small tables are so fragile that they must surely have been assembled after arrival; some tables have tops in the fashionable satinwood. Large quantities of this furniture entered Brighton Pavilion in the early 1800s; it usually contains inserts of little openwork 'plaques' of ornament, sometimes resembling moresque knots or 'Etruscan' frets: from these were taken motifs that appeared, enlarged but unchanged, on the vanished Pavilion

wall decorations of 1801–4.[66] Those interiors, described by a contemporary as 'like Concetti in poetry, in *outré* and false taste, but for the kind of thing as perfect as can be',[67] would nowadays be labelled 'ethnic'; their *outré* chinoiserie – rockwork, bamboo fretwork, marbling and a general air of rustic inconsequence – was largely taken from the quaintly colourful Chinese export gouaches. Some of their furniture, such as the simulated side cabinets, was placed in the Corridor begun in 1815 [590] which, despite its later date and the sobering removal of lacquer from the cabinets, still gives some idea of the earlier 'ethnic' style.

Chinoiserie accommodated itself to 'archaeological' neo-classicism. There is no shortage of volumetric lacquer case furniture with heavy paw feet in 'archaeological' style. The armchair [589] made in the early 1820s for the Music Room at Brighton includes in its decoration Chinese fret (less ambiguous than usual), 'bamboo', crocodile (?) heads, the imbricated roof-tile pattern, and bat-wings. It was originally painted lilac and gilded. Behind all lurks the ghost of the Roman klismos as reproduced in stone sculpture [10:H].

Chinese figures; dragons, birds, monkeys

Europeans were beguiled by the enigmatic physiognomies and gay costumes of the Chinese, and figures in native costume frequently inhabited chinoiserie schemes. A

591 A Roman grotesque ceiling with elongated caryatids, published in Paris in 1789 by Nicolas Ponce (from *Arabesques antiques des Bains de Livie et de la Ville Adrienne*).

resplendent bureau in polychrome 'Boulle' [274] pictures a flock of brightly coloured mandarins, flamingos, peacocks, parrots, cranes, ducks, geese, an ostrich, trees and plants set upon a gleaming ground; the spring-like freshness of the scenes strangely recalls late mediaeval illuminated manuscripts or Italian cassone paintings. The gilt-bronze mounts depict flowers and fruit. The rich assortment of materials includes brass, ebony, kingwood, purpleheart, mother o' pearl, and shells stained in various colours.

The painting and marquetry that ornamented furniture often depicted scenes of humble Chinese life. The beguiling engravings of Jean Pillement (1728–1808), who had been influenced deeply by the chinoiserie of Watteau and Boucher, were a frequent source. A bureau [593] by the Rhineland cabinet-maker David Roentgen (1743–1807) has marquetry that reveals subtle undertones not only of Cathay but of Pompeii;[68] Januarius Zick (1730–97), who designed marquetry for Roentgen from the early 1770s, borrowed from Pillement for his chinoiseries but imparted to them elements imbibed from his teacher Anton Raphael Mengs, a fervent Pompeian partisan who painted a Pompeian fake that had deceived Winckelmann.

592 A pier table in ebony-veneered oak, gilt and painted bronze, griotte marble and mirror, made by Adam Weisweiler and placed first in the Chinese Drawing Room at Carlton House, London; French, 1787–90.

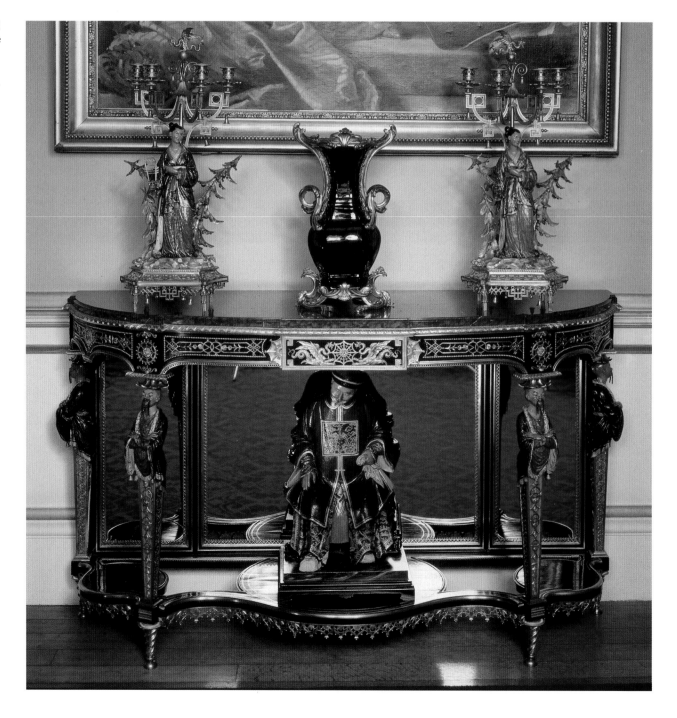

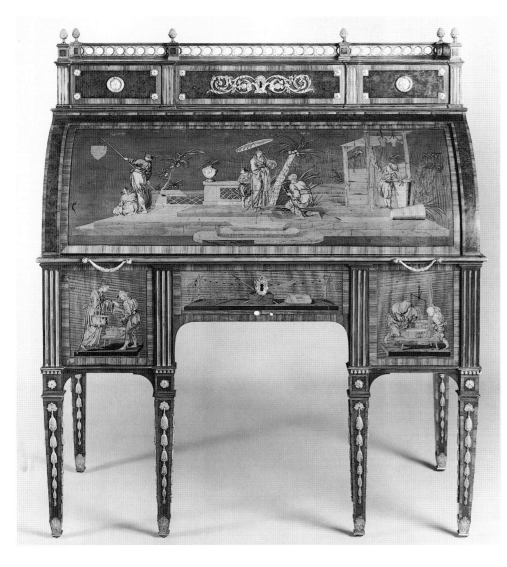

593 A roll-top bureau, with marquetry in sycamore, tulipwood, burr walnut, satinwood, white mahogany, ebony and greenheart, and with gilt-bronze mounts, by David Roentgen; German (Neuwied), *c.* 1775–80.

594 A commode veneered in tortoiseshell, with gilt-bronze mounts and a marble top; French, *c.* 1735.

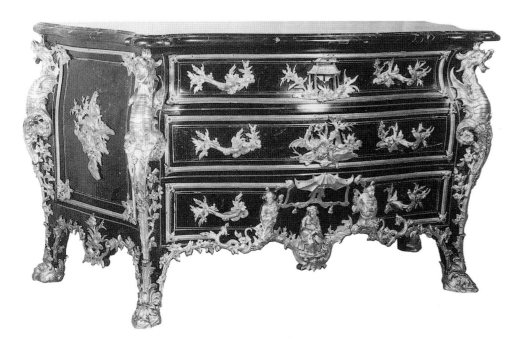

Mandarins and Chinese ladies are writ large at Drottningholm [572] and Brighton, where life-size models dressed in real gaudy Chinese robes stand or stood in chinoiserie rooms. Chinese figures also frequently replaced the blackamoors or terms that traditionally supported candle-stands and pier tables. A Chippendale candle-stand design [320] incorporates a figure in hybrid dress (no well-conducted Chinese maiden would have had a neckline that showed cleavage). The Weisweiler pier table [592] is upheld by elongated mandarins that bear some resemblance to a common grotesque motif which consists of elongated caryatids supporting an 'entablature' that already suggests a table [35, 591]; an example of it, shown isolated in such a way that it heightens the resemblance, was published in 1779 – still hot news in the 1790s.[69] Chinoiserie figures were frequently brightly coloured.

Of all Chinese motifs applied to furniture, the dragon is the most exotically flamboyant. Having entered Western art in remote antiquity, it has remained there ever since. Re-acquaintance with the original springs of inspiration refreshed the beast, resulting in some splendid flame-like confections [585]. A French commode of about 1735 veneered in tortoiseshell, by an unknown but accomplished ébéniste, uses comparatively stolid legless dragons as corner caryatids [594]; the ormolu decoration includes pagodas and oriental figures; the flowered decoration of the handles hints at the stiff flowering branches of the East; otherwise shape and ornament are occidental. Dragons could take over, as they did in some of the artefacts made for the Royal Pavilion at Brighton; not surprising, when the Prince Regent was urging his sideboards towards 'Larger dragons'.[70] Serpents, a prominent antique motif [10:J], were also associated with chinoiserie.

Monkeys often appear in chinoiserie paintings and marquetry. Kircher's illustrations[71] depict them in a domestic environment; the animals are seen en masse in a Japanese temple pictured in 1670 by Erasmus Franciscus.[72] They were nothing new in decoration: they appear in Cycladic wall paintings of 1600 BC,[73] in antique Roman grotesque, sometimes in a context (such as an Egyptianizing Pompeian decoration) that implies exoticism, in a fourteenth-century Gothic reliquary (p. 82), in sixteenth-century Italian grotesque, and they inhabit the grotesque/chinoiserie designs of Sezenius. The earliest examples of Chinese figures and monkeys by Berain were published in the late 1690s.[74] Shortly afterwards the 'singerie', a decoration in which monkeys engage in quasi-human activities, became common. The old and well-known association of the monkey with lechery added piquancy; a heroine of Lord Rochester's scandalous poetry addresses her pet monkey: 'Kiss me, thou curious Miniature of Man;/How odd thou art, how pretty, how japan.'[75] Audran became especially fond of the genre, which migrated from grotesque to easel painting, painted firescreens and furniture; rococo mirrors were inset with masterly paintings of monkeys by J.-B. Oudry, who worked in Audran's atelier. Monkeys are depicted in marquetry and 'Boulle' (Boulle's sons produced furniture in the 'goût de la Chine'[76]).

Turkish and Indian furniture

It is often difficult before the nineteenth century to separate Chinese from Indian influences. 'Chintz' has been mentioned (p. 283); *singeries* may have been assisted by the importation of Hindu palampores which showed monkeys aiding Vishnu against demons. Exotic mixtures appeared from the early

sixteenth century onwards: the Portuguese style associated with Manuel I (1495–1521) was partly inspired by Indian temples and Mughal mosques and tombs. Dietterlin has a splendid elephant[77] caparisoned with a saddle-cloth decorated with lambrequins and grotesque heads; it carries a howdah that resembles an antique altarpiece; the elephant's capacious ears are hung with bells; monkeys, parrots, and aigrettes add to the melange. Berain incorporated Red Indians, Arabs and Moors into his designs: in 1737–41 Desportes designed the 'Teintures des Indes' for the Gobelins, which depict elephants, negroes, plantains and bananas. From the seventeenth century onwards ebony furniture, in Western baroque styles with an Indian tincture, was imported from Goa and elsewhere. In the eighteenth century English furniture styles were reproduced in India in exotic materials such as sandalwood and ivory, with ornament that reflected Indian ornament; 'Chippendale' furniture of this type was put by George IV into the chinoiserie Corridor at Brighton.

Turkey also was 'exotic': Turks often appear in sixteenth-century grotesque; the court of Charles II of England adopted Turkish dress for about a year, and Samuel Pepys put himself into a caftan. Turks [258] and Turkish symbols such as the crescent adorn beds and other furniture. Turkey became fashionable in the late eighteenth and early nineteenth centuries, but Turkish interior decoration was short on pictorial sources and was usually half-hearted: the Cabinet Turc at Fontainebleau, designed by Mique in 1775, was distinguished from antique grotesque only by the inclusion of turbans and crescents. The porcelain plaques used on furniture sometimes depicted Turkish scenes [364]. The fondness for 'Turkish Cabinets' in the post-rococo period[78] coalesced with Napoleonic dreams of Eastern empires; orientalizing Zuber wallpapers and draperies decorated walls and cashmere shawls were flung negligently on furniture and draped upon ladies. 'Divan rooms' were installed in palaces from Sweden to Sicily;[79] these often contained a piece of seraglio furniture that became ubiquitous in all kinds of settings in the early nineteenth century, the 'ottoman' [461]. Many ottomans were completely upholstered, with no framework visible, and these have almost completely vanished. Ottomans were associated with exotic decorations generally (although they also existed in antiquity); there was a long ottoman in the Prince Regent's Chinese Room at Carlton House, and a circular ottoman and side ottomans in the Indian Saloon at Brighton Pavilion.

India was a different proposition from China and Japan. The Westerner was not a tolerated visitor, who could be thrust forth when the visit became inopportune or the visitors abused their hosts: trade was fast becoming empire, and to the glamour of exotic distance were added the more solid satisfactions of possession and spoil. Mughal art, as distinct from Hindu art, had stylistic links with both Grecian and (through Islam) Gothic, and was easily synthesized with either – or both. It is surprising that Mughal-inspired architecture and furniture was not more plentiful in the West (the Indian fashion in the West was prominent in literature).

The illustrated books on India, few but beautiful, that supplied the information necessary for exotically inclined architects and designers were produced by the British, usually supported by British officialdom. Such was the case with William Hodges, who between 1785 and 1788 published two volumes of aquatints from drawings made in India.[80] These, painterly and free, are in a Guardiesque manner that suggests rather than delineates architectural detail. None the less, the romantic strangeness of the verandahs, minarets, shrines, and fantastically carved oriels, set in giant palms and weirdly twisted trees, made a deep impression, and the buildings depicted were specifically recommended as architectural inspiration by that pillar of antiquity and Michelangelo, Sir Joshua Reynolds.[81] Thomas and William Daniell spent eight years in India from 1785, and published six volumes of more precise views between 1795 and 1808. The concepts of the Sublime and the Picturesque and the vaporous golden light which suffused their Claudian compositions made the aquatints irresistible. It was primarily from the work of the Daniells that the brilliantly exotic confections of the Royal Pavilion at Brighton and Aloupka Palace in the Crimea – Mughal, Gothic and Chinese mixed – were conjured.[82]

Indian architectural motifs were used in interior decoration and miniaturized in furniture. The Saloon at Brighton Pavilion, although not as grandiloquently opulent as the Banqueting or Music Rooms, mixes Indian and Chinese motifs with unparalleled flair and taste. Ottomans originally lined the walls; they were replaced in about 1824 by superb cabinets designed by Robert Jones [595] in ivory and gold, the 'chryselephantine' Egyptian combination that was taken over by the Greeks. The cabinets, in shape wholly European, mingle cusped, faintly ogee arches edged with lotus petals in gilt bronze (the same motif is found in giltwood on the walls) with enwreathed gilt-bronze columns, bells, acanthus, and lotus flowers painted in colours on silver leaf. All the carving is repeated on the inside, since the mirror at the back reflects the reverse sides. The ornament used in the Saloon includes the Egyptian winged disc – did George IV, who was well read in antique literature, envied the fame of Napoleon, and imagined himself as having fought at Waterloo, in some dream induced by cherry brandy and laudanum picture himself also as an Alexander?

595 A cabinet in gilded, silvered, carved and painted wood and gilt bronze, designed by Robert Jones for the Saloon of Brighton Pavilion; British, c. 1824.

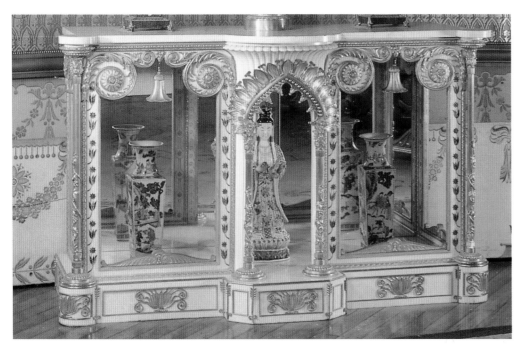

XI *Chapter 2* The influence of Egypt

596 A table supported by sphinxes, in use as a sideboard: detail of an Hellenistic sardonyx vase, published in Paris in 1719–24 by Bernard de Montfaucon (from *L'Antiquité expliquée*).

597 A centre table in parcel-gilt walnut and sandalwood, with a later marble top, designed by GiorgioVasari and made by Dionigi Nigetti; Italian (Florentine), before 1574.

'…more monuments which beggar description are to be found there than anywhere else in the world.'[83] So wrote Herodotus of Egypt four centuries before Christ; his opinion still holds. Egyptian solemnity was transmuted into Pompeian playfulness; hieroglyph, obelisks, cobras, pyramids, lions, crocodiles, columns after Egyptian patterns – and Egyptian furniture – were used as decoration; sphinxes lost their hieratic aloofness and became skittish [49]. The importation of Egyptian worship into Rome encouraged Roman use of Egyptian motifs; the famous tripod from the Temple of Isis at Pompeii [42] mingles Hellenistic motifs with the sphinxes that also decorated the walls of the temple; papyrus flowers and sphinxes support Roman tables [44, 596]; the strange inhabitants of the Egyptian pantheon were copied with academic accuracy [41]. The segmental pediment, the pediment topped with an arc, which had associations with the goddess Isis[84] (it was shaped like the moon, the symbol that passed from Isis to the Virgin Mary), entered Roman architecture and interior decoration in the second century AD, often being used alternating with triangular pediments [34:B,C]; it eventually became a common motif in Western architecture and furniture [198, 226, 512]. The palm, also associated with Isis, entered Roman art at the same time, where it often ornamented sepulchres;[85] thence it entered Western furniture [263]. The Romans were not the only people to dabble in Egyptian religion: the existence of a Greek dynasty in Egypt encouraged syntheses, and by the third century BC the cult of Isis at Alexandria was being celebrated in Greek.[86]

The inclusion of Egypt in the Islamic Empire in AD 641 isolated it from the West for a thousand years; mystery encouraged legends, as it did with China and Japan. However, Romano-Egyptian motifs already domiciled in Rome survived the fall of the Empire to be resurrected as part of various European renaissances; for instance, the sphinxes and lions that support Italian Romanesque thrones were based on Romano-Egyptian types.

Egyptian motifs in the West from the Renaissance to 1790

Egypt, and Egyptian architecture and works of art, presented as fascinating a puzzle to the Renaissance as to Herodotus two thousand years before. Western scholars virtually never visited Egypt, although Ciriaco of Ancona saw the antiquities of Gizeh in the first half of the fifteenth century. Egypt's learning, its hermetic tradition and necromancy had a vague but prodigious reputation that contributed to the long-enduring Renaissance fashion for hieroglyphs and emblems (pp. 117–18).

Renaissance architects, artists and craftsmen showed great interest in Romano-Egyptian motifs. Mantegna, for instance, displayed pseudo-hieroglyphs amongst other antique impedimenta in his *Triumph of Caesar*. Artists took Egyptian and Romano-Egyptian motifs from all kinds of object, ranging from obelisks and large sculptures to canopic jars. The first museum to be founded in modern times, that of Pope Sixtus IV (1471–84) on the Capitol, contained numerous Romano-Egyptian artefacts; motifs taken from the Capitoline collections and from Romano-Egyptian mosaics

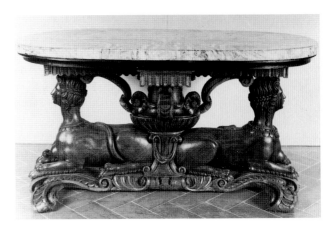

and other works in Rome [44] were reproduced in the artists' drawings that were circulated as models for other artists and in actual works of art – for example Giulio Romano, under the superintendence of Raphael, painted on the ceiling of the Sala dell'Incendio di Borgo in the Vatican the image of the Capitoline Museum's red granite telamones from Hadrian's Villa. The *Mensa Isiaca* was published by Enea Vico in 1559 and was hereafter repeatedly republished [41]; it was constantly used by Egyptianizing artists, including Piranesi.

Architects and writers continued to speak vaguely of Egyptian wonders: Serlio in the sixteenth century referred to 'the most marvellous things of Egypt',[87] and Fréart de Chambray in the seventeenth wrote of the Egyptians as 'those divine spirits to whom we owe our knowledge of so much in the fine arts…the unmeasured grandeur of their tombs [shows them] to have been giants, and as it were Gods among men'.[88] Félibien wrote that 'the great works of the Persians and Egyptians, however brutal and rough, are an eternal witness to the grandeur of their kings'.[89] Such comments helped to prepare the ground for later large-scale use of true Egyptian motifs.

Romano-Egyptian motifs – sphinxes, telamones, obelisks, pyramids (of the acutely pointed type of the pyramid of Cestius in Rome) and segmental pediments – appeared in Renaissance buildings and gardens. They also decorated furniture. Vasari designed a table supported on sphinxes for the Grand Duke of Florence [597] (p. 108); the sphinxes are more 'Roman' than those seen on furniture in the grotesque manner [226]. The motif continued popular throughout the Renaissance into the eighteenth and nineteenth centuries; apart from their waving acanthus tails, the sphinxes that perch upon the broken curves of a Kent table at Houghton [295] are very much of the Vasari type.[90]

Renaissance art usually hoisted the obelisk upon a pier-shaped base, sometimes placed upon balls, which, said a later critic, 'gives a ricketty, weak, disgusting appearance to the whole Conception, and is directly contrary…to the great principles of Egyptian architecture'.[91] Obelisks were profusely ornamented, often becoming merely one ingredient in the cluster of ornaments that topped the 'attics' of seventeenth-century cabinets. Sphinxes were a constant furniture ornament. Seventeenth-century Italian sphinxes retain some Roman solemnity; English Palladian sphinxes are often suavely blank; rococo sphinxes are flippant – those that were given the features of the far from sphinx-like ladies of Louis XV's court glance flirtatiously sideways rather than staring

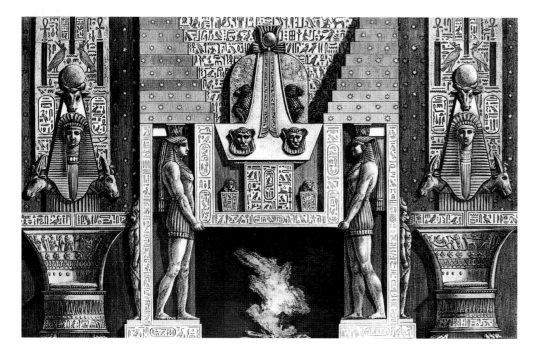

forms volume and weight that Egyptian-style furniture could reproduce something of the Egyptian equation between substance and style: 'There was in Egypt a complete identity between matter and taste', as the anti-Egyptianizing pedant Quatremère de Quincy declared in 1803.[92] Between about 1600 and 1750 the ground was being prepared: the Romano-Egyptian motifs available to Renaissance designers were gradually supplemented by accurate depictions of native Egyptian artefacts that retained something of unalloyed ancient Egyptian force. Montfaucon, Caylus (p. 163), and others illustrated mummy cases and canopic jars of uncompromising Egyptian cast; Egyptian architectural monuments were pictured in the books of the 1740s and 1750s that succeeded the journeys of Pococke[93] and Norden.[94] These un-Romanized Egyptian motifs were gathered together by Piranesi in his famous designs for the Caffè Inglese at Rome, published in 1769; crocodiles, sphinxes, hieroglyphs, scarabs, telamones, pyramids and crushingly weighty stones were deployed in a bizarrely imaginative manner – grotesque Egyptianized and petrified [598]. Piranesi looked hard at Egyptian art: 'an understanding eye will see in it not only the grand and the majestick…but likewise that delicacy, that fleshiness, and that palpableness, which is supposed to have been known only to the Greeks, and never to the Egyptians'.[95] In France, a rococo stronghold, the 'goût grec' admitted a new monumentalism; the Piranesian *Jeune Moine à la grecque* [335] is a monumentally pyramidal young man, although his pyramid is the Roman pyramid of Cestius rather than the Great Pyramid of Gizeh.

Piranesi's forcefully inventive Egyptian designs were almost immediately followed by Egyptianizing 'archaeological' furniture; he had shown the way to eclectic synthesis by including within his Egyptian fantasies a version of a marble Etruscan throne decorated with hieroglyphs [598, 599].[96] Hereafter, until the early nineteenth-century publications of Denon provided numerous illustrations of actual Egyptian furniture, neo-classical Egyptian-style furniture adopted Piranesi's formula of applying Egyptian ornament to classical forms. An 'Egyptian' pier table concocted in this way is seen in a portrait dated 1777 of the Marchesa Gentili Boccapaduli [600], whose up-to-date learned and archaeological tastes are evident in the 'antique' design of the étagère laden with 'Etruscan' vases, shells, coral, butterflies and stuffed bird; her furniture is so avant-garde that one is surprised to see her in long-waisted and ruffled silks rather than high-waisted Empire muslin. The Marchesa knew Piranesi, who advised her on furniture.[97] The table's legs are influenced by the two red granite telamones earlier copied by Giulio Romano; its sides are adorned with hieroglyphs and the top is made up of specimen marbles.

A splendid Italian centre table of about 1780, in poplar ornamented with gilded hieroglyphs and sphinx heads on a ground painted to simulate Egyptian granite, has a Piranesian solidity [603]; the flutes on the backs of the legs are an anomaly for the purist (the Marchesa's Piranesian table repeats the telamones on its back legs). The Piranesian hieroglyph in relief are influenced by stone rather than painted sources – although real Egyptian hieroglyphs are often incised rather than in relief. The Piranesian influence continued into the new century – a pier table designed by Voronikhin in about 1805 for the Greek Hall at Pavlovsk has front legs made up of elongated Egyptian terms decorated with hieroglyphs [604]. The materials of which it is made, smoothly carved and gilded wood rather than wood and

sternly ahead; they pose no riddles at all (those of Percier and Fontaine are more seemly). 'Rococo neo-classical' sphinxes are often foppish: Dugourc endowed his sphinxes with butterfly wings taken from Pompeian murals, put peacock feathers into their hair, twisted their tails into fanciful knots and portrayed them grasping mirrors in their hairy paws. Patent incompatibilities between Egyptian and rococo or 'rococo neo-classical' art made 'authentic' use of Egyptian forms or ornament in furniture in those styles difficult if not impossible.

Philippe Jullian's brilliantly clever apophthegm, 'Egypt is the China of neo-classicism', enshrines a perception especially pertinent to furniture. It was only when 'archaeological' neo-classicism straightened legs and gave

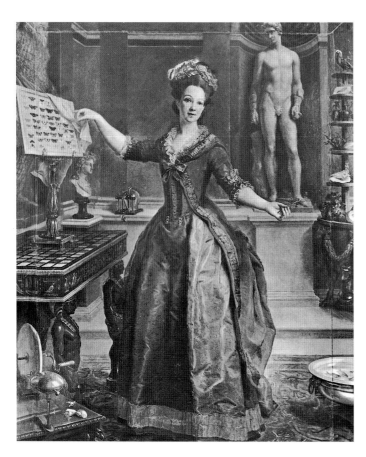

top 598 A design by G. B. Piranesi in Egyptian style, with chairs influenced by the 'Corsini Throne'; Italian, published in Rome in 1769 (from *Diverse maniere d'adornare i cammini*).

above left 599 The marble 'Corsini Throne', discovered in 1732; Etruscan, in the style of the fourth century BC.

left 600 A side table in Egyptian style and an 'antique' étagère, in a portrait of the Marchesa Gentili Boccapaduli by Lorenzo Pecheux; Italian, 1777.

601 A design for a gallery in the great palace of Haga, planned for Gustav III of Sweden but unbuilt, by L.-J. Desprez; Swedish, 1788–92.

right 602 A pier table in gilded and painted thuya wood with bronze and gilt-bronze mounts; probably of mixed provenance, *c.* 1800.

far right 603 A centre table in poplar painted red, marbled green and black to simulate Aswan granite, and decorated with hieroglyphs; Italian, probably *c.* 1780.

below 604 A pier table in carved, painted and gilded wood with a blue glass top and mirror back, designed by Andrei Voronikhin for Pavlovsk; Russian, *c.* 1805.

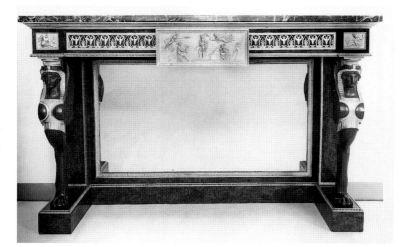

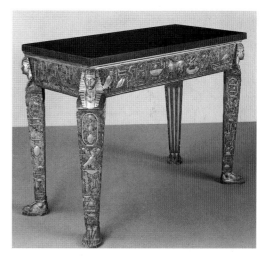

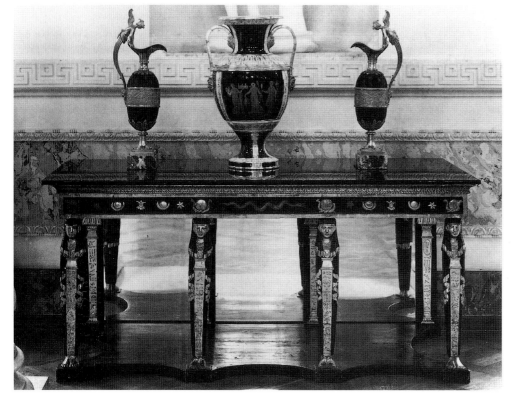

bronze, give a more authentically 'Egyptian' air to the decorations than gilt bronze would have allowed. The top is in blue glass, possibly a reference to lapis lazuli.

Piranesi's Egyptian designs were part of a general movement. Wedgwood pursued the same policy as with its 'Greek' wares: it issued fine Egyptianizing designs from 1770 onwards, based upon Montfaucon and the *Mensa Isiaca*; they had a European circulation. Egyptian architecture had long been dignified as the ultimate source of early Greek architecture; the taste for the Sublime brought both into favour, and they influenced modern buildings, first in spirit and then in form. In the 1780s and 1790s pyramids, obelisks and gargantuan Egyptian forms dignified the designs of French Romantic Classical architects and their followers in England and Germany. They were also employed in interiors. Of these, one of the most famous was the 'Stanza Egizia' of the Villa Borghese in Rome, installed by Antonio Asprucci (1723–1808) and Sebastiano Conca between 1778 and 1782.[98] Its influence extended to Haga near Stockholm, where Louis-Jean Desprez, noted for his paintings of vegetation-encrusted and crumbling classical ruins, designed a gargantuan and never-executed Romantic Classical palace for King Gustaf III of Sweden, whom he had met in Rome. Haga's projected grand Egyptian gallery [601] is heavily neo-classical rather than Egyptian in character, despite its

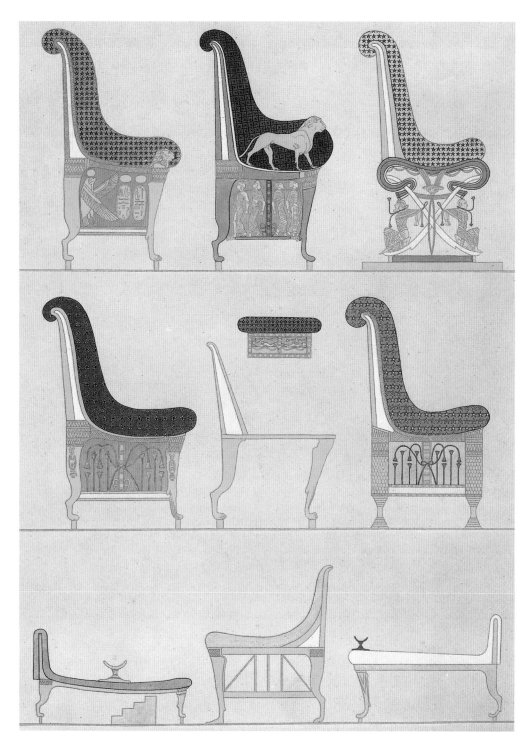

605 Thrones of Rameses III, from an Egyptian tomb painting of the Twentieth Dynasty, published in Paris in 1809–28 (from the *Description de l'Égypte*).

606 An armchair in carved and parcel-gilt mahogany with bronze inlay and gilt bronze, designed by Dominique Vivant Denon and made by Jacob-Desmalter; French, c. 1803–13.

portentous telamones,[99] statue of Isis and ambiguous sphinxes; the sketchy but staccato postures of the ornament of its frieze and four-square furniture indicate the use of Egyptian motifs.

A quite un-Piranesian pier table in thuja wood [602] looks at first sight to be fully fledged Empire. However, the existence in Russia of four pieces of furniture that employ the same plaques and frieze has encouraged the identification of the whole group with furniture imported from France into Russia in 1782; their date has been suggested to be about 1780, and the pier table has been attributed to Georges Jacob, the mounts being thought to be by Thomire or Ravrio.[100] Doubts of an Empire date were first aroused by the table's frieze and gilt-bronze plaques: the smaller are in Louis XVI style, and the centre plaque is a version of the *Apotheosis of Virgil* designed by Flaxman for Wedgwood 'probably in 1786'[101] (in fact, by 1778 the Flaxman *Apotheosis* design was already generally available in 'extremely popular' small and large-scale variants[102]).

Various points come to mind. Ornament such as that of the frieze was used in various contexts well into the nineteenth century (it was also, of course, used in 'Etruscan' rooms[103] – those of 1810–20 relied heavily on such abstract ornament). The table's main features look suspiciously Empire, especially the large expanse of uninterrupted mirror at the back. The side-plaques of Mars and Venus, in a Louis XVI style influenced by Renaissance mannerism, could hardly have been designed to co-exist with the gilt-bronze version of Flaxman's *Apotheosis* (into which the maker has introduced perspective). Pier tables were often related to the decoration of the wall behind them. These considerations prompt a thought – might not the use on the table of the ill-matched gilt-bronze ornaments indicate attempts to adapt a group of assorted furniture to a Russian room that employed the large version of the *Apotheosis* as part of a wall decoration (Russia was a good customer of Wedgwood)? Was an Empire table tampered with to fit an 'Etruscan' room? This would explain its incongruities, and a later interference would explain the clumsy juxtapositions.

Early nineteenth-century 'Egyptomania'

Most of the furniture discussed above pre-dates Napoleon's Egyptian adventure of 1798, which provided raw materials for 'archaeological' Egyptian furniture.

Dominique Vivant Denon (1747–1825) had a dizzy career extending from the curatorship of Madame de Pompadour's medal collection to the directorship of the brigand Emperor's 'Musée Napoléon', set up to house paintings and sculpture stolen from collections and museums throughout Europe. He accompanied Napoleon to Egypt, publishing the *Voyage dans la Basse et la Haute Égypte* in 1802. Denon's book coincided with an interest in Egypt of an intensity described by contemporaries as 'mania'. In both France and England, patriotism heightened the enthusiasm for Egyptian-style artefacts – Napoleon's spectacularly easy conquest was matched in English minds by Nelson's victory in the Nile in 1798; Nelson was hailed by his buxom inamorata, Lady Hamilton, as 'Duke Nelson, Marquis Nile, Earl Alexandria, Viscount Pyramid, Baron Crocodile and Prince Victory'.[104]

A chair that has been attributed to Denon in archaeologizing Egyptian taste was executed by Jacob-Desmalter between 1803 and 1813 in mahogany and gilt bronze [606]; it was inspired by the ancient Egyptian couch or chair formed from an entire animal [605]. The chair's lions have the broadly modelled features of Egyptian lions (as

607 The Temple at Dendera, Egypt; from a watercolour made by Antoine Cécile on Napoleon's Egyptian expedition for the *Description de l'Égypte*, French, 1799.

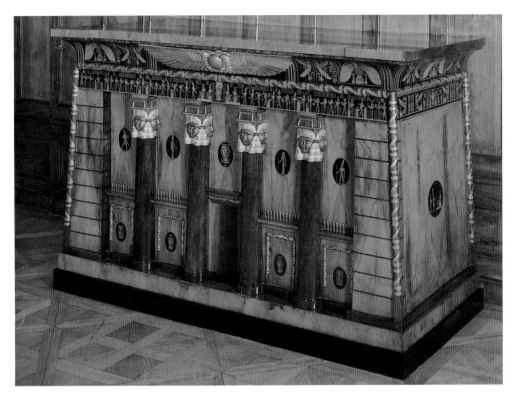

608 A cabinet made to hold the *Description de l'Egypte*, with marquetry of wild cherry and ebonized wood, carved and parcel-gilt, designed by Abbot Albert IV for St Peter's Abbey, Salzburg, and signed by Johann Hoegl; Austrian, 1822–28.

with the florid magnificence of a cabinet made to house the *Description de l'Égypte* [608], the twenty-four huge volumes of the official Egyptian record published between 1809 and 1828. Designed by the abbot of St Peter's Abbey at Salzburg, who 'took the idea from the sumptuous temple of Dendera pictured in the fourth volume of 'Antiquities'[107] [607], it took six years to make; Johan Hoegl, who signed it, is an unknown who executed only the marquetry. The design certainly follows the general aspect of Dendera, but its ham-fisted departures from its architectural exemplar betray the fact that the abbot was, as a designer, still in his noviciate. The construction of Egyptian templar cabinets to hold elephant folios was paralleled elsewhere: America saw one made for the Athenaeum at Providence, Rhode Island, in 1838.[108]

Thomas Hope, who bought from Percier and Fontaine, acquired copies of the Denon armchair for his country house, the Deepdene. The grand simplicity of Denon's armchair and the refinement of the Percier coin cabinet are alike in a different vein from the equally grand but more gaudy, eclectically 'cut-and-paste' furniture designed (before 1807) by Hope for his London house, which held the most distinguished English Egyptianizing decorations of the period. These were undertaken principally, according to Hope, because the colours of his Egyptian antiquities – granite, serpentine, porphyry and basalt – did not harmonize with his white Greek marbles.[109] The 'Egyptian' room – which Hope did not himself call 'Egyptian' – was decorated with Egyptian motifs (not exclusively, since 'antique drapery' was included) in 'pale yellow and bluish green…relieved by masses of black and gold'.

Hope's 'Egyptian' designs vary from grace to an eccentric strength. An elegant 'Candelabrum, composed of a Lotus flower issuing from a bunch of ostrich feathers' [411] is a realistic rendering ('those productions of Nature herself!'[110]) of a motif pictured both by Norden in 1755[111] and Quatremère de Quincy in 1803[112] – both sources mentioned or quoted (unacknowledged[113]) by Hope. Much more forceful are a black and gold armchair and couch [609, 610] from the 'Egyptian' room; they mix Egyptian with archaic Greek motifs. The sofa bears lions copied from well-known Egyptianizing lions in Rome; the same lions appear on the chimneypiece. Beneath the lions are plaques of the gods Anubis and Horus, similar to examples on the *Mensa Isiaca* [41]. The legs of the couch recall, at a remove, the cut-out couch; the side profile of the chair's front leg has the plank-like attributes of the cut-out leg. They are decorated with anthemion and scroll motifs of sixth-century BC Greece, versions of the volute-calyx – two gigantically superb examples of the motif embellished the parapets of the

Hervé's chair has the broadly modelled falcon [587]). The ornament that curves along the side upright of the back is derived from the conventionalized feather of Egyptian art, which frequently bends at its top [615] (Owen Jones refers to the 'law' that made leaves bend 'in graceful curves from the parent stem', saying that the Egyptians 'learned the same law from the feather'[105]). The coats-of-arms on the sides of the chair are heraldically incorrect.

Denon owned a splendidly restrained coin cabinet of about 1809–19 inlaid in silver by M.-G. Biennais (1764–1843), its form derived from the ancient Egyptian cupboard, which itself had derived it from the pylon with its 'battered' walls (p. 20). It was probably designed and made by Percier (an enemy of Denon), perhaps using mounts of the early 1790s.[106] Its 'archaeological' refinement contrasts vividly

609, 610 An armchair and couch in carved, painted and gilded mahogany. designed by Thomas Hope and probably made by foreign craftsmen in London; British, *c.* 1800.

611 A cabinet in birch and ebonized wood, with traces of gilding on the hieroglyphs, attributed to Johan Udbye; c. 1825.

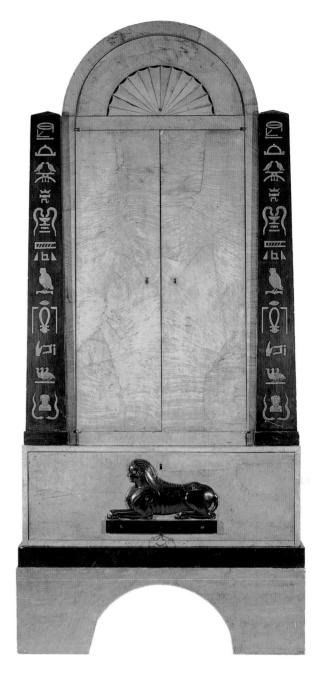

great altar of the temple of Athena at Syracuse in Sicily.[114] Hope obviously meant to recall the links between archaic Greece and Egypt. The feet are decorated with scarabs, and scorpions adorn the sides. The spirit of Piranesi is strong in Hope's chair; its back-board and back legs are influenced by the klismos, and its front legs, influenced by the volute-calyxes of the Greek cut-out chair, contain archaic Greek scroll motifs. The sources of its Egyptian ornaments are described by Hope himself: 'The crouching priests supporting the elbows are copied from an Egyptian idol in the Vatican: the winged Isis placed in the rail is borrowed from an Egyptian mummy-case in the Institute at Bologna: the Canopuses are imitated from the one in the Capitol: and the other ornaments are taken from various monuments at Thebes, Tentyris, &c.'.[115] Hope followed Giulio Romano in going to the Capitoline Museum for his motifs. The learned assemblage was originally accompanied by a stool that was decorated with little circles, ovals and rectangles containing a cross: all completely abstract, and equivocally Egyptian or 'Etruscan'.

It has been suggested that Hope's 'Egyptian' furniture may be of Italian manufacture.[116] This seems to the present author quite likely: an Italian hand (the furniture could, of course, have been actually made in London) would account for the theatrical breadth of handling of decorative detail, strange in an English context. Hope's use of foreign workmen was attested by himself:[117] his well-known 'Egyptian clock' was (in the author's opinion) designed as well as made by an Italian in Paris, Hope merely adding a crescent moon to Isis's head.[118]

Hope's occasional plagiarist George Smith designed a formidable cheval glass [429] that has some Egyptian detail, including bewigged heads above pedestals decorated with ornament that resembles hieroglyphs without actually being hieroglyphs. A more 'archaeological' English piece, a couch set on crocodile feet and decorated with Egyptianizing designs in green and gold [612], is based upon a Nile boat, perhaps abstracted from one of the modern views that set the scene in Denon's book and in the *Description de l'Égypte*. It anticipates Eileen Gray 's 'Pirogue' [644].

There was a powerful anti-Egyptian lobby. To Laugier, whose theories were still highly regarded in the early

612 A couch in gilded and painted beech; British, c. 1810.

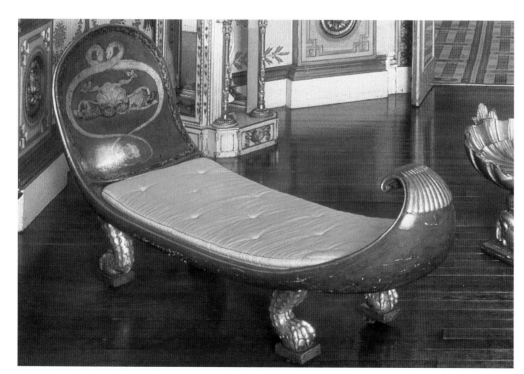

nineteenth century (six copies survive from the library of Sir John Soane, the English Regency architect), the Pyramids were 'a dreadful mass of prodigious material satisfying an outrageous pride…mountains of marble [marble! – what a revelation of the neo-classical vision] to cover a corpse that needed only six feet of ground'.[119] Hope made a qualified defence, voicing the Romantic Classical sentiment that Egyptian monuments 'amaze the intellect, through the immensity of their size and the indestructibility of their nature';[120] however, he deprecated the use of pasteboard materials and meaningless hieroglyphs (a comment to be expected from a devotee of emblemism). His words echo those in which the powerful French savant, Quatremère de Quincy, had expressed disapproval.[121]

Egyptianizing fads attracted popular ridicule in France and England, with some justification: the fastidious Hope exhibited a mummy in his reception rooms, and the Duke of Richmond and Gordon kept one in his 'Egyptian' dining room at Goodwood.[122] Decorations in the form of mummies had been suggested by Neufforge in his *Recueil* of 1757, and they were actually made in the 1780s,[123] but real corpses in a dining room carried 'archaeological' furnishing a little far.

Biedermeier furniture handled Egyptian motifs with admirable taste; they went naturally with the plain and massive forms of architectural Romantic Classicism. A magnificent birch cabinet [611] attributed to Johan Udbye (1785–1845), a Danish master cabinet-maker in Stockholm, is adorned with massive black obelisks decorated with hieroglyphs; the primitivistic sphinx has an Egyptian masculinity. By no means 'archaeological', the cabinet has a half velarium above its door. The full velarium depicted on a forceful Biedermeier sofa [440] wittily mimics the ends of the cushions that usually occupied that position; the arms combine the cornucopia and the lotus in a shape exactly paralleled in the Islamic/Byzantine mosaic decoration of the Dome of the Rock at Jerusalem[124] – one wonders how far designers went for their sources. Beneath the seat is a 'sun-ray' decoration. Could the veneered decoration on the back possibly be a highly abstracted winged disc? Ancient Egyptian examples of the winged disc bent to fit into a curve are shown in the *Description de l'Égypte*, one depicted beside convex fluting of the type seen on the sofa.[125]

Egyptian Biedermeier furniture motifs could be finely subtle. A Viennese desk in walnut [617] has Egyptianizing flared and swollen columnar legs[126] decorated with the black-stained, convex fluting (common on Biedermeier furniture) that is also a motif of Egyptian architecture [618, 619]; the pole that connects them resembles an Egyptian carrying pole. The small columns of the turned balustrade also have flared capitals. The slender black-stained edging above the small drawers is made up of two formalized feather fans like those carried by the sacred vulture as depicted on the ceilings of Egyptian temples [616]; the vulture (omitted on the desk) carries the fans with the round-headed feathers gracefully curved downwards, as on the desk. The common Biedermeier/Secessionist motif of two balls connected by a rod (p. 271) ornaments the top of the small drawers; the origin of this motif is puzzling, but one observes that a disc frequently marked the transition from pole to feather on the fans carried by vultures, and that the interception of the vulture's tail between the two fans often gives the impression that the two poles are one: the vulture also often held the fans by two rings, thus providing an uninterrupted length of pole between the disc next to the feather and the disc of the ring. Did this, purged of surplus ornament, perhaps suggest 'Biedermeier balls'?

Egyptiana after the mid-century

An interest in ancient Egyptian art was shown by advanced English designers from 1840 onwards (an informative book that included coloured plates of Egyptian furniture was published in 1839 by George Philips[127]). The Egyptian collections in the British Museum, largely acquired between 1818 and 1821 through the explorer Belzoni, were unparalleled in Europe – 'If we could revive a subject of old Rameses or Sesostris, draw him into life from his bituminous shell, and place him in one or two of the rooms in the British Museum, he would think himself at home, and miss little of the domestic comforts which he enjoyed in his Theban villa.'[128] Egyptian artefacts, including the magnificent Egyptian sculpture, were at first not regarded by the Museum authorities as 'art';[129] however by 1856, when Owen Jones wrote his influential book on ornament, Egyptian art had acquired peculiar virtues for Victorians desperately seeking an unpolluted style. Jones, who had himself been to Egypt, belauded it: 'In the Egyptian we have no traces of infancy or of any foreign influence; and we must, therefore, believe that they went for inspiration direct from nature.…Egyptian ornament, however conventionalized, is always true.…We venture…to claim for the Egyptian style, that though the oldest, it is, in all that is requisite to constitute a true style of art, the most perfect.'[130]

Such high claims reinforced existing historicist tendencies, and Egyptian furniture was copied as well as improvised upon. In 1855–57,[131] exactly contemporary with Jones's book, the Pre-Raphaelite painter William Holman Hunt designed a chair in 'archaeological' Egyptian style; it was made by the Crace firm in mahogany and sycamore inlaid with ebony and ivory. Fifty years later, Hunt explained, in words that make clear – yet again! – the part played by painters and museums in the evolution of furniture design: 'In furnishing my new house I was determined, as far as possible, to eschew the vulgar furniture of the day…a more independent effort was the designing of a chair, based on the character of an Egyptian Stool in the British Museum, to serve as a permanent piece of beautiful furniture.…When I showed my small group of household joys to my P.R.B. [Pre-Raphaelite Brotherhood] friends the contagion spread, and Brown [Ford Madox Brown] who idolised the Egyptian chairs, set a carpenter to make some of similar proportions.' Brown's 'Egyptian' chair synthesized Egypt with the English vernacular ladder-back.[132]

The British Museum's collections inspired other copies. The 'Thebes stool', a type which in 1837 was judged to be 'not unlike those used by the peasants of England',[133] a very different kettle of Egyptian fish from the aristocratic chair copied by Hunt, was reproduced commercially by Liberty in London, which had current vernacular interests (p. 249). An Egyptian sculpture of a kneeling viceroy in the British Museum is of a type, perhaps the actual piece, that inspired a glazed earthenware stool of 1880 or thereabouts.[134]

The Egyptian leanings of Owen Jones were shared by Christopher Dresser (pp. 37–38), and their publications eased Egyptianizing furniture into middle-class dwellings. A simple English stool of about 1870 [621] is painted with ornament similar to depictions in Jones's 1856 book.[135] A handsome English wardrobe of 1878–80 [618] is completely covered with Egyptian ornament, including hieroglyphs, lotuses,

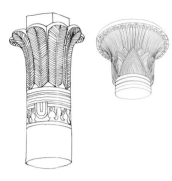

above left 613 A Graeco-Egyptian capital of the Roman period (after Owen Jones, *The Grammar of Ornament*).

above right 614 A capital from the Temple at Luxor (Thebes), Egypt.

left 615 An Egyptian feather fan, an insignia of office (after Owen Jones, *The Grammar of Ornament*).

below 616 Feather fans and vulture (after E. Prisse d'Avennes, *Atlas of Egyptian Art*).

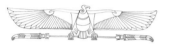

617 A desk in turned, carved and inlaid walnut, partly ebonized; Austrian (Viennese), *c.* 1825.

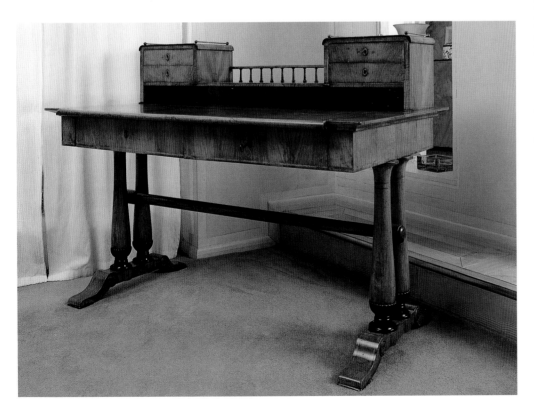

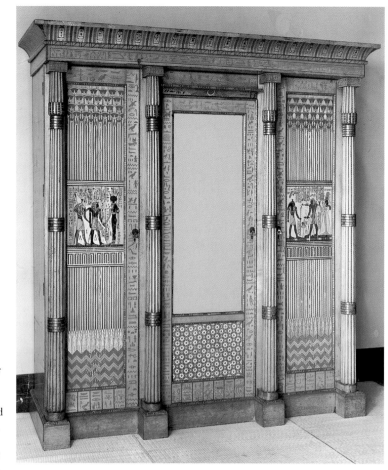

right **618** A wardrobe in oak and pine with turned, painted and inlaid decoration; British, 1878–80.

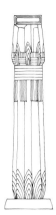

619 An Egyptian papyriform column from Karnak (after E. Prisse d'Avennes, *Atlas of Egyptian Art*).

below **620** Papyrus and lotus in water, from an Egyptian decoration (after Owen Jones, *The Grammar of Ornament*).

right **621** A stool painted with Egyptian motifs; British, *c.* 1870.

below **622** A piano case in carved and inlaid mahogany, gilt bronze and cloisonné enamel; French, 1893.

below right **623** A table in ebonized, painted and gilded mahogany, probably by Pottier and Stymus of New York; American, *c.* 1870–75.

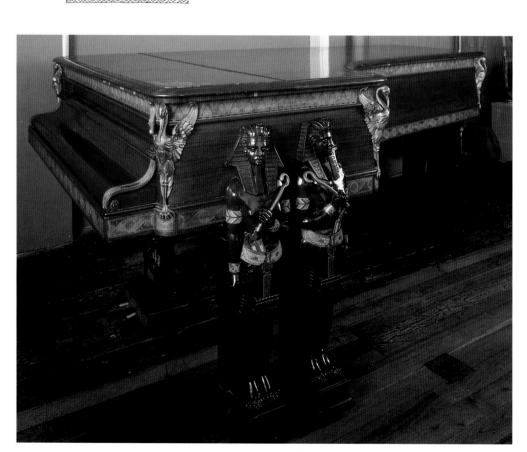

and paintings taken from the Egyptian 'Book of the Dead'; it has a cavetto cornice, and its pillars are of the convex-fluted Egyptian type.

Such 'academic' Egyptianizing furniture did not inhibit the continued manufacture of eclectic compilations. A table probably by Pottier and Stymus of New York [623] curiously mixes antique and baroque motifs. The ornament is largely Egyptian in origin, although the form of the legs upon which it is superimposed derives from Roman furniture. The stretchers are based on a form of the late seventeenth and early eighteenth centuries [268, 279] that, revived in Louis XVI furniture based on Louis XIV furniture, was revived again in nineteenth-century 'Louis Quatorze'. The table has even a hint of Renaissance Revival. Another aggressive concoction, a superb piano of 1893 [622] in mahogany, gilt bronze and cloisonné enamel, was built in Paris for the London firm of Erard. The six figures that support the piano freely interpret pharaonic themes; other ornament includes a frieze of lotuses, and gilt-bronze ibises that are realistic versions of Romanizing monopodia. An ibex wearing a solar disk adorns the base of the asymmetrical pedal board, simulating an ancient musical instrument of which the strings are represented by the pedal bars.

'Aesthetic' and later Egyptianizing furniture

From the middle of the nineteenth century onwards, furniture designers increasingly used Egyptian forms and ornament in ways subtle enough to obscure their origins, utterly different in approach from such 'archaeological'

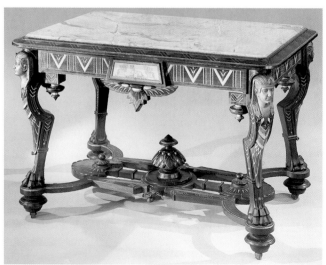

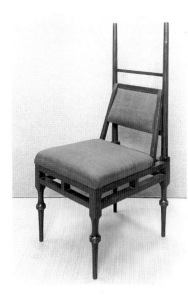

624 A chair in ebonized oak designed by E. W. Godwin; British, c. 1885.

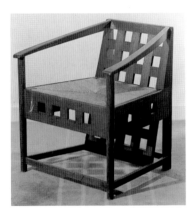

625 A hall chair in oak, designed by C. R. Mackintosh for Hill House, Helensburgh; British, 1904–6.

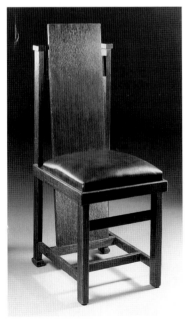

626 A chair in oak with leather upholstery, designed by Frank Lloyd Wright for his own house in Oak Park, Illinois; American, 1904.

realizations as that of the 'Thebes stool'. The inner angled back, for instance, common and easily recognizable in Egyptian chairs [8] but alien to Greek or Roman furniture and therefore for long ignored by Western furniture designers, now appeared in modern adaptations. A suspicion of it appears in English grand armchairs published by Hope and George Smith in 1807 and 1808, in which an upholstered flat-surfaced cushion, wedge-shaped in section, was inserted within the chair back.[136] An armchair designed by Philip Webb and made by the Morris firm in 1861–62 has an angled back supported by diagonal struts; its surface is ebonized, with gilded bands; these features, all 'Egyptian',[137] were integrated into the chair's prevailing English vernacular style. Christopher Dresser liked Webb's chair, and himself used the angled back in an openly Egyptian sofa with animal heads and feet of about 1880; a pole placed at each side carries the angle down almost to the floor. Others, including Dante Gabriel Rossetti, also flirted with the Egyptian angled back.

Webb's, Dresser's, and Rossetti's adaptations compare with those of E. W. Godwin, who noted the Egyptian angled back in his sketchbooks and used it in his 'Greek' chair of about 1885 [624].[138] Godwin synthesized Greek and Egyptian detail in a splendidly original design: the chair is ebonized and the angled back is directly quoted. The styles of the back are carried exaggeratedly high. The legs come from a chair drawn by Godwin from the Parthenon frieze (another drawing shows an Egyptian leg that closely approaches the Greek in profile); the sheet is headed 'Anglo-Egyptian'. Many of Godwin's attractive light tables display shallow Egyptian-type turning and Egyptian forms.

The furniture of Charles Rennie Mackintosh (1868–1928) shows that he had looked hard at ancient Egyptian design. For instance, a pencil drawing of 1900 for a mirror in the Ladies' Dressing Room of the Ingram Street Tea Rooms in Glasgow reveals that it was modelled on an Egyptian doorway in pylonic style, even to the cavetto cornice; the influence is less clear in the realized mirror because volume has been turned into flat decoration.[139] A small table is close to Egyptian prototypes.[140] Several chairs show the influence of the angled Egyptian chair back: the hall chair in stained oak of 1901 designed for Windyhill, which has an exaggeratedly tall back and is derived from the caqueteuse, carries its pylon-shaped back down to the ground;[141] a white-enamelled chair of 1903 with high back and coloured squares inset with purple glass designed for the Room de Luxe at the Willow Tea Rooms has a 'rear panel, which…swells out towards the back in a concave curve, and is fastened at the bottom to a stretcher'.[142] The Egyptian influence on Mackintosh resurfaces in an oak hall chair for Hill House of 1904–6 [625], which takes the angled back down to the stretchers.

Mackintosh's use of the square may owe something to Egyptian ornament [661]. As may his highly idiosyncratic three-dimensional ornament [657], which often displays smoothly rounded and scooped-out forms, an unusual motif that has nothing to do with Art Nouveau fluidity but that recurs in Egyptian art, as in the shape of the sistrum or the patterned hood of the cobra [43, 658]; as pictured by Owen Jones, the divisions within the hood are filled in with different colours, like enamels. A motif frequently seen in Egyptian art is an extremely long, slender and completely perpendicular stem topped by lotus flowers and buds or other ornament [620]; the closed bud is often depicted as an outline crossed within it by the line of the calyx, which begins to approach

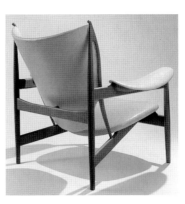

627 An armchair in teak and oxhide, designed by Finn Juhl; Danish, 1949.

forms that in Mackintosh have become completely abstract – but which still top a tall stem. Similar tall stems are given to some of Mackintosh's abstracted roses.[143]

A chair designed in 1904 – the same year as the Mackintosh Hill House chair [625] – by Frank Lloyd Wright (1867–1959) for his own house near Chicago [626] is partly influenced by the same Japanese wooden architecture as is his architecture (p. 306) – the 'strict use of horizontals and verticals to support the angled plane of the back derives from [Wright's] architectural vocabulary'. The angled plane itself, however, which extends down to a stretcher in the Mackintosh manner, came originally from Egypt. The Chicago architectural modernism of the 1890s that influenced Wright was itself touched by Egypt.[144] Other similarities between Wright's chair and simple ancient Egyptian chairs [8] are perhaps coincidental – perhaps not. Gerrit Rietveld (1888–1964) at one point reproduced furniture by Wright;[145] the language of a Rietveld chair of 1917 or 1918 is similar to Wright's, and its back also has Egyptian reminiscences.[146] The 'folk' furniture of ancient Egypt would have satisfied Rietveld's aspirations (p. 306) towards impersonal timelessness.

The use of the Egyptian angled back continues: the ancient Egyptian chair has 'a marked resemblance to a hypothetical chair which illustrated a study of the modern chair in relation to human posture, made a few years ago at the Bauhaus in Dessau'.[147] Such angled backs occur in 1990s chrome and black leather; as they do in furniture from a different tradition, that of Scandinavia. The Egyptian influence on the furniture of Finn Juhl (b. 1912) was acknowledged, as his 'Egyptian chair' of 1949 demonstrates.[148] Juhl, trained as an architect at the Copenhagen Academy, believed that furniture should combine functionalism with individualism, in this openly opposing the classical impersonality of the school of Klint (p. 269). He was influenced by the wooden tools of primitive peoples and such wooden weapons as hunter's bows.[149] He made a point after 1945 of separating upholstery from frame in a manner hailed as new (a similar principle had helped to shape rococo and neo-classical chairs [356]). An armchair of 1949 [627] in teak and oxhide combines the Egyptian double back with Arts and Crafts and other influences. The smoothly turned members and the curve of the stiles of the inclined back echo the forms of wooden tools; there is a hint of the saddle in the seat and back, a resemblance increased by the material that composes it; the 'organic' upholstered arms have something of the fluidity of Art Nouveau. The Egyptian fever that followed the opening of the tomb of Tutankhamun in 1922 led to flamboyantly gaudy pastiches being made; more recently an hotel in Cairo was entirely furnished with academic copies of the simpler types of ancient Egyptian furniture. So 'modern' was the effect that it is doubtful whether most guests noticed.

628 Four wooden constructions, from the *Manga* printed book of sketches by Hokusai (1760–1849); Japanese.

Nineteenth-century japonisme

'The princess was terribly revolutionary this evening. With a table full of academic guests to dinner, she asserted roundly and loudly that she much preferred a Japanese vase to an Etruscan vase'.[150]

The revolutionary princess was Princesse Mathilde, niece of Napoleon I and a noted Parisian hostess; the year was 1865; her observation was recorded by the Goncourt brothers, early devotees of 'japonisme' and of eighteenth-century rococo (p. 311). Three years before, they had confided to their diary that 'Japanese art is as great as Greek art. Speaking frankly, what is Greek art? No fantasy, no dreams. The rule of line. Not one grain of opium, so sweet, so caressing…'[151] The heady vapours of Symbolism were gathering.

The Goncourts perceived the interest in nature common to the differing anti-classicisms of Japanese art, Gothic art, and the rococo, and denied it (obviously thinking of ornament) to the Greeks.[152] The English Gothicist William Burges [491], who was collecting Japanese prints by the late 1850s, and the influential illustrator Walter Crane (1845–1915), who later played a prominent part in the Arts and Crafts movement (p. 249), both saw in Japanese art a 'mediaeval' quality.[153] Not surprisingly, within a very few years Japanese art united with vernacular Gothic in Arts and Crafts, and in the 1890s it united with rococo in Art Nouveau (p. 311).

The Japanese goods that entered the West as a result of the opening up of Japan to Western contacts and trade in 1854 caught the imagination of Europe. They came at a time when thoughtful people interested in design had been brought near to despair by the depressing quality of contemporary arts. A perceptive observer, the American painter John La Farge, explained how the prints of Hokusai had struck him when he first encountered them in 1857: 'I noticed in the first place the Japanese value of quality analogous to what we see in the surface and material of lacquer or porcelain as connected with its design. With us, of European descent, this feeling for *quality* has diminished very greatly for several centuries'; in Hokusai's prints 'there seemed to be the greatest possible economy of effort, and of what might be called work'.[154] His general drift is clear: Western arts had since the end of the Renaissance increasingly lost a feeling for tactile values and quality of design, and Japanese works of art had retained it. Japanese arts had also retained the virtues of spontaneity (lost to the West through the dominance of the machine). La Farge was not alone in making such observations: Japanese taste had shocked perceptions wired to high Victorian revivalism. '*Japonisme*' made an immediate impression in France and England: the Goncourts disdainfully recorded in 1868 that the taste had spread to imbeciles and middle-class women.[155] The American James McNeill Whistler (1834–1903), as a painter not in the same league as the French but a clever publicist and decorator (he had an avant-garde taste for Empire furniture), participated in the movement in all three roles. His paintings first showed Japanese influence in 1863.

A French collector, Louis Gonse, said in the 1880s that 'People have reasonably asserted that [Japanese] lacquer was the most perfect artefact that had come from the hands of men'[156] (he also thought the Japanese to be 'the most outstanding decorators in the world'[157]). But it was the Japanese print that most inspired early japonisme. A proletarian art in Japan, it seemed aristocratic to the cruder tastes of Europe; the influence of its line, composition, and colour was wide. Its most important gift was, without doubt, to one of the finest of all schools of painting, French Impressionism and Post-Impressionism. It also directly influenced interior decoration, furniture, china, glass, metalwork and textiles. Kakiemon, the beautiful Japanese porcelain in oriental taste imported from 1659 by the Dutch East India Company, provided much ornament for European designers at the beginning of the craze. It was overtaken by the Japanese artefacts of all kinds that flooded into Europe after being assembled en masse in the 'Japanese Court' of the 1862 Exhibition in London. Collectors of Japanese artefacts sprang up like mushrooms.

In fashionable quarters, muted Japanese colours displaced the violent colour clashes of Victorian interior decorating: the delicate hues of the prints appeared everywhere, light greens, buff yellows and pale lilacs; the blue and white of oriental porcelain was imitated in tiles and set into furniture. The influence of Japanese colour penetrated where Japanese form did not; for instance, it permeated 1890s schemes of decoration and furniture in 'Louis le Who?' style.

Western furniture was influenced both by Japanese furniture and by the wooden structures of Japanese buildings. Japanese furniture frequently combined highly decorated and worked surfaces with extreme austerity of line; simple rectangular cupboards were placed asymmetrically within a

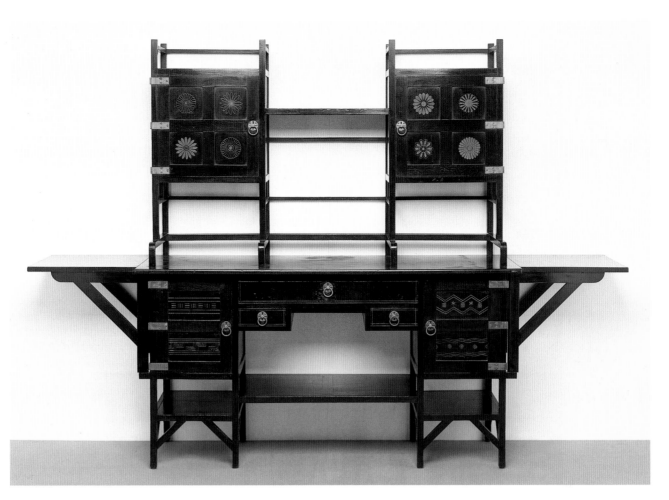

629 A sideboard of ebonized and
gilded mahogany, designed by
E. W. Godwin; British, 1885–88.

rectangular grid of shelves, which themselves often projected horizontally outwards; at all times the influence of the flat plank remained apparent. The simple Japanese buildings so often pictured in the prints also emphasized the plank, frequently displaying 'revealed construction'. They had undergone progressive simplifications during the Edo period (1615–1867) that made them highly attractive to craft-orientated avant-garde furniture designers: the complicated ornamental brackets that had once supported the beams of ceilings had been replaced by ingenious joints that made brackets superfluous or ornamental [628]. As Arthur Lazenby Liberty, one of the main merchants of oriental goods, said: 'The Japanese are a people of carpenters.'[158] Godwin, the most important English furniture designer influenced by Japanese taste, wrote: 'their wood building…is an art full of refinement and capable of wide adaptation';[159] it was characterized by 'propriety, modesty, and beauty'; 'Such effect as I wanted I endeavoured to gain, as in economical building, by the mere grouping of solid and void and by a more or less broken outline…nor can I see wherein I can, to any great extent, improve [it] as cheap furniture.'[160] Hokusai's prints helped to instruct Godwin in the principles of Japanese wood construction.

Godwin decorated his London house in Japanese style in 1862, and designed interiors for Whistler and Oscar Wilde which represented 'Aesthetic' ideals in their purest form: he said in 1873, 'I look upon all my work as Art Work.'[161] This echoes Whistler's 'Art for art's sake'. The refinement was as evident in colour as in form. His furniture for Oscar Wilde was described by Wilde in his mawkish fairy-tale manner as 'sonnets in ivory' (dining chairs) and 'a masterpiece in pearl' (a dining table).[162] Wilde was not alone in picking out such qualities in Godwin's work: 'No description…except perhaps that which may be conveyed in the form of music, can give an idea of the tenderness and…ultra-refinement of the

delicate tones of colour which form the background to the few but unquestionable gems in this exquisitely sensitive room…a room has a character that may influence for good or for bad the many who may enter it, especially the very young.'[163] The movement was painfully open to parody.

A sideboard designed by Godwin [629] is one of a series which appeared between 1867 and 1888. The first example was made in cheap deal (p. 269): this proved a mistake, and Godwin had it remade in mahogany. The decoration of the sideboards varies; the earliest, perhaps the prototype, has Japanese 'Powderings or Crests'[164] on the upper doors and sides, the latter having a simple fret as background: another, post-1870, has Japanese embossed leather papers on the upper doors; yet another is plain.[165] The sideboard illustrated came late in the series, and is the most highly decorated of those extant; it has Japanese gold-stencilled chrysanthemum crests on the upper tier (a motif that resembles antique rosettes), and linear decoration on the lower, placed asymmetrically, that could be Egyptian as easily as Japanese. All the sideboards have ring handles. Godwin designed a range of domestic furniture in a related style, much of which was commercially reproduced – and pirated – but nothing else quite equalled the sideboards' spare and novel reforming elegance.

Godwin's furniture, in its European context, was revolutionary. Most of it owed as much to Egypt and the antique as to Japan, but despite his pronounced eclecticism – 'Mr. Godwin appears to be perplexed by a divided duty between Ireland and Japan with an occasional leaning to the Mediaeval glories of Europe'[166] – he successfully absorbed various influences into his own style [517]. The distinguished nature of his achievement becomes clear if one glances at a pleasant essay in Japanese historicism by W. E. Nesfield (1835–88) of 1867, the same year as the first of the sideboards. A screen of ebonized wood [630] has six tall and

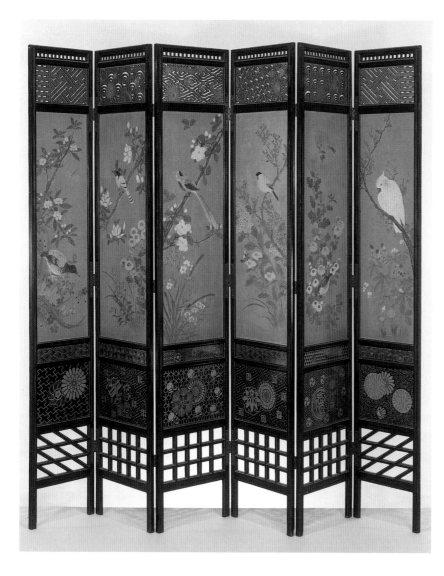

630 A screen in ebonized and gilded wood with panels of Japanese paper, designed by W. E. Nesfield and made by James Forsyth; British, 1867.

631 'Cobweb' lamp in leaded glass, glass mosaic and bronze, by Louis Comfort Tiffany; American, c. 1904.

'The most rapid intuitions of genius'.[172] Gallé's love of flowers came from several sources (p. 312) but his portrayal of them displays strong Japanese mannerisms [646]. Louis Gonse, writing before Art Nouveau took wing, declared that industrial designers should learn nature, truth, harmony, asymmetry, and simplicity from Orientals, from 'this passion for nature, from this religion of work which shows itself in all the products of Japan, which makes them more aware of the harmonic laws of colour, releases them from the routine formulas of colour, and reveals to them…the essential simplicities of decoration'.[173]

Louis Comfort Tiffany (1848–1933) came from a family of New York jewellers; beginning as a painter (he painted in Paris in the late 1860s), he turned to the decorative arts in the late 1870s. In 1885 he founded the Tiffany Glass Company; he showed at Bing's 'À L'Art Nouveau' in Paris, and his iridescent 'Favrile' glass became an ornament of Art Nouveau interior decoration. Iridescence, which gives surfaces the miasmic gleam of marsh pools, seems peculiarly appropriate to a decadent and Symbolist art. Tiffany's lamps owe their form partly to the invention of electric light, which could safely be completely enclosed; light emanating from within a network of brilliant stained glass, lead and shells has an hypnotic intensity. Moresque and Byzantine styles influenced Tiffany's art,[174] but his flowers, insects and other motifs recall Japanese art; native forms such as dogwood and poppies were pictured together with lilies, dragonflies, and clematis. A lamp [631] that displays hydrangeas and wistaria is supported on tree-like forms, in this resembling the more extreme types of Art Nouveau furniture. Its cobweb is a frequent Japanese motif; Hokusai made comic prints of people imprisoned in them,[175] and a well-known Japanese painting shows the 'web of government' with helpless insects caught in it: the spider, the Shogun, is at its centre.[176]

Charles Rennie Mackintosh was greatly interested in the motif of the repeated square, using it both in flat patterns and three-dimensionally (pp. 302, 318). His Chinese Room of 1911 in the Ingram Street Tea Rooms, Glasgow, an orientalizing essay, was dominated by screens of lattice squares, and the pay box was entirely enclosed in squared lattice.[177] The lattice was combined with a stepped 'ziggurat' motif, which also has Eastern affiliations; it appears in furniture designed by Mackintosh for other locations.[178] His chair of 1902 in ebonized wood [632], intended to fill a narrow space between two wardrobes, has a panel of little squares set upon an exaggeratedly elongated and attenuated back that is taken down almost to the floor in a highly mannered way; its preciosity is carried far beyond practicality: it is wall decoration quite as much as furniture. Its back is of the type generally described as a 'ladder-back', and certainly it resembles, for a good deal of its length, a ladder. However, the term 'ladder-back' has vernacular associations that do not quite fit this chair. The squares are ambiguous; they could have come from Egypt [661], from Greek vases via the 'Etruscan' fashion and Vienna (pp. 318–19); or they could have come from a different source – Japan. The four inner leaves of Nesfield's screen have squares in rows of five – the same number as on Mackintosh's chair, and also in ebonized wood – at their base; each leaf has the same proportions as the back of Mackintosh's chair; the likeness is accentuated by the frequent horizontal bands on the screen. Was japonisme one source of Mackintosh's 'ladder-back' chair?

narrow panels adorned with real Japanese watercolours. Its gilded and carved Japanese motifs include key frets, chrysanthemum rosettes, wave motifs, diaper patterns, and so on, mostly with pronounced asymmetry; their accuracy may indicate an origin in a textile pattern-book, a book of prints such as Hokusai's *Manga* [628], or perhaps even textile stencils.[167] The screen has little stylistic enterprise, although Nesfield decorated his office in London with 'a very jolly collection of Persian, Indian, Greek and Japanese things'.[168]

By the 1880s, Art and Artistic living had become a fashionable mania; 'Aesthetic Mixed Seeds' were bought for caged birds. It was said in 1876 in the English *Furniture Gazette* that 'there has assuredly never been since the world began an age in which people thought, talked, wrote and spent such inordinate sums of money and hours of time in cultivating and indulging their tastes'[169] – a statement that has a limited truth if one replaces 'people' with 'the middle classes'. The Japanese influence crossed the Atlantic and is apparent in such furniture as that made by the Herter brothers of New York.

The chasm that lies between Godwin's japonisme and the japonisme of Art Nouveau (pp. 312–13) demonstrates how designers select from an alien style only that which suits their own proclivities. In 1871 Gallé visited London, then at the height of its Japanese craze. He was entranced by Japan; some of his vases have the words 'alla japonica' beside his signature[170] and some of his furniture so closely approaches the asymmetrical forms of Japanese furniture as almost to become a pastiche.[171] Significantly, Gallé greatly admired the art of Claude Lorraine, especially his spontaneous sketches –

Twentieth-century *japonisme*

In 1888 Gonse took 'our decorative artists who produce Japanese pastiches' to task for their grave error in servilely copying forms and decoration designed to suit a particular people. He objected to the use of Japanese motifs such as cherry-blossom, herons and bamboo on French furniture.[179] The lesson, or something like it, seems to have been taken to heart by twentieth-century designers influenced by *japonisme*. The accurate copying of idiosyncratically Japanese motifs receded before influences of a subtler order. Ideas were now taken principally from Japanese techniques and materials, and from an appreciation of the spirit of Japanese art – its exquisite refinement, its significant spaces, its voluptuous austerity, its decoration without decoration.

One of the main sources of new ideas was a Japanese pictorial art not disdained by the Japanese connoisseur – the screen. Screens are an ancient oriental type; first mentioned in the Chinese Chou Dynasty (206 BC-AD 220),[180] they entered Japan in the eighth century. A necessity for open-plan houses, unlike the purely decorative Chinese screens, they came to be considered as high art objects, comparable with the framed oil paintings of the West. The screen's distinguishing characteristic is the flexible hinge that enables it to fold two ways; it always had an even number of panels. Chinese and Japanese screens entered Europe in large quantities from the seventeenth century onwards, and the type was imitated by Western artists and craftsmen: Lancret, Boucher, and Watteau painted chinoiserie singeries on screens (Cézanne painted a folding screen which he decorated on the back with grotesque![181]). Stamped, gilded and painted leather was also used for European screens.

The delicate, sometimes wraith-like forms that adorned the Japanese painted screen were frequently set against gold

or silver backgrounds patterned in the squares in which the leaf was laid [634]. The squares, as squares, had affinities with the little 'Etruscan'-inspired squares of Josef Hoffmann and other Viennese designers, sometimes seen in association with 'seals' [663]. In the early twentieth century, silver and gold leaf laid in squares became popular in interior decoration and furniture: the fashion for silver walls and ceilings had come to Britain from France by 1922, when *House and Garden* warned that 'it is well to recognise that where silver predominates the room will be more or less precious' and that a silver too dull might produce 'a dim chilliness where the designer had looked for a recondite elegance'.[182] Did London scent danger in Paris fashions? If it did, it was not deterred: the architect and designer Edward Maufe, never adventurous, sent a desk in silver leaf to the 1925 Paris Exhibition.[183] The fashion persisted into the thirties; the walls of the theatre of the great transatlantic liner, the *Normandie*, were entirely lined with silver leaf in 1935.

Some of the finest Art Deco (pp. 320–22) silvered furniture in Japanese taste was designed by the decorator Armand-Albert Rateau (1882–1938), who worked in several styles, all distinguished [671]. A superb three-fold screen designed for his own Parisian apartment about 1930 is the finest of his silver-leaf screens [633]; it cunningly uses the different techniques of laying leaf to delineate the design: the background is in burnished water-leaf, whilst the scene, said to be a view over the sea from a balcony in Monte Carlo, is in matt oil leaf. The pointed leaves of the olive trees and the mannered perspective of the design – the simple balcony is like a ladder laid horizontally – emphasize the Japanese air. The feet are bronze. From these heights, silver leaf descended the fashion scale: the Rowley Gallery in London produced commercial furniture covered in silver leaf, often decorated with vestigial oriental wave patterns.

632 A high-backed chair in ebonized wood, designed by C. R. Mackintosh for Hill House, Helensburgh; British, 1902.

right 633 A screen in matt and burnished silver leaf, on bronze feet, designed by A-A. Rateau for his own apartment; French, *c.* 1930.

634 A Japanese screen in silver leaf painted with maple, bamboo and chrysanthemums, by Hoitsu (1761–1828).

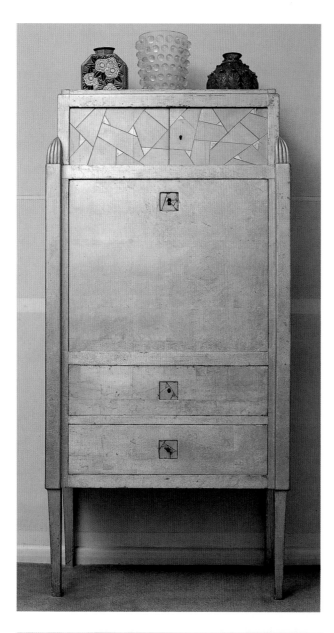

635 A secretaire in gilded and silvered wood, with silver keys; French, c. 1925.

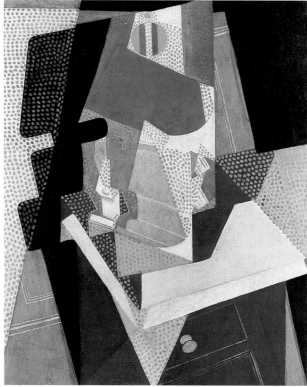

636 *The Lamp*, an oil painting by Juan Gris; Spanish, 1916.

A French secretaire of the 1920s [635] is covered in squares of matt silver leaf in the pattern derived from Japanese screens. Its shape is basically late eighteenth or early nineteenth century, as is the gadrooned detail of its upper part; this, a common mannerism of French Art Deco, was current in the early nineteenth century; it resembles the 'tasselled' ornament of ancient Persia [6]. The keys, which act as handles, are solid silver. The cupboard doors and the squares around the keyholes are decorated in 'green' gold leaf, 'regular' gold leaf, and silver leaf, in typical Art Deco angular, asymmetrical shapes. This motif may have originated as a simplification, under the influence of African-influenced Cubism (p. 307), of the angular, asymmetrical shapes of Japanese geometrical ornament, especially the sun-ray (a common twenties and thirties ornament) or the formalized chrysanthemum. The cubist paintings of Juan Gris [636], for instance, abound in such sharp triangular shapes. The interior of the secretaire is lined with simulated crocodile skin, another 'African' influence.

Lacquer re-entered high fashion in the 1920s, both for European-style and orientalizing furniture. Jean Dunand (1877–1942), a Swiss who was trained as a sculptor, made metal vases; his interest in lacquer was aroused by seeing its use by Japanese coppersmiths; by 1910 he was imitating them.[184] In 1912 he studied under Sougawara, a noted lacquer craftsman who had already taught Eileen Gray the complicated needs of oriental lacquer (high humidity during the drying process, and as many as forty coats to obtain a deep lustre) [641, 644]. After the First World War, Dunand brought Indo-Chinese craftsmen to Paris; he became the leading Parisian maker of oriental lacquer, using it for furniture from his own designs and for those of others, including Ruhlmann (pp. 324–25) and Legrain (p. 308). A large and poetic 'Japanese' screen by Dunand of about 1926–28 [637], which once belonged to Eileen Gray, is in black and silver lacquer; in parts the lacquer is mixed with sand and worked over with a spatula to give variety of finish. Not all Dunand's lacquer is 'Japanese'; much reflects the arts of black Africa. He also decorated furniture with eggshell lacquer, a refined and beautiful Japanese technique of pressing crushed eggshells into lac. Dunand created total lacquer rooms: for the 1925 Paris Exhibition he designed the smoking room of 'L'Ambassade française' with a ceiling of silver lacquer with red touches, black lacquer furniture, and an off-white carpet.[185]

Jean-Michel Frank (1895–1941) was a decorator and designer who specialized in the art of luxurious under-statement, a Japanese characteristic, although expressed in his case in predominantly cubic forms. He covered walls, cubic-shaped chairs and sofas, and side and coffee tables in squares of parchment, vellum, or split straws, the last an infinitely laborious technique; he was fond of gold lacquer and shagreen. The last was another material associated with the East that became popular in 1915 or so (Gris' painting [636] has ornament that resembles it) and continued in favour into the 1920s and 1930s; it was bleached and stained in delicate 'Japanese' colours. Frank made coffee tables in Chinese style and covered them with it; sucha table stood in his own living room. He banished fringes and trimmings, nothing interfered with the total effect of grand simplicity.

The Parisian metalworker Edgar Brandt (1880–1960) produced furniture and other artefacts in bronze, copper, silver and gold; some of his favourite motifs were based upon Japanese cloud forms, the sunburst, and Japanese birds and

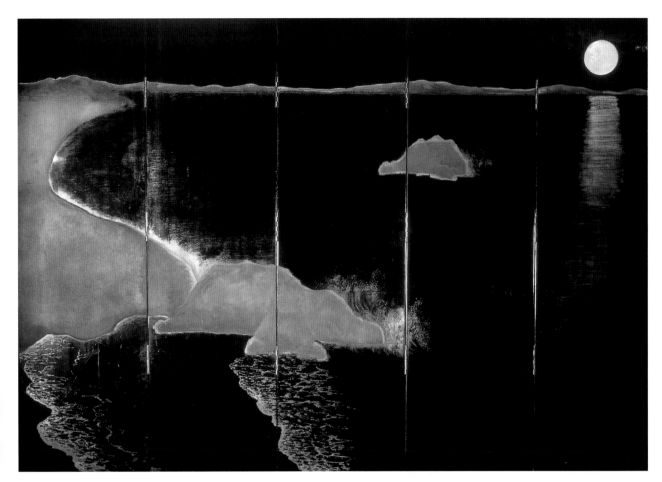

637 'Clair de Lune', a lacquer screen, designed and made by Jean Dunand; French, c. 1926–28.

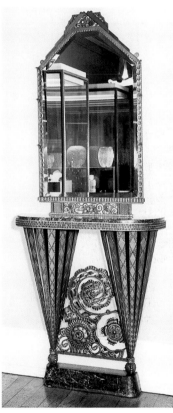

638 A console table and mirror in wrought iron, copper and marble, designed and made by Paul Kiss; French, c. 1927.

right 639 A cabinet in carved and veneered ebony, inlaid with mother o' pearl and silver, by Louis Süe and André Mare; French, c. 1927.

animals such as storks and deer. He used Japanese crests in his designs for radiator covers.[186] Paul Kiss (1886–1962), who came originally from Budapest and worked from 1907 with Brandt, designed and made a console table and mirror in wrought iron, copper (some of the iron details are 'washed' with copper) and marble [638]; it employs motifs drawn from antique fluting together with scrolls that allude to Japanese crests and cloud forms. Cloud forms had aroused Western interest for some time; according to Christopher Dresser they originated in primitive fire-worship: 'There can be no doubt about certain forms having been derived from flame and cloud (or cloud-like smoke) in India, Europe, Persia, Arabia and Japan.'[187] Godwin had included cloud forms in his stand in the Universal Exhibition in Paris of 1878[188] (which attracted sixteen million visitors); cloud forms were synthesized with flowers in Secessionist and Wiener Werkstätte design, which often surrounded the compound with a continuous repeated wavy line, whence it became a prominent motif of the 1920s and 1930s.

Chinese art had some influence in the 1920s and 1930s; a resplendent commode of 1927 in ebony, mother o' pearl and silver [639] cunningly combines French rococo with Chinese forms; in the midst of an ebony ground is a glistening mother o' pearl bouquet, much in eighteenth-century style but with far from eighteenth-century effect. The makers were Louis Süe (1875–1968) and the painter André Mare (1885–1932), who together founded the Compagnie des Arts Français in 1919, one of the largest interior decorating firms in France. The partnership was dissolved in 1928.

Japanese architecture inspired a type of twentieth-century furniture utterly distinct from the luxurious orientalizing caprices of Art Deco. Frank Lloyd Wright had avidly collected Japanese prints, and Japanese wood construction helped to form his architectural style, lightening the weight

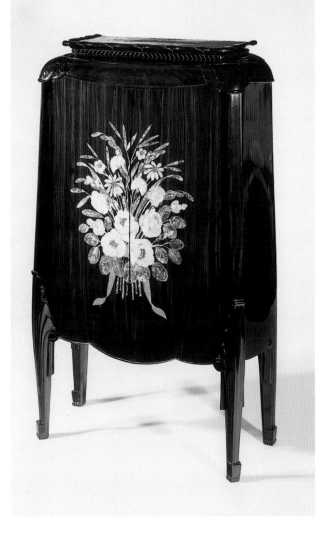

of folksiness inherited from recent American architecture [497]. Wright had also spent five years in the office of Louis Sullivan, a Chicago architect whose belief that 'Form follows function' was in the tradition of Pugin, Owen Jones, Dresser, et al. Wright's architecture is more distinguished than his furniture, and it was the former rather than the latter that influenced the furniture of the Dutchman Gerrit Rietveld. Rietveld, a 'gifted avant-garde furniture designer who took up architecture', was a member of the De Stijl movement, founded in 1917, which hoped to obliterate the distinctions between the fine and applied arts and create an impersonal universal language (one is reminded of the Greek concept of *techne*: p. 262).

Rietveld wrote in 1971 of the chair he had designed in 1917 or 1918 (p. 299) that it was 'created with the intention of demonstrating that an aesthetic and spatial object could be constructed with linear material and made by machinery. I therefore sectioned the central part of the plank into two, obtaining a seat and a back, then, with lintels of varying lengths, I constructed a chair. When I made it, I did not realise it would have such an enormous significance for me and also for others, nor did I imagine that its effect would be so overwhelming even in architecture.'[189] The chair was

executed in black and white. It combined ideas taken from the Japanese-influenced architecture of Wright and from the decorative paintings of Mondrian. Mondrian believed that vertical elements were active, horizontals passive, and that their perpendicular conjunction represented tension and balance; this is a classical doctrine (founded in architecture) with which all might agree – but we might think also that it represented a beginning of design rather than its end (the addition of a few of Laugier's 'arcades vicieuses' would have given Mondrian's paintings real excitement!). Rietveld transformed Wright's slabs of matter into Mondrianesque floating planes. The resultant chair is diametrically opposed to the cubic preoccupations of those interested in 'elementary forms'.

The influence of African, Islamic and primitive art

North Africa and Algeria began to intrigue French Symbolist writers and other writers and artists from the 1880s onwards. The Italian designer Carlo Bugatti (1856–1940), who went to North Africa in the 1880s, translated that interest into visual form. A photograph of an interior designed by him in about 1901 gives some measure of his extraordinarily exotic style [640], a coherent whole despite its eclectic sources. These

640 A bedroom designed by Carlo Bugatti for Lord Battersea's house in London; Italian, *c.* 1901.

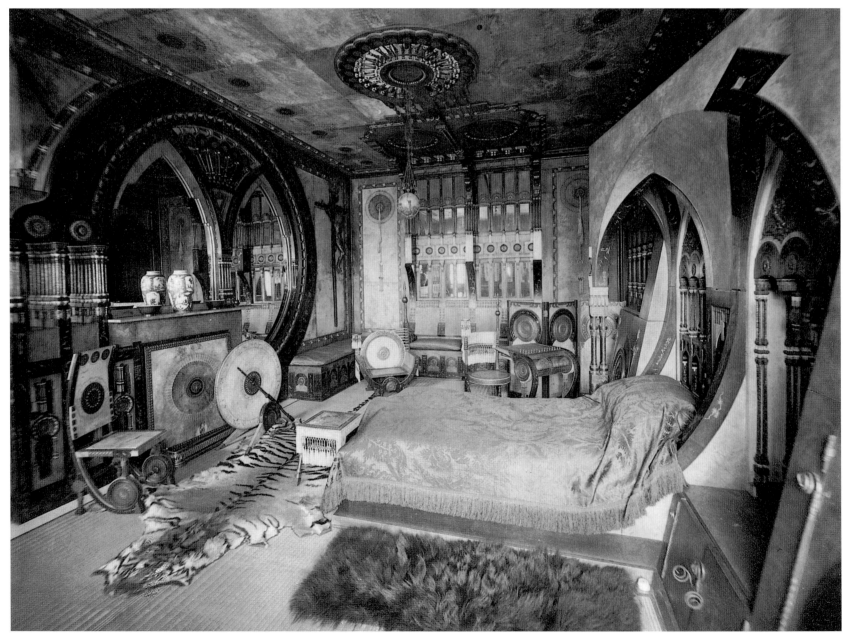

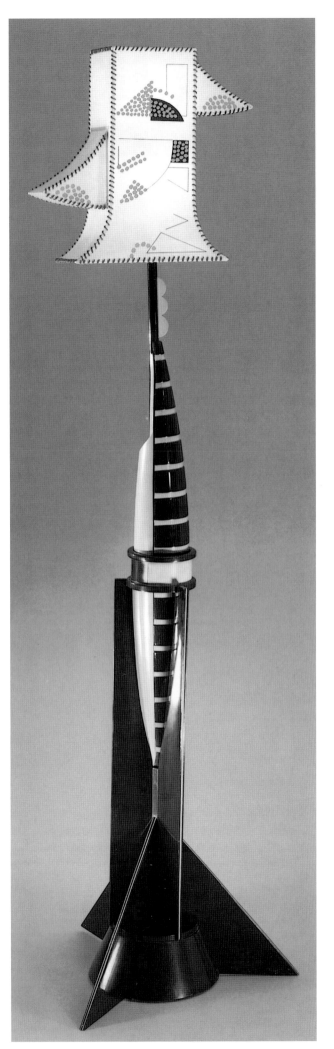

641 A standard lamp in lacquered wood with a painted parchment shade, designed and made by Eileen Gray; French, 1923.

far right 642 A chair in oak, palmwood and parchment, designed by Pierre Legrain; French, 1924.

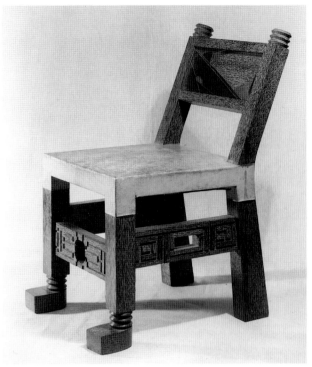

included the antique and the Renaissance (an X-frame chair is in the photograph): elementary forms strongly appealed to him, and some of his most exaggeratedly *outré* designs owe much to late Empire.[190] Much of his decoration is Islamic North African in origin – far removed from the suave 'moresque' that was influencing contemporary Art Nouveau – and it was executed in materials that include parchment, beaten copper, inlaid pewter and ivory, and leather; he frequently used Islamic script as a decorative motif. Bugatti's work owes much to the nineteenth century, but in other ways it forecasts the future (for instance, the ceiling of the room illustrated is in parchment squares, similar to the 1920s and 1930s idiom that was extended to furniture).

The Moorish constituents of Bugatti's style were not primitive. However, true primitive art, especially the tribal art of black Africa, exercised a powerful influence on European arts in the early twentieth century. Picasso, Braque and others collected African tribal artefacts from about 1905 onwards, and Picasso's 'African' Cubist painting, *Les Demoiselles d'Avignon* (1906–7), took the unprecedented step of fragmenting pictorial content into geometric planes and forms. In 1911 a Cubist exhibition was held in Paris. The great patron of early Art Deco furniture, the couturier Jacques Doucet, was collecting African tribal art by 1912. By that time Cubism had moved beyond its early brutalism into a systematic and formalized arrangement of geometric shapes ('Analytical Cubism') that was accused of 'degenerating' into decoration (p. 273). It certainly had become decoration [636] – which is a way of saying that its African elements had been assimilated into a European idiom – and as such was called into service by all the decorative arts, including furniture. As was African art itself; in 1922, a large exhibition in Paris of art from French colonies made the general public aware of what had by then become high fashion. Nothing more clearly demonstrates the absorption of African tribal art and Cubism into fashion than the accomplished works of Jean Dupas, whose faceted angular style and mask-like women with columnar necks synthesize African tribal art with fifteenth-century Italian paintings,

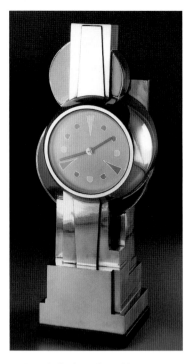

including those of Piero della Francesca. Dupas was the favourite decorative painter of Ruhlmann, who used his work in his most important interiors.

Primitive art affected furniture in two main ways: through the adoption of 'African' and other textures, and through the use of primitive forms. African primitive forms were not infrequently realized in techniques and in materials taken not from African but from Japanese art. African influence is apparent in the rosewood carved to simulate rattan (a material often used in tribal artefacts) of a sofa by Marcel Coard.[191] More extreme are the blunt 'African' forms (with a primitive Cubist design on the back-rest) of a chair of 1924 designed by Pierre Legrain [642].

Primitive forms employed by furniture designers were not necessarily African, as is apparent in a couch of about 1919–20 and standard lamp of 1923 by Eileen Gray (1879–1976). An Irishwoman who had first learned the techniques of oriental lacquer in the late 1890s in London,[192] she continued her studies in Paris in about 1907 with Sougawara; by 1913 she had mastered the medium. The couch [644], in dark brown and silver lacquer, imitates a South Sea Islands dugout canoe (*pirogue* in French) – did Eileen Gray, who moved steadily towards functionalism, know the 'functionalist' gondola theories of Lodoli (p. 262)? The lamp [641], in lacquered wood and parchment, is also influenced by South Sea Islands art; it demonstrates, despite

its dandification, the hardihood of attempting to use as decoration an art utterly foreign to its adopting culture; the darker purposes of the primitive original make themselves felt beneath the decorative suavities.

A smart clock of 1929 in silvered bronze, enamel and marble by Jean Goulden (1878–1947) [643] is the Cubist equivalent of the many clocks composed in earlier periods after antique, Renaissance and later sculpture. A purely decorative object (and none the worse for it), no Roman or Arabic numerals are allowed to disturb the idiom, and even the disposition of the dominant triangles on the face is decorative, irrational and non-functional (a child would find it impossible to learn to tell the time from such a clock). Goulden had been taught the techniques of enamelling by his friend Jean Dunand, and designed lacquer commodes made by Dunand.

African styles were called into exotic requisition just in time. The point of an exotic style is its strangeness, the escape it offers from the known, the familiar, a short cut to the dream for the sophisticate jaded with the familiar. It seems unlikely that exoticism can work its magic in an age when images of distant lands are commonplaces and 'ethnic' arts and crafts of a debased kind are peddled from every street corner. 'Far other Worlds, and other Seas' are now perforce extra-terrestrial, and extra-terrestrial worlds and seas can hardly provide motifs for furniture – or can they?

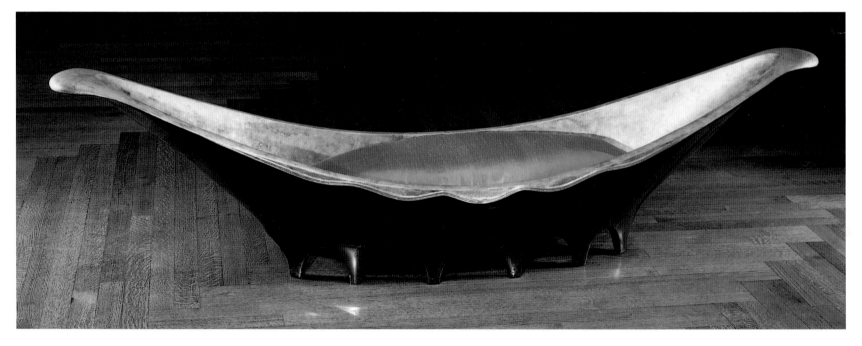

644 A 'Pirogue' couch in dark brown and silver lacquer, by Eileen Gray; French, c. 1919–20.

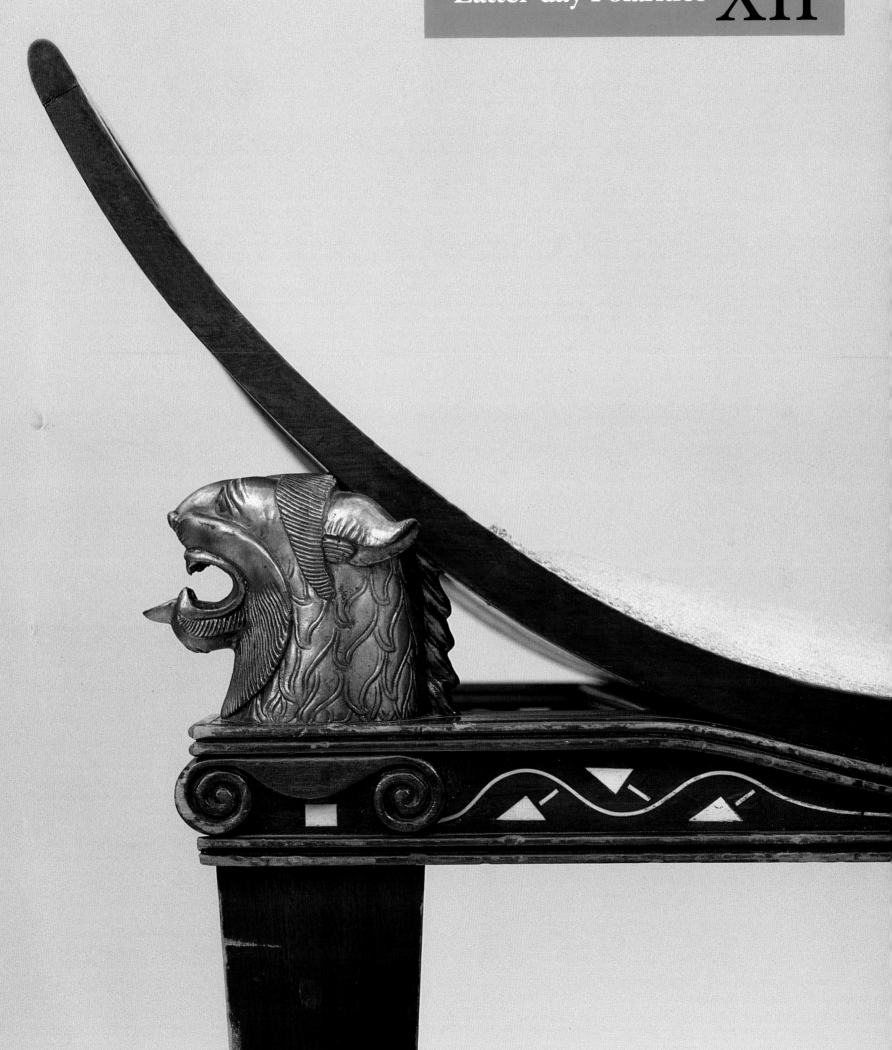

overleaf **645** A detail of a stool, of mahogany with ivory inlay and gilt metal mounts, in the reception room of the Villa Stuck, Munich, designed by Franz Stuck; German, 1897.

646 'La Forêt Lorraine', a desk in oak carved and inlaid with various woods, designed by Émile Gallé; French, *c.* 1900.

AT THE END of the nineteenth century, revivalism departed from slavish copying or uninspired improvization to join hands with other influences in creating a style called in tribute to its startling originality 'Art Nouveau'.

This term is frequently used to cover three distinct styles that flourished between about 1890 and 1905: the curvilinear and naturalistic Art Nouveau of France, Belgium, Italy and Spain, the more geometric and formalistic Jugendstil and Secessionist styles of Germany and Austria, and the idiosyncratic and beautiful Scottish School centred on Mackintosh. The stylistic likenesses – novelty and to some extent ornament – arose from common reforming aims and the common ideas and ornament which travelled by way of international exhibitions and magazines: the strongly 'anti-classical' influence of Symbolism pervaded everything. The stylistic differences can be accounted for by the shaping effect of the major influences: rococo, Gothic and moresque in the case of French and Belgian curvilinear Art Nouveau; Romantic Classicism, Biedermeier, 'Etruscan', Byzantine and Arts and Crafts in the case of Germany and Austria. Some furniture designers who began with one style – Henry van de Velde, for instance – ended with another. The differences are such that any 'umbrella' term that covers them all is misleading – what do a desk by Gallé [646], a chair by Mackintosh [625], and a bookcase by Koloman Moser [667] have in common? This chapter is therefore confined to the predominantly curvilinear, Latin-orientated Art Nouveau that arose especially in France and Belgium, with a footnote on the 'spook school' of Mackintosh.

Art Nouveau furniture had two faces. On the one hand it emphasized truth to materials, spontaneity and individuality, finding its ideal in aspects of Gothic, rococo, Japanese art, and British Arts and Crafts. Its principal designers had their own distinct styles – they signed their work, whilst Liberty's products were anonymous. They did not confine themselves to one medium: Georges de Feure, for example, designed furniture, textiles, porcelain, posters, theatrical costumes and books. Illustrated magazines emphasized the idealistic and artistic nature of the style. On the other hand, the use of modern machinery compromised the quality and destroyed the integrity of much Art Nouveau furniture; carved wood, elaborate marquetry and intricate gilt bronze are unsuited to short cuts. Émile Gallé (1846–1904), the most brilliantly talented of French Art Nouveau furniture designers, was happy to use motor-driven tools, but 'commercial' Gallé furniture differs sadly from his masterpieces. Merchants helped to shape the movement, which received its very name from a shop in Paris – 'À l'Art Nouveau' – opened in 1895 by Samuel Bing. Bing played for Parisian Art Nouveau the part that Arthur Lazenby Liberty played for Arts and Crafts; he averred that 'Art nouveau…was simply the name of an establishment opened as a meeting place for young and ardent spirits who wished to show their modernity'.[1] He showed the work of Mackintosh and other leading foreign 'jeunes esprits ardents'.

Arts and Crafts furniture is puritan and moral; curvilinear Art Nouveau furniture is at best amoral, at times depraved: its forms and ornament had been invaded by the equivocal unease of Symbolism and its discovery of beauty in corruption. Symbolist moodiness pervaded Europe during the last twenty years of the nineteenth century; by the 1890s, exactly coincidental with Art Nouveau, its influences were everywhere. Symbolism and Decadence have complex roots, which include Walpolean and Beckfordian Gothic, gothick horror, Edgar Allen Poe, sadistic orientalisms of the *Sardanapalus* variety, Baudelaire, the Swedish mystic Swedenborg, and the 'divine Marquis'; even the Aesthetes (principally a British creation, oddly enough). As early as 1866 the Goncourt brothers' *Journal* made the peculiar statement that 'Basically, passionate feeling is created by the *gaminess* of animate creatures or inanimate things' – 'Au fond, ce qui fait l'appassionnement: c'est le *faisandage* des êtres et des choses.'[2] 'Gaminess' is a well-chosen epithet, and gaminess was most clearly expressed in literature, which deeply influenced Art Nouveau furniture; the latter not only gave visual embodiment to ideas that had been expressed in words, but actually inlaid wooden surfaces with (necessarily ungamey) Symbolist inscriptions and poems. Some French

and Flemish Art Nouveau furniture drips Symbolism; the Glasgow School did not escape it.

The charms of Symbolism are fleeting, and the Symbolist content of Art Nouveau and 'spook school' furniture probably explains their short lives – the 1900 Exhibition at Paris marked the triumph and decline of Art Nouveau. The Viennese movement, on the other hand, which largely freed itself of Symbolism after 1900, and which rejected the 'spook' side of Mackintosh, went on to become a fount of Modernism. The darker side of Symbolism is evident in the art of Gallé: he made 'vases de tristesses' in black and mauve glass[3] and his eccentric bed, 'L'aube et crépuscule', symbolized dawn and twilight, the eternal cycle of the days. All very thought-provoking, but hardly a bed to take one's cocoa in.

More accessible is a desk shown at the Paris Exhibition of 1900 [646]. Much of Gallé's furniture aspires to the condition of poetry (as does his glass): he associated his native forest with certain lines by Baudelaire, and on the top of this desk are inlaid the words 'forêt Lorraine tout y parlerait à l'âme en secret sa douce langue natale' ('everything there spoke secretly to the soul in its sweet native tongue'). The lines that precede those inlaid on the desk mystically celebrate the sheen on old furniture in association with rare flowers, scents, rich ceilings and the dark profundity of mirrors (the last was later to fascinate Cocteau – Symbolism and Surrealism are linked):

> Des meubles luisants,
> Polis par les ans,
> Décoreraient notre chambre;
> Les plus rares fleurs
> Mêlant leurs odeurs
> Aux vagues senteurs d'ambre,
> Les riches plafonds,
> Les miroirs profonds,
> La splendeur orientale,
> Tout y parlerait
> À l'âme en secret
> Sa douce langue natale.[4]

What a hymn to the poetry of interiors, given piquancy by the characteristic 'Decadent' inclusion of the word 'oriental'! The cryptic nature of the unquoted lines did not worry the Symbolist furniture maker, who dealt in cryptograms. The poem ends with the most famous of all Baudelaire's words, words quoted by Gallé on another occasion, when he declared that for him the 'forêt de Lorraine' invoked a world in which 'all is only order and beauty, luxury, repose and sensuality' – 'tout n'est qu'ordre et beauté, luxe, calme, et volupté'.

The influence of rococo and the organic

Gallé, in common with many Art Nouveau designers, regarded furniture as a natural organism: 'Our ideal is a piece of furniture treated like a naked body…adorned…its organs laid out like those of an animal or plant, its nerves, flesh, fur, feathers, tissues, membranes, skin, in bud, flower and fruit…'[5] Animal or plant furniture might possibly, one supposes, have exhibited the equivalent of the tight musculature and rigid forms of 'a naked body' by Mantegna, the Pollaiuoli, or early Michelangelo. It did not, although one furniture designer, Carabin (1862–1932), carried such theories to a logical conclusion and produced furniture made up of human bodies influenced in style by the leading French sculptors and painters of the period. For the most part, furniture concentrated on vegetables.

However, much Art Nouveau furniture does have disconcertingly alive 'organic' qualities [654]. These were embodied in forms drawn from several sources, including curvilinear Gothic [108], rococo [313], and arabesque [647, 648]. All these 'anti-classicisms', the intertwined histories of which have been traced in earlier parts of this book – and most of which ultimately derived their organic vitality from the antique vegetal scroll – now came together in the 'anti-classical' art of Art Nouveau. The Gothic influence is less overt than other influences, but it is none the less real. By the time Art Nouveau arrived on the scene, revived Gothic had manifested itself in diverse ways: Morris and Ruskin ('Fraternel, dogmatique et contradictoire Ruskin!', as Gallé called him in 1897[6]) were still forces to be reckoned with; Viollet-le-Duc's *Entretiens sur l'architecture* (1863, 1872), which preached constructional principles founded in Gothic architecture, was exceedingly influential. The Gothic influence on Art Nouveau decoration and furniture is seen not in pointed arches but in such motifs as the far-flung supports that unite the whiplash line of moresque with the 'fairy viaducts' of the flying buttress [132, 652].

Art Nouveau was also influenced by rococo. French connoisseurs and writers extolled its virtues. Such a connoisseur is pictured by Balzac in a novel set in 1844: the poverty-stricken Pons rummages in the antique shops of Paris and buys a fan by Watteau, 'this divine masterpiece… certainly ordered by Louis XV himself'; it has 'such spirit, such verve, such colour! And it was thrown off in a moment – like a flourish by a teacher of calligraphy: no feeling of effort!' Pons remarks that 'the Parisians are realizing that the famous German and French inlayers of the sixteenth, seventeenth and eighteenth centuries created real pictures in wood', and that 'certain articles in marquetry and porcelain will never be made again'.[7] Ten years after Balzac's novel, the first of the Goncourt brothers' historical reconstructions of the eighteenth century appeared; the titles of their books, which drew on evidence from letters, documents, and engravings, give an idea of their contents: *Portraits intimes du XVIIIe siècle* (1857), *La Femme au XVIIIe siècle* (1862), and *La du Barry* (1878). This marked emphasis on the 'feminine' and 'boudoir' characteristics of rococo is reflected in much Art Nouveau furniture, especially the smaller items. In 1861 the brothers began a series of novels in which 'the very element of sight is discomposed, as in a picture by Monet….Seen through the nerves…the world becomes a thing of broken patterns, conflicting colours and uneasy movement.'[8] Between 1859 and 1875 they also published a series on eighteenth-century art. They, like Balzac, praised the spontaneity, verve, delicacy, wit, technical virtuosity and originality of rococo; for the Goncourts, the coarse inelegancies of Rococo Revival furniture, recognized by many as a failure as early as the late 1820s, were intolerable.

The influence of rococo on curvilinear Art Nouveau furniture is apparent in the most obvious way – serpentine lines, the cabriole leg, direct quotations of rococo forms and marquetry ornament; it affected even such wayward spirits as Antonio Gaudí (1852–1926), who blended it with baroque and Renaissance motifs and and, especially, with his own Catalan repertoire of Gothic and Moorish architecture and ornament. The Iberian rococo furniture [651] that itself had been influenced by English furniture is reflected in the broken curves and convoluted arms of a bench made in about 1904 for the Casa Calvet in Barcelona [650] (chairs in a related style designed for the study of the same house have seats scooped out in a manner not unlike that of an English

647 Three Turkish ornaments (after Owen Jones, *The Grammar of Ornament*).

648 Detail of wall decoration from the Palace of Sultan Abdul Aziz, Istanbul; Turkish, nineteenth century.

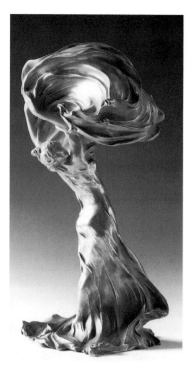

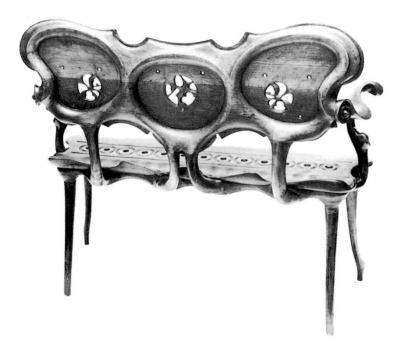

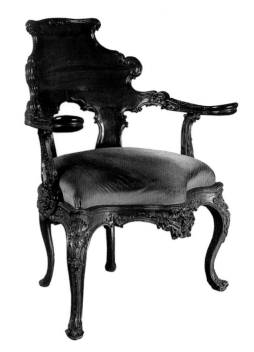

649 'Salome', an electric lamp in gilt bronze by F.-R. Larche; French, c. 1909.

650 A bench in carved oak, designed by Antonio Gaudí for the Casa Calvet, Barcelona; Spanish, c. 1904.

651 A library chair in carved rosewood inlaid with cearu rosewood; Portuguese, c. 1750–75.

'Windsor' chair). The openwork motifs in the back of the bench look like a disintegrated Gothic wheel window or ornament, and resemble details of Gaudí's Church of the Sagrada Familia in Barcelona.

Gilt bronze, an integral part of French rococo furniture, played the same role in much French Art Nouveau save that, following the Empire example, it was extended to seat furniture. Gallé's 'La Forêt Lorraine' desk [646] has no gilt bronze; it is made of oak, the traditional wood of much of the finest rococo carving – but oak was the wood of the *menuisier* rather than that of the *ébéniste*, and the legs and carved detail of the desk come from the rococo chair [651] rather than the rococo desk.

Curvilinear Art Nouveau motifs every now and then curiously replay that precursor of the rococo, seventeenth-century Flemish and French auricular expressionism. The lax droop of some Art Nouveau furniture makes it look as if it has strayed into an auricular swamp. Metaphors used to describe Art Nouveau recall auricular motifs: the Belgian style is called the 'paling stijl' from the word for an eel, and the interiors of Victor Horta's Hôtel Solvay in Brussels were described as like water, 'flexible, mobile, transparent'.[9] Gilt-bronze figures designed by the sculptor François-Raoul Larche (1860–1912) as electric lamps [649] portray the dancer Loie Fuller, who was well known for the artistry with which she manipulated the transparent veils of a cruel icon of Symbolist art – Salome, who had attracted Wilde, Beardsley, and Knopff, and whose diaphanous gyrations had as their end the gift of the Prophet's head. It is difficult to believe that Larche had not looked at seventeenth-century auricular metalwork, the arch-medium of that style; the fluid ambiguity of not only the veils, dress and hair but of the body itself are all auricular mannerisms. The sculptor Auguste Rodin, whose *Gates of Hell* had been begun in 1880, also had a deliquescent style, but it lacks the overt historicist references of Larche's lamps.

The influence of nature and flowers

Naturalism in art had been opposed by theorists like Owen Jones, who was repelled by the high Victorian splurge of naturalistic ornament. Prompted by classical idealism, Jones taught that the imitation of nature was a sign of decline: 'in every period of faith in art, all ornamentation was ennobled by the ideal'; even Gothic naturalism was bad –in 'the best periods of Gothic art the floral ornaments are treated conventionally, and a direct imitation of nature is never attempted'.[10]

'Nature' in general is a noticeable feature of much 'anti-classical' Art Nouveau furniture, to such an extent that some pieces look as if they have grown [654] – 'floraison, fructification'… Flowers carried into Art Nouveau furniture a freshness never quite drowned in Symbolist miasmas – although Symbolism heavily weighted flowers with extraneous meaning. Gallé, like Baudelaire, believed that 'flowers and dumb things' had their own language, 'le langage des fleurs et des choses muettes'; they might become 'flowers of evil' – the famous 'fleurs du mal'. On one occasion Gallé, who had studied botany, designed the whole furnishing of a room from the dahlia. Art Nouveau flowers came principally from two sources: eighteenth-century Europe, and Japan. In the rococo and post-rococo periods, naturalistic flowers and plants became three-dimensional [362]: Georges Jacob decorated Louis XVI furniture with sunflowers, lilac, violets, roses, poppies and water-lilies. Flowers are common in Japanese art, and many Art Nouveau flowers assumed Japanese characteristics. 'Japanese' flowers, set in a 'Japanese' landscape, are inlaid into the front of Gallé's desk [646]. For such inlays, Gallé used the exotic woods that had entranced him when he first encountered them in 1885; by 1889 he had six hundred woods available for use as veneers and inlay.[11] Flowers were not the only botanical ornament used by Art Nouveau furniture makers; the eighteenth-century European and oriental interest in 'twig' and 'root' furniture [570, 571] was repeated; Horta found the questing energy of roots more intriguing than the passive beauty of flowers or fruit.

Insects were an ideal natural ornament for the Symbolists, who shared something of the Renaissance's fascination in living examples of metamorphosis. Insects are strange and alien beings; their beauty often has a sinister cast. Dragonflies were dearly beloved; Lalique made ravishing dragonfly jewellery in his early career; Gallé decorated his glass vases

652 Writing desk veneered in pearwood and various other woods, designed by Léon Benouville; French, c. 1900.

653 A version of the guéridon supported on dragonflies, carved and inlaid with walnut and various other woods, by Émile Gallé; French, 1904.

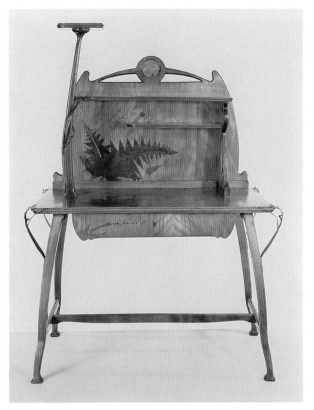

with them. Gallé's famous dragonfly guéridon [653], at first sight a typical Art Nouveau product, is exceptional in that the 'anti-classical' influences that shaped it are here combined with an overt allusion to antique style. The table, a tripod table, is nothing other than an Art Nouveau version of the Roman tripod. Gallé's own words suggest a conscious relationship between his concept and that of the famous Pompeian tripod supported by satyrs [5]: after referring to the faun motif as used by jewellers, he adds that he has 'tried to add to the chimerical menagerie of furniture some real images' and that '"the quivering dragonfly," stilled for a moment, has lent its wings to immobile console tables'.[12] The wings of the 'quivering dragonfly' have been reduced in size in relation to the body and head: the tail now curves up in the manner of a cabriole leg, and the ridges on the body are so formalized as to resemble simulated bamboo. The conversion into a voracious monster was noticed by a reviewer of 1898, who wrote 'The enlargement of the frail insects…has transformed them into monstrous creatures.'[13] He recognized their monstrous nature, but not the ancient lineage of their monstrosity.

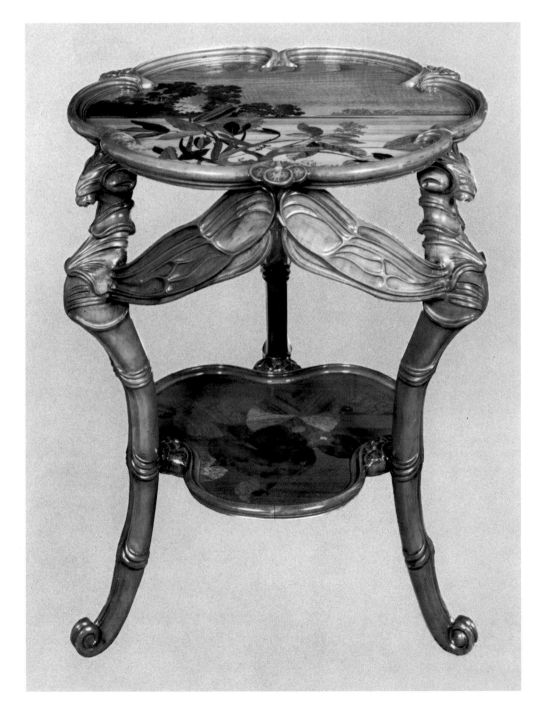

Japanese asymmetry, moresque, the auricular and Gothic

Japan, rather than the rococo, gave asymmetry to Art Nouveau furniture; Japanese asymmetry is more fundamental than that of most rococo furniture, which had been a matter of detail more than form (p. 174). Some Art Nouveau furniture, including furniture by Gallé himself, is virtually a pastiche of Japanese furniture. A lady's writing desk by Léon Benouville (d. 1908), as unlike the Gallé desk as possible, has its little drawers and filing racks placed determinedly on one side in 'Japanese' manner; the flowers that decorate it are Japanese in character. Benouville cast his brass mounts as praying mantises and beetles, and the legs of a similar piece [652] have the stick-like fragility of insects; the metal mounts that emerge from them are at once plant-like, insect-like and Gothic.

Islamic arabesque deeply influenced not only the curvilinear Art Nouveau furniture of France and Belgium but the stiffer forms of Munich and Vienna. Arabesque, in its specific form of moresque, the art of Moorish Spain, had received favourable attention in France from before mid-century; Owen Jones thought the Alhambra at Granada the apex of decorative art, giving moresque a clean bill of health in regard to the two contemporary shibboleths, utility and ornament: 'They [the Moors] ever regard the useful as a vehicle for the beautiful', and they 'ever regarded what we hold to be the first principle in architecture – *to decorate construction, never to construct decoration.*'[14] Gallé made moresque-inspired glass and ceramics early in his career.

The features of moresque that most interested Art Nouveau designers[15] were thick-and-thin scrolls [69, 648], the broken curve [213] and the knot [67]; all were shared with Celtic art. Thick-and-thin scrolls and broken curves occur in the early graphic and other work of Van de Velde, Horta, Guimard, and others. The geometrical lines that are used in conjunction with moresque in Art Nouveau

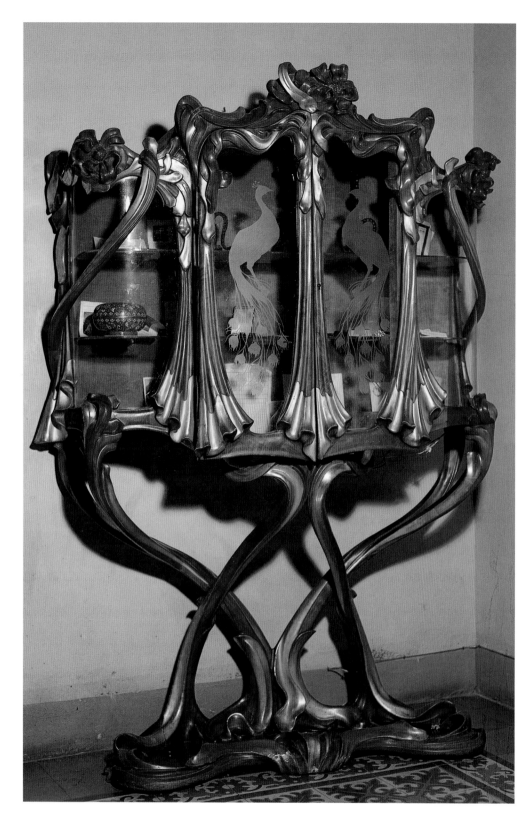

ornament owe something also to the geometric interlace of Berainesque grotesque. The influences are deeply interfused, as in the brilliant line of that calligraphic meteor Aubrey Beardsley, who was influenced by grotesque, rococo and moresque ornament; Beardsley's work was shown by Bing at his shop and was freely available in publications. The sinuosity of Art Nouveau flowers came not only from Japanese art but from the scrolls of arabesque. There may have been other converging influences; was the swaying motion of the proto-Art Nouveau back of the well-known chair designed by A. H. Mackmurdo (1851–1942) in 1882–83 influenced by the graceful droop imparted to Egyptian depictions of flowers and buds[16] (although Mackmurdo's flower heads are botanically vague)?

A vitrine [654] by Alego Clapes Puig (1850–1920), a portrait and religious painter who painted wall decorations in Gaudí's Palacio Guell in Barcelona and who was inspired by Gaudí to design furniture in an extreme Art Nouveau style, is in that heavily scented style that seems made as a background for exotic sin. Elements in the vitrine recall both auricular deliquescence and the thick-and-thin lines of moresque; the cabinet's unsteady sway upwards from its extraordinarily crossed legs, plus the impression that its sinuous organism is composed of a soft rather than hard material – perhaps a kind of caramel? – turn the whole piece into expressionist sculpture rather than furniture. The peacocks etched into the glass have strayed from Japan.

In contrast with this boneless Art Nouveau, a settle of about 1898 [655] by the Belgian architect Gustave Serrurier-Bovy (1858–1910) looks as if it has just emerged from the gymnasium. The designer was described in 1902 by Van de Velde as 'unquestionably the first artist on the Continent who realised the importance of the English Arts and Crafts style and had the courage to introduce it to us and defend it':[17] his shop in Liège, which opened in 1884, acted as an agent for Liberty goods.[18] The influences are diverse: the form comes ultimately from the Gothic seat with its overhanging canopy [138], possibly partly via Ruskin, Morris, and British

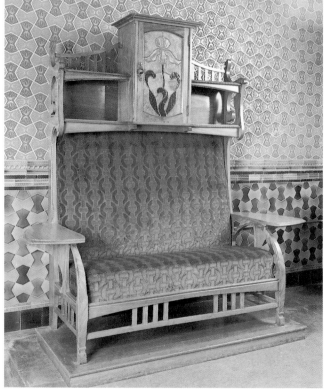

654 A vitrine in carved and parcel-gilt wood, designed by Alejo Clapes Puig for the Ibarz house in Barcelona; Spanish.

right 655 A settle in padouk and stained glass, designed by Gustave Serrurier-Bovy; Belgian, *c.* 1898.

656 Three papyrus plants and three lotus flowers held in a king's hand; Egyptian (after Owen Jones, *The Grammar of Ornament*).

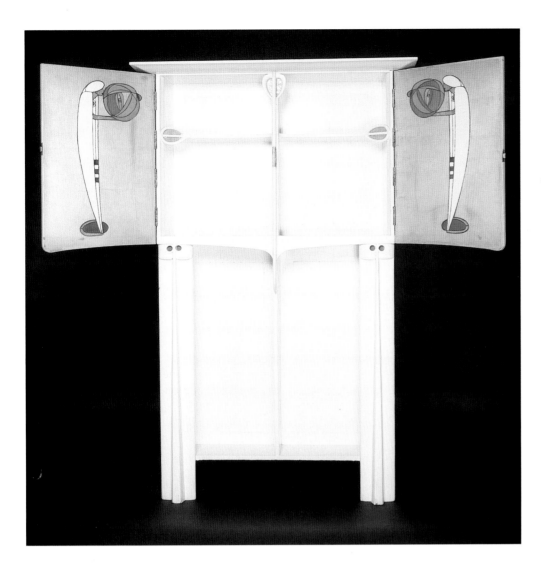

in view of his later move from Belgian Symbolism, where he was never really at home, to German Modernism; in 1904 he became a professor at the Weimar Art School, which under Gropius, his successor, was to become the Bauhaus (p. 272). He read in his youth the works of Ruskin and Morris; his early furniture in Art Nouveau style has traces of Gothic and Arts and Crafts, but nothing of the French interest in *boiserie* – it is not surprising that he accepted the machine. His later pieces have 'revealed construction', undisguised screws and joints; he disliked the use of modern materials to imitate others, believed with Viollet-le-Duc that ornament must be part of the structure, and repudiated naturalism for abstraction.

The Scottish School: Mackintosh

Without any doubt, the British designer who had the most fructifying influence on European furniture at the turn of the century was Charles Rennie Mackintosh (p. 299). This came mainly through his contacts with Vienna; in the late 1890s he became a sensation in Europe. Mackintosh and his associates were an early example of the deliberate desire to be called 'modern'; Glasgow and the Scottish School did informally what the Secessionists in 1897 did formally. The Eighth Secession Exhibition of 1900 was devoted to interior decoration; C. R. Ashbee, Mackintosh and the Macdonald sisters were asked to show, as was Van de Velde. At the Exhibition, Hoffmann and Moser met Mackintosh, and Hoffmann later visited Glasgow. In 1903 the Wiener Werkstätte was formed along the same lines as Ashbee's 'Guild of Handicrafts'.

The influences that went to make up the Mackintosh style included Gothic, the vernacular, Japanese, Egyptian, and Art Nouveau, all blended into a mature and coherent whole of which a main characteristic was a dandified elegance that had affinities with that of the Viennese – except that in place of Viennese volume and four-squaredness, Mackintosh's furniture and interior decoration depended primarily upon rectilinear outline. His colour – green, lilac, rose, black and white – was much influenced by the Aesthetic movement and by Japanese prints. Margaret Macdonald Mackintosh's elongated ladies, who decorate his furniture and interiors, strangely and effectively blend 'whiplash' Art Nouveau, which has moresque antecedents, with Celtic, Scandinavian and Japanese influences (they sometimes recall the full-length prints of Japanese women with their high waists, broad sashes and billowing kimonos). Some of these influences are seen in the work of Beardsley and Toorop, who have been suggested as influences on Mackintosh: it is more likely that the resemblances arise from a common, highly publicized aesthetic environment.

The exquisite preciosity of a cabinet of about 1903 [657], in which white-painted oak is embellished with coloured glass and silvered panels, speaks of Vienna. However, the various influences are perfectly absorbed in a highly distinguished synthesis. Japan contributed the silvered squares; the figures combine Greece (the squares) and Japan; the rose has the squared-off petals that became a leitmotif of French Art Deco. The inner legs that taper up to two 'eyes' may have been influenced by the tapering legs of a simple, even 'vernacular' type of Greek *diphros* that had not attracted earlier neo-classicists;[20] some tables by Mackintosh appear to reflect these Greek stools, whose legs often swell out again towards the top.[21] The same simple tapering shape, frequently topped by vestigial scrolls that might have suggested Mackintosh's two 'eyes', occurs in Egyptian decoration [658:A] and on Greek aedicules.[22]

657 A cabinet in oak, painted in white and silver and decorated with stained glass, designed by C. R. Mackintosh; Scottish, *c.* 1903.

658 A fragment of Egyptian ornament (A), ornament from an Egyptian tomb (B), and an Egyptian royal head-dress with two cobras (C) (after Owen Jones, *The Grammar of Ornament*).

Arts and Crafts, all greatly admired by Serrurier-Bovy. However, Gothic seats with canopies had been profusely illustrated in Continental sources, including Viollet-le-Duc (who influenced Horta, chronologically the father of Art Nouveau). It was Viollet-le-Duc who gave Serrurier-Bovy a desire for rational furniture and the ideal of an all-pervading style: 'a civilization cannot pretend to have an art unless that art pervades everything, including the most vulgar utensils.'[19] Another interest of Serrurier-Bovy's, Japan, is hinted at in the settle's stained-glass iris. The broad arms of the settle, though found elsewhere in Art Nouveau furniture, may be influenced by colonial types: shortly before it was made, Serrurier-Bovy had had much to do with the Colonial Exhibition at the Château de Tervueren; this prompted him to use exotic woods, such as the padouk from which this piece is made.

The Art Nouveau furniture style of Henry van de Velde (1863–1957) is also of the 'muscular' variety. Van de Velde was born in Antwerp; in his early career as a painter he switched from Impressionism, an art based on momentary illusion, to Pointillisme, an art based on immobile form that deliberately looked to antiquity for motifs. This is significant

A B C

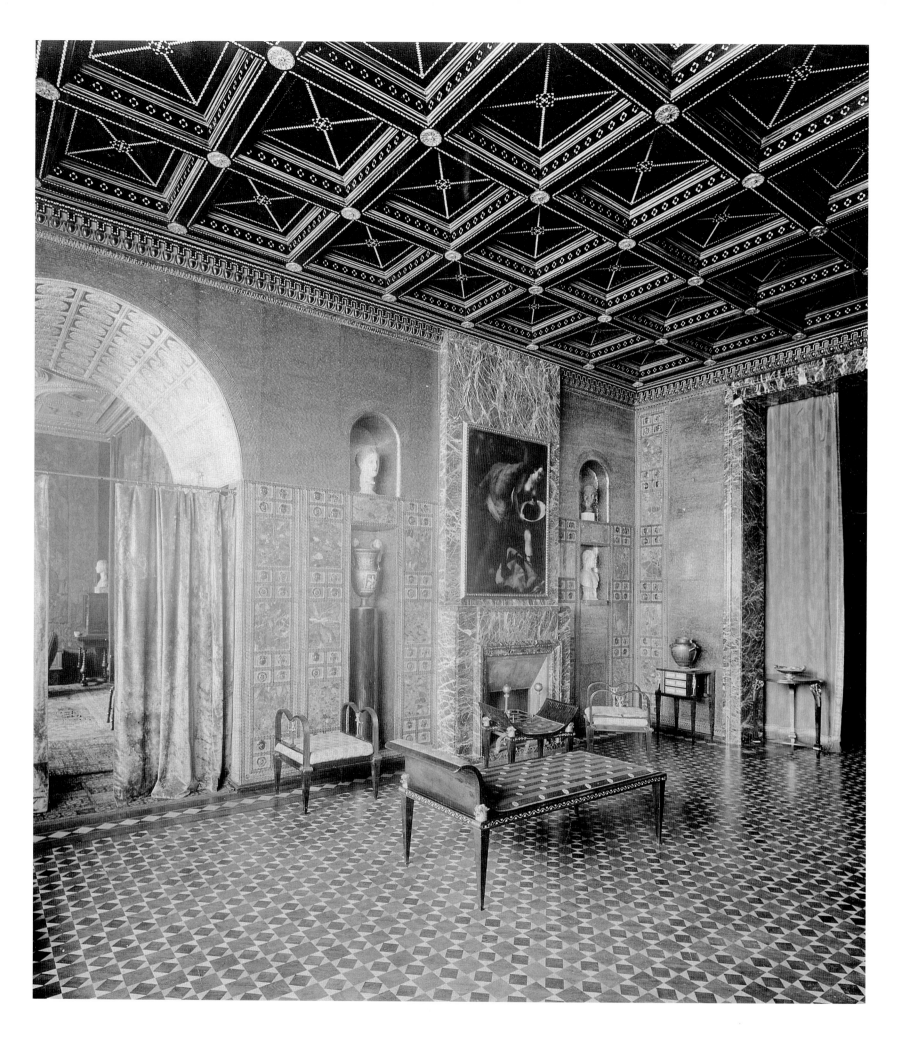

German and Austrian neo-classicism

659 An early photograph of the reception room in the Villa Stuck, Munich, showing furniture in mahogany and in mahogany stained black, inlaid with ivory and decorated with gilt bronze, the whole designed by Franz Stuck; German, 1897.

At the latter end of the nineteenth century, two European schools of furniture arose that developed a highly distinguished style influenced by antiquity and by earlier neo-classical styles. They were that of Austria, which called largely upon antique, Byzantine and neo-classical influences, and which reached its height in the work of the Vienna Secessionists and the Wiener Werkstätte; and that of the Munich Secession, called generally 'Jugendstil' after the Munich magazine *Jugend*. These were followed hard by French Art Deco, which called upon the whole repertoire of antique and post-rococo neo-classical decoration for inspiration, including the modified rococo of the later eighteenth century, and which reached its apogee in the twenties. Art Deco was accompanied and followed by the International Modernism of the 1930s, which was especially influenced by Biedermeier and by preoccupations with volume inherited from French Romantic Classicism. The thread was then broken by the Second World War.

The current for classicism that had been running for some time in late nineteenth-century Germany and Austria surfaced in Munich in a complete work of art, the Villa Stuck, designed between 1897 and 1898 by the painter Franz Stuck (1863–1928). Stuck, who had become a founder member of the Munich Secession in 1892, was fascinated by the antique world (as was his fellow painter Arnold Böcklin, who influenced him); his paintings of fighting satyrs, convincing revivifications of antique myth, are taken virtually unaltered from Pompeian murals;[23] when ennobled in 1905 he chose a centaur for his arms, and on his death in 1928 was wrapped in a toga. His decoration synthesized ancient Greek architecture, sculpture and interior decoration with 'Etruscan' and 'Pompeian' motifs, the whole steeped in a neurotic Symbolism that came partly direct from Byzantium, partly from the fin-de-siècle artists who 'liked best to compare their own [period with] the long Byzantine twilight, that gloomy apse gleaming with dull gold and gory purple, from which peer enigmatic faces, barbaric yet refined, with dilated neurasthenic pupils'.[24] Byzantinism had been in the air for some time; Alma-Tadema, a less original eclectic classicist, had designed a 'Byzantine' piano for his own house in 1879–80.

The dimly rich reception room of the Villa Stuck [659], more severely Greek in its decoration than most of the Villa's interiors, gleamed with elongated panels of 'Byzantine' gold mosaics beneath a coffered 'Greek' ceiling. It contained a group of furniture designed by Stuck and made by a Munich cabinet-maker in the 'Etruscan' colour scheme of black, red (mahogany) and white (ivory); this homogeneous set was accompanied by an 'archaeological' version of the Pompeian sphinx tripod [42].[25] Stuck's furniture included two different types of stool. One has Aeolic capitals and curvaceously sagging sides upheld by gilt-metal figures that have points of resemblance with a mirror from Corinth of about 460 BC in the Munich Glyptothek. The other [645] has primitive Ionic capitals, a formalized Greek running tendril of a type seen on Greek vases [48], and gilt-metal lion heads exactly copied from an Etruscan bronze of about 540 BC, also housed in the Glyptothek. Its curved and slatted seat manages to combine the vernacular (breathed upon by Arts and Crafts?) and the

archaic. An armchair from the same set has curved-over arms that resemble a motif used in innovatory English furniture – it is seen, for example, in a sofa by Godwin of about 1867.[26] Stuck's sketches for furniture curiously mix the archaic and the avant-garde; they clearly betray the influence of the Greek 'cut-out' chair and the antique X-frame chair: is it possible that he had also perhaps seen and been influenced by a type of ancient German furniture discovered as grave-goods?[27]

Impulses similar to those that propelled Stuck led to the creation of the extraordinary Villa Kérylos (1902–8) in the south of France at Beaulieu. Its style is a rich version of ancient Greek, the result of a collaboration between Theodor Reinach (1860–1928), an archaeologist and Hellenic scholar, and the architect Emmanuel Pontremoli. Its exterior is in the same genre as Hoffmann's Palais Stoclet at Brussels (1905–11), although it lacks the originality and refinement of Hoffmann; it was furnished with copies of ancient Greek furniture.

Interesting and beautiful as is Stuck's furniture, it yields before the innovatory genius of the Viennese of the Secession and the Wiener Werkstätte, who united frugality of line and functionalism with luxury of surface and materials to create a style all in all more coherently distinguished – if narrow – than any that has succeeded it. Its diverse sources, displayed as fully in its ceramics (which include archaic Greek gods as motifs) and furniture as in architecture and decoration, include Egyptian ornament, Byzantine mosaics, Romantic Classical architecture, Biedermeier functionalism, and English and Scottish permutations of vernacular and Japanese styles, especially those of Godwin and Mackintosh. Symbolist angst is present, although the shadows of the city of Freud are lightened by Greek sunlight.

Amongst the strongest influences on Secessionist art (the term itself comes from the *secessio plebis* of ancient Rome[28]) were those of mainstream classicism – archaic Greek sculpture and architecture, 'Etruscan' vase painting, and Roman art and architecture. In 1895, Hoffmann won the Prix de Rome, and visited Pompeii and Sicily; he found Italian 'impressions at first overwhelming, especially the remaining monuments of antiquity, which produced a staggering effect upon me' (he sought to sober himself with Italian vernacular architecture). Joseph Maria Olbrich was similarly affected; in 1899 he wrote that he wished the walls of his Vienna Secession building to 'arise, shining white, sacred and chaste', and that he sought a 'solemn, all-pervading dignity – that pure, sublime feeling which came upon me, overpowered as I stood alone before the unfinished [archaic Greek] temple at Segesta....I wanted...to see my burning passions frozen in the icy stone.'[29] The last phrase perfectly describes the glacial beauty of much Secessionist art, Expressionism turned to ice.

The paintings of Gustav Klimt, which express a troubled sensibility through an extreme formalization tending to abstraction, concentrate many of the influences [664]. Klimt used either paint to resemble mosaic, or mosaic itself – in both media with much gold; in 1906 his style was described as 'something like a mosaic of vague metals and enamels, lovely as jewels to the eye, like the *féerie* of the Byzantine mosaics at Ravenna, Palermo and the Church of St. Mark'.[30] He employed scrolls that are at the same time Mycenaean, archaic Greek and Byzantine (a few years later they were to

right 660 A painted terracotta lekythos in the form of a sphinx; Greek (Athenian), *c.* 400 BC.

661 An Egyptian painted coffin with geometric and other ornament, *c.* 2000 BC.

be synthesized with Japanese cloud forms in the metal furniture of Edgar Brandt and his followers[31] [638]); 'jewels', also influenced by Byzantine mosaics and ultimately by Sassanian art; and little squares and rectangles. Hoffmann was influenced by Klimt, although Hoffmann's obsession with rectilinear forms after 1900 signalled his total submission to classical values. Hoffmann said that 'The pure square and the use of black and white rather than colour particularly interest me, for these lucid elements were not a feature of previous styles.'[32] Back to Aristotle and the nobility of black and white!

Some Viennese motifs have been said to have been borrowed from the work of Mackintosh; a present-day critic has written: 'The style they [Hoffmann's pupils] evolved bore little resemblance to the pieces Mackintosh had actually exhibited in Vienna, but their growing dependence upon white paint, coloured inlays, and the use of the square as a decorative motif, points to their considerable knowledge of other pieces designed by Mackintosh which were not shown at Vienna.…I believe that the increasing use of geometrical motives in the Secessionists' designs was inspired by Mackintosh.'[33]

White and pale, delicate colours had been around for some time, partly as a result of 'japonisme' (p. 300) – Whistler's *White Girl* had been painted in 1864; a late nineteenth-century 'Egyptian' stool was painted with designs influenced by Owen Jones on a white ground in a style that in some details closely approaches Secessionist style [621]. Mackintosh shared Godwin's Japanese-inspired interest in 'sensitive' colours – lilacs, pale greens, and off whites – which he set off by masses of black. The 1890s revival of Louis XVI in France (p. 320) and elsewhere [539] added to the stock of white-painted furniture.

As far as the chequer-board square is concerned, Mackintosh himself may have come to it partly through Japan (p. 302); the motif was also common in ancient Egyptian [661], Mycenaean and Minoan art. Greek vase paintings abound in chequered squares; they decorate not only fabrics [11] but helmets and couches [13]; Klimt used such motifs in a form that directly recalls Greek vases [663, 664]. It is surely more likely that Secessionist squares came via the Secessionist revival of 'Etruscan' Biedermeier rather than from Mackintosh. Biedermeier was Austrian home ground: Otto Wagner and other Viennese designers included old Biedermeier furniture in their modern interiors, and chequer-board squares occur frequently in the Biedermeier Greek-inspired patterned textiles that were much adapted – and reproduced virtually unaltered – by the Secessionists.

662 Byzantine ornament, including scrolling and strip patterns, roundels with cusping, and formalized monsters, beasts and trees on the vault and walls of the Sala di Ruggero, a Norman Byzantine chamber in the Palazzo Reale, Palermo, *c.* 1170.

663 Ancient Greek ornament – squares, the Greek key fret and a 'seal' – from an 'Etruscan' vase published in Naples in 1800–1803 by Wilhelm Tischbein (from *Peintures des vases antiques de la collection de Son Excellence M. le Chevalier Hamilton*).

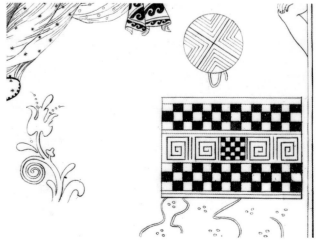

right **664** Scrolls, squares and other ornament in *Fulfilment*, by Gustav Klimt, a design for the wall of the dining room in the Palais Stoclet, Brussels; Austrian (Viennese), *c.* 1905–9.

665 Ornament from a Greek vase (after Owen Jones, *The Grammar of Ornament*).

666 A chest of drawers in ebony, boxwood and mother o' pearl, designed by Eduard Josef Wimmer-Wisgril and made by Wilhelm Niedermoser; Austrian (Viennese), 1908.

Little squares occur also in the Byzantine decorations that inspired Wagner, Hoffmann and other Secessionist designers, who arranged small triangles, formalized 'trees', elongated rectangles, sometimes Greek key patterns, in long strips that strikingly resemble the strips so often seen in Byzantine and Cosmati mosaics (mosaics themselves are made up of squares) [107, 662]; such strips outline the exteriors of Secessionist buildings and on interior walls define compartments, areas, and doorways – as they do on furniture [666]. It was from Byzantium that the Wiener Werkstätte took its controlled frigidity, austere splendour, hieratic grandeur and luxurious, at times bejewelled quality of surface, with use of rich inlays. The interior of the Steinhof Church in Vienna by Otto Wagner makes the Byzantine debt explicit. Hanging lamps, such as a group of three designed by Otto Prutscher,[34] betray the influence of 'Byzantine' lamps such as those still used in Orthodox churches.

From the antique came the sculptural garlands that had influenced 'goût grec'; these, reinterpreted as flowers and fruit, a motif seen in antiquity, were passed on to French Art Deco [669], as were chubby putti and a sweetness that is seen in antiquity and bcomes sentimental in the archaizing porcelains of the Wiener Werkstätte; a Greek sphinx [660] could easily be a Viennese porcelain ornament. Other motifs that appeared in Wiener Werkstätte decoration and furniture included geometrical and curvilinear moresque interlace.

Viennese furniture can be extraordinarily simple [544] or extremely rich; it always has presence. The sumptuous 'Goldener Stuhl' of Olbrich had the lofty squareness of a Byzantine throne.[35] A chest of drawers of 1908 in ebony, boxwood, and mother o' pearl (the last a favourite Biedermeier embellishment) [666] exhibits the Byzantine fondness for strip patterns translated into a new language. Designed by Eduard Josef Wimmer-Wisgril (1882–1961), a pupil of Hoffmann,[36] it would have strongly appealed to 'Quadratl' Hoffmann. Its volumetric stepped form recalls various ancient buildings: the conjectural restorations, an obsession of architects for hundreds of years, of a Wonder of the World, the tomb of Mausolus at Halicarnassus (353 BC), the four symmetrical stepped towers of the 'Porte de Meste en Cilicie' illustrated in Montfaucon,[37] or the stepped pyramid of ancient Egypt, explicitly related by Adolf Loos[38] to his projected mausoleum for Max Dvořak of 1921, a cubic assemblage that closely parallels Wimmer-Wisgril's chest. The chest's pattern of repeated rectangles recalls those of Greek and Roman coffering, used in a less exaggerated form in their original location as a ceiling in another work by Loos, the Kärntner Bar in Vienna of 1908 (exactly contemporary with the chest). Loos also used such rectangles in his furniture. It is remarkable how these ancient motifs could be re-used to produce furniture of high quality that is indisputably of the twentieth century.

Scarcely less masterly are a bookcase [667], desk and chair designed in 1903 by Koloman Moser (1868–1914) for the breakfast room of a Viennese apartment. Their severely

rectangular and cubic forms are set off by luxurious veneers in thuya and satinwood; the square motifs give an impression of the Greek key without actually being one; patterns related to the 'trumpet' motifs with their strong vertical contrasts occur in a common type of Hellenistic mosaic[39] [668]. This mosaic pattern had migrated to a fictive painted door, partly in trompe-l'oeil tortoiseshell (the last a highly favoured furniture ornament), in a Roman villa at Boscoreale;[40] given the relationships between grand doors and furniture, it seems quite on the cards that the same pattern might have been employed in furniture in antiquity. Its origin lies in Egypt – the 'trumpet' is the ghost of the lotus [620] – although it is similar also to the imbricated ornament of antique sarcophagi [185] that imitates roof tiles. Greece has influenced the figures of the frieze inlaid in brass on the front of the desk[41] that accompanied the bookcase (their robes display the chequered bands that enliven the robes worn by figures on Greek vases); the heroic frontal stances and vertical folds of archaic Greek kouroi and Byzantine saints are duplicated in much Secessionist and Wiener Werkstätte architecture, furniture and porcelain. Typical of Vienna is the use of little squares or rectangles of bevelled glass, which add a hard brilliance to the general hardness of Viennese style.

French Art Deco

Art Nouveau was never completely taken to French hearts, and white-painted Louis XVI and Directoire furniture was revived in the 1890s as an alternative. It began to be collected, and a market in reproductions arose; the fashionable portraits of Paul Helleu (an original of Proust's 'Elstir') depict society figures sitting on such furniture. By the early years of the next century, talented French designers were beginning to play variations on Louis XVI, Directoire and other post-rococo neo-classical styles. French Art Deco, the dominating style of the 1920s, was largely a combination of these historicist influences with others from Vienna and Munich that also had drawn much on neo-classical sources; many Art Deco motifs occur in the Munich periodical *Die Kunst* for 1906.[42] It was greatly influenced by painters, including those working in the avant-garde styles of African-inspired Cubism, Futurism, and Surrealism. Despite these 'anti-classical' influences, Art Deco was basically neo-classical – in a fresh and original way, far from the slavish historicism that maintained neo-classical bastions in England. The style was ripe by 1915; the Paris Exhibition of 1925 of 'arts décoratifs' from which its name has been derived was originally planned to take place in 1915. It was an exhibition of 'Modern Art exclusively. No copy or pastiche of old styles will be admitted.'[43]

International Modernism, a style that existed by 1925 and dominated the 1930s, is often loosely included within the Deco definition but is really a distinct style inspired by volumetric Biedermeier, Negro art, Cubism and the Bauhaus; it intermingled with true Art Deco, but there was overt hostility from the Art Deco camp towards 'this rationalism that verges on unreason…[these] geometric abstractions, international concepts…this sorry aridity'; French designers were adjured to 'guard this spirit of moderation that Paris has inherited from Athens'.[44] The Société des Artistes Décorateurs welcomed the Deutsche Werkbund to its 1930 Spring Salon, and the two extremes met: the standardized Werkbund designs (p. 272) were denounced as recalling the barbaric existence 'which many of us have known in the barracks'.[45] However, the German influence helped to 'cool'

667 A bookcase veneered in thuya and satinwood, with brass mounts, designed by Koloman Moser and made by Caspar Hradzil; Austrian (Viennese), 1903.

668 A detail of a Roman mosaic from Pompeii, published in Naples in 1808 (from *Gli ornati delle pareti ed i pavimenti…dell'antica Pompeii*)

opposite 669 A dressing table and chair in carved, gilded and bronzed wood, designed by Paul Follot; French, 1913.

Art Deco, and thirties 'classical Modernist' designers such as Jean-Michel Frank (p. 304) or Serge Chermayeff [546] show few traces of direct neo-classical quotation.

One of the earliest furniture designers to work in a recognizably Art Deco idiom was Paul Follot (1877–1941). His early interests had included Pre-Raphaelitism and Gothic, but he had adopted the emerging style by 1909. Its complete originality, despite its deep-dyed neo-classicism, is demonstrated in a dressing table and chair of carved, gilded, and bronzed wood designed originally in 1913[42] [669]. The most obvious historicist influence on table and chair is that of eighteenth-century 'goût grec'; the strongly modelled cornucopias and formalized flowers and fruit speak of the distant influence of stone sculpture and of Greek inclinations towards abstraction; other features – the fluid lines of the back frame of the chair and the droop of the cornucopias – show the lingering influence of Art Nouveau. The braid that encircles the cornucopias, ornament taken from textiles, recalls the hothouse luxury of the Second Empire, when stools were made of simulated twisted braid.

Decorators who were also designers and dress designers, and professional decorators who were not architects, played leading roles on the Art Deco stage; society women entered their ranks. However, the most influential decorator was a man, Paul Poiret, who had been impressed by Hoffmann and the Wiener Werkstätte. He set up the Atelier Martine in 1912, which used drawings by untrained girl pupils as a basis for design;[46] it became known for brilliant colour and spontaneous 'dash'. One influence on the 'Maison Martine' was peasant art, taken via the Wiener Werkstätte from the vernacular-orientated British; another was neo-grec; a third was the incandescent Ballets Russes. Poiret denied Russian influences, but they certainly helped to form the tastes of his clients, and not only in France: '"We hear you're going to pull down half the Cathedral," Miss Wookie said tragically, "and put in a Russian Ballet window. Is it *true*?"'[47]

An enterprising director at the Beauvais tapestry works, Jean Ajalbert, between 1920 and 1934 engaged avant-garde artists and designers, who included painters such as Dufy

and designers such as Follot; the latter designed the frames and upholstery of the armchairs and chairs of a set called 'Le Parc' [670]. The Beauvais tapestry covers are in the typical French high Art Deco style influenced by the Atelier Martine and the Russian Ballet: a classically composed formal garden with arches and a fountain is scattered with Art Deco flowers which mingle Japanese cloud forms with peasant art, all rendered in bright colour; the latticed seats compare with the backs of the chairs made for Schloss Seehof [315]; as with those, the formal and the rustic are successfully fused. These flowers are quite different from the coldly formalized roses with square-cut petals of designers such as Ruhlmann. The cubic rose, found in 'goût grec' furniture [339] and in the work of Mackintosh [657], became ubiquitous in the 1920s, bursting in sprays over commodes, wallpapers, carpets and vases. The understated elegance of the forms, in painted and parcel-gilt walnut, derives largely from French rococo neo-classicism; the bold rococo cabriole has softened to a slight curve.

Antique influences

Ancient Greece was again fashionable: Poiret was strongly enamoured of it. Greek fashions in dress had happened before, in the early nineteenth century and in the 'Regency Revival' illustrations of Walter Crane and Kate Greenaway (even Poiret's famous discarding of women's corsets had been anticipated in the scandalous 'wet' Greek look of the early nineteenth century). Greek influence accompanied avant-garde painting; Picasso, the principal founder of Cubism, had a pronounced neo-classical phase in the 1920s; his *Guernica* of 1932, despite its revolutionary style, derived the most important elements in its composition from Greek vases and from engravings of a Greek sculpture.[48]

The direct influence of antique furniture and ornament, as opposed to the influence of neo-classical styles, became again apparent in furniture of the 1920s and 1930s (in certain cases supplemented by modern classicizing influences from Vienna). Its motifs are most individually manifested in the green-patinated bronze furniture of Armand-Albert Rateau, a kind of latter-day Stuck who designed furniture and interiors in an extraordinarily exotic manner influenced by Greek, Etruscan (real Etruscan), Roman, Minoan, Syrian and Persian styles; the result, despite its peculiar eclecticisms, is distinguished, completely unmistakable and original [671]. Ancient furniture also influenced the art of Diego Giacometti, as Etruscan bronzes influenced that of his brother: he designed tables, lamps and chandeliers in a corroded style that recalled decayed metal furniture unearthed from Pompeii and Herculaneum, and produced for Jean-Michel Frank distinguished plaster versions of ancient Egyptian lamps.

Ancient motifs were transmuted into a totally novel type of furniture. René Lalique (1860–1945) had an extraordinary facility of invention and an enormous range: all styles seemed to offer him something, and he transmuted all into something accomplished, exciting and novel; he had a grasp of both line and volume, and a sense of the poetic that gives to some of his inventions a haunting beauty. He began as an Art Nouveau jeweller, and turned to glass after 1901; his commercially produced glass presents a seemingly inexhaustible wealth of ideas. The cool clarity of a table in etched glass held within a chromium-plated steel frame, of about 1930 [672], brings up to date a combination of glass and metal that was not new in French furniture [458]. Despite the lack of bases and capitals, the reference to

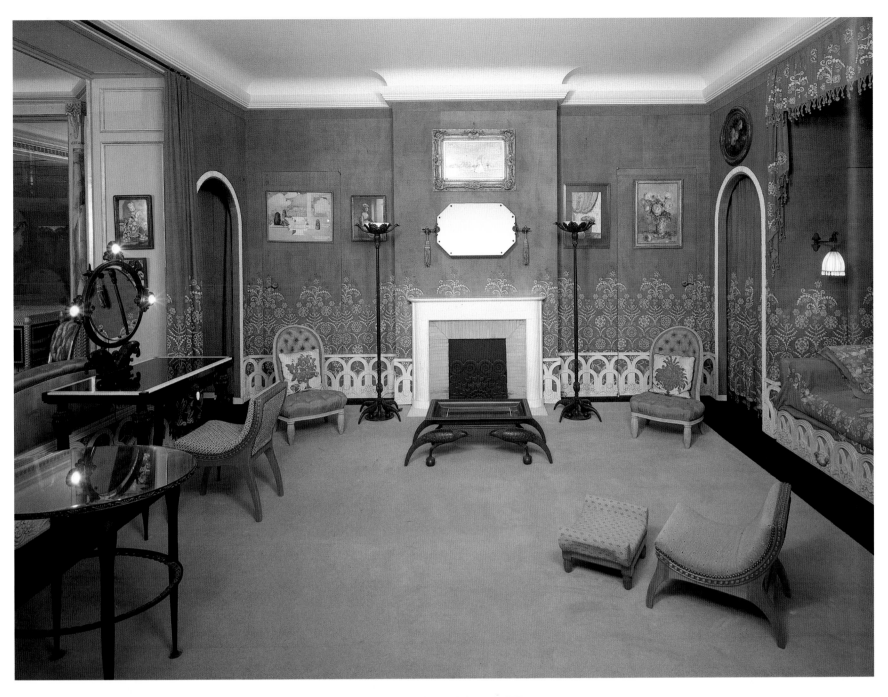

classical fluting is clear, and the curve of the platform echoes the moulding of the base of a column. The versatility of ornament is seen in the resemblance of the rectilinear pattern on the top of the table, derived from classical sources, to the rectilinear patterns of the decorative paintings of Piet Mondrian, who influenced quite another type of furniture.

In one prominent instance, still largely ignored for reasons of 'political correctness', classicism became megalomaniac. Germany had had no stand at the 1925 Exhibition for political reasons, but its revolutionary avant garde had exercised considerable influence; in the 1930s, the Fascist régime suppressed that avant garde, and fostered the formidable classicism associated with the architecture of Albert Speer (who also designed furniture).

The continued interest in antique design was accompanied by ignorance: designers, hitherto for hundreds of years trained in antique design, began to suffer from the fragmentation that learning in general has since undergone at an increasing pace. The naive conversion in 1933 to Greek art of the Anglo-American designer T. H. Robsjohn-Gibbings (1905–76) (he was apparently unaware of such recent enterprises as the Villa Kérylos, p. 317) makes it clear

673 A chair in oak by Gunnar Aagaard Andersen; Danish, 1964.

674 A dressing table veneered in padouk and amaranth, inlaid with ebony and ivory, by J.-É. Ruhlmann; French, 1919–23.

675 Two chairs in rosewood, dyed shagreen, ivory and mother o' pearl, designed by Clément Rousseau; French, c. 1925.

that it was now possible for a perceptive designer to be untrained in any knowledge of antique art. He tells the story himself. 'I was designing interiors for a London firm....Fashionable English rooms were a mixture of Queen Anne, Georgian and Spanish styles....I often went to the British Museum [where I saw] a bronze miniature chair on the base of a Greek candelabrum. As I discovered later, it was...called a klismos. Looking at the painted Greek vases with new eyes, I saw chairs, couches, stools, chests, and tables....It is difficult to describe my excitement.' He 'saw furniture that was young, untouched by time' (a reaction exactly like that of Plutarch to the temples of the Acropolis: p. 32). 'Vitality surged through this furniture. I had wandered unsuspecting into a new world'[49] (he meant an old one). Between 1936 and 1937 Robsjohn-Gibbings recreated a 'Greek' room, with Greek furniture, Greek mosaic floors and plaster walls treated with wax. When 'everyone had gone I sat and looked around the room. I had no sense that the chairs and tables in front of me had been designed over two thousand years ago. Time was powerless, nonexistent.' Robsjohn-Gibbings' furniture is subtly more anodyne than the originals; the rails of his stools, for instance, do not have the exaggerated depth of the Greek. Also, despite the fact that he was assisted by the scholar Gisela Richter, he never mentions the possibility that the original klismos was made of bentwood.

A different and more vigorous form of Greek revivalism is seen in the archaic forms revived by a Dane (influenced, ultimately, by the Abildgaard tradition [393, 395]). A chair of 1964 by Gunnar Aagaard Andersen unites the strength of ancient Greece with that of the 'folk' [673].[50]

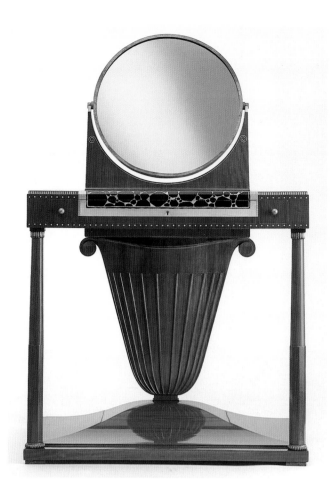

Biedermeier influence and cubic Modernism

The furniture style of the 1920s and 1930s was greatly influenced by the decorative, functional, and volumetric aspects of Biedermeier furniture; these came principally via Secessionism and the Wiener Werkstätte, although the publication of illustrated books on Biedermeier furniture during the 1920s helped to bring historic Biedermeier into focus.[51] Volumetric French Empire was also highly influential. The 'grande sévérité [des] années 1930',[52] in other words 'Modernism', owed much to both: it is a mistake to attribute 'Modern' cubic or volumetric shapes only to 'Cubist' or 'Functionalist' influences. Volumetric architectural Romantic Classicism was openly revived in the paintings of De Chirico.

The decorative Biedermeier influence is epitomized in two refined chairs by Clément Rousseau in rosewood, shagreen, ivory and mother o' pearl [675]. Their backs closely approach a common Biedermeier type – save for the brilliant imposition of the 'elementary form' of the circle upon the original waisted Biedermeier shape, the whole subtly informed by Art Nouveau. A distant Japanese influence shines out from the motif, half sun-ray and half chrysanthemum, on the front and sides of the seat, and in the flowers that adorn the back.

Jacques-Émile Ruhlmann (1879–1933) is generally accepted as the greatest of Art Deco designers. From his large workshop issued extremely expensive pieces of furniture exquisitely finished in the most luxurious materials; the lapse between sketches and furniture sometimes extended to eight years.[53] His neo-classical style was modelled upon other neo-classical styles: rarely did he go back directly to the antique. The influences included the great Romantic Classical architect and decorator Ledoux [329], volumetric

Empire and Biedermeier, and Biedermeier functionalism; sometimes Ruhlmann saw neo-classicism through Secessionist spectacles. He moved towards ever greater simplicity. A dressing table is in his most luxurious manner [674]. The table itself is influenced by Empire tables; the 'fluted' decoration of the supporting vase synthesizes the vase with a classical column. The little circles in rows and the scroll beneath the glass owe something to Vienna and to 'Etruscan' vases; the ebony and ivory pattern inlaid into the top of the dressing table resembles the patterns of shagreen writ large, and even recalls the inlaid seat of Tutankhamun's chair [4], discovered in 1922. The perfectly round mirror is an 'elementary form'. The influences are absorbed in masterly fashion, with no hint of obtrusive historicism. Different as is the dressing table from a bed designed in 1921 and made of macassar ebony [676], called by Ruhlmann a 'Sun' bed, the guiding spirit is the same: the most obvious inspiration here is geometrical Biedermeier. The veneers are skilfully but simply arranged to simulate rays; the headboard,

which has two integral side tables, dominates with its three huge circular discs.

The classically orientated, volumetric styles discussed above were too assertive for the faint-hearted, as were the grand, hard materials associated with them. Especially in the Britain of the 1930s: the Regency Revival was confined to a minority of 'buffoons' interested in 'decoration' (p. 271), and the most imposing of British late neo-classical mansions, The Grange in Hampshire, was turned down when offered with its contents to the nation.[54] Prevailing attitudes were described by John Betjeman: 'The new policy of the *Architectural Review*…was modern as opposed to *moderne*. We didn't like Cubism but we liked what was pure and simple and Scandinavian [540]….Marble, bronze and gold were out, pastel shades were in. There had already been a Swedish number of the *Review*.'[55] 'Pure and simple and Scandinavian'! The way was being prepared for the timid compromises and vernacular revivals of 'Habitat'…[56]

676 The 'Sun' bed in macassar ebony and white oak, by J.-É. Ruhlmann; French, designed in 1921.

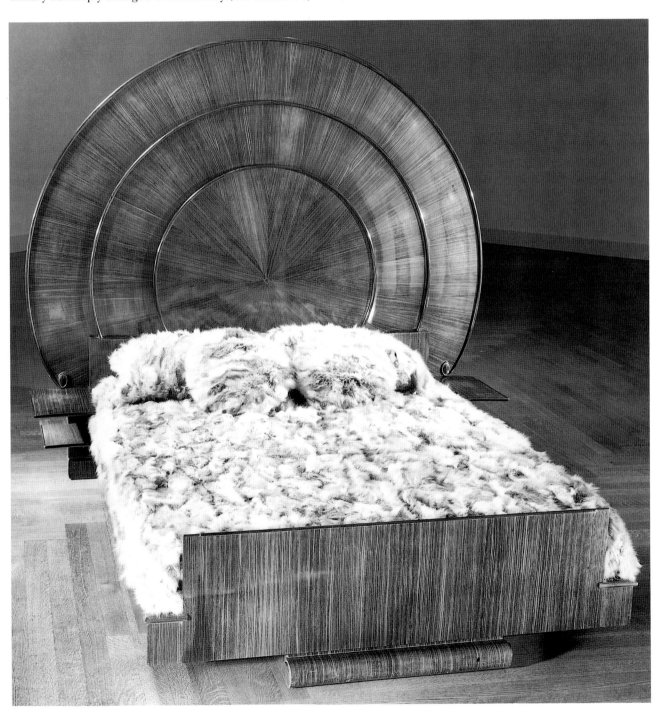

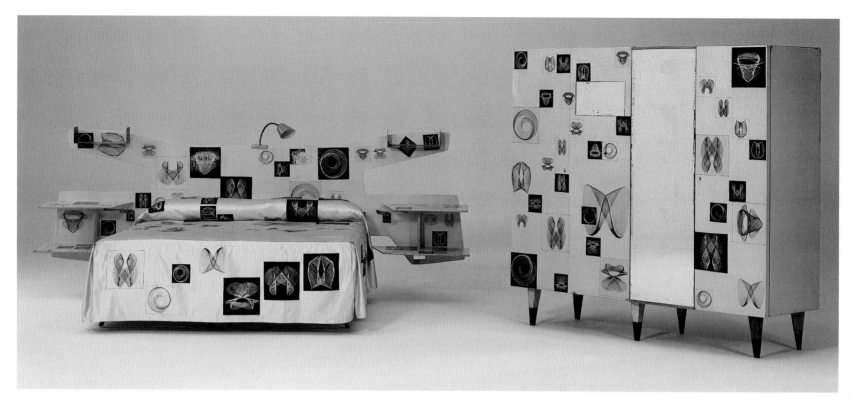

677 A bed and wardrobe in printed wood-fibre board and laminated wood, and with a printed counterpane, designed by Gio Ponti and Piero Fornasetti; Italian, 1951.

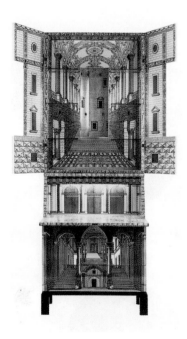

678 A secretaire in wood-fibre board and laminated wood, designed by Gio Ponti and Piero Fornasetti; Italian, first designed in 1951, the top and legs later modified by Fornasetti.

Furniture influenced by the grotesque and Surrealism

Painters and sculptors retained an influence on furniture design, and were especially active in the 1930s. The range was wide. Two highly fertile twentieth-century artists fascinated by antiquity and the Renaissance (and whose work also shows an unmistakable interest in Gothic) were Gio Ponti (1892–1979) and Pietro Fornasetti (1913–88); both Italians, both were immersed in Italian and Roman antiquarianism (in 1930 Ponti made a large centre table to demonstrate the lightness and strength of aluminium; its legs were an almost pure 'archaeological' rendering of Roman concave/convex turning).[57]

Ponti was a trained and practising architect who was also a painter and a designer of ceramics, furniture, cutlery and textiles. His superbly sophisticated and witty ceramics often employ themes adapted from the antique, including grotesque. His furniture demanded high skills – he thought Italian crafts important – which he found in particular craftsmen.[58] A bed and wardrobe [677] he designed in conjunction with Fornasetti have the combination of fantasy with practicality that characterized their collaboration. The patterns within the asymmetrical forms are abstract – do they owe something to photographs of light in movement? Was the bedhead itself influenced by the wings of aeroplanes which also move in light? Fornasetti's other work makes explicit the fact that the patterns themselves are disposed like the little cupboards and shelves pictured in 'Pompeian' grotesque paintings; for instance, a folding screen, the 'Paravento Pompeiano' of 1952 which pays overt homage to grotesque painting, has exactly the same asymmetrical squares, this time filled with antique objects in the grotesque manner. Grotesque was one of Fornasetti's main sources of inspiration; examples include the fish and serpents, influenced by the subject matter of mosaics, with which he decorated plates. His grotesque spirit – a gladiator's foot and leg serves as an umbrella stand – contrasts strangely with the Teutonic solemnities of the Modern Movement.

Fornasetti followed old design methods in culling antique, Renaissance and Mannerist themes from 'encyclopaedic'

antiquarian, architectural and other books – a favourite motif, the radiating sun, was taken from early emblem books.[59] He employed them to decorate Ponti's cabinets, commodes, secretaires and chairs in what one might call 'perspettiva povera' [678]: not marquetry, nor even paint, but lithographed paper in black on ivory white stuck to a wood-fibre surface. Technically, these pieces are impeccable, and they have great charm.

The old cult of the ruin was revived in the 1930s. Diderot's exclamation in 1767 'Oh! les belles, les sublimes ruines!…une douce mélancolie'[60] might serve as an epigraph on a wardrobe of 1939 [679] – a date that presaged many 'undouce' ruins. Upon a form of classical primitivism are painted not the gracefully elegiac ruins of Hubert Robert but the brutalist ruins of Piranesi and French Romantic Classicism. The designer, Eugène Berman (1899–1972), whose initials are written on a piece of trompe-l'oeil paper (pinned into 'stone'!) on the keystone, was a brilliant Russian expatriate painter and stage designer.

With Berman we arrive at Surrealism. The subversive irrationality of Surrealist furniture came of a creed that had much in common with 1880s and 1890s Symbolism; the influences stretched back through Baudelaire into the symbolic dream world of the grotesque (in 1792 'arabesque' – in the French sense of grotesque – was called, appropriately, 'the dreams of Painting'[61]). Surrealist fantasy was largely the grotesque 'House of Sleep'[62] stripped – or almost stripped – of mythological content in favour of the doctrines of the fashionable Viennese witch-doctor. The surrealist era of Dalí, Buñuel, Cocteau, and Schiaparelli was also a period in which neo-baroque decoration became a cult in certain quarters in France and England: one of its leaders was Charles de Beistegui, who, repudiating his early enthusiasm for the 'uninhabitable machine' created for him by Le Corbusier in his apartment on the Champs-Elysées, had enlivened the boring spaces with baroque and neo-baroque furniture and objects. In England, Edward James transformed a Lutyens house, Monckton House in Sussex, into a masterpiece of Surrealism; its rich furniture and objects, startlingly

679 A wardrobe in pine with oil paint on canvas, designed and painted by Eugène Berman; French, 1939.

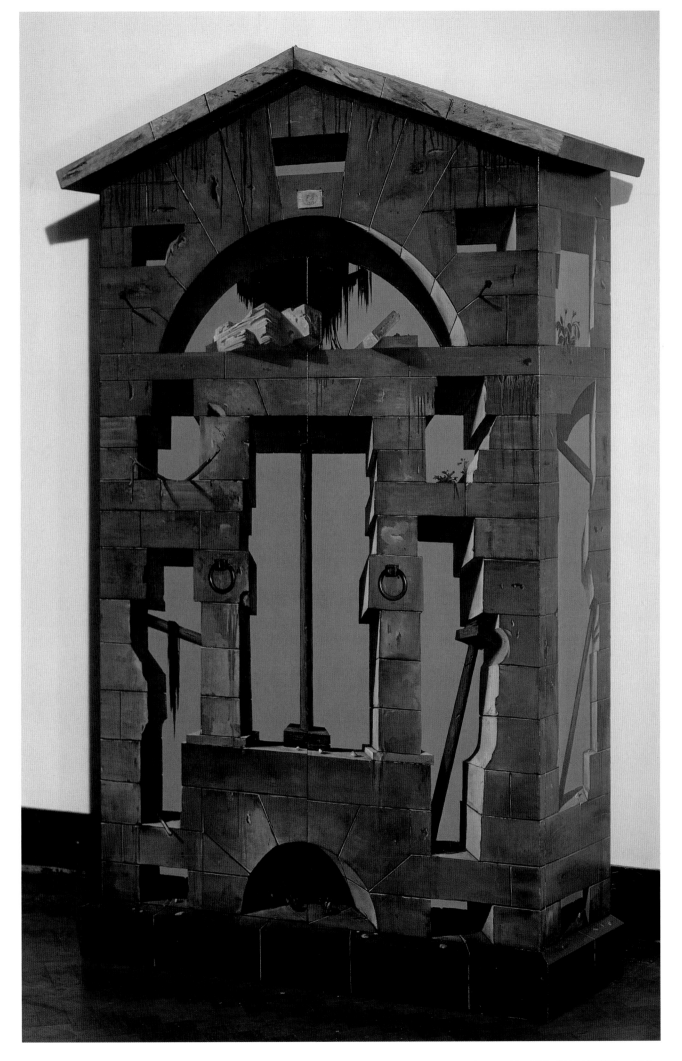

juxtaposed, were sold soon after James's death by his Trustees, who thus dismantled the most complete series of Surrealist interiors in Europe. James, a friend of both Berman and Dalí, was described by Dalí as a 'humming-bird poet, [who] ordered aphrodisiac lobster telephones, bought the best Dalís and was naturally the richest [of my friends]'.[63] Dalí lived for some time at James's expense in Sussex and designed furnishings for Monckton.

In the library at Monckton, which had deeply buttoned felt walls (a prey to moth), were two examples of Dalí's famous 'Mae West Lips' sofa of about 1936 [680]. The 'lips' theme was first adumbrated by Dalí in paintings; a design exists[64] of a room in which one sees, behind a portière 'made' of Mae West's hair, the 'lips' sofa in front of a 'nose' chimneypiece flanked by two 'eye' paintings. The sofa was first realized in Paris by Jean-Michel Frank, who had upholstered it in 'shocking pink' silk for Schiaparelli; the Monckton sofas, in deep and pale pink felt, were made by Green and Abbott. The design brilliantly unites Surrealism and neo-baroque; the realistically simple portrayal of the lips conceals the affiliations between the curved and modelled upholstery and the lines of contemporary neo-baroque and rococo upholstered furniture; the top line of the lips is essentially a highly abstracted version of the constantly reworked 'opposed scroll' that so often topped classical sarcophagi and altars [477]. This combination of old forms with witty novelties is a characteristic technique both of Fornasetti's 'new grotesque' and of practically all Surrealist furniture: indeed, it makes an essential contribution to the Surrealist shock. It is entertaining and sometimes beautiful, but creates an undercurrent of parodic unease. It has its dangers:

'The composer: "He [the artist] could heighten the play, by playing with forms out of which, as he well knew, life had disappeared."
The Devil: "I know, I know. Parody. It might be fun, if it were not so melancholy in its aristocratic nihilism."'[65]

680 The 'Mae West Lips' sofa, designed by Salvador Dalí and upholstered in pink felt by Green and Abbott, c. 1936.

Epilogue

'Clown: "Alas, sir, I know not Jupiter; I never drank with him in all my life."'[1]

What of the present – and the future? One way of encountering that question is to look in the light of the present at the circumstances that engendered the furniture of the past.

The humblest everyday objects feed upon the grandeurs of the past. A 'garbage can' is ornamented with 'humble fluting – last echoes of grooves on the shafts of columns'; from its lid 'ripples…diverge from a fantastically ancient center'.[2] Furniture, by no means garbage but nevertheless a minor art, is at its best when part of that larger entity called 'interior decoration', especially decoration controlled by a great artist or architect: the most significant pieces of furniture that survive from earlier times usually were originally part of a designed scheme, or were made to fit into a designed scheme. The more furniture is conceived of as an independent unit, the weaker and more episodic its design is likely to be.

When the greater arts flourish, the 'applied' arts, including furniture, flourish with them; when the greater arts decline or fail, furniture declines or fails also. The first question, then, to ask in considering the state of contemporary furniture is: what is the architecture, sculpture, and painting of today that might nourish it? Subsidiary questions must include: does a cultural unity exist in our society beyond that imposed by capitalism, mass consumerism and advertising? Is there an original and creative style in interior decoration (apart from the various types of eclecticism that rely heavily on old furniture)? Do we have a discriminating patronage stimulated by a vigorous intellectual background? Do we have a confident belief in our society and its standards?

The degree of self confidence enjoyed by societies has varied from period to period. The Romans saw themselves as educated in taste by the Greeks, but applauded their own achievements. The early sixteenth century was quite sure that its arts were superior to any save those of antiquity, by which it meant Rome. The eighteenth century congratulated itself upon its Enlightenment and discovery of comfort. The most influential interior decorators of the early nineteenth century, Percier and Fontaine, were quite sure that the generations that had passed since the sixteenth century had 'failed to equal it, all the more in that they thought they had surpassed it'.[3] By the middle of the nineteenth century, people interested in aesthetics thought that the design of furniture had never been so bad. Much of the blame was put on 'commerce' – not industrialization, but an ignorant and rich purchasing public in search of fashionable novelties. In the early twentieth century, artists of all kinds recognized that the cultural era that began in the Renaissance had ended, and revolutionary aesthetic theories sanctioned cultural iconoclasm. Standards faltered to the extent that a great Renaissance table [189], celebrated for hundreds of years, could go directly from the Leverhulme collection into oblivion, to be rescued only because a 'keen eye happened to notice the Farnese arms awkwardly emerging from beneath a heap of rubbish'.[4]

The later twentieth century, jolted by catastrophic wars and social changes, has undergone another development. 'Commerce', or uneducated taste, has been succeeded by the 'proletarianization of taste[5] (in modern jargon, 'dumbing down'); it is backed by 'anti-élitism' (a term for aggressive proletarianization) and 'political correctness' (which amongst other things corrupts language, the basic medium through which we attempt to communicate intellectual ideas). Only the Savage has access to poetry in Aldous Huxley's prescient *Brave New World*, in which regimented and cloned humans are presided over by the dictator 'Ford' (named after the motor-car manufacturer) and the Community Arch-Songster of Canterbury. In 1932, it seemed a fantasy.

Whatever happens in the future, we have had a good run.

Notes

Preface and Terminology *pp. 7–8*

1 P.Mainardi, *H.N.C.A. Newsletter*, V, no. 1, 1998, p. 6.
2 J. Fleming and H. Honour, *The Penguin Dictionary of Decorative Arts* (Harmondsworth 1979), p. 354.
3 Giovanni da Udine's drawings of the Colosseum stuccos were etched by Caylus as 'Grotesques': *Recueil d'Estampes d'après les plus beaux tableaux…dans le cabinet du Roi* (Paris 1729).

Introduction and **I** Antiquity
pp. 10–44

1 Plutarch [Bib. C], 'Life of Pericles', p. 155.
2 *Montaigne's Essays*, trans. J. Florio (London 1980), III, Bk III, ch. IX, p. 2.
3 Herodotus [Bib. C], Bk II, p. 151.
4 Hesiod [Bib. C], p. 303.
5 *The Letters of Madame 1661–1708*, trans. and ed. G. S. Stevenson (London 1985), p. 185.
6 Mme de Sévigné, *Letters from the Marchioness de Sévigné*, trans. c. 1730 (London 1927), I, p. 96; the 'tabouret' was reserved for duchesses, who might sit in the King's presence.
7 *Memoirs of the Duke of Rovigo* (London 1826), III, p. 177.
8 See C. Graham, *Ceremonial and Commemorative Chairs in Great Britain* (Bath 1994).
9 *Einhard and Notker the Stammerer: Two Lives of Charlemagne*, trans. L. Thorpe (Harmondsworth 1984), p. 89.
10 J. Beckwith, *Early Christian and Byzantine Art* (Harmonds-worth 1970), p. 44.
11 F. Bacon, 'Of vicissitude of things', *Essays or Counsels, Civil and Moral* (London, n.d.), p. 189.
12 A. Riegl, *Problems of Style*, trans. E. Kain (Princeton, N.J., 1992), p. 31.
13 Rev. Sydney Smith in *Edinburgh Review* (July 1807), p. 478.
14 Athenaeus [Bib. C], I, p. 29.
15 G. Richter, *The Furniture of the Greeks, Etruscans and Romans* (London 1966), p. 14.
16 ibid., p. 15.
17 Plato, *Republic*, X, 596b–597b.
18 Homer, *Iliad*, XVIII, 368; these, made of gold, have been interpreted as sun-disks which, like the sun, were mobile: R. Graves, *The Greek Myths* (Harmondsworth 1960), p. 88.
19 Pausanias [Bib. C], II, pp. 479–95.
20 Richter (cit. at n. 15), p. 51.
21 H. S. Baker, *Furniture in the Ancient World* (London 1966), p. 297.
22 ibid.
23 The description 'turned' in Part I will indicate the appearance rather than the technique of turning, and everywhere in the book will be applied to the imitation of turning in metal.
24 E. Simpson, *Early Evidence for the Use of the Lathe in Antiquity* (in course of publication) will contain a useful recent digest of opinion.
25 Turning in the true sense could have originated in the late New Kingdom: G. Killen, 'Ancient Egyptian Carpentry', in *The Furniture of Western Asia Ancient and Traditional*, ed. G. Herrmann (Mainz 1993), p. 19.
26 Richter (cit. at n. 15), p. 125.
27 Baker (cit. at n. 21), pp. 60–61.
28 Athenaeus [Bib. C], I, p. 314.
29 ibid., p. 318.
30 C. L. Ransom, *Couches and Beds of the Greeks, Etruscans and Romans* (Chicago 1905), p. 41.
31 ibid., p. 41.
32 ibid., p. 50.
33 Athenaeus [Bib. C], I, p. 364 .
34 A. Lucas, *Ancient Egyptian Materials and Industries* (London 1926, 1989), p. 238.
35 M. Andronicus, *Vergina, The Royal Tombs* (Athens 1984), pp. 124–33, 207.
36 Juvenal, *Satire* XI (London 1739, 307): 'latos nisi sustinet orbes/Grande ebur, et magno sublimis pardus hiatu,/Dentibus ex illis…/nam pes argenteus illis/Annulos in digito quod ferreus'.
37 Bed of Yuia (Cairo Museum): Baker (cit at n. 21), p. 72.
38 J. Carcopino, *Daily Life in Ancient Rome* (Aylesbury 1956), p. 42.

39 ibid., p. 75.
40 Richter (cit. at n. 15), p. 122.
41 Petronius, *Satyricon*, trans. P. G. Walsh (Oxford 1996), p. 114.
42 Ill. Baker (cit. at n. 21), p. 38.
43 ibid., p. 31.
44 Homer, *Odyssey*, XXIII, 195.
45 E. Simpson, K. Spitydowicz and V. Dorge, *Gordion, the Study, Conservation and Reconstruction of the Wooden Furniture from Gordion* (Ankara 1992).
46 Baker (cit at n. 21), p. 80, quoting Howard Carter.
47 Pliny, *Natural History* [Bib. C], IV, Bk XVI, LXXIV, p. 537.
48 Richter (cit. at n. 15), p. 117.
49 Ill. Andronicus (cit. at n. 35), p. 194.
50 Catullus, *Carmina*, LXIV: 'Talibus amplifice vestis decorata figuris/pulvinar complexa suo velabat amictu'.
51 C. McCorquodale, *The History of Interior Decoration* (Oxford 1983), p. 13.
52 Richter (cit. at n. 15), ill. 56.
53 Denon [Bib. A], pl. LXXXI.
54 Montfaucon [Bib. A], suppl., T. II, following ill. XXIX.
55 *Antichità di Ercolano: Le pitture antiche d'Ercolano*, II (Naples 1760), pl. XXV, p. 159.
56 Ammianus Marcellinus [Bib. C], I, p. 321.
57 C. Aldred, *Egypt to the End of the Old Kingdom* (London 1984), p. 72.
58 In the funerary entrance hall of Zoser at Saqqara.
59 A. Riegl, *Problems of Style*, trans. E. Kain (Princeton, N.J., 1992), , p. 61.
60 Pausanias [Bib. C.], IV, p. 407.
61 The monument of Lysicrates and the Temple of Zeus Olympia, Athens.
62 Aristotle, *Treatise on Poetry* [Bib. C], p. 123.
63 Plutarch, *Lives of the Noble Grecians and Romans*, trans. J. Dryden (New York, n.d.), 'Life of Marcellus', pp. 378–79. Did this influence Boullée's 'Tomb of Sir Isaac Newton'?
64 W. I. Macdonald and J. A. Pinto, *Hadrian's Villa and its Legacy* (New Haven 1995), p. 18.
65 ibid., p. 196.
66 ibid., p. 15.
67 M. E. Edey, *Lost World of the Aegean* (1975), pp. 58, 59.
68 J. Boardman, ed., *Classical Art* (Oxford 1993), p. 20.
69 The feet of Greek couches are often found embedded in floors.
70 By the Elder Pliny [Bib. C], XXXVI, 101: see Á. Boethius, *The Golden House of Nero* (Univ. of Michigan 1960), p. 27.
71 *Handbook of Roman Art*, ed. M. Henig (Oxford 1983), p. 93.
72 F. Cramer, *Astrology in Roman Law and Politics* (Philadelphia 1954), pp. 201, 172.
73 Macdonald and Pinto (cit. at n. 64), p. 51; the Temple of Venus and Rome was designed by Hadrian opposed by his architect Apollodorus.
74 A tripod in Brussels Archaeological Museum.
75 Caylus, *Recueil* [Bib. A], II (1756), Pt 3, pl. LIII (reworked 1766 by Cavaceppi).
76 Metropolitan Museum, New York, c. 3100 BC.
77 See p. 18 and nn. 42, 43.
78 Jones, *Grammar* [Bib. A], p. 22.
79 Baker (cit. at n. 21), ill. 26.
80 ibid., p. 89.
81 Such a chair from *The Antiquities of Athens* (1794) ill. J.Morley, *Regency Design 1790–1840* (London 1993), p. 362. Now at Teffont Manor, Salisbury.Salisbury.
82 Richter (cit. at n. 15), ills. 354, 574.
83 Millin [Bib. A], II, pl. LIII.
84 Cut-away throne with six discs, two in the middle and two on either side: Richter (cit. at n. 15), ill. 286; also shows lions and 'stars' painted on the couch rail; see also ill. 320.
85 Ransom (cit. at n. 30), pp. 46–47.
86 It has been said that the cut-out surface was never placed at the side, but examples in Greek sculpture seem to the author to contradict this assertion.
87 The broad face may possibly have occasionally faced outwards from the sides: see e.g. the sculptured 'Apotheosis of Zeus' (sixth century BC) in the Acropolis Museum, Athens.
88 Richter (cit. at n. 15), ill. 328.

89 Ransom (cit. at n. 30), n. p. 47.
90 Richter (cit. at n. 15), ill. 487.
91 The author here describes reassembled fragments shown in the Museum at Vergina in Macedonia; for an earlier but extended description see Andronicus (cit. at n. 35), pp. 123–36.
92 Information kindly given by Professor Elizabeth Simpson.
93 e.g. Tischbein, *Recueil* [Bib. A], I, pl. 18.
94 e.g. Millin [Bib. A], I, pl. 111.
95 Richter (cit. at n. 15), ill. 334.
96 e.g. Tischbein, *Peintures des vases antiques*, IV, pl. XXXIV.
97 Richter (cit. at n. 15), p. 102.
98 Pausanias [Bib. C], I, p. 139.
99 O. Wanscher, *Sella Curulis, the Folding Stool, an Ancient Symbol of Dignity* (Copenhagen 1980), p. 70.
100 ibid., pp. 16, 124.
101 Athenaeus [Bib. C], III, p. 821.
102 An Etruscan third-century BC relief shows a folded-up stool hanging on a pillar: Wanscher (cit. at n. 99), p. 107.
103 ibid., p. 132.
104 Athenaeus [Bib. C], I, p. 80.
105 *Antichità di Ercolano: Le pitture*, II (cit. at n. 55), pl. XXI.
106 Richter (cit. at n. 15), ill. 484.
107 Quintus Curtius, trans. J. C. Rolfe (London 1946), II, p. 497.
108 Athenaeus [Bib. C], III, p. 821.
109 ibid., p. 861.
110 ibid., p. 857.
111 A fringed linen undergarment, worn according to Herodotus by the Egyptians; also worn by both Persians and Greeks.
112 Athenaeus [Bib. C], III, pp. 841–42.
113 *The Epistles of Horace*, Bk II, ep. I, trans. J. Conington (London 1872), p. 156.
114 *Antichità di Ercolano: Le pitture* (cit. at n. 55), V (1779), pl. LXXXII, p. 365.
115 *The Architecture of M. Vitruvius Pollio*, trans. W. Newton (London 1791), II, Bk VII, ch. V, p. 163. The Latin word 'harpaginetuli' is translated by T. Vallaurius, *Lexicon latini italique sermonis*, I (7th edn, 1879), as 'piccolo graffio' (small scratches), with Vitruvius as a source. However, 'harpaginetuli' is replaced in M. Vitruvio Pollione, *De Architectura Libri X* (Pordenone 1990), pp. 328, 329, with 'pro fastigiis appagineculi', which (unlike the rest of the text) is left untranslated. A possible meaning is 'for the summit of the roof, striped [or fluted] reeds'.
116 Quoted by J. Evans, *Pattern, a Study of Ornament in Western Europe from 1180 to 1900* (Oxford 1931), II, p. 109.
117 The Greeks toned new marble with opaque varnishes.
118 Plutarch, *Lives* [Bib. C], pp. 156–57.
119 J. J. Pollitt, *Art in the Hellenistic Age* (Cambridge 1986), pp. 187, 188.
120 Borromini [Bib. B], p. 15.
121 By Sestos of Pergamon.
122 Richter (cit. at n. 15), ill. 111.
123 Athenaeus [Bib. C], III, p. 855.
124 Pausanias [Bib. C], I, p. 99.
125 *Encyclopaedia Britannica* (New York 1910–11), XXII, p. 617.
126 Athenaeus [Bib. C], I, p. 313.
127 Richter (cit. at n. 15), p. 119, quoting Athenaeus.
128 ibid., ills. 95, 92.
129 e.g. Prisse d'Avennes [Bib. A], pl. I.20.
130 Richter (cit. at n. 15), ill. 107.
131 Pliny, *Natural History* [Bib. C], IV, Bk XIII, 91, pp. 153–54.
132 Original at S. Vitale, Ravenna.
133 Ovid, *Metamorphoses*, bk. 737–38: 'ebore et testudine cultos, Tres habuit thalamos'.
134 *Handbook of Roman Art* (cit. at n. 71), pl.16; see n. 99.
135 O. Elia, *Le Pitture del Tempio di Iside* (Rome 1942), p. 7, pl. 4, 'Ekklesiasterion'.
136 ibid., 'Sacrarium', p. 21, fig. 25.
137 Ransom (cit. at n. 30), p. 67.
138 See 'Orestes, Pylades and Iphigeneia', *Antichità di Ercolano: Le pitture* (cit. at n. 55), I, pl. XII, p. 67.
139 *Antichità di Ercolano: Le lucerne ed i candelabri d'Ercolano*, I (Naples 1792), pl. LX, p. 300.
140 ibid.
141 Montfaucon [Bib. A], II, Pt II, CXXXIX.

142 It belonged to Cardinal Bembo. See E. Scamuzzi, *La 'Mensa Isiaca' del Regio Museo di Antichità a Torino* (Rome 1949).
143 *Egyptomania* (Ottawa 1994), cat. 13.
144 Alberti [Bib. B], II, Bk VI, p. 20.
145 Jones, *The Grammar* [Bib. B], pp. 2, 5–8, 14, 22, 33, 39, 54.
146 Dresser [Bib. B], pp. 1, 117, 3, 4 18, 10, 9, 40, 9, 141, 107.
147 Riegl (cit. at n. 12), p. 190.
148 Oxford Dictionary.
149 Diodorus of Sicily, c. 50 BC (London 1933), Bk I, n. 1, p. 222.
150 There are other explanations: see Riegl (cit. at n. 12), pp. 319–20.
148 For the complex arguments, see Riegl (cit. at n. 12), pp. 56, 314, 318; also Boardman (cit. at n. 68), p. 20.
152 P. Oliver-Smith, 'Representations of Aeolic Capitals on Greek Vases', in *Essays in Memory of Jarl Lehmann*, ed. Lucy Sandler (New York 1964), p. 234.
153 See M. Pallottino, *Etruscologia* (Milan 1982), p. 319.
154 The frontal view of the acanthus leaf is a 'naturalized' formal Greek palmette, and the profile is a 'naturalized' half palmette; its emergence is evident on surviving monuments.
155 See J. M. C. Toynbee and J. B. Ward Perkins, 'Peopled Scrolls, a Hellenistic motif in Imperial Art', *Papers of the British School at Rome* (London 1950).
156 R. Firbank, *Inclinations* (1916), ch. XIII.
157 An English furniture historian has used the 'Italian' words 'la candelabra' (sing.) and 'candelabre' (plur.) – which are not Italian words – to denote the kind of decoration called here (following Italian usage) a 'candeliera'. The author thanks Mr Giovanni Caselli and Dr Luca Leoncini for helping to clarify this subject.
158 A name used in Europe from the late eighteenth until the early twentieth century.
159 Athenaeus[Bib. C], III, p. 832.
160 Piranesi, *Antichità Romane* [Bib. A], II, LIX, 'guisa di vasta conchiglia'.
161 In the Larger Bath, now virtually disappeared.
162 Smugliewicz, Mirri and Brenna [Bib. A], no. 10.
163 Athenaeus [Bib. C], III, p. 824.
164 Plutarch, *Lives* [Bib. C], 'Life of Themistocles', p. 117.
165 Richter (cit. at n. 15), ill. 284.
166 Athenaeus [Bib. C], III, p. 868.
167 Macdonald and Pinto (cit. at n. 64), p. 162.
168 Riegl (cit. at n. 12), p. 272.
169 ibid., p. 274.
170 Ciampini [Bib. A], pp. 78, 80: 'Operum musivorum originem antiquissimam esse… Verum, e Persarum confinio ad Assyrios sinitimos, a quibus ad Graecos, postremo in Latium, Sylle temporibus'.
171 The use of different names by different writers for the same basic ornament can be confusing. This book will use 'guilloche' for the classical form of the ornament and 'plait' for the non-classical type. Both will be distinguished from the term 'knot', which will be reserved for interlace that could, conceivably, be actually knotted.
172 As have the tragic masks of Japanese theatre with Greek theatre: see S. Noma, *Japanese Theater* (Kobe 1993), pp. 8, 9.
173 P.-F. D'Hancarville, *Antiquités étrusques, grecques et romaines* (Paris 1785), I, p. 12.
174 'in effigiem moderantum cuncta deorum': Ovid, *Metamorphoses*, I, 83, quoted by Voltaire, *Philosophical Dictionary*, trans. Theodore Besterman (Harmondsworth 1979), p. 219.
175 Athenaeus [Bib. C], III, p. 943.
176 Greek satyrs had pointed ears, tails and horns; later Roman poets gave them the larger horns and goat feet of Roman 'fauni', a distinct species, thus causing confusion.
177 Plutarch [Bib. C], 'Life of Philipoemen', Pt II, p. 343.
178 Pompeii, *Gli ornati* [Bib. A], p. 4.
179 Plutarch, *Lives*, trans. J. Dryden (cit. at n. 63) 'Life of Philopoemen', p. 448.
180 B. E. Perry, ed., *Babrius and Phaedrus* (London 1965) pp. 258–59.

II The Disintegration of Classicism *pp. 46–64*

1 E. Gibbon, *Decline and Fall of the Roman Empire* (London 1818), II, p. 181. It seems, incidentally, useful to retain the generally understood term 'barbarian', which in the late Empire replaced 'Germani' (it had a wider connotation, including the Huns and other peoples: see R. Hachmann, *The Germanic Peoples*, trans. J. Hogarth (London 1971)).
2 J. Beckwith, *Early Christian and Byzantine Art* (Harmondsworth 1970), p. 10.
3 ibid., p. 16.
4 H. Pirenne, *Mohammed and Charlemagne* (London 1965), p. 258.
5 J. H. Harvey, *The Mediaeval Architect* (London 1972), p. 171.
6 T. Hobbes, *Leviathan* (London 1983), p. 381.
7 Pirenne (cit. at n. 4), p. 131.
8 ibid., p. 258.
9 *Encyclopaedia Britannica* (cit. at n. I/125), X, p. 300.
10 Pirenne (cit. at n. 4), p. 177.
11 J. Romilly Allen, *Celtic Art in Pagan and Christian Times* (London 1912), pp. 246–63 *et passim*.
12 See n. I/171.
13 P. Brown, *The Book of Kells* (London 1980), p. 83.
14 M. Gough, *The Origins of Christian Art* (New York/Washington 1964), p. 187.
15 Romilly Allen (cit. at n. 11), p. 149, says of 'late Celtic foliageous art' that '[its] general shape resembles that of what are known as arabesques'. Cf. Jones, *Grammar* [Bib. A], p. 96.
16 See H. Schmitz, *Das Möbelwerk* (Leipzig n.d.), p. 36, for a variant of the type.
17 P. Eames, *Furniture in England, France and the Netherlands from the Twelfth to the Fifteenth Century* (London 1977), pp. 211–12.
18 Bede, *A History of the English Church and People*, trans. L. S. Price (Harmondsworth 1977), p. 102.
19 Richter (cit. at n. I/15), ill.505.
20 M. Biddle and B. Clayre, *Winchester Castle and the Great Hall* (Winchester 1983).
21 Bodleian Library, Oxford, ms. Rawl. liturg. d.6 (15857), *c.* 1470–80.
22 Gibbon (cit. at n. 1), I, p. 233.
23 A. Grabar, 'The Message of Byzantine Art', in *Byzantine Art and European Art* (exh., Athens 1964), p. 61.
24 Riegl (cit. at n. I/59), p. 241.
25 Gibbon (cit at n. 1), VII, p. 121.
26 Beckwith (cit. at n. 2), p. 76; influenced by the Church of the Holy Apostles at Constantinople.
27 Little is known about secular decoration: ibid., p. 161. Unfortunately Byzantine art may never be seen as it was meant to be seen – a totality of aesthetic experience.
28 ibid., p. 75.
29 Pirenne (cit. at n. 4), p. 134.
30 The term 'throne', as used of royal rather than episcopal seats, appears to have become usual only in post-mediaeval times. Information kindly supplied by Mr Ronald Lightbown.
31 Beckwith (cit. at n. 2), p. 53.
32 McCorquodale (cit. at n. I/51), p. 32.
33 See an ivory casket, north Italian or Roman, *c.* 375 AD, Beckwith (cit. at n. 2), ill. 34.
34 E. Simpson, 'Furniture in Ancient Western Asia', in J. M. Sasson, ed., *Civilisations of the Ancient Near East* (New York 1995), p. 1660.
35 N. Oikonomedes, 'The Contents of the Byzantine House from the Eleventh to the Fifteenth Century', in A. Veselovskij, ed., *Dumbarton Oaks Papers* (Washington 1990), p. 123, n. 43.
36 *The Works of Liutprand of Cremona*, ed. F. A. Wright (London 1930), pp. 237–38.
37 ibid., pp. 207–8.
38 S. Runciman, *Byzantine Style and Civilisation* (Harmondsworth 1975), p. 89.
39 e.g. Constantine VII Porphyrogenitus, *Le Livre des cérémonies*, ed. and trans. A. Vogt (Paris 1935), I, pp. 87, 88.
40 Humphreys, *Antiquity Explained* [Bib. A], III, p. 69.

41 W. S. Heckscher, 'Relics of Pagan Antiquity in Mediaeval Settings', *Journal of the Warburg Institute* (London 1937, repr. 1965), I, p. 212.
42 ibid.: a transparent stone has 'claritatem Dei, et lumen eius simile lapidi pretioso tamquam lapidi iaspidis, sicut crystallum'.
43 ibid., p. 209.
44 As on the second Matilda Cross at Essen, ill. ibid., p. 217.
45 Gough (cit. at n. 14), p. 88.
46 Heckscher (cit. at n. 41), p. 215.
47 Schmitz (cit. at n. 16), ill. pp. 22, 23.
48 Ruskin, *Stones of Venice* [Bib. C], II, p. 68.
49 The notion of integrity or perfection might have played a part: 'the school of incrusted architecture is *the only one in which perfect and permanent chromatic decoration is possible*': Ruskin, ibid., p. 73.
50 Baker (cit. at n. I/21), p. 141, ill. 214: seat furniture from the workmen's village, Deir el-Medina.
51 Beckwith (cit. at n. 2), p. 106.
52 Schmitz (cit. at n. 47), ill. p. 116.
53 Athens National Library, ms. 56, fol. 4v.
54 Athens National Library, ms. 57, fol. 265v.
55 Beckwith (cit. at n. 2), p. 116.
56 Pirenne (cit. at n. 4), p. 131.
57 ibid., p. 132.
58 ibid., p. 133.
59 ibid.
60 Beckwith (cit. at n. 2), p. 100.
61 ibid., p. 47.
62 McCorquodale (cit. at n. I/51), p. 51.
63 Beckwith (cit. at n. 2), p. 70.
64 Duchesse d'Abrantes, *At the Court of Napoleon, memoirs of the Duchesse d' Abrantes* (Adlestrop, Glos., 1991), p. 247.
65 M. Weinberger, 'The Chair of Dagobert', in L. F. Sandler, ed., *Essays in Memory of Karl Lehmann* (New York 1964), p. 381; note X, p. 376, sums up previous opinion.
66 Wanscher (cit. at n. I/99), p. 220.
67 e.g. St Luke sits on a stool with a lion leg much like that of the 'Dagobert' chair in the ninth-century *Ebbo Gospels*, from Rheims: Grabar (cit. at n. 49), ill. 18.
68 Beckwith (cit. at n. 2), p. 159.
69 e.g. those of Flavius Anastasius, consul 517 AD (Victoria & Albert Museum, London), and Clementinus, 513 AD (Liverpool Museums).
70 L. Grodecki, F. Mutherich, J. Tarulon and F. Wormald, *Il Secolo dell'anno mille* (Milan 1974), p. 267.
71 J. Laver, *A Concise History of Costume* (Norwich 1969), p. 52.
72 e.g. Beckwith (cit. at n. 2), ills. 179, 180, 181.
73 ibid., p. 70.
74 G. Matthew, *Byzantine Painting* (London 1950); St Luke (British Museum, London, Add. ms. 28815 f, fol. 162v).
75 J. M. Roberts, *The Triumph of the West* ([Netherlands] 1985), pp. 96–97.
76 C. R. Dodwell, *The Canterbury School of Illumination* (Cambridge 1954), pp. 41–47. See also *The Eadwine Psalter*, ed. M. Gibson, T.A. Heslop and R. Pfaff (Pennsylvania 1992), p. 183.
77 Eames (cit. at n. 17), cat.1, 2, 10.
78 Romilly Allen (cit. at n. 11), p. 226.
79 V. Chinnery, *Oak Furniture, The British Tradition* (Woodbridge, Suff., 1986), pp. 98–101.
80 L. Feduchi, *Historia del mueble* (Barcelona 1994), ill. 105, p. 178.
81 St Augustine, from a Commentary on St Augustine, 1130–60 (Bibl. Municipale, Douai).
82 Wanscher (cit. at n. I/99), p. 232.
83 C. Martin, *L'Art roman en France* (Paris 1910), pl. LXIII.
88 Ill. Feduchi (cit. at n. 80), p. 115.
84 W. Oakeshott, *The Mosaics of Rome* (London 1967), p. 98.
85 ibid., pl. XXVIII.
86 The Mediterranean had its own perils, swarms of Islamic pirates; as late as the eighteenth century the ladies in Voltaire's *Candide* had their left buttocks eaten by them.
89 Jairazbhoy (cit. at n. 87), pp. 307–8. The tomb of Bohemund (d. 1112), leader of the First Crusade, at Canosa bears Kufic script of African origin: K. Watson, *French Romanesque and Islam* (Aarp 1972), p. 5.
90 F. Rossi, *Mosaics, A Survey of their History and Techniques* (London 1970), p. 88.
91 See, for example, the pulpit of 1272 in

Ravello Cathedral.
92 *S. Trinita Madonna, c.* 1280 (Uffizi, Florence).
93 *Rucellai Madonna,* 1285 (Uffizi, Florence).
94 e.g. a *Madonna and Child* painted for the Ognissanti, *c.* 1310 (Uffizi, Florence).
95 Uffizi, Florence.
96 A. Schiaparelli, *La Casa fiorentina e i suoi arredi nei secoli XIV e XV* (Florence 1908), p. 270.

III The 'Pointed' Styles *pp. 66–84*

1 The contrary view, that the Islamic contribution to French Gothic was 'artistically unimportant' (E. Male in 1923, quoted by K. Watson, 'Islamic Contributions to Western Architecture', *Boletín de arqueologia medieval*, 7 (1993), p. 2), was influentially expressed in French nationalistic terms by Viollet-le-Duc in his *Encyclopédie* (1866)– although Viollet-le-Duc himself urged Marcel Dieulafoy to search Syria and Persia for the beginnings of Gothic architecture. See A. E. Pope, 'Possible contributions to the beginning of Gothic architecture', in *Beiträge zur Kunstgeschichte Asiens in memoriam Ernst Diez* (Istanbul 1963), pp. 1, 2.
2 At Qasr-ibn-Wardan in Syria: Pope (cit. at n. 1), p. 20.
3 D. Talbot Rice, *Islamic Art* (London 1993), p. 45: Mosque of Ibn Tulun, Cairo (876–879). It had been anticipated in the 'Gothic'-arched tombs of Lycia (modern Turkey), *c.* sixth century BC.
4 ibid.; seen by the eighth century, e.g. the Baghdad Gate, Raqqa, ill. p. 30.
5 ibid., p. 83; B. Brend, *Islamic Art* (London 1991), p. 29.
6 K. A. C. Cresswell, *Early Muslim Architecture*, Pt I, *Umayyads, AD 622–650* (Oxford 1932), p. 168.
7 e.g. the Sassanian palmette was influenced by Diocletian's Palace at Spalatro.
8 Jones, *Grammar* [Bib. A], p. 59.
9 C. Piccolpasso, *The Three Books of the Potter's Art*, trans. and introd. B. Rackham and A. Van de Put (London 1934), p. 51, pl. 44b, 'una rabesca…o voglian dire grotescha'.
10 Riegl (cit. at n. I/59), pp. 234, 251.
11 Jones, *Grammar* [Bib. A], pl. XXXVIII.
12 See E. Marec, *Hippone la Royale*, 'Antique Hippo Regius'. Note by Mr Giovanni Caselli: 'Alexandria was the centre of diffusion of some of these Afro-Oriental motifs, and Alexandria was in touch with Palmyra, and Palmyra was in contact with Dura-Europos and with the terminus of the silk routes. Discoveries at Dura-Europos, Palmyra and Egypt show contact continued in the Dark Ages.'
13 Motifs from Nineveh and Persia (see Jones, *Grammar* [Bib. A], figs. 23–25) relate both to Byzantine and Islamic art.
14 ibid., Nineveh and Persia, pl. XIV, 12 and 19.
15 ibid., p. 63.
16 Riegl (cit. at n. I/59), p. 269, border in the Mosque, Cordoba, dated 965.
17 Schiaparelli (cit. at n. II/96), p. 249, on geometrical tarsia: 'La sua origine prima e certo orientale; i nostri artefici pero, piuttosto che i modelli arabi e bizantini, imitarvano le decorazioni a mosaico…Badia di Fiesole, S. Miniato al Monte, S. Giovanni'.
18 Feduchi (cit. at n. II/80), ills. 190–92.
19 ibid., ill. 196, for a similar cupboard, unrestored and open.
20 Jones, *Grammar* [Bib. A], pl. XXXII, 1–7, from the Mosque of Sultan Kalaoon (Qalaun) in Cairo (1284–85).
21 See *Meuble español estrado y dormitorio* (Madrid 1990), p. 166: 'La composición de los frentes difiere del resto de las tipologías del ultimo gotico europeo, y entronca con los de la Antiguedad y de la Alta Edad Media, como los representados en el Mausoleo de Gala Placidia y en el Codex Amiatinus'.
22 Talbot Rice (cit. at n. 3), ill. 35, p. 42.
23 J. Harvey, *Mediaeval Craftsmen* (London 1975), p. 156.
24 Ruskin, *Stones of Venice* [Bib. C], I, p. 12.
25 Harvey, *Architect* (cit. at n. II/5), p. 20 (Poggio Bracciolini and Cencio Rusticio).
26 J. Summerson, 'An Interpretation of Gothic', *Heavenly Mansions* (London 1949), p. 13.
27 ibid., p. 16.
28 ibid., p. 16.
29 ibid., pp. 16–17.
30 See also T. Raquejo, 'The "Arab

Cathedrals," Moorish Architecture as seen by British Travellers', *Burlington Magazine*, CXXVIII, Aug. 1986.
31 Harvey, *Architect* (cit. at n. II/5), p. 94.
32 Pope (cit. at n. 1), pp. 23–24.
33 This is the 'window of appearance', which has a counterpart in Umayyad palaces of the eighth century (and can be traced back to New Kingdom Egypt): S. Ferber, *Islam and the Medieval West*, I (Albany 1975), p. 68.
34 A. Fikry, *L'Art roman du Puy et les influences islamiques* (Paris 1934), argues that the architect of Le Puy must have been trained in an Islamic school.
35 See A. Grabar, 'Le Succès des arts orientaux à la cour byzantine sous les Macédoniens', in *Münchner Jahrbuch*, 3 Folge III (1951).
36 Watson, *French Romanesque* (cit. at n. II/89), p. 2.
37 ibid, p. 6. The journey of an abbot of Cluny to Spain in 1142 'resulted in the direct transmission of Islamic culture into the Latin West': J. Knitzeck, *Peter the Venerable and Islam* (Princeton 1964).
38 Watson, 'Islamic Contributions' (cit. at n. 1), p. 118.
39 Such as that of the Normans into Spain in 1064.
40 Pope (cit. at n. 1), p. 15.
41 In the Sassanian palace at Sarvistan: ibid., p. 21.
42 ibid.
43 Riegl (cit. at n. I/59), p. 9.
44 A grotesque ceiling at Bukovice, Czech Republic, on which hares act the part of humans.
45 Eames (cit. at n. II/17), p. 88.
46 ibid., p. 189.
47 ibid., p. 216.
48 D. Strong and D. Brown, eds, *Roman Crafts* (Wallop, Hants, 1976), p. 159.
49 The Ministry of Works guide book to Melrose, pp. 10–11, courtesy of Miss Emily Lane.
50 Ill. Feduchi (cit. at n. II/80).
51 Harvey, *Architect* (cit. at n.II/5), p. 131.
52 ibid., p. 153.
53 Eames (cit. at n. II/17), p. 1, uses 'armoire' (with doors) to distinguish from 'cupboard' (an open board), a distinction useful in the context of her book but arbitrary in any other.
54 Feduchi (cit. at n. II/80), ill. 149.
55 Harvey, *Craftsmen* (cit. at n. 23), p. 181.
56 Also in Basel Historical Museum.
57 Eames (cit. at n. II/17), p. xix.
58 For the pedigree of the lion throne as a type, see Jairazbhoy (cit. at n. II/87), pp. 279–81.
59 Beckwith (cit. at n. II/2), p. 31 (the *Cotton Genesis*).
60 Eames (cit. at n. II/17), p. 75. H. Colvin, *History of the King's Works*, I, pp. 497–98.
61 Eames (cit. at n. II/17).
62 ibid., p. 81; inventory of the Duke of Burgundy.
63 ibid., cat. 28, p. 101.
64 The Annunciation, *Heures à l'usage de Rouen, c.* 1500 (Bibl. de l'Arsenal, Paris, ms. 416, fols 18v and 19r), ill. K. Perls, *Manuscrits et peintures de l'école de Rouen* (Paris 1913).
65 Eames (cit. at n. II/17): 'grand tablier double marqueté par dedans pour jouer aux tables et aux échacs', inventory of the Comtesse d'Avelin, Château des Baux, 1426, p. 4.
66 ibid., p. 57: Aliénor de Poitiers, *c.* 1484–91, 'Madame de Charrolois n'avoit que quatre degrez sur son dressoir, & Madame la Duchesse sa fille en avoit cinq…nulles Princesses ne debvoient avoir cinq degrez, fors seulement la Royne de France…mais cela ne peut deroger, ny abolir les anciens honneurs & estats que sont faits & ordonnez par bonne raison & déliberation', pp. 257–68.
67 ibid., pp. 274, 275.
68 Harvey, *Craftsmen* (cit. at n. 23), p. 155.
69 See V. Klingsbald, *Catalogue raisonné de la collection juive du Musée de Cluny* (Paris 1981), pp. 94–96.
70 See Schiaparelli (cit. at n. II/96), I.
71 ibid., p. 241.
72 C. Cennini, *The Book of the Art*, trans. C. J. Herringham (London 1899), ch. 145, p. 122.
73 ibid., ch. 170, p. 150.
74 ibid., ch. 144, p. 121.

75 See Schiaparelli (cit. at n. II/96).
76 P. Young, J. Darrah, J. Pilc and J. Yorke, 'A Sienese Cassone', *The Conservator*, no. 15 (1991), pp. 45–54.
77 Gesso as used for furniture was a mixture of whiting and size, sometimes with linseed oil and glue added.
78 Evans (cit. at n. I/116), I, p. 129.
79 ibid., pp. 42, 44.
80 ibid., p. 71.
81 ibid., p. 59.

IV The Renaissance Revival of Antiquity *pp. 86–134*

1 Summerson (cit. at n. II/26), pp. 49, 48.
2 The association of Ferrarese painters with the proto-grotesque studioli of Federigo da Montefeltro prompts speculation on possible grotesque influences. For details of the rooms see O. Raggio, 'Les cabinets-studioli', in J. Delumeau and R. Lightbown, *La Renaissance* (Paris 1996), pp. 213–17.
3 Was the form of the dolphins influenced by the more fantastic armour of the period?
4 Filarete, *Filarete's Treatise on Architecture*, trans. J. R. Spencer (New Haven 1965), Bk VIII, fol. 129, p. 102.
5 G. Ciampini, *Vetera monumenta* (Rome 1690–99).
6 R. Zulch, *Entstehung des Ohrmuschelstiles* (Heidelberg 1932), p. 14: 'Hor son spelonche ruinate grotte/di stucco di rilievo altri colore/die man di cimabuba appelle giotte'.
7 See P. P. Bober, *Census of Antique Works of Art known to Renaissance Artists* (XXth International Congress of the History of Art, Princeton 1963).
8 Pointed out to the author by Mr Michael Jones.
9 Pope Pius II, *Smith College Studies in History*, ed. F. A. Gragg and L. C. Gabel, XXII (Northampton, Mass., Oct. 1936–Jan. 1937), p. 20.
10 E. Muntz, *Histoire de l'art pendant la Renaissance* (Paris 1889), p. 92: 'parce que cet ouvrage merveilleux cadre sa tête dans les nues'.
11 Raphael, *Lettera sulle antichità di Roma scritta da Raffaello d'Urbino a Papa Leone X* (Rome 1834), pp. 18–19.
12 Alberti, *On Painting* [Bib. C], p. 61.
13 H.-W. Kruft, *A History of Architectural Theory from Vitruvius to the Present*, trans. Taylor, Wood and Callander (London 1994), p. 97.
14 B. Scardeone (*c.* 1478–1574); quoted by R. Lightbown, *Mantegna* (Oxford 1986), p. 18.
15 ibid.
16 Vasari, *Lives* [Bib. C], I, p. 469.
17 Muntz (cit. at n. 10), I, p. 401.
18 *Codex Escurialensis* (28.11.12) and Giuliano da Sangallo (R.M. fig. 96 p. 309 Vol IV).
19 R. Macaulay, *The Pleasure of Ruins* (London/New York 1966), p. 4.
20 R. Weiss, *The Renaissance Discovery of Classical Antiquity* (Oxford 1969), p. 104.
21 Colonna [Bib. C].
22 C. Mitchell, 'Archaeology and Romance in Renaissance Italy', in E. F. Jacob, ed., *Italian Renaissance Studies* (London 1950), pp. 467–68.
23 Colonna [Bib. C]; I quote from the 1592 edn, pp. 467–68.
24 ibid., p. 25.
25 Filarete (cit. at n. 4), p. 16.
26 e.g. *Codex Santarelli* (Uffizi, Florence), by Buonaccorso Ghiberti.
27 See G. Scaglia, 'Fantasy architecture of Roma antica', *Arte Lombarda Rivista di Storia dell'Arte* (Milan 1970).
28 e.g. Matteo di Giovanni, *Vision of St Augustine* (Art Institute of Chicago).
29 Alberti, *De Pictura*, published in 1436 by a version for artists, *Della Pittura*.
30 Schiaparelli (cit. at n. II/96), p. 265.
31 Colonna [Bib. C], 1592 edn, p. 58.
32 By Antonio Manetti and Angelo di Lanzero; designs for tarsie in the Sacristy probably supplied in 1463 by Maso Finiguerra. A. M. Hind, *A History of Engraving and Etching* (New York 1968), p. 40.
33 Fra Luca Pacioli, *De Divina Proportione* (1509); quoted by R. Lightbown, *Piero della Francesca* (London/New York 1992), p. 75.
34 Vasari, *Lives* [Bib. C], II, p. 240.
35 C. Sterling, *La Nature morte de l'Antiquité à nos jours* (Paris 1952), p. 30.

36 E. H. Gombrich, *The Heritage of Apelles* (Oxford 1976), p. 28.
37 ibid., p. 28.
38 Vasari [Bib. C], II, p. 11.
39 P. Thornton, *The Italian Renaissance Interior 1400–1600* (London 1991), p. 149.
40 Vasari [Bib. C], II, p. 241.
41 L. Faenson, *Italian Cassoni* (Leningrad 1983), cat. 11–14.
42 Thornton, *Italian Renaissance Interior* (cit. at n. 39), p. 97.
43 L. Lanzi, *History of Painting* (London 1828), p. 331.
44 Vasari [Bib. C], I, pp. 328–29.
45 ibid., p. 357: 'Many houses in Florence possess small pictures by the hand of this master, painted to adorn couches, beds, and other household articles.'
46 Lightbown, *Mantegna* (cit. at n. 14), p. 147.
47 Andrea del Sarto painted two *spalliere* in 1515: see A. Braham in *Burlington Magazine*, CXXI (1979).
48 Vasari [Bib. C], I, pp. 328–29.
49 ibid., III, p. 351.
50 ibid., II, p. 114.
51 J. de Arphe y Villafane, *De Varia commensuración para la esculptura, y architectura* (Seville 1585), unpag. prologue: 'que antigua-mente no avia difercia delos Artifices q aora llamamos Esculptores y Architectos alos q aora son Plateros'.
52 In the Hermitage, St Petersburg.
53 Example in S. Ambrogio, Milan, ill. Gough (cit. at n. II/14), pp. 110, 111.
54 e.g. L. Leoncini, *Il Codice detto del Mantegna* (Rome 1993), p. 80: 'e per molti aspetti il frutto di una mentalità ancora medievale o, se si vuole, gotica'.
55 Ruskin, *Stones of Venice* [Bib. C], III, p. 110.
56 *Codex Escurialensis* (Escurial), pp. 17, opp. 18, 12, 14, 18, 33, opp. 55, 66, 69, 28.
57 Muntz (cit. at n. 10), p. 334.
58 S. Maria del Popolo, Rome (*c.* 1488), Chapel of Basso della Rovere, bands in vault.
59 e.g. *The Painted Page, Italian Renaissance Book Illumination 1450–1550* (London/Munich 1984), p. 79.
60 Bufalini Chapel, Church of the Aracoeli, Rome, as early as 1483–85.
61 Chapel of S. Brice, Orvieto Cathedral (1500–1504).
62 Vasari [Bib. C], III, p. 347.
63 N. Dacos, *La Découverte de la Domus Aurea et la formation des grotesques à la Renaissance* (London 1969), p. 102.
64 J. S. Byrne, *Renaissance Ornament Prints and Drawings* (New York 1981), p. 60. Vico's 1541 Barlacchi plates are copied from an earlier set.
65 A. Gruber, ed., *The History of Decorative Arts*, I, *The Renaissance and Mannerism in Europe* (New York/London/Paris 1994), p. 240.
66 'Leviores et (ut videtur) extemporaneae picturae quas grotteschas vulgo vocant'.
67 Evans (cit. at n. I/116), I, p. 25. Du Cerceau's later grotesques contain more northern type monsters.
68 *Codex Escurialensis*, fol. 58; for the crypto-porticus, see Dacos, *Domus Aurea* (cit. at n. 63), p 62.
69 Sterling (cit. at n. 35), p. 39; the term 'nature morte' was first employed in 1756.
70 ibid., p. 32: 'Tous ces motifs...sont ceux des peintures décoratives antiques du Second et du Quatrième Style'.
71 F. Pacheco, *Arte de la pintura* (1649), ed. B. Bassegoda i Hugas (Madrid 1990); see W. B. Jordan and P. Cherry, *Spanish Still Life* (London 1995), p. 15.
72 Vasari [Bib. C], I, p. 470. Vasari categorized an ornament on a Donatello *Annunciation* as in the 'grotesque manner'.
73 e.g. descriptions of still lifes by Zeuxis, Parrhasius and Peraikos. Pliny in his work on painting [Bib. C] mentions genre and still life mixed in a way that anticipates Jacopo Bassano.
74 e.g. by Giovanni Volpato.
75 Known in an early seventeenth-century copy: Sterling (cit. at n. 35), p. 36, fig. 29.
76 W. Odom, *History of Italian Furniture* (New York 1918), I, p. 223.
77 Gruber, *Renaissance and Mannerism* (cit. at n. 65), p. 290.

78 ibid., pp. 337, 338.
79 ibid., p. 290.
80 Including H. Schönesperger, *Furm oder Modelbüchlein* (Augsburg 1523), P. Quentell, *Eyn New Kunstlich Boich* (Cologne 1527), and W. Vorsterman, *Ce est ung tractat de la noble art de leguille* (Antwerp *c.* 1527), translated as *A neave treatys as concernynge the excellency of the needleworcke*.
81 *La Fleur de la science de pourtraicture; patrons de broderie. Façon arabique et ytalique* (Paris 1530).
82 P. Flötner, *Gedruckt zü Zurich Rudolfi Wyzzenbach formschnyder* (1549).
83 B. Sylvius, *Variarum protractionum quaes vulgo Maurusias vocant Libellus* (1554).
84 F. Haskell, *History and its Images* (New Haven 1993), p. 120.
85 The same table appears in Loggie 'Bible' paintings by Guillaume Marcillat and Pedro Machuca: see N. Dacos, *Le Logge di Raffaello* (Rome 1977).
86 Seen in 'The Last Supper' by V. Tamagni in the Logge.
87 Caffaggiolo maiolica dish, perhaps by Jacopo Fattorini (Victoria & Albert Museum, London, 1717–1855).
88 T. Hope, *An Historical Essay on Architecture* (London 1840), p. 473.
89 Vasari [Bib. C], V, p. 272.
90 ibid., I, pp. 328–29.
91 Compare also with the marble lectern in the *Annunciation* by Verrocchio's pupil Leonardo (Uffizi, Florence).
92 O. Raggio, 'The Farnese table...by Vignola', *Metropolitan Museum of Art Bulletin* (New York, March 1960), p. 214.
93 ibid., p. 217.
94 ibid., p. 224.
95 A. Fulvio, *Illustrium Imagines* (Rome 1517).
96 E. Vico, *Le Imagini delle Donne Auguste* (Venice 1557).
97 G. B. Cavalieri, *Romanorum imperatorum effigies* (Rome 1583).
98 T. Gallaeus, *Illustrium imagines...quae extant Romae* (Antwerp 1598)
99 H. Goltzius, *Vivae omnium fere imperatorum imagines* (Antwerp 1557).
100 E. Colle, ed., *I mobili del Palazzo Pitti, il periodo dei Medici* (Turin 1997), postulates that the ensemble consists of Flemish, French and German designs. This may well be so, but northern influences are not so obvious as are those (for example) on Allori's grotesque ceilings in the Uffizi. The table's supports are called 'harpies' in the inventory quoted, which seems to have been a common vagueness (the Farnese table siren supports are so described also: Raggio, 'Farnese table' (cit. at n. 92), p. 215).
101 ibid., p. 115.
102 K. Piacenti, 'Un tavolo granducale del Cinquecento', pp. 365–69 (extract from an unidentified journal, Furniture Dept, Victoria & Albert Museum, London).
103 J. B. Fischer von Erlach, *Entwurff einer historischen Architectur* (Leipzig 1725), Bk 5.
104 *Gothic and Renaissance Art in Nuremberg 1300–1550* (New York 1986), p. 444.
105 'cose tanto piacevoli et fantastiche'; quoted from Antonio de Beatis (1517) by Gombrich (cit. at n. 36), pp. 80–81.
106 J. F. Hayward and W. Rieder, 'Thomas Rucker's iron chair', *Waffen- und Kostumkunde Jahrgang* (Munich/Berlin 1976), p. 85.
107 ibid., p. 96.
108 ibid., p. 96.
109 J. Florio, *Queen Anna's World of Words* (London 1611).
110 *Life of St John the Baptist*, by Francesco Granacci, *c.* 1510 (Metropolitan Museum of Art, New York, 1970.134).
111 J. Morley, *Regency Design* (London 1993), ill. p. 362.
112 Leoncini (cit. at n. 54), 53(c), 63(c).
113 M. Praz, *Illustrated History of Interior Decoration* (London 1964), ill. p. 94.
114 Thornton, *Italian Renaissance Interior* (cit. at n. 39), p. 136.
115 ibid., p. 155.
116 ibid., p. 136, by Marcantonio Raimondi, *Modi*.
117 N. Riley, *World Furniture* (London 1980), p. 28.

118 F. Watson, introd., *The History of Furniture* (New York 1976), p. 38 (Louvre, Paris).
119 Thornton, *Italian Renaissance Interior* (cit. at n. 39), ill. p. 142 (Prince Ernst of Hanover).
120 ibid., p. 165.
121 McCorquodale (cit. at n. I/51), p. 77.
122 M. Riccardi-Cubitt, *The Art of the Cabinet* (London 1992), col. pl. 9.
123 H. Millon and V. M. Lampugnani, *The Renaissance from Brunelleschi to Michelangelo* (London 1994), p. 577.
124 A. Labacco, *Libro d'Antonio Labacco... antiquità di Roma* (Rome 1557).
125 ibid., p. 7.
126 A. Lafréry, *Speculum romanae magnificatiae* (Rome 1575).
127 Kruft (cit. at n. 13), p. 71.
128 A. Palladio, *I Quattro Libri dell'architettura* (Venice 1570).
129 Serlio's publication sequence is summarized in Kruft (cit. at n. 13), pp. 73–79.
130 V. Scamozzi, *Tutte l'opere d'architettura di Sebastiano Serlio* (Venice 1584), Bk VII, p. 68: 'Li cammini veramente sono di grande ornamento alle habitationi'.
131 Raggio, 'Farnese table' (cit. at n. 92), p. 225.
132 K. S. Jervis, *Printed Furniture Designs before 1660* (Leeds 1974), pl. 6 (Daniel Hopfer I).
133 A. Wells-Cole, 'An Architectural Source for Furniture Decoration', *Furniture History* (Leeds 1985), pp. 17–18.
134 Scamozzi (cit. at n. 130), Bk III, p. 54.
135 J. Byam Shaw, *J. B. S. Selected Writings* (London 1968), p. 46.
136 *Vues d'optiques* (Orléans 1551).
137 Scamozzi (cit. at n. 130), Bk II, pp. 49, 50.
138 It was confusing to contemporaries; Lomazzo, who in 1584 defended the 'grotesque' against Vitruvius and his commentators, classifies it as 'la vera, e antica forma del far le grotesche', and distinguishes it from the 'rebesche' (arabesque) by its structural qualities (*Trattato dell'Arte de la pittura* (Milan 1584), p. 430).
139 Gothic scheme for S. Petronio by Cristoforo Lombardo and Giulio Romano (Prague, Codex Chlumczansky, fol. 96v).
140 Plutarch [Bib. C], 'Life of Alcibiades', pp. 237–38.
141 From the 'Greek Anthology' (assembled from about 100 BC onwards), which consists of 4,500 short Greek poems, called 'epigrams' but usually not epigrammatic, collected in the tenth century and revised in the fourteenth. See K. Dilthey, *Epigrammatum Pompeis repertorum trias* (Zurich 1876).
142 Loeb *Antiphilus*, Bk XVI, epigram 147.
143 Epigrams are words that illustrate objects or concepts: see M. Praz, *Studies in Seventeenth-Century Imagery* (London 1919, 1947), p. 18.
144 *Emblemata* (Lyons 1550), trans. and annot. B. I. Knott, introd. J. Manning (Chippenham 1996), p. 146.
145 Pliny, Tacitus, Plutarch, Apuleius, Clement of Alexandria, Plotinus, etc.: see Praz (cit. at n. 143), p. 23.
146 ibid., p. 24.
147 Alberti, *Ten Books* [Bib. B], p. 169.
148 C. C. Via, 'Pinturicchio et la décoration...de l'appartement Borgia', *Revue de l'Art* (1991–94), p. 18.
149 D. Bartoli, *De Simboli trasportati al morale*, quoted by Praz (cit. at n. 143), p. 19.
150 Evans cit. at n. I/116), I, p. 156. The mottoes may be translated, respectively: 'Respect for the gods will recall from the confinement of the Underworld'; 'She plunders for herself any light [glory] on which she sets her eyes'; 'Full of grief and empty of hope'; 'Thrown down and without hope'.
151 C. Acidini Luchinat, 'La grottesca', *Storia dell'arte italiana* (Turin 1982), IV, p. 185.
152 Dacos, *Domus Aurea* (cit. at n. 63), pp. 181–82, quoting Pirro Ligorio: 'pitture antiche, che'l vulgo l'appella grottesche che tutte hanno significato di morali documenti..., fingendo le pene gravi, la immortalita, le cose dolci mutarsi in amari fonti...le nausee, i fastidii, gli interiti, la morte, l'emulazione, gli odii, i resentimenti, le querele, i sfocamenti dell'ira et di sanguinolenti petti, le lascivie, gli stupri, gli inganni, et tutti i mali che perturbano'.

153 ibid., p. 425: 'che pur con quelle se può legriadramente accenare la lascivia nel satiro & nella donna ignuda, l'amante giocondo nel pastore e ninfa [superbly illustrated in the text of Monteverdi's 1651 'Dialogo di Ninfa e Pastore'], la viltà dell'amante nella bellezza della sirena, la prudenza nella Sfinge, & tutti gli altri concetti'.

154 ibid., pp. 178–79: 'per ciò che egli [Vitruvius] il significato, dell'animali, voleva che si mettessero nelli freggi o zophori dell'ordini, dei quali venivano significati per simboli degli iddii a'quali erano fatti tempii'.

155 ibid., pp. 178–79: 'sono queste cose finite nella strana pittura, che grottesca si chiama, in cui ogni strana fantasia si rappresenta in tanti accidenti, et in tanti desiderii mundani, che sono al fine tutte vanità. Perciò vi si trovano tante e varie transmutationi dall'antica schola ritrovata da philosophi pythagorici et da poeti'.

156 *Versuch einer Allegorie* (Dresden 1766).

157 *Iconology, or, a Collection of Emblematical Figures, moral and instructive* (London 1778).

158 Sheraton, *The Cabinet-Maker and Upholsterer's Drawing Book* [Bib. B], pp. 15–16.

159 Hope, *Household Furniture* [Bib. B], p. 42.

160 M. Proust, *Remembrance of Things Past*, trans. C. K. Scott Moncrieff (London 1961), VI, p. 290.

161 In the Old Sacristy of S. Lorenzo, Florence.

162 Ill. Thornton, *Italian Renaissance Interior* (cit. at n. 39), pl. 184.

163 Pomponio Gaurico, *De sculptura* (1504), condemns unnatural hybrids.

164 Aristotle, *Treatise on Poetry* [Bib. C], p. 108.

165 Cennini (cit. at n. III/72), ch. 70, p. 65.

166 Vasari [Bib. C], II, p. 372.

167 Gruber, *Renaissance and Mannerism* (cit. at n. 65), p. 208, quoting Francesco de Hollanda.

168 F. Zuccaro, *L'Idea de' pittori, scultori, et architetti* (Turin 1607), p. 17.

169 Victoria & Albert Museum, London, E.598-1888.

170 Henry Peacham, *Graphice* (1612), quoted by Evans (cit. at n. I/116).

171 Celio Calcagnini (d. 1541), quoted by J. Shearman, *Mannerism* (Harmondsworth 1967), p. 156.

172 B. Castiglione, *The Book of the Courtier, done into English by Sir Thomas Hoby Anno 1561* (London 1900), p. 61.

173 McCorquodale (cit. at n. I/51), pl. 253.

174 T. Mann, *Dr Faustus*, ch. VI, XII.

175 Ruskin, *Stones of Venice* (cit. at n. II/48), II, p. 110.

176 J. Hayward, *Virtuoso Goldsmiths and the Triumph of Mannerism* (New York 1976), p. 75.

177 S. Beguin, *Rosso e Primaticcio al Castello di Fontainebleau* (Geneva 1965).

178 e.g. H. Zerner, *The School of Fontainebleau, Etchings and Engravings* (New York 1969), AF 40.

179 M. Lodovico, *Descrittione di tutti Paesi Bassi* (Antwerp 1567), quoted by S. Sune, *Cornelius Bos* (Stockholm 1965) p. 107.

180 S. Sune, *Cornelis Bos* (Uppsala 1965), figs. 4–11, 14.

181 Virgil, *Aeneid*, Bk VI, 240–74.

183 B. Cellini, *Life*, trans. J. A. Symonds (Geneva 1968), pp. 126–27.

184 Cardinal Paleotti: see G. A. Gilio, *Due dialogi degli errori de'pittori* (Camerino 1564).

185 Žulch (cit. at n. 13), p. 14.

185 Vasari [Bib. C], V, pp. 79–80: a festival of the 'Company of the Trowel', founded by Giovan-Francesco Rustici.

186 B. Palissy, *Oeuvres complètes de Bernard Palissy* (Paris 1880), p. 470: 'pour faire esmerveiller les hommes… trois ou quatres vestus et coiffes de modes estranges'.

187 ibid., p. 468–69, 'Grotte pour la Royne Mère': 'Et quant aux termes…il y en auroit un qui seroit comme une vieille estatue mangée de l'ayr ou dissoulte à cause des gelées, pour demonstrer plus grande antiquité'.

188 B. Palissy, *Architecture…de la grotte rustique de Monseigneur le duc de Montmorancy* (1563, repr. Paris 1919), p. 469: 'il y en auroit un aultre qui seroit taillé en forme d'un rochier rustique, au long duquel il y auroit plusieurs

189 Palissy (cit. at n. 186), p. 468: 'Notez que le grand rocher…seroit inculpé par un nombre infini de bosses et de concavités, lesquelles bosses et concavités seront enrichies de certaines mousses et de plusieurs espèces d'herbes qui ont accoustume de croitre es rochiers lieux aquatiques'.

190 Zerner (cit. at n. 178), AF 82. Bibl. de l'Arsenal, Paris.

191 Palissy, *Architecture & Ordonnance Oeuvres*, cit. at n. 186, p. 164): 'un cabinet auquel j'ay mis plusieurs choses admirables et monstreuses que j'ay tirées de la matrice de la terre'.

192 Palissy (cit. at n. 186), pp. 468–70: 'plusieurs lézars, langrottes, serpens et… un nombre infini de grenouilles, chancres, escrevisses, tortues et yraigues de mer, et…poisson couvert d'un nombre infiny de pissures d'eau qui…par certains…mouvemens de l'eau,…on penseroit que ledict poisson se fust démené ou couru dans ladicte eau…ung nombre de chailloux,…un aultre qui seroit tout formé de diverses qoquilles maritimes; scavoir les deux yeux de deux qoquilles; le nez, bouche, menton, front, joue, le tout de qoquilles, voire tout le résidu du corps'.

193 Hayward (cit. at n. 176), p. 55.

194 ibid., p. 126, source of 1610.

195 Palissy (cit. at n. 186), p. 470: 'quant aux niches, colonnes, pieds d'estracz et pilastres, je les vouldrais fere de diverses couleurs de pierres rares…pourphires, jaspes, cassidoines et de diverses sortes d'agates, marbres et grisons madrez'.

196 Especially his *Livre d'Architecture* (Paris 1559, Bk II 1561).

197 H. Vredeman de Vries, *Différents pourtraicts de menuiserie à scavoir* (1588?), and W. Dietterlin, *Architectura* (Strasbourg 1598). Hans's son, Paul Vredeman de Vries, published *Verscheijden Schrynwerck* (Amsterdam 1630) that shows how Renaissance ornament persisted in furniture.

198 Muntz (cit. at n. 10), p. 299: 'on dirait parfois de la menuiserie, non plus de l'architecture. A cet égard, Serlio est le vrai précurseur de Dietterlin'.

199 Dietterlin (cit. at n. 197), 65, 'vases', entablature, etc .

200 e.g. ibid., 49–51, 65.

201 ibid., 66.

202 Sambin [Bib. B], p. 60.

203 F. Haskell and N. Penny, *Taste and the Antique* (London 1988) pp. 301–2.

204 Kruft (cit. at n. 13), p. 121.

205 Copy at the National Gallery, London.

206 Gruber, *Renaissance and Mannerism* (cit. at n. 65), p. 248.

207 Jervis (cit. at n. 132), p. 25.

208 Gibbon (cit. at n. II/1), V, p. 267.

209 In the Archaeological Museum, Palermo.

210 G. Jackson-Stops, *The Treasure Houses of Britain* (New Haven/London 1985), p. 134.

211 See D. Bostwick, 'The French Walnut Furniture at Hardwick Hall', *Furniture History* (London 1995).

212 Jackson-Stops (cit. at n. 211), cat. 32.

213 H. Vredeman de Vries (cit. at n. 197), pl. 8: the first supported by sphinxes with scrolled tails; dogs support the centre section of the second; the third supported by winged sphinxes.

214 Bostwick (cit. at n. 211), design and portrait ill. p. 3.

215 Jackson-Stops (cit. at n. 210), p. 108.

216 A. Alciati, *Viri clarissimi…emblematum* (Paris 1542, repr. Darmstadt 1967), 223, 224.

217 A. Gruber, *L'Art décoratif en Europe*, II, *Classique et Baroque* (Paris 1992), ill. p. 54, for a candlestick by Vico with the sinister 'eyes'.

218 ibid., p. 76.

219 In the Rijksmuseum, Amsterdam.

220 'Schnacken' was a word used to denote auricular ornament.

221 Hayward (cit. at n. 176), p. 291.

222 N. Rouseel, *De Grotesco* (London 1623).

223 See the prints of Johannes Lutma after 1650.

224 Gruber (cit. at n. 217), p. 40.

225 ibid., p. 76.

226 É. Du Pérac, *I vestigi dell'antichità di Roma* (Rome 1575).

V Baroque Contrasts *pp. 135-160*

1 Félibien, *Entretiens* [Bib. A], p. 23: 'un amas confus de corps avancez & d'arrière-corps… avec autant de testes qu'une Hydra, & autant de bras que Briarée…une infinitée d'angles & d'inégalitez'.

2 Hope, *Historical Essay* (cit. at n. IV/88), p. 489.

3 From a Handel opera, probably *Solomon*.

4 J. Bunyan, *The Pilgrim's Progress*, 1678; ed. N. H. Keeble (Oxford 1984), p. 240.

5 By Algardi, for instance, at the Palazzo Doria-Pamphili, Rome.

6 'Journal du Voyage du Chevalier Bernini en France par M. Chantelou', quoted in M. Salmi and others, *The Complete Works of Raphael* (New York 1969), p. 613.

7 Now the Hôtel de Lauzun.

8 G. Brice, *Description nouvelle de ce qu'il y a de plus remarquable dans la ville de Paris* (2nd edn, Paris 1685; 7th edn, 1717), p. 53: 'La plupart des plafonds de ces appartemens sont d'une exquise beauté. Il y en a d'un certain *Grimaldi*, que l'on fit venir exprès d'Italie en 1648, aussibien que *Romanelli*, disciple de *Pierre de Cortonne*, qui a peint dans la galerie'.

9 From the English trans. of the 1st edn of Brice's *Description nouvelle*, *A New Description of Paris* (London 1687), I, p. 338.

10 Duc de Saint-Simon, *Memoirs*, trans. B. St John (Ohio 1961), II, pp. 90–92. Louvois, Superintendent of Buildings, was also Minister for War!

11 Félibien (cit. at n. 1), pp. 25 24.

12 ibid., p. 66: 'La Compagnie a désapprouvé plusieurs de ces nouvelles manières, qui sont défectueuses et qui tiennent la plupart du gothique'.

13 See E. Mandowsky and C. Mitchell, *Pirro Ligorio's Roman Antiquities* (London 1963).

14 See *The Paper Museum of Cassiano dal Pozzo* (London 1993).

15 R. Fréart de Chambray, *Parallèle de l'architecture antique et de la moderne* (Paris 1650).

16 E. Harris and N. Savage, *British Architectural Books and Writers* (Cambridge 1990), p. 197.

17 F. Perrier, *Icones et segmenta nobilium* (Rome 1638) and *Icones et segmenta illustrium* (Paris 1645/55).

18 Félibien, *Statues et bustes* [Bib. A]. In one plate, a antique 'Agrippina' sits on a stool that has goat legs of the type seen on Louis XIV furniture, including Boulle commodes.

19 M.-A. de La Chausse, *Romanum museum sive Thesaurus, Le gemme figurate* (Rome 1700).

20 F. Kimball, *Creation of the Rococo* (Philadelphia 1943), p. 62.

21 De Piles [Bib. C], p. 307.

22 Percier and Fontaine, *Recueil* [Bib. B], p. 3: 'toujours les formes de l'ameublement se sont trouvées dans un accord parfait avec le génie qui présidait aux inventions de l'architecte, du sculpteur, et du peintre. L'orfèvrerie du siècle de Louis XIV est empreinte du goût de Le Brun, l'armoire et le guéridon de Boule ont les contours, les profils et les cartels de Mansard'.

23 R. Borghini, *Il Riposo*, 1584, ed. Bottari (Florence 1730), p. 187.

24 F. Rossi, *Mosaics, A Survey of their History and Techniques* (London 1970), p. 118.

25 Raggio, 'Cabinets-studioli' (cit. at n. IV/2), p. 209.

26 D. Alcouffe, 'Les Maces, ébénistes et peintres', *Bulletin de la Soc. de l'Histoire de l'Art français* (1971).

27 *Vide* the lignum vitae and silver cabinets at Windsor Castle made for Queen Henrietta Maria.

28 'a large cabinet entirely faced, inside and out, with pieces of ivory must have struck the seventeenth-century beholder as something absolutely astonishing': P. Thornton and M. Tomlin, *The Furnishing and Decoration of Ham House* (London 1980), p. 34.

29 Riccardi-Cubitt (cit. at n. IV/22), ill. p. 88.

30 See F. J. B. Watson, *Wallace Collection Catalogues, Furniture* (London 1956), pp. 30–32.

31 ibid., p. 824.

32 Colle (cit. at n. IV/100, from whom other details are taken, pp. 220–22.

33 Seen in e.g. the chapel designed by Vanvitelli and made in Rome for Valletta Cathedral, Malta.

34 P. Verlet, *French Royal Furniture* (London 1963), p. 50.

35 ibid., p. 52.

36 ibid., p. 51.

37 P. Verlet, *Les Bronzes dorés français du XVIIIe siècle* (Paris 1987), p. 52.

38 ibid.

39 De Piles [Bib. C], p. 89.

40 See Félibien, *Entretiens* (cit. at n. 1), I, p. 64, for the *Laocoön*'s influence on the Carracci.

41 In the Palazzo Pitti, Florence.

42 'The transformation of Io into a Heyfer', in *Ovid's Metamorphoses in Fifteen Books*, trans. J. Dryden (London 1727), p. 30.

43 P. Thornton, *Seventeenth-Century Interior Decoration in England, France and Holland* (New Haven/London 1978), p. 151.

44 Burckhardt, quoted in G. C. Bauer, ed., *Bernini in Perspective* (New Jersey 1976), p. 63. Also on Bernini, F. Milizia, *Dictionary of the Fine Arts* (Bassano 1797), p. 54.

45 For an English example, see Thornton, *Seventeenth-Century…Decoration* (cit. at n. 43), p. 168.

46 Ovid, *Metamorphoses*, trans. F. J. Miller (London 1916), I, lines 846–47.

47 An even more extraordinarily mannered French bed (also from the Tessin collection in the Nationalmuseum, Stockholm), in which the draperies seem indefinitely extended, is ill. Thornton, *Seventeenth-Century…Decoration* (cit. at n. 43), p. 18, pl. 15, where it is associated with the Trianon de Porcelaine. According to *Versailles à Stockholm* (Stockholm, Nationalmuseums Skriftserie NS 5, 1985), pp. 152–53, both drawings are by Nicodemus Tessin the younger; the drawing ill. here shows the bed installed in the Chambre des Amours in 1672, and was made as a record in 1687, shortly before the building's demolition.

48 Ponce, *Descriptions* [Bib. A], pls. 20, 21.

49 Such as those by the architect and cabinet-maker Johann Indua: *Neue Romanische Zierathen* (Augsburg, before 1685) and *Nova invenzione di rabeschi, e fogliami romani* (Vienna 1686).

50 J. Hardy, 'The Kedleston Sofas', *Furniture History* (Leeds 1990), pp. 90–91.

51 The famous tent of Ptolemy Philadelphus had four 'pillars…made to resemble palmtrees': Athenaeus [Bib. C], I, p. 313.

52 H. Hayward and P. Kirkham, *William and John Linnell* (London 1980), I, pp. 112–33.

53 H.-P. Trenschel, *150 Meisterwerke aus dem Mainfränkischen Museum, Würzburg* (Würzburg 1977), cat. 73, p. 162.

54 *Antichità di Ercolano: Le pitture* (cit. at n. I/55), IV, pl. LXV, p. 325.

55 Follower of Rogier van der Weyden (Metropolitan Museum, New York, Robert Lehman Coll.).

56 H. Kreisel, *Die Kunst des deutschen Möbels, Spätbarock und Rokoko* (Munich 1970), ill. 196.

57 F. Castro Freire, *50 dos melhores moveis portugueses* (Museu Nacional de Arte Antigua, Lisbon), p. 33.

58 ibid.

59 Victoria & Albert Museum, London (E 029. 4254-6, 1910).

60 K. Gesner, in V. Cordus, *De Hortis germaniae liber* (1561).

61 Evans (cit. at n. I/116), I, p. 80.

62 Jackson-Stops (cit. at n. IV/210), details p. 150.

63 Evans (cit. at n. I/116), II, p. 56.

64 A Boulle design for a table top, ill. Gruber, *Classique et Baroque* (cit. at n. IV/217), p. 189, significantly lacks the extended lips of the Bos original.

65 Complete collection issued in Paris in 1711 by Boulle's son-in-law, Jacques Thuret: *Ornemens inventez par J. Berain et se vendent chez Monsieur Thuret*.

66 ibid., 29th ill. (copy in British Library, London, 56.J.15, with unnumbered plates).

67 Caylus, *Tableaux* [Bib. A], p. XXIII.

68 By Thomas Regnardin and François Girardon: P. Hughes, *Wallace Collection; Catalogue of Furniture* (London 1996), II, p. 824.

69 'Bandwork' (German *Laub* and *Bandelwerk*), a term used of flat curvilinear and geometrical interlace, is here avoided because flat interlace is discussed with three-dimensional interlace, and proliferating terms confuse.

70 C. Wilk, *Western Furniture 1350 to the Present Day* (London 1996), p. 84.
71 Copied by Oppenord in 1692–99 into his Roman sketchbook, now in Berlin.
72 C. Gilbert, *Furniture at Temple Newsam House and Lotherton Hall* (Bradford/London 1978), II, pp. 264–68 for details.
73 Thornton, *Seventeenth-Century…Decoration* (cit. at n. 43), ch. VII, for a full account.
74 M. Bencard and J. Hein, 'Three Cabinets', *Furniture History* (London 1985), pp. 147–55.
75 Kreisel (cit. at n. 56), ill . 312.
76 Wilk (cit. at n. 70), p. 86.
77 Ill. ibid.
78 Chippendale [Bib. B (1767/1966)], e.g. nos. LXVII, LXX, LXXII.
79 M. H. Heckscher, *American Furniture in the Metropolitan Museum of Art* (New York 1985), II, p. 277.
80 Thornton and Tomlin (cit. at n. 28), p. 64.
81 Gilbert, *Temple Newsam* (cit. at n. 72), I, p. 79.
82 Heckscher (cit. at n. 79), pp. 99–100.
82 Hepplewhite [Bib. B], pl. 8.

VI The Battle of Styles *pp. 162–84*

1 Hope, *Household Furniture* [Bib. B], p. 51.
2 G. Cumberland, *Thoughts on Outline* (London 1796), p. 3. He also warned against the *Museo Pio-Clementino*!
3 Including *Colonna Traiana* (Rome 1665), *Veteres arcus Augustorum triumphis* (Rome 1690), *Le pitture antiche del sepolcro de' Nasonii nella Via Flaminia* (Rome 1680), *Admiranda Romanorum antiquitatum* (Rome, c. 1690), *Gli antichi sepolcri* (Rome 1697).
4 L. Pascoli, *Vite de' pittori, scultori, ed architetti perugini* (Rome 1732), p. 231.
5 ibid., p. 233: 'Ne l'età ne la corpulenza, ne la grossezza, ne la fatica di scendere, e salire, ne qualqunque altro disago ritener lo potevan dall'entrar ne' sotterranei per genio, per gusto, e dir si poteva ancora per istinto'.
6 ibid., p. 231: 'che andò in Inghilterra, dove l'opere sue si stimano assaissimo'.
7 G. P. Bellori, *Le Vite de' pittori, scultori et architetti moderni* (Rome 1672), p. 392. The list quoted comes from Bellori's description of the Algardi decorations in the Palazzo Doria-Pamphili, and its closeness to Montfaucon's categories shows how useful the latter's books must have been to artists.
8 Evans (cit. at n. I/116), II, p. 101.
9 The term probably first appeared in print in 1670, in *The Voyage of Italy*, by R. Lassels: M. Wilson, *William Kent* (London 1984), p. 23.
10 Wilson (cit. at n. 9), p. 95.
11 ibid., p. 106.
12 ibid., pp. 106, 96.
13 A. Bowett, 'The Commercial Introduction of Mahogany and the Naval Stores Act of 1721', *Furniture History* (Leeds 1994), pp. 43–56.
14 As noted by P. Ward-Jackson, *English Furniture Designs of the Eighteenth Century* (London 1984), p. 7.
15 Wilk (cit. at n. V/70), ill. 89. The theory advanced on p. 88 that the design alludes to the origin of the Corinthian capital seems unlikely.
16 Gilbert, *Temple Newsam* (cit. at n. V/72), II, pp. 353–56. For a drawing by Lock see Ward-Jackson (cit. at n. 13), ill. 48.
17 Vardy, *Some Designs of Mr. Inigo Jones and Mr. William Kent* [Bib. B].
18 J. Harris and M. Snodin, *William Chambers Architect to George III* (New Haven/London 1997), p. 163.
19 M. Tomlin, *Catalogue of Adam Period Furniture* (London 1972), p. 3.
20 e.g. *The Death of Hector*, 1761, engraved by Domenico Cunego in 1764.
21 Piranesi, *Antichità d'Albano e di Castel Gandolfo* (Rome 1764), pl. VIII, repr. J. Friedman, *Spencer House* (London 1993), p. 138.
22 G. Beard and C. Gilbert, *Dictionary of English Furniture Makers* (Leeds 1986), p. 545.
23 Voltaire, *The Age of Louis XIV*, trans. M. P. Pollack (London 1969), p. 337.
24 Brice, *Description* (cit. at n. V/8; 1713 edn), p. 111: 'incomparablement plus commode & plus agréable, que celuy que l'on suivoit autrefois…les architectes françois surpassent de bien loin en cet article, ceux qui les ont

précédé, et les Italiens même'.
25 Mme Campan, *Memoirs of Marie Antoinette* (London n.d.), ch. 1, p. 9.
26 Comte de Caylus, *Mémoires et réflexions 1717–1740*, in *Le Portefeuille de M. le Comte de Caylus* (Paris 1874), p. 25. 'Quelle est la cause de cette aimable vivacité?…c'est que les femmes donnent absolument le ton à tout qui se passe dans cette grande ville'.
27 The story occurs somewhere in the Memoirs of Saint-Simon.
28 ibid., (cit. at n. II/1), III, p. 236.
29 Mariette, *Abécédario* [Bib. A], XII, p. 173: 'une touche aimable et facile, des couleurs simples, mais agréables, et surtout un naturel et une naïveté qui enchantent'.
30 J. Casanova, *Memoirs* (London 1922), I, p. 183.
31 *Le Portefeuille de M. le Comte de Caylus* (Paris 1880), p. 45.
32 Pierre Patte, quoted by S. Eriksen, *Early Neo-classicism in France* (London 1974), pp. 21, 22.
33 Cochin, letter to the Abbé R…, 1755, quoted ibid., p. 245.
34 Gruber, *Classique et Baroque* (cit. at n. IV/217), p. 336.
35 The statement is repeated elsewhere; Leblond [Bib. B], p. 400: 'L'idée en vient des Anciens, Raphaël les a fait revivre, & M. Audran s'y est distingué dans ces derniers tems'.
36 Comte de Caylus, *Vies d'artistes du XVIIIe siècle* (Paris 1910), p. 6.
37 J. S. Byrne, *Renaissance Ornament Prints and Drawings* (New York 1981), p. 60: 'for me, if for no one else, number 13 is an arabesque, number 57 is a grotesque in sixteenth-century imitation antiquity, and number 59 is a grotesque as we think of it today.' One disagrees, but one sympathizes!
38 Berain's ceiling of the bedroom of the Hôtel de Mailly of 1687–88 is almost halfway between grotesque and rococo.
39 Some chimneypieces were published in the *Livre de cheminées executées à Marly sur les desseins de Monsr. Mansart Surintendant…dessinées et gravées par P. Le Pautre Graveur du Roi* (Paris c. 1699).
40 Often modifying 1680s work; see Kimball (cit. at n. V/20), p. 71.
41 Letters from Cronstrom to Tessin and to Josephson: 'Celui qui jouit après Berain de la plus grand renommée de ce genre, arabesque, est Audran, un neveu du graveur…. Audran…de nombreux éléments dus à sa propre fantaisie', 'Il est plus exquis et plus svelte'; *Dessins du Nationalmuseum de Stockholm, Collections Tessin et Cronstedt* (Paris 1950), p. xvii.
42 Brice (cit. at n. V/8; 1713 edn), pp. 71–72: 'un des premiers dessinateurs du temps, sur tout pour les Arabesques & pour les ornemens de grotesques, dans le goût du fameux Raphael'.
43 Leblond [Bib. B], p. 266: 'La plus belle couleur est le blanc, parce qu'il augmente la lumière, & réjoisit la vue'.
44 e.g. Boucher designed a 'rock' vase with an auricular neck like those of Enea Vico.
45 Gruber, *Classique et Baroque* (cit. at n. IV/217), p. 333.
46 A.-J. Dézallier d'Argenville, *L'Histoire naturelle éclairée dans une de ses parties principales, la lithologie et la conchyliologie*.
47 By J. Mondon, *Premier Livre de forme rocquaille et cartel* (Paris 1736).
48 C. Normand, *Nouveau Recueil en divers genres d'ornements* (1803), quoted by Gruber, *Classique et Baroque* (cit. at n. IV/217), p. 329.
49 See e.g. a marquetry commode stamped DF, Getty Museum, ill. Gruber (cit. at n. IV/217), p. 377.
50 Gruber, *Classique et Baroque* (cit. at n. IV/217), p. 364.
51 A. González-Palacios, *Pietro Piffetti e gli ebanisti a Torino* (1992), cat. 24.
52 François Ladatte (1706–87) and Giovanni Paolo Venasca. See Wilk (cit. at n. V/70), p. 94.
53 Published in T. Johnson, *One Hundred and Fifty New Designs*, ill. p. 39.
54 Gilbert, *Temple Newsam* (cit. at n. V/72), II, p. 296; Jackson-Stops (cit. at n. IV/210), p. 435.
55 Ward-Jackson (cit. at n. 13), ill. 357.
56 The first use of the term 'ancien régime' came in 1789: Evans (cit. at n. I/116), II, p. 114.
57 See N. Pevsner, *Studies in Art, Architecture and Design* (London 1968), pp. 103–4 (with S.

Lang).
58 J.-J. Rousseau, *La nouvelle Héloïse* (1759).
59 Morley (cit. at n. IV/111), pp. 42, 45.
60 In 1751; Gruber, *Classique et Baroque* (cit. at n. IV/217), ill. p. 45.
61 Ruskin, *Stones of Venice* (cit. at n. II/48), II, p. 83.
62 Verlet, *Royal Furniture* (cit. at n. V/34), p. 28.
63 D. Sutton, 'Rococo Furniture from Schloss Seehof', *Apollo* (London, Oct. 1982), pp. 262–64.
64 S. Sangl, 'Spindler', *Furniture History* (Leeds 1991), pp. 23, 29.
65 ibid., pp. 30–31.
66 M. Salmi ed., *Encyclopaedia of World Art* (New York/Toronto/London 1963), VI, p. 350.
67 Félibien, *Entretiens* (cit. at n. V/1), II, p. 359: 'chaque ordre de prestres, & ceux qui conduisoient les chariots chargés de tableaux & de statues, avoient leurs basteleurs, leurs musiciens, leurs *Pantomimi* ou farceurs'.
68 ibid., p. 161: Canta-Gallina 'avoit gravé plusieurs Scènes de Comédies, des Balets & des Carousels….A leur exemple Callot commença à dessiner en petit'.
69 Eriksen (cit. at n. 32), p. 228.
70 Ill. Gilbert, *Temple Newsam* (cit. at n. V/72), I, cat. 270.
71 W. Hogarth, *The Analysis of Beauty* (London 1753).
72 C. Gilbert, *The Life and Work of Thomas Chippendale* (New York 1978), p. 152.
73 G. Beard, *Craftsmen and Interior Decoration in England 1660–1820* (London 1981), p. 189.
74 They are to be seen in *Discorsi sopra l'antichità di Roma di Vincenzo Scamozzi* (Venice 1582).
75 Bibl. Nationale, Paris.
76 Watson (cit. at n. V/30), p. 55.
77 ibid., p. 54.
78 Verlet, *Royal Furniture* (cit. at n. V/34), p. 54.
79 Verlet, *Bronzes* (cit. at n. V/37): 'Bronzes de large desson que, faute de preuve, on n'ose pas attribuer aux Caffiéri'.
80 Kreisel (cit. at n. V/56), ill. 430.
81 Webley's *Priced Catalogue*, which also includes Le Pautre, Pillement, Toro, Lajoue and Watteau; see Gilbert, *Chippendale* (cit. at n. 72), p. 111.
82 ibid., n. 1, p. 111.
83 Gilbert, *Chippendale* (cit. at n. 72), p. 83.
84 Laugier, *Essai* [Bib. C], p. 104: 'Heureusement …cette epidémie dangereuse est sur ses fins'.
85 ibid., p. 17.
86 Laugier, *Observations* [Bib. C], p. 113: 'l'effet est toujours chétif'.
87 Laugier, *Essai* [Bib. C], p. 29: 'vicieuses arcades…un usage contre nature'.
88 ibid., p. 62.
89 Laugier, *Observations* [Bib. C], p. xvi: 'Le génie avoit atteint la perfection de fort sous le règne d'Alexandre, l'imitation avoit mis la copie presque à l'égalité du modèle sous le regne d'Auguste'.
90 Laugier, *Essai* [Bib. C], p. 74: 'Rien de moins fastueux, rien même de plus sec et de plus pauvre'.
91 E. Burke, *Reflections upon the French Revolution* (Harmondsworth 1986), p. 245.
92 Laugier, *Observations* [Bib. C], pp. 110–11.
93 ibid., p. 290 .
94 ibid., p. 112.
95 G. B. Piranesi, *Il Fasti* Rome 1762), XII, pl. 21: 'ornata agguisa di pilastro con vari arabeschi'.
96 See *Antichità romane* [Bib. A], III, pls XLV–XLVIII.
97 Borromini, *Opus architectonicum* [Bib. B], p. 15.
98 Piranesi, *Antichità romane* [Bib. A], II, t. XII, pls X, XVIII, XXX, LIX, LX.
99 Caylus, *Vies* (cit. at n. 36), p. 6.
100 ibid., p. xxxi.
101 Laugier, *Essai* [Bib. C], p. 56.
102 A.-J. Roubo in his *L'Art du menuisier* (Paris 1768); see Eriksen (cit. at n. 32), p. 68.
103 The beginning of the *Ars Poetica*.
104 Eriksen (cit. at n. 32), p. 46.
105 ibid., p. 231, quoting Abbé Le Blanc (1737–44).
106 ibid., p. 39.
107 ibid., p. 41.
108 ibid., p. 33.
109 ibid.
110 Still French usage.
111 Walpole, April 1764; quoted by Evans (cit. at n. I/116), II, p. 108.

112 Eriksen (cit. at n. 32), pp. 264–65. Grimm in 1763 used the term in a very general sense.
113 ibid., p. 162.
114 Patte (1777), from Blondel; quoted by ibid., p. 21.
115 ibid., p. 97.
116 A. Pradère, *French Furniture Makers*, trans. P. Wood (London 1989), pp. 258–60.
117 Watson (cit. at n. V/30), pp. 136–37; Verlet, *Royal Furniture* (cit. at n. V/34), pp. 115–16.
118 Hughes (cit. at n. V/68), II, p. 895.
119 Ill. Gruber, *Classique et Baroque* (cit. at n. IV/217), p. 84.
120 Hughes (cit. at n. V/68), I, p. 325.
121 ibid., p. 285.
122 G. Albertolli, *Alcune decorazione di nobili sali ed altri ornementi* (Milan 1787), author's preface, unpag.: 'se si proporranno per loro modelli gli eccelenti originali, che loro si presentano ne' marmi antichi….Pero io d'ora in avanti fornire di un maggior numero di esemplari ai giovani disegnatori, i quali spero, che con questi soccorsi non si abbandoneranno si facilmente, e si inavvedutamente all'inverisimile e secco stile delle pitture, che si veggono nelle grotte delle antiche Terme di Roma, nelle rovine di Ercolano e altrove, che alcuni vorrebbero pure introdurre anche fra noi.'
123 A. González-Palacios, 'Disegno di Gioconda Albertolli', *Arte Illustrata* (May 1971), p. 25.
124 *Magazzino di mobili* (Florence 1796–98, repr. Florence 1981), unpag.

VII 'Modified Rococo' and the New Neo-Classicism *pp. 186–208*

1 The confusion has been caused by the recent fashion for indiscriminate capital letters in denoting styles, irrespective of the words' origins: 'neo-classical' is not misleading at all, 'Neo-classical' most definitely is.
2 A. F. Gori, *Museum Florentinum* (1731–66).
3 G. B. and E. Q. Visconti, *Il Museo Pio-Clementino* (1782–1807).
4 Leplat, *Recueil des marbres…à Dresde* (1733).
5 G. G. Bottari, *Musei Capitolini* (1750–82); vol. IV by Foggini.
6 ibid., III.
7 B. Cavaceppi, *Raccolta d'antiche statue* (1768–72).
8 Wood, *Palmyra* [Bib. A], preface.
9 ibid., p. 23.
10 Adam, *Ruins of the Palace of…Diocletian at Spalatro* [Bib. A].
11 H. Walpole, *Horace Walpole's Correspondence*, ed. Lewis, Lam and Bennett (New Haven/London 1948), XIII–XIV, p. 222.
12 The Prince d'Elboeuf.
13 e.g. T. Piroli, *Le antichità di Ercolano* (Rome 1789–95).
14 Letter from abbate Ferdinando Galiani to Bernardo Tanucci, 1767: 'Tutti gli orefici, bigiuttieri, pittori di carozze, di soprapporte, tappezzieri, ornamentisti, hanno bisogno di questo libro. Sa V. E. che tutto si ha da fare oggi a la grecca, che e lo stesso a Erculaneum…. Quella pittura d'una donna che vende amoretti come polli, io l'ho vista ricopiata qui in piu di dieci case'; quoted in *Rediscovering Pompeii* (New York/London 1990), p. 78.
15 *The Works of Anthony Raphael Mengs* (London 1796), p. 28.
16 *Gli ornati delle pareti ed i pavimenti delle stanze dell'antica Pompeii* (1796–1820).
17 C. Cameron, *Baths of the Romans* (1772); F. Smugliewicz, L. Mirri and V. Brenna, *Vestigia delle Terme di Tito* (c. 1781); N. Ponce, *Bains de Titus* (1786).
18 Mariette, *Pierres gravées* [Bib. A], pp. ii, iii: 'Comparables en tout aux plus belles Statues antiques'. See e.g. Agostini (1657–69; 267 gems), Gori, Stosch (1724), Mariette (1750; 254 gems), Spilsbury (1785), Raspe (1791; over 15,000 gems uninspiringly illustrated).
19 G. P. Bellori, *Adnotationes in XII priorum Caesarum* (Rome 1730).
20 J. Eckhel, *Pierres gravées du Cabinet Impérial des antiques*, Vienna (1788 [Bib. A]).
21 e.g. Worlidge, *Select Collection of Drawings* (c. 1780 [Bib. A]).

22 e.g. the gems published by Venuti, *Collectanea antiquitatum Romanorum* (1736 [Bib. A]).

23 Eriksen (cit. at n. VI/32), p. 41.

24 ibid., p. 73.

25 Gilbert, *Chippendale* (cit. at n. VI/72), p. 35.

26 Evans (cit. at n. I/116), II, p. 148.

27 Jones, *Grammar* [Bib. A], p. 67: the Greeks always used 'portions of curves of a very high order…we never find portions of circles. In Roman architecture…this refinement is lost…. Roman mouldings are therefore parts of circles, which could be struck with compasses.'

28 e.g. Newby Hall, Yorks., and Croome Court, Worcs.

29 A. Kuchamov, *Pavlovsk Palace and Park*, trans. V. Travlinsky and J. Hine (Leningrad 1975), cat. 95.

30 Louis-Philippe, King of the French, *Memoirs 1773–1793*, trans. J. Hardman (New York/London 1977), pp. 189–90.

31 Jacob made chairs in 'Etruscan' style for English clients such as the Duke of Bedford.

32 Eriksen (cit. at n. VI/32), p. 143.

33 ibid.

34 ibid., p. 39.

35 ibid., p. 144.

36 A. Gordon and M. Dechery, 'The Marquis de Marigny's Purchases of English Furniture and Objects', *Furniture History* (Leeds 1989), pp. 87–94.

37 Smith, *Cabinet-Maker* [Bib. B], p. v.

38 Pradère (cit. at n. VI/116), p. 413.

39 Watson (cit. at n. V/30), p. 185.

40 Pradère (cit. at n. VI/116), p. 296.

41 Watson (cit. at n. V/30), p. 151.

42 Hughes (cit. at n. V/68), II, p. 979.

43 Watson (cit. at n. V/30), p. 116.

44 Hughes (cit. at n. V/68), II, p. 100, suggests the oval plaque is early nineteenth-century, although the same model occurs on a Riesener commode (Getty Museum).

45 Similar motif in G. Dosio, *Das Skizzenbuch des Giovanntonio Dosio* (Berlin 1933). Berol. fols 86, 87 give details of a ceiling from the large Baths at Hadrian's Villa (also illustrated by Piranesi and Ponce).

46 Verlet, *Royal Furniture* (cit. at n. V/34), p. 159.

47 ibid., pp. 158–60; Pradère (cit. at n. VI/116) gives slightly different dates.

48 R. Gofen, *The Calouste Gulbenkian Museum* (New York 1982), p. 88.

49 Pradère (cit. at n. VI/116), p. 349.

50 ibid.

51 It lingered in the borders that confined rococo scrolls.

52 *L'Antichità di Roma* (Rome 1554), p. 14.

53 Kent to Massingberd, 1716; E. Croft-Murray, *Decorative Painting in England* (London 1970), vol. I, p. 26.

54 Tatham to Henry Holland, Rome, 4 April 1796: C. H. Tatham, Letters and Drawings (Print Room, Victoria & Albert Museum, London).

55 A design of 1759 exists for the Painted Room at Spencer House, which was completed by 1765; Adam worked at Hatchlands from 1758 (H. Colvin, *Biographical Dictionary of British Architects* (London 1978), p. 52).

56 J. Friedman, *Spencer House* (London 1993), p. 186.

57 Soane Museum, London: Raphael, vol. 26, 2–32, 191–201; grotesque panels by Michelangelo, ibid., 108–9.

58 ibid., pl. 158.

59 An unused design of 1765 for the Hôtel d'Uzès is the earliest known example; Ledoux *c.* 1766 used sculptural grotesque *boiserie* in the Hôtel d'Hallwyl, later also using painted grotesque. Clérisseau painted at the Hôtel Grinod de la Reynière 'dans le style arabesque' in 1777.

60 Adam, *Works* [Bib. B], I, p. 5

61 From a letter of 1781; G. Loukomski, *Charles Cameron*, trans. N. de Gren (London 1943), p. 52.

62 Piranesi, *Diverse Maniere* [Bib. B], pp. 4–5.

63 H. Groth, *Neo-Classicism in the North* (London/New York 1990), ill. 50, p. 212 (Nordiska Museet).

64 Piranesi, *Vasi* [Bib. A], VIII, unpag.

65 Groth (cit. at n. 63), ill. p. 212, cat. 49.

66 See M. Praz, *Neoclassicism* (London 1959), pp. 89–90; and S. Eriksen and F. J. B. Watson, 'The Athenienne', *Burlington Magazine* (March 1963).

67 A. Alison, *Essays on the Nature and Principles of Taste* (Edinburgh 1825), pp. 368, 371.

68 The table not illustrated here is ill. Eriksen (cit. at n. VI/32), pl. 330.

69 The design may have been executed; see J. Wilton-Ely, *The Mind and Art of Giovanni Battista Piranesi* (London 1988), p. 104.

70 Ward-Jackson (cit. at n. VI/13), ill. 273.

71 Wilk (cit. at n. V/70), p. 132.

72 Richardson, *Ceilings* [Bib. B] (in English and French), p. 11

73 And in 'the printed and painted silks executed of late by Mr. Eckhardt, at his manufactury at Chelsea': Sheraton, *Accompaniment* [Bib. B], p. 16.

74 Deep shadows articulate the ceiling, as in all Adam's depictions (it is a grievous solecism to illuminate them with spotlights).

75 Dugourc, *Arabesques* [Bib. B], 2, 'La Terre' (Cooper-Hewitt Museum, New York).

76 Gilbert, *Chippendale* (cit. at n. VI/72), p. 46.

77 Adam used the velarium constantly; his design for a ceiling at Gawthorpe Hall of 1766 (Soane Museum, London, II, 168 4, 5) is entirely made up of velaria.

78 Sheraton, *Cabinet Dictionary* [Bib. B], p. 314.

79 V. Alfieri, *Memoirs*, trans. 1810 (Oxford 1961), p. 31.

80 H. Honour, *Cabinet Makers and Furniture Designers* (London 1969), p. 182.

81 'contrastent un Amour avec un Dragon, & un coquillage avec une aile de Chauve-Souris…nous sommes revenus à la barbarie des Goths'; quoted by Eriksen (cit. at n. VI/32), p. 228.

82 Sheraton, *Accompaniment* [Bib. B], p. 14.

83 Written in 1830 of 1809, the height of 'archaeological' fashions: 'At that period, women tied the belts of their dresses just below the bust, in imitation of Greek statues; it was a pitiless fashion for those whose bust line was not perfect' – H. de Balzac, from *Scenes of Domestic Life*, 'Domestic Peace'.

84 See *The Influence of Rome's Antique Monumental Sculptures on the Great Masters of the Renaissance*, ed. Pogany-Balas (Budapest 1980), ills 222–24.

85 Morley (cit. at n. VI/111), ill. p. 234.

86 Cameron, *Baths* [Bib. A], p. 51: 'Non lumina cessant,/ Effulgent camerae, vario fastigia vitro…/… nitent/ Argento faelix propellitur unda/ Argentoque cadit, labrisque nitentibus instat/ Delicias mirata suas'. Cameron makes an interesting mistake, if mistake it were: *lumina* (light), a word far more in the Cameronian idiom, is substituted for *limine* (threshold, the accepted reading).

87 ibid., pp. 13–14.

88 Tischbein, *Collection of Engravings* [Bib. A], I, p. 34.

89 J. B. Passeri, quoted by A. Blunt, *Studies in Western Art* (London 1963), introd. p. 11.

90 De Piles [Bib. C], p. 74.

91 *Dionysius Longinus on the Sublime*, ed. W. Smith (London 1742).

92 E. Burke, *Philosophical Enquiry into the Origin of our Ideas of the Sublime and the Beautiful* (London 1756).

93 The publications include *The Antiquities of Athens*, I (1762), II (1787), III (1794), IV (1814); *Ionian Antiquities*, I (1769), II (1797); and *Specimens of Ancient Sculpture* (1809).

94 See ibid., II (1787), p. 11.

95 e.g. John Berkenhout, *The Ruins of Poestum* (London 1767); Thomas Major, *The Ruins of Paestum* (London 1768); G. M. Dumont, *Les Ruines de Paestum* (Paris/London 1769); P. A. Paoli, *Paestanae dissertationes* (Rome 1784); and C. M. Delargadette, *Les Ruines de Paestum* (Paris 1799). An account of the influence of Paestum is given in *Paestum and the Doric Revival*, ed. J. R.Serra (Centro Di 1986).

96 Percier and Fontaine, *Recueil* [Bib. B], p. 11.

97 Millin [Bib. A], pp. ii–iii. Thomas Dempster (1579–1625) was the first to call the vases 'Etruscan', influencing Gori, Caylus and Montfaucon; Winckelmann recognized that

they came not only from Etruria; d'Hancarville called them both 'Greek' and 'Etruscan'; Passeri retained 'Etruscan'; Tischbein called them 'Greek'.

98 D'Hancarville, *Antiquités* [Bib. A; Naples 1766 edn], p. 10.

99 Tischbein, *Collection of Engravings* [Bib. A], I, Foreword.

100 ibid., p. 10.

101 R. Worsley, *Museum Worsleyanum* (London 1794 [1798–1803]). The publication date is open to speculation: see I. Jenkins and K. Sloan, *Vases and Volcanoes* (London 1996), p. 102.

102 A. L. Millin, *Peintures des vases antiques vulgairement appelés étrusques* (Paris 1808–10).

103 ibid., p. iv.

104 As Balzac somewhere remarks.

105 Adam, *Works* [Bib. B], II, pls. VII, VIII.

106 D'Hancarville, *Antiquités* (cit. at n. I/173), p. 12.

107 *Tatham Album*, p. 30 (Soane Museum, London).

108 Quoted by Honour (cit. at n. 80), p. 172.

109 Hope, *Costumes of the Ancients* [Bib. A], II, pl. 276.

110 See 'Le Thé' from the series 'La Tenture Chinoise' after sketches by Boucher (Louvre, Paris).

111 Honour (cit. at n. 80), p. 169.

112 Ill. A. Gruber, *L'Art décoratif en Europe*, III, *Du Néoclassicisme à l'Art Déco* (Paris 1994), p. 81.

113 S. Rigaud, 'A Memoir of John Francis Rigaud', ed. W. L. Presley, *Walpole Soc.* (1984), p. 75.

114 Ill. *The Age of Neo-Classicism* (London 1972), p. 144b.

115 Hope, *Household Furniture* [Bib. B], p. 53.

116 T. Kappel, 'The Heir Presumptive, Abildgaard and Thorwaldsen', in *Copenhagen as it was in 1796* (Copenhagen 1996), pp. 43–49.

117 Designs issued in Leipzig in 1795 by F. G. Hoffmann, *Neues Verzeichnis und Muster-charte des Meublen-Magazins*, include many exactly copied from Hepplewhite.

118 e.g. Richter (cit. at n. I/15), ill. 276 .

119 In two terracottas, *Aphrodite and Thanatos* and *Aphrodite and Eros*, by Rombout Pauwels (1625–92) in the Musée des Beaux Arts, Lille. Regrettably, the author saw these amazing pieces too late to include a photograph.

VIII Grotesque and 'Archaeological' Classicism *pp. 211–32*

1 *Paper Museum* (cit. at n. V/14), p. 233.

2 T. Ashby, 'Drawings of Ancient Paintings in English Collections, Part I – the Eton Drawings', *Papers of the British School at Rome*, VII (n.d.), no. I.

3 Caylus, *Vies* (cit. at n. VI/36), introd. pp. xviii, iv.

4 Evans (cit. at n. I/116), II, p. 120.

5 Mme de Rémusat, *Memoirs* (London 1880), I, p. 65.

6 Dubois and Marchais, *Recueil de dessins des armures, casques, cuirasses, etc., tirés du Musée Impérial de l'artillerie de France et des cabinets particuliers* (1808).

7 Said of Professor Franz Passow (1786–1833), who taught Greek at Weimar, by Thomas Mann, *Lotte in Weimar*, trans. H. Lowe-Porter (London 1982), p. 116.

8 H. Lefuel, *Jacob-Desmalter* (Paris 1925), p. 91.

9 In 1672 it was suggested that papier-mâché could ornament picture frames; an artificial wood was patented in 1693: P. Kirkham, 'The London Furniture Trade 1700–1780', *Furniture History* (Leeds 1988), ch. IX, 'New Materials and Techniques', pp. 117–22.

10 C. Witt-Dörring, 'Seat Furniture from the Danhauser Factory', *Furniture History* (Leeds 1993), p. 149.

11 Evans (cit. at n. I/116), II, p. 125.

12 Percier and Fontaine, *Recueil* [Bib. B], p. 12.

13 Hope, *Household Furniture* [Bib. B], p. 10.

14 *Horace Walpole's Correspondence with the Countess of Upper Ossory*, ed. W. S. Lewis and D. Wallace (London 1955), XXVIII, pp. 101–2.

15 *Works* (cit. at n. VII/15), preface, p. 35.

16 'giudico disgustosa, fatua e degna di essere distrutta tutta la pittura (ed anche la scultura)';

quoted by R. Averini, *Palazzo Baldassini e l'arte di Giovanni da Udine* (Inst. di Studi Romani 1957), p. 37.

17 F. de Guevara, *Commentarios de la pintura* (Madrid 1788), p. 68.

18 The figure is influenced by an antique type of Diomedes, frequently found on gems.

19 Lefuel (cit. at n. 8), p. 32.

20 Percier and Fontaine, *Recueil* [Bib. B], p. 11.

21 ibid., pp. 5, 2.

22 *Un Age d'or des arts décoratifs* (Paris 1991), pp. 180, 181.

23 ibid., p. 35.

24 Hope, *Household Furniture* [Bib. B], pl. 18.

25 ibid., pl. 23.

26 ibid., pl. 20 (1, 2), 22 (4).

27 ibid., pl. 39.

28 For an explanation of 'panelling out', see Morley (cit. at n. IV/111), pp. 255–56.

29 ibid., ill. p. 399.

30 It did occur, however, to the carvers of the gilded wooden screens of Greek Byzantine churches. A tentative thought – was this 'artisan' motif possibly taken to America by emigrant workmen?

31 Some pieces were copied by Jeanselme of Paris.

32 See L. Bandera Gregori, 'Filippo Pelagio Pelagi', *Apollo* (May 1973).

33 Smith (cit. at n. I/13), p. 478.

34 ibid., p. 484.

35 G. Smith, a 'Dwarf Library Bookcase', 1804, ill. Morley (cit. at n. IV/111), p. 390.

36 G. Smith, 'Ottoman for a Music Room', 1806, ill. J. Harris, *Regency Furniture Designs* (London 1961), no. 112.

37 *Journal of Elizabeth, Lady Holland* (London 1908), II, p. 41.

38 Hope, *Household Furniture* [Bib. B], pl. 11.

39 Incorrectly identified in the Monticello catalogue with an 'étagère' purchased in France.

40 A. Chenevière, *Russian Furniture* (London 1988), p. 163.

41 Ill. Gilbert, *Temple Newsam* (cit. at n. V/72), II, p. 308.

42 'It should be stressed that there is no evidence whatever for the commonly held belief that C. H. Tatham was a designer of furniture as such': D. Udy, 'The Neo-Classicism of Charles Heathcote Tatham', *Connoisseur*, CLXXVII (1971), p. 271.

43 Hope, *Household Furniture* [Bib. B], pl. 5.

44 Ill. Morley (cit. at n. IV/111), p. 392.

45 I. Jenkins and K. Sloan, *Vases and Volcanoes, Sir William Hamilton and his Collection* (London 1996), p. 232.

46 e.g. examples with solid porphyry tops, Royal Pavilion, Brighton.

47 Hope, *Household Furniture* [Bib. B], p. 35.

48 Durand [Bib. A], pl. 65.

49 D'Hancarville, *Antiquités* (cit. at n. VII/98), p. 120.

50 O. van Veen, *Vaenius emblemata sive Symbola* (Brussels 1624). Goethe owned an incomplete copy of Alciati's *Emblemata*.

51 Ill. Morley (cit. at n. IV/111), p. 369.

52 Dated by pencil on the bottom of a drawer 'M. Oliver married the 5 of October 1811'.

53 C. P. Landon, *Annales du Musée* (Paris 1801), p. 16.

54 Ill. P. Agius and S. Jones, *Ackermann's Regency Furniture and Interiors* (Marlborough, Wilts., 1984), p. 99.

55 G. Himmelheber, *Biedermeier Furniture*, trans. S. Jervis (London 1974), pp. 35, 33.

56 A sofa with some similarities is ascribed to Holstein: ibid., pl. 70. Dr C. Witt-Dörring told the author he considered it Viennese.

57 Ill. Himmelheber (cit. at n. 55), pl. II.

58 ibid., pls 15, 16.

59 See Hope's rendering of lyres in his sketchbook (RIBA, London), *Household Furniture* [Bib. B], pl. 56, and *Costumes of the Ancients* [Bib. A], II, 200.

60 *Un Age d'or* (cit. at n. 22), cat. 103.

61 *Clarissimi Viri D. Andreae Alciati Emblemata* (Paris 1542), p. 52.

62 The term 'sofa' first appeared in 1717, from the Arabic, it had the connotation of comfort.

63 Gilbert, *Temple Newsam* (cit. at n. V/72), II, cat. 627, 628.

64 *Encyclopaedia Britannica* (cit. at n I/125), V, p. 926.

65 Morley (cit. at n. IV/111), ill. p. 372.
66 Praz, *Interior Decoration* (cit. at n. IV/113), ill. 179.
67 The elbows of Abildgaard's chair, on the other hand, probably originate in an influential 'cut-out' chair depicted in the *Antichità di Ercolano* (*Le pitture* cit. at n. I/55), IV, pl. XLIV, p. 211) and elsewhere [10]. The same painting probably influenced a cut-out chair of about 1800 by Abildgaard [395] and a well-known armchair by Schinkel of 1828; the latter replaced the cut-out legs by legs of his own invention but retained the rod-like arms and sphinxes of the original.
68 Percier and Fontaine, *Recueil* [Bib. B], pl. 65.
69 M. Snodin, *Karl Friedrich Schinkel, A Universal Man* (London 1991), p. 114.
70 Morley (cit. at n. IV/111), ill. p. 93.
71 *Un Age d'or* (cit. at n. 22), p. 130.

IX Eclectic Revivalism *pp. 234–60*

1 Gruber, *Classique et Baroque* (cit. at n. IV/217), ill. p. 28.
2 ibid., p. 204.
3 Knight [Bib. C], p. 167.
4 Eastlake, *Gothic Revival* [Bib. A], p. 36.
5 A. B. Sprague, *Tides in English Taste, A Background for the Study of Literature* (Cambridge, Mass., 1937), II, p. 52; also ch. IV.
6 Eastlake, *Gothic Revival* [Bib. A], p. 102. Pugin was less obtuse, quoting Walpole, 'it has blundered into a picturesque scenery, not void of grandeur', *Specimens of Gothic Architecture* (London 1825), I, p. xii.
7 Earl of Shaftesbury, *Characteristics of Men, Manners, Opinions, Times* (London 1732), III, p. 401.
8 Evans (cit. at n. I/116), II, p. 160, quotes a French author (1702): 'L'architecture est un art de bâtir selon l'objet, selon le sujet, et selon le lieu.... Entre tous les ouvrages qu'il y a dans Paris, je choisirai…l'église Notre-Dame, la Sainte-Chapelle…'
9 Cordemoy [Bib. C], p. 110: 'il l'auroit été encore d'avantage, s'il eût retenu en même tems ce qu'il y a de bon dans le Gotique'.
10 ibid., p. 110: '& sentir en soi-même une secrète joye mêlée de vénération et d'estoime'. Soane later incorporated these words into a lecture.
11 Books by Bentham, Carter, Gough [all Bib. A], Halfpenny [Bib. B], and F. Grose, *The Antiquities of England and Wales* (London 1773–87).
12 Sprague (cit. at n. 5), II, p. 72.
13 *Itinerarium curiosum*; see Evans (cit. at n. I/116), II, p. 161.
14 Sprague (cit. at n. 5), II, p. 63.
15 Vardy [Bib. B], pls. 22, 31.
16 J. Archer, *The Literature of British Domestic Architecture 1715–1842* (Cambridge, Mass./ London 1985), p. 477.
17 Decker, *Gothic Architecture Decorated* [Bib. B].
18 See a design for three 'Gothick' chairs in Chippendale, *Director*, 1754 [Bib. B], pl. XXI.
19 Ward–Jackson (cit. at n. VI/13), p. 50.
20 T. B. Macaulay, quoted by Eastlake, *Gothic Revival* [Bib. A], p. 44.
21 Chambers, *Treatise* [Bib. B.], II, n.p. 307.
22 28 Sept. 1786; *Walpole's Correspondence with the Countess of Upper Ossory* (cit. at n. VIII/14), XXXIII, II, p. 329.
23 T. Wainwright, *The Romantic Interior* (New Haven/London 1989), p. 90.
24 *c.* August 1752; *Walpole's Correspondence* (cit. at n. VII/11).
25 For details see Gilbert, *Temple Newsam* (cit. at n. V/72), II, pp. 338–39.
26 Ill. G. Beard, *The Work of Robert Adam* (Edinburgh 1978), pl. 90.
27 Richardson, *Ceilings* [Bib. B], p. 11.
28 ibid., pp. 339–41.
29 J. Morley, *The Making of the Royal Pavilion, Brighton, Designs and Drawings* (London 1985), pp. 23, 228.
30 This last comment referred to Burlingtonian Palladianism, which influenced his architecture.
31 Evans (cit. at n. I/116), III, p. 167, quoting the Goncourts: 'genre gothique…absolument l'architecture de nos anciennes chapelles'.
32 ibid.

33 Quoted by M.-L. Biver, *Pierre Fontaine* (Paris 1964), p. 207: 'le goût des ogives, des petites colonnes, des vitraux…celui-ci est trop éloigné de nos moeurs'.
34 Agius and Jones (cit. at n. VIII/54), p. 173.
35 ibid., p. 167.
36 Revived rococo furniture was deliberately placed within Gothic Revival rooms: Morley (cit. at n. IV/111), pp. 318, 408.
37 Knight [Bib. C], p. 160.
38 Quoted by Agius and Jones (cit. at n. VIII/54), p. 162.
39 Gothic decoration was frequently applied to the antique sarcophagus shape.
40 *Un Age d'or* (cit. at n. VIII/22), p. 29.
41 G. Sand, *Story of my Life*, ed. T. Jurgrau (New York 1991), p. 843.
42 Ill. *Un Age d'or* (cit. at n. VIII/22), cat. 57.
43 ibid., cat. 157.
44 Ruskin, *Stones of Venice* (cit. at n. II/48), p. 169
45 M. Praz, *The Romantic Agony*, trans. A. Davidson (Oxford 1970), p. 403.
46 C. Eastlake, *Hints on Household Taste* (London 1878), p. 158.
47 Morley (cit. at n. IV/111), p. 14.
48 e.g. '[George] Smith was constrained to admit that the "spirit for design" was at length checked and weakened; he knew the cabinet trade to be commercialized': R. Fastnedge, *English Furniture Styles* (London/Tonbridge 1961). Indeed, but the commercialization lay in the buyers as much as the trade.
49 Smith (cit. at n. I/13), p. 478.
50 C. Brontë, *The Professor* (Ware 1994), pp. 153–54; written 1845–46, published 1857.
51 Mazois [Bib. A], pp. 11, 13: 'et la noble et élégante simplicité des Grecs fut remplacée par une magnificence barbare dont l'Asie offert [sic] les modèles'. This comment echoes Pliny, *Natural History*, ch. 3.
52 *Memoirs of the Prince de Talleyrand*, ed. Duc de Broglie (London/Sydney 1891), II, p. 19.
53 *Un Age d'or* (cit. at n. VIII/22), pp. 507–10.
54 Jones, *Grammar* [Bib. A], p. 67.
55 See e.g. a French dressoir, probably *c.* 1855 (Frick Coll., New York, 16.5.66).
56 *Memoirs of the Duke of Rovigo* (London 1828), I, p. 296.
57 Muntz (cit. at n. IV/10), p. 400: 'Le quinzième siècle a précédé le Premier Empire dans cette prédilection, mais où celui-ci a mis la lourdeur et l'ennui, la Renaissance a mis la distinction et le charme'.
58 Eastlake, *Hints* (cit. at n. 46), p. 4.
59 M. Aldrich, ed., *The Craces, Royal Decorators 1768–1899* (Over Wallop, Hants, 1990), p. 55.
60 Croft-Murray, *Decorative Painting* (cit. at n. VII/53), II, p. 58.
61 W. Morris, *The Decorative Arts, Their Relation to Modern Life and Progress* (London 1878), p. 5.
62 Eastlake, *Hints* (cit. at n. 46), p. 4.
63 'Machinery', *Furniture History* (Leeds 1988), pp. 112–13.
64 Via the Society of Industrial Art (founded 1845) and its successor the 'Union Centrale des Beaux-Arts' (1863).
65 Via the 'Museum of Manufactures' and the 'Museum of Ornamental Art'.
66 Knight [Bib. C], p. 162.
67 The nomenclature of English Gothic was sorted out in T. Rickman, *Attempt to Discriminate the Styles of Architecture in England* (1819).
68 Eastlake, *Gothic Revival* [Bib. A], p. 91. Especially by Britton, Pugin, and Rickman: see Bib. A.
69 Eastlake, *Hints* (cit. at n. 46), p. 37.
70 Château de Loppem, Belgium, ill. Gruber, *Du Néoclassicisme à l'Art Déco* (cit. at n. VII/112), p. 178.
71 *Contrasts; or a Parallel Between the Noble Edifices of the Fourteenth and Fifteenth Centuries and similar buildings of the Present Day; Shewing the Present Decay of Taste* (Salisbury 1836).
72 Viollet-le-Duc, *Dictionnaire du mobilier* [Bib. A].
73 See M. Barker, 'An Appraisal of Viollet-le-Duc and his influence', *Decorative Arts Soc. Journal* (York 1992), pp. 3–14.
74 Eastlake, *Hints* (cit. at n. 46), p. 38: 'Judged by the light of a maturer taste, they may appear deficient in artistic quality'.

75 'Revealed construction' was Laugierian. Hope, *Household Furniture* [Bib. B], p. 63, said a marble chimneypiece represented 'rude and massy timber-work…the upright posts, the transverse beams, the rafters, the wedges and the bolts'.
76 Eastlake, *Hints* (cit. at n. 46), p. 21.
77 W. Morris, preface to Ruskin, *The Nature of Gothic, A Chapter of the Stones of Venice* (London, Kelmscott Press, 1892), p. iv.
78 J. Ruskin, *The Diaries of John Ruskin*, selected and ed. J. Evans and J. H. Whitehouse (Oxford 1956), pp. 160–61, 3 March 1841.
79 Morris, preface (cit. at n. 77), p. i.
80 Hope, *Household Furniture* [Bib. B], p. 17.
81 Morris, *Decorative Arts* (cit. at n. 61), pp. 18, 19, 5.
82 Morris himself, Dante Gabriel Rossetti, Ford Madox Brown, Edward Burne-Jones, and Arthur Hughes.
83 *Building News* (9 Aug. 1861); quoted by Wilk (cit. at n. V/70), p. 158.
84 Wilk (cit. at n. V/70), p. 154.
85 ibid., p. 154.
86 Eastlake, *Hints* (cit. at n. 46), p. 57.
87 *The Pre-Raphaelite Era 1848–1914* (Delaware Art Museum, 1976), p. 62.
88 Talbert, *Gothic Forms* [Bib. B], pl. 15.
89 ibid., p. 5.
90 ibid., p. 1.
91 ibid.
92 C. Dickens, *Pickwick Papers*, ch. XIV.
93 G. Meredith, *The Egoist*, 1879 (Harmondsworth 1987), p. 199.
94 L. Parry, ed., *William Morris* (London 1996), p. 165.
95 Hope, *Household Furniture* [Bib. B], p. 17.
96 Morris, preface (cit. at n. 77) p. i.
97 Morris, *Decorative Arts* (cit. at n. 61), p. 16.
98 G. W. Smalley, *Studies of Men* (London 1895), p. 180.
99 In 1869–70 the average agricultural wage for men in Herefordshire was 10s. 3d. per week; by 1882 it was 13s.
100 Parry (cit. at n. 94), p. 176, cat. J.26.
101 T. Hardy, *Jude the Obscure*, 1895 (London 1971), p. 317.
102 Significant examples were the 'Century Guild' (1882) and its magazine *The Hobby Horse*, the 'Art Workers' Guild', the Arts and Crafts Exhibitions Society (from 1888), and the 'Guild and School of Handicraft' (1888).
103 From 1897 it was also published in the USA.
104 Tatham, Letters (cit. at n. VII/54).
105 M. H. Baillie Scott (1865–1945), an Arts and Crafts designer touched by Secessionist style, very successful in Europe.
106 Somewhere in the memoirs of Mme Vigée Lebrun.
107 Lefuel (cit. at n. VIII/8), p. 89.
108 Tatham, *Etchings…of Ancient Ornamental Architecture* [Bib. A], p. 4.
109 Tatham sketchbook (RIBA, London), O66–10, 'Elbow chair from an old Picture of Paul Veronese'.
110 Hughes (cit. at n. V/68), II, p. 610.
111 Morley (cit. at n. IV/111), p. 275.
112 ibid., p. 276.
113 ibid.
114 ibid., ill. p. 268.
115 ibid., pp. 305–7.
116 Prince Pückler-Muskau, *Tour of a German Prince* (London 1832), IV, p. 339, 29 April 1828.
117 W. Papworth, *J. B. Papworth* (London 1879), pp. 107–8.
118 Whittock [Bib. B], p. 192.
119 Scott, *The Ornamentist* [Bib. B].
120 G. de Bellaigue and P. Kirkham, *Furniture History* (Leeds 1974), p. 7.
121 *Furniture History* (Leeds 1988), p. 121.
122 Eastlake, *Hints* (cit. at n. 46), p. 158.
123 ibid., p. 56.
124 See S. de Voe, *English Papier Mâché of the Georgian and Victorian Periods* (London 1971).
125 Quoted in *The Pre-Raphaelite Era* (cit. at n. 87), p. 36.
126 *Masterpieces in the Brooklyn Museum* (New York 1988), p. 161.
127 P. Macquoid, *The Age of Satinwood* (London 1923), p. 105.
128 See C. Vincent, 'Belter's Patent Furniture', *Furniture History* (Leeds 1967), for a description of the processes.

129 Riccardi-Cubitt (cit. at n. IV/122), p 184.
130 E. English and W. Maddox, *Views of Lansdown Tower, Bath* (London 1844), p. 6.
131 ibid, preface.
132 Morley (cit. at n. IV/111), pp. 279–81.
133 ibid., ills. LXXVII, LXXVIII.
134 English and Maddox (cit. at n. 130), p. 6.
135 M. Gelfer-Jørgensen, *Herculanum paa Sjaelland* (Copenhagen 1988), cat. 53.
136 ibid., p. 370.
137 Smith, *Cabinet-Maker* [Bib. B], p. vi.35, quoted by Morley (cit. at n. IV/111).
138 Pückler-Muskau (cit. at n. 116), II, p. 43.
139 Details given in *American Art* (Washington, D.C.), X, no.2.
140 Talbert, *Examples* [Bib. B], unpag.
141 Solon, *Inventions décoratives* (1866).
142 Wilk (cit. at n. V/70), p. 164.
143 Gell [Bib. A, 1832], p. 1.
144 Gell [Bib. A, 1817–19], p. vi.
145 Jones, *Grammar* [Bib. A], p. 40.
146 Gelfer-Jorgensen (cit. at n. 135), ill. 119, p. 141.
147 A fabric 'adapted' from the original textile is shown on the chair belonging to the Metropolitan Museum, New York: D. O. Kisluk-Grosheide, *Metropolitan Museum Journal*, XXIX, p. 152.
148 ibid., pp. 172–74.
149 S. MacDonald, , 'Gothic Forms applied to Furniture', *Furniture History* (Leeds 1987), p. 45.

X Frugality and Functionalism
pp. 262–74

1 Aristotle, *Nicomachean Ethics*, trans. H. Rackham (London 1934), I.VII.10, 14–16.
2 ibid., trans. D. Ross (Oxford 1998) I.VII.7, 12–13.
3 Quintus Curtius (cit. at n. I/107), pp. 379, 347.
4 'étoit conforme à la raison & à la vérité'; Cordemoy [Bib. C], p. 14.
5 Quoted by H. Honour, *Neo-classicism* (Harmondsworth 1968), p. 113.
6 Memmo [Bib. C]. The quotations that follow come from vol. I, pp. 84–86, first printed in 1786. Mr Giovanni Caselli helped with the knotty points of the translation.
7 Winckelmann, *Histoire de l'Art*, Bk IV, ch. II, p. 20, quoted by Evans (cit. at n. I/116), II, p. 106.
8 Memmo [Bib. C]: 'Riflettiva per la medesima causa di dar pensiero all'oggetto finale delle cose, essersi perfezionata quella parte di nautica che spetta alle gondole veneziane, che salve le patrie santuarie leggi non potevano essere ne più scorrevoli ne più ubbidienti, ne più forti ne più leggiadre in ogni loro parte, appunto perche ogni pezzo di legno aveva la sua figura proporzionala alla differente sua indole, ed era messo a luogo con ragione; che se si fosse fatto il fondo di carrubo e le coste d'abete, cioè il contrario, la gondola sarebbe stata una rovina.'
9 The sequence of publications that derived from Lodoli's ideas is given in *Age of Neo-Classicism* (cit. at n. VII/114), pp. 590–91.
10 J. J. Winckelmann, *Reflections on the Painting and Sculpture of the Greeks*, trans. H. Fuseli (London 1765), p. 30.
11 Pradère (cit. at n. VI/116), p. 368.
12 Ill. Morley (cit. at n. IV/111), p. 381.
13 John Joseph Merlin, *The Ingenious Mechanick* (London 1985), p. 63.
14 Information kindly supplied by Mr A. L. Odmark.
15 ibid., for Merlin's career.
16 Sheraton, *Cabinet-Maker and Upholsterer's Drawing-Book* [Bib. B], Pt III, pl. 30.
17 *Un Age d'or* (cit. at n. 42), cat. 156.
18 In 1903, Adolf Loos wrote: 'There was a time when there was no difference between English and Austrian furniture and the products of the carpenter's shop. That was at the time of the Vienna Congress' (almost one hundred years earlier). Quoted by C. Witt-Dörring, 'Illusion and reality – Form and Function in Modern Furniture, *c.* 1900', *Decorative Arts Soc. Journal*, no. 7 (Swindon, 1982), p. 24, 25. This article contains an analysis of relationships and ideas between Viennese, Scottish and English innovators.
19 G. Cumberland, *Thoughts on Outline* (London 1796), p. 8.

20 Aristotle, *Treatise on Poetry* (London 1812), p. 120: 'in painting, the most brilliant colours, spread…without design, will give far less pleasure than the simplest outline of a *figure*'.
21 *Vienna in the Age of Schubert* (Uxbridge, Mddx.), cat. 55, unpag.
22 All the designs mentioned here are reproduced in P. and S. Asenbaum and C. Witt-Dörring, *Moderne Vergangenheit 1800–1900* (Vienna 1981), p. 221.
23 Snodin, *Schinkel* (cit. at n. VIII/70), p. 49.
24 See Dr Windisch-Graetz, 'Le bon goût selon M. Biedermeier', *Connaissance des Arts* (Sept. 1959), pp. 76–83.
25 Sheraton, *Cabinet Dictionary* [Bib. B], I, p. 46. See P. E. Kane, 'Samuel Gragg, his bentwood fancy chairs', *Yale University Art Bulletin*, 33, no.2 (autumn 1971), for a useful summary.
26 T. D. Rieman and J. M. Burks, *The Complete Book of Shaker Furniture* (New York 1993), p. 20.
27 ibid., p. 22.
28 ibid., pp. 25–26, 31.
29 C. Dickens, *American Notes*, ch. XV.
30 C. Dickens, *Dombey and Son*, ch. VII.
31 Rieman and Burks (cit. at n. 26), respectively cat. 58, 158, 264, 301, 315.
32 ibid., p. 46.
33 For the use of stains by the Shakers, ibid., p. 60; a chest p. 19, p. 114, and a blanket box pl. 62, p. 90, both stained yellow. Yellow was used for Biedermeier furniture.
34 Gelfer-Jorgensen (cit. at n. IX/135), pp. 370–71.
35 E. Aslin, *E. W. Godwin, Furniture and Decoration* (London 1986), p. 7.
36 ibid., p. 7.
37 ibid.
38 G. Cavalli-Bjorkman and B. Lindwall, *The World of Carl Larsson* (La Jolla, Calif., 1982), pp. 134, 151.
39 Gelfer-Jorgensen (cit. at n. IX/135), p. 4.
40 ibid., p. 82.
41 ibid., p. 167, cat. 158.
42 N. Pevsner, *Pioneers of Modern Design* (Harmondsworth 1984), p. 27.
43 H. G. Wells, *Kipps* (Harmondsworth 1941), p. 52.
44 Witt-Dörring, 'Illusion' (cit. at n. 18), p. 20, quoting *Kunst und Kunsthandwerk* (1908).
45 ibid., p. 20.
46 ibid., pp. 18–19, 22.
47 F. R. Brandt, *Late Nineteenth and early Twentieth Century Decorative Arts, the Sidney and Frances Lewis Collection in the Virginia Museum of Fine Arts, Richmond* (Richmond, Va., 1985), p. 114.
48 Ill. Morley (cit. at n. IV/111), ill. 330, p. 412. It was designed by Robert Mallet (1810–81), an engineer.
49 J. Kallir, *Viennese Design* (New York/London 1986), p. 73.
50 B. Hillier, *The Young Betjeman* (London 1989), p. 259.
51 See J. Conrad, *The Secret Agent*.
52 M. Trachtenberg and I. Hyman, *Architecture, from Prehistory to Post-Modernism* (London 1986), p. 519.
53 F. Camard, *Ruhlmann, Master of Art Deco* (London 1984), p. 14.
54 ibid.
55 Windisch-Graetz (cit. at n. 24), p. 81.
56 S. Chermayeff, *Design and the Public Good*, ed. R. Plunz (London 1982), p. 11.
57 For details of the timing and techniques of early tubular steel furniture see C. Benton, '"L'Aventure du Mobilier," Le Corbusier's Furniture Designs of the 1920s', *Decorative Arts Soc. Journal*, no. 6 (Swindon 1981), pp. 7–17.
58 M. Battersby, *The Decorative Twenties* (London 1969), p. 60.
59 H. Muthesius, *Das Englische Haus* (Berlin 1904–5).
60 Pevsner, *Pioneers* (cit. at n. 42), pp. 34, 35.
61 Said in 1914; ibid., p. 37.
62 The pseudonym of Charles Édouard Jeanneret.
63 Trachtenberg and Hyman (cit. at n. 52), p. 527.
64 Hope's design for an X-frame stool in *Household Furniture* [Bib. B], pl. 12 (3), has similar curves, although less close to Mies van der Rohe than to the Egyptian chair.

65 Wilk (cit. at n. V/70), ill. p. 204.
66 ibid., p. 206.
67 ibid., ill. p. 206.
68 Asenbaum and Witt-Dorring, *Moderne Vergangenheit* (cit. at n. 22), p. 219, ills 148, 149.
69 *Furniture Godwin and Breuer* (typed cat., Bristol Museum, 1976), unpag.
70 N. Whiteley, '"Semi-Works of Art", Consumerism, Youth Culture and Chair Design in the 1960s', *Furniture History* (Leeds 1987), p. 110.
71 *Overseas Review*, p. 48 (undated photocopy in Furniture Dept archives, Victoria & Albert Museum, London). The 'structural total' of Saarinen's chair almost undoubtedly did come ultimately from ancient Egypt: see a papyrus of Her-Heru and Queen Netchemet in the British Museum which shows offering tables, probably ceramic, with waisted bases identical to that of the chair and table (a ceramic – plastic – origin is the only possible 'structural' origin of such a motif). See E. A. Wallis Budge, *The Literature of the Ancient Egyptians* (London 1914), ill. opp. p. 52.
72 P. Sparke, review of J. Meikle, 'American Plastic', *Studies in the Decorative Arts, the Bard Graduate Center*, IV, no.2 (New York 1997), p. 111.

XI The Wilder Shores of Style
pp. 276–308

1 See V. Dumitrescu, *L'arte preistorica in Romania fino all'inizio dell'età del ferro* (Florence 1972).
2 Wanscher (cit. at n. I/99), p. 279; the earliest written evidence points to a foreign origin.
3 The author is told that nothing has been published on the inter-relationships between European, Japanese and Chinese ornament, although Japanese scholars were working on the subject before the Second World War.
4 D. Shvidkovsky, *The Empress and the Architect* (New Haven/London 1996), p. 176.
5 H. Joyce, 'The Ancient Frescoes from the Villa Negroni', *Art Bulletin* (Providence, R.I., Sept. 1983), p. 423.
6 From Diderot's *Encyclopédie*: 'une variété bizarre, et sans rapport ni symétrie, comme dans l'Arabesque ou dans le goût chinois'; quoted by Evans (cit. at n. I/116), II, p. 75.
7 Cordemoy [Bib. C]: 'le R. P. Tournemine Jésuite également célèbre & par une érudition profonde, & par un goût tout particulier pour les beaux Arts, en attribue au contraire l'invention aux Mores. Ses conjectures paroissent assez bien fondées.'
8 ibid., pp. 241–43.
9 Cordemoy [Bib. C], p. 280: 'ou ce qui est la même chose, les Arabes, qui ont eu dans leur Architecture le même goût que dans leur Poésie. L'une & l'autre a été faussement délicate, chargée d'ornemens superflus, toujours éloignée du naturel. L'imagination… a rendu les édifices des Arabes aussi extraordinaires que leur pensées.'
10 'La Compagnie a désapprouvé plusieurs de ces nouvelles manières, qui sont défectueuses et qui tiennent la plupart du gothique'; quoted by Kimball (cit. at n. V/20), p. 66 .
11 Castell [Bib. A], p. 107.
12 In his *Lettres familières écrites d'Italie à quelques amis*: 'Les Italiens nous reprochent qu'en France…nous redonnons dans le goût gothique, que nos cheminées, nos boîtes d'or, nos pièces de vaisselle d'argent sont contournées et recontournées, comme si nous avions perdu l'usage du rond et du carré, que nos ornements deviennent du dernier baroque'; quoted by Gruber, *Classique et Baroque* (cit. at n. IV/217), p. 328.
13 Mercier in *Tableau de Paris*: 'le comte de Caylus a ressuscité parmi nous le goût grec et nous avons enfin renoncé à nos formes gothiques'; quoted by Eriksen (cit. at n. VI/32), p. 162.
14 R. Ling, 'Studius and the Beginnings of Roman Landscape Painting', *Journal of Roman Studies*, LXVII (London 1977), pp. 12, 13.
15 Described and ill. *Paper Museum* (cit. at n. V/14), pp. 113–14.
16 Sotheby's cat., London, 9 April 1970, p. 15, lot 160.

17 Whittock [Bib. B], p. 114.
18 C. Dresser, *Studies in Design* (London 1874), p. 3.
19 C. Dickens, *Little Dorrit* (1855–56), ch. XIII.
20 Voltaire (cit. at n. VI/23), ch. XXXIX.
21 Nieuhof [Bib. A], Bk II, p. 138.
22 G. de Roubrock, *Livre des merveilles du monde* (1252–54).
23 *Histoire du Grand Royaume de la Chine* (1585).
24 Voltaire (cit. at n. VI/23), p. 322.
25 In this narrative the term 'japonaiserie' will be replaced when discussing eighteenth-century material with the nineteenth-century term 'japonisme' when it comes to discussing the profound effects on European arts and furniture that followed the reopening of Japan's borders in 1854.
26 For the whole subject, see H. Walravens, *China illustrata* (Wolfenbüttel 1987).
27 'à la manière de toutes les nations célébres qui sont au monde, à l'italienne, à l'allemande, à la turque, à la persane, à la manière du Mogol, du Roi de Siam, de la Chine etc.'; quoted by Gruber, *Du Néoclassicisme à l'Art Déco* (cit. at n. VII/112), p. 63.
28 Nieuhof, *L'Ambassade de la Compagnie Orientale des Provinces Unies vers l'empereur de la Chine* [Bib. A].
29 See E. Standen, *European Post-Medieval Tapestries and Related Hangings in The Metropolitan Museum of Art* (New York 1985), II, p. 464.
30 Kircher, *China Illustrata* [Bib. A].
31 Dapper, *Gedenkwurdige Verrichtung…in dem Kaiserreich Taising oder Sina* [Bib. A].
32 Jean Revel, *Livre des Dessins Chinois* (1735).
33 Designed by Le Camus de Mézières and built 1761–75.
34 Not Fischer von Erlach's *Historische Architektur* of 1721, as stated in the official guide to Troia (Prague, n.d.), p. 26.
35 Fischer von Erlach, *Entwurff* [Bib. A].
36 Hope, *Historical Essay* (cit. at n. IV/88), pp. 21, 25. He thought Chinese architecture had a sameness as if arrested 'by an attack of palsy'.
37 A. Boyd, *Chinese Architecture and Town Planning* (London 1962), pp. 26–29, 39.
38 H. Honour, *Chinoiserie, The Vision of Cathay* (London 1961), p. 42.
39 A. Kircher, *La Chine* [Bib. A], p. 253.
40 Chambers, *Chinese Buildings* [Bib. B].
41 Honour, *Chinoiserie* (cit. at n. 38), p. 89.
42 'Una lettiera dell'Indie tutta dorata', three chairs 'indiane di legname nero', 'Un tavolino di Chine del indie'; quoted by Thornton, *Italian Renaissance Interior* (cit. at n. IV/39), pp. 157–58.
43 Hakluyt, quoted by Honour, *Chinoiserie* (cit. at n. 38), p. 30.
44 ibid., p. 30; Mr Honour points out that the Greek word for 'China' gave the Romans their word for 'silk', as Europeans called porcelain 'china' and lacquer 'japan'.
45 By Mathias Beitler (Victoria & Albert Museum, London, EO 6, E2157–61 1911).
46 e.g. a chair in rosewood and beech made in China, *c.* 1740 (Temple Newsam, Leeds, cat. 648).
47 For details see W. Watson, ed., *The Great Japan Exhibition, Art of the Edo Period 1600–1868* (London 1981), cat. p. 99.
48 'd'établir une manufacture de vernis pour être appliqué sur toutes sortes de toiles et étoffes de laine, de soie, de cuir et autres matières ployables et de toutes sortes de couleurs, propres à faire des meubles'; quoted by Evans (cit. at n. I/116), II, p. 59.
49 By Macret and Saunier; Pradère (cit. at n.VI/116), pp. 221, 336–37. *Tôle peinte* is japanned tinware.
50 Thornton, *Italian Renaissance Interior* (cit. at n. IV/39), p. 165.
51 Brice (cit. at n. V/9), p. 53.
52 Evans (cit. at n. I/116), II, p. 60.
53 Jackson-Stops (cit. at n. IV/210), p. 442.
54 Pub. in A. Laborde, *Voyage pittoresque et historique de l'Espagne* (Paris 1807–18), 4 vols. Ill. *Un Age d'or* (cit. at n. VIII/22), pp. 413–14.
55 ibid., cat.229.
56 Honour, *Chinoiserie* (cit. at n. 38), p. 100.
57 Hepplewhite, *Cabinet-Maker and Upholsterer's Guide* [Bib. B], p. 2.
58 Gombrich (cit. at n. IV/36), p. 13, pls 44–46.

59 C. Jagger, *Royal Clocks* (London 1983), pp. 136, 139.
60 Morley (cit. at n. IV/111), pp. 340–41.
61 See Ponce [Bib. A], pl. 57.
62 G. de Bellaigue, 'The Furnishings of the Chinese Drawing Room, Carlton House', *Burlington Magazine* (Sept. 1967), p. 520.
63 Chenevière (cit. at n. VIII/40), pp. 65, 68.
64 Pradère (cit. at n. VI/116), p. 299.
65 Details given by D. O. Kisluk-Grosheide, 'A Japanned Secretaire', *Metropolitan Museum Journal*, XXI (New York 1986).
66 Ill. extensively in Morley, *Pavilion* (cit. at n. IX/29).
67 ibid., p. 338.
68 F. Dietrich, *Roentgenmöbel aus Neuwied* (Bad Neustadt 1986), p. 119; J. M. Greber, *Abraham und David Roentgen, Möbel für Europa* (Starneberg 1980), II, pp. 217–19.
69 Ill. and discussed Morley (cit. at n. IV/111), p. 427, and *Country Life* (18 April 1991), pp. 118–20.
70 Abstract of Accounts of Royal Pavilion, Brighton, facing p. 10 (East Sussex County Library).
71 Kircher [Bib. A], pp. 262, 310.
72 Franciscus [Bib. A], opp. p. 1044.
73 C. Doumas, *Santorini, the Prehistoric City of Akroteri* (Athens 1957), ill.58.
74 J. Berain, *Desseins de cheminées dédiez à Monsieur Jules Hardouin Mansard…surintendant …des bâtiments* (Paris, prob. 1699), pl. 2.
75 *Poems of John Wilmot, Earl of Rochester*, ed. V. de Sola Pinto (London 1964): 'A Letter from Artemisa in the Town to Cloe in the Country', lines 143–44, p. 83.
76 G. Wilson, 'Boulle', *Furniture History* (Leeds 1972), p. 50.
77 Dietterlin [Bib. B], p. 18.
78 e.g. the Cabinet Turc at the Hôtel de Beauharnais, Paris, and Queverdo 'Kiosk à la Turque' of 1788 'Arabesques'.
79 In the Palazzo Cinese, near Palermo, Pompeian-Chinese exotic ornament is organized into a 'Pompeian' scheme.
80 Hodges, *Select Views in India* [Bib. A].
81 See Reynolds' *Discourse* to the Royal Academy, London, Dec. 1786.
82 Morley (cit. at n. IV/111), pp. 186–87, 201.
83 Herodotus [Bib. C], Bk II, p. 142.
84 See J. S.Curl, *The Egyptian Revival* (London 1982), p. 21.
85 See, for instance, 'Urne Sépolcrale', Montfaucon [Bib. A], V, Pt I, p. 54.
86 Curl (cit. at n. 84), p. 7.
87 Serlio [Bib. A], Bk III, p. cliii: 'Le maravigliossime cose di l'Egitto'.
88 Fréart de Chambray [Bib. A], p. 87: 'les Égyptiens (ces divins esprits à qui nous avons l'obligation de la connaissance de tant de beaux arts)…à voir cette grandeur si démesurée de leurs tombeaux, avoir esté des géants, & comme des Dieux entre les hommes'.
89 Félibien, *Entretiens* [Bib. A], I, pp. 6, 431: 'ces grands ouvrages des Perses & des Égyptiens, quoy que brutes & mal Polis, sont des marques éternelles de la grandeur de leurs monarques'.
90 Jackson-Stops (cit. at n. IV/210), ill. p. 241.
91 P. Conner, ed., *The Inspiration of Egypt* (Croydon 1983), p. 16.
92 A.-C. Quatremère de Quincy, *De l'Architecture égyptienne* (Paris 1803), p. 207: 'Il n'y eut en Égypte identité de matière et de goût'.
93 Pococke, *A Description of the East* [Bib. A].
94 Norden, *Voyage d'Égypte* [Bib. A].
95 Piranesi, *Diverse Maniere* [Bib. B], p. 14; quoted in Conner (cit. at n. 91), p. 18.
96 Later re-used by Grognard as chairs covered with printed blue hide for an Egyptian Room probably designed for the Duchess of Alba.
97 ibid., p. 76.
98 For more information and a Borghese Egyptian-style chair ill., ibid., cat. 4.
99 For the sculpture, ibid., pp. 101–3.
100 *Masterwerk I Nationalmuseum*, ed. C. Hernmarck (Stockholm 1954), p. 147.
101 ibid.
102 B. Tattersall, 'Flaxman and Wedgwood', in D. Bindman, ed., *John Flaxman R.A.* (London 1979), p. 47.

103 As at Osterley in England.
104 Conner (cit. at n. 91), p. 28.
105 Jones, *Grammar* [Bib. A], p. 24.
106 *Egyptomania* (cit. at n. 96), p. 206.
107 ibid., p. 326.
108 C. Monkhouse, 'A Temple for Tomes', *Furniture History* (Leeds 1990), pp. 157–64.
109 Hope, *Household Furniture* [Bib. B], p. 26.
110 ibid., p. 17.
111 Norden [Bib. A], pl. CXLIV.
112 Quatremère de Quincy (cit. at n. 92), pls. 1, 9.
113 See Morley (cit. at n. IV/111), pp. 190–91, 343–45.
114 In the Archaeological Museum at Syracuse.
115 Hope, *Household Furniture* [Bib. B], p. 44.
116 By A. González-Palacios in *Egyptomania* (cit. at n. 96), p. 189.
117 Hope, *Household Furniture* [Bib. B], p. 10.
118 Discussed and ill. Morley (cit. at n. IV/111), pp. 377, 384.
119 Laugier [Bib. C], p. 291: 'un terrible amas de matériaux prodigue à satisfaire un orgueil outré…des montagnes de marbre pour couvrir un corps à qui il ne faut que six pieds de terrain'.
120 Hope, *Household Furniture* [Bib. B], p. 27.
121 Morley (cit. at n. IV/111), pp. 343–44.
122 Conner (cit. at n. 91), p. 12.
123 *Egyptomania* (cit. at n. 96), p. 74.
124 K. A. C. Creswell, *Early Muslim Architecture* (Oxford 1932), Pt I p. 184.
125 *Description de l'Égypte* (repr. Tours 1993), IV, pl. 23.
126 See Denon [Bib. A], pl. LXXIX.
127 Conner (cit. at n. 91), p. 97.
128 ibid.
129 Morley (cit. at n. IV/111), p. 191.
130 Jones, *Grammar* [Bib. A], pp. 22–24.
131 Conner (cit. at n. 91), p. 101.
132 See Parry (cit. at n. IX/94), ill. J5, p. 164.
133 Wilkinson [Bib. A], II, pp. 197, 198.
134 Ill. Conner (cit. at n. 91), p. 137, pl. 239.
135 The top is said to derive from pl. X,16 in Jones's *Grammar* [Bib. A] (Conner (cit. at n. 91), p. 102); the legs have elements from pls IV,10 and V,9; the sides are not directly related to any of the Jones plates.
136 Hope, *Household Furniture* [Bib. B], pl. 22 (5, 6); Smith, *Collection* [Bib. B], pls. 46, 55, 58.
137 Parry (cit. at n. IX/94), ill. J.16, p. 172. The 'Egyptian' combination militates against the eighteenth-century influences suggested in the catalogue.
138 Aslin, *Godwin* (cit. at n. X/35), ills 60, 62–65.
139 Ill. R. Billcliffe, *Charles Rennie Mackintosh The Complete Furniture Drawings and Interior Designs* (London 1980), cat. d.1900.71. The mirror is in Glasgow Art Gallery and Museum.
140 ibid., cat. 1904.51.
141 ibid., cat. 1901.31.
142 ibid., cat. 1903.20.
143 Riegl (cit. at n. I/59), p. 56, describes the source of cyma recta and egg and dart moulding in alternating lotus blossoms and buds.
144 Trachtenberg and Hyman (cit. at n. X/52), p. 497.
145 Wilk (cit. at n. V/70), p. 196.
146 ibid., ill. 196.
147 Baker (cit. at n. I/21), p. 132, ill. 186.
148 ibid., ill. p. 59.
149 E. Hiort, *Modern Danish Furniture* (London 1956), p. 9.
150 *The Goncourt Journals 1851–1870*, trans. L. Galantière (New York 1987), p. 210.
151 E. and J. de Goncourt, *Mémoires de la vie littéraire 1864–78*, Bk II (Paris 1903), p. 1011, Jan. 1862: 'L'art japonais est un art aussi grand que l'art grec, tout franchement, qu'est-il? pas de fantaisie, pas de rêve. C'est l'absolu de la ligne. Pas ce grain d'opium, si doux, si caressant.'
152 ibid., II, p. 85, 30 Sept. 1864: 'Leur art [Japanese art] copie la nature, comme l'art gothique. Au fond, ce n'est pas un paradoxe de dire qu'un album japonais et un tableau de Watteau sont tirés de l'intime étude de la nature. Rien de pareil chez les Grecs.'
153 'The Japanese Court in the International Exhibition', *The Gentleman's Magazine*
(July–Sept. 1862), pp. 243–45.
154 J. La Farge, *Hokusai, a talk about Hokusai, the Japanese Painter, at the Century Club, March 28 1896* (New York 1897), pp. 5–7.
155 Goncourt (cit. at n. 152), p. 465, 29 Oct. 1868: 'Ce goût aujourd'hui envahissant tout et tous, jusqu'aux imbéciles et aux bourgeoises'.
156 L. Gonse, *L'Art japonais* (Paris 1883), II, p. 181: 'On a dit avec raison que les laques étaient les objets les plus parfaits qui fussent sortis de la main des hommes.'
157 ibid., Bk I, p. 1: 'les premiers décorateurs du monde'.
158 Gruber, *Du Néoclassicisme à l'Art Déco* (cit. at n. VII/112), p. 218.
159 A. Watson, 'Not Just a Sideboard', *Studies in the Decorative Arts*, IV (New York 1997), no. 2, pp. 79–80.
160 ibid., p. 65
161 Aslin, *Godwin* (cit. at n. X/35), p. 8.
162 ibid., p. 19.
163 ibid.
164 See Godwin's drawing of 'Powderings or Crests', ibid., ill. 75, p. 90.
165 Neue Sammlung, Staatliches Museum für Angewandte Kunst, Munich; Victoria & Albert Museum, London; and The Wolfsonian Collection, Miami, respectively. All ill. Watson (cit. at n. 159).
166 Aslin (cit. at n. X/35), p. 11.
167 M. Komanecky and V. Butera, *The Folding Image* (New Haven/London 1984), p. 128.
168 ibid., x
169 E. Aslin, *The Aesthetic Movement* (London 1969), p. 13.
170 P. Garner, *Émile Gallé* (London 1976), p. 56.
171 Gallé étagère in Japanese taste in the Musée de l'École de Nancy: ibid., p. 52.
172 É. Gallé, 'L'Art expressif et la statue de Claude Gelée par M. Rodin', *Écrits pour l'art* (1908, repr. Marseille 1980), pp. 134–47: 'Les intuitions les plus rapides du Génie'.
173 Gonse (cit. at n. 156), I, p. 11: 'cette passion de la nature, de cette religion de travail qui éclatent dans toutes les oeuvres de Nippon, les rend plus sensibles aux lois harmonieuses de la couleur, les dégage des formules routinières de la symétrie, leur révèle…la simplification en matière de décor'.
174 A. Duncan, *Art Nouveau Furniture* (London/New York 1982), ills. 479–82.
175 Gonse (cit. at n. 156), II, p. 208.
176 Watson (cit. at n. 47), cat. 88.
177 Billcliffe (cit. at n. 139).
178 For Derngate and Ingram Street.
179 Gonse (cit. at n. 156), p. 11: 'nos artistes décorateurs ou pastiche japonais'.
180 Komanecky and Butera (cit. at n. 167), p. 15.
181 ibid., p. 44.
182 M. Battersby, *The Decorative Twenties* (London 1969), p. 139.
183 Silver furniture (not imitating life) tends to turn to gold: an indignant Lady Maufe complained to the author in 1969 that the Victoria & Albert Museum had turned her 'golden' desk to silver (it had removed yellowed varnish).
184 Battersby (cit. at n. 182), p. 39.
185 ibid., p. 42.
186 ibid., ill. p. 38.
187 Dresser [Bib. A], p. 327.
188 Aslin (cit. at n. X/35), pl. 28.
189 T. Brown, *The Work of G. Rietveld* (Utrecht 1958), p. 38.
190 See a throne by J. K. Bromeis, *c*. 1835–40 (Schloss Wilhelmshöhe, Kassel; Kreisel (cit. at n. V/56), III, ill. 503) and, especially, an armchair made up of Medusa shields (ill. G. Bazin, *The Loom of Art* (London 1962), pl. 373).
191 In the Virginia Museum of Art, 85.99.
192 S. Johnson, *Eileen Gray, Designer 1879–1976* (London 1979), p. 11.

XII Latter-day Polarities *pp. 310–28*

1 Gruber, *Du Néoclassicisme à l'Art Déco* (cit. at n. VII/112), p. 290.
2 For a comment see Praz, *Romantic Agony* (cit. at n. IX/45), p. 45.
3 Garner (cit. at n. XI/171), ill. p. 135.
4 ibid., p. 139.
5 'Voilà donc notre idéal réalisé, le meuble traité comme un corps nu…, orné…de ses organes épanouis comme ceux de l'animal ou du végétal, en leurs nerfs, en leurs chairs, pelages, plumages, tissus, membranes, écorces, en leur bourgeonnement, floraison, fructification': Gallé in *Revue des Arts décoratifs*) Nov.–Dec.1900), *Écrits pour l'art* (cit. at n. XI/173), p. 275.
6 See *French Symbolist Painters* (London 1972), introd. P. Jullian, p. 13.
7 H. de Balzac, *Cousin Pons* (1847).
8 *Encyclopaedia Britannica* (cit. at n. I/125), XI, p. 231.
9 'tout reste flexible, mobile, transparent': quoted by Gruber, *Du Néoclassicisme à l'Art Déco* (cit. at n. VII/112), p. 297.
10 Jones, *Grammar* [Bib. A], p. 70.
11 Garner (cit. at n. XI/170), p. 70.
12 'Nous avons essayé cependant d'ajouter à toute la ménagerie chimérique du mobilier quelques images réelles, et la "frissonnante libellule," immobilisée un instant, a prêté ses ailes à la statique des consoles': Gallé, 'Le Mobilier contemporain orné d'après la nature' (1900), *Écrits* (cit. at n. XI/172), pp. 263–64.
13 Duncan (cit. at n. XI/174), p. 13.
14 Jones, *Grammar* [Bib. A], p. 67.
15 Pevsner, *Pioneers* (cit. at n. X/42), pp. 37 onwards. His account of Art Nouveau is vitiated by his ignoring Islamic influence.
16 e.g. Jones, *Grammar* [Bib. A], pl. V(10).
17 J. Rutherford, *Art Nouveau, Art Deco and the Thirties, The Furniture Collections at Brighton Museum* (Brighton 1983), p. 12.
18 *Cahiers Henry van de Velde* (Brussels 1970), no. 11, p. 10.
19 ibid.; Serrurier-Bovy, quoting Viollet-le-Duc: 'une civilisation ne peut prétendre posséder un art que si cet art pénètre partout, s'il fait sentir sa présence dans les ustensiles les plus vulgaires'.
20 Richter (cit. at n. I/15), ills. 201, 209, 210, 228–30.
21 Billcliffe (cit. at n. XI/139), cat. 1904.19A.
22 Richter (cit. at n. I/15), ill. 193.
23 e.g. a Pompeian mural (ill. Ternite [Bib. A], pl. VIII, 'Pan and Bock in Stosskampf') was used virtually unaltered by Stuck for *Kämpfende Faune* of 1889 (Neue Pinacothek, Munich).
24 Praz, *Romantic Agony* (cit. at n. IX/45), p. 397.
25 J.-A. Birnie Danzker and B. Hardtwig, *Franz von Stuck die Sammlung des Museums Villa Stuck* (Munich 1997), pp. 192, 196, 204, 214, 215.
26 Bristol Art Gallery and Museum.
27 See a Stuck-like bronze bed, *c*. 650–600 BC, from Eberdingen-Hochdorf (excavated 1970s); S. Moscati and others, *I Celti* (Milan 1991), pp. 86–113.
28 The plebeians of legendary republican Rome won voting rights from the patricians by the modern expedient of a strike – they marched out under arms to the Sacred Mount and threatened to set up a New Rome. Eventually the two sides came together. The name 'Secession' implies an eventual hope of reconciliation.
29 P. Vergo, *Art in Vienna 1898–1918* (London 1975), pp. 127, 124.
30 L. Hevesi, 'Modern Painting in Austria', *The Studio* (1906), unpag.
31 Did current (incorrect) theories that the spiral originated in the shapes of coiled wire influence Secessionist ornament? See Riegl (cit. at n. I/59), p. 127.
32 Quoted by Gruber, *Du Néoclassicisme à l'Art Déco* (cit. at n. VII/112), p. 306.
33 Billcliffe (cit. at n. XI/139), p. 13.
34 Hevesi (cit. at n. 30).
35 Ill. *Ein Dokument Deutscher Kunst* (Darmstadt 1976), V, p. 65.
36 For long thought to be by Hoffmann; Dr Christian Witt-Dörring discovered that it was designed by Wimmer and made for the Kunstschau in 1908 (information kindly given by Dr Gabriele Fabiankowitsch). It has a companion piece in dark wood. See V. J. Behal, *Möbel des Jugendstils, Sammlung des Österreichisches Museum für Angewandte Kunst* (Munich 1988), cat. 218, 219.
37 Montfaucon [Bib. A], III, Pt I, pl. XCVIII.
39 The mausoleum project and Kärntner Bar
ill. *The Architecture of Adolf Loos* (London 1985), pp. 37, 56.
39 Whence they were re-used in baroque pavements, e.g. the pavement of the Oratorio del Rosario, Palermo.
40 Now in the Metropolitan Museum of Art, New York.
41 Now in the Victoria & Albert Museum, London.
42 Battersby (cit. at n. XI.182), p. 22.
43 Y. Brunhammer and S. Tise, *French Decorative Art, the Société des Artistes Décorateurs* (Paris 1990), p. 49.
44 Said in 1929 by the French Under-Secretary of State for the Fine Arts: ibid., p. 140.
45 ibid., pp. 171–79.
46 The thirties style of Clarice Cliff is a later provincial offshoot.
47 R. Firbank, 'Vainglory' (1915), *The Complete Firbank* (London 1975), p. 133.
48 Millin [Bib. A], p. IV. The painting's sources are investigated in E. C. Oppler, ed., *Picasso's 'Guernica'* (New York/London 1987). This one has not hitherto been noticed. See the fifth figure from the left, ill. 26 in this book, for another *Guernica* motif.
49 Robsjohn-Gibbings [Bib. A], p. 38.
50 Gelfer-Jørgensen (cit. at n. IX/135), p. 365, fig. 349.
51 Bibliography in Himmelheber (cit. at n. VIII/55), p. 79.
52 Gruber, *Du Néoclassicisme à l'Art Déco* (cit. at n. VII/112), p. 80.
53 ibid., p. 22.
54 Rejected on the advice of John Summerson, John Brandon-Jones, and the government Inspector, Antony Dale, according to a tale told to the author.
55 Hillier (cit. at n. X/50), pp. 260, 261.
56 A British store founded by Terence Conran.
57 L. L. Ponti, *Gio Ponti 1923–1978* (Milan 1990), ill. p. 40; made by Volonte of Milan and shown at the 4th Monza Triennale, 1930.
58 ibid., p. 136.
59 See e.g. J. W. Zincgref, *Emblemata ethico-politica* (1619; repr. Tutinghem 1993), XXXVI, p. 86.
60 Quoted by Evans (cit. at n. I/116), II, p. 105.
61 'Arabesque…rêves de la peinture': Watelet and Lévesque, *Dictionnaire des arts de peinture et sculpture* (Paris 1792).
62 See 'The House of Sleep' by Taddeo Zuccaro, *Italian Renaissance Drawings from the Louvre* (New York 1974), cat. 74.
63 From *The Secret Life of Salvador Dalí*, quoted by Rutherford (cit. at n. 17), p. 60.
64 Art Institute of Chicago, ill. ibid., p. 61.
65 T. Mann, *Dr Faustus*, ch. XXV.

Epilogue

1 W. Shakespeare, *Titus Andronicus*, Act IV, Scene 3.
2 V. Nabokov, 'The Vane Sisters', *The Stories of Vladimir Nabokov* (New York 1997), p. 621.
3 'Ne comptons-nous pas les générations, si l'on peut dire, par les formes des tables, des chaises, des meubles, des tapisseries?…Quel amateur ne paie pas chèrement tous ces restes épars du goût du XVIe siècle, ce siècle qui, après une longue stérilité, parut être une sorte de rejet [new shoot] de l'antiquité, et que les siècles suivans, malgré tous les efforts de l'esprit novateur, ont égalé d'autant moins, qu'ils ont cru l'avoir surpassé?': Percier and Fontaine [Bib. B], p. 2.
4 Raggio, 'Farnese table (cit. at n. IV/92), p. 216.
5 A phenomenon that has been categorized as a sign of the imminent collapse of a civilization: A. Toynbee, *A Study of History* (abridgment, Oxford 1954), pp. 455–65. Toynbee saw few signs of it in 1940s Britain; today they are omnipresent – a recent one being the destruction of the BBC's Radio Three, the watered–down version of the educationally idealistic Third Programme.

Select Bibliography

It is impractical to attempt a comprehensive bibliography for a book that covers such a long period, and this list is merely a selection from books consulted by the author. It confines itself to primary works that influenced designers, and separates them into three broad categories: (A) archaeologically inclined illustrated books on the antique, the exotic, and Gothic; (B) furniture and other pattern books and books of modern ornament of various kinds; and (C) books that influenced taste or ideas.

Many titles are abbreviated; the dates given are not necessarily those of first publication. Where one person has published much, a token work only is often listed. Pattern and ornament books often lack publication details, although these can sometimes be deduced. Some earlier periodicals are included.

Loose prints, books of original drawings, and exhibition catalogues are not included. No attempt has been made to include twentieth-century printed design sources, which are legion; the reader should consult monographs on particular designers.

Works of modern scholarship have been cited in the notes to the text.

The way in which designers used published sources was perfectly illustrated by Thomas Hope in 1807, when he ended his book of furniture designs with a 'list of the different works, either representing actual remains of antiquity, or modern compositions in the antique style, which have been of most use to me in my attempt to animate the different pieces of furniture here described, and to give each a peculiar countenance and character, a pleasing outline, and an appropriate meaning.' **Books mentioned in Hope's list are here printed in bold type.** His is a 'heavy' list, but designers are as likely to seize on the light, and the books listed here make a curious mixture.

A
BOOKS CONTAINING ANTIQUE, EXOTIC, AND GOTHIC SOURCES OF DESIGN

Adam, R., *Ruins of the Palace of the Emperor Diocletian at Spalatro* (London 1764)
Aglio, A., *Architectural Ornaments* (London 1820)
Agostini, L., *Le Gemme antiche figurate* (Rome 1657–69)
Aikin, E., *An Essay on the Doric Order of Architecture* (London 1810)
Alexander, W., *The Costume of China* (London 1805)
Antichità di Ercolano: see [Herculaneum]
Antonini, C., *Manuale di vari ornamenti* (Rome 1781)
Apianus, P., and B. Amantius, *Inscriptiones sacrosanctae vetustatis* (Ingolstadt 1534)
Aringhi, P., *Rome subterranea novissima in qua post Antonium Bosium antesignanum* (Rome 1651/Paris 1659)
Barbault, J., *Les Plus Beaux Monuments de Rome ancienne* (Rome 1761)
– *Monumens antiques* (Rome 1783)
Barrow, J., *Travels in China* (London 1804)
– *A Voyage to Cochin China* (London 1806)
Bayardi, O. A., *Antichi Monumenti disotterrati dalla discoperta città di Ercolano* (Naples 1755)
Becker, G. [Wilhelm] G., *Augusteum ou description des monumens antiques…à Dresde* (Leipzig 1804–11)
Bellicard, J. C., *Observations sur les antiquités de la ville d'Herculaneum* (Paris 1754)
Bellori, C. P., *Veterum illustrium philosophorum* (Rome 1685)
Bentham, J., *The History of Gothic and Saxon Architecture in England* (London 1798)
Berkenhout, J. (prob. by Dr J Longfield), *The Ruins of Poestum, or Posidania* (London 1767)
Bianchini, F., *Del Palazzo dei Cesari* (Verona 1738)

Bisschop, J. de (J. Episcopius), *Signorum veterum icones* (Amsterdam, c.1670)
Blundell, H., *Engravings and Etchings of the Principal Statues, Busts, Bass-Reliefs…etc. at Ince* (Liverpool 1809)
Boissard, J.-J., *Romanae urbis topographia et antiquitates* (Frankfurt 1597–1602)
Borioni, A., and R. Venuti, *Collectanea antiquitatum romanorum* (Rome 1736)
Bosio, A., *Roma sotterranea opera postuma* (Rome 1632)
Bottari, G. G., *Musei Capitolini* (Rome 1750–82)
Bracci, D. A., *Commentaria de antiquis sculptoribus* (Florence 1784)
Brenna, V., L. Mirri and F. Smugliewicz, *Vestigia delle Terme di Tito* (Rome c.1781)
Britton, J., *Historical and Descriptive Accounts…of…English Cathedrals* (London 1836)
Bruyn, A. de, *Omnium pone gentium imagines* (Cologne 1577)
Bry, J. T. and J. I. de, *Orientalisch Indien* (Frankfurt 1597–929)
Buonarroti, F., *Osservazione sopra alcuni medaglioni antichi* (Rome 1698)
– *Osservazione sopra alcuni frammenti de vasi antichi* (Florence 1716)
Butterfield, W., ed., *Instrumenta Ecclesiastica* (1844–47, 1850–56)
Cameron, C., *The Baths of the Romans* (London 1772, repr. 1774, 1775)
Cartari, V., *Le vere e nove imagini de gli dei delli antichi* (Venice 1556/Padua 1615)
Carter, J., *Specimens of ancient Sculpture and Painting* (1780–94)
– *Views of Ancient Buildings in England* (1786–93)
– *Archaeologia, Plans, Elevations, sections and specimens of the architecture and ornaments of Exeter Cathedral* (London 1797/Bath 1798/Durham 1801/Gloucester 1809)
Cassini, G. M., *Novus thesaurus gemmarum veterum* (Rome 1780/1782/1786/1797)
Castell, R., *The Villas of the Ancients* (London 1728)
Cavaceppi, B., *Raccolta d'antiche statue, busti, teste cognite ed altre sculture antiche* (Rome 1768–72)
Cavalieri, G. B., *Antiquarum statuarum urbis Romae primus et secundus liber* (Rome 1569)
– *Romanorum imperatorum effigies* (Rome 1583)
– *Antiquarum statuarum urbis Romae icones* (Rome 1584)
Caylus, A.-C. P., Comte de, *Recueil d'antiquités égyptiennes, étrusques, grecques, romaines et gauloises* (Paris 1752–67)
– *Mémoire sur la peinture à l'encaustique et sur la peinture à la cire* (Geneva/Paris 1755)
– *Tableaux tirés d'Homère et de Virgile* (Paris 1757)
Chambers, W., *Designs of Chinese Buildings, Furniture, Dresses, Machines and Utensils* (London 1757)
Chiari, G., *Statue di Firenze* (Florence, c. 1790)
Ciampini, G., *Vetera Monimenta* (Rome 1690–99)
Clarac, Comte de, *Musée de sculpture antique et moderne…plus de 2500 statues antiques* (Paris 1826–53)
Clérisseau, C.-L., *Antiquités de la France* (Paris 1778)
Cochin, C. N., and J.-C. Bellicard, *Observations sur les antiquités de la ville d'Herculaneum* (Paris 1754)
Cock, H., *Praecipua Romanae Antiquitatis Ruinarum Monimenta* (Antwerp 1551)
Dalton, R., *Antiquities and views in Greece and Egypt* (London 1751)
Daniell, T. and W., *Oriental Scenery* (London 1795–1808)
Dapper, O., *Gedenkwurdige Verrichtung…in dem Kaiserreich Taising oder Sina* (Amsterdam 1675)
Delargadette, C. M., *Les Ruines de Paestum* (Paris 1799)
Denon, D. V., *Voyage dans la basse et la haute Egypte* (Paris 1802)
Description de l'Égypte (Paris 1809–28, repr. Tours 1993)
Desgodetz, A., *Les Édifices antiques de Rome* (Paris 1682)

Dilettanti, Society of, *The Antiquities of Athens*, I (1762), II (1787), III (1794), IV (1814)
– Chandler, R., N. Revett and W. Pars, *Ionian Antiquities Published for the Society of Dilettanti* (London 1769, 1797)
– *Antiquities of Ionia* (London 1797)
– *Specimens of Ancient Sculpture* (London 1809)
Dolce, F., *Descrizioni di dugento gemme antiche* (Rome 1792)
Donato, Al., *Roma vetus ac recens* (Rome 1665)
Dosio, G. A., *Urbis aedificiorum illustriumque supersunt reliquiae* (Florence 1569)
Dresser, C., *Japan, its Architecture, Art and Art Manufactures* (London 1882)
Du Cerceau, J. Androuet, *Arcs et monuments antiques d'Italie et de France* (1560)
– *Le Livre des édifices antiques romains* (1584)
Du Halde, J.-B., *Ausführliche Beschreibung des chinesischen Reichs* (Rostock 1747–56)
– *Description géographique, historique…de la Chine* (The Hague 1736)
Dumont, G. M., *Les Ruines de Paestum* (Paris/London 1769)
Du Pérac, Étienne, *I vestigi dell'antichità di Roma* (Rome 1575)
Durand, J.-L.-N., *Recueil et parallèle d'édifices anciens et modernes* (Paris 1802)
Eastlake, C. L., *A History of the Gothic Revival* (London 1872, repr. New York 1975)
Eckhel, J. H. von, *Choix des pierres gravées du Cabinet Impérial des Antiques* (Vienna 1788)
Episcopius, J.: see Bisschop
Ercolani, G. M., *I tre ordini d'architettura… pressi dalle fabriche piu celebri del'antica Roma* (Rome 1744)
Fabretti, R., *De columna Trajani* (Rome 1683)
Félibien, A., *Statues et bustes antiques des maisons royales* (Paris 1679)
– *Entretiens sur les vies et sur les ouvrages des plus excellens peintres anciens et modernes* (Paris 1685)
Ficoroni, F. de', *I tali ed altri strumenti lusori degli Antichi Romani* (Rome 1734)
– *Le vestigia e rarità di Roma antica* (Rome 1744)
– *De Larvis scenicis et figuris comicis* (Rome 1754)
– *Gemmae antiquae litteratae* (Rome 1757)
Fischer von Erlach, J. B., *Entwurff einer historischen Architectur* (Leipzig 1725)
[Florence] *Museum Florentinum* (Florence 1781–92)
Foggini, P. F., *Musei Capitolini tomus quartus* (Rome 1782)
Franciscus, E., *Neu-polirter Geschicht-, Kunst- und Sittenspiegel* (Nuremberg 1670)
Fréart de Chambray, R., *Parallèle de l'architecture antique et de la moderne* (Paris 1650, trans. J. Evelyn London 1664)
Fulvio, A., *Illustrium imagines* (Rome 1517)
Gallaeus, T., *Illustrium imagines… quae extant Romae* (Antwerp 1598)
Gell, W., *Pompeiana* (London 1817–19)
– *Pompeiana* (London 1832)
Ghezzi, P. L., *Camere sepolcrali de liberti e liberte di Livia Augusti ed' antichi Cesari* (Rome 1731)
Goltzius, H., *Vivae omnium fere Imperatorum Imagines* (Antwerp 1557)
– *C. Julius Caesar sive Historiae imperatorum… ex antiquis numismatibus restitiae* (Bruges 1563)
– *Graecia sive historiae urbium et populorum Graeciae ex antiquis numismatibus* (Bruges 1576)
González de Mendoza, J., *Historia de las cosas mas notables…del gran reyno de la China* (Rome 1585)
Gori, A. F., *Museum Etruscum* (Florence 1737–43)
– *Museum Florentinum* (Florence 1731–66)
– *Catalogue des marbres antiques… dans la Galerie Royale des Antiquités à Dresde* (Dresden 1812)
Gough, R., *Sepulchral Monuments in Great Britain* (London 1786–96)
Graevius, J. G., *Thesaurus* (Utrecht 1694–99)
Gronovius, J., *Thesaurus Graecarum Antiquitatum* (Leiden 1697–1702)
Guattani, G. A.,*Monumenti antichi inediti* (Rome 1784–5, 1789)
Hamilton, Sir W.: see
– Hancarville, *Collection of Etruscan, Greek, and Roman Antiquities*

– 'Kirk's Outlines'
– Tischbein, *Collection of Engravings from Ancient Vases mostly of pure Greek workmanship*
Hancarville, P.-F. Hugues d', *Antiquités étrusques, grecques et romaines* (Naples 1766; Paris 1785)
– ***Collection of Etruscan, Greek, and Roman Antiquities from the Cabinet of the Hon. W. Hamiton* [bilingual edn of *Antiquités*] (Naples 1766–67)**
– *Recherches sur l'origine…des arts de la Grèce* (London 1785)
Happel, E.-W., *Thesaurus exoticorum* (Hamburg 1688)
Havercamp, S., *Médailles…du Cabinet de la Reine Christine…gravées…par le célèbre Pietro Santes Bartolo* (The Hague 1742)
[Herculaneum] [***Delle*] *Antichità di Ercolano*, ed. Accademia Ercolanense (Naples 1757–92): incl. *Le pitture antiche*; *Le lucerne ed i candelabri***
Herwart ab Hohenburg, von, *Thesaurus Hieroglyphicorum e museo J. G. H.* (?Munich ?1610)
Hittorff, J.-I., *Architecture antique de la Sicile* (Paris 1827)
– *Architecture polychrome chez les Grecs* (Paris 1851)
Hodges, W., *Select Views in India* (London 1785–88)
Hoffstadt, F., *Gothisches A.B.C. Buch* (Frankfurt 1840)
Hope, T., *Costume of the Ancients* (London 1809)
Humphreys, D., *Antiquity Explained and represented in Sculptures*, trans. of Montfaucon, q.v. (London 1721)
Ides, *Dreyjahrige Reise nach China* (Frankfurt 1707)
Jones, O., *Plans, Details and Sections of the Alhambra* (London, 1836–45)
– *Views on the Nile* (London 1843)
– *Illuminated Books of the Middle Ages* (London 1850)
– *The Grammar of Ornament* (London 1856)
– *Examples of Chinese Ornament* (London 1867)
Kircher, A., *China Illustrata* (1667)
– trans. F. S. Dalquie, *La Chine* (Amsterdam 1670)
'Kirk's Outlines': *Hamilton and Englefield Collections: Outlines from the Figures and Compositions upon the Greek, Roman and Etruscan Vases of the late Sir William Hamilton* (W. Miller, 1804)
Labacco, A., *Libro d'Antonio Labacco… antiquità di Roma* (Rome 1557)
Laborde, A., *Mosaïque d'Italica* (Paris 1802)
– *Collections des Vases grecs de M. le Comte de Lomberg* (Paris 1813–24)
La Chausse, M. A. de, *Romanum Museum sive Thesaurus* (Rome 1690)
– *Le Gemme figurate* (Rome 1700)
Lafréry, A., *Speculum Romanae Magnificentiae* (Rome 1545–92)
Lalande, M. de, *Voyage en Italie* (Yverdun 1769, 1787–88)
Landon, C. P., *Les Annales du Musée français* (Paris 1800–1809)
Lauro, G., *Antiquae urbis splendor* (Rome 1612)
– *Antiquae Urbis vestigis quae nunc extant* (Rome 1628)
Lavallée, J., *Voyage pittoresque et historique de l'Istrie et de la Dalmatie* (Paris 1802)
Le Comte, L., *Nouveaux mémoires sur l'état présent de la Chine* (Paris 1701)
Legrand, A., *Galerie des antiques* (Paris 1803)
Lenoir, A., *Musée des Monuments français* (Paris 1800–1806)
Leplat, B., *Recueil des marbres antiques…à Dresde* (Dresden 1733)
Le Roy, J. D., *Les Ruines des plus beaux monuments de la Grèce* (Paris 1758)
Madden, F., *Illuminated Ornaments selected from manuscripts and early printed books* (1833)
Maffei, A., *Raccolta di statue antiche e moderne* (Rome 1704)
– *Gemme antiche figurate.* (Rome 1707–8)
Major, T., *The Ruins of Paestum* (London 1768)
Maréchal, P. S., *Antiquités d'Herculaneum gravées par F. A. David* (Paris 1780–1803)
Mariette, P. J., *Traité des pierres gravées* (Paris 1750)

– *Abécédario, Recueil de peintures antiques* (Paris 1851–53)

Marliano, B., *Urbis Romae topographia* (Rome 1544)

Martini, M., *De bello tartarico historia* (Amsterdam 1655)

Martyn, T., and J. Lettice, *The Antiquities of Herculaneum* (London 1773)

Mason, G. H., *The Costume of China* (London 1800)

Massi, P., *Indicazione antiquaria del pontificio Museo Pio-Clementino* (Rome 1792)

Mazois, F., *Les Ruines de Pompéi* (1812–38)

Mémoires…des chinois, Par les missionnaires de Pékin (Paris 1776–91)

Millin de Grandmaison, A. L., *Peintures de vases antiques vulgairement appelés étrusques* (Paris 1808–10)

Mirri, L.: see Brenna, V.

Mitelli, G., *Dell'antichità di Roma vestige antiche* (Rome 1742)

Montfaucon, B. de, *L'Antiquité expliquée et représentée en figures* (Paris 1719–24)
– *Monumens de la monarchie française* (Paris 1729–33)

Moreau, C., *Fragments et ornemens d'architecture dessinés à Rome, d'après l'antique* (Paris 1800),

Morse, E., *Japanese Homes and their Surroundings* (London 1886)

Moses, H., *A Collection of Antique Vases, Altars, Paterae, Tripods, Candelabra, Sarcophagi etc.* (London 1814)

Musée Français, *Recueil complet* (Paris 1803–9)

Nardini, F., *Roma antica* (Rome 1771)

Nibby, A., *Descrizione della Villa Adriana* (Rome 1827)

Nieuhof, J., *L'Ambassade de la Compagnie Orientale des Provinces Unies vers l'empereur de la Chine* (Amsterdam 1665, trans. London 1669)

Norden, F. L., *Voyage d'Égypte et de Nubie* (Copenhagen 1755)

Ogilby, J., *Africa…the Regions of Ægypt, Barbary, Lybia and Billedulgerid*, trans. of O. Dapper, q.v. (London 1670)

Ornati: see [Pompeii]

Orsini, F., *Imagines et elogia virorum illustrium et eruditor ex antiquis lapidibus* (Rome 1771)

Overbeck, J., and A. Mau, *Pompeji in seinen Gebäuden, Altertumern, und Kunstwerken* (Leipzig 1884)

Overbeke, B., *Reliquiae antiquae urbis Romae* (Amsterdam 1708)

Palafox y Mendoza, J. de, *Historia de la conquista de la China* (Paris 1670)

Palladio, A., *I Quattro Libri dell'architettura* (Venice 1570)
– *Fabbriche Antiche disegnate da Andrea Palladio…Conte di Burlington* (London 1730)

Paoli, P. A., *Paestanae dissertationes* (Rome 1784)

Passeri, G. B., *Osservazioni…sopra alcuni monumenti greci e latini conservati in Venezia* (Venice 1759–60)
– *Picturae Etruscorum in Vasculis* (Rome 1767–75)
– *Novus Thesaurus gemmarum veterum* (Rome 1781–97)

Perrier, F., *Icones et segmenta nobilium signorum et statuarum quae Romae extant* (Rome 1638)
– *Icones et segmenta illustrium* (Paris '1645' [1655])

Pignorii, L., *Mensa Isiaca* (Amsterdam 1669)

Piranesi, F., *Raccolta de' tempi antichi* (Rome c. 1780–90)
– *Collection des plus belles statues de Rome* (Paris c. 1805)

Piranesi, G. B. [particular works were not specified by Hope]
– *Prima parte di architettura e prospettive* (Rome 1743)
– *Antichità de' tempi della repubblica* (Rome 1748)
– *Opere varie di architettura, prospettiva, groteschi, antichità* (Rome 1750)
– *Le Antichità romane* (Rome 1756)
– *Trofei di Ottaviano Augusto* (Rome 1753)
– *Della magnificenza ed architettura de' Romani* (Rome 1761)
– *Lapides Capitolini* (Rome 1762)
– *Antichità d'Albano e di Castel Gandolfo* (Rome 1764)
– *Vasi, candelabri, cippi, sarcophagi* (Rome 1778)

– *Différentes Vues de quelques restes de… l'ancienne ville de Pesto* (Rome 1778)

Piroli, T., *Le antichità di Ercolano* (Rome 1789–1807)

Pococke, R., *A Description of the East* (London 1745)

[Pompeii] *Gli ornati delle pareti ed i pavimenti delle stanze dell'antica Pompeii* (Naples, 1796–1820)

Ponce, N., *Descriptions des Bains de Titus* (Paris 1786)
– *Arabesques antiques des bains de Livie, et de la Ville Adrienne* (Paris 1789)

Prisse d'Avennes, E., *Atlas of Egyptian Art* (Paris 1868–78, partially repr. Cairo 1997)

Pugin, A. C., *Architectural Antiquities of Normandy* (London 1828)
– *Specimens of Gothic Architecture* (London 1821, 1823)
– *Gothic Ornaments* (London 1828–31)
– *Examples of Gothic Architecture* (London 1831–38)

Pugin, A. W. N., *Gothic Furniture in the style of the 15th century* (London 1835)
– *Floriated Ornament* (London 1849)

Raffei, S., *Osservazioni sopra alcuni antichi monumenti…Albani* (Rome 1771, 1772, 1773)

Raspe, R. E., *A Descriptive Catalogue of a general Collection of Ancient and Modern Engraved gems…by James Tassie* (London 1791)

Rickman, T., *An Attempt to discriminate the styles of English Architecture* (Liverpool 1817)

Riou, S., *The Grecian orders of architecture… explained from the antiquities of Athens* (1768)

Robsjohn Gibbings, T. H., and C. W. Pullin, *Furniture of Classical Greece* (New York 1963)

Rossi, D. de', *Raccolta di statue antiche e moderne* (Rome 1704)

Rossi, R., *Collectanea antiquitatum Romanorum* (Rome 1736)

Rudiments of Ancient Architecture (London 1789)

Sadeler, M., *Vestigio delle antichità di Roma a Tivoli Pozzuolo et altri luochi* (Paris 1660)

Saint-Non, J.-C.-R. de, *Voyage pittoresque de Naples et de Sicile* (Paris 1781–86)

Sandrart, J. von, *Iconologia deorum* (Nuremberg 1680)
– *Sculpturae veteris admiranda* (Nuremberg 1680)

Santi Bartoli, F. and P., *Raccolta di camei e gemme antiche* (Rome 1727)

Santi Bartoli, P., *Virgilius Maro* (Rome c. 1677)
– *Colonna Traiana* (Rome 1665)
– *Le pitture antiche del sepolcro de Nasonii nella Via Flaminia* (Rome 1680, 1693, 1737, 1791) [listed by Hope as *Bellori Picturae Antiquae*]
– *Veteres arcus Augustorum triumphis* (Rome 1690)
– *Admiranda Romanorum antiquitatum* (Rome 1690, 1693)
– *Le Antiche lucerne* (Rome 1691)
– *Gli antichi sepolcri* (Rome 1697/ed. Mariette, Paris 1757)
– *Columna Cochlis* (Rome 1704)
– *Museum Odescalchum* (Rome 1747)
– *Picturae antiquae cryptarum Romanorum et sepulcri Nasonum* (Rome 1737, 1795)

Sayer, R., *Ruins of Athens* (1759, repr. Farnborough 1969)

Scamozzi, V., *Tutte l'opere d'architettura di Sebastiano Serlio* (Venice 1584)
– *Discorsi sopra l'antichità di Roma di Vincenzo Scamozzi* (Venice 1582)

Schenck, P., *Picturae Sinicae* (Amsterdam? 1702)

Serlio, S., *Architettura*: IV (Venice 1537), III (Venice 1540) I, II (Paris 1545), V (Paris 1547), 'Extraordinario Libro' (Lyons 1551), VII (Frankfurt 1575), VI (facsimile of ms, Milan 1967). Complete works brought out in 1580s: *see* Scamozzi
– *Il Primo Libro d'architettura* (1551)

Shaw, H., *A Series of Details of Gothic Architecture* (London 1823)
– *Specimens of Ancient Furniture* (1836)
– *The Encyclopaedia of Ornament* (1842)

Smugliewicz, F.: see Brenna, V.

Spilsbury, J., *A Collection of Fifty Prints from Antique Gems in the Collections of… Earl Percy etc.* (London 1785)

Spitzel, G., *De re literaria sinensium commentarius* (Leiden 1660)

Stosch, P., *Pierres antiques gravées* (Amsterdam 1724)

Strada, J., *Kunstbuch* (Zurich 1549)
– *Imperatorum Romanorum… ex antiquis numismatis* (Zurich 1559)

Stuart, J., and N. Revett, *The Antiquities of Athens* (London 1762–1816)

Tatham, C. H., *Etchings of Ancient Ornamental Architecture drawn from the originals in Rome* (London 1799)
– *Etchings, representing fragments of antique Grecian and Roman architectural ornament* (London 1806)

Ternite, W., *Wandgemaelde aus Pompeji und Herculaneum* (Berlin 1839–59)

Thiry, L., *Fragmentae structurae veteris* (Orléans 1550)

Tischbein, A. W., *Collection of Engravings from Ancient Vases mostly of Pure Greek workmanship* (Naples 1791–95)
– *Recueil de gravures d'après les vases antiques…tirées du cabinet de M. le Chevalier Hamilton* (Naples 1791)

Turnbull, G., *A Treatise on Ancient Painting and A Curious Collection of Ancient Paintings* (London 1740, 1741)

Vaccaria, L. della, *Antiquarum statuarum urbis Romae* (Venice 1584)

Valadier, G., and F. A. Visconti, *Raccolta delle più insigni fabbriche di Roma Antica* (Rome 1810–18)

Vecellio, C., *Habiti antichi e moderni di tutto il mondo* (Venice 1598)

Veneziano, A., *Sic Romae in impluvio ex marmore sculp.* (1536)

Venuti, R., *Collectanea antiquitatum Romanorum* (Rome 1736)

Vico, Aenea, *Vases* (1543)
– *Ex antiquis cameorum et gemmae delineata* (1550)
– *Le Imagini con tutti i riversi trovati et le vite de gli imperatori* (Venice 1548)
– *Le Imagini delle Donne Auguste* (Venice 1557)

Viollet-le-Duc, E.-E., *Dictionnaire du mobilier francais de l'époque carolingienne à la Renaissance* (Paris 1858–75)
– *Dictionnaire raisonné de l'architecture française* (Paris 1858–68)

Visconti, F. A., and G. A. Guattini, *Il Museo Chiaramonti* (Rome 1808)

Visconti, G. B. and E. Q., *Il Museo Pio-Clementino* (Rome 1782–1807)

Vitruvius, *The Architecture of M. Vitruvius Pollio*, trans. W. Newton (London 1791)

Volney, C. F. C., Comte de, *Voyage en Syrie et Égypte (Les Ruines)* (Paris 1787)

Wilkins, W., *The Antiquities of Magna Graecia* (Cambridge 1807)

Wilkinson, J. G., *Manners and Customs of the Ancient Egyptians* (London 1837)

Winckelmann, J. J., *Monumenti antichi inediti* (Rome 1767–72)
– *Geschichte der Kunst des Alterthums* (Dresden 1764)

Wood, R., *The Ruins of Palmyra* (London 1753)
– *The Ruins of Balbec* (London 1757)

Worlidge, T., *A Select Collection of Drawings from Curious Antique Gems* (London '1768' [c. 1780])

Worsley, R., *Museum Worsleyanum* (London 1794 [1798–1803])

Zanetti, A. M., *Delle antiche statue greche e romane…della libreria di San Marco* (Venice 1740–43)

Zimmermann, E. A. W., *Taschenbuch der Reisen* (Leipzig 1810)

B

PATTERN AND ORNAMENT BOOKS

Ackermann, R., *Repository of Arts* (London 1809–28)
– *A Selection of Ornaments* (London 1817)
– *Fashionable Furniture* (London 1823)

Adam, R., *Works in Architecture of Robert and James Adam* (London 1773–8), II (1779), III (1822)
– see also Polidoro da Caravaggio

Alberti, L. B., *Ten Books on Architecture*, trans. J. Leoni (1726, repr. London 1955)

Albertolli, G., *Alcune decorazione di nobili sali ed altri ornementi* (Milan 1787)

– *Ornamenti Diversi* (Milan 1782)
– *Miscellanea per i giovani studiosi del disegno pubblicata da Giocondo Albertolli* (Milan 1796)

Alciati, A., *Emblematum liber* (Augsburg 1531)
– *Clarissimi viri D. Andreae Alciati Emblemata* (Paris 1542)
– *Viri clarissimi…Emblematum* (Paris 1542, repr. Darmstadt 1967)
– *Emblemata* (Lyons 1550; trans. annotated by B. I. Knott, introd. J. Manning (Chippenham, Wilts., 1996)

Bacqueville, P. P., *Livre d'ornemens propres pour les meubles et pour les peintres* (Paris c. 1710)

Baillie Scott, M. H., *Furniture made at the Pyghtle Works, Bedford* (1901)

Basoli, A., *Vari ornamenti* (Bologna 1838)

Beauvallet, P. N., *Fragmens d'ornemens* (Paris 1804)

Berain, J., *Oeuvres de Jean Berain* (1688)
– *Ornemens peints dans les appartemens des Tuileries* (Paris 1690)
– *Ornemens inventez par J. Berain et se vendent chez Monsieur Thuret* (Paris 1711)
– *Fac-simile des oeuvres de Jean Berain* (Paris 1862)
– *100 Planches principales de l'oeuvre complète de Jean Berain* (Paris 1882)

Blondel, J.-F., *Cours d'architecture…Nouvelle édition par Pierre-Jean Mariette* (Paris 1760)

Blum, H., *Quinque columnarum* (Zurich 1550)

Borghini, R., *Il Riposo* (Florence 1730)

Borromini, F., *Opera del Caval. Francesco Borromini* (Rome 1720)
– *Opus architectonicum* (Rome 1725)

Borsato, G., *Opera ornementale* (Venice 1822)

Bos, Cornelis, *Book of Moresques* (before 1544)

Boucher, J.-F., *Diverses Figures chinoises* (1731)
– *Livre de cartouches*
– *Cahier d'arabesques*
– *Nouveaux morceaux pour des paravents* (1737)

Boulle, A. C., *Nouveaux desseins de meubles et ouvrages de bronze et de marqueterie* (Paris)

Boutemie, D., *Ouvrage rare et nouveau* (1636)

Boyceau, J., *Traité de jardinage* (Paris 1638)

Braun, A. E., *Specimens of Ornamental Art by L. Grüner* (London 1850)

Bridgens, R., *Furniture with Candelabra and Interior Decoration* (London 1838)

Brown, R., *The Rudiments of Drawing Cabinet and Upholstery Furniture* (London 1822)

Brunetti, G., *60 Different Sorts of Ornaments* (London 1736)

Chambers, W., *A Treatise on Civil Architecture* (1759/London 1825)

Charles, R., *Cabinet Makers' Sketch Book* (London 1866)

Chedel, P. Q., *Fantaisies nouvelles* (Paris 1738)

Chenavard, A., *Recueil de dessins de tapisseries, tapis, et autres objets d'ameublement* (Paris 1828)
– *Ornemens Gothiques* (Paris 1839)

Chippendale, T., *The Gentleman and Cabinet-Maker's Director* (edns in 1754, 1755, 1759, 1762, 1767; 1767 edn repr. London 1966)

Coade, E., *A Descriptive Catalogue of Coade's Artificial Stone Manufactory…Pieces of Furniture* (London 1784)

Collinson & Lock, *Sketches of Artistic Furniture* (London 1871)

Columbani, P., *A New Book of Ornaments Containing a Variety of elegant Designs for Modern Pannels Commonly executed in Stucco, Wood, or Painting* (London 1775)

Contant d'Ivry, P., *Les Oeuvres d'architecture de Pierre Contant d'Ivry* (Paris 1758, 1786)

Copland, H., *A New Book of Ornaments* (London 1746)
– *A New Book of Ornaments* (London 1752)

Cotelle, J., *Livre de divers ornemens* (c. 1640)

Crunden, J., *The Joyner and Cabinet-Maker's Darling* (London 1765)
– *The Carpenter's Companion for Chinese Railings and Gates* (1765)

Darly, M., *A New Book of Chinese Gothic and Modern Chairs* (London 1750–51)
– *A New Book of Chinese Designs* (London 1754)
– *Sixty Vases of English, French and Italian Masters* (London 1768)
– *The ornamental Architect or young Artist's Instructor* (London 1770)
– *A New Book of Ornaments in the Present (Antique) Taste* (London 1772)

Decker, P., *Groteschgen Werk vor Mahler, Goldschmidte, Stucato* (Nuremberg 1700)

– *Fürstlicher Baumeister oder Architectura* (Augsburg 1711)
Decker, P. [the younger], *Gothic Architecture Decorated* (London 1759)
– *Chinese Architecture* (London 1759)
Dedaux, *Chambre de Marie de Médicis au Palais du Luxembourg, ou, Recueil d'arabesques, peintures et ornemens qui la décorent* (Paris 1838)
De La Cour, William, *First Book of Ornament* (London 1741; subsequent bks –1747)
Delafosse, C., *Nouvelle Iconologie historique* (Paris 1768, 1771)
Delaunay, S., *Compositions couleurs idées* (Paris 1930)
Della Bella, S., *Ornamenti di fregi e fogliami*
– *Raccolta di varii capricci* (Paris 1646)
– *Nouvelles inventions de cartouches* (Paris 1747)
Delorme, P. de, *Nouvelles inventions de bien bastir* (Paris 1561)
– *Le Premier Tome de l'architecture de P. de L'Orme* (Paris 1658)
Dezallier d'Argenville, A.-J., *L'Histoire naturelle éclairée dans une de ses parties principales, la lithologie et la conchyliologie* (Montpellier 1742)
Dietterlin, W., *Architectura* (Strasbourg 1598)
Dresser, C., *Modern Ornamentation…for…Manufactures in Wood, Metal, Pottery etc., also for the Decoration of Walls & Ceilings* (London 1886)
Dubois & Marchais, *Recueil de desseins des armures, casques, cuirasses, etc., tirés du Musée Impérial de l'artillerie de France et des cabinets particuliers* (1808)
Du Cerceau, J. Androuet, *Fragmenta structurae veteris* (1550)
– *De eo picturae genere quod grottesche Itali vocant* (1550, repr. Paris 1880; Paris 1562, 1566)
– *Livre d'architecture* (3 bks, Paris 1559, 1561, 1572)
– *Les Plus Excellents Bastiments de France* (Paris 1576, 1579)
– *Oeuvre de J. A. dit de Cerceau, coupes, vases, trophées, cartouches etc.* (Paris)
Dugourc, J. D., *Arabesques* (Paris 1782)
– *Recueil d'arabesques* (Paris 1802)
Dürer, A., *Underweysung der Messung* (Nuremberg 1525)
Dusch, J. A., *Entwürfe zu gothischen möbeln* (Augsburg c. 1800)
Eckhout, G. van den, *Veelderhande Nieuwe Compartimente*
– *Verscheyde Aerdige Compartimenten* (1655)
Feuchère, L., *L'Art industriel* (1842)
Flaxman, J., *The Iliad* (London 1794)
– *The Odyssey* (London 1805)
– *Compositions from the Tragedies of Aeschylus* (London 1795)
– *Compositions from…Hesiod* (London 1817)
Floris, C., *Design for Ewers* (Antwerp 1548)
– *Veelderley Verunderinghe van Grottissen* (1556, 1557)
Flötner, P., *Gedruckt zu Zurich Rudolfi Wyzzenbach formschnyder* (Zurich 1549)
– *Imperatorum Romanorum Imagines* (1559)
Fordrin, L., *Livre de Serrurerie de composition angloise*
– *Nouveau Livre de serrurerie* (Paris 1723)
Forty, J. F., *Oeuvres de sculptures en bronze* (n.d.)
Fraisse, J.-A., *Livre de desseins chinois* (1735)
Fréart de Chambray, J., *Parallèle de l'architecture antique et de la moderne* (Paris 1650)
Gedde, W., *A Booke of Sundry Draughtes* (London 1615)
Gibbs, J., *A Book of Architecture* (London 1728)
Gribelin, S., *A New Book of Ornaments usefull to all Artists* (1704)
– (with Félibien), *The Tent of Darius explain'd* (London 1704)
Gropius, M., *Archiv für Ornementale Kunst* (Berlin 1871–79)
Grüner, L.,*.The Decorations in the Garden Pavilion…Buckingham Palace* (London 1846)
– *Fresco Decorations… in Italy…With an Essay on the Arabesques of the Ancients* (London 1854)
– *A Selection of the Art Treasures in Dresden* (Dresden 1862)
– see also Braun
Guilmard, D., ed. (to 1882) *Le Garde Meuble* (Paris 1844–1903)
– *Album du Menuisier Parisien* (Paris 1855–61)
– *Les Maîtres Ornemanistes* (Paris 1880–81)
Halfpenny, W., *New Designs for Chinese Temples…Garden Seats, Palings* (London 1750–52)
– *Rural Architecture in the Gothick Taste* (London 1752)
Has, G., *Kunstlicher und Zierlicher Neuer Funffzig Perspectifischer Stuck* (Vienna 1583)
Hay, D. R., *Original Geometrical Diaper Designs* (London 1844)
Heal, A., *Plain Oak Furniture* (London 1898)
– *Simple Bedroom Furniture* (London 1899)
Heideloff, C. A. von, *Der Bau- und Möbelschreiner oder Ebenist* (Nuremberg 1832–37)
– *Die Ornamentik des Mittelalters* (Nuremberg 1838–43)
Hepplewhite, G., *The Cabinet-Maker and Upholsterer's Guide* (1788, 1789, 1794; repr. of 1794 edn New York 1969)
Hettwig, C., *Sammlung moderner Sitzmöbel* (Dresden 1882–94)
Hoffmann, F. G., *Abbildungen der vornehmsten Tischlerarbeiten* (Leipzig 1789)
– *Neues Verzeichnis und Muster-charte des Meublen-Magazins* (Leipzig 1795)
Hope, T., *Household Furniture and Interior Decoration* (London 1807)
– *Costumes of the Ancients* (London 1809)
– *Designs of Modern Costume* (1812)
Huet, C.e, *Singeries, ou différentes actions de la vie humaine* (Paris)
Huquier, J.-B., *Nouveau Livre de trophées de fleurs et fruits étrangers*
Ince, W., and J. Mayhew, *The Universal System of Household Furniture* (London 1762)
Indua, J., *Neue Romanische Zierathen* (Augsburg, before 1685)
– *Nova invenzione di rabeschi, e fogliami romani* (Vienna 1686)
Iribe, P., *Les Robes de Paul Poiret* (Paris 1908)
Jacques, M., *Vases nouveaux* (Paris)
Jamnitzer, C., *Neuw Grotszken Buch* (Nuremberg 1610)
Jamnitzer, W., *Perspectiva corporum regularium* (Nuremberg 1568)
Johnson, T., *Twelve Girandoles* (1755)
– *One hundred and Fifty New Designs* (1758, 1761)
Jombert, C.-A., *Répertoire des artistes* (Paris 1765)
Jones, W., *The Gentlemens or Builders Companion…Slab tables, Pier Glasses* (London 1739)
Kent, W., *Designs of Inigo Jones with some Additional Designs* (London 1727)
Kilian, L., *Newes Gradesca Buchlein* (Augsburg 1607)
– *Newe Gradisco Buech* (Augsburg 1624)
Kimbels, W., *Journal für Möbelschreiner und Tapezierer* (Frankfurt 1835–53)
King, T., *The Modern Style of Cabinet Work Exemplified* (London 1829)
– *Designs for Carving and Gilding* (London c. 1830)
Krammer, G., *Architectura* (Prague 1600)
– *Schweiff Büchlein* (Prague 1602) [supplementary sequel, with more ornamental detail]
La Joue, Jacques de, *Livre de Buffets* (1735)
La Mésangère, P. de, *Collection de meubles et objets de goût* (Paris 1802–35)
Landi, G., *Architectural Decorations* (London 1810)
Langley, B., *Antient Architecture Restored and Improved* (1742)
– *Gothic Architecture* (London 1747)
Langlois, J., *Dessins pour tables, bureaux et autres ouvrages de marqueterie* (Paris)
La Vallée Poussin, É. de, *Nouvelle Collection d'arabesques propres à la décoration des appartemens* (Paris)
Leblond, J., *Cours d'Architecture* (Paris 1691; ed. P.-J. Mariette, Paris 1760)
Le Corbusier, *Almanach d'Architecture moderne* (Paris 1925)
Ledoux, C.-N., *L'Architecture considérée* (Paris 1804, 1847)
Le Geay, J. L., *Collection de divers sujets de vases, tombeaux, ruines, et fontaines* (1770)
Le Noir, A., *Nouvelles Collections d'arabesques propres à la décoration des appartements*
Lepape, G., *Les Choses de Paul Poiret* (Paris 1911)
Le Pautre, J., *Montans de trophées d'armes à l'antique* (Paris 1659)
– *Les Cabinets*
– *Alcoves à l'italienne* (Paris 1661)
– *Livre de Lit [sic] à la romaine* (Paris 1670?)
– *Alcoves à la romaine* (Paris 1670?)
– *Livre de miroirs tables et guéridons* (Amsterdam 1670?)
– *Collections des plus belles compositions de Lepautre* (Paris 1850?)
Le Pautre, P., *Cheminées et lambris à la mode* (Paris 1685?)
Lock, M., *A Book of Tables, Candle Stands, Pedestals, Tablets etc.*
– *Six Tables* (1746)
– *A New book of Ornaments* (1752)
– *A New Book of Ornaments…in the Chinese Taste*
Loris, D., *Le Thrésor des parterres de l'univers* (Geneva 1629)
Loudon, J. C., *Encyclopaedia of Cottage, Farm and Villa Architecture and Furniture* (1833, 1842, 1843)
Magazzino di mobili (Florence 1796–98)
Malton, T., *Compleat Treatise on Perspective* (1773, 1779)
Manwaring, R., *The Carpenter's Compleat Guide to the Whole System of Gothic Railing* (1765)
– *The Cabinet and Chair-Maker's Real Friend and Companion* (1765)
Mariette, P.-J., *L'Architecture Française* (1727–38)
– *Architecture à la Mode*
Marot, D., *Oeuvres* (The Hague 1703, Amsterdam 1713)
Meissonnier, J. A., *Oeuvre de Juste Aurèle Meissonnier* (Paris 1723, 1735)
– *Oeuvres* (Paris 1750)
Mitelli, A., *Cartouches* (Paris 1636, 1742)
Moglia, D., *Collezione di oggetti ornamentali ed architettonici* (Milan 1837–38)
Mondon, J., *Premier Livre de forme rocquaille et cartel* (Paris 1736)
– *Rocailles, Trophies [sic] etc.* (Paris 1736, 1749)
Monnoyer, J.-B., *Livres de plusieurs vazes de fleurs*
Moses, H., *Designs of Modern Costume* (London 1809, 1823)
Neufforge, J.-F., *Recueil élémentaire d'architecture* (Paris 1757–80)
Nicholson, P., and M. A., *Practical Cabinet Maker, Upholsterer and Complete Decorator* (London 1826)
Nonnenmacher, M., *Der Architectonische Tischler* (Nuremberg 1710, 1751)
Normand, C., *Nouveau Recueil en divers genres d'ornemens* (Paris 1803)
– *Décorations intérieures et extérieures* (1803, 1828)
– *Nouveau Parallèle des ordres* (1819)
Oppenord, G.-M., *Livre de différents morceaux* (Paris 1744–48)
– *Oeuvres* (Paris 1748)
Over, C., *Ornamental Architecture in the Gothic, Chinese and Modern Taste* (London 1758)
Palliser, Mrs, *History of Lace* (1865) [the appendix has a list of pattern books]
Passe, C. de (the younger), *Oficina Arcularia* (Utrecht 1621, Amsterdam 1642)
Pélerin, J., *De Artificiali Perspectiva* (Toul 1505)
Pellegrino, F., *La Fleur de la science de pourtraicture* (Paris 1530)
Percier, C., and P.-F.-L. Fontaine, *Quinti Horatii Flacci Opera* (ill. Percier) (Paris 1799)
– *Palais, maisons, et autres édifices modernes dessinés à Rome* (Paris 1798)
– *Recueil de décorations intérieures* (Paris 1801, enlarged 1812)
Pergolesi, M., *Designs for Various Ornaments* (1777–1801)
– *Original Designs…in the Etruscan and Grotesque Style* (1814)
Petit, J., *Collection de dessins d'ornement*
Petitot, E.-A., *Suite de vases* (Parma 1764)
– *Mascarade à la Grecque* (Parma 1771)
Peyrotte, A., *Livre de différents trophées* (Paris)
Pillement, J., *A New Book of Chinese Ornaments* (London 1755)
– *Four Elements* (1759, 1774)
– *Études de différentes figures chinoises* (Paris 1758)
– *Recueil de fleurs chinoises, de fontaines chinoises, de tentes chinoises, de barques chinoises* (1760, 1770)
– *Fleurs idéales* (Paris 1770)
Pineau, N., *Dessins de pieds de tables et de vases et consoles de sculpture* (Paris)
– *Nouveaux desseins de lits* (Paris)
Piranesi, G. B., *Grotteschi* (Rome 1750)
– *Prima Parte di architettura e prospettive* (Rome 1743)
– *Diverse Maniere d'adornare i cammini* (Rome 1769)
Polidoro da Caravaggio, *Vasa a Polydoro Caravaggio…inventa Cherubinus Albertus* (Rome 1582)
– *Designs for Vases and Foliage…by Robert Adam Esq.* (London 1821)
Primaticcio, F., *Feuillages modernes faicts au Château Royal de Fontainebleau* (Paris)
Pugin, A. W. N., *Gothic Furniture in the Style of the Fifteenth Century* (London 1835)
– *Contrasts…Between…the Fourteenth and Fifteenth Centuries and…the Present Day* (Salisbury 1836)
Quentell, P., *Eyn New Kunstlich Boich* (Cologne 1527)
Queverdo, F. M. I., *Premier Cayer de panneaux, frises et sujets arabesques* (Paris 1788)
[Raphael] M. Pagliarini, P. Camporesi, G. Ottaviani and G. Volpato, *Arabesques of the Vatican Loggie* (Rome 1772–75)
– *Recueil d'Arabesques…d'après Raphael, et…d'après Normand, Queverdo, Boucher etc.* (Paris 1802)
Revel, J., *Livre de dessins chinois* (1735)
Richardson, C. J., *Architectural Remains of the Reigns of Elizabeth and James I* (London 1840)
– *Studies of Ornamental Design* (London 1851)
Richardson, G., *A Book of Ceilings, composed in the style of the antique grotesque* (London 1776)
– *Iconology; or, a Collection of Emblematical Figures, moral and instructive* (London 1778)
– *A Treatise on the Five Orders of Architecture* (London 1787)
– *New Designs of Vases and Tripods decorated in the Antique Taste* (London 1793)
Riou, S., *The Grecian Orders of Architecture* (London 1768)
Ripa, C., *Iconologia* (Rome 1593, 1603/Perugia 1764–67)
Rivius, W., *Vitruvius Teutsch* (Nuremberg 1548)
Roubo, J.-A., *L'Art du menuisier* (Paris 1768)
Rouseel, N., *De Grotesco* (London 1623)
Saly, J. F. J., *Vases* (1746)
Sambin, H., *L'Oeuvre de la diversité des termes* (Lyons 1572)
Sayer, R., *The Compleat Drawing Book* (1757)
Schönesperger, H., *Furm oder Modelbüchlein* (Augsburg 1523)
Schubler, J. J., *Medaillen Schranke* (Nuremberg 1730, 1738)
Scott, W. B., *The Ornamentist, or Artisan's manual…designs selected from…Dietterlin, Berain, Blondell, Meisonier, Le Pautre, Zahn, Boetticher* (London, Dublin and Edinburgh 1845)
Sheraton, T., *The Cabinet-Maker and Upholsterer's Drawing Book* (London 1794, repr. 1972)
– *An Accompaniment to the Cabinet-Maker and Upholsterer's Drawing Book* (London 1794, repr. 1972)
– *The Cabinet Dictionary* (London 1803)
– *The Cabinet Maker, Upholsterer, and General Artist's Encyclopaedia* (London 1805)
Shute, J., *First and Chief Groundes of Architecture* (London 1563)
Smith, G., *A Collection of Designs for Household Furniture and Interior Decoration* (London 1808)
– *The Cabinet-Maker and Upholsterer's Guide* (London 1808)
Solis, V., *Moriske und Turckicher ein facher und Duppelter art zuglein durch* (Nuremberg 1550)
Solon, M., *Inventions décoratives* (Paris 1866)
Stalker, J., and G. Parker, *A Treatise of Japanning and Varnishing* (Oxford 1688)
Stoer, L., *Geometria et Perspectiva* (Augsburg 1567)
Sylvius, B., *Variarum protractionum quaes vulgo Maurusias vocant Libellus* (1554)
Tagliente, G. A., *Essempio di recammi* (Venice 1527)
Talbert, B. J., *Gothic Forms applied to Furniture Metal Work and Decoration for Domestic Purposes* (London 1867)
– *Examples of Ancient and Modern Furniture Metal Work Tapestries Decorations etc.* (London 1876)
– *Fashionable Furniture…a collection of original designs by the late Bruce Talbert, interiors by Henry Shaw* (New York c 1880)

Toro, J. B. H., *Livres de Tables de diverses formes* (Paris)

Ungewitter, G. G., *Entwürfe zu Gothischen Möbel* (Leipzig 1851)

Unselt, J., *Neues Zierathen Büchlein* (Augsburg 1690)

– *Neues Zierathen Buch* (1695–96)

Unteutsch, F., *Neues Zierathen Buch* (Frankfurt 1640s?)

Vardy, J., *Some designs of Mr. Inigo Jones and Mr. William Kent* (1744)

Vauquer, J., *Livre de fleurs dessinées d'après nature* (Paris)

Veen, O. van, *Vaenius Emblemata sive Symbola* (Brussels 1624)

Vico, E., *Leviores et….extemporaneae picturae quas grotteschas vulgo vocant* (1541)

Vignola, G. Barozzi da, *Regole delle cinque ordini* (1563, Amsterdam 1642)

Vorbilder für Fabrikanten und Handwerker (1821–37)

Vorsterman, W., *Ce est ung tractat de la noble art de leguille* (Antwerp c. 1527; trans. *A neave treatys as concernynge the excellency of the needleworcke*)

Vouet, S., *Livres de diverses grotesques, peintes dans le cabinet et bains de la Reyne Régente, au Palais Royal*, engr. M. Dorigny (Paris 1647)

Vredeman de Vries, H., *Hortorum viridariorum…Dorica, Ionica, Corinthia* (Antwerp 1583)

– *Variae architecturae formae* (Antwerp c. 1560)

– *Panoplia* (1572)

– *Differents pourtraicts de menuiserie à scavoir…* (probably Wolfenbüttel, c. 1588)

– *Recueil de cartouches, …caryatides; …arabesques* (all Brussels 1870)

Vredeman de Vries, P., *Verscheyden Schrynwerck* (Amsterdam 1630)

Ware, I., *A Complete Body of Architecture* (London 1756)

– *Designs of Inigo Jones and others* (London 1743)

Watt, W., *Art Furniture Designed by Edward W. Godwin F.S.A.* (London 1877)

Weigel, J. C. [d. 1746], *Neu Inventirtes Laub Bandl und Groteschengen Wirk* (Nuremberg)

Whittock, N., *The Decorative Painters' and Glaziers' Guide* (London 1827)

Willson, M., *The Antique and Modern Embellisher* (London 1766)

Wrighte, W., *Grotesque Architecture…Grotesque and Rustic Seats* (London 1567)

C
SOME BOOKS THAT INFLUENCED TASTE OR IDEAS

Alberti, L. B., *Della Architettura* (trans. G. Leoni, London 1739)

– *De Pictura* (1435; *On Painting*, trans. C. Grayson, intr. M. Kemp, London 1991)

Ammianus Marcellinus, *History* (trans. J. Rolfe, London/Cambridge, Mass., 1935)

Aristotle, *The Nicomachean Ethics*

– *Treatise on Poetry* (London 1812)

Athenaeus, *The Deinosophists* (London 1854)

Baudelaire, C., *Oeuvres complètes* (Paris 1868–70)

Bible, The Holy: Old and New Testaments

Burke, E., *Philosophical Enquiry into the Origin of our Ideas of the Sublime and the Beautiful* (London 1756)

Castiglione, *Il cortigiano* (trans. *The Book of the Courtier, done into English by Sir Thomas Hoby Anno 1561*, London 1900)

Colonna, F., *Hypnerotomachia Poliphili* (Venice 1499, 1545); French trans. (Paris 1546, 1561); partial English trans., *Hypnerotomachia: The Strife of Love in a Dream* (London 1592); complete English trans. by J. Godwin in preparation, not seen by the author (London 1999)

Cordemoy, J. L. de, *Nouveau Traité de toute l'architecture* (Paris 1714)

De Piles, R., *The Art of Painting* (London 1750)

Diderot, D., *Encyclopédie* (Paris 1751–65)

'Dionysius the Areopagite'

The Greek Anthology (trans. Loeb Classical Library, Cambridge, Mass.)

Herodotus, *The Histories* (trans. A. de Selincourt, Harmondsworth 1972)

Hesiod, *The Homeric Hymns and Homerica* (trans. Loeb Classical Library, Cambridge, Mass., 1970)

Homer, *The Iliad* and *The Odyssey*

Horace, *Odes* and *Ars Poetica*

Horapollo, *Hieroglyphica* (trans. F. Fasanini, 1517)

Huysmans, J. K., *A Rebours* (Paris 1891)

Kant, E., *Observations on the Sense of the Beautiful and the Sublime* (1764)

Knight, R. Payne, *An Analytical Inquiry into the Principles of Taste* (1801, repr. London 1806)

Laugier, M.-A., *Essai sur l'architecture* (Paris 1755)

– *Observations sur l'architecture* (Paris 1765)

Lomazzo, P., *A tracte containing the arts of curious Painting Carvinge building…by Jo. Paul Lomatius painter of Milan* (Oxford 1598)

Longinus, *Dionysius Longinus on the Sublime*, ed. W. Smith (London 1742)

Memmo, A., *Elementi d'architettura lodoliana* (Milan 1833)

Mengs, A. R., *Opere* (Rome 1787)

Morris, William: poems and other writings

Ovid, *The Metamorphoses*

Pausanias, *Description of Greece* (trans. W. H. S. Jones, London 1926)

Pliny the Elder, *Natural History* (trans. H. Rackham, London 1968)

– *The Historie of the World* (London 1601)

– *Histoire de la Peinture ancienne, extrait de l'Histoire Naturelle de Pline* (London 1725)

Plutarch, *Lives* (trans. Langhorne, New York/London n.d.)

Polo, M., *Travels*

Rousseau, J.-J., *La nouvelle Héloïse* (1759)

Ruskin, J., *The Seven Lamps of Architecture* (London 1849)

– *The Stones of Venice* (London 1851–53)

– *The Nature of Gothic, A Chapter of the Stones of Venice*, preface by W. Morris (London 1892)

Sade, Marquis de, *Justine*

Schopenhauer, A., *The World as Will and Idea* (trans. 1818)

Scott, Sir W., novels and poetry

Semper, G., *Der Stil* (Zurich 1860, 1863)

Shaftesbury, Earl of, *Characteristics of Men, Manners, Opinions, Times* (London 1732)

Vasari, G., *Vite de' piu eccellenti architetti, pittori, et scultori italiani* (Florence 1550–58; trans. Mrs Foster, *Lives of the most eminent Painters, Sculptors and Architects*, London 1900)

Virgil, *The Aeneid, The Georgics, The Pastoral Poems*

Walpole, H., *The Castle of Otranto* (1757)

Winckelmann, J. J., *Reflections on the Imitation of Greek Art* (1755)

Acknowledgments for Illustrations

Where a location or a printed source has been given in the caption, it is not repeated here.

BL By permission of The British Library, London
BM © The British Museum, London
BN Bibliothèque nationale, photo © Bibliothèque nationale de France, Paris
Brighton Royal Pavilion, Art Gallery and Museums, Brighton
Louvre Musée du Louvre, Paris
MAK MAK-Österreichichisches Museum für angewandte Kunst, Vienna
Naples Museo Archeologico Nazionale, Naples
SBPK Staatsbibliothek zu Berlin - Preussischer Kulturbesitz. Photo © bpk, Berlin
SMPK Staatliche Museen zu Berlin - Preussischer Kulturbesitz. Photo © bpk, Berlin
V&A © V&A [Victoria & Albert Museum, London] Picture Library
Wallace Collection Reproduced by Permission of the Trustees of the Wallace Collection, London

The drawings for ills. 14, 16–19, 46–48, 113, 114, 119, 120, 125–127, 133, 151–155, 177, 199–201, 230, 464, 561–568, 613–616, 619, 620, 647, 648, 656, 658 and 665 were specially prepared by Michael Jones.

1 Philadelphia Museum of Art: Given by the Samuel H. Kress Foundation · 2 Hulton Getty · 3 Naples · 4 Egyptian Museum, Cairo/Kodansha Ltd · 5 Naples/Scala · 7 Museo Archeologico Regionale, Palermo/Publifoto · 8 Museo Archeologico Nazionale, Florence · 9 SMPK, Antikenabteilung/ Jutta Tietz-Glagow · 11 Naples/Leonard von Matt · 12 The Metropolitan Museum of Art, New York, Gift of J. Pierpont Morgan, 1917 (7.190.2076) · 13 Kunsthistorisches Museum, Vienna · 21 Archaeological Museum, Istanbul · 22 Alinari · 25 Cabinet des Médailles, BN · 27 BM · 26, 28, 29 BL (688.l.11) · 30 Naples/Scala · 31 Museo dei Conservatori, Rome/Scala · 32 V&A · 33 BL (4.Tab.56) · 34 © Gordion Furniture Project · 35 Leonard von Matt · 36 Scala · 37 By courtesy of the Trustees of Sir John Soane's Museum, London · 38 Monumenti, Musei e Gallerie Pontificie, Vatican City/Alinari · 39 BL (7703.c.9-15) · 41 BL (604.f.32) · 42 Naples/Scala · 44 Naples · 49 BN · 50 Medelhavsmuseet, Stockholm · 51 Scala · 52 © Peter Clayton · 53 M. Petsas · 55 Reproduced by permission of the Provost and Fellows of Eton College · 56 The Metropolitan Museum of Art, New York. Rogers Fund, 1906 (06.1021.301) · 58 H. Roux ainé, L. Barré and J. Borries, *Herculanum et Pompéi* (1861) · 60 Naples · 61 Monumenti, Musei e Gallerie Pontificie, Vatican City · 62 BL (146.i.22) · 63 Staatliche Antikensammlungen, Munich · 67 Trinity College, Dublin · 68 University Library, Cambridge · 69 BM · 70 formerly Berlin, Staatliche Museen · 71 Universitetets Oldsaksamling, Oslo · 72 Antikvarisk-Topografiska Arkivet (ATA), Stockholm · 73 Great Hall, Winchester Castle/E. Frankl · 74 Biblioteca de El Escorial · 75 Biblioteca Medicea Laurenziana, Florence · 77 Museo Arcivescovile, Ravenna/Gabinetto Fotografico Nazionale, Rome · 78 Iraq Museum, Baghdad · 79 Museo Arcivescovile, Ravenna/Hirmer · 80 Private collection · 81 V&A · 82 SMPK, Museum für Spätantike und Byzantinische Kunst/Liepe · 83 SMPK, Museum für Spätantike und Byzantinische Kunst · 84 National Library of Greece, Athens · 85 Louvre · 86 Lucca Cathedral/Alinari · 87 BM · 88 Bayerische Staatsbibliothek, Munich · 89 Bayerische Staatsbibliothek, Munich · 90 Bayerische Staatsbibliothek, Munich · 91 SBPK, Kunstgewerbemuseum · 92 The State Hermitage Museum, St Petersburg · 93 SBPK, Handschriftenabteilung · 94 By permission of the Master and Fellows, Trinity College, Cambridge · 96 Notre-Dame de Valère, Sion · 97 BN · 99 Antikvarisk-Topografiska Arkivet (ATA), Stockholm · 101 Domschatz, Halberstadt/Schütze/ Rodemann Fotodesign VBK, Halle · 103 Suermondt-Ludwig-Museum, Aachen/© Foto Anne Gold · 104 Alinari · 106 Musée des Arts décoratifs, Paris/Laurent-Sully Jaulmes. Tous droits réservés · 107 Georgina Masson · 108 Martin Hürlimann · 109 © Bernard O'Kane · 110 Archivo Fotográfico, Museo Arqueológico Nacional, Madrid · 111 BL (688.i.3-6) · 115, 116 Instituto de Valencia de Don Juan, Madrid · 117 Fundación Lázaro Galdiano, Madrid · 121 Musée du Moyen-Age Cluny, Paris/© R.M.N., Gérard Blot · 122 BL (ms. Add. 29433, f. 1) · 129 Ulmer Museum, Ulm · 130 Historisches Museum, Basel/Maurice Babey · 131 Ian Whatmore, Romsey · 132 BN · 134 Musées royaux d'Art et d'Histoire, Brussels · 136 Copyright Bibliothèque royale Albert 1er, Brussels (KBR 9967, f. 47v) · 137 Instituto de Valencia de Don Juan, Madrid · 138 Institut de France - Musée Jacquemart-André, Paris, France · 139 Scala · 141 Musée du Moyen-Age Cluny, Paris/© R.M.N., Gérard Blot/C. Jean · 143 Oeffentliche Kunstsammlung Basel, Kunstmuseum/Oeffentliche Kunstsammlung Basel, Martin Bühler · 144 © National Gallery, London · 145 Landeshauptstadt Hannover, Kestner-Museum · 146 Museo Nacional del Prado, Madrid · 147 Musée des Beaux-Arts, Rouen/Giraudon · 148 The Metropolitan Museum of Art, New York, The Friedsam Collection, Bequest of Michael Friedsam, 1931 (32.100.60) · 149 Collegio del Cambio, Perugia/Alinari · 150 © National Gallery, London · 156 Galleria dell'Accademia, Venice/Scala · 157 Alinari · 158 The State Hermitage Museum, St Petersburg · 159 The Courtauld Gallery, London · 160 The Minneapolis Institute of Arts. The William Hood Dunwoody Fund · 161 M. Pagliarini, P. Camporesi, G. Ottaviani and G. Volpato, *Arabesques of the Vatican Loggie* (Rome 1772-75) · 162 Monumenti, Musei e Gallerie Ponitificie, Vatican City/Scala · 163–165 SMPK, Kunstbibliothek · 166, 167 V&A · 168 Palazzo Davanzati, Florence/Scala · 169 BL (1231.m) · 170 Fundación Casa Ducal de Medinaceli, Seville · 171, 172 W. M. Odom, *A History of Italian Furniture* (1918) · 173, 174 The State Hermitage Museum, St Petersburg · 175 Bayerisches Nationalmuseum, Munich · 176 V&A · 178 Schweizerisches Landesmuseum, Zurich · 179 Palazzo Davanzati, Florence/Alinari · 180 Ashmolean Museum, Oxford · 181 Monumenti, Musei e Gallerie Pontificie, Vatican City/Scala · 182 V&A · 183 National Trust Photographic Library/Horst Kolo · 184 Alinari · 185 Archaeological Museum, Istanbul · 186 The State Hermitage Museum, St Petersburg · 187 Institut de France - Musée Jacquemart-André, Paris, France · 188 Museu Municipal de Portalegre · 189 The Metropolitan Museum of Art, New York, Harris Brisbane Dick Fund, 1958 (58.57a-d) · 190 © Kupferstichkabinett, SMPK/Jörg P. Anders · 191 Private collection/Courtauld Institute of Art, London · 192 Palazzo Guicciardini, Florence/ Soprintendenza per i Beni Artistici e Storici, Gabinetto Fotografico, Florence · 193 Biblioteca nacional, Madrid · 194 Scala · 195 Musée du Louvre/© R.M.N., Daniel Arnaudet · 196 O. Elia, *Monumenti della pittura antica scoperti in Italia, La pittura ellenistica-romana, Pompei*, Fasc. I, Sez. III, *Le Pitture della Casa del Citarista* (1938) · 197 Kunstgewerbemuseum, Dresden · 198 Museo dell'Opera di S. Maria del Fiore, Florence · 202 Palazzo Davanzati, Florence/Alinari · 204 Bayerisches National-Museum, Munich · 205, 206 © Rijksmuseum-Stichting, Amsterdam · 207 The Pushkin Museum of Fine Arts, Moscow · 208 Westfälisches Landesmuseum für Kunst und Kulturgeschichte, Münster · 210 Musée Historique de Mulhouse/Christian Kempf · 211 V&A · 212 Biblioteca Comunale Malatestiana, Cesena · 213 Musée de la Renaissance, Écouen/© R.M.N., G. Blot/J.Schormans · 214 BM · 215 V&A · 216 Museum Gustavianum, Uppsala · 217 BM · 220 Louvre/© R.M.N., R. G. Ojeda · 222 Historisches Museum, Basel/Maurice Babey · 222 V&A · 223 National Museum, Copenhagen · 225 Hessisches Landesmuseum, Darmstadt/HLM, Werner Kumpf · 226 National Trust Photographic Library/Angelo Hornak · 229 Musée Paul Dupuy, Toulouse/the author · 231 Lacock Abbey, courtesy Anthony Burnett-Brown Esq. · 232 National Trust Photographic Library/John Bethell · 233 Germanisches Nationalmuseum, Nuremberg · 234 Alinari · 236 BM · 240 Centraal Museum, Utrecht · 241 Fritz von der Schulenburg/The Interior Archive (Property: Ham House) · 242 V&A · 243 Collection of the Duke of Northumberland · 244 Private collection · 245 Wallace Collection · 246 Louvre/© R.M.N., Arnaudet · 247 Scala · 248 © Christie's Images Ltd 1999 · 249 V&A · 250 Sotheby's, London · 251 National Archaeological Museum, Athens/Sir John Boardman · 252, 253 Cà Rezzonico, Venice · 254 The Royal Collection, © 1999 Her Majesty Queen Elizabeth II · 255 The J. Paul Getty Museum, Los Angeles [Attributed to André-Charles Boulle with medallions after Jean Varin, cabinet on a stand, c. 1675-80. Oak veneered with ebony, pewter, tortoiseshell, brass, ivory, horn, boxwood, pear, thuya, stained and natural sycamore, satinwood, beech, amaranth, cedar, walnut, mahogany, ash; with drawers of lignum vitae; painted and gilded wood; bronze mounts. H 7ft 6½ in.; w 4 ft 11½ in.; D 2 ft 2¼ in. (H 22.9 cm; w 151.2 cm; D 66.7 cm)] · 256 BM · 259 Alexander Zielcke · 260 V&A · 261 © photo Nationalmuseum, Stockholm · 262 Private collection, UK · 263 National Trust Photographic Library/Nadia MacKenzie · 265 © Rijksmuseum-Stichting, Amsterdam · 266 Mainfränkisches Museum, Würzburg, Germany · 267 Museu Nacional de

Arte Antigua, Lisbon · **268** V&A · **269** BL (LR.300.c.6) · **270** Museu Nacional de Arte Antigua, Lisbon · **271** V&A · **272** BM · **274** © Christie's Images Ltd 1999 · **275** Châteaux de Versailles et de Trianon/© R.M.N., Blot/Lewandowski · **276** V&A/Pip Barnard · **277** Museo Nacional de Artes Decorativas, Madrid · **278** Leeds Museums and Galleries (Temple Newsam House), UK/ Bridgeman Art Library, London · **279** De Danske Kongers Kronologiske Samling, Rosenborg · **280** The Metropolitan Museum of Art, New York, Gift of Mrs. Russell Sage, 1910 (10.125.81) · **281** BM · **282** Abbey of Pomposa · **283** De Danske Kongers Kronologiske Samling, Rosenborg, Copenhagen · **284** V&A · **285** Leeds Museums and Galleries (Temple Newsam House), UK · **286** V&A · **289** © Crown copyright, RCHME · **291** The National Gallery of Art, Washington. Samuel H. Kress Collection · **292** © Jarrold Publishing, Neil Jinkerson · **293** The Country Life Picture Library · **296** Leeds Museums and Galleries (Temple Newsam House), UK · **297** V&A · **298** Blair Castle. The Duke of Atholl/White Horse Studios · **299** The Country Life Picture Library · **300** V&A · **301** RSA, London · **302** V&A/Pip Barnard · **303** From the Collection at Althorp · **304** National Trust Photographic Library/Nadia MacKenzie · **305** Louvre · **307** BN · **306** Cooper-Hewitt, National Design Museum, Smithsonian Institution/Art Resource, New York. Purchased for the Museum by the Advisory Council 1921-6-168 [Designer: Gilles-Marie Oppenord (1672–1742). Engraver: Charles Nicolas Cochin the elder (1688–1754). French, early 18th century. Design for Tapestry Dedicated to the Seasons, from 'Wandfüllung', c. 1750. Etching on cream laid paper, 10½ × 13⅜ inches (267 × 340 mm)] · **308** BN · **310** SMPK, Kunstgewerbemuseum · **311** Private collection · **312** Leeds Museums and Galleries (Temple Newsam House), UK · **313** Hessische Hausstiftung, Museum Schloss Fasanerie, Eichenzell bei Fulda · **314** V&A · **315** The Metropolitan Museum of Art, New York, The Leyland and Emma Sheafer Collection, Bequest of Emma A. Sheafer, 1973 (1974.356.119) · **316** Louvre/© R.M.N. · **317** Neues Palais, Potsdam. Stiftung Preussische Schlösser und Gärten, Berlin-Brandenburg · **318** Museo Correr, Venice · **321** National Museum of Ireland, Dublin · **322** V&A · **323** Fundação Ricardo do Espirito Santo Silva, Lisbon · **324** Wallace Collection · **326** Bayerische Verwaltung der staatlichen Schlösser, Gärten und Seen Fotoarchiv/G. Schmidt · **327** BL (147.i.14) · **328** BL (147.i.15) · **330** By kind permission of the Marquess of Tavistock and the Trustees of the Bedford Estate · **331** Ste Marguerite, Paris/© Photothèque des Musées de la Ville de Paris · **333** Dr Andrew T. Stoga, Lazienki, Warsaw · **334** V&A · **335** BN · **336** The Metropolitan Museum of Art, New York, Purchase, Joseph Pulitzer Bequest, 1973 (1973.38) · **339** Wallace Collection · **340** The J. Paul Getty Museum, Los Angeles · **341** V&A · **342** Wallace Collection · **343** D. Krenker, T. von Lüpke and H. Winnefeld, Baalbek ergebnisse der Ausgrabung und der Untersuchungen in den Jähren 1898 bis 1905 (1923) · **344** Wallace Collection · **345** Musée Condé, Chantilly/Giraudon · **346** Gripsholm Castle · **347** V&A · **348** Wallace Collection · **349** National Gallery of Canada, Ottawa. Purchased, 1984 · **351** © Rijksmuseum-Stichting, Amsterdam · **352** National Trust Photographic Library/John Bethell · **353** Châteaux de Versailles et de Trianon/© R.M.N., Varga · **354** V&A · **355** The Metropolitan Museum of Art, New York · **356** Châteaux de Versailles et de Trianon/© R.M.N., Varga · **357** The State Hermitage Museum, St Petersburg/Ministry of Culture · **359** National Trust Photographic Library/Bill Batten · **360** Catherine Palace, Pushkin/Ministry of Culture · **361** Wallace Collection · **362** The Metropolitan Museum of Art, New York, Bequest of William K. Vanderbilt, 1920 (20.155.12) · **363** Wallace Collection · **364** Fundação Calouste Gulbenkian, Museu, Lisbon/Arquivo Fotografico · **339** M. Pagliarini, P. Camporesi, G. Ottaviani and G. Volpato, Arabesques of the Vatican Loggie (Rome 1772–75) · **367** © Spencer House, London · **368** The State Hermitage Museum, St Petersburg/Ministry of Culture · **369** Château de Fontainebleau · **370** Musée des Arts décoratifs, Paris · **372** Cooper-Hewitt, National Design Museum, Smithsonian Institution/Art Resource, New York. Gift of the

Countess Costantini, 19246-1 [Side Chair in the style of Michaelangelo Pergolesi, late 18th century, probably Italy. Wood, paint, gilding, upholstery] · **375** Cooper-Hewitt, National Design Museum, Smithsonian Institution/Art Resource, New York. Gift of the Council, 1921-6-362(5) [D175] [Designer: Michel (French, active 1785). Engraver: Jacques Juillet (French, 1739–1817). French, second half of 18th century. 'Design for a Wall Sconce', plate 5 of IIe Cahier d'Arabesques à l'usage des artistes..., Paris: Mondhare. Plate: 14⅜ × 7¾ inches (366 × 254 mm). Sheet: 15¾ × 10 inches (400 × 254 mm)] · **376** By courtesy of the Trustees of Sir John Soane's Museum, London · **377** Châteaux de Versailles et de Trianon/© R.M.N. · **378** Harewood House. The Earl and Countess of Harewood · **379** Château de Fontainebleau · **382** Catherine Palace, Pushkin/Ministry of Culture · **383** Courtesy Ordine Mauriziano, Patrimonio Storico Culturale, Turin · **384** © Crown copyright. RCHME · **385** © Rijksmuseum-Stichting, Amsterdam · **386** The Metropolitan Museum of Art, New York, Gift of John Richardson, 1992 (1992.173.1), photograph © 1993 The Metropolitan Museum of Art · **387** Châteaux de Versailles et de Trianon/© R.M.N. · **388** Louvre · **389** Fritz von der Schulenburg/The Interior Archive · **390** Royal Library, Stockholm · **391** Monumenti, Musei e Gallerie Pontificie, Vatican City/Scala · **393** Kunstindustrimuseet, Copenhagen/© Ole Woldbye, Copenhagen · **395** Kunstindustrimuseet, Copenhagen · **397** MAK · **398** The Stapleton Collection, London, UK · **399** H. Blairman & Sons Ltd, London · **400** Didier Aaron (London) Ltd · **401** The Royal Collection © 1999 Her Majesty Queen Elizabeth II · **402** Louvre/© R.M.N. · **403, 404** The World of Interiors/Simon Upton · **405** The Minneapolis Institute of Arts. The William Hood Dunwoody Fund · **407** Collection of the New-York Historical Society, New York City · **408** Cooper-Hewitt, National Design Museum, Smithsonian Institution/Art Resource, New York, Bequest of The Reverend Alfred Duane Pell, by transfer from the National Museum of American History, Smithsonian Institution, 1991-31-2 [Jewel cabinet, 1824–26, France. Manufactured at the Sèvres Porcelain Factory. Porcelain with enameled and gilded decoration, gilt bronze, glass, wood] · **410** Museum, Vergina/the author · **412** The Metropolitan Museum of Art, New York, Gift of Francis Hartman Markoe, 1960 (60.29.1ab) · **414** © Christie's Images Ltd 1999 · **415** Board of Trustees of the National Museums and Galleries on Merseyside (Walker Art Gallery, Liverpool) · **416** © Edizione Gribaudo, Cavallermaggiore · **417** Bayerische Verwaltung der staatlichen Schlösser, Gärten und Seen, Munich · **418** The Metropolitan Museum of Art, New York, Gift of J. Pierpont Morgan, by exchange (1987.62.1) · **419** The State Hermitage Museum, St Petersburg/Ministry of Culture · **422** Monticello/Thomas Jefferson Memorial Foundation Inc. · **423** Musée Antoine Vivenel, Compiègne · **424** Brighton · **425** Ministry of Culture · **426** V&A · **427** The Royal Collection © 1999 Her Majesty Queen Elizabeth II · **428** The State Hermitage Museum, St Petersburg/Ministry of Culture · **429** The Stapleton Collection, London, UK · **430, 431** Stiftung Weimarer Klassik/Museen · **432** Châteaux de Versailles et de Trianon/© R.M.N. · **433** Château de Fontainebleau/© R.M.N., Lagiewski · **434** The Metropolitan Museum of Art, New York, Purchase, 1969, Gift of Mrs. Russell Sage, 1910, and other donors (69.203). Photograph © 1986 The Metropolitan Museum of Art · **435** Staatliche Kunstsammlungen Dresden, Museum für Kunsthandwerk · **436** Schloss Montbijou, Berlin · **437** Hermitage Antiques PLC, Pimlico Road, London · **438** Bayerische Verwaltung der staatlichen Schlösser, Gärten und Seen, Munich · **439** © Landeshauptstadt Hannover, Kestner-Museum/Ernst · **440** Private collection · **441** Landeshauptstadt Hannover, Kestner-Museum/Friedrich · **442** Musée Carnavalet, Paris/© Photothèque des Musées de la Ville de Paris, photo Habouzit · **445, 446** Kunsthistorisches Museum, Vienna · **447** National-museum, Copenhagen · **448** The Metropolitan Museum of Art, New York, Gift of C. Ruxton Love, 1960 (60.4.1) · **449** Musée Carnavalet/© Photothèque des Musées de la Ville de Paris, photo Joffre/Degraces · **451** Destroyed in the 1939–45 war · **452** By courtesy of the Trustees of

Sir John Soane's Museum, London · **453** Kund-industrimuseet, Copenhagen/© Ole Woldbye, Copenhagen · **454** Museo de la Vida en Palacio, Palacio Real, Aranjuez. Copyright © Patrimonio Nacional · **456** The Stapleton Collection, London, UK · **457** Museo de Pontevedra · **458** Louvre/© R.M.N., Vivien Guy · **460, 461** The Stapleton Collection, London, UK · **462** A. F. Kersting · **463** BL (61.b.15(2)) · **467** The Stapleton Collection, London, UK · **468** V&A/Pip Barnard, Courtesy of the Worshipful Company of Joiners & Ceilers · **469** Collection of The Duke of Northumberland · **470** Private collection · **471** Sotheby's, London · **472** Leeds Museums and Galleries (Temple Newsam House), UK · **474, 475** The Stapleton Collection, London, UK · **476** V&A · **477** Private collection · **478** © Nordiska museets bilbyrå, Stockholm · **480** V&A · **481** The Bernadotte Gallery, The Royal Palace, Stockholm. The Royal Collections/Lennart af Petersens · **482** Petit Palais, Musées des Beaux-Arts de la Ville de Paris/© Photothèque de la Ville de Paris, photo Pierrain · **483** Copyright reserved · **484** Schloss Hohenschwangau; Wittelsbacher Ausgleichsfonds Inventärverwaltung, Schloss Nymphenburg, Munich · **485** Musée des Arts décoratifs, Paris/Laurent-Sully Jaulmes. Tous droits réservés · **486** Musée d'Orsay, Paris/© R.M.N., Guy Vivien · **487** The Stapleton Collection, London, UK · **489, 490** V&A · **491** The Metropolitan Museum of Art, New York, Rogers Fund 1926 (26.54) · **492** BL (ms. Add. 49598, f. 51v) · **493** Birmingham Museums & Art Gallery · **494** Cheltenham Art Gallery and Museums · **495** National Gallery of Ireland, Dublin · **496** The Stapleton Collection, London, UK · **497** The Henry E. Huntington Library and Art Gallery, San Marino, Calif. · **498** Private collection · **499** Wallace Collection · **500** © Musée des Beaux-Arts, Dijon · **501** V&A · **502** Museo Nacional de Artes Decorativas, Madrid · **503** The Stapleton Collection, London, UK · **504** Sotheby's, London · **505** The Brooklyn Museum of Art, Gift of Mrs. Ernest Victor · **506** National Trust Photographic Library/Michael Caldwell · **507** Sydsjaellands Museum · **508** Fine Arts Museum of San Francisco, Gift of Mr. and Mrs. John D. Rockefeller 3rd, 1979.7.67 · **509** Leeds Museums and Galleries (Temple Newsam House), UK · **510** © Christie's Images Ltd 1999 · **511** The Metropolitan Museum of Art, New York, Friends of the American Wing Fund, **1986** (1986.47.1) · **512** V&A · **513** Châteaux de Versailles et de Trianon/© R.M.N. · **514** V&A/Pip Barnard · **515** Statens Museum for Kunst, Copenhagen · **516** V&A · **517** Private collection/photo The Stapleton Collection, London, UK · **518** © photo Nationalmuseum, Stockholm · **519** Reproduced by permission of the Provost and Fellows of Eton College · **520** Landesmuseum, Trier · **521** BM · **522** Preston Manor, Brighton · **525** Private collection. Courtesy The Iveagh Bequest, Kenwood, London · **526** Musée de l'Armée, Paris · **527** Sotheby's, London · **528** Louvre/© R.M.N., Guy Vivien · **529** Stiftung Preussische Schlösser und Gärten Berlin-Brandenburg/Bildarchiv, Potsdam · **530, 531** MAK · **532** MAK · **533** Museen des Mobiliendepots, Kaiserliches Hofmobilien-depot, Vienna · **534** Museum Oskar Reinhart am Stadtgarten, Winterthur · **535** Sammlungen des Fürsten von Liechtenstein, Schloss Vaduz/Johann Kräftner · **536** The Metropolitan Museum of Art, New York, Rogers Fund 1978 (1978.413) · **537** Kunstindustrimuseet, Copenhagen/© Ole Woldbye, Copenhagen · **538** Collection of the Kentucky Museum, Western Kentucky University · **539** © photo Nationalmuseum, Stockholm · **540** Kunstindustrimuseet, Copenhagen/© Ole Woldbye, Copenhagen · **541–543** Private collection · **544** MAK · **545** Stedelijk Museum, Amsterdam. © DACS 1999 · **547** Christie's, New York. © FLC/ADAGP, Paris and DACS, London 1999 · **548** Brighton · **549** Private collection. © DACS 1999 · **550** The Brooklyn Museum of Art, Gift of the Italian Government · **551** Collection Mr and Mrs Christopher Forbes · **552** Collection, The Museum of Modern Art, New York. Gift of the manufacturer, Herman Miller Furniture Co., USA. · **553, 554** The Knoll Group · **555** Herman Miller · **556** Cassina S.p.A, Milan · **557** The Stapleton Collection, London, UK · **560** BL (568.g.7/1-2) · **569** The Metropolitan Museum of Art, New York, Gift of Mrs. J. Insley Blair, 1948 (48.71) · **570** Museo Nacional de Artes Decorativas, Madrid · **571** V&A · **572** The Royal

Collections/Erik Liljeroth · **573** BL (56.i.7) · **574** V&A · **575** Ashmolean Museum, Oxford · **576, 577** V&A · **578** Cooper-Hewitt, National Design Museum, Smithsonian Institution/Art Resource, New York. Museum purchase, Friends of the Museum Fund, 1938-88-3487 [Nicola Fiore (dates unknown), Italian, 18th century. Wall decoration for Ante-room to the Queen's Bathroom, Palazzo Reale, Caserta, Italy, 1775. Pen and brush and black ink, brush watercolour, white gouache, on off-white laid paper, 24½ × 21¹¹⁄₁₆ inches (623 × 545 mm)] · **579** The National Trust, Waddesdon Manor/H. Maertens · **580** The National Trust. Calke Abbey, Derbyshire (Harper-Crewe Collection) · **581** Louvre/© R.M.N., Arnaudet · **582** The Royal Palace, Stockholm. The Royal Collections/Håkan Lind · **584** © Reserved · **585** Brighton · **586** The Metropolitan Museum of Art, New York. The Jack and Belle Linsky Collection, 1982 (1982.60.57) · **587, 589** The Royal Collection © 1999 Her Majesty Queen Elizabeth II · **588** The State Hermitage Museum, St Petersburg/Ministry of Culture · **590** The Stapleton Collection, London, UK · **591** BN · **592** The Royal Collection © 1999 Her Majesty Queen Elizabeth II · **593** The Metropolitan Museum of Art, New York, Rogers Fund, 1941 (41.82) · **594** Private collection · **595** Brighton · **597** Museo degli Argenti, Pitti Palace, Florence · **599** Palazzo Corsini, Rome · **600** Private collection · **601, 602** © photo Nationalmuseum, Stockholm · **603** The Metropolitan Museum of Art, New York, Gift of Robert Lehman, 1941 (41.188) · **604** Ministry of Culture · **606** V&A · **607** Louvre · **608** O. Anrather · **609, 610** The Faringdon Collection Trust, Buscot Park · **611** Private collection/Nordén Auktioner, Stockholm · **612** Brighton · **617** Private collection · **618** V&A · **622** Brighton · **623** The Metropolitan Museum of Art, New York, Anonymous Gift, 1968 (68.207) · **624** V&A · **625** The National Trust for Scotland Photographic Library. Crown Copyright: Royal Commission on the Ancient and Historical Monuments of Scotland · **626** Virginia Museum of Fine Arts, Richmond. Gift of The Sydney and Frances Lewis Foundation. Photo: Katherine Wetzel. © Virginia Museum of Fine Arts [Frank Lloyd Wright (1867–1959). Side chair, 1904. Oak, leather upholstery. 40¼"H × 15"W × 18¾"D (102.2 cm × 38.1 cm × 47.6 cm). Note: Unsigned; from Frank Lloyd Wright's residence in Oak Park, Illinois] © ARS, NY and DACS, London 1999 · **627** Kunstindustrimuseet, Copenhagen/© Ole Woldbye, Copenhagen · **628** BM · **629** National Gallery of Victoria, Melbourne. Felton Bequest, 1977 · **630** V&A · **631** Virginia Museum of Fine Arts, Richmond. Gift of Sydney and Frances Lewis. Photo: Katherine Wetzel. © Virginia Museum of Fine Arts [Tiffany Studios (New York, 1900–1938). Cobweb Lamp, ca. 1904. Leaded glass, glass mosaic tiles, bronze. 29½"H × 20"D (74.9 × 50.8 cm)] · **632** Crown Copyright: Royal Commission on the Ancient and Historical Monuments of Scotland · **633** Brighton · **634, 635** Private collection · **601** Private collection · **636** Philadelphia Museum of Art: The Louise and Walter Arensberg Collection · **637** Brighton. © ADAGP, Paris and DACS, London 1999 · **638** Brighton · **639** Virginia Museum of Fine Arts, Richmond. Gift of The Sydney and Frances Lewis Foundation. Photo: Katherine Wetzel. © Virginia Museum of Fine Arts [Louis Süe (1875–1968) and André Mare (1885–1932). Cabinet, 1927. Ebony, mother-of-pearl, silver. 61⅞"H × 35⅜"W × 15¾"D (156.6 cm × 89.8 cm × 40 cm). Note: Paper label on base: Chenue Emballeur, 5 Rue de la Terrasse Paris] © ADAGP, Paris and DACS, London 1999 · **640** Photograph courtesy of Christopher Wood · **641** Virginia Museum of Fine Arts, Richmond. Gift of The Sydney and Frances Lewis. Photo: Katherine Wetzel. © Virginia Museum of Fine Arts [Eileen Gray (born Ireland, 1879–1976). Floor Lamp, 1923. Lacquered wood, painted parchment. 73"H × 20½"D (185.4 cm × 52 cm). Note: Unsigned] © DACS 1999 · **642** Musée des Arts décoratifs, Paris/Laurent-Sully Jaulmes. Tous droits réservés · **643** Virginia Museum of Fine Arts, Richmond. Gift of The Sydney and Frances Lewis. Photo: Linda Loughran. © Virginia Museum of Fine Arts [Jean Goulden (1878–1947). Clock, 1929. Silvered bronze, enamel, marble. 19½"H × 8"W × 7½"D (49.5 cm × 20.3 cm × 19 cm). Note: Signed, dated, numbered on lower rear, XLVII 29 Jean Goulden] © ADAGP, Paris and

DACS, London 1999 · **644** Virginia Museum of Fine Arts, Richmond. Gift of Sydney and Frances Lewis. Photo: Katherine Wetzel. © Virginia Museum of Fine Arts [Eileen Gray (1879–1976). *Pirogue Chaise Longue* (Canoe Sofa), ca. 1919–1920. Lacquered wood, silver leaf. 28⅜"H × 106⁹⁄₁₆"W × 29⁹⁄₁₆"D (72 cm × 270 cm × 64.9 cm). Note: Not signed. For the Paris apartment of couturière Suzanne Talbot] © ADAGP, Paris and DACS, London 1999 · **645** Museum Villa Stuck (Schenkung Ziersch), Inv. Nr. M 91 1-5/Wolfgang Pulfer, Munich · **646** Brighton · **649** Hessisches Landesmuseum Darmstadt/Sina Althöfer ·

650 F. Marcilhac · **651** Private collection · **652** V&A · **653** Private collection/W. Feldstein Jr · **654** Casa-Museu Gaudí, Barcelona · **656** Brighton · **657** © Hunterian Art Gallery, University of Glasgow, Mackintosh Collection · **659** Museum Villa Stuck, Munich · **660** The State Hermitage Museum, St Petersburg · **661** Residenzmuseum, Munich/the author · **662** Publifoto · **663** BN · **664, 666** MAK · **667** Brighton · **668** BL (1231.m) · **669** Brighton · **670** Collection du Mobilier national, Paris, cliché du Mobilier national/ Jean-Claude Vaysse · **671** Musée des Arts décoratifs, Paris/Laurent-Sully Jaulmes. Tous droits réservés

· **672** Brighton. © ADAGP, Paris and DACS, London 1999 · **673** Private collection. © DACS 1999 · **674** V&A/Pip Barnard · **675** Virginia Museum of Fine Arts, Richmond. Gift of Sydney and Frances Lewis. Photo: Katherine Wetzel. © Virginia Museum of Fine Arts [Clément Rousseau (1872–?). *Pair of Chairs*, ca. 1925. Rosewood, sharkskin, upholstery, mother-of-pearl. Ea.: 36½"H × 17"W × 20½"D (92.7 cm × 43.2 cm × 52.1 cm). Note: Signed on inside front frame of seat supports, *Clément Rousseau*] · **676** Virginia Museum of Fine Arts, Richmond. Gift of Sydney and Frances Lewis. Photo: Katherine Wetzel.

© Virginia Museum of Fine Arts [Emile-Jacques Ruhlmann (1879–1933). *'Sun' Bed*, 1930. Macassar ebony, white oak. 77"H × 83½"W × 85¾"D (195.6 cm × 212.1 cm × 217.8 cm). Note: Signed *Ruhlmann* on back of headboard & twice on inside of footboard] · **677, 678** Courtesy Archivio Fotografico Gio Ponti, Milan, and Immaginazioni, s.r.l., Milan · **679** V&A · **680** Brighton. © Salvador Dalí–Foundation Gala-Salvador Dalí/DACS 1999

Index

Main mentions in the text are printed in **bold**; illustration numbers are printed in *italic*.

Buildings and institutions are indexed under place. Full names, dates, and principal occupations of individuals are given where known. The examples of ornament on furniture given here are not comprehensive, merely for purposes of illustration.

The Contents list (pp. 5–6) is a rudimentary index of main subjects in the order in which they occur in the book.